# *Readings*

# *in Art History*

## Third Edition

### VOLUME II • THE RENAISSANCE TO THE PRESENT

*Edited by Harold Spencer*

Charles Scribner's Sons, New York

Library of Congress Cataloging in Publication Data
Main entry under title:

Readings in art history.

    Includes bibliographical references and index.
    Contents: v. 1. Ancient Egypt through the Middle
ages—v. 2. The Renaissance to the present.
    1. Art—History—Addresses, essays, lectures.
I. Spencer, Harold, 1920–    .
N5300.R38  1982      709         82–5521
ISBN 0-02-414390-1

5 7 9 11 13 15 17 19       20 18 16 14 12 10 8 6 4

Printed in the United States of America.

# Contents

v

# CONTENTS

# READINGS IN ART HISTORY

## Third Edition

### VOLUME II

# INTRODUCTION

T he aim of this anthology is to assemble a convenient and useful collection of modern writings on the history of Western art. As a supplement to the texts usually assigned in introductory courses in art history, this anthology should prove at least a partial answer to the familiar problem of providing multiple copies of supplementary readings on library reserve shelves. But, apart from its use in surveys of Western art, this anthology will offer a valuable set of readings to any student of Western civilization or of the creative life.

Although each selection stands alone on the merits of its content, the reader will soon discover that patterns tend to develop throughout the anthology and at some level link themes from a number of selections into a logical relationship across time and space. The context of art, comprising a wide range of cultural forces that affect the artist's creation, is one such linkage. In the selection by the Krautheimers, for example, the role of the Italian humanists in shaping Renaissance tastes and the role of the guild system in matters pertaining to art are vividly sketched, while the economics and the factors of quality control in the production of Quattrocento painting are revealed in Baxandall's discussion of the contractual relations between artist and patron. The connection between the literary culture and the visual arts is the focus of Peckham's essay on Constable and Wordsworth, but this general theme also surfaces in Ettlinger's article on David and in Mras' selection on Delacroix. The influence of a classical education on the neo-classical artist is a major theme in the Ettlinger selection, recalling the persistent thread of classical tradition that can be found, too, in the selections by the Krautheimers, Freedberg, Ackerman, Pevsner, Rosenberg, Wittkower, Mras, Elsen, and others. And finally, Ashton's emphasis on the artist's milieu of galleries and critics in the middle decades of the twentieth century provides rewarding comparisons with the selections by Baxandall and the Krautheimers.

Another series of interrelationships can be found in some of the

3

selections that deal with aspects of the Baroque. The brief excerpt from Wölfflin's *Principles of Art History* emphasizes form-concepts in distinguishing between Renaissance and Baroque styles, whereas the article that follows it, John Rupert Martin's essay on the Baroque, stresses the significance of Baroque content and iconography. A few selections later, Rudolf Wittkower treats the sculpture of the great Baroque master, Bernini, primarily in terms of style, calling attention to his pictorial approach. And both Martin and Wittkower call attention to some of Wölfflin's ideas. This kind of cross-reference occurs again and again.

Many of the selections in this volume focus on individual artists. Here there has been an attempt to assemble readings that would demonstrate a variety of critical approaches as well as present a variety of artists. The selection on Lorenzo Ghiberti by Richard Krautheimer and Trude Krautheimer-Hess places this artist in the immediate setting of the crucial competition he won at the beginning of the Renaissance and in the extended setting of humanist learning and the classical tradition. This multiple scrutiny brings the artist into focus and at the same time reveals many essential features of the Italian Renaissance of the fifteenth century. Sydney Freedberg brings an intricate, involuted analysis to the intellectual style of Raphael and the humanist program for his frescoes in the Stanza della Segnatura. The result is harmonic. Anthony Blunt's essay on Michelangelo develops a restricted context in which the artist's weaving of Neoplatonic elements through his ideas about art sets an introspective mood, while Jakob Rosenberg's selection on Rembrandt places that artist in the broad context of his times. The selection from George P. Mras, *Eugène Delacroix's Theory of Art*, examines the art of this important nineteenth-century master in the light of both tradition and innovation, offering a balanced view of the ambiguities inherent in the conventional classical-romantic confrontation.

As in the first volume, the editor has chosen readings that range widely in the degree of difficulty they present to the reader, thereby, it is hoped, increasing the flexibility of the anthology.

In some instances it has been necessary to reduce or eliminate footnotes that appeared in the original publications, but this practice has been kept to a minimum. In some cases the requirements of available space were involved, in others it was a matter of special problems—such as footnotes in the selection interlocking too firmly with footnotes and text material elsewhere to permit proper adjustments—that determined the editing. In many instances footnotes

## Introduction

leading to specialized study were retained, even though the anthology is aimed primarily at the undergraduate level.

Illustrations, of course, have been limited by necessity, but the editor has included as many as possible in an effort to enhance the usefulness of the anthology. As in the first volume, they have been placed as close as possible to relevant portions of the text, which should prove a welcome convenience. Now and then, illustrations from one selection will be found to relate, directly or indirectly, to another reading, and the choice of illustrations also permits comparisons and suggests problems of art history beyond those examined in the anthology itself.

The headnotes are intended chiefly as bibliographical devices, and, being brief, do not impinge on space better served by the selected readings than by the intrusions of the editor. Except where foreign publications are cited for explanatory purposes relating to particular developments, the bibliographical references are limited to works in English. No anthology can hope to serve perfectly the needs of every situation and the habit of every instructor, but there is enough variety and quality in these selections to meet most situations at least part way.

Although the sequence of the selections approximates customary chronology, thus correlating with traditional periods, some selections will be found to reach beyond the limits of a single period or movement.

No project of this kind is ever completed without the assistance of many persons. It would be ungracious to conclude without acknowledging these contributions: scholars too numerous to mention, whose ideas have become an essential part of my own attitudes and convictions; my teachers, colleagues, and students over the years; my colleague, Bette Talvacchia, who offered advice on this revision; Helen McInnis and Jennifer Crewe at Scribners for help in putting the anthology together; and my wife, Editha, whose sensitive perceptions are resources I continue to value more than she suspects.

HAROLD SPENCER

# 1. JAN VAN EYCK

# AND ROGER VAN DER WEYDEN

## *Erwin Panofsky*

### INTRODUCTION

The art of Jan van Eyck and Roger van der Weyden, while resonant in continuities from the northern Gothic tradition, also brilliantly exemplifies the accelerated growth and refinement of pictorial means that characterized fifteenth-century painting in the Lowlands. At the same time, in Italy, early Renaissance artists were transforming painting in equally significant ways. The occasional question of whether Jan van Eyck and Roger van der Weyden should be designated as "Renaissance" or "Late Gothic" painters smacks of mere academic exercise—however entertaining it may be—and the very existence of the question surely implies some currency of ambivalence regarding the validity of extending the idea of a Renaissance into the Lowlands during the early fifteenth century. But whatever the reader's preference in this matter, the following selection by Erwin Panofsky should offer welcome observations on the painting styles and social status of both Jan van Eyck and Roger van der Weyden, as well as numerous indications of the productive interlacings of tradition and innovation in early Netherlandish art.

The translation into English (1967–1975) of Max J. Friedländer's essential fourteen-volume work, *Die altniederlandische Malerei* (1924–1937) joins the same author's *Early Netherlandish Painting from Van Eyck to Bruegel*, 2nd ed. (1965), and Erwin Panofsky's *Early Netherlandish Painting*, 2 vols. (1953) as the best general sources for further information on the subject. Other studies of special interest are Erwin

Panofsky, "Jan van Eyck's Arnolfini Portrait," *The Burlington Magazine*, LXIV (March 1934), 117–127; Millard Meiss, "Light as Form and Symbol in Some Fifteenth-Century Painting," *The Art Bulletin*, XXVII, 3 (1945), 175–181; by the same author, "Highlands in the Lowlands: Jan van Eyck, the Master of Flemalle and the Franco-Italian Tradition," *Gazette des Beaux-Arts*, series 6, LVII (1961), 273–314; Jules Desneux, "Underdrawings and *Pentimenti* in the Pictures of Jan van Eyck," *The Art Bulletin*, XL, 1 (1958), 13–22; Karl M. Birkmeyer, "The Arch Motif in Netherlandish Painting of the Fifteenth Century," *The Art Bulletin*, XLIII, 1–2 (1961), 1–20, 99–112.

Other works relating to these artists are Margaret Whinney, *Early Flemish Painting* (1968), an introductory survey of the fifteenth- and early sixteenth-century painting in the Low Countries; L. Naftulin, "Note on the Iconography of the Van Der Paele Madonna," *Oud Holland*, LXXXVI, 1 (1971), 3–8; Lotte B. Philip, *The Ghent Altarpiece and the Art of Jan Van Eyck* (1972); Ann M. Schulz, "The Columba Altarpiece and Roger Van Der Weyden's Stylistic Development," *Munchner Jahrbuch der Bildenden Kunst*, series 3, XXII (1971), 63–116; and Sir Martin Davies, *Rogier van der Weyden* (1972).

In addition, there are Elizabeth Dhanens, *Hubert and Jan van Eyck* (1973); Lorne Campbell, *Van der Weyden* (1980); Carol J. Purtle, *The Marian Paintings of Jan van Eyck* (1982); J. L. Ward, "Hidden Symbolism in Jan van Eyck's Annunciations," *The Art Bulletin*, LVII, 2 (1975), 196–220; C. H. McCorkel, "Role of the Suspended Crown in Jan van Eyck's *Madonna and the Chancellor Rolin*," *The Art Bulletin*, LVIII, 4 (1976), 516–520; J. Duverger, "Jan van Eyck as Court Painter," *Connoisseur* 194 (March 1977), 172–179; Theodore H. Feder, "A Reexamination Through Documents of the First Fifty Years of Roger van der Weyden's Life," *The Art Bulletin*, XLVIII, 3–4 (1966), 416–431; S. N. Blum, "Symbolic Invention in the Art of Rogier van der Weyden," *Konsthistorisk Tidskrift*, XLVI (December 1977), 103–122; B. G. Lane, "Rogier's Saint John and Miraflores Altar-pieces Reconsidered," *The Art Bulletin*, LX, 4 (1978), 655–672; A. H. van Buren, "Canonical Office in Renaissance Painting: More About the Rolin Madonna," *The Art Bulletin*, LX, 4 (1978), 617–633; *Rogier van der Weyden—Rogier de la Pasture*, Exhibition Catalogue, City Museum of Brussels (1979), which contains several short essays on the artist and his times; and P. H. Jolly, "Rogier van der Weyden's Escorial and Philadelphia Cruci-

8

fixions and Their Relation to Fra Angelico at San Marco," *Oud Holland,* 95, 3 (1981), 113–126.

# JAN VAN EYCK

Jan van Eyck is first heard of as painter and *varlet de chambre* to John of Bavaria, the unconsecrated Bishop of Liége who, after the death of his brother, William VI of Holland, had usurped the territory of his niece, Jacqueline, and established residence in the Hague. He employed Jan for the decoration of his castle from October 24, 1422 (at the latest) until at least September 11, 1424. And since Jan is already referred to as "master" at the time of his appointment we may assume that he was born not later than *c.* 1390. There is also some doubt as to his birthplace. For many centuries it has been taken for granted that both brothers were born at "Eyck," viz., Maaseyck, some eighteen miles north of Maastricht. Recently it has been proposed that they were natives of Maastricht itself where the name "van Eyck" is not uncommon as a family name. But since the evidence for this hypothesis is as yet inconclusive, I am inclined to accept, for the present, the traditional view.

At the end of his employment in Holland, Jan van Eyck repaired to Bruges, but stayed there for only a short time. On May 19, 1425, he was appointed as painter and *varlet de chambre* to Philip the Good of Burgundy and moved to Lille prior to August 2 of this year. Here he resided, with major and minor interruptions, until the end of 1429, having married, at an undetermined date, a lady of whom nothing is known except that her Christian name was Margaret, that she was born in 1406, and that she presented him with no less than ten children. Soon after, presumably in 1430, he established himself at Bruges for good and spent the rest of his life in a stately house "with a stone front" (acquired in 1431 or 1432), combining the office of a court artist with the normal activities of a bourgeois master painter who would not consider it beneath his dignity to accept such commissions as the coloring and gilding of the statues on the façade of the Town Hall. He died on July 9, 1441.

Throughout the sixteen years of their association the Duke and his painter—the first Early Flemish master to sign his works and,

11

so far as we know, the only one to imitate the nobles in adopting a personal motto, the famous *Als ich chan,* "As best I can," in which becoming pride is so inimitably blended with becoming humility—lived on terms of mutual esteem and confidence. Philip the Good not only admired Jan van Eyck as a great artist but also trusted him as a familiar and a gentleman. As early as 1426 the painter undertook, in the name of his master, certain confidential pilgrimages and "secret voyages," and during the following years he was a member of two embassies to the Iberian peninsula. After two previous marriages, both terminated by death, Philip the Good was still without an heir, and the first of the voyages overseas, lasting from early summer to October, 1427 (when Jan van Eyck received his *vin d'honneur* at Tournai on the eighteenth), was undertaken, it seems, in order to negotiate a marriage with Isabella of Spain, daughter of James II, Count of Urgel. This having failed for reasons unknown, another mission was dispatched to Portugal in order to obtain the hand of the eldest daughter of King John I, also named Isabella. This time the envoys succeeded, though only at the price of two exceedingly rough and dangerous crossings—entailing lengthy stopovers in England on both trips. They started on October 19, 1428, and returned—with the Infanta—as late as December, 1429; the marriage took place on January 10, 1430.

Apart from another "secret mission" in 1436, the Duke of Burgundy honored his painter by at least one personal visit to his workshop, showed him his favor by all kinds of extra payments and an occasional gift of silver cups, exempted him from a general cutback in jobs and salaries decreed in 1426, and acted as godfather by proxy (at the sacrifice of another half dozen silver cups) when a child of Jan's was baptized sometime before June 30, 1434. He even extended his affection beyond the grave. After Jan van Eyck's death his widow received a substantial gratuity "in consideration of her husband's services and in commiseration with her and her children's loss"; and nine years later, in 1450, his daughter Livina (Lyevine) was enabled to enter the Convent of St. Agnes at Maasseyck by a special grant from Philip the Good.

On one occasion, when the bureaucrats in Lille had made some difficulties about Jan's salary, the Duke came down upon them with an order that has the ring of the Italian High Renaissance rather than of the Northern Middle Ages. He enjoined them, under threats of gravest displeasure, to honor the claims of Jan

van Eyck without delay or argument; for he, the Duke, "would never find a man equally to his liking nor so outstanding in his art and science": "nous trouverions point le pareil a nostre gré ne si excellent en son art et science."

What may be dismissed as humanistic hyperbole in Bartolommeo Fazio, who praises Jan van Eyck as a man of literary culture (*litterarum nonnihil doctus*), proficient in geometry, and a master of "all arts that may be added to the distinction of painting," is thus bòrne out by the testimony of Philip the Good. By the very wording of his reprimand (*art et science,* a phrase not uncommon in the early fifteenth century) he implies that the achievement of an artist, and particularly those of his favorite painter, had to be considered not only as a matter of superior skill but also of superior knowledge and intelligence.

This judgment is confirmed by Jan van Eyck's pictures. Only a keen intellectual curiosity could have devoted so much interest to theological texts, chronograms, astronomical details, cabalistic invocations and even paleography. Only a logical mind could have so thoroughly refined and systematized the principle of "disguised symbolism" that in his world, as I expressed it, "no residue remained of either objectivity without significance or significance without disguise." Only the instinct of a historian could have rediscovered the indigenous Romanesque and recaptured its spirit in all its phases and manifestations. And only an imagination controlled and disciplined by geometry, the "art of measurement," could have determined the impeccable proportions of Eyckian architecture.

That Jan was also an expert in alchemy, as Vasari would have it, is of course an assumption derived from the belief that he was the inventor of oil painting. This belief, we know, can no longer be maintained. Yet the fact remains that he must have devised certain improvements unknown before—improvements which enabled him to surpass both in minuteness and in luminosity whatever was achieved by his predecessors, contemporaries and followers. Whether he distilled new varnishes, driers and diluents —and in this case Vasari's reference to alchemy and his amusing tale of Jan's innovations having started with the development of a quick-drying varnish might, after all, contain a grain of truth— or merely applied the processes of the *nouvelle pratique* with greater sophistication, it is difficult to say. Certain it is, however,

that in his pictures the oil technique, though not invented by him, first revealed itself in its full glory, the translucency of the colors— "radiant by themselves without any varnish"—enhanced by an increasingly economical use of lead white which he employed (apart, of course, from the rendering of linen, etc.) for luminary surface accents rather than the construction of plastic form.

From the sheer sensuous beauty of a genuine Jan van Eyck there emanates a strange fascination not unlike that which we experience when permitting ourselves to be hypnotized by precious stones or when looking into deep water. We find it hard to tear ourselves away from it and feel drawn back by what Magister Gregorius, compelled to revisit a statue of Venus again and again although it meant a walk of more than two miles, described as "some kind of magical persuasion." Whoever has tried to give a fair amount of conscientious attention to other paintings hung in the same room will remember that even a Rubens may strike him as "just a painting," a mere semblance as opposed to a reality, when looked at with an eye still carrying the imprint of a Jan van Eyck. In fact, a picture by Jan van Eyck claims to be more than "just a painting." It claims to be both a real object—and a precious object at that—and a reconstruction rather than a mere representation of the visible world.

The first of these claims is stressed by the very treatment of the frames which he invariably provided himself and which have come down to us in at least eight instances. Setting aside the exceptional case of the Ghent altarpiece, these frames are elaborated into complex moldings and painted so as to simulate marble or porphyry. Moreover, this marbleization is carried over to the back of the panel, and carefully lettered inscriptions are seemingly incised into the artificial stone. By this legerdemain, which may seem reprehensible to the purist, Jan van Eyck not only showed off his virtuosity (as did the Limbourg brothers when they fooled the Duc de Berry with the wooden dummy of a gorgeous Book of Hours) but also emphasized and glorified the materiality of the picture. The modern frame is nothing but a device for isolating the picture space from the space of nature. The Late Medieval frame, exemplified by the van Beuningen altarpiece with its carved rosettes, or, more extravagantly, by the "Carrand diptych" with its elaborate gilt tracery, is an ornamental setting which compasses the picture as chased metal does a precious stone. Jan van Eyck's frames are, in a sense, both. In subduing them

coloristically, he stressed the modern idea of the panel as a "picture," that is, the projection plane of an imaginary space. But in transfiguring them into what looks like marble, he retained the idea of the panel as a tangible piece of luminous matter, united with its frame into a complex *objet d'art* composed of many precious materials.

The impression that paintings by Jan van Eyck confront us with a reconstruction rather than a mere representation of the visible world is more difficult to rationalize. Very tentatively, we may say this: the naturalists of the fifteenth century, avid for observation yet in many ways committed to convention, were plagued by the problem of striking a balance between the general and the particular—between the total aspect of a face or hand and the wrinkles of the skin, between the total aspect of a piece of fur or fabric and its individual hairs or fibers, between the total aspect of a tree and its individual leaves. Before Jan van Eyck, these details, if not entirely suppressed, tended to remain distinct from each other as well as from the whole and give the impression either of a whole incompletely differentiated or of a mass of details incompletely unified. The hand of the St. George in the "Madonna van der Paele," however much detailed, remains a totality so that no contradiction is felt between its complexity and the simplicity of the polished armlet from which it emerges (Fig. 1). The face of the Giovanni Arnolfini in the London double portrait, smooth though it is, seems sufficiently rich in detail to harmonize with the intricacies of the plaited Italian straw hat and fur collar.

This Eyckian miracle was brought about by what may be likened to infinitesimal calculus. The High Renaissance and the Baroque were to develop a technique so broad that the details appeared to be submerged, first in wide areas of light and shade and later in the texture of impasto brushwork. Jan van Eyck evolved a technique so ineffably minute that the number of details comprised by the total form approaches infinity. This technique achieves homogeneity in all visible forms as calculus achieves continuity in all numerical quantities. That which is tiny in terms of measurable magnitude yet is large as a product of the infinitesimally small; that which is sizable in terms of measurable magnitude yet is small as a fraction of the infinitely large.

Thus Jan van Eyck's style may be said to symbolize that structure of the universe which had emerged, at his time, from the pro-

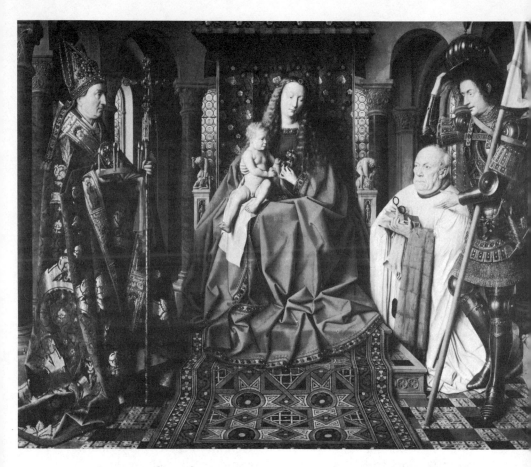

1. Jan van Eyck, *Madonna of Canon van der Paele*, 1436, Approximately 48" x 62" (Musée Communal, Bruges)

longed discussion of the "two infinites"; he builds his world out of his pigments as nature builds hers out of primary matter. The paint that renders skin, or fur, or even the stubble on an imperfectly shaved face seems to assume the very character of what it depicts; and when he paints those landscapes which, to quote Fazio once more, "seem to extend over fifty miles," even the most distant objects, however much diminished in size and subdued in color, retain the same degree of solidity and the same fullness of articulation as do the very nearest. Jan van Eyck's eye operates as a microscope and as a telescope at the same time—and it is amusing to think that both these instruments were to be invented, some 175 years later, in the Netherlands—so that the beholder is compelled to oscillate between a position reasonably far from the

picture and many positions very close to it. And while thus being reminded of the limitations of nature, we share some of the experience of Him Who looks down from heaven but can number the hairs of our head.

However, such perfection had to be bought at a price. Neither a microscope nor a telescope is a good instrument with which to observe human emotions. The telescopic view tends to reduce human beings to those "figures of diminutive size" which people distant landscapes; the microscopic view tends to magnify their very hands and faces into panoramas. In either case the individual is apt to be de-emotionalized, whether he be reduced to the status of a mere part of the natural scenery or expanded into a small universe.

By nature, Jan van Eyck was by no means an impassive artist, and where occasion demanded it—as in the animated Genesis scenes on one of the capitals in the "Rolin Madonna" or in the truly terrifying "Slaying of Abel" in the Ghent altarpiece—he could be as dramatic as any other artist of his time. But in the "classic," unanimously accepted works of his maturity these dynamic elements are relegated to the background. The emphasis is on quiet existence rather than action, and with the significant exception of the Annunciate in the comparatively early picture at Washington, who retains, in much attenuated form, the emotional *contrapposto* attitude of her Italianate predecessors, the principal characters are nearly motionless, communicating with each other only by virtue of spiritual consubstantiality. Measured by ordinary standards, the world of the mature Jan van Eyck is static. . . .

## ROGER VAN DER WEYDEN

Roger van der Weyden was born, we recall, at Tournai in 1399 or 1400, the son of a master cutler named Henry. Nothing is known of his boyhood and early youth except that he was not at Tournai on March 18, 1426, when the house of his father, recently deceased, was sold without his participation. In the same year he married (as can be concluded from the fact that his first child, a son named Corneille, was eight years old in 1435), and his marriage, too, would seem to have taken place outside Tournai: his bride, Elizabeth Goffaerts, hailed from Brussels. Her mother, Cathelyne, however, bore the same family name, van Stockem, as

did the long-suffering wife of Robert Campin, and this very fact lends further support to the assumption that it was the latter, alias the Master of Flémalle, whose workshop Roger entered on March 5, 1427, and left as "Maistre Rogier" on August 1, 1432.

Where the young master turned immediately upon his "graduation" is unknown. Certain it is, however, that he was most successful from the outset and ultimately settled in the native city of his wife. As early as October 20, 1435, he was able to invest a considerable sum of money in Tournai securities, and on May 20, 1436, the city fathers of Brussels resolved not to fill the position of City Painter ("Portrater der stad van Brussel" or "der stad scildere") after Roger's death—a resolution from which we learn that this position was his at the time and may infer that it had been especially created for him not long before. Whether he was appointed for the express purpose of supplying the courtroom of the Town Hall with the "Examples of Justice" that were to delight eight generations of travelers is not known. Certain it is, however, that these four celebrated panels are not mentioned until 1441, and that the first pair of them was not completed until 1439. It was about this time that he was granted the privilege of wearing the same particolored cloak (*derdendeel*) as did the "geswoerene knapen" of the city of Brussels.

Internationally famed and financially prosperous (further purchases of Tournai securities are recorded for 1436–1437, 1442 and 1445, and in 1449 he gave 400 crowns to Corneille who wished to enter the Charterhouse of Hérinnes), Roger van der Weyden represents, perhaps even more paradigmatically than Jan van Eyck, the novel type of bourgeois genius. Though honored by princes and dignitaries at home and abroad, he lived the dignified and uneventful life of a good citizen charitable to the poor, generous to religious institutions, intent upon the welfare of his community, and solicitously providing for his wife and children. He received splendid commissions from Spain and Italy, yet did not disdain to polychrome and emblazon a stone relief in the Minorites' Church or to attend to the coloring of twenty-four brass statuettes. And except for occasional business trips and a pilgrimage to Italy in the Holy Year of 1450, nothing seems to have interrupted his quiet, laborious life until it ended on June 18, 1464.

Of Roger's personality we know little more than that he was a man of integrity and rare unselfishness. It was to him that people turned as an arbitrator when a dispute arose between a fellow

painter and his clients. On May 7, 1463, the Duchess of Milan, Bianca Visconti, effusively thanked her "noble and beloved master Roger of Tournai, painter in Brussels" for the courtesy and kindness which he had shown to her young protégé, Zanetto Bugatto, and the unstinting generosity with which he had instructed him "in everything he knew about his art." And in 1459 the Abbot of St. Aubert at Cambrai noted with gratification that Roger had improved and considerably enlarged the stipulated dimensions of an altarpiece commissioned in 1455 "pour le bien de l'oeure." These are small things, perhaps, in themselves, but not quite usual at a time when painters were secretive about their methods and even the greatest were paid according to working hours and the cost of materials used.

Happily such scanty records are supplemented, and corroborated, by two portraits which, however inadequately, inform us of Roger's physical appearance. His features are known, first, from an inscribed drawing in the "Recueil d'Arras"; and, second, from his self-portrait in one of the "Examples of Justice" which is transmitted to us through the Berne tapestry. In spite of the indifferent quality of the Arras drawing and the inevitable distortion of the woven copy, we feel at once that we are in the presence of greatness, and this impression is borne out by no less illustrious a witness than Nicolaus Cusanus. In an attempt to describe the way in which God looks at the world, the Cardinal refers to "that face of the outstanding painter Roger in the most precious picture preserved in the Town Hall at Brussels" (*facies illa . . . Bruxellis rogeri maximi pictoris in preciosissima tabula quae in praetorio habetur*). Though a motionless image, he says, this face seems to pursue the beholder with its glance wherever he goes as does the eye of God which observes the human being "wherever he may be" and is fixed on him "as though on him alone." After an established custom of medieval scholasticism, Cusanus endeavored to carry the mind of his readers to that which is divine by means of a *similitudo* taken from human activity. But he might not have chosen this particular simile had his imagination not been stirred by this thoughtful, deadly-serious face and deep, bitter folds around a wide, generous mouth and enormous, visionary, indeed inescapable eyes.

"Jan van Eyck," Max J. Friedlaender once aptly remarked, "was an explorer; Roger van der Weyden was an inventor." Not that

Roger was unable to do justice to what may be called the surface blandishments of the visible world. There are enchanting details in many of his pictures, and in sensibility to color he was second to none. No visitor to Beaune or Philadelphia will ever forget the modulations of blue in Roger's "Last Judgment" or the polyphony of warm, lilac-rose, pale gray-blue, flaming vermilion, drab gray, and gold in his "Calvary." But it is true that Roger substituted for Jan van Eyck's pantheistic acceptance of the universe in its entirety a principle of selection according to which inanimate nature and man-made objects are less important than animals, animals less than man, and the outward appearance of man less than his inner life. One of his contemporaries admired his paintings for *sensuum atque animorum varietas,* and Carel van Mander praised him for having improved the art of the Lowlands by an increase in movement and, most particularly, by the "characterization of emotions such as sorrow, anger or joy as was required by the subject."

Thus Roger's world is at once physically barer and spiritually richer than Jan van Eyck's. Where Jan observed things that no painter had ever observed, Roger felt and expressed emotions and sensations—mostly of a bitter or bittersweet nature—that no painter had ever recaptured. The smile of his Madonnas is at once evocative of motherly affection and full of sad foreboding. The expression of his donors is not merely collected but deeply pious. Even his design is expressive rather than descriptive; it was he, for instance, who discovered how much the pathos of a Crucifixion might be intensified by contrasting the rigidity of the Body with the undulating movement of a billowing loincloth. His iconographic innovations, too, were often designed to create new emotional situations. He permitted donors directly to participate in sacred events and, conversely, introduced contemporary personages into Biblical narratives as *dramatis personae* who, as Leone Battista Alberti would say, "attract the eyes of the beholder even though the picture may contain other figures more perfect and pleasing from an artistic point of view." He combined half-length portraits with half-length Madonnas into diptychs in which the sitter is represented in prayer. And it seems to be he who if not invented, at least reformulated and popularized the subject of St. Jerome compassionately extracting the thorn from the foot of his faithful lion.

When we compare, for example, Jan van Eyck's "Madonna van

der Paele" (Fig. 1) with the central panel of Roger van der Weyden's "Columba altarpiece" (so called after the Church of St. Columba in Cologne which was its home from 1493) we perceive what seems to be an irreconcilable contrast. The "Madonna van der Paele" is strictly symmetrical, and its weighty, immobilized figures, receding from the central plane as well as from each other, are painted as though they were crystallizations of light itself. Its style is static, spatial and pictorial. In the Columba altarpiece (Fig. 2) the central group is shifted to the left and the slender, supple figures of St. Joseph and the Magi, all in action, are pressed against the picture plane so as to form a sharply delineated pattern; its style is dynamic, planar and linear. Roger's composition looks almost like a throwback to the fourteenth, if not the thirteenth century, and he has often been said to represent a kind of Gothic counterrevolution against Jan van Eyck. However, while it is true that Roger's style has fundamental characteristics in common with what we call High Gothic and that he revived a number of motifs and devices nearly forgotten for half a century or more, he was not, as has occasionally been said, a "reactionary." He arrived at his apparently archaic solutions not only from an entirely "modern" starting point but also for a very "modern" purpose: far from simply opposing to the ideals of Jan van Eyck and the Master of Flémalle those of an earlier period, he attempted to break new ground by the old device of *reculer pour mieux sauter*.

Jan van Eyck had not so much resolved as negated the problems posed by the great painter of Tournai; he had eliminated the tensions and contradictions characteristic of the latter's manner by abolishing their very *raison d'être*. Where, as in Jan's mature style, all physical and emotional action was absorbed into pure existence there could be no conflict between movement and rest. Where all surface relations were transposed into space relations there could be no conflict between two-dimensional design and composition in depth. Where all details were perfectly integrated with total form there could be no conflict between a pictorial and a linear mode of presentation. Roger van der Weyden, however, set out to develop the expressive and calligraphical possibilities inherent in the style of the Master of Flémalle without forfeiting the consistency and purity attained by Jan van Eyck.

While Roger's figures are more dynamic than Jan's their movements are both more fluent and more controlled than the Master

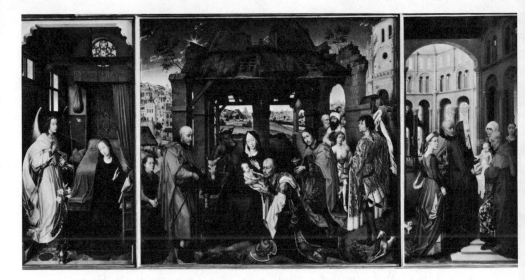

2. Roger van der Weyden, *Columba Altarpiece, c.* 1460, Center panel, 54⅝₆" x 60¼", Each wing 54⅝₆" x 27⅝₆" (Alte Pinakothek, Munich)

of Flémalle's. And while their grouping is denser and more diversified than in an Eyckian composition it is less crowded and more coordinated than in a Flémallesque one. It is as though a living chain of figures were thrown across the picture plane—a chain whose links remain distinct though conjoined by artful repetition and variation. And the component parts of every figure, body and garments alike, are both articulated in form and function and unified by an uninterrupted flow of energy. In short, Roger van der Weyden may be said to have introduced into Flemish fifteenth-century art the principle of *rhythm* in contradistinction to meter—definable as that by which movement is articulated without a loss of continuity.

This rhythm unfolds within a kind of foreground relief neatly divorced from the space behind it. But both foreground relief and background space are what I should like to call "stratified" into a series of planes deliberately frontalized yet interconnected in depth. The entire picture space is thus made to obey a common principle analogous to the "rhythmical" organization of figure movement: articulation is accomplished without destroying continuity. In the central panel of the Columba altarpiece this system of interlocking frontal planes is particularly evident, not only in the general disposition of the figures, the succession of piers, arches and posts in the building, and the stratification of the land-

scape but even in inconspicuous details. The donor on the extreme left looks on from a plane located between that of the St. Joseph and the pillar behind him. The little greyhound on the extreme right attaches the figure of his master to the very front plane (the hat in front of the oldest king, incidentally, fulfills a similar function) and the rigidly frontalized animals behind the Virgin Mary obligingly bend their heads into the planes in front of them.

As the principle of rhythm overcomes the tension between movement and rest in the behavior of the figures, and between surface and depth in the organization of space, so does it overcome the tension between the pictorial and the graphic in the presentation of plastic form as such; and this, I believe, is the very essence of Roger van der Weyden's "linearism." As in all Early Flemish painting, his lines are not abstract contours separating two areas of flat color, but represent a condensation or concentration of light or shade caused by the shape and texture of the objects. However, in Roger's paintings these forms assume a linear quality without relinquishing their luminary significance. Eyebrows or eyelids, the bridge of a nose, the edge of the lips, strands of hair, or, for that matter, the borders and folds of a garment are indicated by lines designed with the precision of an engineering drawing yet innervated by a vital force that sharpens their angles and intensifies their curvature. While never disrupting the unity of plastic shapes and color areas, they achieve a purely graphic beauty and expressiveness.

# 2. PAINTING IN ITALY AND THE LOWLANDS DURING THE FIFTEENTH CENTURY

## Erwin Panofsky

### INTRODUCTION

A quickening energy infused the art of painting in Western Europe during the early fifteenth century, concentrating about two centers: the Lowlands and Italy. Although painting in both regions was generally committed to a convincing transcription of the visible world, in which space was conceived as a three-dimensional continuum, there was a striking difference between the style of painting that developed in Italy and that of the North.

This selection from Erwin Panofsky's *Early Netherlandish Painting* (1953) defines the characteristic features of these two styles and isolates within each context those conditions and tendencies that contributed to the polarity of the two.

For further reading on the polarization of art in Italy and the Lowlands consult Panofsky's *Renaissance and Renascences in Western Art* (1960), 162–168. John White's book, *The Birth and Rebirth of Pictorial Space*, rev. ed. (1967), focuses on the technical, mathematical, and illusionistic aspects of painting, drawing, and relief, emphasizing the rational and scientific side of the Renaissance that produced the substructure of form underlying the world of appearances in Italian Renaissance art. The reader should also consult Ernst Gombrich,

"Light, Form and Texture in Fifteenth-Century Painting North and South of the Alps," *Royal Society of Arts Journal* (October 1964), appearing also as one of the selections in Gombrich's *The Heritage of Apelles* (1976); and S. Y. Edgerton, Jr., *The Renaissance Rediscovery of Linear Perspective* (1975).

When two men of the sixteenth century as widely disparate as Luther and Michelangelo turned their conversation to painting, they thought only two schools worth mentioning, the Italian and the Flemish. Luther approved of the Flemings, while Michelangelo did not; but neither considered what was produced outside these two great centers. Giorgio Vasari, the sixteenth-century historiographer of art, quite correctly refers to Dürer as a German when deploring his influence upon a great Florentine; but as soon as the discussion takes a more general turn, the same Vasari automatically classifies not only Dürer but also Dürer's forerunner, Martin Schongauer, as "Flemings" operating in Antwerp.

One-sided though it is, such a reduction of the whole diversity of European painting to one antithesis is not without justification when considered in the light of the preceding developments. From about 1430 down to the end of the fifteenth century, Italy and Flanders (or, to be more precise, the Netherlands) had indeed enjoyed a position of undisputed predominance, with all the other schools, their individual differences and merits notwithstanding, depending either on Italy and Flanders in conjunction or on Flanders alone. In England, Germany and Austria, the direct or indirect influence of the "great Netherlandish artists," as Dürer calls them, ruled supreme for two or three successive generations; in France, in the Iberian peninsula, and in such borderline districts as the southern Tyrol, this influence was rivaled but never eclipsed by that of the Italian Quattrocento; and the Italian Quattrocento itself was deeply impressed with the distinctive qualities of Early Flemish painting.

Italian princes, merchants and cardinals commissioned and collected Flemish pictures, invited Flemish painters to Italy, and occasionally sent their Italian protégés to the Netherlands for instruction. Italian writers lavished praise upon the Flemings and some Italian painters were eager to fuse their *buona maniera antica* with what was most admired in the *maniera Fiamminga*. In Colantonio of Naples and Antonello da Messina the Flemish influence is so strong that the latter was long believed to have

27

been a personal pupil of Jan van Eyck. That Ghirlandaio's "St. Jerome" and Botticelli's "St. Augustine," both in the Church of Ognissanti, are patterned after an Eyckian "St. Jerome" then owned by the Medici is common knowledge; and so is the fact that the adoring shepherds in Ghirlandaio's "Nativity" of 1485 were inspired by Hugo van der Goes' Portinari altarpiece, which had reached Florence just three or four years before. When we take into account, in addition to such direct "borrowings," the less palpable but even more important diffusion of a Flemish spirit in psychological approach and pictorial treatment (Piero di Cosimo's landscapes, for example, would be inexplicable without the wings of the Portinari altarpiece just mentioned), the influence of Flanders upon the Italian Quattrocento becomes almost incalculable.

What the Italians of the Renaissance—enthusiasts and skeptics alike—considered as characteristic of this Flemish spirit can be inferred from their own words.

First, there was the splendor of a new technique, the invention of which was ascribed, first by implication and later expressly, to Jan van Eyck himself. Second, and in a measure predicated upon this new technique, there was that adventurous and all-embracing, yet selective, "naturalism" which distilled for the beholder an untold wealth of visual enchantment from everything created by God or contrived by man. "Multicolored soldier's cloaks," writes Cyriacus of Ancona, the greatest antiquarian of his time, in 1449, "garments prodigiously enhanced by purple and gold, blooming meadows, flowers, trees, leafy and shady hills, ornate halls and porticoes, gold really resembling gold, pearls, precious stones, and everything else you would think to have been produced, not by the artifice of human hands but by all-bearing nature herself." Third, there was a peculiar piety which seemed to distinguish the intent of Flemish painting from the more humanistic—and, in a sense, more formalistic—spirit of Italian art. A great lady of fifteenth-century Florence wrote to her son that, whichever picture she might be forced to dispose of, she would not part with a Flemish "Holy Face" because it was "una divota figura e bella"; and Michelangelo is said to have remarked, to the dismay of the saintly Vittoria Colonna, that Flemish paintings would bring tears to the eyes of the devout, though these were mostly "women, young girls, clerics, nuns and gentlefolk without much understanding for the true harmony of art."

## Painting in Italy and the Lowlands

The most circumstantial and outstanding tribute is paid to Flemish painting in a collection of biographies, composed in 1455 or 1456 by Bartolommeo Fazio, a humanist from Genoa who lived at the court of Alphonso of Aragon at Naples. Of the four painters included in this *Book of Famous Men* no less than two are Flemings: Jan van Eyck and Roger van der Weyden, the latter still alive at the time of Fazio's writing. Jan van Eyck is referred to as "*the* foremost painter of our age" (*nostri saeculi pictorum princeps*). He is praised for his scholarly and scientific accomplishments and credited with the rediscovery of what Pliny and other classics had known about "the property of pigments"—an obvious allusion to those technical innovations which a good humanist felt bound to derive, by hook or by crook, from classical antiquity. In his descriptions of such individual works as he had seen—unfortunately all of them lost—Fazio, too, untiringly stresses pious sentiment on the one hand, and verisimilitude on the other. He is moved by the grief of Roger van der Weyden's Josephs of Arimathea and Marys, witnessing the Descent from the Cross, and by the Virgin's "dismay, with dignity preserved amidst a flow of tears" when she received the news of Christ's arrest. But no less keen is his enthusiasm for Jan van Eyck's "Map of the World" in which all the places and regions of the earth were represented in recognizable form and at measurable distances; his delight in Jan's "St. Jerome in His Study," where a bookcase, "if you step back a little, seems to recede in space and to display the books in their entirety while he who comes near sees only their upper edges"; and his admiration for a donor's portrait with "a sunbeam stealing through a chink in the wall so that you would think it was the real sun." And Fazio's highest praise is reserved for Jan's picture of a Women's Bath—perhaps a rendering of magic practices—which must have been a *summa* of optical refinements. It included a mirror showing, in addition to the back of a bather represented in front view, whatever else was in the room; an aged woman attendant who "seemed to perspire"; a little dog that lapped up the spilled water; a lamp "looking like one that really burns"; and, furthermore, a landscape—apparently seen through a window—where "horses, people of diminutive size, mountains, woods and castles were elaborated with such artistry that one thing seemed to be separated from the other by fifty miles."

In thus describing the direct juxtaposition of the minutiae of an interior with a vast, almost cosmic panorama, of the microscopic

with the telescopic, so to speak, Fazio comes very close to the great secret of Eyckian painting: the simultaneous realization, and, in a sense, reconciliation, of the "two infinites," the infinitesimally small and the infinitely large. It is this secret that intrigued the Italians, and that always eluded them.

## II

When we confront Jan van Eyck's famous double portrait of Giovanni Arnolfini and His Bride of 1434 (Fig. 3) with a nearly contemporary and relatively comparable Italian work, such as the "Death of St. Ambrose" in San Clemente at Rome executed about 1430 by Masolino da Panicale (Fig. 4) we observe basic similarities as well as basic differences. In both cases the scene is laid in an interior drawn to scale with the figures and furnished according to upper class standards in fifteenth-century Flanders and Italy, respectively; and in both cases advantage has been taken of that representational method which more than any other single factor distinguishes a "modern" from a medieval work of art (and without which the rendering of such interiors would not have been possible), namely, perspective. The purposes, however, to which this method has been turned are altogether different.

"*Perspectiva*," says Dürer, "is a Latin word and means a '*Durchsehung*'" (a view through something). As coined by Boethius and used by all writers prior to the fifteenth century, the word *perspectiva* refers to *perspicere* in the sense of "seeing clearly," and not in the sense of "seeing through"; a direct translation of the Greek ὀπτική, it designates a mathematical theory of vision and not a mathematical method of graphic representation. Dürer's definition, on the other hand, gives an excellent and brief description of "perspective" as understood in postmedieval usage, including our own. By a "perspective" picture we mean indeed a picture wherein the wall, panel or canvas ceases to be a solid working surface on which images are drawn and painted, and is interpreted—to quote another theorist of the Renaissance, Leone Battista Alberti—as a "kind of window" through which we look out into a section of space. Exact mathematical perspective as developed in the fifteenth century is nothing but a method of making this "view through a window" constructible, and it is well known that the Italians, significantly under the guidance of an

3. Jan van Eyck, *The Marriage of Giovanni (?) Arnolfini and Giovanna Cenami (?)*, 1434, Panel 33" x 22½" (National Gallery, London)

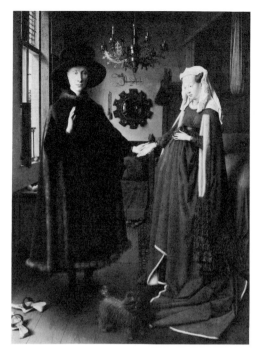

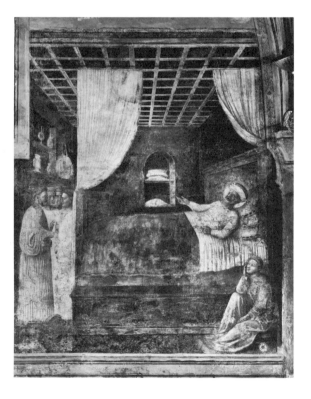

4. Masolino da Panicale, *Death of St. Ambrose*, Fresco, c. 1430 (San Clemente, Rome; Alinari/ Editorial Photocolor Archives, Inc.)

architect, Filippo Brunelleschi, had achieved this end about 1420 by drawing the mathematical consequences from the window simile. They conceived of the visual rays as of straight lines that form a pyramid or cone having its apex in the eye and its base in the object seen; of the pictorial surface as of a plane intersecting this pyramid or cone; and of the picture itself as of a central projection onto this plane—perfectly analogous to that produced in a photographic camera—which can be constructed by elementary geometrical methods. It should be noted, however, that the Flemings, about thirty years later arrived at a no less "correct" solution on a purely empirical basis, that is to say, not by deriving a workable construction from optical theory, but by subjecting shop traditions and direct visual experience to draftsmanlike schematization until consistency was reached.

However arrived at, the "correct" construction implies the following rules: in the perspective picture all parallel lines, regardless of location and direction, converge in one of an infinite number of "vanishing points"; all parallels intersecting the picture plane at right angles ("orthogonals," often loosely referred to as "vanishing lines" pure and simple) converge in a *central* vanishing point (often loosely called the "point of sight") which can be defined as the foot of the perpendicular dropped from the eye onto the picture plane and which determines the "horizon" of the picture. This horizon is the locus of the vanishing points of all parallels located in horizontal planes, and all equal magnitudes diminish in direct proportion to their distance from the eye. . . .

Modern perspective—whether developed on a theoretical or an empirical basis, whether handled with mathematical precision or intuitive freedom—is a two-edged sword. Since it makes solids and voids equally real and measurable, it can be used for plastic and, if I may say so, topographical purposes on the one hand, and for purely pictorial ones on the other. Perspective permits the artist to clarify the shape and relative location of corporeal things but also to shift the interest to phenomena contingent upon the presence of an extracorporeal medium: the way light behaves when reflected by surfaces of different color and texture or passing through media of different volume and density. Since it makes the appearance of the world dependent upon the freely determined position of the eye, perspective can produce symmetry as well as asymmetry and can keep the beholder at a respectful distance from the scene as well as admit him to the closest

intimacy. Since it presupposes the concept of an infinite space, but operates within a limited frame, perspective can emphasize either the one or the other, either the relative completeness of what is actually presented or the absolute transcendence of what is merely implied.

It is these dual possibilities that are exemplified by Jan van Eyck's Arnolfini portrait and the "Death of St. Ambrose" in San Clemente. It matters little—and is in fact hardly perceptible without the application of ruler and compass—that the "Death of St. Ambrose," executed by an artist already familiar with Brunelleschian methods, is fairly "correctly" constructed whereas the Arnolfini portrait is not and has four central vanishing points instead of one. What matters is that the Italian master conceives of light as a quantitative and isolating rather than a qualitative and connective principle, and that he places us before rather than within the picture space. He studies and uses light mainly in terms of rectilinear propagation, employing modeling shadows to characterize the plastic shape of material objects, and cast shadows to clarify their relative position. Jan van Eyck, however, studies and uses light, in addition, in terms of diffraction, reflection and diffused reflection. He stresses its action upon surfaces as well as its modification by solids and thereby works that magic so ardently admired throughout the centuries: those reflexes on brass and crystal, that sheen on velvet or fur, that subdued luster of wool or seasoned wood, those flames that look "as though they were really burning," those mirrored images, that colored chiaroscuro pervading the whole room. And where the death chamber of St. Ambrose is a complete and closed unit, entirely contained within the limits of the frame and not communicating with the outside world, the nuptial chamber of the Arnolfinis is, in spite of its cozy narrowness, a slice of infinity. Its walls, floor and ceiling are artfully cut on all sides so as to transcend not only the frame but also the picture plane so that the beholder feels included in the very room; yet the half-open window, disclosing the thin-brick wall of the house and the tiniest strip of garden and sky, creates a kind of osmosis between indoors and outdoors, secluded cell and universal space.

. . . It is a truism that northern Late Gothic tends to individualize where the Italian Renaissance strives for that which is exemplary or, as the phrase goes, for "the ideal," that it accepts the things created by God or produced by man as they present

themselves to the eye instead of searching for a universal law or principle to which they more or less successfully endeavor to conform. But it is perhaps more than an accident that the *via moderna* of the North—that nominalistic philosophy which claimed that the quality of reality belongs exclusively to the particular things directly perceived by the senses and to the particular psychological states directly known through inner experience—does not seem to have borne fruit in Italy outside a limited circle of natural scientists; whereas it is in Italy and, more specifically, in Florence that we can witness the resurgence and enthusiastic acceptance of a Neo-platonism according to which, to quote from its greatest spokesman, Marsilio Ficino, "the truth of a created thing consists primarily in the fact that it corresponds entirely to its Idea."

Thus we can understand the peculiarly one-sided relation between Flemish and Italian painting in the fifteenth century. Flanders and Italy shared the basic principles of "modern" art; but they represented the positive and negative poles of one electric circuit and we can easily conceive that during the fifteenth century the current could flow only from north to south. Exploiting the plastic rather than the pictorial possibilities of perspective, the Italians could gracefully accept some of the Flemish achievements and yet go on with the pursuit of that "beauty" which they found embodied in the art of the Greeks and their own ancestors, the Romans: "I solemnly surrender these beautiful statues to the Roman people whence they had once arisen," wrote Sixtus IV when restoring a part of the papal collection to the Capitol. The Flemings, conceiving of perspective as a means of optical enrichment rather than stereographical clarification and unchallenged by the visible remains of classical antiquity, were long unable to understand an idiom so strongly flavored with Hellenism and Latinism. It was, with but a few and well-motivated exceptions, not until the very end of the fifteenth century that Flemish painting came to be drawn into the orbit of the Italian Renaissance, the classicizing influence first sneaking in, as it were, in the shape of such decorative accessories as garlands of fruits and leaves, playful *putti* or ornamental medallions fashioned after classical cameos; and it took the spirit of a new century, the rise of new artistic centers, and even help of a German, Albrecht Dürer, to open Netherlandish eyes to the more basic values of the Italian *rinascimento*.

# 3. GHIBERTI, ANTIQUITY,

# AND THE HUMANISTS

## Richard Krautheimer
## and Trude Krautheimer-Hess

### INTRODUCTION

When Giorgio Vasari, from the vantage point of the mid-sixteenth century, looked back on the accomplishments of recent generations of Italian artists and discerned a pattern of progression, he was codifying, as it were, an idea—*rinascita*, rebirth—that became for history the Italian Renaissance. It was a Janus-like concept that had been gathering substance in educated minds since the fourteenth century and the poet Petrarch: not only was it a retrospective vision of a distant, idealized past whose example could infuse the present with new vitality, but it visualized the prospects of a future in this revivified ambience as an outlook worthy of supreme confidence—an optimism firmly rooted in Florentine patriotism. The new spirit of humanism engendered by the growing sense of antiquity's greatness was essentially a pursuit of learning based on the study—and imitation—of Greek and Latin writers as the means of achieving excellence, in short, the acquisition of a style both formal and ethical that would make the humanists better individuals and improve society as well.

Although there was in all this something like a step aside from the central concerns of the Middle Ages, the Renaissance was not a distinct break with medieval patterns. Religious institutions, for example, continued to play a significant role in the changing order.

If any one event could be singled out as a rewarding focus for examining both the continuities and the innovations interwoven in the cultural fabric of the Early Renaissance, no better instance could be

35

found than the announcement by a Florentine guild, in 1401, of a competition for artists to fashion a new pair of bronze doors for the Baptistry in Florence. This is the subject of the following selection from the Krautheimers' fine study, *Lorenzo Ghiberti*, in which the cultural ambience of fifteenth-century Florence is richly developed to add its dimension to the accomplishments of one of its most distinguished artists.

The literature on the Renaissance is immense, and the following titles represent an extremely austere selection, aimed at presenting a wide range of its aspects. For background the following works are helpful: Jakob Burckhardt's classic study *The Civilization of the Renaissance in Italy*, in several editions, in conjunction with which it would be well to read Hans Baron, *The Crisis of the Early Italian Renaissance*, 2 vols. (1955); Frederick Antal, *Florentine Painting and Its Social Background* (1948); and Paul O. Kristeller, *The Classics and Renaissance Thought* (1955). Frederick Hartt's *History of Italian Renaissance Art* (1969) is a good, extensive survey containing a useful bibliography. Elizabeth Holt, ed., *A Documentary History of Art*, 2 vols. (1957, 1958), is a handy paperback anthology that contains a sampling of documents from the Renaissance itself. In the category of theory there are Anthony Blunt, *Artistic Theory in Italy, 1450–1600* (1966), and Erwin Panofsky, *Studies in Iconology: Humanistic Themes in the Art of the Renaissance* (1939), also available in a paperback edition (1962). For Giorgio Vasari, the basic work in English translation is *Lives of the Most Eminent Painters, Sculptors, and Architects*, trans. by G. du C. De Vere, 10 vols. (London, 1912–1915). Vasari, it should be pointed out, must be read with caution and checked against recent scholarship. Of special interest is John Pope-Hennessy, "The Sixth Centenary of Ghiberti," in his recent volume, *The Study and Criticism of Italian Sculpture* (1980), 39–70.

The selection that follows is reprinted from *Lorenzo Ghiberti* by Richard Krautheimer. Copyright © 1956 by Princeton University Press. Selections, pp. 31–38, 44–49, 277–81, and 294–302, reprinted by permission of Princeton University Press.

Ghiberti first steps into the light of history at roughly the age of twenty. In the winter of 1400–1401 he returned from Pesaro to Florence in order to enter the competition announced by the *Arte di Calimala* for the commission of the new bronze door of the Baptistery.

The Baptistery had long been the pride of Florentines. By the thirteenth century it had been forgotten that this splendid example of Tuscan proto-Renaissance architecture was designed and built between 1059 and 1150;[1] legend had arisen, instead, that it dated as early as the mid-sixth century. . . . Late in the thirteenth or perhaps early in the fourteenth century another conjecture came to the fore: the Baptistery was believed to be a real Roman building, a temple of Mars rededicated to the Baptist. . . . In short, to a Florentine of the fourteenth and fifteenth centuries, the Baptistery was the supreme witness of his city's noble past.

Any undertaking in connection with the Baptistery therefore was an event of major importance in the eyes of the citizenry. The construction proper was terminated in 1150, but for centuries after there was continuous endeavor to give the building a decoration worthy of its reputed origin. . . . Finally, in 1329 Andrea Pisano was asked to design a bronze door,[2] meant no doubt to compete in splendor with the doors of the Cathedral of Pisa, the old rival of Florence. . . . When the door was completed in 1338 it was, according to one tradition, set up on the gate opposite the Cathedral.[3] But it is more likely that it occupied from the first its present place in the south portal which was then the most important of the three Baptistery gates because it alone faced the city; the east portal, certainly originally intended for the main entrance, still faced a disorderly building site upon which the Cathedral had hardly begun to take form; before the north portal lay the suburbs, an area as yet not built up. For the next two generations Andrea's door remained the last great work to be erected in honor of S. Giovanni.

For a long time it had been the custom in Florence to entrust

the supervision of work on important public buildings to the seven Greater Guilds.[4] Without necessarily financing the work, a particular guild acted in the capacity of deputy for communal administration and trustee for the funds assigned to the buildings in its charge. Nothing could have been more suitable than that the decoration of S. Giovanni should be put in the hands of the most influential and affluent guild in town: the *Arte dei Mercatanti di Calimala*. From time immemorial they had stood under the patronage of Saint John the Baptist. . . . The committee which the *Calimala* had put in charge of the Baptistery, the *Officiali del Musaico* or as it was popularly called the *Operai* or *Governatori*,[5] very likely set up the general conditions of the contest, presumedly with the approval of the consuls of the guild, and allotted the funds necessary for the occasion. To assure themselves of having a competent master they decided to announce a contest, inviting "skilled masters from all the lands of Italy" to participate. In order to prepare for and supervise the competition properly, the *Officiali del Musaico* held a consultation with an advisory jury of thirty-four members on questions of technical and artistic conduct. The committee must have been responsible for the rules of the contest and obviously determined the general scheme of the door which in the end was to be commissioned to the winner as an award: like Andrea's, it was to be divided into twenty-eight panels, each a *braccio* wide and containing a quatrefoil. The committee selected the general subject matter and possibly, though not necessarily, determined the sequence of scenes and individual figures thereof. Certainly it was the committee that decided upon the subject for the competition panel and set the deadline for its completion.

The competition, proceeding by and large along these lines, was not without its difficulties. During the contest or shortly thereafter, just before work began, the program of the door was changed. At the commencement of the competition, the projected subject matter was the Old Testament; Ghiberti writes that the committee insisted on making every competitor design "one story of this door . . . the Sacrifice of Isaac." Later, "it was decided to place the New Testament on this door" and to save the prize-winning relief of the Sacrifice of Isaac "for the other door, if there the Old Testament should be represented" (Dig. 6; Doc. 33; p. 370 in the book from which this selection is taken).

Since a cycle of the Old Testament was planned, the choice of

the competition panel obviously had to be a scene common to Old Testament cycles, for it would only be sensible to incorporate the winning relief into the final scheme. The Sacrifice of Isaac was the outstanding typological prefiguration of the Crucifixion and as such formed throughout the Middle Ages part and parcel of all large Old Testament cycles. To choose this theme for the competition was then the natural thing to do.

But the committee of the *Operai*, instead of simply prescribing this subject, apparently went further and drew up a specific set of requirements; for it can hardly be by chance that the competition reliefs of both Brunelleschi and Ghiberti contain the same number of figures and exceed the limits of the Sacrifice proper. Alongside the traditional elements of the subject—Abraham, Isaac, the angel appearing from heaven, the ram and thicket—there are two servants at the foot of the rock and an ass drinking from the fountain. The appearance of this particular combination of figures in both reliefs is so remarkable a coincidence as strongly to suggest that the committee of the *Calimala* requested it. The combination is not traditional. As a rule, the Sacrifice and the waiting servants form two different scenes. . . .

## THE COMPETITION RELIEFS: GHIBERTI AND BRUNELLESCHI

A division of opinion would seem not only justified but almost forced upon the experts when they were confronted with the reliefs of Ghiberti and Brunelleschi: two artists could hardly be more different in style, technique, personality, and background. Together they vividly illuminate the divergent artistic trends in Florence at the beginning of the fifteenth century. Opinions were bound to clash among the members of the jury and their disagreement no doubt had repercussions in talk all over town.[6]

Brunelleschi approaches the Abraham and Isaac story with dramatic force (Fig. 5). . . . All the figures are in the round; their draperies are heavy, with deep, massive folds. The faces are strong, with broad planes. . . . The scenery is confined to a few props: a steep, sharply cut cliff, two dwarfed trees with scanty, fan-shaped twigs. Every corner of the plaque is painstakingly filled. . . .

At first glance the relief appears strikingly new and exciting,

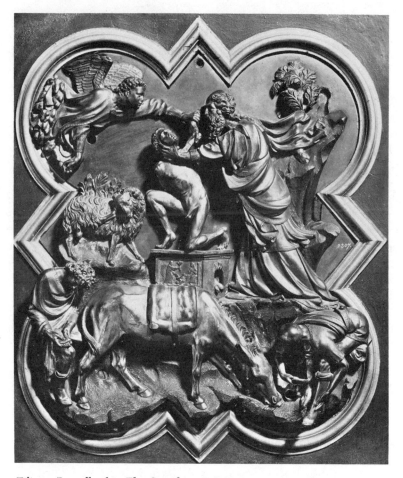

5. Filippo Brunelleschi, *The Sacrifice of Isaac*, 1401–1402, Bronze, 21″ x 17″
(Museo Nazionale, Florence; Alinari/Editorial Photocolor Archives, Inc.)

and a good number of the judges, artists and laymen, must have been impressed. It is the work of a young man, awkward in places. But it is brimming over with the impetuosity and the endless curiosity of youth; it teems with an experimenter's love of difficult problems and intricate solutions. . . . The dramatic force of the narrative and the abundance of realistic detail were bound to arouse admiration. . . .

. . . This spirit of inquiry is the very essence of his design. Various elements borrowed from antiquity, scattered as they are

throughout the relief, form part and parcel of this approach. They were used not merely because they were obviously rare tidbits for humanist connoisseurs, but because the figures *all'antica*, seated, kneeling, crouching, bent and double-bent, were bold experiments in, and useful tools for, the study of movement. All this makes a daring and aggressive competition piece; but it does not necessarily make a great piece of sculpture. Indeed, the entire relief is full of strange inconsistencies. Alongside the genuine discovery of reality as a means of forceful artistic expression and antiquity as a tool for its realization, stands a bulky and conservative figure design and composition. Certainly the result proves that the jury did not consider these revolutionary and experimental aspects a decisive factor in their final judgment. Perhaps the majority were more aware of the awkwardness of composition, its somewhat trite plan, the overloading with detail, the incongruencies between traditional types and dramatically new additions. The conservative taste of some jurors may well have been shocked by Brunelleschi's experiments.

The goldsmiths on the jury were probably struck by the technical deficiency of Brunelleschi's competition piece. Instead of casting the relief in one piece, as did Ghiberti, he cast a solid plaque, approximately 5 mm thick and soldered onto it the individual pieces of his composition, cast solid and fastened down with crude pegs for greater safety. One large piece comprises the block of rock in the foreground, the ass and ram to the left, the altar and possibly the body of Isaac,[7] the figure of Abraham, together with the rock behind him and the left hand of the angel. Four smaller, individual pieces are added: the two servants, the angel, and the tree on the rock rising behind Abraham. The rock, again in contrast to Ghiberti, is roughened not by casting but by the traditional method of stippling. This method of casting the relief in several pieces, fastening them onto a solid plaque, must have weighed heavily in the jury's adverse decision, for practical as well as technical reasons. If the entire relief were cast in one hollow sheet, as Ghiberti's was, minor failings could be easily corrected by soldering small pieces onto the back of the relief. But if the figures were cast solid, such corrections would be made impossible.[8] Secondly, Brunelleschi's relief was much heavier than Ghiberti's, 25.5 kg as against 18.5 kg (76⅔ Florentine pounds vs. 55⅔ pounds).[9] The twenty-eight reliefs of the North door, if cast by Brunelleschi, would thus have required an additional 600

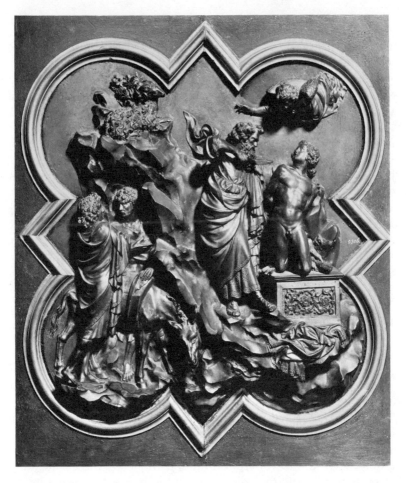

6. Lorenzo Ghiberti, *The Sacrifice of Isaac*, 1401–1402, Bronze, 21″ x 17″ (Museo Nazionale, Florence; Alinari/Editorial Photocolor Archives, Inc.)

Florentine pounds of bronze. No doubt the *prudentes viri* of the *Calimala* thought twice before agreeing to raise the cost of the reliefs even by roughly 60 florins[10] for additional materials alone. True, within the final overall cost of the door 60 florins made little difference. But in 1402 and 1403 the enormous total cost of 16,000 florins could hardly have been foreseen even by the most far-sighted committee members.

Nothing could be more in contrast to Brunelleschi's relief than Ghiberti's (Fig. 6). Technically it was infinitely superior. Only

the figure of Isaac was cast separately, together with Abraham's left hand and a small piece of the rock underneath; all the rest was cast in one piece, forming a strong sheet of bronze, an average of 9 mm thick, and hollow, save for the solid top, right edges, and lower left lobe of the quatrefoil. Minor failings in the casting had been repaired and weak spots reinforced, notably behind the figure of Isaac and behind the foreleg of the donkey. The lesser weight and the ease with which such recasting could be carried out made Ghiberti's relief the more economical. Also an exceedingly fine job of finishing was done throughout. The tiny flaws in the surface are hardly visible and every detail has been gone over with chisel and file: the faces are worked, down to the smallest wrinkle; the little snail-like curls reveal every strand of hair; Abraham's toes are visible through the stockings, the embroidered details of his garment are clear down to the tiniest twig and flower.

The contrast is equally marked in design and narrative. True, Ghiberti also divides the quatrefoil into two sections corresponding to the two parts of the narrative. But he is careful not to cut it up horizontally into two tiers. Instead, he presents the story in two groups which are both separated and connected by a diagonal rocky ridge running from upper left to lower right. . . . The quatrefoil serves merely as a frame; much different from Brunelleschi's, it is not scrupulously filled up in all its lobes and corners. The figures fall into clear small groups, separated by scenery. They are set off against rock or placed against carefully balanced stretches of blank ground. The pause, as it were, has been turned into a dynamic feature of creative design.

Also, in contrast to Brunelleschi's design, the groups in Ghiberti's relief do not run parallel to the front plane. Two or three figures are crowded together. They frequently turn into the relief or half out of it in poses that stress three-quarter views, half-lost profiles or movements that twist slightly from one pose to the other. . . . An intricate network of directional forces is established. . . .

Every movement hints at depth. The figures do not, as in Brunelleschi's relief, take violent, yet frozen poses: Abraham in a beautifully swaying, almost protective curve, bends over his son and the boy's body follows the curve of his father's stance. The angel above, the cloak below, continue the movement of the patriarch, closing the half circle and completing the rhythm of the group. In a counter-movement, the servants swing out towards

the left in a slight curve. Every gesture is sure, yet delicate and nervous. . . . The draperies, thin and light, follow the motions of the figures in long-drawn curves.

Every detail aims at supporting this melodious, yet not prettified beauty. . . . Small particulars are modeled with the utmost sharpness and precision. . . . The entire drapery is lively and articulate, whereas in Brunelleschi's design a few strong folds are separated by wide empty gaps. Light and shade flicker over the surface in tempered contrast of light and dark, with highlights on shoulders, thighs, ribs and arms, on the ridges of the folds in the cloaks, on brows and cheekbones, creating a network of relationships that leads the eye quickly from figure to figure and ties the composition into a perfect, yet lightly held unit.

The narrative, while clearly intelligible, merely hints at the events. It does not present them with brutal directness as does Brunelleschi. Abraham has raised the knife, but hesitates to strike; his left arm is placed lovingly around Isaac's shoulder. The boy looks at his father, full of confidence; the angel floats down leisurely, sure to arrive in good time. The servants, to the left, talk to each other and the older appears to indicate the mountain where the miracle takes place. Although avoiding dramatic gestures, they are not wholly unconcerned like Brunelleschi's waiting servants, but participate from afar as supporting actors in the drama of the Sacrifice, fulfilling a role not unlike the choir in a Greek tragedy. All the participants of the drama communicate with each other by glances and slight gestures. . . . The interplay of movements and glances, the psychological differentiations, are incredibly complex. But they are presented with the greatest possible ease.

As one would expect of any work done between the years 1390 and 1410, realistic details heighten the credibility of the scene: the donkey stands with his forelegs apart, drinking from the fountain; its saddle is shabby and worn through like the one in Brunelleschi's relief. Logs are heaped on the altar. A lizard scurries across the rock in the foreground. But such elements are few, employed with reticence. . . . Indeed, he strives for credibility rather than for realism: credibility based on the perceptive handling of a face and body . . . on the subtle interplay of glances and gestures. . . . Like Brunelleschi, Ghiberti draws time and again on the art of antiquity. Isaac's torso is taken from an antique; a Roman acanthus scroll fills the front slab of the altar. But none of

these motifs sticks out obtrusively. Ghiberti merges all elements into a consistent and unified atmosphere, with no attempt to overwhelm the beholder; he convinces him instead by the very ease and perfect sureness of his presentation.

Ghiberti's relief in its complete mastery of means is of almost uncanny perfection; superbly finished in every detail, a great feat of craftsmanship and in its sureness hardly credible as the work of a young man just past twenty. It lacks the freshness and vehemence of Brunelleschi's relief; it shows none of the love of experiment or the rebellious violence which made Brunelleschi's piece both awkward and intriguing. Yet the very absence of rebellious elements in Ghiberti's relief may have been one of its great virtues in the eyes of part of the jury. The perfect ease of the design, the convincing yet forceful quiet of the composition and narrative and, last not least, its infinitely superior technical perfection were decisive, one would suppose, in obtaining the much coveted award for the young goldsmith Ghiberti. . . .

## GHIBERTI AND ANTIQUITY

Our picture of ancient art has been shaped largely by two periods: the era of great discoveries in the soil of Rome, the sixteenth century, and the years from Winckelmann to the present day, during which the focus gradually shifted to Greece, to the Hellenistic East and back again to Rome as the center of the Roman Empire. This picture is based on a wealth of monuments, on architecture, vase and mural painting, sculpture in the round and in relief, sculptural ensembles, bronzes, coins, and jewelry. It is further based on a concept of successive stages in the development of ancient art. Altogether it has little in common with the image of the art of antiquity held by a Florentine of the early fifteenth century. To him Greece and the East were fabulous territories known only from the tall tales of a lonely explorer. Even within Italy his range of visual exploration was confined to Tuscany and Rome. Only rarely did it extend beyond the Apennines to include Venice and possibly Ravenna. . . . The body of known Roman monuments to all practical intents excluded painting and the bulk of sculpture in the round, which still lay underground. Poggio maintained in 1430 that aside from the few bronzes on public exhibit at the Lateran palace—the *lupa*, the

45

*spinario,* the *Camillus,* and the colossal head and hand of the bronze statue of Constans II—only six statues had survived in Rome commemorating great men: two river gods and the horse tamers on the Quirinal; the Marforio near Santa Martina at the foot of the Capitol; finally the Marcus Aurelius, then near the Lateran. True, Poggio narrowed the field to these few pieces since he was after all concerned with the changes of fortune; the inheritance of extant statuary was slightly greater than he claimed.[11] Nevertheless, the number was desperately small, even including a few new finds, such as the hermaphrodite which Ghiberti had witnessed being brought to light before Poggio drew up his list.[12] North of Rome the number of known ancient statues would seem to have been equally small. On the other hand, relief sculpture was common all over Italy, and while the reliefs on the columns of Trajan and Marcus Aurelius in Rome exerted little influence before 1480, the triumphal arches with their historical reliefs had great impact. The churches of Rome, of Pisa and, to a lesser extent, of Florence housed aside from an occasional piece of decorative sculpture large numbers of mythological, historical, and ceremonial sarcophagi which had been reused during the Middle Ages for burial and for altars. As late as the early sixteenth century archeological draftsmen and writers in Rome were still basing their observations largely on these historical and sarcophagus reliefs. Of the latter alone the churches of Rome sheltered two or three dozen. Throughout the Middle Ages the Campo Santo, the Cathedral and other churches in Pisa had formed a large repository of ancient sculpture. Smaller groups of sarcophagi had survived elsewhere. From at least the thirteenth century four had stood in and near the Baptistery and one in San Pancrazio in Florence.[13] Another group, mostly Early Christian and Byzantine sculpture *all'antica* had been assembled in Saint Mark's at Venice; finally, all over the country individual sarcophagi and reliefs were to be found. . . .

This material was supplemented to some degree by coins, gems, medals, and small bronzes. . . . But it would seem that only after 1430 did they become more numerous in the humanist circles of Florence and Rome. Only around the middle of the century when Cosimo and Piero Medici and Cardinal Pietro Barbo, later pope Paul II . . . formed their large collections, did they occupy the center of attention and gradually determine the image of ancient art.[14] . . . They represented on a small scale the material which

would illustrate the writings of the ancients: gods, historical events and personalities, ceremonies, sacrifices, triumphal processions. They were, in a way, the photographs of the time, and the game of scholarship could be won by the owner of the greatest collection. But simply because they represented to the fifteenth century objects of scholarship, gems and coins gained real importance only after 1430 when scholarship and art entered into a new relationship. . . .

However, the situation around 1400, unexplored though it is, appears to have been vastly different. Its intricacies become apparent in a small group of sculptures, Ghiberti's and Brunelleschi's competition reliefs, the decoration of the Porta della Mandorla, and the Virgin Annunciate in the Museo dell'Opera. Ghiberti's figure of Isaac is designed decidedly in an antique manner, but it remains extremely puzzling. There is no doubt but that the figure draws on an antique prototype, even though thus far no specific model can be indisputably established. The pose would seem to be derived from a kneeling figure . . . and the modeling of the figure in the round leads one to think of a statue or a torso. Indeed, in pose the Isaac is reminiscent of the kneeling son of Niobe [Rome, Museo Capitolino]. But while the outlines correspond, the body of Isaac with its small rippling planes and its silky skin is far closer to Greek sculpture of the fourth century than to the harsh, flat nude of the Niobide. . . . Yet the exact model for the Isaac remains unknown and its relation to the antique a riddle as taunting as the figure is beautiful.

. . . The head of Abraham recalls Zeus, but the resemblance is vague. On the other hand, the two servants are derived from a specific antique group, the figures of Pelops and his companion on a Roman sarcophagus [Brussels, Musées Royaux]. . . . Indeed, the grouping of the two facing servants, as well as their placement at the left edge of the composition, corresponds exactly to the Pelops sarcophagus.

This recurrence of antique motifs in the early relief falls into place when viewed within the contemporary atmosphere of Florence. During the last decade of the fourteenth century Coluccio Salutati, grand old man of the early humanist movement in Florence, had successfully set out to instill in a generation of civic and intellectual leaders and their sons the spirit of humanism. Scions of old families such as Niccolo Niccoli and the much younger and much wealthier Palla Strozzi provided both financial

and intellectual backing. . . . Humanist studies became the basic discipline for training the young. . . . Against this literary, humanist background must be placed the *all'antica* fashion which sprang up in Florentine art in the last decade of the Trecento.

The reliefs on the jambs of the Porta della Mandorla [north side, cathedral, Florence] throw light on the links between humanism and art in Florence during these years. Putti chase one another over the volutes of the tendrils on the inner jambs, female half figures grow out of *rinceaux*, a nude helmeted warrior kneels at the top of the left jamb, on the lintel a Zeuslike figure reclines next to one who may be Prometheus. On the diagonal jambs, double curved acanthus candelabra enclose other antique and pseudo-antique figures . . . a half-naked Abundantia stands holding a cornucopia; . . . one is unmistakably Hercules wearing the lion's skin; another seen from the back, youthful, almost boyish, clasps two snakes, and is thus again presumably Hercules. These two figures of Hercules are supplemented by the representation of at least two of his outstanding deeds in the *rinceaux* of the left inner jamb: the wrestling match with Antaeus and the battle with the Nemean lion. The preponderance of incidents from the Hercules story on the jambs of a late fourteenth century portal in Florence calls to mind the fact that it is in these years that Coluccio Salutati completed his work on the Labors of Hercules, one of its four books being the first complete treatise (Petrarch's early attempt was abortive)[15] to be written on the antique hero in modern times. It cannot be a mere coincidence that both the Florentine humanists and the masters of the Porta della Mandorla developed a simultaneous interest in Hercules.

If the humanists influenced the choice of a program, it was the artists who turned for its execution to specific models from Roman art. While acanthus scrolls are part and parcel of the vocabulary of Trecento decoration, the combination of double curved acanthus candelabra with interspersed standing figures recalls nothing so closely as a set of Roman pilasters, then in Old St. Peter's in Rome. . . . Hercules with the lion's skin, its head dangling over his shoulder, reproduces a rare type known only in two Roman bronze statuettes, and indeed not even they are identical. But the very rarity of the motif bespeaks its dependence on a genuine antique model,[16] and the handling of the surface reveals the master's deep concern for the tactile values of ancient sculpture. . . .

It is hardly possible to overrate the importance and exceptional position of the Porta della Mandorla and the related works. For the first time in many centuries a cycle of antique motifs has been carried over without a change in iconography—Hercules remains Hercules, Abundantia remains Abundantia. Only fifty years later was this principle broadly adopted. But at the turn of the century the retention of both the form *and* the content of an antique prototype was extremely rare.[17] Concomitantly, it is inconceivable that within the highly organized framework of Florentine art patronage such works could have been designed without the express approval, if not at the suggestion of, the commissioning guild. Thus, one wonders if the committee in charge of the competition for the Baptistery door in 1401 may not likewise have insisted upon the use of motifs *all'antica* as one of the conditions for the contestants. For it cannot be by pure chance that both Ghiberti and Brunelleschi placed motifs drawn from antiquity at key points in their competition reliefs. The inclusion of such elements must have been an established condition, explicitly or by implication. Certainly the motifs *all'antica* would have recommended the work to the attention of the jury. The learned among the judges would have admired the humanist connotations of such elements. By implication they would also have admired the skill of an artist able to emulate the works of the ancients. . . .

## HUMANISTS AND ARTISTS

The visual image of antiquity, such as we hold at present, goes back to Winckelmann and Jefferson, to the Adam brothers and David, and beyond them to Bellori and Poussin, to the Carracci, Raphael, and Vasari. Through the continuous interplay of creative art and creative scholarship, a picture of antiquity has been formed, multiform but consistent. By and large this interplay came to an end around the middle of the nineteenth century. But the mutual impregnation of art and scholarship, extending over four centuries, has remained potent to this day. Indeed, it has led us to forget that when antiquity was rediscovered in the fourteenth and fifteenth centuries in Italy, such cross-fertilization did not necessarily exist. Throughout the fourteenth century, and far into the fifteenth, there stood on one side the literary set, the learned—poets, philosophers, historians, antiquarians—and on

the other, in a separate camp, those whom contemporaries called the experts and connoisseurs. Though these latter may have been erudite, they were not so of necessity. While undoubtedly some were to be found among the humanists, the majority, it would seem, were either collectors or practitioners of art.

Petrarch's concept of antiquity established the approach of the learned.[18] Needless to say, his outlook was permeated with medieval thought: Rome and antiquity were synonymous; Rome and her monuments symbolized all that was worth remembering of antiquity, and memorable to Petrarch was that only which had living significance for the present. History to him, as to the entire Middle Ages, was part of politics, and the past, therefore, represented a political reality. Consequently, like many a medieval visitor in Rome, he expected to find the city a tangible symbol of the entire past in which Christian and pagan elements were inextricably interwoven.[19] But once arrived in Rome, the Christian memories, though essential to his philosophy, did not greatly affect his image of the city. It was the pre-Christian past (rather this than the pagan) that prevailed in his mind. From his reading of Virgil, Horace, and Ovid, he had conjured up a preordained idea of Rome and her past; hence in his wanderings around the city, he saw the dream image, not the reality.[20] Instead of monuments, he saw sites, meaningful to him only insofar as they were scenes of historic or pseudohistoric events. . . . To Petrarch it mattered little whether or not a site was commemorated by a monument, or merely haunted by memories. For his approach was entirely literary, almost emphatically nonvisual. . . . Delving into antiquity was not a pastime for Petrarch; it was a serious and essential occupation. Rome was to become again the *caput mundi;* she was to be revived, and this rebirth would succeed through a revival of her ancient virtues. They had made possible her great deeds of the past, and by implication they promised a comparable future. Hence her monuments were mementos not so much of the past, and certainly not of the past alone, as of an exemplary and timeless way of life, of *virtus,* manliness with all its historical and pragmatic connotations. At the same time these monuments held out a promise of future greatness and were, besides, reminders of the passing of all earthly grandeur—a concept medieval in origin. . . .

Thus in the circle of Petrarch and his learned humanist followers, the determining factors in their image of antiquity were

moral and political by implication, literary by character, and always comprised more a mood than a clear concept. . . . Rarely does this approach find clearer expression than in a letter written from Rome by Giovanni Dondi, Petrarch's learned medical friend from Padua.[21] As he saw them in 1375, Roman monuments and their inscriptions were mementos of Roman virtue and of great men: "the statues . . . of bronze or marble preserved to this day and the many scattered fragments of broken sculptures, the grandiose triumphal arches and the columns that show sculptured into them the histories of great deeds and many other similar ones erected publicly in honor of great men, because they established peace and saved the country from threatening danger or enlarged the empire by subjugating the barbarians; as I remember reading about, not without some remarkable excitement, wishing you also might see them [the monuments] some day, similarly strolling and stopping a little somewhere and perhaps saying to yourself: These are indeed the testimonies of great men."[22] The inscription on the Arch of Septimius Severus had moral and political meaning for Dondi, just as the writings of the ancients seemed to him testimony of their superiority in "justice, fortitude, temperance and prudence."[23] It would seem the realm of Roman *virtù* was in all innocence being invaded by the quadrivium of medieval virtues.

This nonvisual, evocative approach to antiquity among the learned has dominated nearly all humanist thought down to recent times. To this day the literary outlook survives among historians, philologists, and educated sightseers. Of all Coluccio Salutati's letters, none shows any concern over a work of art except for an occasional reference to subject matter. This is only natural, since literary men will follow literary lines, and humanism has reached us largely through its literature. The prevalence of the literary point of view has thus obliterated the fact that once a different, indeed, a diametrically opposed approach to antiquity existed among men who did not live by their pens, men who were artists for the most part. Their attitude is to be gleaned from occasional remarks, and has been made crystal clear in a passage from the same letter by Giovanni Dondi. . . . The learned doctor deplores the small number preserved of "works by those geniuses of old," and tells how eagerly these relics were hunted and highly paid for "by those who have a feeling for the matter"; he remarks on how these remnants demonstrate the greater natural talent and the superior skill of the ancients as compared to those of

today: "I am referring to the ancient buildings and statues and reliefs and other similar things. If our modern artists look at them carefully they are stunned. I myself used to know a marble sculptor—a craftsman in this field, famous among those whom Italy then had, particularly in working figures. More than once I heard him discuss the statues and sculptures he had seen in Rome with such admiration and veneration that in his discourse he seemed to be all beyond himself, so full of wonder was the subject. It was said that once he came along with five friends [to a site] where some such images were to be seen; he looked and was so arrested by the wonder of the craftsmanship that he forgot his company and stood there until his friends had gone on half a mile or more. He talked a great deal about the excellence of these figures and praised their makers and acclaimed their genius beyond all measure. He used to conclude—I quote his own words —that if such sculptures had only the spark of life, they would be better than nature; as if he wanted to say that by the genius of such great artists nature had not just been imitated but indeed excelled."

Dondi's story is illuminating from more than one point of view. We have no idea which sculptor he had in mind. . . . Whatever his name, age and origin, however, to Dondi the scholar, he was obviously an expert, and one who loved art. Nor was he unique, for he belonged to a wider circle of men with "a feeling for the matter" among whom were some willing to pay good money for works of ancient art—collectors who did not seek such objects solely for their literary value. In contrast to them, Dondi, despite all his learning, did not feel altogether at home with ancient art. He was purblind to the very qualities which others looked for. But he by no means felt inferior to these art lovers. He simply regarded them as artists and collectors who admired beyond comprehension achievements of antiquity to which his own criteria did not apply. . . . Clearly it was the visual aspect that attracted them. . . .

That artists and collectors should adopt a visual approach to antiquity was nothing new to the fourteenth century. . . . As far back as the twelfth century, Henry of Winchester had exposed himself to the ridicule of serious scholars by scouring Rome for ancient statues,[24] "his beard unkempt." The collecting of antiques, along with other art objects, sporadically continued all through the Middle Ages. . . . Such collecting . . . was apparently wide-

spread in the High Middle Ages. Against this background must be viewed the classical renascence movements which pervaded France, Germany, and Italy in the eleventh, twelfth, and thirteenth centuries:[25] the schools of Provence and Campania; Villard de Honnecourt; the Peter and Paul Master and the Visitation Master of Rheims; the Master of the Bamberg Visitation; Capuan and other South Italian workshops; Niccolo Pisano. These schools and masters readily transposed antique models into their own language. The art of antiquity was not alien to them or to their patrons. They saw no chasm between their own products and those of the faraway past. Their approach to antiquity was naïvely visual. Occasionally a scholar would look at the art of antiquity with the same naïve pleasure. . . .

During the course of the fourteenth century, this naïve, simple appreciation came to an end with the recognition of a fundamental difference between the late medieval present and the ancient past.[26] In the courtly *ambiente* of France and in North Italy this recognition led to picturing literary works of antiquity in contemporary settings, to transposing Greek and Roman history and legends into an atmosphere of chivalresque romance. . . . Personages and themes from antiquity were transcribed into contemporary costume, with just a detail *all'antica* added, a laurel wreath or the like. . . . Naïve delight felt by artists and collectors was considered suspect, perhaps slightly ridiculous. Scholars and artists parted ways. The artists, in Tuscany at any rate, continued on their way undisturbed. At least, during the first half of the fourteenth century they absorbed and admired antique forms, at times assimilating the vocabulary into their own work. Andrea Pisano's reliefs of the *artes* on the Campanile include Hercules as the representative of war, an antiquish ploughman as the symbol of agriculture and an antiquish horseman as the personification of horsemanship. Ambrogio Lorenzetti's *Pax* from the Palazzo Pubblico and the reclining *Eve*, from the Lorenzetti workshop, both *all'antica*, are proof of the impact of antique vocabulary on the art of Siena. Dondi's sculptor may well have been the contemporary of Pisano and Lorenzetti.

After the middle of the fourteenth century, however, antiquity no longer found an echo in either Florence or Siena. Circumstances did not favor the use of a vocabulary *all'antica* in public art. In the general mood of penitence and asceticism that followed the Black Death,[27] a Hercules or a Venus, even disguised as Eve,

as a Christian Virtue, or as one of the *artes*, was none too acceptable. The destruction by the Sienese in 1357 of the statue of Venus for which Ambrogio Lorenzetti had still recorded his appreciation in a drawing, reflects the change of atmosphere. . . .

But in the last years of the Trecento a new and positive approach to the art of antiquity began to appear, both in northern Italy and in Florence. In Padua, from about 1390 on, the medals of the house of Carrara reproduced Roman imperial coins.[28] . . . In Florence the jambs of the Porta della Mandorla and, a few years later, both Brunelleschi's and Ghiberti's reliefs for the competition of 1401, reflect a fresh vogue for the antique. In fact, under the leadership of Petrarch's disciple, Coluccio Salutati, Florence, shortly before the turn of the century, was fast becoming the center of humanist endeavor south of the Apennines. It is doubtful, to say the least, if all the leaders and scholars of the new generation, from Niccolo Niccoli to Palla Strozzi, appreciated or were indeed interested in the visual interpretation of antiquity manifested in the work of the Hercules Master and young Ghiberti. What scholars would obviously welcome was antique subject matter, a Hercules or an Abundantia, for its power to evoke the antique world and all it meant to a learned humanist. This renewed interest in antiquity was bound to reactivate among artists the fascination which ancient sculpture had held for their predecessors of the first half of the fourteenth century. Its lifelike quality, "better than nature," its relaxed movements and tactile values, while perhaps not attracting the run-of-the-mill sculptors, would and did attract the best, such as the Hercules Master from the workshop of the Porta della Mandorla and young Ghiberti.

Yet, the fresh visual attraction which antique art had for this generation was not limited to the artists' workshops. It would appear that by the end of the century, at least some humanists no longer felt the sense of superiority towards the visual aspects of art, either antique or reborn, that Giovanni Dondi had felt. . . . The interest of learned humanists in subject matter, and that of artists spellbound by the aesthetic qualities of antique art, while not coincident, were slowly approaching one another. . . .

The gradual rapprochement between artists and humanists continued during the next decades, reaching a peak of coincidence in the twenties and thirties. A number of contemporary phenomena concurred to make it apparent: the increasing desire on the part of humanists to build up collections of antiques; the new spirit in

which these collections were assembled; the new approach of artists to the world of antiquity and to both its artistic and scholarly interpretation; and—a revolutionary phenomenon—the exchange of ideas between artists and humanists on ancient and modern art. Art became permeated with the concepts and vocabulary of humanism; it became a part of humanist endeavor. Concomitantly, the humanists turned art into a problem of their own. . . .

Indeed, prior to 1450, the scholars, rather than the *grand-seigneurs*, appear to have concentrated on collecting antiques. What is more important, they did so in a new spirit. Niccolo Niccoli was foremost among them. True, as scion of an old family and a gentleman through and through,[29] he had a good deal of the *grand-seigneur* about him, and like them, he collected medieval paintings as well.[30] But by and large his emphasis was on antiques. Friends and agents combed Italy and the Near East seeking Greek and Roman relics to send him.[31] . . . No doubt Niccolo's image of antiquity, like Petrarch's, was largely determined by his profound knowledge of Greek and Latin literature. His collection of antiques, much as he rejoiced in it, was mainly for the purpose of illustrating and evoking past history. . . . Still, his approach did differ from that of previous generations. For one thing, Niccolo's collection was enormous in comparison to the few paltry coins and potsherds which Petrarch had owned; second he lived amid his antique objects as everyday surroundings; he regarded them not only as objects of study, but used the drinking cups, table plate and so forth, as implements of his household. They were a part of his normal existence, the tools of his single purpose in life, to relive antiquity and thus to revive it. And while his approach was decidedly that of a learned man, he liked these works of art beautiful as well—and this was the third new phenomenon. This attitude is reflected clearly in his correspondence. . . . He advised not only scholars but artists as well "knowing much about painting, sculpture, and architecture and giving them great support in their profession: Pippo di Ser Brunellesco, Donatello, Luca della Robbia, Lorenzo di Bartoluccio—and with all of them he was on the most friendly terms."[32]

What remains unclear is Niccolo's exact relation to these artists. We know of his personality and behavior. We picture him as "dressed always in rose-colored stuffs . . . trailing on the ground" and as having meticulous table manners.[33] He was no doubt very

55

agreeable. But he was perhaps a bit awe-inspiring. Consequently, one would suspect that his attitude toward artists was slightly patronizing. Great scholar and gentleman that he was, he must have been only too happy to give advice from his enormous store of knowledge to artists who sought it; but he would have had to be the one to give, and they the ones to receive. . . .

Poggio Bracciolino went much further than Niccolo Niccoli in his approach to artists and their works a few years later.[34] Niccolo's junior by twenty years, and—a point of some relevance—not a gentleman by birth, Poggio was a *literateur*. When in 1429, in the company of Antonio Loschi, he looked at the ruins of Rome from the foot of the *rupe Tarpeia,* he was deeply imbued with the nostalgic, literary, moralizing mood of Petrarch and his circle. Poggio's interpretation of Rome, like theirs, was fundamentally literary: the importance of antique remnants lay in their inscriptions; the admonitory flavor of these inscriptions he stressed time and again; and his prevailing mood was one of sorrow over the decay of the ancient buildings listed in his treatise on the changes of fortune, *De Varietate Fortunae:* "few . . . are left and they are half destroyed and decayed." Still, Poggio represented also a new kind of humanist. His list of Roman ruins was not only a good deal longer than Petrarch's, it also excluded all Christian sites; most important, it was based on visual impressions, on observations of monuments, not on mere sites. His motives for collecting were different from Niccolo Niccoli's, and his choice of objects new. He focused exclusively on works of ancient art—probably he could not afford medieval *objets d'art;* he copied inscriptions and epitaphs but did not collect them. What he owned, however, he loved. Overtones of pride, often clad in bantering self-persiflage, permeate his letters to Niccolo whenever he mentions his treasures: "I have gone a bit crazy and do you want to know how. I have had my bedroom furnished with marble heads; one is elegant and intact, the others have had their noses broken off, but still they will delight a good artist. . . ."[35] "I have picked up the marble bust of a woman, the breast well preserved—anyway, I like it. . . ."[36] "[Francesco di Pistoia] . . . has written me from Chios that he holds for me three marble heads of Juno, Minerva, and Bacchus, by Polycletus and Praxiteles. As for the names of the sculptors I would not be sure: you know those little Greeks talk a lot and may have made up those names to raise the ante. I hope I am wrong. . . . The head of Minerva wears a marble

wreath; that of Bacchus has two little horns. When they arrive I shall place them in my little study. Minerva will not be out of place. I shall put her among my books. Bacchus will fit even better. Also for Juno we shall find a place. She was once married to a philanderer; now she will be a concubine. I have here also [he writes from Rome] something I shall send home. Donatello has seen it and praised it greatly."[37] To more distant acquaintances he wrote more seriously about what he saw in ancient works of art and why he wanted to own them: "I am moved by the genius of the artist when I see how the very forces of nature are represented in marble. . . . Many suffer from other diseases; but mine is that I admire too much perhaps and more than a learned man should, those marbles carved by great artists. True, nature herself must be greater than those who work like her; but I am forced to admire the art of him who, in mute matter, expresses [her] as living so that often nothing but the spirit seems to be lacking."[38] Or else he says, "I am greatly delighted by sculptures and bronzes made in memory of the excellent men of old. I am forced to admire their genius and art since they render a mute and lifeless thing as if it breathed and spoke; often indeed they represent even the emotions of the soul so that a thing which can feel neither pain nor joy looks to you as if it laughed or mourned."[39]

All this points to one simple fact: Poggio loved ancient art. He did so with a bad conscience. He tried to rationalize his feelings to himself and his correspondents in the traditional terms of an aesthetic inherited from the Trecento. He felt a learned man should not dote on these playthings quite so much, and he poked fun at his passion for a pastime which was perhaps not altogether shared by Niccolo; he jested about the broken noses of his marble heads, about the way he was going to distribute the gods over his study so they would fit in nicely; he possibly did not know the head of a faun from one of Bacchus; nor did he care—at least he pretended not to—who made the sculptures in his collection, whether Polycletus or Praxiteles; but then he retorts: "anyway, I like them"; "still they will delight a good artist"; or he insists that Donatello has seen it and says it's good. Doubtless Poggio was on the defensive against Niccoli and possibly others. He thought himself just as good a scholar as they, but he sought in ancient art not only its subject matter but its beauty.[40] To justify his stand he appeals to his own taste and to the judgment of contemporary artists, among them Donatello. Scholar though he

was, he combined for the first time scholarly knowledge, not only with a highly developed taste, as did also Niccolo Niccoli, but also with a genuine love of ancient art and a deep respect for the artists of his time. The time had ended when Giovanni Dondi could only shake his learned head in amazement over the enthusiasm of an unlearned sculptor. Poggio called on Donatello to hear his judgment on the quality of a work of ancient art.

Humanist scholars and artists in the twenties and thirties groped for a new mutual understanding. An exchange of ideas began to take place. The group of artists and scholars involved was small—among the scholars, certainly Poggio and to some degree Niccolo Niccoli; among the artists, as witness Vespasiano da Bisticci, Brunelleschi, Donatello, Ghiberti, Luca della Robbia. It was obviously not by chance that in 1436 Alberti named these same four artists together with the late Masaccio as the leaders of the new style.[41] In the eyes of their learned contemporaries they represented a new type of artist who had grown beyond the stature of the traditional craftsman. They knew and cared about art by inclination and training. For years they had been enthusiastic about the art of antiquity, vaguely and emotionally, with intuitive understanding, but without what the humanists would have considered precise knowledge. They had attempted along scientific lines to solve problems of space representation, proportion, balance, and a credible rendering of reality. They had begun to build a vocabulary *all'antica* in architecture, sculpture and, to a lesser degree, in painting. Now the scholars would guide them toward an ever greater number of antique monuments and explain precisely matters large and small: the subject matter of these monuments, their meaning, the costume of antiquity, the new antique lettering, *veterum helementorum forma*, the scientific basis of perspective, the importance of collecting and thus living in daily contact with works of ancient art. Thus enlightened by humanist scholars, the artists would be able to help create the new world for which every humanist longed. They would be the artists of humanism. . . .

*NOTES*

[1] W. Horn, "Das Florentiner Baptisterium," *Mitteilungen des Kunsthistorischen Instituts in Florenz*, V (1935), pp. 100 ff., and W. and E. Paatz, *Die Kirchen von Florenz, ein kunstgeschichtliches Handbuch*, II (Frankfort/Main, 1940 ff.), pp.

173 ff., where also the history of the Baptistery and of its legendary origins have been summed up.

[2] For the history of the Andrea Pisano door see Paatz (*op. cit.*, II, p. 95 and notes 123 ff.) and I. Falk (*Studien zu Andrea Pisano*, Diss. [Zürich, Hamburg, 1940]).

[3] Falk (*op. cit.*, p. 57) assumes, though with reservations, that the door was originally placed opposite the Cathedral.

[4] The importance of the guilds in the art life of Florence was first pointed out by A. Doren (*Studien aus der Florentiner Wirtschaftsgeschichte: I, Die Florentiner Wollentuchindustrie* [Stuttgart, 1901]; *Das Florentiner Zunftwesen* [Stuttgart and Berlin, 1908]) and later by M. Wackernagel (*Der Lebensraum des Künstlers in der Florentinischen Renaissance* [Leipzig, 1938]).

[5] Ghiberti himself uses the term *operai di detto governo;* see Lorenzo Ghiberti, *Lorenzo Ghiberti's Denkwuerdigkeiten (I Commentarii)*, 2 vols., ed. J. von Schlosser (Berlin, 1912), I, p. 46.

[6] Comparisons between Ghiberti's and Brunelleschi's reliefs are legion. We refer only to F. R. Shapley and C. K. Kennedy, "Brunelleschi in Competition with Ghiberti," *Art Bulletin*, V (1922–1923), pp. 31 ff.

[7] Even after repeated rechecking, I am not certain whether the body of Isaac was cast separately or together with this large piece.

[8] I am indebted for this and many other observations on the technique of Ghiberti's works to Cavaliere Bruno Bearzi.

[9] I am most grateful to the *Sopraintendenza ai Monumenti* in Florence and especially to Dr. Filippo Rossi, for giving me permission to take the two competition reliefs off their wooden frames.

[10] The standard price for bronze fluctuated from 6½ to 7 *soldi* per *libra;* see Docs. 19, 121 and Dig. 78 [in R. Krautheimer and T. Krautheimer-Hess, *Lorenzo Ghiberti,* from which this selection is taken].

[11] Poggio-Bracciolini, *Poggii Bracciolini . . . Historiae De Varietate Fortunae Libri IV*, ed. D. Georgius (Paris, 1723), pp. 20 f., quoted also by C. L. Urlichs (*Codex Urbis Romae topographicus* [Wurzburg, 1871], p. 241). The passage refers apparently only to statues still *in situ* which had been on public display in ancient Rome. Thus it excludes the Lateran collection as no longer *in situ* and all reliefs, as not being statues. Even so, however, Poggio's list omits, among others, the "Pasquino" and four statues, Constantine and his three sons, then on the Quirinal, all of which were certainly known to the fifteenth century; see A. Michaelis, "Monte Cavallo," *Roemische Mitteilungen*, XIII (1898), pp. 248 ff.

[12] Ghiberti-Schlosser, *op. cit.*, I, pp. 61 f., and II, pp. 187 ff.; R. Lanciani, *Storia degli scavi di Roma* (Rome, 1902 ff.), I, p. 46. The type is known through a number of replicas in Rome (Villa Borghese), Munich (Glyptothek) and elsewhere, but according to Schlosser, the statue Ghiberti saw excavated appears to be lost.

[13] For bibliography on the foregoing, see App. A, introduction and list [in Krautheimer and Krautheimer-Hess, *op. cit.*].

[14] E. Muentz, *Les Collections des Médicis au XV Siècle . . .* (Paris, 1888); Muentz, "Essai sur l'Histoire des collections italiennes d'antiquitées . . . ," *Revue archéologique*, LXIX (1879), pp. 45 ff., 84 ff.; Ministero della Pubblica Istruzione, *Documenti Inediti per servire alla storia dei musei d'Italia* (Rome, 1878 ff.), I, pp. 1 ff.

[15] See T. Mommsen, "Petrarch and the Story of the Choice of Hercules," *Journal of the Warburg and Courtauld Institutes*, XVI (1953), pp. 178 ff.; Coluccio Salutati's *De laboribus Herculis* was begun between 1383 and 1391; see Coluccio Salutati, *De laboribus Hercules*, ed. B. L. Ullman (Zurich, 1951), p. vii.

[16] Hercules statues resembling the Hercules of the Porta della Mandorla in general pose are frequent in antiquity: the weight resting on the right foot, the right arm hanging and loosely holding the club, which in the model known to the Hercules Master was evidently broken off. Also the motif of the left hand wrapped in the lion's skin occurs in at least one Hercules type (see P. W. Lehmann, *Statues on Coins* [New York, 1946], p. 7). But the combined features of the hand wrapped in the lion's skin and of the lion's head resting on the shoulder of Hercules are at this point unknown to me. To be sure, in an early fourth century bronze statuette from Alt-Szoeny, Hungary (Vienna, Kunsthistorisches Museum; H. Bulle, *Der Schoene Mensch in Altertum* [Munich, 1912], pl. 57), the lion's head is worn on the left shoulder; but the left hand is not wrapped in the skin and the position of the right arm is different from the Hercules on the Porta della Mandorla. A similar small bronze, formerly in the Uffizi, at present in the Museo Archeologico in Florence (*Reale Galleria di Firenze illustrata*, ser. IV, vol. III, pp. 36 f., pl. 115; S. Reinach, *Répertoire de la Statuaire Grecque et Romaine* [Paris, 1897 ff.], I, p. 474, no. 1964D), is possibly a sixteenth century imitation. (Information by the museum staff, kindly relayed through Mr. Myron Laskin Jr., Institute of Fine Arts, New York University.) On the other hand, the presence in fifteenth century Florence of such a Hercules statue seems to be confirmed by a drawing in the Francesco di Giorgio codex (Florence, Bibl. Nazionale, cod. Magl. II, 1, 141; see W. Lotz, "Eine Deinokratesdarstellung des Francesco di Giorgio," *Mitteilungen des Kunsthistorischen Instituts in Florenz*, V [1940], pp. 428 ff.), representing a youth in the stance of the Hercules bronze in the Museo Archeologico and the figure from the Porta della Mandorla, wearing a lion's skin, draped this time over both shoulders, but with the lion's head resting on his right shoulder.

[17] For the retention in medieval art of antique subject matter transformed or, vice versa, the retention of antique types with changed subject matter, see E. Panofsky and F. Saxl, *Classical Mythology in Mediaeval Art* (Metropolitan Museum Studies, IV, 2) (New York, 1933).

[18] E. Muentz and Prince d'Essling, *Petrarque* (Paris, 1902), p. 32, note 2, and pp. 37, 38, note 1; G. B. De Rossi, "Sull' archeologia nel secolo decimo quarto," *Bulletino di corrispondenza archeologica* (1871), pp. 3 ff.

[19] Francesco Petrarca, *Le familiari*, ed. V. Rossi (Florence, 1933 ff.), I, p. 95 (Ep. fam. II, 9).

[20] *ibid.*, II, pp. 56 ff. (Ep. fam. VI, 2).

[21] J. Morelli, "De Joanne Dondio," *Operette*, II (1920), pp. 285 ff., with excerpts from Dondi's letters (Venice, *Marc. lat.*, Cl. XIV, 223, ff. 47–68v).

[22] Letter to Fra Guglielmo da Cremona, *op. cit.*, fol. 56 ff.; Morelli, *op. cit.*, pp. 303 f.

[23] Letter to Paganino da Sala; Morelli, *op. cit.*, p. 302.

[24] John of Salisburg, *Joannis Sarisberiensis Historiae quae supersunt*, ed. R. L. Poole (Oxford, 1927), pp. 60 ff.

[25] E. Panofsky, "Renaissance and Renascences," *Kenyon Review*, VI (1944), pp. 201 ff.

[26] J. Adhémar, *Influences antiques dans l'art du moyen âge français* (London, 1937), pp. 270 ff.; Panofsky-Saxl, *op. cit.*, pp. 255 ff.; Panofsky, *op. cit.*

[27] M. Meiss, *Painting in Florence and Siena after the Black Death* (Princeton, 1951), *passim.*

[28] J. von Schlosser, "Die aeltesten Medaillen und die Antike," *Jahrbuch der Kunsthistorischen Sammlungen des Allerhoechsten Kaiserhauses,* XVIII (1897), pp. 86 ff.

[29] Vespasiano da Bisticci, *Vite di uomini illustri* . . . , ed. A. Mai and A. Bartoli (Florence, 1859), p. 470.

[30] Poggio's funeral oration for Niccoli as quoted in excerpts by Mehus, in Ambrogio Traversari (Ambrosius Traversarius), *Latinae Epistolae* . . . , ed. P. Cannetus and L. Mehus (Florence, 1759), I, p. li.

[31] Traversari, *op. cit.*, II, cols. 393 f., 417 (Lib. VIII, epp. 35, 48).

[32] Bisticci, *op. cit.*, pp. 478 f.

[33] *ibid.*, p. 480.

[34] The passages referring to Poggio's collecting activities have been compiled from his letters by Mehus (Traversari, *op. cit.*, I, pp. lii ff.) and by E. Walser, *Poggius Florentinus, Leben und Werke (Beiträge zur Kulturgeschichte des Mittelalters und der Renaissance,* 14) (Leipzig and Berlin, 1914), pp. 147 ff.

[35] Poggio-Bracciolini, *Epistolae,* ed. T. de Tonellis (Florence, 1831 ff.), I, pp. 213 ff. (Lib. III, ep. 15).

[36] *ibid.*, p. 284 (Lib. III, ep. 37).

[37] *ibid.*, I, pp. 322 ff. (Lib. IV, ep. 12).

[38] *ibid.*, I, pp. 330 ff. (Lib. IV, ep. 15). In the last sentence I have emended the word "*ipsum*" to "*ipsam.*"

[39] *ibid.*, I, pp. 374 ff. (Lib. IV, ep. 21).

[40] I fail to see how C. S. Gutkind ("Poggio Bracciolini's geistige Entwicklung," *Deutsche Vierteljahrsschrift für Geistesgeschichte,* X [1932], pp. 548 ff.), an understanding scholar, could characterize Poggio's attitude as "the learned sentimentality of a recording antiquarian."

[41] Bisticci, *op. cit.*, p. 476; L. B. Alberti, *Leone Battista Alberti's Kleinere Kunsttheoretische Schriften (Della Pittura libri tre; De Statua; I cinque ordini Architettonici),* ed. H. Janitschek (*Quellenschriften für Kunstgeschichte,* ed. R. Eitelberger von Edelberg, XI) (Vienna, 1877), p. 47.

# *4.* PAINTERS AND CLIENTS

# IN FIFTEENTH-CENTURY

# ITALY

## *Michael Baxandall*

INTRODUCTION

This selection, from Michael Baxandall's *Painting and Experience in Fifteenth-Century Italy*, sets forth the relationships between artists and their patrons, chiefly in central Italy, during the Quattrocento. The contracts drawn up between these two parties document the mutual obligations attending the creation of the work of art, and provide, by implication, an image of the economic and social status of the Quattrocento artist.

Other portions of Baxandall's book, not included here, draw attention to the very limited vocabulary of criticism during this era and to a practice of moralizing visual experience that extended to Renaissance perspective itself. Elsewhere in the book, Baxandall presents a case for some correspondences between skills that had evolved in fifteenth-century Italian society—with respect to oratory, dance, and practical volumetric calculations—and certain aspects of painting and the perception of painting.

What emerges from the selection in this anthology is the suggestion of a strong proprietary involvement on the part of the patron (or client, as Baxandall prefers) with the actual production of the work of art and the quality of the materials used in its making; in other words, the patron does not enter the scene after the fact to purchase an existing work of art that pleases him, but instead orders something to his own specifications. This selection, by documenting the "conditions of trade"

surrounding the creation and acquisition of art, serves, therefore, to round out the picture of Quattrocento painting that is so often drawn primarily in terms of stylistic developments, form, and iconography. It also invites comparison with analogous circumstances in our own contemporary art world, as they are alluded to in the last three selections in this anthology.

For further reading on the general subject of this selection, see Frederick Antal, *Florentine Painting and Its Social Background* (1948); Arnold Hauser, *The Social History of Art* (1951); Frederick Hartt, "Art and Freedom in Quattrocento Florence," *Marsyas: Studies in the History of Art*, suppl. I, *Essays in Memory of Karl Lehmann* (1964), 114–131; David S. Chambers, ed., *Patrons and Artists in the Italian Renaissance* (1971), a handy source book of documents of the fifteenth and early sixteenth centuries; C. H. Clough, "Federigo da Montefeltro's Patronage of the Arts, 1468–1482," *Journal of the Warburg and Courtauld Institutes*, XXXVI (1973), 129–144; Martin Wackernagel, *The World of the Florentine Artist: Projects and Patrons, Workshop and Market*, trans. by Alison Luchs (1981); and G. F. Lytle and S. Orgel, *Patronage in the Renaissance* (1982).

For information regarding patronage in the Lowlands, see Shirley N. Blum, *Early Netherlandish Triptychs. A Study in Patronage* (1969); Lorne Campbell, "The Art Market in the Southern Netherlands in the Fifteenth Century," *The Burlington Magazine*, CXVIII (1976), 188–198; J. Bartier, "Art Patronage in Van Der Weyden's Time," in *Rogier van der Weyden—Rogier de le Pasture*, an exhibition catalogue, City Museum of Brussels (1979); and M. T. Smith, "On the Donor of Jan van Eyck's Rolin Madonna," *Gesta*, XX, 1 (1981), 273–279. For patronage in the seventeenth century, see Francis Haskell, *Patrons and Painters: A Study of the Relations Between Italian Art and Society in the Age of the Baroque*, rev. ed. (1980). On the language of criticism in the Renaissance, see Ernst Gombrich, "The Leaven of Criticism in Renaissance Art: Texts and Episodes," in his *The Heritage of Apelles* (1976), which appeared earlier in C. S. Singleton, ed., *Art, Science and History in the Renaissance* (1967).

The selection that follows is reprinted from *Painting and Experience in Fifteenth-Century Italy* by Michael Baxandall, © Oxford University Press, 1972. Reprinted by permission of Oxford University Press.

A fifteenth-century painting is the deposit of a social relationship. On one side there was a painter who made the picture, or at least supervised its making. On the other side there was somebody else who asked him to make it, provided funds for him to make it and, after he had made it, reckoned on using it in some way or other. Both parties worked within institutions and conventions—commercial, religious, perceptual, in the widest sense social—that were different from ours and influenced the forms of what they together made.

The man who asked for, paid for, and found a use for the painting might be called the *patron*, except that this is a term that carries many overtones from other and rather different situations. This second party is an active, determining and not necessarily benevolent agent in the transaction of which the painting is the result: we can fairly call him a *client*. The better sort of fifteenth-century painting was made on a bespoke basis, the client asking for a manufacture after his own specifications. Ready-made pictures were limited to such things as run-of-the-mill Madonnas and marriage chests painted by the less sought after artists in slack periods; the altar-pieces and frescoes that most interest us were done to order, and the client and the artist commonly entered into a legal agreement in which the latter committed himself to delivering what the former, with a greater or lesser amount of detail, had laid down.

The client paid for the work, then as now, but he allotted his funds in a fifteenth-century way and this could affect the character of the paintings. The relationship of which the painting is the deposit was among other things a commercial relationship, and some of the economic practices of the period are quite concretely embodied in the paintings. Money is very important in the history of art. It acts on painting not only in the matter of a client being willing to spend money on a work, but in the details of how he hands it over. A client like Borso d'Este, the Duke of Ferrara, who makes a point of paying for his paintings by the square foot—for the frescoes in the Palazzo Schifanoia Borso's rate was ten Bolognese *lire* for the square *pede*—will tend to get a different

sort of painting from a commercially more refined man like the Florentine merchant Giovanni de' Bardi who pays the painter for his materials and his time. Fifteenth-century modes of costing manufactures, and fifteenth-century differential payments of masters and journeymen, are both deeply involved in the style of the paintings as we see them now: paintings are among other things fossils of economic life.

And again, pictures were designed for the client's use. It is not very profitable to speculate about individual clients' motives in commissioning pictures: each man's motives are mixed and the mixture is a little different in each case. One active employer of painters, the Florentine merchant Giovanni Rucellai, noted he had in his house works by Domenico Veneziano, Filippo Lippi, Verrocchio, Pollaiuolo, Andrea del Castagno and Paolo Uccello —along with those of a number of goldsmiths and sculptors—"the best masters there have been for a long time not only in Florence but in Italy." His satisfaction about personally owning what is good is obvious. Elsewhere, speaking now more of his very large expenditure on building and decorating churches and houses, Rucellai suggests three more motives: these things give him "the greatest contentment and the greatest pleasure because they serve the glory of God, the honour of the city, and the commemoration of myself." In varying degrees these must have been powerful motives in many painting commissions; an altarpiece in a church or a fresco cycle in a chapel certainly served all three. And then Rucellai introduces a fifth motive: buying such things is an outlet for the pleasure and virtue of spending money well, a pleasure greater than the admittedly substantial one of making money. It is a less whimsical remark than it seems at first. For a conspicuously wealthy man, particularly someone like Rucellai who had made money by charging interest, by usury indeed, spending money on such public amenities as churches and works of art was a necessary virtue and pleasure, an expected repayment to society, something between a charitable donation and the payment of taxes or church dues. As such gestures went, one is bound to say, a painting had the advantage of being both noticeable and cheap: bells, marble paving, brocade hangings or other such gifts to a church were more expensive. Finally, there is a sixth motive which Rucellai—a man whose descriptions of things and whose record as a builder are not those of a visually insensitive person—does not mention but which one is ready to attribute to

him, an element of enjoyment in looking at good paintings; in another context he might not have been shy of speaking about this.

The pleasure of possession, an active piety, civic consciousness of one or another kind, self-commemoration and perhaps self-advertisement, the rich man's necessary virtue and pleasure of reparation, a taste for pictures: in fact, the client need not analyse his own motives much because he generally worked through institutional forms—the altarpiece, the frescoed family chapel, the Madonna in the bedroom, the cultured wall-furniture in the study—which implicitly rationalized his motives for him, usually in quite flattering ways, and also went far towards briefing the painter on what was needed. And anyway for our purpose it is usually enough to know the obvious, that the primary use of the picture was for looking at: they were designed for the client and people he esteemed to look at, with a view to receiving pleasing and memorable and even profitable stimulations.

. . . For the moment, the one general point to be insisted on is that in the fifteenth century painting was still too important to be left to the painters. The picture trade was a quite different thing from that in our own late romantic condition, in which painters paint what they think best and then look round for a buyer. We buy our pictures ready-made now; this need not be a matter of our having more respect for the artist's individual talent than fifteenth-century people like Giovanni Rucellai did, so much as of our living in a different sort of commercial society. The pattern of the picture trade tends to assimilate itself to that of more substantial manufactures: post-romantic is also post-Industrial Revolution, and most of us now buy our furniture ready-made too. The fifteenth century was a period of bespoke painting . . .

In 1457 Filippo Lippi painted a triptych for Giovanni di Cosimo de' Medici; it was intended as a gift to King Alfonso V of Naples, a minor ploy in Medici diplomacy. Filippo Lippi worked in Florence, Giovanni was sometimes out of the city, and Filippo tried to keep in touch by letter:

> I have done what you told me on the painting, and applied myself scrupulously to each thing. The figure of St. Michael is now so near finishing that, since his armour is to be of silver and gold and his other garments too, I have been to see Bartolomeo Martelli: he said he would speak with Francesco Cantansanti about the gold and what you want, and that I should do exactly what

you wish. And he chided me, making out that I have wronged you.

Now, Giovanni, I am altogether your servant here, and shall be so in deed. I have had fourteen florins from you, and I wrote to you that my expenses would come to thirty florins, and it comes to that much because the picture is rich in its ornament. I beg you to arrange with Martelli to be your agent in this work, and if I need something to speed the work along, I may go to him and it will be seen to. . . .

If you agree . . . to give me sixty florins to include materials, gold, gilding and painting, with Bartolomeo acting as I suggest, I will for my part, so as to cause you less trouble, have the picture finished completely by 20 August, with Bartolomeo as my guarantor . . . And to keep you informed, I send a drawing of how the triptych is made of wood, and with its height and breadth. Out of friendship to you I do not want to take more than the labour costs of 100 florins for this: I ask no more. I beg you to reply, because I am languishing here and want to leave Florence when I am finished. If I have presumed too much in writing to you, forgive me. I shall always do what you want in every respect, great and small.

Valete. 20 July 1457.
Fra Filippo the painter, in Florence.

Underneath the letter Filippo Lippi provided a sketch of the triptych as planned (Fig. 7). Left to right, he sketched a St. Bernard, an Adoration of the Child, and a St. Michael; the frame of the altarpiece, the point about which he is particularly asking approval, is drawn in a more finished way.

A distinction between "public" and "private" does not fit the functions of fifteenth-century painting very well. Private men's commissions often had very public roles, often in public places; an altarpiece or a fresco cycle in the side-chapel of a church is not private in any useful sense. A more relevant distinction is between commissions controlled by large corporate institutions like the offices of cathedral works and commissions from individual men or small groups of people: collective or communal undertakings on the one hand, personal initiatives on the other. The painter was typically, though not invariably, employed and controlled by an individual or small group.

It is important that this should have been so, because it means that he was usually exposed to a fairly direct relationship with a lay client—a private citizen, or the prior of a confraternity or

7. Fra Filippo Lippi, *Sketch of an Altarpiece* (Mediceo avanti il Principato VI, 255), 1457, Pen and Ink (Florence, Archivo di Stato)

monastery, or a prince, or a prince's officer; even in the most complex cases the painter normally worked for somebody identifiable, who had initiated the work, chosen an artist, had an end in view, and saw the picture through to completion. In this he differed from the sculptor, who often worked for large communal enterprises—as Donatello worked so long for the Wool Guild's administration of the Cathedral works in Florence—where lay control was less personal and probably very much less complete. The painter was more exposed than the sculptor, though in the nature of things clients' day-to-day interference is not usually recorded; Filippo Lippi's letter to Giovanni de' Medici is one of rather few cases where one can clearly sense the weight of the client's hand. But in what areas of the art did the client directly intervene?

There is a class of formal documents recording the bare bones of the relationship from which a painting came, written agreements about the main contractual obligations of each party. Several hundred of these survive, though the greater part refer to paintings that are now lost. Some are full-dress contracts drawn up by a notary, others are less elaborate *ricordi*, memoranda to be held by each side: the latter have less notarial rhetoric but still had some contractual weight. Both tended to the same range of clauses.

There are no completely typical contracts because there was no fixed form, even within one town. One agreement less untypical than many was between the Florentine painter, Domenico Ghirlandaio, and the Prior of the Spedale degli Innocenti at Florence; it is the contract for the *Adoration of the Magi* (1488) still at the Spedale:

Be it known and manifest to whoever sees or reads this document that, at the request of the reverend Messer Francesco di Giovanni Tesori, presently Prior of the Spedale degli Innocenti at Florence, and of Domenico di Tomaso di Curado [Ghirlandaio], painter, I, Fra Bernardo di Francesco of Florence, Jesuate Brother, have drawn up this document with my own hand as agreement contract and commission for an altar panel to go in the church of the abovesaid Spedale degli Innocenti with the agreements and stipulations stated below, namely:

That this day 23 October 1485 the said Francesco commits and entrusts to the said Domenico the painting of a panel which the said Francesco has had made and has provided; the which panel the said Domenico is to make good, that is, pay for; and he is to colour and paint the said panel all with his own hand in the manner shown in a drawing on paper with those figures and in that manner shown in it, in every particular according to what I, Fra Bernardo, think best; not departing from the manner and composition of the said drawing; and he must colour the panel at his own expense with good colours and with powdered gold on such ornaments as demand it, with any other expense incurred on the same panel, and the blue must be ultramarine of the value about four florins the ounce; and he must have made and delivered complete the said panel within thirty months from today; and he must receive as the price of the panel as here described (made at his, that is, the said Domenico's expense throughout) 115 large florins if it seems to me, the abovesaid Fra Bernardo, that it is worth it; and I can go to whoever I think best for an opinion on its value or workmanship, and if it does not seem to me worth the stated price, he shall receive as much less as I, Fra Bernardo, think right; and he must within the terms of the agreement paint the predella of the said panel as I, Fra Bernardo, think good; and he shall receive payment as follows—the said Messer Francesco must give the abovesaid Domenico three large florins every month, starting 1 November 1485 and continuing after as is stated, every month three large florins. . . .

And if Domenico has not delivered the panel within the abovesaid period of time, he will be liable to a penalty of fifteen large

florins; and correspondingly if Messer Francesco does not keep
to the abovesaid monthly payments he will be liable to a penalty
of the whole amount that is, once the panel is finished he will have
to pay complete and in full the balance of the sum due.

Both parties sign the agreement.

This contract contains the three main themes of such agree-
ments: (i) it specifies what the painter is to paint, in this case
through his commitment to an agreed drawing; (ii) it is explicit
about how and when the client is to pay, and when the painter
is to deliver; (iii) it insists on the painter using a good quality of
colours, specially gold and ultramarine. Details and exactness
varied from contract to contract.

Instructions about the subject of a picture do not often go
into great detail. A few contracts enumerate the individual
figures to be represented, but the commitment to a drawing is
more usual and was clearly more effective: words do not lend
themselves to very clear indication of the sorts of figure wanted.
The commitment was usually a serious one. Fra Angelico's
altarpiece of 1433 for the Linen-maker's Guild at Florence was
of this kind; in view of the sanctity of his life the matter of price
was exceptionally entrusted to his conscience—190 florins or
however much less he considers proper—but, saintliness only
trusted so far, he is bound not to deviate from his drawing.
Around the drawing there would have been discussion between
the two sides. . . . If there was difficulty in describing the sort of
finish wanted, this could often be done by reference to another
picture: for example, Neri di Bicci of Florence undertook in
1454 to colour and finish an altarpiece in S. Trinita after the
same fashion as the altarpiece he had made for a Carlo Benizi
in S. Felicità in 1453.

Payment was usually in the form of one inclusive sum paid in
installments, as in Ghirlandaio's case, but sometimes the painter's
expenses were distinguished from his labour. A client might
provide the costlier pigments and pay the painter for his time
and skill: when Filippino Lippi painted the life of St. Thomas in
S. Maria sopra Minerva at Rome (1488–93) Cardinal Caraffa
gave him 2,000 ducats for his personal part and paid for his
assistants and the ultramarine separately. In any case the two
headings of expenses and of the painter's labour were the basis
for calculating payment. . . . The sum agreed in a contract was

not quite inflexible, and if a painter found himself making a loss on a contract he could usually renegotiate: in the event Ghirlandaio, who had undertaken to provide a predella for the Innocenti altarpiece under the original 115 florins, got a supplementary seven florins for this. If the painter and client could not agree on the final sum, professional painters could act as arbitrators, but usually matters did not come to this point.

Ghirlandaio's contract insists on the painter using a good quality of colours and particularly of ultramarine. The contracts' general anxiety about the quality of blue pigment as well as of gold was reasonable. After gold and silver, ultramarine was the most expensive and difficult colour the painter used. There were cheap and dear grades and there were even cheaper substitutes, generally referred to as German blue. (Ultramarine was made from powdered lapis lazuli expensively imported from the Levant; the powder was soaked several times to draw off the colour and the first yield—a rich violet blue—was the best and most expensive. German blue was just carbonate of copper; it was less splendid in its colour and, much more seriously, unstable in use, particularly in fresco.) To avoid being let down about blues, clients specified ultramarine; more prudent clients stipulated a particular grade—ultramarine at one or two or four florins an ounce. The painters and their public were alert to all this and the exotic and dangerous character of ultramarine was a means of accent that we, for whom dark blue is probably no more striking than scarlet or vermilion, are liable to miss. We can follow well enough when it is used simply to pick out the principal figure of Christ or Mary in a biblical scene, but the interesting uses are more subtle than this. In Sassetta's panel of *St. Francis Renouncing his Heritage* in the National Gallery [London] the gown St. Francis discards is an ultramarine gown. In Masaccio's expensively pigmented *Crucifixion*, the vital narrative gesture of St. John's right arm is an ultramarine gesture. And so on. Even beyond this the contracts point to a sophistication about blues, a capacity to discriminate between one and another, with which our own culture does not equip us. In 1408 Gherardo Starnina contracted to paint in S. Stefano at Empoli frescoes, now lost, of the *Life of the Virgin*. The contract is meticulous about blue: the ultramarine used for Mary is to be of the quality of two florins to the ounce, while for the rest of the picture ultramarine

at one florin to the ounce will do. Importance is registered with a violet tinge.

Of course, not all artists worked within institutions of this kind; in particular, some artists worked for princes who paid them a salary. Mantegna, who worked from 1460 until his death in 1506 for the Gonzaga Marquises of Mantua, is a well documented case and Lodovico Gonzaga's offer to him in April 1458 is very clear: "I intend to give you fifteen ducats monthly as salary, to provide lodgings where you can live comfortably with your family, to give you enough grain each year to cover generously the feeding of six mouths, and also the firewood you need for your own use. . . ." Mantegna, after much hesitation, accepted and in return for his salary not only painted frescoes and panels for the Gonzagas, but filled other functions as well. Lodovico Gonzaga to Mantegna, 1469:

> I desire that you see to drawing two turkeys from the life, one cock and one hen, and send them to me here, since I want to have them woven by my tapesters: you can have a look at the turkeys in the garden at Mantua.

Cardinal Francesco Gonzaga to Lodovico Gonzaga, 1472:

> . . . I beg you to order Andrea Mantegna . . . to come and stay with me [at Foligno]. With him I shall entertain myself by show- ing him my engraved gems, figures of bronze and other fine antiques; we will study and discuss them together.

Duke of Milan to Federico Gonzaga, 1480:

> I am sending you some designs for pictures which I beg you to have painted by your Andrea Mantegna, the famous painter . . .

Federico Gonzaga to Duke of Milan, 1480:

> I received the design you sent and urged Andrea Mantegna to turn it into a finished form. He says it is more a book illuminator's job than his, because he is not used to painting little figures. He would do much better a Madonna or something, a foot or a foot and half long, say, if you are willing . . .

73

Lancillotto de Andreasis to Federico Gonzaga, 1483:

I have bargained with the goldsmith Gian Marco Cavalli about making the bowls and beakers after Andrea Mantegna's design. Gian Marco asks three lire, ten soldi for the bowls and one and a half lire for the beakers . . . I am sending you the design made by Mantegna for the flask, so that you can judge the shape before it is begun.

In practice Mantegna's position was not quite as tidy as Gonzaga's offer proposed. His salary was not always regularly paid; on the other hand, he was given occasional privileges and gifts of land or money, and fees from outside patrons. But Mantegna's position was unusual among the great Quattrocento painters; even those who produced paintings for princes were more commonly paid for a piece of work than as permanent salaried retainers. It was the commercial practice expounded in the contracts, and seen at its clearest in Florence, that set the tone of Quattrocento patronage.

To return to the contracts, though one can generalize this far about them, their details vary a great deal from case to case; and, what is more interesting, there are gradual changes of emphasis in the course of the century. What was very important in 1410 was sometimes less important in 1490: what 1410 had not specially concerned itself with sometimes demanded an explicit commitment in 1490. Two of these shifts of emphasis—one towards less insistence, the other towards more—are very important, and one of the keys to the Quattrocento lies in recognizing that they are associated in an inverse relationship. While precious pigments become less prominent, a demand for pictorial skill becomes more so.

As the century progressed contracts became less eloquent than before about gold and ultramarine. They are still commonly mentioned and the grade of ultramarine may even be specified in terms of florins to the ounce—nobody could want the blue to flake off their picture—but they are less and less the centre of attention and the gold is increasingly intended for the frame. Starnina's undertaking of 1408 about different grades of blue for different parts of the picture is very much of his moment: there is nothing quite like it in the second half of the century. This lessening preoccupation with the precious pigments is quite

74

consistent with the paintings as we see them now. It seems that clients were becoming less anxious to flaunt sheer opulence of material before the public than they had previously been.

It would be futile to try to account for this sort of development simply within the history of art. The diminishing role of gold in paintings is part of a general movement in western Europe at this time towards a kind of selective inhibition about display, and this shows itself in many other kinds of behaviour too. It was just as conspicuous in the client's clothes, for instance, which were abandoning gilt fabrics and gaudy hues for the restrained black of Burgundy. This was a fashion with elusive moral overtones; the atmosphere of the mid-century is caught very well in an anecdote told about King Alfonso of Naples by the Florentine bookseller Vespasiano da Bisticci:

> There was a Sienese ambassador at Naples who was, as the Sienese tend to be, very grand. Now King Alfonso usually dressed in black, with just a buckle in his cap and a gold chain round his neck; he did not use brocades or silk clothes much. This ambassador however dressed in gold brocade, very rich, and when he came to see the King he always wore this gold brocade. Among his own people the King often made fun of these brocade clothes. One day he said, laughing to one of his gentlemen, "I think we should change the colour of that brocade." So he arranged to give audience one day in a mean little room, summoned all the ambassadors, and also arranged with some of his own people that in the throng everyone should jostle against the Sienese ambassador and rub against his brocade. And on the day it was so handled and rubbed, not just by the other ambassadors, but by the King himself, that when they came out of the room no-one could help laughing when they saw the brocade, because it was crimson now, with the pile all crushed and the gold fallen off it, just yellow silk left: it looked the ugliest rag in the world. When he saw him go out of the room with his brocade all ruined and messed, the King could not stop laughing. . . .

The general shift away from gilt splendour must have had very complex and discrete sources indeed—a frightening social mobility with its problem of dissociating oneself from the flashy new rich; the acute physical shortage of gold in the fifteenth century; a classical distaste for sensuous licence now seeping out from neo-Ciceronian humanism, reinforcing the more accessible sorts

75

of Christian asceticism; in the case of dress, obscure technical reasons for the best qualities of Dutch cloth being black anyway; above all, perhaps, the sheer rhythm of fashionable reaction. Many such factors must have coincided here. And the inhibition is not part of a comprehensive shift away from public opulence: it was selective. Philippe le Bon of Burgundy and Alfonso of Naples were as lush as ever—if not more so—in many other facets of their public lives. Even within the limitation of black costume one could be as conspicuously expensive as before, cutting the finest Netherlandish fabrics wastefully on the cross. The orientation of display shifted—one direction inhibited, another developed—and display itself went on.

The case of painting was similar. As the conspicuous consumption of gold and ultramarine became less important in the contracts, its place was filled by references to an equally conspicuous consumption of something else—skill. To see how this was so—how skill could be the natural alternative to precious pigment, and how skill could be clearly understood as a conspicuous index of consumption—one must return to the money of painting.

A distinction between the value of precious material on the one hand and the value of skilful working of materials on the other is now rather critical to the argument. It is a distinction that is not alien to us, is indeed fully comprehensible, though it is not usually central to our own thinking about pictures. In the early Renaissance, however, it was *the* centre. The dichotomy between quality of material and quality of skill was the most consistently and prominently recurring motif in everybody's discussion of painting and sculpture, and this is true whether the discussion is ascetic, deploring public enjoyment of works of art, or affirmative, as in texts of art theory. At one extreme one finds the figure of Reason using it to condemn the effect on us of works of art in Petrarch's dialogue *Physic against Fortune*: "It is the *preciousness*, as I suppose, and not the *art* that pleases you."

At the other extreme Alberti uses it in his treatise *On painting* to argue for the painter representing even golden objects not with gold itself but through a skilful application of yellow and white pigments:

There are painters who use much gold in their pictures because they think it gives them majesty: I do not praise this. Even if you were painting Virgil's Dido—with her gold quiver, her golden

76

hair fastened with a gold clasp, purple dress with a gold girdle, the reins and all her horse's trappings of gold—even then I would not want you to use any gold, because to represent the glitter of gold with plain colours brings the craftsman more admiration and praise.

One could multiply instances almost indefinitely, the most heterogeneous opinions being united only by their dependence on the same dichotomy between material and skill.

But intellectual concepts are one thing and crass practice is something else: the action of one on the other is usually difficult to demonstrate because it is not likely to be direct or simple. What gave Petrarch's and Alberti's distinction its special charge and geared it immediately into the dimension of practical business was that the same distinction was the whole basis of costing a picture, as indeed any manufacture. One paid for a picture under these same two headings, matter and skill, material and labour, as Giovanni d'Agnolo de' Bardi paid Botticelli for an altarpiece to go in the family chapel at S. Spirito:

Wednesday 3 August 1485:
At the chapel at S. Spirito seventy-eight florins fifteen soldi in payment of seventy-five gold florins in gold, paid to Sandro Botticelli on his reckoning, as follows—two florins for ultramarine, thirty-eight florins for gold and preparation of the panel, and thirty-five florins for his brush [*pel suo pennello*].

There was a neat and unusual equivalence between the values of the theoretical and the practical. On the one hand, ultramarine, gold for painting with and for the frame, timber for the panel (material); on the other Botticelli's brush (labour and skill)....

There was another . . . means of becoming an expensive purchaser of skill, already gaining ground in the middle of the century: this was the very great relative difference, in any manufacture, in the value of the master's and the assistants' time within each workshop. We can see that with the painters this difference was substantial. For instance, in 1447 Fra Angelico was in Rome painting frescoes for the new Pope Nicholas V. His work was paid for not with the comprehensive figure usual in commissions from private men or small secular groups but on the basis of his and three assistants' time, materials being provided. An entry

from the Vatican accounts will show the four men's respective rates:

23 May 1447.
To Fra Giovanni di Pietro of the Dominican Order, painter working on the chapel of St. Peter, on 23 May, forty-three ducats twenty-seven soldi, towards his allowance of 200 ducats per annum, for the period 13 March to the end of May . . .
<div align="right">43 florins 27 soldi</div>
To Benozzo da Leso, painter of Florence working in the above-said chapel, on the same day eighteen florins twelve soldi towards his allowance of seven florins the month for the period 13 March to the end of May . . .                      18 florins 12 soldi
   To Giovanni d'Antonio della Checha, painter in the same chapel, on the same day two ducats forty-two soldi, towards two and two-fifths months at one florin the month, for the period up to the end of May . . .               2 florins 42 soldi
To Jacomo d'Antonio da Poli, painter in the same chapel, on 23 May, three florins, his allowance for three months to run up to the end of May at the rate of one florin the month . . . 3 florins

The annual rate for each of the four, keep excluded, would therefore be:

| | | |
|---|---|---|
| Fra Angelico | 200 florins | |
| Benozzo Gozzoli | 84 florins | |
| Giovanni della Checha | 12 florins | 108 florins |
| Jacomo da Poli | 12 florins | |

When the team moved to Orvieto later in the year they got the same rates, except for Giovanni della Checha whose pay doubled from one to two florins the month. Clearly much money could be spent on skill if a disproportionate amount of a painting—disproportionate not by our standards but by theirs—were done by the master of a shop in place of his assistants.

   It was this that happened. The contract for Piero della Francesca's *Madonna della Misericordia*:

11 June 1445.
Pietro di Luca, Prior, . . . [and seven others] in the behalf and name of the Fraternity and Members of S. Maria della Misericordia have committed to Piero di Benedetto, painter, the making and painting of a panel in the oratory and church of the said

Fraternity, of the same form as the panel which is there now, with all the material for it and all the costs and expenses of the complete furnishing and preparation of its painting assembly and erection in the said oratory: with those images figures and ornaments stated and agreed with the abovesaid Prior and advisor or their successors in office and with the other abovesaid officers of the Fraternity; to be gilded with fine gold and coloured with fine colours, and specially with ultramarine blue: with this condition, that the said Piero should be bound to make good any defect the said panel shall develop or show with the passing of time through failure of material or of Piero himself, up to a limit of ten years. For all this they have agreed to pay 150 florins, at the rate of five lire five soldi the florin. Of which they have undertaken to give him on demand fifty florins now and the balance when the panel is finished. And the said Piero has undertaken to make paint decorate and assemble the said panel in the same breadth height and shape as the wooden panel there at present, and to deliver it complete assembled and set in place within the next three years; and that *no painter may put his hand to the brush other than Piero himself.*

This was a panel painting; for large scale fresco commissions the demand could be softened. When Filippino Lippi contracted in 1487 to paint frescoes in the Strozzi chapel of S. Maria Novella he undertook that the work should be ". . . all from his own hand, and particularly the figures" (*tutto di sua mano, e massime le figure*): the clause may be a little illogical, but the implication is obvious—that the figures, more important and difficult than architectural backgrounds, should have a relatively large component of Filippino's personal handiwork in them. There is a precise and realistic clause in Signorelli's contract of 1499 for frescoes in Orvieto Cathedral:

> The said master Luca is bound and promises to paint [1] all the figures to be done on the said vault, and [2] especially *the faces and all the parts of the figures from the middle of each figure upwards*, and [3] that no painting should be done on it without Luca himself being present. . . . And it is agreed [4] that all the mixing of colours should be done by the said master Luca himself. . . .

This was one interpretation of how far a master should personally intervene in the carrying out of his designs, on a very large-scale

fresco undertaking. And in general the intention of the later contracts is clear: the client will confer lustre on his picture not with gold but with mastery, the hand of the master himself. . . .

The fifteenth-century client seems to have made his opulent gestures more and more by becoming a conspicuous buyer of skill. Not all clients did so: the pattern described here is a perceptible drift in fifteenth-century contracts, not a norm with which they all comply. Borso d'Este [see p. 65] was not the only princely primitive out of touch with the decent commercial practice of Florence and Sansepolcro. But there were enough enlightened buyers of skill, spurred on by an increasingly articulate sense of the artists' individuality, to make the public attitude to painters very different in 1490 from what it had been in 1410. . . .

# 5. RAPHAEL'S FRESCOES

# IN THE

# STANZA DELLA SEGNATURA

## Sydney J. Freedberg

### INTRODUCTION

Sydney Freedberg's *Painting of the High Renaissance in Rome and Florence* is a detailed study of interrelationships in the painting of these two cities from the latter part of the fifteenth century to 1521. The text weaves back and forth between Florence and Rome and back and forth from artist to artist, developing an intricate evolution of form and style. The selection chosen for this anthology analyzes Raphael's first challenging commission at the papal court of Julius II: a series of frescoes long recognized as both a definitive monument in the classical style of the High Renaissance and the maturation of Raphael's art. The intensity of Freedberg's analysis provokes new insights into the nature of High Renaissance art, particularly with respect to the blend of ingredients that make up what we have called the Classical style.

The prototype for Freedberg's study is a familiar "classic": Heinrich Wölfflin's *Classic Art*, first published in German (1899). It is instructive to read in conjunction with Freedberg's work the reviews of it by Juergen Schulz in *The Art Bulletin*, XLV, 2 (1963), and by Creighton Gilbert, in *The Art Journal*, XXI, 4 (1962). Freedberg's *Painting in Italy 1500 to 1600* (1971) modifies some interpretations in the work cited above. For further reading on Raphael, see Oskar Fischel, *Raphael*, trans. by Bernard Rackham (1948); John Pope-Hennessy, *Raphael* (1970); Edgar Wind, "The Four Elements in Raphael's Stanza

della Segnatura," *Journal of the Warburg and Courtauld Institutes,* II (1938–1939); Kurt Badt, "Raphael's Incendio del Borgo," *Journal of the Warburg and Courtauld Institutes,* XXII (1959); J. White and J. Shearman, "Raphael's Tapestries and Their Cartoons," *The Art Bulletin,* XL, 3–4 (1958); H. B. Gutman, "The Medieval Content of Raphael's 'School of Athens'," *Journal of the History of Ideas,* II (1941); F. Hartt, "Lignum Vitae in Medio Paradisi: The Stanza d'Eliodoro and the Sistine Ceiling," *The Art Bulletin,* XXXII (1950); John Pope-Hennessy, *The Raphael Cartoons* (1950); J. Shearman, "Raphael's Unexecuted Projects for the Stanze," in *Walter Friedlaender zum 90. Geburtstag* (1965); I. L. Zupnick, "The Significance of the Stanza dell' Incendio; Leo X and François I," *Gazette des Beaux-Arts,* series 6, LXXX (1972), 195–204; and Philipp Fehl, "Raphael's Reconstruction of the Throne of St. Gregory the Great," *The Art Bulletin,* LV (1973), 373–379.

Additional publications the reader may wish to consult are Ulrich Middeldorf, *Raphael's Drawings* (1945); *Italian Drawings in the Department of Prints and Drawings in the British Museum,* Vol. III; Philip Pouncey and John A. Gere, *Raphael and His Circle,* 2 vols. (1967); John Shearman, *Raphael's Cartoons in the Collection of Her Majesty the Queen, and the Tapestries for the Sistine Chapel* (1972); Ernst Gombrich, "Raphael's *Stanza della Segnatura* and the Nature of Its Symbolism," in his *Symbolic Images* (1972); M. van Lohuizen-Mulder, *Raphael's Imagery of Justice, Humanity, Friendship* (1977); and N. Rash-Fabbri, "Note on the *Stanza della Segnatura,*" *Gazette des Beaux-Arts,* series 6, 94 (October 1979), 97–104.

The Stanza della Segnatura. The Sistine Ceiling is perhaps the highest and swiftest flight of spirit ever undertaken by an artist, and in the range of style it explores it may be the longest. In four-odd years of labor Michelangelo accomplished an evolution that embraced, in summary and essential terms, the possibilities of the Classical style from a relatively elementary to an apparently final stage, and also tested its impossibilities. No development in any other artist is comparable to this one in succinctness in time and space. Yet the pattern of development is not unique, and though it was doubtless isolated in its process of generation within Michelangelo's mind, it was not historically isolated in contemporary Rome.

Essentially independently, owing only little to knowledge of Michelangelo's example, Raphael moved in a similar orbit through the development of a mature Classical style: less high and swift, but in compensation investigating the regions through which it moved more broadly and more thoroughly. The distinction between Michelangelo's and Raphael's development depends not only on their different personality, and on their different quality and kind of genius but, as we have observed before, on the habit and aesthetic of their different métier: it is Raphael who explores the Classical style in the more diffuse and more complicated range of the painter's problems. . . .

The given architectural substance of the Stanza was altogether such as to solicit, in the mind of a painter of mature Classical disposition, a whole pictorial decoration that should conform to the internally balancing, centralized unity shaped by the walls themselves. The opportunity implicit in the architectural frame was not merely accepted but decisively exploited by Raphael; like Michelangelo in the Chapel, Raphael created a painted structure far more articulate than the actual Quattrocento space of its Classical aesthetic potential. Each whole wall became, in Raphael's scheme, itself a centralized unit of scanned, controlled expansion into space: a unit that elaborates, extends, and concords with the given architectural form. Almost as much as the sculptural reference is pervasive in the Sistine Ceiling, so is the architectural

reference of the pictorial form evident in the Segnatura. In Raphael's enrichment by fictitious architectonic spaces of the simple central structure of the actual room, its effect of form becomes profoundly like that of the contemporary conceptions (as for St. Peter's) of Bramante: the frescoed space becomes a domed quatrefoil, in which responsive curving movements are arranged into a central harmony.

The thematic material that was given Raphael for the decoration of the Segnatura was, even more than the fortunate accident of the given architecture, of a kind to stimulate a Classicizing character of artistic thought. The identity of the author or authors of Raphael's iconography is not known; it is only sure that, unlike Michelangelo, Raphael did not command a culture sufficient to invent his themes or to conceive their symbolic associations. Raphael's problem, vast enough, was to translate a given program (perhaps already earlier invented for Sodoma) into its visible form. What he was called upon to translate was, in the style of its ideas, of one community with the principles of art that he had brought from Florence and which, in part from the stimulus of this program, he was to develop more fully in this place. Unlike the program of the Sistine, in which a Classical cast of form and expression had been given to a profoundly Christian theme, the program of the Segnatura was, inversely, basically Classicizing and only secondarily theological. Its content represents a culminating expression of the humanism of the Renaissance: the program for the Segnatura, produced in Julius' court, is as remarkable a landmark in the history of classicism within Christianity as is the form in which Raphael illustrated it.

The humanist inventors of the program considered, as their starting point, the functions of the room that was to be decorated. These seem, from old tradition, to have been two: this Stanza was apparently the meeting place of the papal tribunal of the *Segnatura,* usually presided over by the Pope in his role as chief officer of the canon and the civil law; and it seems also to have housed the personal library of the Pope, the visible evidence of his character as a Renaissance man of learning, and of his sympathy with humanist letters and Christian humanist philosophy. Both these functions, projections not only of a papal personality in general but of the particular personality of Pope Julius, were to be indicated in the Stanza, but the key to their union was sought by the humanists in the circumstance that was at once more personal

to the Pope and most sympathetic to them: the role of the Stanza as Julius' library. The library was already a concrete expression of these functions, and to the Renaissance observer this was more immediately clear than now, from the habit of arranging libraries of the time according to "faculties," like those of the contemporary university. The Julian reference of the room led to the selection, as the thematic basis of the program, of those "faculties" which were pertinent to him, but these were in any case the ones of widest general significance: theology, law, philosophy (which included natural science), and arts (literary, not visual). These themes once selected, their specific origin, either in Pope Julius or his library, was mostly absorbed—characteristically for the High Renaissance mentality—in their possibilities for making of ideal generalization.

One wall was to be devoted to the description of each of these faculties illustrated by a rich cast of historical characters brought together on an invented, but noble and meaningful pretext; the historical accent is more literal, but not more deeply felt, than in the Sistine. On the wall devoted to Theology the invention is of an imaginary council of great defenders of the dogmas of the Roman Church, supervised by a heavenly senate of saints and prophets, and presided over by the Trinity. The subject of their disputation is the justification of the doctrine of transubstantiation: a theme at once vastly general in its central importance for Catholic theology, and also topical and personal in its reference to Julius' own veneration and defense of a then disputed article of belief. The wall opposite, which illustrates Philosophy, is an ideal assembly of the great philosophers of the Ancient world, metaphysicians and scientists alike, led jointly by Plato and by Aristotle. In this juxtaposition of Christianity and pre-Christianity, one seeking revelation and the other possessed of it, there is an analogue, but in humanistic terms that are more respectful of the illumination of the Ancients, to the scheme of the whole Sistine Chapel. The wall to the right of the *School of Athens* illustrates the arts, chiefly literary, personified in a gathering of Classical authors and of modern Italian humanists and poets. Certainly, the inventors of this program must have been given the due compliment of a place in this Parnassian court, presided over by Apollo and his Muses. Finally, on the wall across the room the Law is represented. On the lower portion of this wall, to either side of the separating window, are the historical foundations of civil and

85

canon law, in the latter of which Julius acts the part of the giver of the Decretals, Gregory IX; and on the upper portion of the wall is the representation of the three virtues, Prudence, Temperance, and Fortitude, which complement the virtue of Justice.

These are the separate illustrations of the faculties, each one an ideal generalization of actors and of situations, but it is a much higher generalization at which the program aims. It intends to describe not only the dignity of each faculty, but their ideal community: their function in a unity which embraces the highest aspects of man's intellectual, spiritual, and social being. The order in which the scenes are placed upon the walls implies relations. Theology and Philosophy lie across from one another; contrasted, not as irreconcilable opposites but as the classicizing humanists saw them, as complementary avenues to truth: one by faith and spiritual revelation, the other by reason and observation. Poetry and the Arts, which men create by inspiration, contrast with but also complement the Law, which man administers by deliberation and by precedent. The different disciplines, and seemingly opposite ways in which men work within them, are matched and balanced to form together a unity of man's intellectual and spiritual endeavor. Reason and faith, discipline and inspiration, become four walls of one ideal temple of the human mind.

The ideal relation among the faculties on the walls is not only that of their complementary contrast, but of a still more positive association of ideas which is made between each faculty and its adjacent neighbor. Within each wall the actors are arranged in such fashion that those toward one half of the scene have a link in ideal character with those of the adjoining half of the next scene; so in the *School of Athens* it is Plato and his disciples who stand toward the side of Parnassus, and Aristotle toward the Jurisprudence; on the wall of Justice it is the Civil Law that adjoins Philosophy, and the Canon Law that adjoins Theology; in the *Disputà* St. Peter is on the side toward Law and the mystics and visionaries toward the side of Poetry; in the *Parnassus* the Christian poets stand near Theology and the Ancient poets, for the most part, stand toward the *School of Athens*.

This association among the faculties is confirmed on the ceiling in an ideal demonstration which links them still more closely. Between the four enthroned personifications of the faculties, and set at an angle equally between them, the four oblong paintings are so devised in subject as to refer to both faculties that they

adjoin: their idea principally illustrates the faculty to the left, but also leads inescapably to that on the right. Between Theology and Justice the oblong painting shows the *Temptation of Adam,* which brought the Fall that made necessary the sacrifice of Christ commemorated in the Eucharist, the subject of the Disputation to the left below. Since this Fall brought a divine judgment upon man, it links the theme of Theology with that of Justice on its right. Between Justice and Philosophy is the *Judgment of Solomon,* the king who here acts in the roles both of philosopher and judge. Between Philosophy and Poetry is an illustration of Astronomy, a branch of "natural" philosophy, in which there is implicit the Platonic doctrine of the harmony of the cosmos that is imitated in the harmonies of art, the "music of the spheres." Finally, completing the interlocking circle of ideas, the *Flaying of Marsyas,* between Poetry and Theology, deals—at the most obvious level only of its meanings—with the double theme of art and the fatal consequence of a challenge of divine authority, implying the results of contest with the sacred dogma of the papal Church. . . .

The painting of the ceiling was a necessary prelude to the major decoration of the Stanza. Beyond the opportunity offered on the ceiling to acquire some mastery of the technique of fresco it was only on the ceiling that Raphael finally attained the capacity, so necessary to the works to come, to make the human form articulate an active human situation. Equally important, the time occupied on the ceiling was a necessary interval in which Rome, Ancient and Julian, aesthetic and literary, could make its decisive impress on the spirit of the artist who, until recently, had been a painter of pictures of Christian devotion for a cultured, but mostly mercantile, Florentine society. By the time Raphael began his paintings of the walls he was possessed by the exalting knowledge of Rome and by the disposition to think and feel—as Michelangelo, by longer Roman experience, as well as private temper, felt already—nobly and universally. What came to happen on the walls of the Stanza della Segnatura is more than a logical development from what we know of Raphael's art before; it is the result of a dramatic magnification, in his new environment, of his personality.

Raphael's first painting on the wall, begun probably fairly early in 1509, was the illustration of Theology (Fig. 8). This scene is conceived as if it were at once an ideal council of the Church, in which its divine and mortal members are gathered to argue and approve the doctrine of transubstantiation, and a symbolic cele-

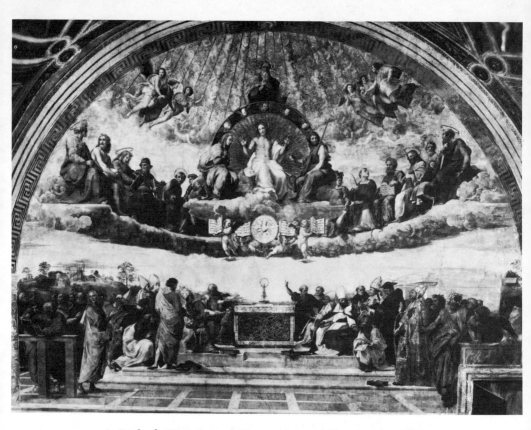

8. Raphael, *Disputà*, 1509, Fresco (Stanza della Segnatura, Vatican)

bration of the Mass; the Eucharist upon the altar is the central
object of the energies of the council just as it is the central object
of the Mass. It is fixed precisely on the middle axis of the picture
and it is upon this object, so small in size but of such vast spiritual
meaning, that all the rest of the design focuses. Above and to both
sides of the Eucharist the mortal disputants and holy witnesses
are disposed in simple, grandly sweeping semicircles which ex-
tend, into the depth of the picture, the shape of the arched wall.
Higher in the picture is a third and smaller semicircle made of
angels and of seraphim, close-packed in upward-rising tiers. The
sequence of semicircles, each dense with figures, instantly sug-
gests an effect as of an architecture, like the apsidal half-dome of
a church. Exploiting the arched shape of the wall itself, Raphael
has conceived an inspired intersection between form and mean-
ing. From the figures who attend the symbolic Mass he has built
an apse to house the Eucharist and the altar on which it stands,
making a church more perfect in its substance than any archi-

88

tecture of stone, out of the divine Persons, the Prophets and Apostles, and the wisest of God's theologians.

The development of compositional form and the integration with it of meaning of idea is at a level that makes insignificant the obvious ancestry of the design in such an early monument of Classical style as Bartolommeo's *Judgment*, or in Raphael's own Perugian fresco of S. Severo. The living architecture of this fresco has a clarity, harmony and spaciousness, as well as a sense of scale, like that of an actual architecture; but this painted structure has the flexibility, unarchitectural, of the vital beings out of which it has been made. The great curves echo and reecho in a grandiose accord; but while, in one sense, they repeat each other, in another sense they are at the same time resiliently opposed. Throughout the composition each curve converges meaningfully toward the Eucharist, and every balance swings from it as from a pivot: upon the mute symbol of the Mystery are concentrated not only the spiritual energies of the actors but the formal energies of the design.

As in a real architecture, the solids of the composition here not only shape but give aesthetic personality to the space that they enclose. The unpopulated spaces of the picture have become an aesthetic agent on a scale, and with an emphasis, that, in Fra Bartolommeo's *Judgment*, had been no more than hinted at. The space has not only the accustomed effects of a perspective struc-ture (here still traditional and conservative) but is informed with the animation of the solids that surround and define it. There is no longer, in this space, the quattrocentesque contrast between solids and a measured void but a unity in which space, itself inspired with personality, acts in flexible and complementary concert with the solid forms. This system, expressed for the first time on monu-mental scale in the *Disputà*, is the normative solution to the prob-lem in Classical pictorial style of relation between substances and spaces; it is a mature midstage in a historical evolution in which Leonardo's *Adoration* and *Last Supper* stand at one end and, as we shall see, Raphael's Tapestry Cartoons at another.

The figures who populate this structure have grown in scale beyond those of Raphael's style in Florence and beyond those, also, of the ceiling; they are as if magnified to accord with the grandeur of the formal and ideal scheme in which they act. Most of the figures tend toward slightly but perceptibly heavier pro-portion than before, which is supported by a more generous

amplitude of drapery. The movement of the body is explicit in articulation in the precise way that Raphael had learned in course of painting of the ceiling, and the draperies are so manipulated as to increase the breadth and clarity of the body's action. The full form and movement of the persons of the *Disputà* conveys, as Raphael's actors rarely had before, a deliberation, a decorum, and even a stateliness that reflects, but even more ennobles, the ideal of behavior of the Classicizing Roman court.

The dignity and Roman sense of decorum in these figure types is new, but the way in which Raphael works with them still depends, even specifically, on lessons learned from Leonardo. The *Disputà* is in a way a fulfillment of ideas first stated in the *Adoration of the Magi,* and several motives indicate that its model was still influential upon Raphael. The left figures of the fresco's lower range particularly recall the by now ancient, but inexhaustible, precedent: there is the same preoccupation as in Leonardo with the differentiation of complementary ideal types, and with the diversifying of expression within a general ideal mood. What Leonardo demonstrates in the *Adoration* in a—by comparison— too tightly interwoven texture is here sorted out into a wonderful lucidity of the component parts.

This process of internal clarifying is in no sense achieved at the expense of the coherence of the whole; it is no more than a function of the whole new power of clarity in Raphael's gestalt. Each individual figure is welded into ineluctable association with its group; and in the group its single parts are bound into a formal and expressive chord of which the resonance is much more than the result of the addition of its parts. As with the figures that compose it each group is distinguished from, yet inescapably associated with the next to make, again, a finally inclusive chorded harmony of whole design.

Within each group Raphael's principle of assembly is, at once, an extension of the principle of counterpoise in harmony, which shapes the posture of the single figure, and a reflection of the synthesis of complementaries which, in ideas of content as well as form, controls the decoration in its entirety. Each posture is related in a rhythmic sequence to the next, and at the same time may be complementary in movement, mass, and place in space. Each group contains, in the meaning of bodily action, in types and in expression of face, a similar interwoven play of complementaries. The relation among groups extends the same concep-

tion, of connecting sequences and simultaneous complementary variation of the general idea of form and mood. In the ordering of groups still other considerations are taken into account: of relation not only to the adjacent group but to the countering, other, half of the balancing design and, almost a primary consideration, the expressive function of the group in the development of the picture's whole communicative sense. So in the *Disputà*, in its actively expressive lower range, among those figures who are (unlike the divinely knowledgeable Senate) the "disputants," there is a succession of diverse states of energy and gravity in the groups that move from left to right and inward toward the altar; on the right there is a slower and more even-tempered progress, of figures almost in columnar sequence, which brings the movement of design to rest; here the articulation into groups is not so scanned or so precise.

It is in this manipulation of a multitude into a differentiated harmony of form and expression that Raphael does, in extent and in terms of quality, what neither he nor any of his predecessors in the painting of the Classical style had done before. Conspicuously, the *Disputà* achieves that which Michelangelo, in his contemporary first stories of the Sistine Ceiling, had attempted unsuccessfully to do and then abandoned. Moreover, even in Michelangelo's own special domain of expressive working with the human form, there is no measurable difference at this stage (probably late in 1509) in the evolution of resources of a Classical figure style. In the *Disputà* the compact, spatially developed figure of St. Augustine's scribe is a form at once as unified and as internally complex as is the *Delfica;* the "Bramante" in the foremost group at left is as handsomely counterpoised and as expressive as Michelangelo's *Isaiah*, and perhaps more expressive than the *Joel* whom, in features, he resembles; Raphael's *St. John Baptist* is almost as easy in his pose as the Ignudi of the Sistine's third bay; and the quiet-gesturing, erect figure at the middle left is as Classically recollective in his posture, quite as monumental, and of not less grave a grace, than are the sons of Noah. In all but the magnitude of form and feeling that is Michelangelo's alone, Raphael's contemporary figures are as eloquent as his in the language of the Classical style; and Raphael's development in this respect is as surely independent at this date of Michelangelo as is his remarkable development of composition, in which Michelangelo could offer no aid or example.

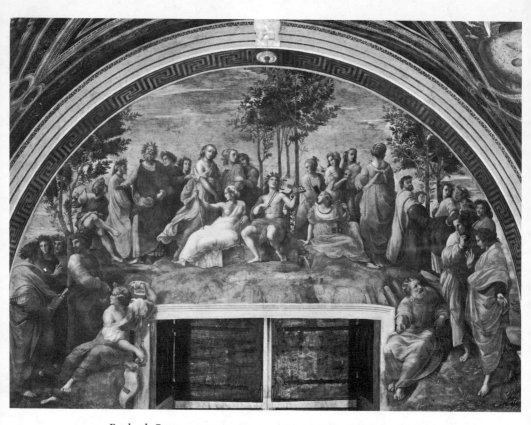

9. Raphael, *Parnassus*, 1510, Fresco (Stanza della Segnatura, Vatican)

The compositional ingenuity that had conceived the idea of exploiting the shape of the wall in the *Disputà* to make of it the basis for a churchly apse is no less demonstrated in the second fresco of the Segnatura, the *Parnassus* (Fig. 9), executed probably in 1510. Here the misfortune of the irregular arched space into which the window juts from below is converted to positive advantage: on and around the intruding window Raphael built the hill of his Parnassus. In this poetic assembly the atmosphere is different from that of the theological gathering in the *Disputà*. Where the *Disputà* evokes a muted and solemn, appropriately celebrant, ardor the *Parnassus* is more lyrically warm, as if in recreation of the atmosphere of a poet's vision of Antiquity. In Raphael's longer residence in Rome, now, he has been exposed successfully to its climate of literary Classicism, but it is more than the subject matter of this fresco that suggests the flavor of an Ancient Classical world. The figures of the *Parnassus* have the accent of an archaeological experience, of Raphael's study in

Antiquity of visible analogues of his own Classical style. The Muses of the fresco reflect this experience with something of the excess of enthusiasm of a novelty: they are reconstructions, in Raphael's most sophisticated current vocabulary, of the sensuous beauty of Ancient Classical images, exaggerating (far beyond what is in this case the identifiable and rather insignificant precise Antique source) generic Classicizing characteristics of almost arbitrary perfection of shape and musically cursive sequences of form.

Not only the Muses but all the inhabitants of Parnassus are more Classically conceived than the actors of the *Disputà*, not merely in their imitative Antique cast of drapery and accessories but in the more essential fact of a yet fuller amplitude of form and graver dignity of posture and of movement. The *Sappho*, who introduces us into this intended reconstruction of an Antique world, summarizes the grander Classicism of figure style in the *Parnassus*. Her body is a more plastically ample, richly rounded presence, composed of suave sequences of rhythm. Her movement is a fullest development of contrapposto, slow and easy, yet instinct with latent strength—an impeccable meshing and balancing of muted energy with rich substance. She makes a spatial arabesque of such beauty as before—and only shortly before—only the figures of Leonardo's third *St. Anne* had achieved, and then not with the Classical accent of sensuous splendor and Antique recall of this Raphaelesque form. Measured against the contemporary accomplishment of the Sistine, the Sappho seems a synthesis of Sibyl and Ignudo.

In the position of the Sappho Raphael exploits the awkward given shape of wall with quasi-illusionistic intention, more assertive than in the "Bramante" who plays a comparable role of introduction in the *Disputà*. As with the "Bramante," the movement of the Sappho is directly integrated into a group, here of poets whose measured dignity of stance complements and compensates the variety of her posture. As in the *Disputà*, this leftward and forward group is distinctly articulated from the group that next succeeds. The internal order of this second group is an inversion of the Sapphic group, beginning with the figure of the Ennias— so Ignudo-like—which echoes and varies, in reverse, the figure of the Sappho. The group of Apollo and his Muses is of singular melodiousness, visibly expressing in its form the suave music diffused through it from Apollo's viol. This melodic line rests in

the figure of the last Muse at the right; it then turns gently to descend the slope, moving in accelerating cadence through the figures of this part of the company of poets. Altogether the movement of the composition has a measure of variety—a close-textured alternation of rich arabesque and yielding pause—that is in every way more developed than in the *Disputà*. Again as in the *Disputà*, but with more decisiveness, the figures at the rightward and forward side of the design act to connect their ideal realm and the spectator's space. The principal form here, that of the aged poet, is the complement of the Sappho in sex, age, in compact and forceful shape, and in the direction of his movement; he leads us back to our reality as Sappho led us beyond it.

The *School of Athens* (Fig. 10) (executed probably from late 1510 through mid-1511) also reconstructs an Antique world, but in a mood unlike that of the *Parnassus*, not golden and sensuously warm but crystalline: an atmosphere of high clear thought per-

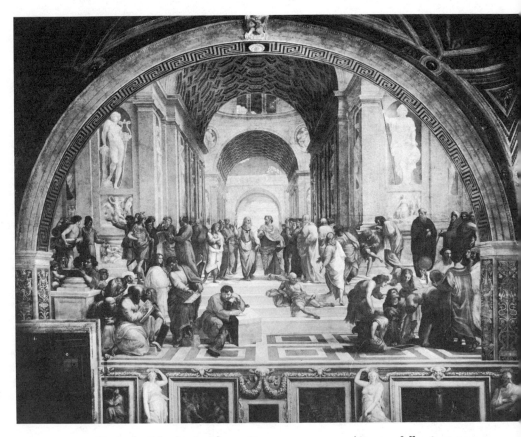

10. Raphael, *School of Athens*, Fresco, 1510–1511 (Stanza della Segnatura, Vatican)

vaded by the energies of powerful intelligence. The architecture sets the temper of the scene; Bramantesque, but with a stricter accent than in his actual architecture of recollective Classicism, it creates a stage for the figures that is of lucid order and extraordinary breadth. Its harmony and vastness is not only the frame for its inhabitants but the symbol of the intellectual structure they have built; this man-made architecture contrasts in form and in idea with the fictive heavenly architecture of the *Disputà*. Within this structure, upon the various levels of its deep foreground space, Raphael distributes its population of philosophers in a scheme that absorbs the experience both of the *Parnassus* and the *Disputà*: it has an internal variety still greater than that of one and the final grandiose stability of the other. By comparison with this fresco the design of the *Disputà* seems stilted; the basic harmony of structure, broader and deeper than that of the *Disputà*, has been immeasurably enriched from within.

The ordnance of the actors of the *School of Athens*, like that of the architecture which supports them, is according to a central scheme. Plato and Aristotle, framed by the diminishing sequence of perspective arches, are the focus of this scheme: in them the axes of the composition intersect and on them the orthogonals of the architecture converge. On both sides of their slow-gesturing, majestic forms the other figures expand in counterpoised, but not symmetrical, waves of movement which accelerate in energy as they descend, in a curving and centralizing embrace, toward the front. Unlike the *Disputà*, where the apsidal design frames, but does not enclose space, this figure composition is developed in ground plan so as virtually to surround a central spatial core; this ground plan not only echoes, loosely, the visible system of the Bramantesque architecture to the rear but that of the central ordnance of the entire decoration of the room: it suggests a quatrefoil in shape. The space thus defined by the figures is not only more inclusively and more articulately shaped than in the *Disputà* but there is also here, in comparison with the *Disputà*, a freer and more vigorous intermingling between the figures and the space. Far more than in the *Disputà*, the space of the *School of Athens* is permeated by the higher and more various energies of the figures, and shows the more complex plasticity of their distribution and their individual design. As in the *Disputà*, this space that is shaped by the figures is accompanied by a traditional and conventional space of Quattrocento perspective and

both spaces, that formed by the figures and that made by the setting in perspective, are much more effectively combined. The space of the architecture and that of the figures wholly interpenetrate, and reciprocally magnify each other. . . .

In the *School of Athens*, the inheritance of the quattrocentesque concept of perspective space, and Raphael's new concept, of a space made by the figures, work in reinforcing concord and in balance. What Raphael has here first realized so profoundly as a space of figures is, however, distinct in fundamental principle from a perspective system. The space made by perspective may be described as the Early Renaissance's rationalization of an experience of space still based on that of medieval art: perspective serves to rationalize a hitherto unmeasurable, or infinite, continuum. The apprehension of the measurement of space was accompanied by that of the measurement of solids; these were concurrent and consistent, but not synthesized apprehensions. The substances were inserted in the space as loci of the geometrically defined continuum: this projection of consonant but separate experiences, of void and solid, was suspended in an abstract harmony in the reticule of perspective. In this system, as Alberti had defined it, the construction of the stage preceded the setting on it of the players.

As, in the course of the Renaissance, a differently integral, vital sense of human substance was evolved, culminating in the first expressions of High Renaissance Classical figure style, it became increasingly less possible to conceive space only as a preexistent geometric void. Figures of the new kind, as they developed in this mature phase of Classical style, came to move in three dimensions into the air around them, charging it with the emanation of their energies. Space, not only in the intervals between such figures but in the immediate ambience even of a single one of them is no longer precedent to substance or distinct from it: the figure creates space around itself, and in groups and compositions, shapes it. Shaped and charged by the enclosing substances (and in itself observed, in the new style, as mobile textured atmosphere) the space becomes not measured void but a palpable phenomenon: a plastically responsive ether. It is an extension and accessory function of the solid forms, and in this sense, in the *School of Athens*, space and substance have become parts of an experiential unity.

The conception of substance and of its effect on immediately adjacent space is like that in the Ancient Classic style, but no

Antique work we know controls so wide and continuous an environment as is in the *School of Athens* with its sense of consistent and connected unity; to achieve this it is precisely the experience of Early Renaissance perspective command over void that must be presupposed. The spatial structure of the *School of Athens* is, like almost every other aspect of High Renaissance Classicism, distinct from Antique analogue and synthesizes Classical rediscovery with the consequence, however transformed, of an ultimately medieval, Christian apprehension of the world.

All this inner unity of space in Raphael's fresco has only limited relation, either by figural devices or perspective, with the space in which the spectator stands. As Leonardo had defined it first, this projection of an ideal world is distinct from ours; it is an accessible but discrete unity. What is in the *School of Athens* as a spatial structure is a synthetic equilibrium, of perspective inheritance and new Classical invention of space shaped by substance; we have observed already that the new Classical component was destined to increase its role. At the climax of Raphael's development of Classicism it would not only eclipse the other; more than this, the sense and the authority of substance, as such, would virtually extinguish even the ancillary function, in design, of space. But now, in this fresco, Raphael has evolved a solution, in terms of purely pictorial aesthetic, of the working of space and substances that is as inaccessible to the sculptural mentality of Michelangelo as it had been to the mind of Classical Antiquity.

The new component in the spatial mechanism of the *School of Athens* is, as we have suggested, a consequence of the matured High Renaissance Classical conception of the human form. In this fresco, this conception has evolved still more; while part of its population is not different from the actors of the *Parnassus* its most prominent figures, those in the foreground, have once more been magnified in their dimension. These figures in particular, but also almost all the others in the painting, are possessed by an energy which now by far exceeds that of the persons of the *Disputà;* they move in, and occupy, space with powerful assertiveness. Because each form is in itself so much developed plastically their gathering together into groups is now more elaborately articulated: to accommodate their spatial movement the enclosing group becomes at once more open within itself and more deep; more than in the *Parnassus* or the *Disputà* we are aware, in the groups of the *School of Athens*, of their expansion as if toward the imaginary fullness

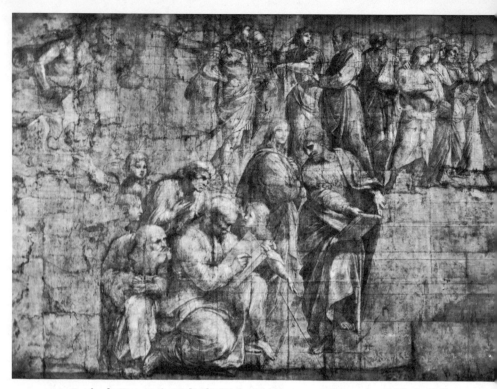

11. Raphael, Cartoon for *School of Athens*, 1509–1510, Charcoal and black chalk, heightened with white, 9'2" x 24'3" (Galleria Ambrosiana, Milan; Alinari/ Editorial Photocolor Archives, Inc.)

of a sphere. Like the organization of the whole compositional structure, that of its parts is more than before spatially inclusive and expansive.

As is necessary in the Classical proposition, the growth of human form is not a growth of physical dimension only; it is equally a growing of the power of spiritual sensation. The size and breadth of action of the figures answers to their grander and more vital energies of mind. Furthermore, these states of mind, as the faces show them, are not only stronger than in the preceding frescoes but also more explicitly defined; and the body also, in its Classical function of interpenetration with the spirit, is much more explicitly articulate than before of its content. What Raphael achieves in the figures of the *School of Athens* represents a measurably higher development of Classical style. Where, however, in the two earlier frescoes it could be asserted that his development in figure style was, in all but force and magnitude, proceeding *pari passu* with that of Michelangelo, it is now evident that the contemporary accomplishment of Michelangelo in 1511 has explored possibilities

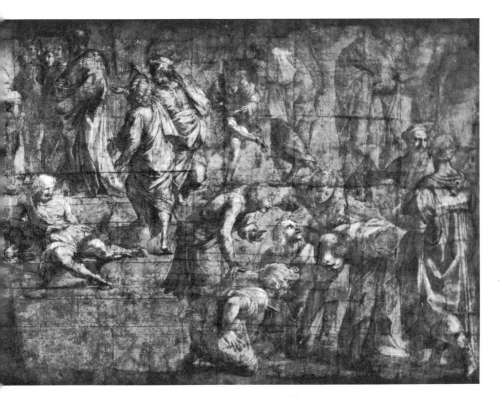

of Classical figure style that Raphael has not approached. This is despite the fact that in the *School of Athens* it becomes for the first time certain that Raphael has studied the Sistine Ceiling, perhaps at first in its half-completed state at the end of 1510.

There is nothing among the figures of the second plan of Raphael's fresco that is not wholly understandable as a consequence of his prior evolution, but the figures of the foreground, exactly those in which he shows himself the most advanced, demand knowledge of Michelangelesque precedent. The *Pythagoras* at the left—still, like the figures just behind him, reminiscent of the models of Leonardo—most strongly shows community with the Sistine Seers; in their developed musculature, complex postures, and extraordinary articulateness of body the youths around Euclid to the right are indebted to the Prophets and Ignudi both. It is the so-called *Heraclitus*, the *Pensieroso* in the center foreground of the fresco (unforeseen in the original cartoon in the Ambrosiana) (Fig. 11), who is most exactly dependent on the Ceiling. This figure, a compound of Michelangelo's *Isaiah* and

99

*Jeremiah*, and so strangely like Michelangelo himself in features and in dress, was added only at the end of painting of the *School of Athens*, after it had been quite finished according to the cartoon. In freedom and immediacy of expressive technique it is advanced much beyond the other figures in this neighborhood. It surely succeeds, in time of conception and in execution, the first official unveiling of the Sistine Ceiling in August 1511.

This addition was provoked by more, however, than a wish to emulate Michelangelo's recent remarkable accomplishment in figure style; it is even more important for its meaning, purely Raphaelesque, within the composition. The *Heraclitus* literally rounds out, to fullness and near-spherical closure, the fresco's spatial scheme and serves in the composition as a final unifying key: it is, almost, a fulcrum for the several parts of the design. Before its meaning of relation to Michelangelo, this figure must be thought of in its significance of a correction to and further fulfillment of the Classical character of Raphael's original design, a correction conceived by Raphael as the fruit of his own development in the interval between invention and completion of the fresco; in this sense it has nothing to do with Michelangelo. It is, however, in this figure that Raphael comes closest to—but yet does not achieve—the sense of scale and of expressive vibrance in the single human figure that is demonstrated by the Michelangelo of this time. The imitation must remain approximate, for it is not motivated, nor inhabited, by the inimitable power of Michelangelo's ideas.

Confined within a less exalted spiritual limit, Raphael's conception of individual humanity does not trespass, even with Michelangelo's guidance, beyond what may be described (in terms of Michelangelo's own development) as a median of idealization. The species of humanity to which Raphael's actors belong, here at his absolute attainment of artistic maturity in the *School of Athens*, is that which Michelangelo had created in the bays of his Ceiling which just precede, but do not quite include, the *Creation of Adam*. However, what may be lacking in concentrated force of each human image is compensated for in Raphael by his quantitative variety of images. Harmonized into a community by their ideal reformation—but a reformation based on their wide, actual, human diversity—the actors of the *School of Athens* represent a concept of mankind much less austere and exclusive than Michelangelo's, but far richer. Like Leonardo before him the mature

## Raphael's Frescoes in the Stanza della Segnatura

Raphael continues to believe in the function of art as comment on the multiform experience of the world. Where Michelangelo's art is the expression of an isolated psyche, and his creatures in the Sistine images of man in an essential isolation, the *School of Athens*—and the frescoes of the Segnatura in general—are the expression less of man as an individuality than of the community of men: representations of the greatness that men attain and promote in social concourse.

In the close-woven texture that Raphael makes of this concourse of humanity he exploits a range and kind of orchestration, both of form and of expression, that is closed to Michelangelo. The sum of this pictorial texture is greater than that of its human parts: the single figures may not rise beyond, or even to the standard of Michelangelo's median in the Sistine, but the aesthetic and contentual measure of the whole is not less nobly ideal. More than Michelangelo's pictured world—superb in both senses of the word; too high, too private and too terrible to imply practical example—the world projected here by Raphael conveys an ethic as well as aesthetic sense; here the beautiful is identified with human good.

# 6. MICHELANGELO'S VIEWS ON ART

*Anthony Blunt*

## INTRODUCTION

In his *Artistic Theory in Italy, 1450–1600* (1940; 2nd ed., 1956), Anthony Blunt traces the artistic theories of the Renaissance from their fully-developed humanist form in the writings of Alberti through the Mannerist doctrines of the sixteenth century.

Of particular interest is the contrast presented by the chapters on Leonardo and Michelangelo. Intensely fascinated by the phenomena of the material world and attuned to "the evidence of the senses," Leonardo emerges representative of the scientific current in Renaissance art. Yet Leonardo's conception of the artist is not that of a mere observer and recorder of phenomena. He is also the imaginative creator, but one whose invention is based nonetheless on the forms of nature. Michelangelo, for all the empirical factors in his conception of the human form, appears initially to comprehend the beauty of the human body as a reflection of the divine in the material world. This notion has its roots in Neoplatonism, which enjoyed an ephemeral popularity in the Italian Renaissance and attracted the artist during his early formative years in Florence. As Michelangelo's religious feeling shifted during the course of his long career toward an increasingly dark and introspective mood, his views on art still retained a measure of Neoplatonic tone. But in these later years, as Blunt demonstrates, he ceased finally to see human beauty as a symbol of the divine. Stylistically as well as chronologically there is a whole lifetime between the physical splendor of his early *David* and the Rondanini *Pietà*, which he left unfinished at his death. What this final work conveys is a spiritual presence, poignant and flawed.

103

For further reading on Michelangelo's thought, consult E. H. Ramsden, ed. and trans., *The Letters of Michelangelo*, 2 vols. (1963); Charles de Tolnay, *The Art and Thought of Michelangelo* (1964); and R. J. Clements, *Poetry of Michelangelo* (1965). Michelangelo's relationship to the Neoplatonic movement is treated in Erwin Panofsky's *Studies in Iconology* (1939), available in paperback form since 1962. Other readings on Neoplatonism are P. O. Kristeller, *The Philosophy of Marsilio Ficino* (1943); J. C. Nelson, *Renaissance Theory of Love* (1958); E. H. Gombrich, "Icones Symbolicae: The Visual Image in Neo-Platonic Thought," *Journal of the Warburg and Courtauld Institutes*, XI (1948); and Erwin Panofsky, *Renaissance and Renascences in Western Art* (1960), especially 182–200. For critical views of the Neoplatonic content in Michelangelo's art, consult Frederick Hartt, "The Meaning of Michelangelo's Medici Chapel," in *Essays in Honor of Georg Swarzenski* (1951), 145–155; and Creighton E. Gilbert, "Texts and Contexts of the Medici Chapel," *Art Quarterly*, XXXIV, 4 (1971), 391–409. An important study of this monument is Johannes Wilde, "Michelangelo's Designs for the Medici Tombs," *Journal of the Warburg and Courtauld Institutes*, XVIII (1955), 54 ff. See also the bibliography in the selection on Michelangelo's architecture by James S. Ackerman for basic works on this artist, to which one should add Frederick Hartt, *Michelangelo. The Complete Sculpture* (1968); and Herbert von Einem, *Michelangelo*, rev. ed. (1973), a work first published in German in 1959.

Additional publications are Leo Steinberg, "Michelangelo's Florentine *Pietà*: the Missing Leg," *The Art Bulletin*, L, 4 (1968), 343–353, "Michelangelo's *Madonna Medici* and Related Works," *The Burlington Magazine*, 113 (March 1971), 144–149, and *Michelangelo's Last Paintings* (1975); Johannes Wilde, *Michelangelo and His Studio* (1975); Juergen Schulz, "Michelangelo's Unfinished Works," *The Art Bulletin*, LVII, 3 (September 1975), 366–373; Leo Steinberg, "Michelangelo's *Last Judgment* as Merciful Heresy," *Art in America*, LXIII (November–December 1975), 49–63, which one should read in conjunction with Marcia B. Hall, "Michelangelo's *Last Judgment*: Resurrection of the Body and Predestination," *The Art Bulletin*, LVIII, 1 (March 1976), 85–92; Esther G. Dotson, "An Augustinian Interpretation of Michelangelo's Sistine Ceiling," *The Art Bulletin*, LXI, 2 (June 1979), 223–256, and 3 (September 1979), 405–429; *The Complete Poems and*

*Selected Letters of Michelangelo,* trans. by Creighton Gilbert (1980); and David Summers, *Michelangelo and the Language of Art* (1981).

Our sources of knowledge for Michelangelo's views on the Fine Arts are varied. Of his own writings, the letters contain almost nothing of interest from the point of view of theory, since they are nearly all personal or business notes to his family or his patrons. The poems, on the other hand, are of great importance, for though they contain few direct references to the arts, many of them are love poems from which it is possible to deduce in what terms Michelangelo conceived of beauty.

In addition to his own writings we have the evidence of three of his contemporaries. The first of these is the Portuguese painter Francisco de Hollanda, who came to Rome in 1538 and worked his way for a time into Michelangelo's circle. He was probably never very intimate with the latter, and his dialogues[1] were almost certainly written to glorify himself and to show how closely he associated with the master. But however great his conceit may have been, his evidence is of importance, since it deals with a period of Michelangelo's life on which we are not otherwise well informed by his biographers.[2]

The second contemporary source is the biography of Michelangelo in Vasari's *Lives*. It was first published in 1550, but was greatly enlarged and almost entirely rewritten for the second edition of 1568. It contains less material than might be expected, but it gives some account of his methods of working and records some of his opinions.

More important is the third authority, Ascanio Condivi, a pupil of Michelangelo, who published a biography of his master in 1553. The life seems to have been written to correct certain false statements made by Vasari; and, though Condivi was a somewhat naïve character, he is probably more reliable than either Hollanda or Vasari when he reports Michelangelo's own views and statements.

Michelangelo lived to a great age, and his views were constantly developing and changing, so that it is impossible to treat his theories as a single consistent whole. Born in 1475, he was trained under masters who still belonged to the Quattrocento. His earliest works in Rome represent the full blooming of the High Renaissance, but before he died in 1564 Mannerism was firmly estab-

lished. It is impossible to divide his works or his ideas into sharply separate compartments, but for the present purpose they can be roughly grouped in three periods, if we ignore the very early years from which no documents survive.

In the first period, ending roughly in 1530, Michelangelo's view of the arts is that of High Renaissance humanism. It is most clearly typified in the ceiling of the Sistine Chapel, the *Pietà* in St. Peter's, and the early love-poems. In these works the various elements which made up Michelangelo's early training are clearly visible. Like Leonardo he was heir to the scientific tradition of Florentine painting, but he was also affected by the atmosphere of Neoplatonism in which he grew up. His highest allegiance, however, was to beauty rather than to scientific truth; and although in his early years at least he felt that the attainment of beauty depended in large part on the knowledge of nature, he did not feel the urge to undertake the investigation of natural causes for their own sake. Consequently the observation of nature which he absorbed in the studio of Ghirlandaio could fairly easily be fused with the doctrines of beauty which he learned from the circle of Lorenzo de' Medici. But there was another factor which favored Michelangelo in comparison with Leonardo. Neither Florence nor Milan could provide the latter with the atmosphere of buoyancy which alone can produce a great synthesis such as had been achieved in Florence in the early years of the fifteenth century. In Rome, on the other hand, Michelangelo found a city at the height of its wealth and politically in a leading position for the whole of Italy. In this atmosphere the artist felt at ease with the world, at which he could look out steadily, and which he could reflect directly in his works. A training in Neoplatonism led to a belief in the beauty of the visible universe, above all in human beauty, which was no longer colored by the nostalgic mysticism of Florence. The grandeur of the figures on the Sistine ceiling depends on far more than the simple imitation of natural forms, but its idealization is based on a close knowledge and study of these forms. Whatever heroic quality is added, the foundation is a worship of the beauty of the human body.

In the field of thought the two apparently conflicting systems of Christianity and paganism are still perfectly fused in the Rome of the High Renaissance. The iconographical scheme of the Sistine ceiling frescoes is based on the most erudite theology, but the forms in which it is clothed are those of pagan gods. In Raphael's

frescoes in the Stanza della Segnatura the four themes of Theology, Pagan Philosophy, Poetry, and Justice are intricately blended. The catalyst, however, is no longer the hard reason of the Florentines like Alberti, but rather the elaborate Neoplatonism of the later Quattrocento stripped of its more nostalgic elements. In Michelangelo the two faiths were both perfectly sincere. From the days when he was first influenced by the teaching of Savonarola he was a good member of the Catholic Church, though at first without that passionate self-abnegation which came into his faith in the last years of his life.

Michelangelo's belief in the beauty of the material world was very great. His early love-poems reflect this feeling in their expression of strong emotional and often physical passion, directed as much towards visible beauty as toward the spiritual beauty of which the Neoplatonists spoke.[3] Moreover, Michelangelo's contemporaries tell us that he did not merely look at nature, but, throughout his life, studied it scientifically. Condivi speaks of his knowledge of perspective,[4] and both he and Vasari record the care which he devoted to anatomy, not merely learning it at second-hand but dissecting bodies himself.[5]

Michelangelo did not, however, believe in the exact imitation of nature. Vasari says that he made a pencil drawing of Tommaso de' Cavalieri "and neither before nor afterward did he take the portrait of anyone, because he abhorred executing a resemblance to the living subject, unless it were of extraordinary beauty."[6] According to Hollanda his scorn for Flemish painting was based on the same idea: "In Flanders they paint with a view to external exactness . . . without reason or art, without symmetry or proportion, without skillful choice or boldness."[7] This view that the artist must select from nature is in agreement with Alberti, though it is unlikely that the latter would have protested so vigorously against Flemish naturalism. His standards were not the same as those of Michelangelo. Alberti acted according to a strictly rational choice, and sought the typical. Michelangelo pursued the beautiful. Condivi describes his methods as follows, alluding to Zeuxis's painting of the Crotonian Venus:

> He loved not only human beauty but universally every beautiful thing . . . choosing the beauty in nature, as the bees gather honey from the flowers using it afterwards in their works, as all those have done who have ever made a noise in painting. That

old master who had to paint a Venus was not content to see one virgin only, but studied many, and taking from each her most beautiful and perfect feature gave them to his Venus.[8]

For Michelangelo it is by means of the imagination that the artist attains to a beauty above that of nature, and in this he appears as a Neoplatonist compared with the rational Alberti. To him beauty is the reflection of the divine in the material world.[9] . . . It is clear that the human figure is the particular form in which he finds this divine beauty most clearly manifested: "I can never now perceive Thy eternal light within a mortal being without great longing."[10]

In other cases he talks of the inward image which the beauty of the visible world arouses in his mind. The idea of beauty set up in this way is superior to material beauty, for the mind refines the images which it receives, and makes them approach more nearly the Ideas which exist in it by direct infusion from God. . . .[11]

But at this time Michelangelo still firmly believes that the inward image is dependent on the existence of beauty in the outside world which is transformed by the mind into something nobler. In an early sonnet, written in the form of a dialogue, he asks Love:

Tell me, Love, I beseech thee, if my eyes truly see the beauty which is the breath of my being, or if it is only an inward image I behold when, wherever I look, I see the carven image of her face.[12]

And Love answers:

The beauty you behold indeed emanates from her, but it grows greater as it flows through mortal eyes to its nobler abode—the soul. Here it becomes divine, perfect to match the soul's immortality. It is this beauty, not the other, which ever outruns your vision.[13]

These passages may be compared with Raphael's letters to Castiglione, referring to his fresco of Galatea in the Farnesina, in which he says: "To paint a beauty I need to see many beauties, but since there is a dearth of beautiful women, I use a certain idea which comes into my mind."[14]

Michelangelo's views, therefore, in his first period are still related to those of Alberti, but with a strong tinge of Neoplatonic

idealism. For Alberti the artist is entirely dependent on nature in his work, and he can only improve on it by attempting to reach the types at which nature aims. For Michelangelo, on the other hand, the artist, though directly inspired by nature, must make what he sees in nature conform to an ideal standard in his own mind. Compared with Alberti this approach may seem already somewhat unrealistic, but compared with Michelangelo's later views it represents a close and direct connection with nature.

By about 1530 the attempts of the Papacy to form a powerful secular State in Italy had failed. The Reformation had split the Church and incalculably weakened the position of the Pope. Financial disorders of every kind added to the confusion, and the greatest single blow of all had come with the Sack of Rome in 1527, which left Clement VII almost powerless. The whole social structure on which the humanist art of High Renaissance Rome was based was swept away. Instead of a sense of security men felt the general disturbance of events, which seemed to threaten the existence of the Catholic Church and, with it, of the whole of Italian society.

This changed situation affected different generations in different ways. The older humanists, men of Michelangelo's age, had felt that the Roman Church was in need of reform, and had anticipated many of the Pauline features in Luther's theology. The latter forms in some respects a parallel to Italian humanism, for, if the humanists asserted the rights of individual reason, Luther asserted those of individual conscience. The Italian humanists were too closely involved with the Church of Rome as an institution to follow Luther when it became a question of schism in the Church, but, as long as it appeared possible to combine the more moderate doctrines of reform, particularly justification by faith, with fidelity to Rome, many of them were in sympathy with the demands of the German reformers. In this way there was formed a party of humanists who aimed at an internal reform of the Roman Church and a compromise with the Protestants. This party, which later received the official support of Paul III, was led by men like Contarini, Pole, and Sadoleto, with whom were associated as close followers and supporters Vittoria Colonna and Michelangelo. The religion of the latter now became fervent, and took on the form of a serious but not fanatical piety, consonant with his humanistic principles, but gradually modifying them. He belongs, that

is to say, to those who wanted to build up a new and spiritualized Catholicism by means of such reforming doctrines as did not destroy the basis of the Roman Church.

This change of outlook naturally affected Michelangelo's art, and the change is most clearly shown in the great work of this period, the fresco of the *Last Judgement* over the altar of the Sistine Chapel, painted for Clement VII and Paul III between 1534 and 1541. This fresco is the work of a man shaken out of his secure position, no longer at ease with the world, and unable to face it directly. Michelangelo does not now deal directly with the visible beauty of the physical world. When he made the *Adam* on the Sistine ceiling he was aiming at a rendering of what would in actual life be a beautiful body, though it was idealized above reality. In the *Last Judgement* his aim was different. Here again nudes appear, but they are heavy and lumpish, with thick limbs, lacking in grace (Fig. 12). The truth is not, as has sometimes been said, that Michelangelo's hand was failing, but that he was no longer interested in physical beauty for its own sake. Instead he used it as a means of conveying an idea, or of revealing a spiritual state. Judged on the humanist standard of 1510 the *Last Judgement* is a failure, and it is not surprising that the admirers of Raphael could not stomach it. But as the most profound expression of the spiritualized Catholicism which Michelangelo practised, it is a masterpiece of equal importance with the ceiling. The ideals of Classic beauty which were relevant in the Sistine ceiling are no longer valid in the *Last Judgement*. Such Classical features as there are, like the Charon and Minos group, are seen through the eyes of Dante and are given a new spiritual significance. The most fundamental principle of the High Renaissance seems here to have been neglected, for there is little reconstruction of the real world, no real space, no perspective, no typical proportions. The artist is intent only on conveying his particular kind of idea, though the means by which he conveys it is still the traditional Renaissance symbol, the human figure.

The new approach to life and to art which is to be found in the *Last Judgement* can also be traced in Michelangelo's writings. In the poems of the thirties and early forties a new attitude toward beauty and toward the problem of love is visible. At this time one of the poet's most frequent themes is that physical beauty passes away, so that love directed toward it cannot give complete satisfaction and is degrading to the mind. . . .[15]

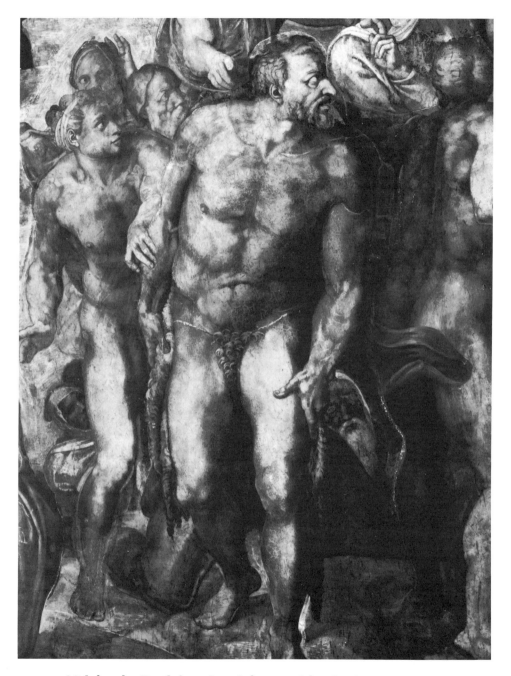

12. Michelangelo, Detail from *Last Judgement*, John the Baptist, 1534–1541, Fresco (Sistine Chapel, Vatican; Alinari/Editorial Photocolor Archives, Inc.)

113

But this element of bitterness and gloom is balanced by a more optimistic Neoplatonic belief. Love of physical beauty is a cheat, but the true love, that of spiritual beauty, gives perfect satisfaction, does not fade with time, and elevates the mind to the contemplation of the divine. This feeling is expressed most clearly in the poems to Tommaso de' Cavalieri, who dominates Michelangelo's emotional life from 1532 onward. The artist was evidently overwhelmed by the physical beauty of the young man, but he regarded it as an outward sign of spiritual and mental beauty, and the friendship was built upon that basis, though the violence of Michelangelo's passion was no less than in his earlier affections. This is summed up in a sonnet to Cavalieri. . . .[16]

However, not only is love directed toward spiritual qualities, but it has also the effect of raising the lover's mind by means of beauty to a contemplation of the divine beauty and therefore to communion with God. . . .[17]

But it must not be supposed that Michelangelo's view of beauty is wholly incorporeal and spiritualized. Visible beauty is still for him of the greatest significance, since it is the most effective symbol for the true spiritual beauty, and the beauty of man leads more easily than any other means to the contemplation of the divine. Love is stirred up most easily through the eye, which, according to the Neoplatonists, was the noblest of the senses. . . .[18] It is only through the eye that the artist is stimulated to creation and the spectator to contemplation of divine beauty. . . .[19] And it is in the human body that divine beauty is most completely manifested:

> Nowhere does God, in his grace, reveal himself to me more clearly than in some lovely human form, which I love solely because it is a mirrored image of Himself.[20]

The same idea is expressed in the following madrigal by means of the familiar Neoplatonic doctrine that beauty is the light which streams from the face of God:

> Neither my eyes in love with all that is beautiful, nor my soul thirsting for salvation, possess any power that can raise them to Heaven but the contemplation of beautiful things. From the highest Heaven there streams down a splendor which draws desire up toward the stars, and here on earth men call it love. And there is nothing that can captivate, fire and give wisdom to a noble heart as can a face lit with star-like eyes.[21]

At this period of his life, therefore, Michelangelo's poems show strongly the influence of the more mystical elements of Neoplatonism. The strong physical passion of the early love poems has given place to doctrines which make of love the contemplation of an incorporeal beauty. This is only another manifestation of the same tendency which we have traced in the paintings of the second period, such as the *Last Judgement*. It is also the equivalent of the spiritualized form of religion with which Michelangelo was associated in the thirties and forties. In all branches of his art and thought we feel a withdrawal from that direct contact with life which characterized the early period.

It may be suggested that this tendency away from the material and toward the things of the spirit can really be put down to the fact that Michelangelo was growing old. No doubt this provides a part of the explanation, but not the whole of it. Not all old men become spiritually minded. They only become so in certain circumstances, and Michelangelo's mysticism was a mode of escape from finding that his own world had crumbled about him. Age played its part, because had he been younger Michelangelo might have been able to fit himself to the changed circumstances, and have been drawn into the Counter-Reformation movement. But the general situation also played its part in breaking up the foundation on which his life was built.

In those passages of Michelangelo's poems which refer directly to the art of painting and sculpture we find a change corresponding to that in his ideas on beauty in the abstract.

In the first place Michelangelo is much more explicit about the religious function of the arts. Hollanda records a conversation in which Michelangelo explains his idea of the religious painter, who according to him must be skillful in his art and at the same time a man of pious life:

> In order to imitate in some degree the venerable image of Our Lord, it is not enough to be a painter, a great and skillful master; I believe that one must further be of blameless life, even if possible a saint, that the Holy Spirit may inspire one's understanding. . . . Often badly wrought images distract the attention and prevent devotion, at least with persons who have but little; while those which are divinely fashioned excite even those who have little devotion or sensibility to contemplation and tears, and by their austere beauty inspire them with great reverence and fear.[22]

115

The view which he expresses here is curiously close to that of Savonarola on religious art.[23] We know from Condivi[24] that Savanarola was an important influence in his life, and it is quite likely that his conception of painting as an art devoted to the service of the Church was affected by the teaching of the Dominican.

In the more purely aesthetic part of Michelangelo's writings on the arts the dominant influence in this period is that of Neoplatonism, which affects his view of the relation of painting to the visible world. Painting is no longer talked of as an imitation of nature, and the artist's interest is diverted almost entirely toward the inward mental image, which excels everything that can be found in the visible world:

> Love, thy beauty is not mortal. No face on earth can compare with the image awakened in the heart which you inflame and govern, sustaining it with strange fire, uplifting it on strange wings.[25]

The idea in the mind of the artist is more beautiful than the final work, which is only a feeble reflection of it. According to Condivi Michelangelo "has a most powerful imagination, whence it comes, chiefly, that he is little contented with his works and has always underrated them, his hand not appearing to carry out the ideas he has conceived in his mind."[26]

At this time Michelangelo lays great stress on the divine inspiration of the artist. God is the source of all beauty.[27] . . . And art is a gift received by the artist from heaven.[28] . . . By means of this divine gift the artist can give life to the stone in which he carves his statue.[29] . . . The stone itself, the material part of the work, is useless and dead till the imagination has acted upon it.[30] . . .

Michelangelo's theory of sculpture can be deduced from some of the poems, particularly the sonnet beginning:

> The greatest artist has no conception which a single block of marble does not potentially contain within its mass, but only a hand obedient to the mind can penetrate to this image.[31]

The explanation of this idea is to be found in the fact that when Michelangelo speaks of sculpture he always has in mind sculpture in marble or stone and not modeling in clay. "By sculpture I mean

the sort that is executed by cutting away from the block: the sort that is executed by building up resembles painting."[32] For Michelangelo the essential characteristic of sculpture is that the artist starts with a block of stone or marble and cuts away from it till he reveals or discovers the statue in it. This statue is the material equivalent of the idea which the artist had in his own mind; and, since the statue existed potentially in the block before the artist began to work on it, it is in a sense true to say that the idea in the artist's mind also existed potentially in the block, and that all he has done in carving his statue is to discover this idea.

In an early version of . . . [sonnet cxxxiv] Michelangelo gives further indications about his methods:

> After divine and perfect art has conceived the form and attitudes of a human figure, the first-born of this conception is a simple clay model. The second, of rugged live stone, then claims that which the chisel promised, and the conception lives again in such beauty that none may confine its spirit.[33]

This "double birth" corresponds exactly to what we know of Michelangelo's methods as a sculptor. In general he did not make a full-size clay version for a marble statue, but worked instead from a small model, perhaps only a foot high, which kept before him the idea which he had in his mind.[34] Starting from this he attacked the block directly, literally uncovering the statue, so that an unfinished figure like the *St. Matthew* (Fig. 13) gives the impression that it is all in the block and that one could just knock off the superfluous marble and reveal the complete statue.

Certain opinions of Michelangelo's which are recorded by his immediate followers show that he had almost consciously broken with the ideals of the earlier humanists. He was opposed, for instance, to the mathematical methods which formed an important part of Alberti's or Leonardo's theory. Lomazzo records a saying of his that "all the reasonings of geometry and arithmetic, and all the proofs of perspective were of no use to a man without the eye,"[35] and Vasari attributes to him the saying that "it was necessary to have the compasses in the eyes and not in the hand, because the hands work and the eyes judge."[36] He disapproved further of the importance which Alberti and the early Renaissance artists attributed to rules in painting, and he seems not to have sympathized at all with their idea that nature was based on general rules and a general orderliness. He condemns Dürer's treat-

ment of proportion in the human figure as too rigid, saying that this is a matter "for which one cannot make fixed rules, making figures as regular as posts";[37] and, according to Vasari, "he used to make his figures in the proportion of nine, ten, and even twelve faces,[38] seeking nought else but that in putting them all together there should be a certain harmony of grace in the whole, which nature does not present."[39] These opinions all show how far Michelangelo in his later period relied on imagination and individual inspiration rather than on obedience to any fixed standards of beauty. The same is true of his attitude toward architecture, for Vasari writes that

> he departed not a little from the work regulated by measure, order and rule which other men did according to a common use and after Vitruvius and the antiquities, to which he would not conform . . . wherefore the craftsmen owe him an infinite and ever-

lasting obligation, he having broken down the bonds and chains by reason of which they had always followed a beaten path in the execution of their works.[40]

This independence of all rule and the individualism that accompanied it account for the opinion which was generally held in the middle of the sixteenth century that Raphael was the ideal balanced painter, universal in his talent, satisfying all the absolute standards, and obeying all the rules which were supposed to govern the arts, whereas Michelangelo was the eccentric genius, more brilliant than any other artist in his particular field, the drawing of the male nude, but unbalanced and lacking in certain qualities, such as grace and restraint, essential to the great artist. Those, like Dolce and Aretino, who held this view were usually the survivors of Renaissance humanism, unable to follow Michelangelo as he moved on into Mannerism. That this difference of aim was apparent to Michelangelo himself is evident from his remark recorded by Condivi that "Raphael had not his art by nature but acquired it by long study."[41]

In the last fifteen or twenty years of his life we can trace a further change in Michelangelo's art and ideas, though in some ways this change consists in an intensification of the characteristics of the art and ideas of the late thirties and early forties.

After about 1545 the situation of the Papacy changed. The schism with Protestantism had reached a more acute stage, and since the Diet of Ratisbon it had become apparent that any kind of compromise was impossible. Therefore the position of the moderate party to which Michelangelo was attached was steadily weakened. The Church could no longer hope to save itself by their methods and was forced to adopt a much more drastic policy. Even Paul III found himself compelled in his last years to give up his attempts at conciliation and to allow the more fanatical Counter-Reformers to put their ideas into practice. At the Council of Trent the survivors of the Contarini party were defeated, and their rivals, the Jesuits and Caraffa, had their way, gradually establishing their system of blind belief in authority, strict obedience, and absolute rigidity of doctrine.

One result of this change was that the moderates found themselves stranded. They could not sympathize with the new and drastic policy, and yet their own methods seemed useless. Their

14. Michelangelo, Rondanini *Pietà*, c. 1555–1564, Marble, 77½″ high (Castello Sforzesco, Milan; Alinari/ Editorial Photocolor Archives, Inc.)

position was, in fact, hopeless, and for this reason their mysticism gradually takes on a more introspective character.

Michelangelo's most representative work in this period is the last group which he carved, the Rondanini *Pietà* (Fig. 14), left unfinished at his death, in which he seems to have deprived his human symbols of all corporeal quality and to succeed at last in conveying directly a purely spiritual idea. Like most of the other works of this period, such as the *Pietà* in the Cathedral of Florence, and the group of late drawings, it is concerned with the central features of the Christian faith, the events of the Passion. Michelangelo has given up Classical subjects, but even the religious themes which he treats are no longer those which he preferred in his younger days. Then he chose for his subjects either Old Testament figures, like David, or themes from the New Testament, like the Holy Family, which had a direct and general human appeal. When he carved a *Pietà*, as in St. Peter's, it was conceived as a human tragedy, without much indication of the supernatural implications. The *Pietà* of the last years is an expression of violent, personal, mystical Christian faith, which appears with equal intensity in the drawings for the Crucifixion of the same period.

A corresponding change takes place in Michelangelo's writings. Much of what has been said about his views in the middle period of his life applies even more strongly to his last years. His approach to the world and the arts becomes even more spiritual, but at the same time more specifically Christian. His religious feeling now combines the mystical conception of Neoplatonism with the intense belief in Justification by Faith which he learned from Savonarola and the Contarini group. But he talks less of an abstract divine essence and more of a God whom he addresses personally. We may suppose that his comment on the paintings of Fra Angelico, which shows how much importance he attributed to Christian piety in an artist, was made about this time: "This good man painted with his heart, so that he was able with his pencil to give outward expression to his inner devotion and piety, which I can never achieve, since I do not feel myself to have so well disposed a heart."[42]

He wishes to abandon the whole world and to fix all his thoughts on God, but he feels that he can do nothing without God's grace. . . .[43] All mortal love must be given up. Michelangelo seems no longer to have faith in human beauty as a symbol of the divine. He rather fears it as a distraction from the pure things of the spirit. . . .[44] He hates and fears the things of this world which he regards as temptations, or, at best, as distractions from a higher duty. In passionate repentance he writes:

> I have let the vanities of the world rob me of the time I had for the contemplation of God. Not alone have these vanities caused me to forget His blessings, but God's very blessings have turned me into sinful paths. The things which make others wise make me blind and stupid and slow in recognizing my fault. Hope fails me, yet my desire grows that by Thee I may be freed from the love that possesses me. Dear Lord, halve for me the road that mounts to Heaven, and if I am to climb even this shortened road, my need of Thy help is great. Take from me all liking for what the world holds dear and for such of its fair things as I esteem and prize, so that, before death, I may have some earnest of eternal life.[45]

But most remarkable of all is the sonnet in which he turns not only against the world and mortal beauty but against the imagination itself and against the arts to which it has led him:

Giunto è già 'l corso della vita mia
   Con tempestoso mar per fragil barca,
   Al comun porto, ov' a render si varca
   Conto e ragion d'ogni opra trista e pia.
Onde l'affettuosa fantasia
   Che l'arte mi fece idol' e monarca
   Conosco or ben, com' era d'error carca
   E quel ch'a mal suo grado ogn' uom desia.
Gli amorosi pensier, già vani e lieti,
   Che fien or s'a duo morte m'avvicino?
   D'una so 'l certo, e l'altra mi minaccia.
Nè pinger nè scolpir fie più che quieti
   L'anima, volta a quell' amor divino,
   Ch'aperse, a prender noi, 'n croce le braccia.[46]

This sonnet is perhaps the supreme proof of the changes that had come over Michelangelo since his youth. It is hard to believe that the humanist creator of the early Bacchus or even the painter of the Sistine ceiling would one day pray to renounce the arts from feelings of Christian piety.

In Michelangelo we have an example of that rare phenomenon, the great artist who is both able and willing to put in writing what he feels about his art. The value of these writings to us depends largely on the light which they throw on the artist's work in painting and sculpture. It is possible to enjoy and even to understand the frescoes on the Sistine roof without reading any of the sonnets, but the appreciation of both the poetry and the paintings can be increased by the comparison of the one with the other; and in the case of Michelangelo's latest works, like the Rondanini *Pietà*, the exposition in words in the late sonnets of the ideas expressed more obscurely, but not less completely, in the carved forms of the statue may provide a clue to the meaning of the latter, for which any one unacquainted with the poems might long search without success. We could deduce the changes traceable in Michelangelo's view of life from his paintings and sculpture, but the evidence of the written word is more compelling, because less liable to mis-interpretation; and an hypothesis based on the former is more than doubled in strength when it is confirmed by the latter. The changes that have been traced above, however, are not merely those of a single individual. For Michelangelo was the type of those men who belonged to the Renaissance but lived on into the

early stages of the Counter-Reformation. The development in his ideas, therefore, follows the change from one epoch to another, and prepares the way for the art and doctrines of Mannerism.

*N O T E S*

[1] Published in 1548 under the title, *Tractato de Pintura Antigua.*

[2] Hollanda's reliability has often and justifiably been challenged, e.g. by Tietze (cf. "Francisco de Hollanda und Donato Giannottis Dialoge und Michelangelo," *Rep. für Kunstwissenschaft.* [1905], xxviii, p. 295) and, more violently, by C. Aru (cf. "I Dialoghi Romani di Francisco de Hollanda," *L'Arte* [1928], xxxi, p. 117).

[3] Cf. Frey, *Die Dichtungen des Michelagniolo Buonarroti*, Nos. v, vi; and Thode, *Michaelangelo und das Ende der Renaissance* (1903), ii, pp. 138 ff.

[4] M. Holroyd, *Michael Angelo Buonarroti*, 2nd ed., p. 70.

[5] Ibid., p. 64; and Vasari, trans. de Vere (London, 1912–15), ix, p. 103.

[6] Vasari, op. cit., p. 106.

[7] Hollanda, *Four Dialogues of Painting*, trans. A. F. G. Bell, p. 15. It must be remembered, however, that in his youth in Florence, Michelangelo copied the work of a northern artist, Schongauer. He even planned a *Trattato di tutte le maniere de' moti umani, e apparenze, e dell' ossa.*

[8] Condivi, op. cit., p. 74.

[9] Frey, iv, probably 1505–11.

[10] Ibid. xxx, c. 1526. For this and the following translations of Michelangelo's poems I am indebted to the late Miss K. T. Butler.

[11] Ibid. xxxiv. 1530: "As my soul, looking through the eyes, draws near to beauty as I first saw it, the inner image grows, while the other recedes, as though shrinkingly and of no account."

[12] Ibid. xxxii. 1529–30.

[13] Ibid.

[14] Passavant, *Rafael* (1839), i. p. 533.

[15] Frey, cix. 34, 1536–46.

[16] Ibid. lxxix, shortly after 1534. The same idea is expressed in xcii, cix. 66 and cix. 101, all probably written in the late thirties or early forties.

[17] Ibid. lxiv. 1533–34; cf. also cix. 99 and xci, both written in the thirties or early forties.

[18] Frey, cix. 104, c. 1545: "The heart is slow to love what the eye cannot see."

[19] Ibid. xciv. 1541–44.

[20] Ibid. cix. 105, "To Cavalieri," 1536–42.

[21] Frey, cix. 99, probably 1534–42.

[22] Op. cit., p. 65.

[23] Cf. above, Ch. III.

[24] Op. cit., p. 74.

[25] Frey, lxii, 1533–34.

[26] Condivi, p. 77; cf. Vasari, *Lives*, ix, p. 104.

[27] Frey, ci. 1547.

[28] Ibid. cix. 94, shortly after 1534.

[29] Ibid. cxxxiv, c. 1547.

[30] Ibid. lxv, referring to Cavalieri.

[31] Ibid. lxxxiii. 1536–47.

[32] Letter to Varchi, 1549.

[33] Frey, p. 480, sonnet cxxxiv, version I, 1544–46.

[34] Cellini in his *Trattato della Scultura* (ch. iv) records that Michelangelo in general worked without a full-scale model, but that in his later work he sometimes used one. He quotes as examples the statues for the New Sacristy of S. Lorenzo.

[35] Lomazzo, *Trattato*, Bk. v, c. 7.

[36] Vasari, *Lives*, ix, p. 105.

[37] Condivi, p. 69.

[38] Though Vasari writes *teste* here he must mean *faces*, for a figure of twelve *heads* would be too elongated even for a Mannerist.

[39] Vasari, *Lives*, ix, p. 104.

[40] Ibid., p. 44; cf. also Condivi, p. 69. Since Vasari's day the licenses taken by Michelangelo with architecture have often been the subject of less favorable comment, as for instance by Symonds, who accuses him of slipping in his later years into "a Barocco-Mannerism."

[41] Condivi, p. 76.

[42] See Paleotti, *Archiepiscopale Bononiense* (Rome, 1594), p. 81.

[43] Frey, cxlviii, c. 1554–55.

[44] Ibid. cxxiii. 1547–50.

[45] Ibid. cl. c. 1555.

[46] Frey, cxlvii, c. 1554: "In a frail boat, through stormy seas, my life in its course has now reached the harbor, the bar of which all men must cross to render account of good and evil done. Thus I now know how fraught with error was the fond imagination which made Art my idol and my king, and how mistaken that earthly love which all men seek in their own despite. What of those thoughts of love, once light and gay, if now I approach a twofold death. I have certainty of the one and the other menaces me. No brush, no chisel will quieten the soul, once it is turned to the divine love of Him who, upon the Cross, outstretched His arms to take us to Himself."

# 7. THE ARCHITECTURE

# OF BRAMANTE

# AND MICHELANGELO

## *James S. Ackerman*

### INTRODUCTION

The creator of such impressive monuments as the *David* and the Medici
Tombs in Florence, the Sistine Ceiling and the *Last Judgement* in Rome,
is generally granted considerable space as a sculptor and painter in the
standard art history survey texts. The attention accorded his architec-
ture is less consistent, varying widely from some three pages of text to
two paragraphs or less. Since the sculpture and painting of Michel-
angelo celebrate in such an awesome way the power of the human
form, his images move us. They elevate in our consciousness the tensive
ply of our own bodies. The appeal is immediate and strong. This
empathic appeal may account to some extent for the relative under-
exposure of Michelangelo the architect. But it is also worth noting that
one of the most important books written during this century on the
architecture of the Renaissance—Rudolf Wittkower's *Architectural
Principles in the Age of Humanism*—gives relatively little space to the
architecture of Michelangelo while dealing extensively with Alberti and
Palladio. Here, of course, we must remind ourselves that Alberti and
Palladio were theorists, and architectural theory was Professor Witt-
kower's chief concern in this instance. Michelangelo's own exposition
of his architectural "theory" is found in a fragment of a letter which
links architecture to anatomy; and the organic, rather than intellectual,
nature of this linkage is apparent both in the sculptural character of
Michelangelo's architectural forms and in the creative flux of his build-
ing practices.

Serious research on the architecture of Michelangelo could be said to have begun in 1904, with the publication of H. von Geymüller's *Michelangelo Buonarroti als Architekt*, and further advanced by Dagobert Frey, *Michelangelo Studien* (1920). Charles de Tolnay's five-volume work on Michelangelo (1943–1960) is the basic study in English on the artist's work in general and James S. Ackerman's two-volume work on the architecture of Michelangelo, from which this selection was taken, is the essential publication on this aspect of the master's career. Other readings are Rudolf Wittkower, "Michelangelo's Biblioteca Laurenziana," *The Art Bulletin*, XVI (1934), an important article on a key monument; James S. Ackerman, "Architectural Practice in the Italian Renaissance," *Journal of the Society of Architectural Historians*, XIII (1954); David Summers, "Michelangelo on Architecture," *The Art Bulletin*, LIV, 2 (June 1972), 146–157; and, for a general view of Italian Renaissance architecture, L. H. Heydenreich and W. Lotz, *Architecture in Italy 1400 to 1600* (1974). To this list should be added Howard Saalman, "Michelangelo: S. Maria del Fiore and St. Peter's," *The Art Bulletin*, LVII, 3 (September 1975), 374–409; H. A. Millon and C. H. Smyth, "Michelangelo and St. Peter's: Observations on the Interior of the Apses, a Model of the Apse Vault, and Related Drawings," *Römisches Jahrbuch für Kunstgeschichte*, XVI (1976), 137–206; and Arnaldo Bruschi, *Bramante* (1977).

In the early years of the sixteenth century the extraordinary power, wealth, and imagination of the Pope, Julius II della Rovere (1503–1513) made Rome the artistic center of Italy and of Europe and attracted there the most distinguished artists of his age. Chiefly for political reasons, the rise of Rome coincided with the decline of great centers of fifteenth-century Italian culture: Florence, Milan, and Urbino. The new "capital" had no eminent painters, sculptors, or architects of its own, so it had to import them; and they hardly could afford to stay at home. This sudden change in the balance of Italian culture had a revolutionary effect on the arts; while the fifteenth-century courts and city-states had produced "schools" of distinct regional characteristics, the new Rome tended to encourage not so much a Roman as an Italian art. No creative Renaissance artist could fail to be inspired and profoundly affected by the experience of encountering simultaneously the works of ancient architects and sculptors— not only in the ever-present ruins but in dozens of newly founded museums and collections—and those of his greatest contemporaries. Like Paris at the beginning of the present century, Rome provided the uniquely favorable conditions for the evolution of new modes of perception and expression.

I described the results as revolutionary. Since Heinrich Wölfflin's great work on this period,[1] the traditional concept of the High Renaissance as the ultimate maturing of the aims of the fifteenth century has been displaced by an awareness that many of the goals of early sixteenth-century artists were formed in vigorous opposition to those of their teachers. What Wölfflin saw in the painting and sculpture was characteristic of architecture, too.

But there is an important difference in the architectural "revolution": it was brought about by one man, Donato Bramante (1444–1514). This reckless but warranted generalization was concocted by a contemporary theorist, twenty-three years after Bramante's death; Sebastian Serlio called him "a man of such gifts in architecture that, with the aid and authority given him by the Pope, one may say that he revived true architecture, which had

been buried from the ancients down to that time."[2] Bramante, like Raphael, was born in Urbino; he was trained as a painter and ultimately found a position at the court of Milan under Lodovico Sforza. Already in his first architectural work of the late 1470's his interest in spatial volume, three-dimensional massing, and perspective illusions distinguishes him from his contemporaries, though the effect of his innovations was minimized by a conservative and decorative treatment of the wall surfaces. When Milan fell to the French at the end of the century, Bramante moved on to Rome, where the impact of his first introduction to the grandiose complexes of ancient architecture rapidly matured his style. The ruins served to confirm the validity of his earlier goals; they offered a vocabulary far better suited to his monumental aims than the fussy terra-cotta ornament of Lombardy, and they provided countless models in which his ideal of volumetric space and sculptural mass were impressively realized.

Architecture is a costly form of expression, and the encounter of a uniquely creative imagination with a great tradition could not have been of much consequence without the support of an equally distinguished patron. That Julius II sought to emulate the political grandeur of the Caesars just as Bramante learned to restore the physical grandeur of ancient Rome continually delights historians, because the occasion may be ascribed with equal conviction to political, social, or economic determinants, to the chance convergence of great individuals, or to a crisis of style in the arts.

As soon as Bramante had completed small commissions in his early years in Rome (e.g., the cloister of Santa Maria della Pace, 1500; the *Tempietto* of San Pietro in Montorio, 1502), the Pope saw in his work the echo of his own taste for monumentality and lost interest in Giuliano da Sangallo, the brilliant but more conservative Florentine architect whom he had consistently patronized when a Cardinal. A year after his election to the pontificate, Julius commissioned Bramante to design a new façade for the Vatican Palace and the huge Cortile del Belvedere; in the following year, 1505, he requested plans for the new St. Peter's, to replace the decaying fourth-century Basilica. Another commission of unknown date initiated projects for a "Palace of Justice" that would have rivalled the Vatican if it had been finished.

The new papal buildings confirm the decisive break with early Renaissance architecture already announced in the *Tempietto*.

This building, though one of the smallest in Rome, is the key to High Renaissance architecture because it preserves traditional ideals while establishing the forms of a new age. It is traditional in being a perfect central plan, a composition of two abstract geometrical forms: the cylinder and the hemisphere. But fifteenth-century geometry had never (except in the drawings of Leonardo, which surely influenced Bramante) dealt so successfully with solids: buildings before Bramante, even those with some sense of plasticity, seem to be composed of planes, circles and rectangles rather than of cylinders and cubes, and to be articulated by lines rather than by forms. In the *Tempietto* the third dimension is fully realized; its geometric solids are made more convincing by deep niches that reveal the mass and density of the wall. Members are designed to mold light and shade so as to convey an impression of body. We sense that where the earlier architect drew buildings, Bramante modelled them. Because the *Tempietto* recites the vocabulary of ancient architecture more scrupulously than its predecessors, it is often misinterpreted as an imitation of a Roman temple. But just the feature that so profoundly influenced the future—the high drum and hemispherical dome—is without precedent in antiquity, a triumph of the imagination.

In the projects for St. Peter's (Fig. 15) the new style attains maturity. Here for the first time Bramante manages to coordinate his volumetric control of space and his modelling of mass. The key to this achievement is a new concept of the relationship between void and solid. Space ceases to be a mere absence of mass and becomes a dynamic force that pushes against the solids from all directions, squeezing them into forms never dreamed of by geometricians. The wall, now completely malleable, is an expression of an equilibrium between the equally dynamic demands of space and structural necessity. Nothing remains of the fifteenth-century concept of the wall as a plane, because the goal of the architect is no longer to produce an abstract harmony but rather a sequence of purely visual (as opposed to intellectual) experiences of spatial volumes. It is this accent on the eye rather than on the mind that gives precedence to voids over planes.

Bramante's handling of the wall as a malleable body was inspired by Roman architecture, in particular by the great Baths, but this concept of form could not be revived without the technique that made it possible. The structural basis of the Baths was brick-faced concrete, the most plastic material available to

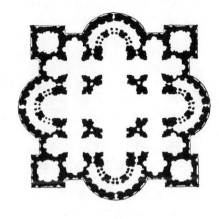

A        B

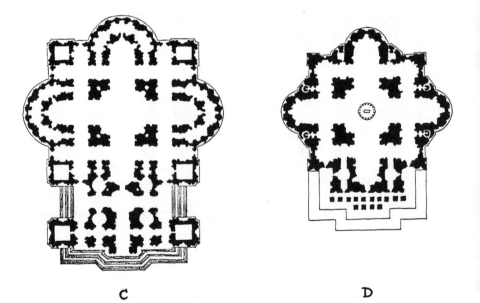

C        D

15. Plans for St. Peter's, Rome (After Ackerman, *The Architecture of Michelangelo*, Fig. 11)

    A. Bramante, 1506              C. Sangallo, 1539
    B. Bramante-Raphael, 1515–1520     D. Michelangelo, 1546–1564

130

builders. For the Roman architect brick was simply the material that gave rigidity to the concrete, and protected its surface. In the Middle Ages the art of making a strong concrete was virtually forgotten, and bricks, now used as an inexpensive substitute for stone blocks, lost the flexibility afforded by a concrete core. Bramante must have rediscovered the lost art of the Romans. The irrational shapes of the plan of St. Peter's (Fig. 15)—giant slices of toast half eaten by a voracious space—are inconceivable without the cohesiveness of concrete construction, as are the great naves of the Basilica, which could not have been vaulted by early Renaissance structural methods.[3] Bramante willed to Michelangelo and his contemporaries an indispensable technical tool for the development of enriched forms.

In the evolution of the design of St. Peter's, Bramante left for Michelangelo the realization of an important potential in the malleability of concrete-block construction; for in spite of his flowing forms, the major spatial volumes of his plan are still isolated from one another. The chapels in the angles of the main cross and, more obviously, the four corner towers, are added to the core rather than fused into it, as may be seen more clearly in elevations (Fig. 16).

The dynamic characterization of space and mass which was the essence of Bramante's revolution is equally evident in his secular buildings, even when he was concerned primarily with façades. In the fifteenth century it was the nature of a façade to be planar, but Bramante virtually hid the surface by sculptural projections (half-columns, balconies, window pediments, heavy rustications) and spatial recessions (ground floor arcades, and loggias on the upper story, as in the court of the Belvedere and the façade of the Vatican). These innovations are not motivated by mere distaste for the flat forms of the early Renaissance façade but by a positive awareness of the range of expression available in a varied use of light. His projections capture the sun in brilliant highlights and cast deep shadows; his half-columns softly model the light; his loggias create dark fields that silhouette their columnar supports. In the façades, as in the interior of St. Peter's, the purely sensual delights of vision inspire the design. The philosophical impulse of fifteenth-century architecture had become sensual.

Bramante's style rapidly changed the course of Renaissance architecture. This was due not only to its novelty, but to the unprecedented situation created by the great size of his papal

projects: for the first time in the Renaissance it became necessary to organize a modern type of architectural firm with a master in charge of a large number of younger architects who were in one sense junior partners, in another sense pupils. Almost every eminent architect of the first half of the sixteenth century, Michelangelo excepted, worked under Bramante in the Vatican "office": Baldassare Peruzzi, Raphael, Antonio da Sangallo, Giulio Romano, and perhaps Jacopo Sansovino. Of these only Peruzzi actually practiced architecture before Bramante's death (e.g., the Villa Farnesina in Rome, 1509); the others learned their profession at the Vatican and later developed Bramante's innovations into individual styles that dominated the second quarter of the century. The effect was felt all over Italy: Peruzzi built in Siena, Raphael in Florence, Sansovino in Venice, Giulio in Mantua, and Sangallo throughout the Papal States. The death of Julius II in 1513 and of Bramante in 1514 simultaneously removed the coauthors of High Renaissance architecture, leaving the monumental Basilica and palaces in such an inchoate state that the next generation found it hard to determine precisely what the original intentions had been. Paradoxically, this was a favorable misfortune, because it liberated the imagination of the younger architects just as they reached maturity. Raphael, Peruzzi and Sangallo, inheriting the leadership of St. Peter's and the Vatican, were free to compose variations on the theme of their master, and were actually encouraged to do so by successive popes who wanted distinctive evidence of their own patronage.

The fact that Michelangelo's career as an architect began in 1516 is directly related to this historical scene. Michelangelo's animosity toward the powerful Bramante kept him out of architecture during Bramante's lifetime. But the election of a Medici, Leo X (1513–1521), as the successor to Julius II, provided opportunities in Florence. Leo, although he chose Bramante's chief disciple, Raphael, to continue the Vatican projects, needed an architect to complete the construction of San Lorenzo, the major Medici monument in Florence. Michelangelo was the obvious choice for this job because he was not only the leading Florentine artist but also a sculptor-painter, ideally equipped to carry out the half-figurative, half-architectural program envisaged by the Medici family. Besides, the commission served the dual purpose of removing Michelangelo from Rome (Leo said: "he is frightening, one cannot deal with him") and of frustrating the completion

of the Tomb of Julius II, which would have competed with Medici splendor.

Although Michelangelo's achievements in Florence proved that he was as eminent in architecture as in the other arts, he was excluded from any important Roman commissions so long as any member of Bramante's circle was alive. When Antonio da Sangallo died in 1546, the only member of the circle who survived was Giulio Romano (Raphael d. 1520, Peruzzi d. 1536), and it is significant that the Fabbrica of St. Peter's called Giulio from Mantua to forestall Michelangelo's appointment as chief architect. But his death, immediately following Sangallo's, finally left the field open to Michelangelo, now 71 years old.

Yet Michelangelo's personal conflict with Bramante cannot by itself explain why the intrigues that it engendered were so successful in excluding him from architectural commissions in Rome. That the popes of this period—Leo X; another Medici, Clement VII (1523–1534); and Paul III, Farnese (1534–1549)—recognized Michelangelo's preeminence is proven by the fact that they tried to monopolize his services as a painter and sculptor. The Medici were even willing to retain him as an architect in Florence after he had fought against them for the independence of the city. The long delay in recognition at Rome must be attributed to the unorthodoxy of his style. It lacked what Vitruvius called *decorum:* a respect for Classical traditions. And in the first half of the century cultivated Roman taste was attuned to a correct antique vocabulary in a classic context. Bramante had formed this taste, and it took a generation to assimilate his innovations.

Raphael was the ideal successor to Bramante. That his concerns as a painter for massive forms and volumetric space in simple compositions of geometric solids were a counterpart of Bramante's architectural goals may be seen in such architectural frescoes as the *School of Athens* and the *Expulsion of Heliodorus.* Consequently, when he succeeded to Bramante's post he could pursue his own interests and at the same time design almost as Bramante would have done if he had lived another six years. If Raphael had been less sympathetic to his master, his architecture would certainly be better known. But in major Vatican works, at the Cortile di San Damaso and Belvedere, the two designers are indistinguishable, and uncertainty about the authorship of projects for St. Peter's has always worried us. In his work outside the papal circle—Palazzo Vidoni-Caffarelli, Palazzo Branconio d'Aquila,

Villa Madama in Rome, and Palazzo Pandolfini in Florence—
Raphael developed Bramantesque principles and vocabulary into
a more individualized expression notable for its greater sophistica-
tion, elegance of decoration, and for its success in binding into a
unity masses and spaces that Bramante had tended to individu-
alize. The propriety of Raphael's accession to Bramante's throne
is further shown by the fact that the very qualities which dis-
tinguish him from his predecessor—moderation, respect for
continuity, sophistication and elegance, unification of discrete
elements—also distinguish his patron, Leo X, from Julius II.

A comparable poetic justice guided the careers of other Bra-
mante followers. Peruzzi, who often worked with the linear and
planar means of fifteenth-century architecture while concentrat-
ing his great ingenuity on exploring new forms and rhythms in
plan and elevation (he was the first to exploit the oval plan and
curved façade), was employed more in his native Siena than in
Rome. That medieval town must have valued him rather for his
superficial conservatism than for the extraordinary inventiveness
which had too little opportunity for expression, and which now
can only be appreciated properly in hundreds of drawings pre-
served in the Uffizi Gallery.

Giulio Romano, whose three or four small Roman palaces repre-
sent a revolt against Bramante's grandeur in the direction of
repression, tightness, and an apparently polemic rejection of
plasticity and volume, found himself more at home outside Rome,
in the court of Mantua, where the tensions induced by the weak-
ness of humanist duchies in a world of power-states could be given
expression in a Mannerist architecture of neurotic fantasy (The
Ducal Palace, Palazzo del Té).

So the Rome which rejected Michelangelo was equally inhos-
pitable to other non-classic architects. Though Peruzzi, as a
Bramante follower, was frequently given a chance to aid in the
design of St. Peter's and the Vatican and to compete for major
commissions (the great hospital of S. Giacomo degli Incurabili,
San Giovanni dei Fiorentini), he never was chosen as a chief
architect. The victor was always Antonio da Sangallo the Younger,
who gave the classic movement its definitive form.

Sangallo's dictatorship in the style of 1520–1545 can be ex-
plained more by his propriety than by his eminence; he was
probably the least gifted of Bramante's pupils. The first major

Renaissance architect to be trained exclusively in the profession, he began as a carpenter at the Vatican in the early years of the century. His practice never had to be set aside for commissions in the other arts and, being a gifted organizer and entrepreneur, he was able not only to undertake all the important civil and military commissions of the papacy but those of private families, among them the Farnese, as well. Nearly a thousand surviving drawings in the Uffizi are evidence of vast building activity throughout central Italy. He is distinguished less for his innovations than for his capacity to apply the experiments and aesthetic of the High Renaissance to the complete repertory of Renaissance building types. The façade of Santo Spirito in Sassia in Rome is the uninspired source of later sixteenth-century façade design; the Banco di Santo Spirito (Rome) has a two story colossal order over a drafted basement in a context that delighted Baroque architects and has never been entirely abandoned; the Farnese palace is the definitive secular structure of the Roman Renaissance, though major components of its design were anticipated by Bramante and Raphael. It is in the plans and models of St. Peter's that the symptomatic weakness of Antonio's architecture may be seen (Fig. 15). The project is unassailable on the grounds of structure or of Vitruvian *decorum,* but it is confusing in its multiplicity: infinite numbers of small members compete for attention and negate the grandeur of scale required by the size of the building; the dome is obese, and the ten-storied campanili are Towers of Babel. Antonio's superior technical and archaeological knowledge proved to be no guarantee of ability to achieve coherence or to control fully such raw materials of architecture as space, proportion, light and scale.

Sangallo, as the first architect of the Renaissance trained in his profession, knew more than his contemporaries about the technical aspects of construction. He was frequently called upon to right major faults in Bramante's structures: to fortify the piers of St. Peter's and the foundations of the Vatican façade, to rebuild the loggie of the Belvedere, which collapsed in 1536, all of necessity to the detriment of the original design. But technical competence was not a preeminent qualification in the eyes of Renaissance critics: Bramante, though called *maestro ruinante* in allusion to his engineering failures, was universally recognized as the superior architect. Of course, this may be attributed simply to

a difference in creative ability, or genius, or whatever one may call it, but it raises an important question for Renaissance architecture, and for Michelangelo in particular: was it possible, in the age of Humanism, for an individual to be fully successful as a specialist? Sangallo, in gaining the advantage of a long apprenticeship in architectural construction, lost the benefits of a generalized body of theoretical knowledge and principles traditionally passed on in the studios of painters and sculptors. Problems of proportion, perspective (the control of space), composition, lighting, etc., as encountered in the figurative arts, were more important in the development of Renaissance architecture than structural concerns, partly because, by contrast to the Gothic period or to the nineteenth century, technology was restricted to a minor role.

In our day, when the concern for technique has threatened to overwhelm all other values in architecture, it is difficult to appreciate the Renaissance view that sculptors and painters were uniquely qualified as architects by their understanding of universal formal problems. The view was vindicated by the fact that it was the artist who made major technical advances—the technician merely interpreted traditional practices.

The Renaissance architect was forced into a preoccupation with broad principles in one way or another. First of all, he had to find a way to justify a revival of pagan grandeur in a Christian society; this involved, among other dilemmas, a rationalization of the conflicting architectural principles of antiquity and the Middle Ages. Further, as is demonstrated by Sangallo's failure to construct a theory out of devoted study of Vitruvius and Roman monuments, antiquity itself taught no clear and consistent body of principles. To give order to a chaos of inherited concepts, many Renaissance architects—Alberti, Francesco di Giorgio and others in the fifteenth century, Palladio in the sixteenth—developed and published theories of architecture of a metaphysical-mathematical cast. But formalized philosophies were not the sole solution; it is intriguing that nothing was written about architecture (or any other art) in the High Renaissance. This reveals a desire to solve the same problems in a new way; a reaction in all the arts against the abstract principles of the fifteenth century produced a temporary shift from intellectual-philosophical precepts to visual and psychological ones that could better be expressed in form than in words. This change of emphasis is a key to Michelangelo's achieve-

136

ment, and for this reason I begin the study of his work with some observations on what we know of his architectural ideas.

## MICHELANGELO'S "THEORY" OF ARCHITECTURE

Michelangelo, one of the greatest creative geniuses in the history of architecture, frequently claimed that he was not an architect.[4] The claim is more than a sculptor's expression of modesty: it is a key to the understanding of his buildings, which are conceived as if the masses of a structure were organic forms capable of being molded and carved, of expressing movement, of forming symphonies of light, shadow and texture, like a statue. The only surviving evidence of Michelangelo's theory of architecture is the fragment of a letter of unknown date and destination in which this identity of architecture with painting and sculpture is expressed in a manner unique in the Renaissance:

> Reverend Sir (Cardinal Rodolfo Pio?): When a plan has diverse parts, all those (parts) that are of one kind of quality and quantity must be adorned in the same way, and in the same style, and likewise the portions that correspond [e.g., portions in which a feature of the plan is mirrored, as in the four equal arms of St. Peter's]. But where the plan is entirely changed in form, it is not only permissible but necessary in consequence entirely to change the adornments and likewise their corresponding portions; the means are unrestricted (and may be chosen) at will [or: as the adornments require]; similarly the nose, which is in the center of the face, has no commitment either to one or the other eye, but one hand is really obliged to be like the other and one eye like the other in relation to the sides (of the body), and to its correspondences. And surely, the architectural members derive [*dipendono*] from human members. Whoever has not been or is not a good master of the figure and likewise of anatomy cannot understand (anything) of it. . . .[5]

It is not unusual for Renaissance theorists to relate architectural forms to those of the human body; in one way or another this association, which may be traced back to ancient Greece and is echoed in Vitruvius, appears in all theories of the age of humanism. What is unique in Michelangelo is the conception of

the simile as a relationship which might be called organic, in distinction to the abstract one proposed by other Renaissance architects and writers. It is anatomy, rather than number and geometry, that becomes the basic discipline for the architect; the parts of a building are compared, not to the ideal overall proportions of the human body but, significantly, to its functions. The reference to eyes, nose, and arms even suggests an implication of mobility; the building lives and breathes.

This scrap of a letter cannot be taken as evidence of a theory of architecture: in fact, it expresses an attitude which in the Renaissance might have been called antitheoretical. But there is more in it than the fantasy of a sculptor, and it may be used as a key to the individuality of Michelangelo's architectural style, primarily because it defines his conscious and thoroughgoing break with the principles of early Renaissance architecture.

When fifteenth-century writers spoke of deriving architectural forms from the human body, they did not think of the body as a living organism, but as a microcosm of the universe, a form created in God's image, and created with the same perfect harmony that determines the movement of the spheres or musical consonances.[6] This harmony could not be discovered empirically, since it was an ideal unattainable in actuality, but it could be symbolized mathematically. Thus the ideal human form was expressed either in numerical or geometrical formulae: numerical proportions were established for the body that determined simple relationships between the parts and the whole (e.g., head : body = 1:7) or the body was inscribed within a square or a circle or some combination of the two, sometimes with the navel exactly in the center. Architectural proportions and forms could then be associated with these formulae.

This entirely intellectual attempt to humanize architecture really made it peculiarly abstract, for rather than actually deriving useful mathematical symbols and proportions from a study of the body, it forced the body, like Procrustes, into figures already idealized by a long metaphysical tradition traceable to Plato and Pythagoras. The perfect mathematical figures and ratios and the way in which they were used to establish the form and proportions of buildings remained quite unaffected by this attempt to "humanize" them. But if reference to the human body was superfluous in practice, it gave fifteenth-century architects a timely philosophical

justification for their method and helped to transform them from medieval craftsmen to Renaissance humanists.

If the human body was to be adapted by the fifteenth-century theorist to a system of proportions, it had to be treated as a static object to be analyzed into a complex of numerically or geometrically interrelated parts. This method inevitably emphasized units: the whole became a harmony among discrete members. By contrast, Michelangelo's demand for an architecture based on anatomy was motivated by a desire to restore the indivisibility of the human form, a unity to be found in the function of the brain and of the nerve and muscle systems, rather than in external appearances.

Michelangelo was fully aware of the significance of these differences and felt compelled to attack the abstract analytical principles of his predecessors and contemporaries. Condivi noted (ch. LII):

> I know well that when he read Albrecht Dürer,[7] it seemed to him a very weak thing, seeing with his (great) insight how much more beautiful and useful was his own concept of this problem [the human figure]. And to tell the truth, Albrecht deals only with the measurement and variety of bodies, concerning which no sure rule can be given, conceiving his figures upright like posts. But what is more important, he says not a word about human actions and gestures.

At the same time, Condivi speaks of Michelangelo's desire to write a treatise on anatomy with emphasis on human *moti* and *apparenze*. Obviously this treatise would not have made use of abstract ratio and geometry; nor would it have been the more empirical one that Leonardo might have written; for the words *moti* (suggesting "emotions" as well as "motions") and *apparenze* imply that Michelangelo would have emphasized the psychological and visual *effects* of bodily functions.

Michelangelo sensed the necessary relationship between the figurative penetration into human beings that gave his art its unique psychological force, and a literal penetration that would reveal the workings of nerves, muscles and bones. His study of anatomy, in contrast to Leonardo's, was motivated by an incalculably important shift from an objective to a subjective approach to reality.

Early Renaissance theories of proportion, when applied to buildings, produced architecture that was abstract in the sense that its primary aim was to achieve ideal mathematical harmonies out of the interrelationship of the parts of a building. Simple geometrical figures were preferred for the plan; walls and openings were thought of as rectangles that could be given a desired quality through the ratio of height to width. Given the basic concept of well-proportioned planes, the ultimate aim of architectural design was to produce a three-dimensional structure in which the planes would be harmonically interrelated. At its best, this principle of design produced a highly sophisticated and subtle architecture, but it was vulnerable to the same criticism that Michelangelo directed against the contemporary system of figural proportion. It emphasized the unit and failed to take into account the effect on the character of forms brought about by movement—in architecture, the movement of the observer through and around buildings—and by environmental conditions, particularly light. It could easily produce a paper architecture more successful on the drawing board than in three dimensions.

Toward the end of the fifteenth century, architects and painters began to be more concerned with three-dimensional effects, particularly those produced by solid forms emphasized by gradations of light and shadow. Leonardo pioneered in the movement away from the planar concept of architecture in a series of drawings which, while still dependent for their effect on mathematical ratios, employed the forms of solid, rather than of plane geometry: cubes, cylinders, hemispheres. Leonardo's theoretical experiments must have inspired the extraordinary innovations of Bramante discussed in the Introduction.* These innovations, which substituted mass and spatial volume for planar design cannot, however, be taken as evidence of a fundamental change in architectural theory. I believe that Bramante still thought in terms of proportion and ratio, as demonstrated by his tendency to emphasize the interplay of distinct parts in a building. In his project for St. Peter's the exterior masses and interior spaces are semi-independent units harmoniously related to the central core (Fig. 16).

Seen in this perspective, Michelangelo's approach to architecture appears as a radical departure from Renaissance tradition.

---

* This refers to the introduction to James S. Ackerman's *The Architecture of Michelangelo.*—Ed.

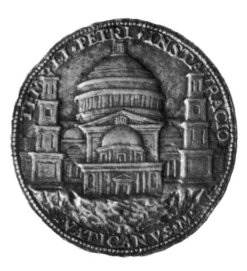

16. Caradosso, Medal of Bramante's Project, St. Peter's, 1506 (Reproduced by Courtesy of the Trustees of the British Museum)

His association of architecture to the human form was no longer a philosophical abstraction, a mathematical metaphor. By thinking of buildings as organisms, he changed the concept of architectural design from the static one produced by a system of predetermined proportions to a dynamic one in which members would be integrated by the suggestion of muscular power. In this way the action and reaction of structural forces in a building—which today we describe as tension, compression, stress, etc.,—could be interpreted in humanized terms. But, if structural forces gave Michelangelo a theme, he refused to be confined to expressing the ways in which they actually operated: humanization overcame the laws of statics in his designs to the point at which a mass as weighty as the dome of St. Peter's can appear to rise, or a relatively light attic-facing to oppress.

While fifteenth-century architecture required of the observer a certain degree of intellectual contemplation to appreciate its symbolic relationships, Michelangelo's was to suggest an immediate identification of our own physical functions with those of the building. This organic approach suggests the injection of the principle of empathy into Renaissance aesthetics by its search for a physical and psychological bond between observer and object.

In Michelangelo's drawings we can see how the concept was put into practice.[8] Initial studies for a building are vigorous im-

17. Michelangelo, Façade Project, San Lorenzo (Casa Buonarroti, Florence; Alinari/Editorial Photocolor Archives, Inc.)

pressions of a whole which search for a certain quality of sculptural form even before the structural system is determined (Figs. 17, 20). Often they even deny the exigencies of statics, which enter only at a later stage to discipline fantasy. Details remain indeterminate until the overall form is fixed, but at that point they are designed with that sense of coherence with an unseen whole which we find in Michelangelo's sketches of disembodied hands or heads. Drawings of windows, doors, cornices are intended to convey to the mason a vivid experience rather than calculated measured instructions for carvings (Fig. 18). Where his contemporaries would sketch profiles to assure the proper ratio of a channel to a torus, Michelangelo worked for the evocation of physical power; where they copied Roman capitals and entablatures among the ruins to achieve a certain orthodoxy of detail, Michelangelo's occasional copies are highly personalized reinterpretations of just those remains that mirrored his own taste for dynamic form. Rome provided other architects with a corpus of

rules but gave Michelangelo a spark for explosions of fancy, a standard that he honored more in the breach than in the observance.

This indifference to antique canons shocked Michelangelo's contemporaries, who felt that it was the unique distinction of their age to have revived Roman architecture. They interpreted a comparable indifference in fifteenth-century architects as evidence of a faltering, quasi-medieval search for the classic perfection of the early 1500's. Implicit in humanist philosophy was the concept that the goal of endeavor, whether in art, government, or science, was to equal—not to surpass—the ancients. Thus, Michelangelo's bizarre variations on Classic orders, coming on the heels of the climactic achievements of Bramante and Raphael, frightened

18. Michelangelo (or Assistant), Study for a Window-Frame (Ashmolean Museum, Oxford)

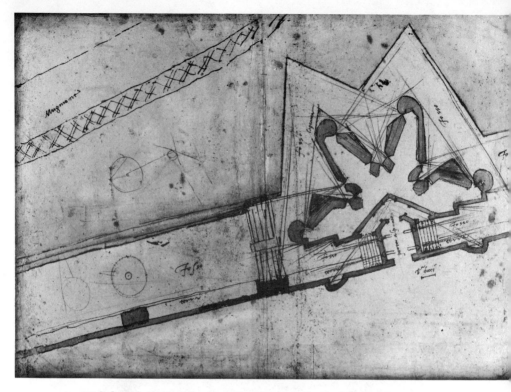

19. Michelangelo, Project for Gate Fortifications, Porta al Prato (Casa Buonarroti, Florence; Alinari/Editorial Photocolor Archives, Inc.)

Vasari, who dared not find fault with the Master, but worried that others might emulate him. When Michelangelo claimed for his design of San Giovanni dei Fiorentini in Rome that it surpassed both the Greeks and the Romans, the Renaissance concept was already obsolete; for the moment any improvement on antiquity is conceivable, the door is opened for modern philosophy of free experiment and limitless progress.

Michelangelo's plan studies appear as organisms capable of motion: the fortification drawings obey a biological rather than a structural imperative (Fig. 19). But even in more orthodox plans (Fig. 20) the masses swell and contract as if in response to the effort of support. Elevation sketches minimize the planes of the wall to accent plastic forms—columns, pilasters, entablatures, frames, etc.—which dramatize the interaction of load and support. I say "dramatize" because the sculptural members, seen as bones and muscles, create an imagined epic of conflicting forces, while it is the anonymous wall that does the mundane job of stabilizing the structure. In building, the wall is further dis-

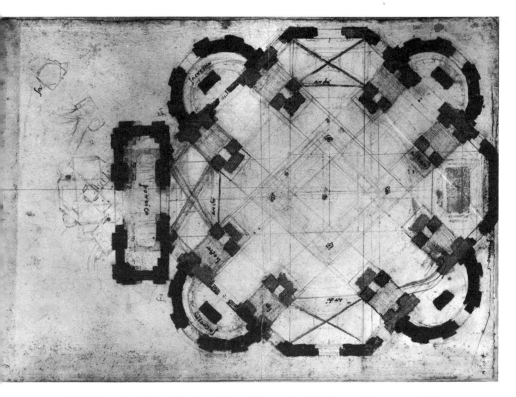

20. Michelangelo, Plan Project, San Giovanni de' Fiorentini, 1559 (Casa Buonarroti, Florence; Alinari/Editorial Photocolor Archives, Inc.)

tinguished from its expressive articulation by the choice and treatment of materials.

By contrast to contemporaries trained in fifteenth-century proportions, Michelangelo rarely indicated measurements or scale on his drawings, never worked to a module, and avoided the ruler and compass until the design was finally determined. From the start he dealt with qualities rather than quantities. In choosing ink washes and chalk rather than the pen, he evoked the quality of stone, and the most tentative preliminary sketches are likely to contain indications of light and shadow (Fig. 18); the observer is there before the building is designed.

Michelangelo rarely made perspective sketches, because he thought of the observer as being in motion and hesitated to visualize buildings from a fixed point. To study three-dimensional effects he made clay models. The introduction of modelling into architectural practice again demonstrates the identity of sculpture and architecture in Michelangelo's mind. It is also a further sign of his revolt against early Renaissance principles, since the malle-

145

ability of the material precludes any suggestion of mathematical relationships or even any independence of parts: only the whole could be studied in terra-cotta. We can infer that when Michelangelo used clay models he sought effects of mass rather than of enclosed space, as in his paintings, where the spatial environment exists only as a receptacle for the bodies. The architectural drawings show the same preference; they communicate mass by contrast to those of Bramante or Sangallo, where lines are drawn around spaces.

This approach to architecture, being sculptural, inevitably was reinforced by a special sensitivity to materials and to effects of light. Michelangelo capitalized upon the structure of his materials because of his desire to get a maximum contrast between members used to express force or tension and "neutral" wall surfaces. He invariably minimized the peculiarities of surface materials such as stucco and brick, while he carved and finished the plastic members in order to evoke—even to exaggerate—the quality and texture of the stone. No one had a comparable sensitivity to the character of the traditional Roman masonry, Travertine, the pitted striations of which became richly expressive in his design.

In speaking of modern architecture we often associate sensitivity to materials with an exposition of their technical functions, but in Michelangelo's work the latter is characteristically absent. In laying masonry, Michelangelo notably avoided any emphasis on the unit (block or brick). He disguised joints as much as possible in order to avoid conflict between the part and the whole, and to sustain the experience of the building as an organism. He was the only architect of his time who did not use quoins, and he rarely employed rusticated or drafted masonry, the favored Renaissance means of stressing the individuality of the block. If his buildings were to communicate muscular force, the cubic pieces had to be disguised.

Light, for Michelangelo, was not merely a means of illuminating forms; it was an element of form itself. The plastic members of a building were not designed to be seen as stable and defined elements but as changing conformations of highlight and shadow. Much of Michelangelo's unorthodoxy in the use of antique detail can be explained by his desire to increase the versatility of light effects. If more of his interiors had been completed according to his design, I believe we would find an astounding variety of com-

positions in light, creating moods quite unknown in the Renaissance. It is fascinating to imagine, for example, what the interior of St. Peter's might have been like if the lantern had been screened by an interior canopy as Michelangelo planned. No doubt Michelangelo's sympathetic adjustment to the brilliance of the Mediterranean sun was a factor that inhibited the exportation of his style to hazier northern countries, where the intellectual reserve of Palladio was much preferred.

The common practice in the sixteenth century of building from large wooden scale models, rather than from drawings, explains the absence of any complete plans or elevations among Michelangelo's surviving sketches. But these sketches differ from those of other Renaissance designers in one significant respect: with two or three exceptions none represents even a small detail as it was ultimately built. It was Michelangelo's habit to keep his design in a constant state of flux until every detail was ready for carving, a method entirely consistent with his organic approach. His conception of a building literally grew, and a change in any part involved sympathetic changes in other parts. The final solution was not reached even in the model: the wooden model for St. Peter's was executed without an attic, and probably without a façade or dome, in order to permit Michelangelo to alter those portions in response to his impressions of the body of the building as it was constructed. There and at the Farnese palace, wooden mockups of cornices were made to full scale and hoisted into position to enable the architect to judge, and possibly to redesign, his project at the last moment; had funds been available he doubtless would have destroyed portions already finished in order to improve them, as he did with his later sculptures. In all his work he seems to have carried the generative drive to a point at which it became an obstacle to completion, an obstacle so frustrating that most of his architectural projects were not executed, and no building was completed according to his plans. So contemporary engravers had to record his projects by combining scattered records of different stages in the process of conception with touches of pure fancy. And the problem is the same for the modern historian. We shall never know for certain what Michelangelo's unexecuted projects—whether abandoned or partly completed—were to have been; in fact, the attempt to do so implies at the outset a misunderstanding of his conception of architecture.

To visualize any of Michelangelo's designs, we must seek to capture not a determinant solution, but the spirit and the goals of a process.

*NOTES*

For a general view of Michelangelo's theories of art, see E. Panofsky, *Idea* . . . (Leipzig and Berlin, 1924), (2nd ed., Berlin, 1960), pp. 64 ff.; *Idem,* "The History of Proportions as a Reflection of the History of Styles," *Meaning in the Visual Arts* (New York, 1955), esp. pp. 88–107; C. de Tolnay, *Werk und Weltbild des Michelangelo* (Zürich, 1949), pp. 87–110. Reflections of Michelangelo's theories appear in Vincenzo Danti, *Il primo libro del trattato delle perfette proporzioni* (Florence, 1567).

[1] Heinrich Wölfflin, *Die klassische Kunst* (Munich, 1899).

[2] *Il terzo libro di Sebastiano Serlio bolognese* (Venice, 1540); quoted from the edition of Venice, 1584, fol. 64v.

[3] On Bramante's revival of Roman vaulting technique, see O. Förster, *Bramante* (Munich, 1956), pp. 277 f.

[4] *Lettere,* p. 431; Wilde 1953, pp. 109 f.; Condivi, ch. LIII.

[5] *Lettere,* p. 554; Schiavo 1949, Fig. 96 (facsimile). Interpreted by Tolnay 1949, p. 95.

[6] On fifteenth-century theory, see: R. Wittkower, *Architectural Principles in the Age of Humanism* (London, 1949); H. Saalman, "Early Renaissance Architectural Theory and Practice in Antonio Filarete's *Trattato* . . . ," *Art Bulletin,* XLI, 1959, pp. 89 ff.

[7] *Vier Bücher von menschlicher Proportion* (Nürnberg, 1528). Cf. E. Panofsky, *Dürer* (Princeton, 1943), pp. 260 f.

[8] On the development of architectural drawing in the Renaissance, see W. Lotz, "Das Raumbild in der italienischen Architekturzeichnung der Renaissance," *Mitt. des Kunsthist. Inst. in Florenz,* VII, 1956, pp. 193 ff.; J. Ackerman, "Architectural Practice in the Italian Renaissance," *Journ. Soc. Architectural Historians,* XIII, 1954, pp. 3 ff.

# 8. THE ARCHITECTURE

# OF MANNERISM

## Sir Nikolaus Pevsner

### INTRODUCTION

Nikolaus Pevsner's article "The Architecture of Mannerism" first appeared in *The Mint*, I, in 1946, and is reprinted here with some additions by Dr. Pevsner especially for this anthology. The current interest in the phenomenon of "Mannerism" in Italian art could be said to have begun in 1914, in a lecture at the University of Freiburg by Walter Friedlaender, which was not published until 1925. This became available in English translation as the first of two essays in Friedlaender's *Mannerism and Anti-Mannerism in Italian Painting* (1957) recognized as the classic definition of these two aspects of sixteenth-century Italian art, and now available in a paperback edition with an excellent introduction by Donald Posner. Pevsner, in the selection below, extends the concept of a Mannerist style into the field of architecture. For other readings on Mannerism in architecture consult Pevsner's bibliography at the end of this article.

The literature on Mannerism has grown considerably since Friedlaender's lecture in 1914. Of works in English, there are Max Dvořák, "El Greco and Mannerism," *Magazine of Art*, XLVI (1953); Harold Wethey, *El Greco and His School* (1962), 53–58; Craig Hugh Smyth, *Mannerism and Maniera* (1963); and Arnold Hauser, *Mannerism: The Crisis of the Renaissance and the Origin of Modern Art*, 2 vols. (1965), a Marxist approach. A session of the Twentieth International Congress of the History of Art was devoted to Mannerism, and the papers have been published in *Renaissance and Mannerism, Studies in Western Art, Acts of the Twentieth International Congress of the History of Art*, II (1963). To this list should be added Sydney J. Freedberg, "Observations on the Painting of the Maniera," *The Art Bulletin*,

XLVII (1965); Rudolf Wittkower, "Michelangelo's Biblioteca Laurenziana," *The Art Bulletin*, XVI (1934); Wolfgang Lotz, "Architecture in the Later 16th Century," *College Art Journal*, XVII (1958); and Sir Nikolaus Pevsner, "The Counter-Reformation and Mannerism," *Studies in Art, Architecture, and Design*, I (1968), 10–33. John Shearman, *Mannerism* (1967), is a handy survey.

For studies on some of the works of architecture mentioned in the following selection, see John Coolidge, "The Villa Giulia: A Study of Central Italian Architecture in the Mid-Sixteenth Century," *The Art Bulletin*, XXV (1943), 177–225; L. W. Partridge, "Vignola and the Villa Farnese at Caprarola," *The Art Bulletin*, LII (1970), 81–87, and "The Sala d'Ercole in the Villa Farnese at Caprarola," *The Art Bulletin*, LIII (1971), 467–486 and LIV (1972), 50–62; and G. Smith, "Stucco Decoration of the Casino of Pius IV," *Zeitschrift für Kunstgeschichte*, XXXVII, 2 (1974), 116–156. The reader may also find useful C. Constant, "Mannerist Rome: Map Guide to Rome in the 16th Century," *Architectural Design*, XLIX, 3–4 (1979), 19–26.

The selection that follows is reprinted by permission of the author, Sir Nikolaus Pevsner.

England distrusts generalizations. The tendency is to treat each case on its own merit and leave the perfection of codes of law to more logical and less practical nations. The extent to which this attitude influences political, social and legal matters is familiar. Less familiar is the connection of this weakness or strength of character with the proverbial vagueness of English philosophical terminology.

Taking research into art and architecture as an example, there is plenty of antiquarian and archaeological work going on, but little that reaches broader conclusions as to the characteristic style of a man or a nation or an age—to say nothing of those still broader conclusions which allow for the carving out of aesthetic theories with their appropriate terminology.

The word style in fact is hardly yet accepted in the sense in which the French, the Italians, the Germans, the Americans use it. To the man in the street its foreground meaning is still that which comes up from associations with "stylish," doing something "in style," and so on. "He writes a good style" is nearer to the philosophical meaning of the term. For it is certainly at least one of the legitimate uses of "style" to denote the personal mode of expression of an author and an artist, and if you write of Wordsworth's as against Keats's style or Rembrandt's as against Rubens's you are philosophically precise and yet not likely to be misunderstood even in England.

But when it comes to introducing such terms as Baroque, nobody can be sure whether it will be taken by the English reading public as a synonym of fantastic or—in the deeper sense—as the final essence distilled out of all the individual qualities of all the leading personalities of one particular age. Hobbes's and Spinoza's philosophy, Bernini's and Rembrandt's art, Richelieu's and Cromwell's statecraft have certain fundamentals in common, and on these we can establish a Baroque style of exact meaning.

England has been characteristically slow in accepting this working hypothesis. Continental art history began to investigate the opposed principles of Renaissance and Baroque art in the eighties of last century, chiefly in Switzerland (Wölfflin 1888),

151

Germany (Schmarsow 1897) and Austria (Riegl, before 1905). The final summing up was Wölfflin's famous *Grundbegriffe*, which came out in 1915 and was translated into (bad) English in 1932. But you can still find in the subject catalogues of important libraries under *Artists, Renaissance:* Raphael, Rembrandt, Reynolds, Rubens.

Now, if fixed terms for styles of ages are there to keep a host of data in reasonable order, then there is obviously no point in using such words as Renaissance, Baroque and so on, unless their very job is to keep Raphael, Rembrandt, Rubens and Reynolds apart. Surely the first step in tidying up the vast number of works of art and architecture produced in the West between the fifteenth and the eighteenth centuries is to separate what expresses Renaissance spirit from what is Baroque, to separate, that is to say, the static from the dynamic, the compact from the expansive, the finite from the infinite, the ideal from the over-real or over-expressive.

However, this juxtaposition which, thanks to the relative popularity of Wölfflin's book, can be taken as known to readers of these pages, if not to the general public, is historically inadequate. Wölfflin chose his examples to illustrate the Baroque almost exclusively—and very wisely—from the seventeenth century. And, as he says himself that after 1520 hardly any work of pure Renaissance character was produced, what happened between 1520 and the end of the sixteenth century? Where do Parmigiano, Tintoretto, Greco belong? The Renaissance believes in the beauty and vigor of the human body; the Baroque does; but these three painters and their contemporaries don't. The Renaissance believes in the proud independence of the human personality and the solidity of matter. The Baroque does; but Parmigiano, Tintoretto, and Greco evidently work toward a contraction of all that is material, in order to achieve an exquisite and decadent elegance or a supreme spiritualization.

Neither of these goals is Renaissance, neither is Baroque. And as our eyes learned to see these specific qualities of sixteenth-century art and our minds (thanks to contemporary developments) widened to understand them, a new term had to be coined to label them. Mannerism had for a long time been used to designate certain schools of painting and sculpture in Italy, carrying on the manner of late Raphael, Michelangelo, Correggio and other Renaissance artists, and an Italianizing school in the Nether-

lands; so the word could easily be widened out to be applicable to the whole style of Italian and perhaps European painting and sculpture of the later sixteenth century. In this new sense Mannerism was first used and its extent and character defined between 1920 and 1925. (Dvořák 1920, Pinder *c.* 1924, W. Friedlaender 1925, Pevsner 1925.) Since then it has become accepted on the Continent and in America. Younger scholars use it in as precise and familiar a way as Renaissance and Baroque.

However, analyses and definitions have proved easier concerning pictures and works of sculpture than concerning buildings. Hardly anything to my knowledge has yet been published in this country about Mannerist architecture, although such books as Anthony Blunt's *Mansart* presuppose familiarity with the term and its architectural implications. So what I propose doing here is to look closely at ten or twelve buildings of the sixteenth century, to prove the incompatability of their formal and emotional character with that of works both of the Renaissance and the Baroque, and then point to certain characteristic events in contemporary thought and feeling to show the same spirit at work in history and architecture.

Bramante, born in 1444, that is eight years before Leonardo da Vinci, stands at the beginning of the High Renaissance. He died in 1514, just before it came to an end. In his old age he designed the Casa Caprini in Rome which Raphael completed for himself in 1517 (Fig. 21). It has since been altered out of recognition. It is a building of five bays and two floors, a comfortable human size, easily manageable by the surveying eye and easily comprehensible to the mind. The ground-floor is rusticated as a base for the main floor, the *piano nobile,* above. This has coupled columns to frame the windows and the generous wall spaces on their sides and above. All the windows have identical balustrades below and pediments above. An entablature and cornice terminate the façade. A minimum of motifs is used, but with a maximum of care for proportion and detail. Ground-floor and upper floor are of exactly the same height. The proportion of the windows between top of balustrade and foot of pediment is repeated by the proportion of the bays between the columns. No ornament appears anywhere. The Doric columns are unfluted, the metopes undecorated. The effect is of a noble perfection and grave harmony.

Bramante's style inspired a whole group of younger architects

in Rome. Raphael, born in 1483, is the most notable of them. To his generation belong Serlio, born in 1475, Peruzzi born in 1481, and Sanmicheli born in 1484. Others were young enough to start as Raphael's assistants. The most important of these is Giulio Romano (1499–1546).

The group was dispersed by the Sack of Rome in 1527, which took Sanmicheli to Verona, while Giulio Romano had gone to Mantua already a few years before. These two were the first to take the innovations of the Roman High Renaissance to the North of Italy. However, in their works the Renaissance seems to have lost its serenity and most of its balance.

About 1530 Sanmicheli designed three palaces at Verona, the Palazzi Canossa, Pompei and Bevilacqua. The first two show him a faithful follower of his master, the third (Fig. 22) is surprisingly original. Here is just as in the case of the Casa Caprini a building of two storeys with a rusticated ground-floor and a first floor with columns to separate the window bays. The entrance was intended to be central so that we have to add in our minds four more bays on the left to the ones actually built. The fenestration of the *piano nobile* is a little more complicated than in the Casa Caprini, but

21. Bramante, Casa Caprini, Rome, Engraving by Antonio Lafreri (The Metropolitan Museum of Art, Harris Brisbane Dick Fund, 1941)

22. Sanmicheli, Palazzo Bevilacqua, Verona, c. 1529–1540

the triumphal arch motif of the openings: low—tall—low or
a—b—a, is in its perfect symmetry and its pyramidal composition
not alien to the Renaissance (Alberti's S. Andrea in Mantua,
Bramante's Belvedere Court in the Vatican, etc.). So if the façade
of the Palazzo Bevilacqua were simply a five-times-repeated
a—b—a—b—a—b—a—b—a—b—a, there would be nothing
new or embarrassing in it. Nor are a decorated frieze or some
figures in the spandrels of the windows ornaments to which the
Renaissance, especially in Northern Italy, would necessarily
object. It is the details which confuse one as soon as they are
studied.

The bays of the ground-floor are not all of the same width.
Narrower and broader spaces alternate, but the difference is not
marked enough to make one feel certain of its meaning, particu-
larly as all the windows have the same dimensions. The composi-
tion of the first floor is even more intricate. The first, the third and
the (missing) fifth main windows have columns with spiral flut-
ing, the second and the (missing) fourth straight-fluted columns.

155

That is logical enough, but the pediments above the small windows do not tally with this rhythm at all. If we call the triangular ones $\alpha$ and the segmental ones $\beta$ we would, over the whole projected extension of the front, get a rhythm looking like this: (from right to missing left) $\alpha$—$\beta$—$\beta$—$\alpha$—$\alpha$—$\beta$. That means that above the central entrance the triumphal arch is rudely thrown out of symmetry. It has two symmetrical spiral columns, but one $\alpha$ and one $\beta$ pediment. You may say that the little pediments are an afterthought of Sammicheli's to achieve superficial symmetry, when he knew that the palace was not going to be carried on to the left. But even if that is so, no Renaissance architect would have tolerated the presence of two alternatively exclusive rhythms in the finished front. They jar painfully once they have been noticed, and they are not even the only motif of such obstinate illogicality. Another is the uncomfortable balancing of the $\alpha$ and $\beta$ pediments, especially the segmental $\beta$ ones, on the round-headed windows.

Victorian ostentatiousness of decoration has made us insensitive to the subtler values of architectural expression. Modern architects suffer from this lack of visual discrimination in the general public. Criticism suffers from it too; this is my excuse for what may be considered unnecessarily close analyses.

How necessary they really are is proved by the fact that Giulio Romano's most famous building at Mantua, the Palazzo del Té, a spacious ducal villa built between 1526 and 1534, appears in textbooks as a characteristic example of the Renaissance style. At a first glance it may well look like that. Yet, is the entrance side really placid and as happily spaced as a Bramante design would be? There are again two storeys, separated by a flat band with a sharply incised key pattern, the ideal Greek solution to the representation of movement in a static ensemble. However, the band is cut up by giant pilasters. Are the two storeys then two, as the band says, or one, as the pilasters say? This lack of clarity would have been intolerable to a pure Renaissance artist. Moreover, pilasters lose their *raison d'être* if they are not spaced regularly, but Giulio breaks that regularity in the very center of his composition to house his three entrances. And he does worse at the corners. To stress these by a coupling of pilasters was in no way against Renaissance feeling. But the two outside pilasters stand closely together, while the two inner ones are separated by niches —a horrid heresy. Then, there is the rustication. The main

windows and the doors have imitation-rusticated surrounds of a jagged restless pattern, and those of the doors jut out into and across the horizontal band.

Now all this is not just haphazardly insensitive. It obviously is the expression of a new will, a deliberate attack on the Renaissance ideal of the isolation and balance of all parts, and, what is more, an attack launched surreptitiously by an artist who all the time takes every care to preserve the *dehors* of classical correctness, a care which has indeed deceived observers of several centuries.

Dissonance is even shriller in the façades toward the inner court. Here attached columns (the plain and sober Doric columns of Bramante) replace the pilasters. The rhythm of openings is the simple triumphal arch rhythm (*a—b—a*) of the Renaissance. But why do the pediments lack bases? Why, if rustication is used, should it occur only in odd places? And why, to take the most scandalous breach of etiquette, should every third triglyph be dropped down so as to hang into the zone of the upper windows? It looks as though the buildings were on the point of collapsing, and that is exactly the impression the architect wished to give: precarious instability instead of the repose of the Golden Age. Evidently, to Giulio and his generation that repose had become unbearable. Restlessness and discomfort appeared as positive values. This is also the reason why the high finish achieved by the Renaissance is placed side by side with rude blocks of unhewn stone, and their incongruous proximity is relished. Nature in the raw becomes for the first time a motif of art. This interpretation of Giulio's rustication is not a modern subtlety. Already in 1537 Serlio wrote about it that it seems "partly a work of nature and partly a work of the artist." The sixth book of his treatise which came out in 1551 is dedicated to nothing but such displays of curious rustication.

Rustication in palace architecture was, it is true, by no means an innovation of the sixteenth century. But when the Early Renaissance uses it, say in Michelozzo's Medici Palace in Florence, it appears as a solid and powerful basis to the noble building of man. Nowhere does it endanger the superiority of the human achievement. In the courtyard of the Palazzo del Té nature breaks into the architect's artificial world, spoiling it and reminding us irritatingly of our own helplessness. How panic-stricken Giulio must sometimes have felt in the presence of nature, is

23. Federico Zuccari, Palazzo Zuccari, Rome, 1593 (19th-century photograph, before restoration), Now the Biblioteca Hertziana

proved by the most famous of his wall-paintings inside the Palazzo del Té, the Hall of the Giants, with walls showing on all sides colossal, brutish giants tumbling down on us amid crashing boulders. Nor can this nightmare of instability, this memento of the untrustworthiness of the material world, be set aside as a mere sign of one artist's deranged mind. It adorned one of the main rooms of the Duke's *maison de plaisance* and was apparently widely admired. The distaste of Renaissance perfection must have spread far—that is evident.

At the same time it ought not to be forgotten that in the Hall of Giants the experience may not have been entirely or always nightmarish. There must also have been a *frisson* of pleasant terror, and one should not underestimate this. Preponderance of pleasant over genuine terror can be assumed in the portals of Mannerism shaped as huge open mouths. At Bomarzo in the early sixties—*sacro bosco* or not— the gaping mouth amid giants and monsters in a natural setting may have frightened indeed, but if Alessandro Vittoria in the fifties gave a fireplace in Palladio's Palazzo Thiene this shape, he can only have expected amusement and appreciation of his inventiveness, and one must assume the same in Federico Zuccari's house in the Via Gregoriana (Fig. 23)

in Rome in 1590, although there a shock at the uncertainty between almost real monsters, architecturally hewn stone and stone left rude must also have been savored.

Infinitely more seriously Michelangelo had pointed out long before what poignancy there can be between figures seemingly real and the raw block from which they seem to be just emerging. The question has often been asked what made him keep the untreated stone below his reclining figures of *Day* and *Night* and *Morning* and *Evening*. The answer is that he wanted to let them appear in the act of coming to life out of a stony, subhuman pre-existence. To shape the image of man entirely liberated from these dark forces must have seemed almost a sacrilege to the young and again the very old Michelangelo. Hence also his many unfinished works.

Again, a different aspect of this new attitude to nature is the Mannerist liking for the grotto. Here such architects as Buontalenti and Palissy employ the highest skill in achieving an elaborate likeness of nature left to herself. There is in this, as well as in Palissy's trick of using casts from lizards, beetles and plants to decorate his bowls and dishes, a good deal of naïve pride, of course, but it should not be forgotten that such verbal imitation of nature, coming as it did, immediately after the great power of idealization which the Renaissance had achieved, is also an admission of defeat and a sign of distrust of human achievement.

To return to Giulio Romano, it must, after the analysis of the Palazzo del Té, be of special interest to see how he expresses himself in a building in which he was entirely free from the wishes of any patron: his own house, built in 1544. Now here he appears at his most formal, evidently determined to prove what was at the time by no means yet accepted: that the artist could be the best mannered of courtiers. We can be sure that he wished to avoid solecisms, yet the design is full of them, according to Renaissance standards. The course between ground-floor and upper floor is pushed up into some sort of fragmentary pediment of the central door; the arch of the door is pressed down into a Tudor shape, and the band which runs along the ground-floor on the level of the imposts of the door arch is broken up into unconnected bits. Or are we to believe that the rusticated frames of the windows conceal the band? This is hardly possible, as any indication of three-dimensionality is absent. All is as flat as paper, and the *piano nobile* windows which one would expect to project with

159

their pediments, are even slightly recessed instead. A most elo-
quent detail is the decorated bands round the windows. Their
ornament seems at first crisp, cool and structurally sound, until it
is seen that they run right on into the pediment zone, without any
cæsura where structural logic would have placed one. The pedi-
ments thus cease to be pediments proper. Their weight is reduced.
Nor are the windows shaped strong enough to support weight.
This deliberate weakness of the windows makes it impossible for
them too to revolt in the sense of the Baroque against the tight-
ness of the arched panels in which they are set.

This denial of expressing strength to carry as well as weight of
load is one of the most significant innovations of Mannerist archi-
tecture. The Romanesque style had mighty massive walls, the
Gothic style shafts soaring-up unimpededly, the Renaissance a
balance of upright and horizontal. Now the wall ceases altogether
to be mass, just as a figure by Parmigiano, Tintoretto or Greco
ceases to be body. Nor is the Mannerist wall a system of active
forces, just as there are no convincing active forces in Parmigiano,
Tintoretto and Greco. But the result of this is by no means immo-
bility, either in painting or in building, owing to the insistence of
the Mannerist on discordant motifs and contradictory directions
everywhere.

Peruzzi's Palazzo Massimi alle Colonne in Rome (1535) is also
a popular textbook illustration of pure Renaissance. To this the
Wölfflin generation has objected that the design of the front is
against Renaissance principles, because the excessive weight of
the three upper storeys presses down the entrance loggia. Against
Renaissance principles the building certainly is, but pressure I fail
to see. On the contrary, the curious thing about the façade is its
seeming paperiness. It is slightly curved, and that alone gives it
something of the appearance of a mere screen. The two rows of
top windows have, instead of the substantial pediments of the
Renaissance, excessively delicate and flat ornamented surrounds,
strap-work of the kind which a little later became so popular in
the North. The gradation of parts which the Renaissance had
evolved is given up as well. The same smooth pattern of the ashlar
stone goes from bottom to top, and the second- and third-floor
windows are of identical size. Peruzzi, who had, in the Villa
Farnesina twenty-five years before, shown a perfect command of
High Renaissance harmonies, has here abandoned them for un-
stable relations in the flat.

24. Michelangelo, Laurentian Library, Florence, Stairway of vestibule; Library begun 1524, Stairway designed 1558–1559

It may need some study to see the Palazzo Massimi in this new light. In Michelangelo's architectural experiments of the twenties no effort is required to see how revolutionary they are. The Laurenziana Library and its anteroom were designed in 1524. The library itself lies fifteen steps above the anteroom, but the anteroom reaches up higher still than the library. This excessive verticalism is yet further emphasized by the many closely set verticals of dark grey marble, streaking the white walls (Fig. 24). The result is a feeling of discomfort which grows worse, when one begins to examine the structural elements in detail. The system is Bramante's approved alternation of window bays (the windows are blind) and coupled Doric columns. But Michelangelo hated Bramante's happy ease; we know that. And so he does all he can to drive out the smooth beauty of his system. His columns, instead of standing out in front of the wall, as all columns have done ever since the first columns were designed, keep farther back than the panels in which the windows are placed. Moreover, they are tightly caged without any of the freedom of development which is their due. They do not support anything either, and they appear to rest precariously on slender brackets. In fact the brackets, themselves encased on left and right, stand farther forward than the columns. So the accepted

161

connection between brackets and columns is broken, just as the accepted connection is broken between columns and bays. No critic has ever, to my knowledge, overlooked these incongruities. But their interpretation has varied a great deal. Burckhardt, the champion of the Renaissance, has called them "evidently a joke of the great master," while Schmarsow, engrossed in his new conception of the Baroque, wrote: "These subdued, encased columns . . . symbolize passionate impetuosity of thought breaking forth and struggling to find an appropriate language." Now this, to my mind, is untrue. I cannot see in the Laurenziana, anything impetuous, any violence, any struggle. Struggle can only arise between forces, and there are no forces in this architecture. Look at the delicate bands of the panels between the brackets, or the lines round the frail-looking niches above the main window zone, or the blind windows themselves, with their square, fluted little brackets below, too weak to carry anything, their tapering and partly fluted pilasters and their capitals retracted where one would expect them to swell out.

Once all this has been observed, it will be patent that, while the columns are indeed painfully incarcerated, they do not revolt. If they did, and if the wall really pressed against them, then one would be justified in speaking of Baroque. Michelangelo's *Slaves* struggle, and they stand indeed at the beginning of a development which the seventeenth-century Baroque was to continue. But Michelangelo's architecture knows no gigantic exertions. It is paralyzed, frozen, as it were, and held by iron discipline in a stiff pose of forced constraint, so accomplished that it even succeeds in appearing elegant: human freedom and human power suppressed, all swelling beauty of the flesh ascetically starved off— a perfect setting for the self-denying etiquette of sixteenth-century society.

The contrast between Michelangelo's architecture and sculpture cannot here be discussed. It is enough to state that Michelangelo (as Raphael, as Correggio) held in his hands the seeds of both Mannerism and Baroque, enough to point to one place where the interaction of the two styles of the future, that of the immediate and that of the later future, becomes most alarmingly evident. The Medici Chapel (Fig. 25) was designed between 1521 and 1534. The tombs of the two Dukes are well enough known. Their composition was to start from violently moving figures of river gods on the floor, lead up to *Day* and *Night*, and *Dawn* and

*Evening,* and find its achievement in the somber, brooding figures of the Dukes—expressive, it has been proved, of Plato's Vita Activa and Vita Contemplativa. Now this idea of an "excelsior" through struggle to repose is wholly Baroque; what Mannerism contributes is only the lack of a final triumph. For neither is Giuliano active nor Lorenzo contemplative. Bernini would have given the one Duke wildly reaching-out gestures of triumph, the other an appearance of sensual self-abandon. Such outpourings of feeling Michelangelo never knew. And so he keeps his architecture as frigid, that is as self-consciously precious, as that of the Laurenziana. Detailed analysis of the niches above the low doors is not necessary. The various layers in depth should be observed, the angular excrescences inside pilasters and pediment, the elaborate over-precision of the garlands, and such illogical motifs as the sunk panels of the pilasters and the unmolded block sticking out at the foot of the niche.

But architecture is not all a matter of walls and wall patterns. It is primarily organized space, and of space hardly anything has

25. Michelangelo, Detail, Medici Chapel, 1524–1534 (San Lorenzo, Florence)

163

so far been said. Now it is, of course, much harder to write of space than of walls; for walls can be photographed and space cannot. To experience space it must be wandered through or at least wandered through with one's eyes. It is a process that takes time and could only be re-evoked by film.

Yet it is easy enough to say that no Renaissance architect would have exaggerated height at the expense of width and depth to the extent that Michelangelo does in the Laurenziana. Standing in the anteroom one feels at the bottom of the well or shaft of a mine. There is lack of balance in this from the Renaissance point of view, and from the Baroque point of view lack of the final solution which a wide-windowed dome with paintings of open skies and glories of saints or kings would give. Schmarsow says that this very solution lies in the change-over from the narrow anteroom into the "simple clarity, repose and satisfaction" of the library proper. This again I cannot see. To me the library is excessively long as against its height and certainly as constrained and precious in its details as the anteroom (brackets of the windows, balusters of the blank windows above). So Michelangelo instead of creating a Baroque overflow of dammed forces out into infinite space, keeps his room as rigidly confined as any artist of the Renaissance, but breaks the harmonious proportions and interrelations which dominate Renaissance rooms. In, say, Brunelleschi's Pazzi Chapel a beautifully balanced anteroom is followed by a beautifully balanced main room. In the Laurenziana we are thrown from a room like the shaft of a mine into a room like a tunnel.

This tendency to excess within rigid boundaries is one of the characteristics of Mannerist space. It is well enough known in painting, for instance in Correggio's late Madonnas, or Tintoretto's Last Suppers with the figure of Christ at the far, far end. The most moving of all examples is Tintoretto's painting of the Finding of the Body of St. Mark (Brera, Milan, c. 1565). Nowhere else is Mannerist space so irresistible. In architecture this magic suction effect is introduced into Giulio Romano's extremely severe Cathedral at Mantua with its tunnel vault and monotonous columns. This was begun in 1545. But its most familiar and easily acceptable example is no doubt Vasari's Uffizi (Fig. 26). Vasari is the Mannerist *par excellence* of the generation following Giulio's. He lived from 1511 to 1574. He founded the first Academy of Art, a typically Mannerist conception with its connotations of dry rule

26. Vasari, Uffizi, Florence, 1560–1574

and social dignity, and wrote the first book on the history of art, his *Vite* of 1555. This again is characteristic of Mannerist mentality: the self-conscious comparison of a late today with a long-past youth and a recent Golden Age. The Uffizi Palace was begun in 1560 to house Grand Ducal offices. It consists of two tall wings along a long and narrow courtyard. The formal elements by now need no special mention: lack of a clear gradation of storeys, uniformity coupled with heretical detail, long, elegant and fragile brackets below double pilasters which are no pilasters at all, and so on. What must be emphasized is the finishing accent of the composition towards the river Arno. Here a loggia open in a spacious Venetian window on the ground floor and originally also in a colonnade on the upper floor replaces the solid wall. This is a favorite Mannerist way of linking room with room, a way in which both a clear Renaissance separation of units and a free

165

Baroque flow through the whole and beyond are avoided. Thus, Palladio's two Venetian churches terminate in the east, not in closed apses, but in arcades—straight in S. Giorgio Maggiore (1565), semicircular in the Redentore (1577)—behind which back-rooms of indistinguishable dimensions appear. And thus Vasari, and then Vignola (1507–73) and Ammanati (1511–92) designed and built the Villa Giulia, the country *casino* of Pope Julius III (1550–55). It deserves as intensive a description as the Uffizi and the Laurenziana.

The villa is approached from the west, and its buildings and garden stretch to the east (really northwest and southeast). On arriving one sees a façade of seven bays and two storeys with short wings in the same direction but set far back. The archway in leads into a large courtyard with, screening the entrance range and its wings, a semicircular colonnade, rhythmically arranged and containing once more the motif of the Palazzo Massimi, short slim columns with straight lintels and much plain wall, sheer but not heavy-looking, above. These stretches of wall separate three major motifs, in the center of the semicircle a triumphal-arch motif, three arches, low-high-low, but at the ends two fragmentary triumphal arches: low-high only—a painful detail, very Mannerist and of the same nature as that analyzed for the façade of the Palazzo del Té. East of the semicircle is a square part of the courtyard with one-storeyed walls to north and south, that is wholly enclosed—wholly except for one door in the middle of the east wall (the three-bay opening dates from 1900). As one passes through, one enters a loggia open in three arched bays to the east. From here one overlooks a second courtyard, again entirely enclosed, this one three-storeyed. However, the two lower storeys are sunk, i.e., one approaches the courtyard on the second upper floor. Semicircular ramps lead down to the first upper floor, and the ground floor is really at first sight no more than a kind of pit. It is of semicircular shape again but much smaller and surrounded at the top by a balustrade so that from the level of the second courtyard one can look down into it. What is revealed there is a small, cool Nymphaeum with statues of deities in niches and its own miniature east apse where slim caryatids carry the upper balustrade.

If, instead of at once descending by the two ramps, one looks eastward from the loggia between first and second courtyard, one sees another loggia at one's own level and the "Venetian" opening

of this allows one to see the grass of a garden lying once more on the level of the first courtyard, i.e., the ground level of the villa. This loggia and the walls to its left and right have more deities in niches, and the east wall of the back garden has as its termination another tripartite piece, with demicolumns and pilasters. So the whole is a sequence of three parts from west to east, all enclosed by solid walls to north and south in such a manner that the progress from the entry to the final set piece of the back garden is rigidly prescribed. The first part is separated from the second by a door, the second from the third by a loggia. Moreover, to add further complexity, the level changes *nel mezzo del cammin* by an unexpected two-storey drop. This sudden change from horizontal to vertical is in the spirit of the Laurenziana, the enclosed progress itself in the spirit of the Uffizi, and also in terms of gardens such as those of the Villa d'Este at Tivoli and the Palazzo Farnese at Caprarola, where there are, it is true, far more varied vistas to be had, but where also no efforts are made to stretch out into infinity as in the Baroque garden at Versailles. Neither do the favorite low loggias on the ground floors of Mannerist buildings indicate infinity—that is, a dark, unsurveyable background of space, as a Rembrandt background. Back walls are too near. The continuity of the façade is broken by such loggias—that is what the Renaissance would have disliked—but the layer of opened-up space is shallow and clearly confined in depth. We have found such loggias at the Palazzo Massimi and the Uffizi. Giulio Romano screens the whole garden front of the Palazzo del Té with them, Palladio all sides of the Basilica at Vicenza. Palladio's Palazzo Chierigati is the most perfect example of this screen technique in palace architecture. It appears again in the addition by Pirro Ligorio (1493–1580) on top of the Belvedere exedra at the Vatican in the early sixties and also in the same architect's Casino of Pius IV, just behind the Vatican (Fig. 27). This was completed in 1561. A main block is separated from a loggia by an oval court with low walls and two side entrances. The oval, though a favorite spatial element of the Baroque, also owes its introduction into architecture to Mannerism. Oval staircases, elongated in a typically Mannerist way from Bramante's circular staircase in the Vatican, appear in Serlio and Palladio; and Vignola designed an oval dome over the little church of S. Andrea (1554) close to the Villa of Julius and a completely oval church plan for S. Anna dei Palafrenieri shortly before his death. These rooms have nothing

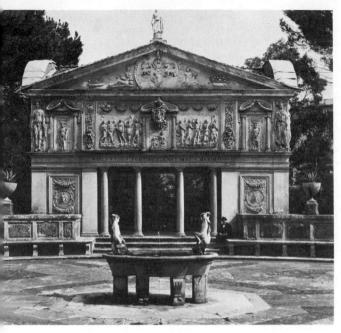

27. Pirro Ligorio, Casino of Pius IV, Rome, Vatican Gardens, 1558–1561

yet of the surging and ebbing, ever-varying flow of such oval Baroque buildings as Bernini's S. Andrea al Quirinale and Borromini's S. Agnese. They are not static as centrally planned Renaissance churches might be; but movement is hemmed in, and the preference for oval as against circle may even be due more to the greater elegance of a long-drawn-out curve than to the spatial qualities of the oval.

The loggia behind the oval court of Ligorio's Casino of Pius is open on the ground floor between its four plain Doric columns in order to achieve a contrast of framed vista and wall. However, the wall again seems to have no solidity; it is only a screen just strong enough to act as a background for innumerable ornamental motifs and scenic reliefs displayed in a confusingly intricate manner: overcrowding but no mêlée. The walls of Mannerist rooms are like that too, with crisp stucco work and elegant figures and with inextricably complicated painted actions and allegories. Under their barrel vaults one feels as though inside a jewel chest (*Studiolo* in the Palazzo Vecchio at Florence of 1570, Gallery in the Palazzo Spada in Rome of 1556–60).

But preciosity is only one side of Mannerism. The style in painting would be incomplete without Parmigiano, but also without Tintoretto and Greco and late Michelangelo. For Michelangelo in his last works of sculpture and drawing displays none of the Baroque tendencies of his earlier life. There are no violent actions,

no gigantic conflicts in the few Crucifixions and Pietàs of the fifties and sixties, the years in which Michelangelo almost exclusively concentrated on architecture, the work on St. Peter's, the Capitol, the Farnese Palace and so on. Of the candor and depth of his religious feelings we know from his sonnets. What is less known is that, when the Jesuits decided to build a large church in Rome, he offered to design and supervise the work without any fee.

He died before the Gesù was begun. But as the Jesuits were the most powerful religious force of the sixteenth century, it is worth looking at the emotional qualities of their architecture in Rome. Most people's expectations will probably be disappointed. For somehow the idea has struck root that Jesuit architecture must be in the most flamboyant Baroque fashion, and that this is what one should expect from the Counter-Reformation. Both notions are wrong. Of the real character of the Counter-Reformation more will be said later, of the character of early Jesuit architecture no better examples can be found than the Gesù on the one hand and the Collegio Romano on the other. Both buildings certainly represent Mannerist tendencies and not tendencies of the Baroque. To prove this, the last two of my analyses may be comparisons of the Collegio Romano and the Gesù with a palace and a church of the Baroque in Rome.

The Collegio Romano (Fig. 28) was built by the Jesuits as their University in 1583. The architect was Ammanati (1511–92). The Palazzo di Montecitorio (Fig. 29), the prewar Houses of Parliament of the Kingdom of Italy, was begun by Bernini in 1650 for the Ludovisi family, continued for the Pamfili and then completed as the seat of the Papal Law Courts at the end of the seventeenth century by Gibbs's Roman master, Carlo Fontana. The Collegio Romano is evidently Mannerist in style, and on this uncommonly large scale the style appears particularly uncomfortable. When one stands in front of the building itself and tries to take in its excessive length of twenty bays and excessive height of six storeys and demistoreys, the total lack of a predominant accent in spite of the stiffest formality otherwise, is most disquieting. The lantern looks as if it were meant as a climax, but it is not, because it is isolated by a balustrade from the rest of the building. Now Bernini —and he was, it should not be forgotten, a restrained architect, as Baroque architects go (though by no means a restrained sculptor and decorator)—leads his composition consistently up to the lantern. The two wings slope back symmetrically in two breaks,

pushing forward the seven central bays. These are further dis-
tinguished by giant pilasters on the right and left. The treble
entrance comes forward beyond the line of the center bays, and
the attic above the main cornice, seven times broken, emphasizes
the center once more, lifting up the top cornice above the clock
and finally surging into the crowning ornament of the lantern. The
*piano nobile* is given its due with an almost Renaissance dignity.
In fact we know from the history of painting that the founders
of the Baroque discovered more to inspire them in the High
Renaissance than in Mannerism. Caravaggio's connections with
the Raphael of the *Transfiguration* and the Carraccis's with the
Raphael of the Farnesina Gallery prove that sufficiently. The art
of the first painters of the Baroque is in many ways a grander,
less dignified and more melodramatic version of Raphael's last
style. Similarly, Bernini's palace is a development of the Palazzo
Farnese and of Michelangelo motifs in a more massive, less nobly
proportioned and more expansive way.

The Mannerist on the other hand takes care to avoid the impres-
sion of weighty masses. He proportions carefully, but with the
aim of hurting, rather than pleasing, the eye. And he is certainly

29. Bernini and Fontana, Palazzo di Montecitorio, Rome, Begun 1650, finished *c.* 1691–1700

far from expansive or melodramatic. The outstanding quality of Ammanati's façade is austerity. Nearly all the windows are to an irritating degree identical. Each storey has the same mezzanine windows above. There is monotony instead of gradation, no crescendo, no climax upward. Nor is there a climax in width. Instead of a central accent, a painfully small, though exquisitely detailed, niche appears in the middle of the middle part. The two symmetrical portals are typically Mannerist in the sense now familiar, with sunk panels in the fragmentary pilasters, square fluted brackets, and everything else to make them look emaciated and of stiff deportment. The large sunk panels of the walls, repeated everywhere, also seem to drain off the substance of the building. They look like plywood with top layers cut back to reveal layers below.

If this frigid, ascetic building is the Jesuit University, what was the Jesuit church in Rome intended to look like when Vignola designed it (Fig. 30)? The foundation stone was laid in 1568. Vignola died before the building was complete. The façade, as well as the upper parts of the interior, are not by him, but by

171

della Porta (who also finished the dome of St. Peter's). According to Vignola's idea the interior was to be dominated by a vast, probably dark, tunnel vault with Mannerist decoration instead of the present painted Baroque glories. The main inner cornice runs through unbroken. It would have driven the visitor eastward into the crossing under the light-shedding dome with a power equal to that of medieval basilicas or of Vasari's Uffizi.

The façade, according to Vignola's intentions, has always been regarded as one of the foundation pieces of the Baroque; and it is indeed more energetically pulled together than contemporary works by other architects. There is consistent development from the flat side bays via the slightly projecting middle bays to the center where columns replace the pilasters. This gradation like the crescendo of Vignola's interior from nave to lofty domed crossing (a type incidentally created as early as 1470 by Alberti), has been repeated and intensified by innumerable Baroque architects. But directly one goes for a comparison to a mature Baroque church in Rome, such as the younger Martino Lunghi's SS. Vincenzo e Anastasio of 1650 (Fig. 31), Vignola's Mannerism prevails everywhere. The difference does not only lie in the Baroque's richer orchestration, with all columns and no pilasters. At least as significant is the way in which the columns elbow each other. Vignola has only two breaks in the lower entablature and one in the upper, Lunghi has four and four. He doubles the lower central pediment and trebles the top one. He holds the top storey on the sides by mighty caryatids, where Vignola uses flat, drily profiled side-pieces. But caryatids were popular with Mannerist architects, too. We have seen them in the Casino of Pius. Other famous examples are in Michelangelo's tomb of Julius II and in the sunk fountain of the Villa Giulia in Rome. The Gesù façade has them twice, and again only as an ornament without strength. As this one motif, so the whole façade: in the Baroque a turbulent struggle and a triumphant end, in Mannerism an intricate and conflicting pattern, and no solution anywhere. The final proof of Vignola's Mannerism may easily escape notice unless expressly pointed out. His ground-floor seems to have a logical composition which may be noted thus: $a$—$b$—$a$, $A$—$B$—$A$, $a$—$b$—$a$. According to both principles, Renaissance and Baroque, one would expect the top storey to provide a crowning $A$—$B$—$A$. In fact, Vignola composes it of $a$—$A$—$B$—$A$—$a$. How then should '$a$' be understood? as part of $a$—$b$—$a$ or as part of $a$—$A$—$B$—$A$—$a$?

30. Vignola, Il Gesù (Façade), Engraving by Antonio Lafreri (The Metropolitan Museum of Art, Harris Brisbane Dick Fund, 1941)

31. Martino Lunghi, SS. Vincenzo e Anastasio, Rome, 1650

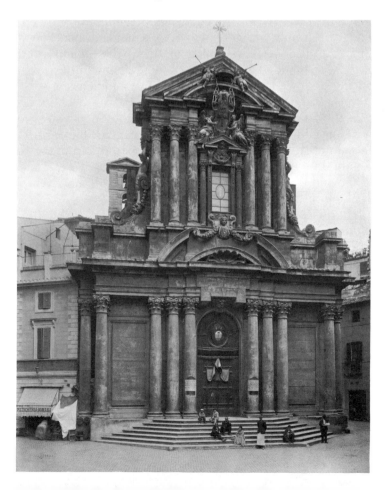

The resulting disturbance is what the architect wants, just as Sammicheli wanted it in the Bevilacqua Palace and Michelangelo in the Laurenziana.

How can this self-conscious dissenting, frustrated style be accounted for? What made such opposed characters as Michelangelo and Giulio Romano evolve it and the Popes and the Jesuits welcome it?

It is said that in 1513 when Leo X, the first Medici Pope, heard that he had been elected, he exclaimed: "God hath just given us the Papacy; now let us enjoy it." Just over fifty years later Pius V was elected. The Vatican under him, we hear from contemporary letters, was like a monastery. Silence was kept at table, and only twice a week was meat served. Leo's interest was hunting and the theater. Pius had been Grand-Inquisitor before he succeeded to the Papacy.

Leo is as characteristic of the High Renaissance as Pius of Mannerism. The end of the Golden Age in art came before or about 1520, with late Raphael and with Pontormo and Rosso. In thought and feeling the break was made in the same years. The Sack of Rome in 1527 is only a convenient reminder of deep inner changes. Groups of men began to assemble, bent on stricter Christian observance. The first of them, the Sodality of Divine Love, was founded in 1518; then new communities and orders quickly followed each other: the Camaldolensians of Monte Corona abandoned their mother house because of its laxity in 1522, the Theatin Order dates from 1524, the Angelican Sisters and the Guastallines date from 1530, the Somasca from 1532, the Barnabites from 1533. The Capuchins separated from the Franciscans in 1535. In the same year the Ursulines were founded; in 1540 came the brothers of the Misericord and, most powerful of all, the Jesuits.

Ignatius of Loyola was born in 1493. His early life was a soldier's. While recovering from wounds received in battle, he conceived the idea of a new militant saintliness. So he retired to Manresa and there prepared himself for his mission with fast and flagellation. Visions haunted him which he tried to overcome. Suppression of human frailty by ever-watchful self-discipline was the hard-gained outcome of his studies—a cold enthusiasm which finds its ultimate form in the *Exercitia Spiritualia* and the system of

strict obedience governing early Jesuit organization. Ignatius is only one of many new saints of the sixteenth century. St. Teresa is another (1515–82), and Bernini's Baroque interpretation of her excessively sensitive character should not blind us to her immense organizational talents. Then there are St. Francis Borgia (1510–1572), St. Philip Neri (1515–94) a character oddly blended of jollity and mysticism, and St. Charles Borromeo (1538–84) the charitable, miracle-working, ascetic Archbishop of Milan who, we hear, wore chains under his Cardinal's clothing. In a recent article in *La Civiltà Cattolica* twenty-five saints are quoted who died between 1530 and 1600.

Saints and saintliness are exceptional at all ages. But life had changed for everybody in these seventy years. The Inquisition was reintroduced in 1542, censorship of books in 1543. The wars of religion ravaged Germany since the twenties. The struggles of old and new creeds, and then of Anglican and Non-Conformist are one—if not the only—main issue of English sixteenth-century history. In the Netherlands, Protestants fought the Duke of Alba's terror, and in France the conflict led up to the Night of St. Bartholomew.

This period of religious primacy was over in France when Henry IV decided for himself that "Paris was worth a Mass" and returned for purely political reasons into the fold of the Roman Church; it was already over in England during Elizabeth's judicious and magnificently worldly reign, and in Italy when the Jesuits Toledo and Bellarmine agreed to accept cardinalates, when the political ideas of independent Venice (Sarpi) defeated the claims of the Pope, and when Paul V (1605–21) adopted the fashion of the little van Dyck beard which had been created by Henry IV. There is a portrait bust of Paul V by Bernini, and it is enough to compare it with the paintings we have of the Popes of the sixteenth century (for instance, Titian's *Paul III*), to see the difference in character and ambition between the two ages. It is like comparing the Shakespeare of the Sonnets with the Shakespeare of Lear, or Hillyard's with van Dyck's portraits of English noblemen.

Not that "conceitism" ended when the Baroque replaced Mannerism. Many indeed were the innovations of the sixteenth century that lived on through the seventeenth. Such popular Baroque motifs as oval ground plans, broken pediments, twisted columns

are of Mannerist origin. Their emotional context, of course, alters their message, just as new dynamic and sensuous qualities distinguish sixteenth- from seventeenth-century mystic poets and courtly poets.

On the other hand, genuine Baroque ideas, first conceived in the world-open days of the Renaissance, kept alive and grew during Mannerism, in spite of its return to medieval mentality. Faith in the autonomy of human thought and the independence of science underlie the precarious and often secret work of such philosophers and scientists as Cardan, Telesio, Sozzini and Bruno. Without them there would be no Galileo, no Spinoza, no Grotius —just as without Vignola's Gesù the favorite scheme of Baroque church architecture would not exist.

After allowance has been made for what connects Mannerism and Baroque—partly by means of a survival of sixteenth-century conceptions into the seventeenth, partly by pioneer work of the sixteenth century towards the seventeenth—it can now safely be said that Mannerism remains a clearly circumscribed style with characteristics as opposed to those of the Baroque as they are to those of the Renaissance. They can be summarized as follows.

Mannerism is a cheerless style, aloof and austere where it wants to show dignity, precious where it wants to be playful. It lacks the robustness of the Baroque as well as the serenity of the Renaissance.

Mannerism has no faith in mankind and no faith in matter. It scorns that bodily beauty in which Renaissance art had excelled and sets against it figures of excessively elongated proportions, sometimes overgraceful, sometimes ascetic. Accordingly it scorns proportions in architecture which are satisfactory to our senses because of their harmony with human proportions. It exaggerates one direction in spatial compositions, as well as in wall compositions, and either breaks symmetry deliberately or over-emphasizes it until it becomes monotony. Moreover, where symmetry is broken, this is not done in the Baroque way to show man conquering matter and subduing it to his will. There is nothing so active in Mannerism. The painter distorts figures to force them into imposed frozen patterns, and the architect designs with seemingly thin materials, which never look strong enough to associate with them the carrying force of the human body, nor ever look massive enough to associate with them the weight of matter

pressing down under the force of gravitation. So the Renaissance problem of balance between weighing and carrying and the Baroque problem of a contrast between the two, leading before our eyes to a final victory of one of them, is replaced by an uneasy neutrality rife with potential disturbance everywhere.

Now this is precisely what one must expect from the period which created and developed Mannerism. The great initial impact was the Reformation. It ended the innocence of the Middle Ages in the North and the—very different—innocence of the Renaissance in Italy. It gained for Europe the modern world, a world of science and individualism, but a split world. The Baroque tried valiantly once more to recover singlemindedness—in Italy by means of a self-confident religious enthusiasm, in the North by means of a science with universal claims. Mannerism could not see either of these possible solutions yet. It is a period of tormenting doubt, and rigorous enforcement of no longer self-understood dogma. What individualism had been developed by the Renaissance was to be crushed, and yet could not be crushed. So Mannerist art is full of contradictions: rigid formality and deliberate disturbance, bareness and over-decoration, Greco and Parmigiano, return to medieval mysticism and the appearance of pornography (Giulio Romano, Aretino). For pornography is a sign of sensuousness with a bad conscience, and Mannerism is the first Western style of the troubled conscience.

Remembering once more now the wars of religion, the prosecution of heretics, Spanish etiquette and the Jesuits, the return of the Inquisition and the intricacies of the sonneteers—all this seems consistent. But one warning must be added in conclusion. This essay is a gross over-simplification. Plenty of important men and events have not been mentioned at all or only inadequately. Take, for instance, the most influential of all Italian sixteenth-century architects: Palladio. His case in the history of style, just as that of his Venetian contemporary Veronese, is far too complicated to be as much as outlined here. Renaissance elements are stronger in both of them than in most others of their generation. Of the typically Mannerist disturbances they know little, and their formality avoids the rigid and austere.

But the very fact that Palladio's influence was much more one of the printed page than of the real building is significant. Mannerism is the age of architectural treatises—an innovation, it

is true, of the Renaissance (Alberti). Serlio lives almost exclusively in his *Libri d'Architettura,* and Vignola was to the architect and virtuoso of the North the author of the *Regole,* and not of the Gesù. The theory of the Five Orders, revived from antiquity, was now made into a fetish. So Vasari's Academy was bound to appear, and his book on the history of art. Not to do more than enumerate these facts in so casual a way, amounts to a serious omission. Equally serious is the omission of Mannerist work outside Italy, not so much that of Italians abroad as original transalpine work in styles seemingly quite different from Italian Mannerism. That Rosso, Primaticcio and Niccolò dell'Abbate worked at Fontainebleau for Francis I is familiar. Their decoration is among the English perhaps the most widely known example of Mannerism. Goujon also belongs to the Mannerists without doubt, and the style of Lescot, Delorme and the other French-born architects of the mid-sixteenth century can hardly be analyzed under any other term. Again, the Escorial, Philip II's palace-monastery, is evidently a monument of the purest Mannerism, forbidding from outside and frigid and intricate in its interior decoration; but it is essentially Italian in style and, as far as painting goes, the work of Italians: Tibaldi, Cambiaso, Zuccari, Carducci.

So it seems that, concerning the architecture of France and Spain, the application of the term Mannerism affords no problems. But when it comes to the Elizabethan style in England and to its parallels and examples in the Netherlands and Germany, are we still justified in speaking of Mannerism? Wollaton or Hardwick or Hatfield obviously are not Renaissance. Nor are they English Baroque, if St. Paul's and Blenheim are Baroque. Strapwork ornament, in its lifelessness, intricacy and stiff preciosity, is typically Mannerist. But the buoyancy and the sturdy strength of Elizabethan building are wholly absent in Italy, and wholly in harmony with the age of Drake and Raleigh.

However, one should not expect criteria of style always to be applicable to different countries without national modifications. French Romanticism is different from English Romanticism and from German. Yet all three are romantic. Similarly Wren is Baroque, but English Baroque, and the Perpendicular style is Late Gothic, but English Late Gothic. Maybe we shall have to learn the same lesson in the case of Mannerism if we wish for a full understanding of Elizabethan architecture.

# The Architecture of Mannerism

FURTHER READING

In English there is still [in 1946] very little: Anthony Blunt's *Artistic Theories in Italy, 1450–1600* (O.U.P., 1940), and some articles in American magazines, especially the *Art Bulletin*. Nothing has as yet appeared on the whole problem of Mannerism or of Mannerist architecture.

MANNERISM IN GENERAL: M. Dvořák: "Greco und der Manierismus" (1920), in *Kunstgeschichte als Geistesgeschichte* (Munich, 1924). W. Friedländer: "Die Entstehung des antiklassischen Stiles . . . um 1520," *Repertorium für Kunstwissenschaft* (1925). N. Pevsner: "Manierismus und Gegenreformation," *Repertorium für Kunstwissenschaft* (1925). E. Panofsky: *Idea* (Leipzig, 1924). W. Pinder: "Zur Physiognomik des Manierismus," in *Die Wissenschaft am Scheidewege* (Leipzig, 1932). N. Pevsner: *Die italienische Malerei vom Ende der Renaissance bis zum ausgehenden Rokoko* (*Handbuch der Kunstwissenschaft*) (Neubabelsberg, 1926–1928).

MANNERISM IN ARCHITECTURE: E. Gombrich on Giulio Romano, in *Jahrbuch der kunsthistorischen Sammlungen in Wien* (1935 and 1936). R. Wittkower on Michelangelo's Laurenziana, in *Art Bulletin*, 1934. J. Coolidge on Vignola and the Villa Giulia, in *Marsyas*, 1942, and *Art Bulletin*, 1943. Also E. Panofsky in *Staedel Jahrbuch*, 1930, and E. Michalski in *Zeitschrift für Kunstgeschichte* (1933). A brief summing up is H. Hoffmann: *Hochrenaissance—Manierismus—Frühbarock* (Zürich, 1938).

# 9. DISTINCTIONS BETWEEN RENAISSANCE AND BAROQUE

*Heinrich Wölfflin*

### INTRODUCTION

Heinrich Wölfflin's *Principles of Art History*, which first appeared in German in 1915, and in English translation in 1932, has become a familiar classic in the literature of art. Concentrating on form rather than content, Wölfflin drew up five pairs of concepts with which he distinguished between the formal characteristics of sixteenth- and seventeenth-century art. Although this system was somewhat limiting, failing as it did to recognize the phenomenon of Mannerism in the sixteenth century or to account for the Classicism of a Poussin in the seventeenth, it nevertheless served to emphasize the importance of improving the analytical tools for treating problems of style.

His early *Renaissance und Barock* (1888) is now available in an English translation (1966), as is his late work *The Sense of Form in Art* (1958), first published in German in 1931. His *Classic Art*, translated into English as early as 1903, has seen long service as a college text for Italian Renaissance art.

The brief selection in this anthology is from that portion of the Introduction to *Principles of Art History* in which the paired concepts are initially presented. The selection by John Rupert Martin which follows it explores the character of the Baroque from quite another point of view. Mention should also be made of Rensselaer W. Lee's brilliant article, now available in a paperbound edition, "*Ut Pictura Poesis:* The Humanistic Theory of Painting," *The Art Bulletin*, XXII (1940), which

defines an ideal prevalent in the art of painting from the fifteenth through the eighteenth centuries and, therefore, relevant to the art under discussion in the selections by Wölfflin and Martin. In presenting yet another aspect of art during the Renaissance and Baroque eras, Lee's study, taken together with the selections by Wölfflin and Martin, demonstrates the rich complexity of significant art.

The reader may wish to consult Walter F. Friedlaender, *Mannerism and Anti-Mannerism in Italian Painting* (1957) and Charles Dempsey, *Annibale Carracci and the Beginnings of the Baroque Style* (1977) for the area between Renaissance and Baroque. Some articles pertinent to Wölfflin's ideas are Howard Hibbard's review of Wölfflin's *Renaissance and Baroque*, in *Journal of the Society of Architectural Historians*, XXV (May 1966), 141–143; Alfred Neumeyer, "Four Art Historians Remembered: Wölfflin, Goldschmidt, Warburg, Berenson," *The Art Journal*, XXXI, 1 (Fall 1971), 33–34; C. McCorkel, "Sense and Sensibility: An Epistemological Approach to the Philosophy of Art History," *Journal of Aesthetics and Art Criticism*, XXXIV, 1 (Fall 1975), 35–50; and A. Mezei, "Toward Improving the Objective Status of Aesthetics: On Style and Content of Figurative Pictorial Art," *Leonardo* XIV, 2 (Spring 1981), 118–121.

The selection that follows is reprinted from *Principles of Art History* by H. Wölfflin, 1950, translated from the German by M. D. Hottinger from the original 1932 edition entitled *Kunstgeschichtliche Grundbegriffe*. Used with permission of the publisher, Dover Publications, New York.

It is a mistake for art history to work with the clumsy notion of the imitation of nature, as though it were merely a homogeneous process of increasing perfection. All the increase in the "surrender to nature" does not explain how a landscape by Ruysdael differs from one by Patenir, and by the "progressive conquest of reality" we have still not explained the contrast between a head by Frans Hals and one by Dürer. The imitative content, the subject matter, may be as different in itself as possible, the decisive point remains that the conception in each case is based on a different visual schema—a schema which, however, is far more deeply rooted than in mere questions of the progress of imitation. It conditions the architectural work as well as the work of representative art, and a Roman Baroque façade has the same visual denominator as a landscape by Van Goyen.

## THE MOST GENERAL REPRESENTATIONAL FORMS

This [chapter] is occupied with the discussion of these universal forms of representation. It does not analyze the beauty of Leonardo but the element in which that beauty became manifest. It does not analyze the representation of nature according to its imitational content, and how, for instance, the naturalism of the sixteenth century may be distinguished from that of the seventeenth, but the mode of perception which lies at the root of the representative arts in the various centuries.

Let us try to sift out these basic forms in the domain of more modern art. We denote the series of periods with the names Early Renaissance, High Renaissance, and Baroque, names which mean little and must lead to misunderstanding in their application to south and north, but are hardly to be ousted now. Unfortunately, the symbolic analogy bud, bloom, decay, plays a secondary and misleading part. If there is in fact a qualitative difference between the fifteenth and sixteenth centuries, in the sense that the fifteenth had gradually to acquire by labor the insight into effects which was at the free disposal of the sixteenth, the (Classic) art of the

Cinquecento and the (Baroque) art of the Seicento are equal in point of value. The word Classic here denotes no judgment of value, for Baroque has its classicism too. Baroque (or, let us say, modern art) is neither a rise nor a decline from Classic, but a totally different art. The occidental development of modern times cannot simply be reduced to a curve with rise, height, and decline: it has two culminating points. We can turn our sympathy to one or to the other, but we must realize that that is an arbitrary judgment, just as it is an arbitrary judgment to say that the rose-bush lives its supreme moment in the formation of the flower, the apple tree in that of the fruit.

For the sake of simplicity, we must speak of the sixteenth and seventeenth centuries as units of style, although these periods signify no homogeneous production, and, in particular, the features of the Seicento had begun to take shape long before the year 1600, just as, on the other hand, they long continued to affect the appearance of the eighteenth century. Our object is to compare type with type, the finished with the finished. Of course, in the strictest sense of the word, there is nothing "finished": all historical material is subject to continual transformation; but we must make up our minds to establish the distinctions at a fruitful point, and there to let them speak as contrasts, if we are not to let the whole development slip through our fingers. The preliminary stages of the High Renaissance are not to be ignored, but they represent an archaic form of art, an art of primitives, for whom established pictorial form does not yet exist. But to expose the individual differences which lead from the style of the sixteenth century to that of the seventeenth must be left to a detailed historical survey which will, to tell the truth, only do justice to its task when it has the determining concepts at its disposal.

If we are not mistaken, the development can be reduced, as a provisional formulation, to the following five pairs of concepts:

(1) The development from the linear to the painterly, *i.e.* the development of line as the path of vision and guide of the eye, and the gradual depreciation of line: in more general terms, the perception of the object by its tangible character—in outline and surfaces—on the one hand, and on the other, a perception which is by way of surrendering itself to the mere visual appearance and can abandon "tangible" design. In the former case the stress is laid on the limits of things; in the other the work tends to look limitless. Seeing by volumes and outlines isolates objects: for the

painterly eye, they merge. In the one case interest lies more in the perception of individual material objects as solid, tangible bodies; in the other, in the apprehension of the world as a shifting semblance.

(2) The development from plane to recession. Classic* art reduces the parts of a total form to a sequence of planes, the Baroque emphasizes depth. Plane is the elements of line, extension in one plane the form of the greatest explicitness: with the discounting of the contour comes the discounting of the plane, and the eye relates objects essentially in the direction of forwards and backwards. This is no qualitative difference: with a greater power of representing spatial depths, the innovation has nothing directly to do: it signifies rather a radically different mode of representation, just as "plane style" in our sense is not the style of primitive art, but makes its appearance only at the moment at which foreshortening and spatial illusion are completely mastered.

(3) The development from closed to open form. Every work of art must be a finite whole, and it is a defect if we do not feel that it is self-contained, but the intrepretation of this demand in the sixteenth and seventeenth centuries is so different that, in comparison with the loose form of the Baroque, classic design may be taken as *the* form of closed composition. The relaxation of rules, the yielding of tectonic strength, or whatever name we may give to the process, does not merely signify an enhancement of interest, but is a new mode of representation consistently carried out, and hence this factor is to be adopted among the basic forms of representation.

(4) The development from multiplicity to unity. In the system of a classic composition, the single parts, however firmly they may be rooted in the whole, maintain a certain independence. It is not the anarchy of primitive art: the part is conditioned by the whole, and yet does not cease to have its own life. For the spectator, that presupposes an articulation, a progress from part to part, which is a very different operation from perception as a whole, such as the seventeenth century applies and demands. In both styles unity is the chief aim (in contrast to the pre-Classic period which did not yet understand the idea in its true sense), but in the one case unity is achieved by a harmony of free parts, in the other, by a

* "Klassisch." The word "Classic" throughout this book refers to the art of the High Renaissance. It implies, however, not only a historical phase of art, but a special mode of creation of which that art is an instance. (Tr.)

union of parts in a single theme, or by the subordination, to one unconditioned dominant, of all other elements.

(5) The absolute and the relative clarity of the subject. This is a contrast which at first borders on the contrast between linear and painterly. The representation of things as they are, taken singly and accessible to plastic feeling, and the representation of things as they look, seen as a whole, and rather by their non-plastic qualities. But it is a special feature of the classic age that it developed an ideal of perfect clarity which the fifteenth century only vaguely suspected, and which the seventeenth voluntarily sacrificed. Not that artistic form had become confused, for that always produces an unpleasing effect, but the explicitness of the subject is no longer the sole purpose of the presentment. Composition, light, and color no longer merely serve to define form, but have their own life. There are cases in which absolute clarity has been partly abandoned merely to enhance effect, but "relative" clarity, as a great all-embracing mode of representation, first entered the history of art at the moment at which reality is beheld with an eye to other effects. Even here it is not a difference of quality if the Baroque departed from the ideals of the age of Dürer and Raphael, but, as we have said, a different attitude to the world.

# 10. THE BAROQUE

## John Rupert Martin

INTRODUCTION

In this essay Professor Martin examines the characteristics of Baroque painting and sculpture, ranging beyond a mere consideration of stylistic forms to matters of iconography and content. He identifies a strong current of naturalism which, apart from its embodiment in verisimilitude, contributed to the elevation in the seventeenth century of such genre as landscape and still life. But this naturalism, the author points out, should be distinguished from that of the nineteenth century by its association with a strong allegorical tendency; and he adds the observation that this duality of naturalism and allegory in Baroque art had its counterpart in the duality of naturalism and metaphysics in seventeenth-century science and philosophy. Furthermore, in accord with the scientific interests of the age, a preoccupation with psychology was manifest in the frequency of such themes as ecstasy, martyrdom, and humor; and a heightened sense of the infinite was expressed through a preoccupation with space, light, and time. Thus, without homogenizing the variety of styles that coexist within the Baroque era, this selection evokes the presence of an underlying unity of content in the art of the period.

For further reading on interpretations of the Baroque, there is Bernard C. Heyl, "Meanings of Baroque," *Journal of Aesthetics and Art Criticism*, XIX (1961). Baroque problems are extensively treated in volumes V (1946), XII (1954), and XIV (1955) of the above journal. Of special significance is Denis Mahon, *Studies in Seicento Art and Theory* (1947).

On the question of the relation of the Baroque to classical antiquity, one should consult the section of this subject in *Latin American Art and the Baroque Period in Europe, Studies in Western Art, Acts of the Twentieth International Congress of the History of Art*, III (1963). For the various national manifestations of the Baroque there are a

number of works: Rudolf Wittkower, *Art and Architecture in Italy, 1600–1750* (1965); *Art in Italy 1600–1700*, Exhibition Catalogue, Detroit Institute of Art (1965); Anthony Blunt, *Art and Architecture in France, 1500–1700* (2nd ed., 1970); George Kubler and Martin Soria, *Baroque Art and Architecture in Spain and Latin America* (1959); H. Gerson and E. H. Ter Kuile, *Art and Architecture in Belgium, 1600–1800* (1960); Jakob Rosenberg, Seymour Slive, and E. H. Ter Kuile, *Dutch Art and Architecture, 1600–1800* (1966); Eberhard Hempel, *Baroque Art and Architecture in Central Europe* . . . (1965); Ellis Waterhouse, *Italian Baroque Painting* (1962); and R. Wittkower and I. B. Jaffe, *Baroque Art: The Jesuit Contribution* (1972). Eugene Fromentin, *The Old Masters of Belgium and Holland,* is a perceptive nineteenth-century work by a French artist and writer, available in a paperbound edition (1963) with an introduction by Meyer Schapiro. For the seventeenth-century context, there are D. Ogg, *Europe in the Seventeenth Century,* 5th ed. (1948); G. N. Clark, *The Seventeenth Century* (1947); and such popular well-illustrated surveys of the period as Michael Kitson, *The Age of the Baroque* (1966); Victor L. Tapie, *The Age of Grandeur* (1966); and Germain Bazin, *The Baroque* (1968). Julius S. Held and Donald Posner, *17th and 18th Century Art: Baroque Painting, Sculpture, Architecture* (1971) is a good survey of the art. Finally, there is John Rupert Martin's *The Baroque* (1977).

The selection that follows is from "The Baroque from the Point of View of the Art Historian" by John Rupert Martin, *Journal of Aesthetics and Art Criticism,* XIV (1955). Reprinted by permission of the author and the publishers.

# THE BAROQUE FROM THE POINT OF VIEW
## OF THE ART HISTORIAN

Let me say at the outset that by "Baroque" I mean, first, that period which is roughly comprehended by the seventeenth century. I take it, moreover, to designate a set of commonly held attitudes. Thus I regard "Baroque art" as being not only the product of the seventeenth century, but also as being shaped and given its characteristic form by those attitudes. Hence, whatever its original connotation may have been, I do not conceive of the term as applying only to that which is theatrical, sensational or bombastic—as calling up the idea of "a lordly racket," to quote Professor Panofsky.

It is certainly not easy to prove that there is such a thing as "Baroque art," rather than a multitude of heterogeneous works which merely happen to have been executed in the Baroque era— or, if even that term seems tendentious, in the seventeenth century. For we must grant that a single Baroque *style* does not exist: on the contrary, one is almost tempted to speak of the very diversity of styles as one of the distinguishing features of the seventeenth century. Attempts have been made, it is true, to define a coherent stylistic vocabulary for the period. The most brilliant of these was Wölfflin's famous comparison of sixteenth- and seventeenth-century art, from which he drew five pairs of concepts. Thus he was able to point to the contrast between "linear and painterly" modes of vision, between "plane and recession," "closed and open form," "multiplicity and unity," and "clearness and unclearness," as illustrating the artistic qualities of the sixteenth and seventeenth centuries respectively. Penetrating as these observations were (and it would be absurd to disparage Wölfflin's work), it is now evident that his categories have certain limitations. First, as is well known, Wölfflin was interested in form rather than in content; consequently his notion of the Baroque was founded on purely optical (one might almost say "Impressionist") considerations. Second, his conception of a unified Baroque style was only arrived at by neglecting "Classic"

artists such as Poussin, although it must be obvious that a comprehensive system which fails to take into account a major artist (no matter how inconvenient) is on that score alone deficient. Third, Wölfflin treated the sixteenth century as an artistic whole, making no distinction between that later phase of it which is now generally termed "Mannerism" and the earlier, classical (or "High Renaissance") phase. Yet it happens that the contrast between Baroque and Mannerism is more striking and illuminating than that between Baroque and High Renaissance. For, as we are now becoming aware, the Baroque came into being not so much through evolution as through revolution; it was deliberately launched, so to speak, in opposition to the principles of Mannerism.

What is required is a definition, not of Baroque stylistic forms, nor yet of Baroque iconography, but of what these reveal to us of Baroque *content*. We shall have to determine the common denominators in all the artistic products of the period—those fundamental attitudes which still persist despite differences of nationality, of individual personality, and even of religious belief, and which are at the same time peculiar to the Baroque era. Needless to say, the few remarks that I shall make here are in no sense intended to answer this requirement. The problem confronting us is much too complicated to be solved in so brief and sketchy a fashion. Furthermore, it is doubtful that it can be satisfactorily solved until we have developed new techniques of scholarship which, by transcending individual areas of specialization (the history of art, of literature, music, philosophy, etc.), will provide us with a more reliable and valid set of criteria than we possess at present. My remarks, then, are of necessity both incomplete and provisional. In order to avoid complications and repetitions, I shall limit myself to the representational arts of painting and sculpture.

Of all the essential characteristics of Baroque art I would place first its naturalism. Verisimilitude, though it takes varying forms, is a principle to which all Baroque artists subscribe. Indeed, it is a factor in the very genesis of the Baroque, conceived as it was in opposition to the stylized conventions and fantasies of Mannerism. It was not merely a careless remark of Caravaggio (who, more than any other, may be credited with inaugurating Baroque naturalism) that the competent painter was one who knew how "to imitate natural things well" (*imitar bene le cose naturali*). Rembrandt too was quoted as saying that "one should

be guided only by nature and by no other rules." A similar attitude is encountered in Rubens: in his essay on the imitation of ancient statues (a practice which in general he approved of) he warned against copying their cold and stony luster. These were no idle words, as Rubens' sensuous rendering of the nude makes very clear. Even much later in the century, when academic rules introduced theoretical complications into the creative process, the innately "natural" vision of the Baroque was never supplanted, as witness the portraitists of the age of Louis XIV who, for all their ornateness and rhetoric, are firmly committed to the representation of appearances. It is to this naturalism that we must look to find the most obvious link between Baroque art and thought: the artistic vision of the age that gave birth to the physical sciences was shaped by a respect for visible, material reality.

Naturalism is of course not merely a matter of verisimilitude. Also implicit in the naturalist aesthetic is the widened range of subject-matter, the addition of new categories to the old, accepted themes. Landscape and still life, for example, although they were not "invented" by the Baroque, were during this period elevated to a position of importance such as they had never hitherto enjoyed. The Dutch masters of the seventeenth century perhaps offer the most vivid illustration of the meaning of Baroque naturalism. Owing to their Calvinist background, religious and mythological subjects hold little interest for them, and still less, it would seem, for their patrons. Individually, they are for the most part specialists in limited categories of subject-matter. But collectively they can be said to have dedicated themselves to recording the multifarious aspects of the world and of the life about them: portraiture, both of individuals and of groups, domestic interiors, church interiors, street scenes, scenes of taverns and markets, views of rivers, harbors and ships, rural countrysides at all seasons of the year, still life subjects of every kind, all of these testify to an extraordinary passion for representing everyday facts and occurrences, or, to see it in another light, for crystallizing the shifting patterns of this world into some permanent and enduring form.

In stressing the importance of Baroque naturalism, however, we must guard against oversimplification. We shall gain only a one-sided and distorted view of the Baroque if we confuse the naturalism of the seventeenth century with that of the nineteenth. The gulf between Velazquez and Manet is fully as wide as that

which separates Galileo and Darwin; to attempt an equation would be as superficial and erroneous for the first pair as for the second. The student of Baroque art, provided he does not restrict himself to a purely formal analysis, soon comes to realize that its inherent naturalism is inextricably bound up with an equally innate tendency to allegory. It is significant that some of the outstanding "realists" of the Baroque—masters whom the later nineteenth century hailed as "forerunners of Impressionism"—frequently elected to paint allegorical subjects. And characteristically, such allegories were often "concealed" beneath a naturalistic, genre-like exterior: this is especially true of the Spaniard Velazquez and the Hollander Vermeer, two painters whose powers of observation, command of representation and sheer technical mastery might seem to preclude any interest in a nonmaterial reality. In the same way, a surprising number of still life paintings are found, on analysis, to embody a moralizing theme such as *Vanitas*, the abstract idea being made more real by being conveyed in the most immediate and concrete terms possible. These are not isolated examples. The importance of allegory in Rubens, Poussin and Pietro da Cortona is too obvious to require emphasis. The equilibrium of naturalism and allegory, which is one of the distinguishing features of Baroque art, plainly echoes a comparable duality of naturalism and metaphysics in Baroque science and philosophy.

In view of the growing scientific spirit of the time, it is not to be wondered at that Baroque art evinces a deep interest in psychology. We find it exemplified in portraiture, in the power of a Rembrandt, a Velazquez or a Bernini to evoke through a likeness an uncanny sense of presence. But the Baroque concern with the phenomena of personality is not manifested solely in portraits. We can observe it quite as plainly in religious art. Thus there are certain subjects which, though they are in no sense innovations of the seventeenth century, yet recur with such frequency as to show that they have a special psychological appeal. The gospel episode of the Supper at Emmaus, in which the identity of the risen Christ is suddenly and dramatically revealed to two unsuspecting disciples, is such a subject. The Catholic Caravaggio and the Protestant Rembrandt were particularly drawn to it. Or again, in the traditional theme of David with the head of Goliath the Baroque also found new possibilities of interpretation. It is characteristic of the period that the youthful hero is usually

presented not as the proud champion elated by his victory, but as a reflective, saddened boy who gazes with something like remorse at his grisly handiwork. In such subjects the Baroque was able to exploit to the full its taste for the portrayal of mixed emotions.

Here we may refer also to another recurrent theme in Baroque religious art: vision and ecstasy. One of the most typical products of seventeenth-century Catholic art is the altarpiece representing, in intensely emotional fashion, a saint in a state of mystical trance, helpless and swooning at the awful realization of divinity. One thinks at once of what is perhaps the greatest work of this kind, Bernini's splendid *Ecstasy of St. Theresa* (Fig. 35). It is not enough to relate such works merely to the religious sensibilities of the age; for the Mannerist period of the sixteenth century, when religious passions were even more deeply felt, produced nothing comparable to them. Over and above their specifically religious purpose, it appears that artists perceived in these subjects an opportunity to explore the psychology of ecstasy and trance, in which the self seeks to be released from human limitations and absorbed in God.

In the same way the favorite Catholic themes of death and martyrdom, initially brought into existence for reasons of faith, became a vehicle for the portrayal of extreme states of feeling. The unspeakable agony of dismemberment, the intense grief and horror of the onlookers, the feral cruelty of the executioners, these things, we are compelled to admit, are the real subject of many a Baroque martyrdom. The paintings of the Spaniard Ribera are among those that come to mind.

Equally symptomatic of the Baroque awareness of psychological factors is the introduction of humor into the domain of art. Witty and humorous elements can even invade the dignified tradition of monumental fresco painting, as is shown by Annibale Carracci's Gallery in the Farnese palace in Rome, where the decorative figures are not content to play a properly solemn and subordinate rôle, but become positively playful. The sixteenth century, with its ingrained notions of the dignity of art, would have found such levity intolerable. It is significant, too, that this same Annibale Carracci, who may be regarded, with Caravaggio, as one of the founders of the Baroque, was the inventor of caricatures in the modern sense. For caricature, with its comic exaggerations and half-mocking, half-sympathetic intent, in itself reflects an understanding of the complexities of personality. Bernini was

fond of drawing caricatures, a number of which have survived. Trivial and hastily executed as they are, they yet derive from the same feeling for humanity that informs his most inspired works of portrait sculpture.

Another of the distinguishing characteristics of Baroque content is what may be called the sense of the infinite. Once again it is hardly necessary to stress the analogy to developments in philosophy, the natural sciences and mathematics. It is not too much to say that the consciousness of infinity pervades the whole epoch and colors all its products. Here it will only be possible to indicate a few of the salient manifestations of that consciousness in works of art.

Some of those subjects which I have just mentioned as illustrating the Baroque interest in psychology may serve also to exemplify the concern with infinity. In Christ's Supper at Emmaus, for example, Baroque artists were able to exploit not only the disciples' sudden realization of their companion's identity, but also the dramatic (because unexpected) intrusion of the infinite and eternal into the everyday world of merely human experience. So also the representation of a saint in mystical ecstasy conjured up the ultimate enlargement of the personality, to the point at which it achieved union with the higher reality. And this desire for expansion of the individual personality (which lies at the very center of the Baroque spirit) is surely to be connected with a new awareness of infinity.

In general, however, the fascination that infinity held for the Baroque artist was expressed in terms of space, light and time. To mention space in Baroque art is to think at once of the widespread interest in landscape, an interest which, incidentally, links together such diverse personalities as Carracci, Rembrandt, Poussin, Rubens, and Vermeer, to name only a few of those who, without being specialists in the subject, turned their attention to landscape at some point in their careers. The typical seventeenth-century landscape painting, with its compelling sweep into depth, and its subordination of humanity to the vaster scale of nature, tells us not only of a fundamentally natural outlook, but something also of the exhilaration which was felt in contemplating the continuum of space.

This is not to say that all Baroque outdoor subjects are monotonously alike. On the contrary, the rich stylistic variety of the period is nowhere more evident than in the widely different

approaches to landscape, ranging from the cool serenity of Carracci's idealized nature to the dynamic turbulence of Ruysdael's forest scenes, in which nature seems to be at war with itself; from the generalized, rationally ordered scenery of Poussin, which seems to have been constructed with a kind of Cartesian logic, to the exact and patient portraiture of place which is found in van der Heyden's views of Dutch towns; from the rural countrysides of Rubens, with their emphasis on physical vitality and material abundance, to the classical landscapes of Claude, which breathe an air of poetic evanescence and nostalgia. But varied and multiform as these interpretations may be, they all stem initially from the same sense of wonder at the continuous expanse of the material universe.

We can observe another expression of the Baroque preoccupation with the infinity of space in the great illusionistic ceiling paintings of which the period was so fond. The breath-taking quality and apocalyptic splendor of such ceilings as that of Il Gesù in Rome result largely from the illusion of an unbroken spatial unity, beginning at an infinite celestial distance, penetrating and dissolving the very substance of the roof, and finally seeming to fuse with the actual space of the church interior. And, conversely, the observer experiences something of the thrill of release from the narrow confines of the material world, by subconsciously identifying himself with the figures who are represented as being swept upward into the celestial glory.

But it is not solely through such overtly "spacious" subjects as landscape and heavenly glory that the seventeenth century betrays its feeling for the infinite prolongation of space. One thinks of the various illusionistic devices employed by Baroque artists to dissolve the barrier imposed by the picture plane between the physical space of the observer and the perspective space of the painting: the out-thrust hands which seem to protrude beyond the surface of the canvas (as in Rembrandt's *Night Watch*), the mirrors in which are reflected persons or objects not contained in the picture and therefore to be understood as being in front of it (as in works by Velazquez and Vermeer), these and similar contrivances are aimed not merely at creating a startling, theatrical effect, but at suggesting a continuous uninterrupted flow of space. Baroque artists were also aware that the limitless can be suggested by the indefinite, as in those Dutch interiors in which an open window or passageway leads provocatively to an

undefined space beyond, or as in Caravaggio and Rembrandt, where the very obscurity of the setting seems to hint at deep recessions.

The mention of Caravaggio and Rembrandt, both of whom depend for their expressive power upon effects of luminosity, may also remind us of the extraordinary emphasis that is given to light as a symbol of the infinite in Baroque art. The representation of light may, it is true, take numerous forms. It may be the selective, polarized light of Caravaggio, descending diagonally from an unspecified external source and throwing certain significant elements into vivid relief, while others are lost to sight in impenetrable shadow. Or it may be Vermeer's sunny daylight, flooding through a casement window and impartially illuminating everything within a perfectly ordered domestic interior. In either case we sense the operation of an external agency which is capable of dissolving the limited confines of the immediate pictorial space, and compels us to feel instead the existence of a boundless, all-pervading spatial expanse. A related phenomenon is the golden luminosity of Rembrandt (Fig. 32) which becomes the symbol of an inner light, seeming to penetrate into the very being of his subjects, and even serving, on occasion, as the vehicle of revelation. Here we may be reminded once more of Bernini's *Ecstasy of St. Theresa*, where the fact of the mystical experience is effectively symbolized by the light which, being admitted through a concealed window above the group, falls upon the saint as the visible sign of the revelation of divinity. Similarly, in those illusionistic ceilings to which we have already referred, the infinity of celestial space is frequently represented in symbolic fashion by a radiant burst of light.

Landscape-painters likewise made use, consciously or unconsciously, of effects of light. It is surely no accident that in many Baroque landscapes the point of maximum depth coincides with the area of greatest brilliance, the glow on the horizon suggesting the endlessness of space. The poignancy of Claude's landscapes owes much to the effect of shimmering sunset which, even while it beckons across the intervening expanse, seems at the same time by its very evanescence to signifiy transience and eclipse.

Closely allied to the Baroque exploitation of space and light as symbols of infinity is the constant preoccupation with time. This concern, it is hardly necessary to say, is usually expressed in allegorical terms. The theme of Truth revealed by Time, for

example, engaged the attentions of Rubens, Poussin and Bernini. Very early in the century we encounter Guido Reni's *Aurora:* the goddess of the dawn heralding the approach of Apollo as he pursues his sunny course through the skies. To penetrate beneath the graceful mythological guise in which the scene is clothed is to feel something of the fascination with the recurring cycle of day and night—the endless revolutions of time. A similar subject by Guercino is made more vivid by its startling illusionism: the figures are seen from below, projected against the vault of heaven, so that to the endlessness of time there is added the infinity of space. In other Baroque artists, notably Salvator Rosa and Jakob van Ruysdael, the obsession with time is reflected in the use of ruins as a symbol of the eternal power of nature and the transience of man and his works. But for the deepest expression of the Baroque concept of time we must look, as Professor Panofsky has observed, to the paintings of Nicolas Poussin. With this master, whom some have sought to characterize as being utterly at odds with the aims and content of the Baroque, time is raised to the stature of a cosmic force, a force that is at once destructive and creative. This conception, which touches upon the very cycle of existence, is expressed not only through iconographical means, but also through the measured, rhythmic movement that animates and gives meaning to his compositions.

These are some of the principal qualities which, as I believe, go to make up the distinctive content of Baroque art. Others might be added; certainly the list is not intended to be final and complete. Moreover, I have necessarily avoided such matters as the lingering vestiges of Mannerism which here and there complicate our understanding of the early Baroque; and I have likewise made no mention of the process of evolution within the Baroque as a whole. But enough has perhaps been said to show why, for most art historians, the word "Baroque" conveys the idea of a unified outlook which is discernible in the artistic products of the seventeenth century.

# 11. REMBRANDT

# IN HIS CENTURY

## Jakob Rosenberg

### INTRODUCTION

Although this selection is primarily concerned with defining Rembrandt's relationship to his times, the spiritual temper and human content of Rembrandt's art are eloquently joined as the writer describes the subjects of Rembrandt's paintings as "humble human beings, bearing the stamp of suffering or old age, but inwardly receptive and therefore open to divine mercy."

Useful beyond its fine assessment of Rembrandt's reputation in his own country, the selection develops a comprehensive view of painting in the Baroque age and evokes, through its references to the relevant literature and to such seventeenth-century figures as Milton and Pascal, the culture in which the art evolved.

The literature on Rembrandt is extensive. For a general view of the period there is Jakob Rosenberg, Seymour Slive, and E. H. Ter Kuile, *Dutch Art and Architecture, 1600 to 1800* (1966). Seymour Slive, *Rembrandt and his Critics: 1630–1730* (1953) is valuable for its treatment of the contemporary and near-contemporary estimate of his work; and C. White, *Rembrandt and his World* (1964) deals with the artist's friends and patrons. Jakob Rosenberg, *Rembrandt*, 2 vols. (1948), revised in a one-volume edition in 1964, is the standard monograph in English.

For the various aspects of his work, there are a vast number of publications, among which are the following selected titles: *Rembrandt: The Complete Edition of the Paintings*, revised by H. Gerson (1969); Otto Benesch, *The Drawings of Rembrandt*, 6 vols. (1954–1957); Seymour Slive, *Drawings of Rembrandt, with a Selection of*

*Drawings by His Pupils and Followers*, 2 vols. (1965); Ludwig Münz, *The Etchings of Rembrandt*, 2 vols. (1952); G. Biörklund and O. H. Barnard, *Rembrandt's Etchings True and False* (1955); K. G. Boon, *Rembrandt: The Complete Etchings* (1963); Sir Kenneth Clark, *Rembrandt and the Italian Renaissance* (1966); W. R. Valentiner, *Rembrandt and Spinoza* (1957); Wolfgang Stechow, "Rembrandt and Titian," *Art Quarterly*, V (1942); Jakob Rosenberg, "Rembrandt and Mantegna," *Art Quarterly*, XIX (1956); Fritz Saxl, "Rembrandt and Classical Antiquity," *Lectures* (1957); W. S. Heckscher, *Rembrandt's Anatomy of Dr. Nicolaas Tulp: An Iconological Study* (1958); Otto Benesch, "Worldly and Religious Portraits in Rembrandt's Late Work," *Art Quarterly*, XIX (1956); Julius Held, "Rembrandt's Polish Rider," *The Art Bulletin*, XXVI (1944); H. M. Rotermund, "The Motif of Radiance in Rembrandt's Biblical Drawings," *Journal of the Warburg and Courtauld Institutes*, XV (1952); Jakob Rosenberg, "Rembrandt's Technical Means and Their Stylistic Significance," *Technical Studies in the Field of the Fine Arts*, VIII (1940); Julius Held, *Rembrandt's 'Aristotle' and Other Studies* (1969); Henri van de Waal, *Steps Toward Rembrandt: Collected Articles 1937–1972* (1974); *Rembrandt and His Century: Dutch Drawings of the Seventeenth Century from the Collection of Frits Lugt* (1978); Margaret Deutsch Carroll, "Rembrandt as Meditational Printmaker," *The Art Bulletin*, LXIII, 4 (December 1981), 585–610; and E. Haverkamp-Begemann, *Rembrandt: The Nightwatch* (1982).

The selection that follows is reprinted from *Rembrandt: Life and Work*, 2nd edition, 1964, by Jakob Rosenberg, published by Phaidon Press, Ltd., London, distributed in the U.S.A. by Frederick A. Praeger, Inc., New York.

In attempting to understand Rembrandt's significance within his century we must extend our perspective beyond the frontiers of Holland and first find his position within the broad category of Baroque painting.[1] One of the signs of Rembrandt's greatness is the paradoxical fact that his art, while highly individual, repeatedly shows a close affinity to the international trends. It is easy to imagine some of Rembrandt's large-scale creations, such as the *Danaë*, the *Blinding of Samson*, or the *Night Watch*—even such late paintings as the *Conspiracy of Julius Civilis* (Fig. 32)—figuring prominently in a representative exhibition of Baroque art which includes works by Caravaggio and Rubens, Van Dyck and Bernini, Poussin and Velazquez. This would hardly be possible, to the same degree, with any of the other Dutch masters. None of Holland's artists approached so many sides of Baroque art, its imaginative power as well as its strong illusionism, its religious fervor as well as its pictorial breadth and splendor.[2] The majority of the Dutch painters fall into the category of "Little Masters"—a type which grew out of certain national peculiarities and has no close parallel in other countries.

The development of Baroque painting may be traced according to generations, and its leading international representatives during the course of the century were Caravaggio (at the side of the Carracci), Rubens, and Poussin. This means that Italy's initial leadership in painting did not last throughout the century, but was succeeded by that of Flanders and France. However, both Rubens and Poussin still received decisive impulses from Italian sources. We may call the three successive phases which these masters represent the Early Baroque, the High Baroque, and the Classicistic phase of the Baroque. A Late Baroque phase follows, in which the Louis XIV style makes itself felt, with the decorative luster of French courtly taste. We have seen how Rembrandt responded to the main phases of this international development and how he adapted to each one to his own ends. As for Caravaggio's influence, Rembrandt's grasp of the chiaroscuro device as a principal means of pictorial expression became a most

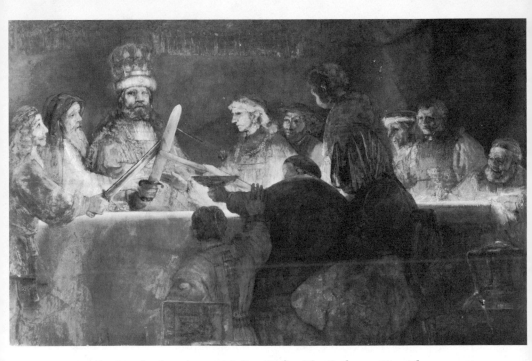

32. Rembrandt, *Conspiracy of Julius Civilis: The Oath*, *c.* 1661, Oil on canvas, 77³⁄₁₆″ x 121⅝″ (Nationalmuseum, Stockholm, Sweden)

decisive feature of his art from the very beginning. From Rubens he derived inspiration to treat dramatic themes on a large scale, full of High Baroque vigor and movement—this at least temporarily during the thirties.[3] There followed, in the forties and fifties, Rembrandt's contact with the international trend of Classicism best represented by Poussin, which led the artist to greater simplicity, breadth, and solemnity, and to more tectonic and monumental compositions. Finally, at the end of Rembrandt's career, even a touch of the Louis XIV style may be detected in the coloristic brilliance and the allegorical flavor of such works as the *Jewish Bride* in the Rijksmuseum or the *Family Portrait* in Brunswick.

While Rembrandt thus never lost contact with the broader trends of his period, it is always the powerful individual character of his art that outweighs its international aspects. Therefore, in the previous chapters, the distinctive, personal features have been stressed, rather than those which Rembrandt shared with his contemporaries. And these personal features, as we have observed, underwent certain changes from the first to the second half of Rembrandt's life. It was only later in his development that he

departed more radically from the ideals of his time, and then only that his personality manifested its ultimate depth.

If we try to define some of the outstanding characteristics which distinguish Rembrandt from his contemporaries, we think perhaps first of his remarkable independence and his unusual urge to follow his own impulse in the choice of subject matter as well as in interpretation and treatment. Rembrandt was in this respect truly "modern"—perhaps the first modern artist of this kind in history.[4] But Rembrandt's forceful individualism never took a completely arbitrary course; it maintained a firm foundation of universal significance. His spiritual tendency embraced all his subjects—portraiture, landscape, and Biblical paintings alike— and since it was linked with an extraordinary human intimacy and empathy, Rembrandt's art comes closer to us than that of the international Baroque, with its more ostentatious character. It is true that the curious blend of the romantic with the realistic which often marks Rembrandt's work is a feature not uncommon in his time. But both these trends, with Rembrandt, were subject to his deep spiritual penetration and thus were relieved of undue theatricality or obviousness. As for his very spontaneous and highly personal technique, this never became an end in itself, but always served the expression of profound human content.

It would be interesting to know how far Rembrandt himself was conscious of his distinctive features, or what theory or opinions he might have formulated to express his own point of view, either in giving instruction to his pupils or in conversations with patrons, fellow artists, and others. Unfortunately we do not have in Rembrandt's case as revealing documents at our disposal as we do for Bernini,[5] Poussin,[6] or Rubens.[7] But there are a few records which, though meager, are not without interest. These records show unmistakably that Rembrandt was opposed to the kind of theory which prevailed in the seventeenth century, particularly the latter half. Joachim von Sandrart complained (as others did also) that Rembrandt "did not hesitate to oppose and contradict our rules of art, such as anatomy and the proportions of the human body, perspective and the usefulness of Classical statues, Raphael's drawings and judicious pictorial disposition, and the academies which are so essential to our professions." And he added, significantly, that Rembrandt, "in doing so, alleged that one should be guided only by nature and by no other rules."[8]

This principle of "nature as the only guide" was obviously a

basic point in Rembrandt's aesthetics, and by the term "nature" he must have meant the totality of life as it appeared and appealed to him. (This same point had been the basic principle for Caravaggio, the greatest independent of the beginning of the century, in his defence against academic rules.)

Rembrandt seems to have demanded in addition, from his pupils, a love of nature. We derive this assumption from a conversation among three of Rembrandt's pupils, Carel Fabritius, Abraham Furnerius, and Samuel van Hoogstraten, reported by the last-named in his *Inleyding tot de Hooghe Schoole der Schilder Konst*.[9] Here we are told that the talent of a young artist depends not only upon his love of art but also upon his "being in love with the task of representing the charms of nature."[10] This emphasis upon an emotional approach, rather than a rational and aesthetic one such as contemporary art theories demanded, seems truly Rembrandtesque, if we extend the meaning of the term "nature," as before, to the totality of life.

From the same conversation we learn that "knowledge of the story" is characteristic of good historical painting. This, to be sure, was generally accepted, and no invention of Rembrandt's, but it sounds like a principle that he might have passed on to his pupils. His many religious subjects always show an intimate familiarity with the Biblical text as a basis for his profound interpretation.[11]

A final point in this recorded disputation among Rembrandt's pupils, is the question as to what is the first rule in good composition, and Carel Fabritius answers: "to select and to organize the finest things in nature" (*de edelste natuerlijkheden*). In both respects, selection as well as organization, Rembrandt's work always excelled. We cannot be so sure, however, that the term *edelste* was precisely the word used by Rembrandt. It has a Classicistic connotation which Hoogstraten may have introduced in recording this conversation more than thirty years after his apprenticeship with Rembrandt, when he himself had become thoroughly imbued with the current Classicistic aesthetics. He is probably again thinking of Rembrandt in another passage when he states that a good master ought to "achieve unity in his composition," and subordinate the details to the whole. The passage goes on to mention the *Night Watch*, saying, "Rembrandt, in his painting at the Doelen in Amsterdam, has brought this out very well, but many feel that he has gone too far."[12]

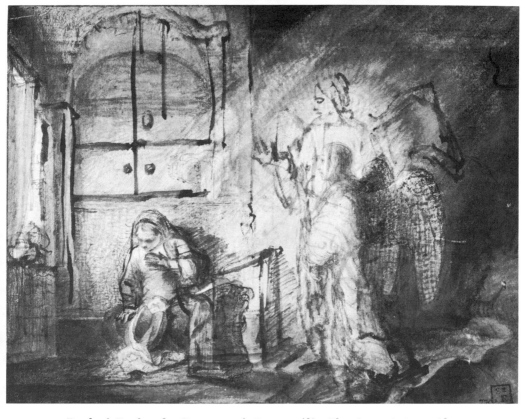

33. Pupil of Rembrandt, Constantyn à Renesse (?), *The Annunciation,* with alterations by Rembrandt (Bildarchiv Preussischer Kulturbesitz, Berlin)

A similar point is stressed by as authentic and direct a source as Sandrart, when he refers to Rembrandt's explicit demand for "universal harmony" in his pictorial organization. Sandrart says that Rembrandt required of the dark accents, which partly obscured his outlines, "nothing but the keeping together of the universal harmony." And he adds, "As regards this latter, he [Rembrandt] was excellent and knew not only how to depict the simplicity of nature accurately but also how to adorn it with natural vigor and powerful emphasis."[13]

As for Rembrandt's method of teaching, we learn, from a number of drawings by his pupils, like the ones by Constantyn à Renesse reproduced here (Fig. 33) that the master often corrected their work by bringing in stronger accents, heightening the articulation as well as the coherence of their compositions—features which are in accord with the statements quoted above.[14]

Finally, there is evidence that Rembrandt demanded absolute independence for his artistic work, presumably for the whole

205

process of creation from the choice of subject matter down to the finishing touches. When he was criticized for the bold and highly personal character of his technique, or his work was mistakenly considered careless or unfinished, he justified himself, according to Houbraken, by saying, "A picture is completed when the master has achieved his intention by it."[15]

These scattered contemporary records about Rembrandt's theoretical remarks do not, by any means, establish a full-fledged theory, but they show that he laid down certain basic points for himself and his pupils. These points reflect primarily the artist's defensive attitude against the current theories of academic Classicism, as well as his strong desire to express himself fully and freely. But there is no insistence, in these records, upon a spiritual approach, so significant in Rembrandt's mature work, nor is there any demand for a spontaneous and personal form of artistic expression. These features were too much a part of his genius, too dependent upon his extraordinary sensibilities and creative powers to be transmitted to others by theories, or compressed into formulas.

In trying to reconstruct the judgment of his contemporaries on Rembrandt's art and personality, we are obliged to rely largely upon late seventeenth-century sources. These records reflect the decline of Rembrandt's reputation after an initial period of extreme popularity which lasted until the forties.[16] After the publication of van Mander's *Schilderboek* in Alkmaar in 1604, art criticism in Holland remained rather inactive until the later years of the century, when the theories of Classicism began to overspread the Continent. By that time the Dutch, German, French, and Italian critics were expressing their opinions on Rembrandt's art in a fairly elaborate and professional form. Their source material was still authentic. Some of the writers, such as Sandrart, Hoogstraten, and de Lairesse, had known Rembrandt personally; others, like Baldinucci and Houbraken, had received direct information from Rembrandt's pupils, or, like Roger de Piles, had lived in Holland at a time when memories of the artist were still fresh. One feels something of a common judgment running through all their accounts, which vary only slightly in appreciation and criticism of Rembrandt's art. His extreme deviations from the standards of Classicism seem to have caused resentment, although his formidable genius commanded considerable respect.[17] Thus a curious mixture of admiration and sharp criticism resulted. We

have seen this typical reaction in Sandrart's biography of Rembrandt. It is not very different with the others. The artist's extraordinary native gifts were admitted—his keen observation, his pictorial and coloristic power, the variety and vividness of expression in his figures, and last, but by no means least, his genius in graphic art. But equally strong was the censure for his outright "naturalism," which did not shrink from ugly and vulgar types, from low-life motifs introduced even into the lofty realm of historical painting.[18] The rarity of Classical subjects in Rembrandt's work was also criticized, and his neglect of clear draftsmanship, which was thought to necessitate complete outlining. There was strong objection to the excessive darkness in his pictures. On the whole, the adverse criticism was directed at Rembrandt's violations of the Classic ideals of linear, and plastic clarity, of formal perfection and beauty, and nobility of taste. It is particularly interesting and revealing to realize how helpless Rembrandt's contemporaries were before the phenomenon of his introvert tendency—how they blamed him for his slow production and apparent indecision. Equally incomprehensible to them was Rembrandt's highly personal technique in his paintings, misinterpreted as unfinished and resulting from willfulness and carelessness on his part. His drawings and etchings were to a certain degree exempted from this criticism, as we see from the appreciative remarks of Houbraken and others.[19]

What were the reasons that Rembrandt, from his early maturity, was so seriously misunderstood in his own century? Why did his contemporaries deplore his rebellious independence, which some believed was bound to lead to disaster?[20] Was this artist really such a lawbreaker, whose "naturalism" was vulgar and indiscriminate, whose forceful and spontaneous individualism was irreconcilable with a spiritual discipline expressing an ideal of universal significance? Even in raising these questions we feel their absurdity. But seventeenth-century criticism was unable to furnish satisfactory answers, since a proper perspective on Rembrandt's art was barred by the prevailing Classicistic views. The artist himself, with the exception of the few defensive formulas just mentioned, was averse to any more elaborate theorizing, which would have explained the very different spiritual basis of his art and shown the consistency of his attitude. This aversion to theorizing Rembrandt shared with the Dutch painters of his time. To all these artists nature was more important than rules, and

none of them—Frans Hals, Vermeer, Ruisdael, Cuyp, nor Pieter de Hooch—have left any trace of a theoretical basis for their art. Neither do we find an adequate critical appreciation of their work in their own day. One may argue that their purely visual approach to nature was a quality peculiar to Dutch painting, and as such appreciated by their countrymen without the need of literary criticism. Huizinga points out in his fine study of Holland's seventeenth-century culture[21] that the Dutch were comparatively inarticulate in their literary expression, while their visual perception and pictorial gift were on an extremely high level. In any case, the situation was such that Holland's writers and critics on art submitted readily to the rules of Classicistic aesthetics as soon as these rules had become firmly established in Italy and France and began to sweep the Continent.

An understanding interpreter of the mature art of Rembrandt in his own day would have faced the difficult task of proving that here also a philosophy was implied—one which could compete with that of Classicism but called for a very different artistic form. This philosophy put truth before beauty. But it was not only the obvious, visual truth of the physical world, but also, penetrating and conditioning it, the spiritual truth which had its roots in the Bible. Rembrandt dealt with man and nature. Both, in his conception, remain dependent upon the Supreme Force that brought them into being. Hence, even his landscapes are not self-sufficient pieces of nature separated from their source and reposing in their own beauty, as, for example, the classic *View of Delft* by Jan Vermeer. They are tied up with the creative process of all earthly life and subject to dynamic changes. There is no such thing, for him, as *nature morte*. Dead peacocks are combined in his still-life paintings with living persons. Rembrandt is unwilling to cut off anything from the continuous stream of creation—even a carcass, as we have seen in his *Slaughtered Ox*. In his figure subjects there is never a staged arrangement, of static finality, such as Poussin offers with great dignity and beauty. Rembrandt's people, wrapped in their own thoughts, are in communication, not with the outside world, like those of Rubens, Van Dyck, or Frans Hals, but with something within themselves that leads, at the same time, beyond themselves. Therefore, an introvert attitude, with Rembrandt, means the search for the spiritual force in man that conditions his life, its origin as well as its course. Man, so to speak, contemplates his state of dependence and accepts it in humility.

Nature also is in this same state of dependence, but without knowing it. This puts man in a higher position, and makes him the most worthy subject for the painter. Rembrandt agrees here with Pascal's "toute notre dignité consiste en la pensée."

Since for Rembrandt the essence of truth about man and nature lies in the ultimate relationship of everything created to the Creator, he accepts all things, beautiful or not; their mere existence makes them worthwhile, as issuing from God. Forms, in his compositions, are not allowed to become too definite or to have finality, since this would break their contact with the life process. If Rembrandt's chiaroscuro has any deeper purpose, it is this: to suggest, to keep alive these mysterious relationships, so true yet so impenetrable for the purely rational approach, so strongly felt by the artist's intuitive and religious mind, yet closed to the view of the aesthete and the Classicist who insist upon beauty and a fully controlled order. While Baroque "naturalism" had nothing to oppose to the Classical ideal save the imitation of nature, Rembrandt's art offered an interpretation of life and nature based upon religious concepts. In his art the Classic and the Biblical worlds, in spite of a certain interpenetration, were no longer indiscriminately mixed, but the former became clearly subordinated to the latter. Thus, one of the oldest problems of Christian civilization was recognized again as a fundamental issue and answered with a new consistency and in a new form.

Small wonder that the consequences for Rembrandt's art were far-reaching. It was not only that he selected subjects of little interest to the Classicists, if not excluded by them: namely, old, sick, or destitute people. In these subjects he discovered the spiritual substance for which the Bible cared most: the human soul in true humility or in sorest need of compassion and salvation. When, on the other hand, Rembrandt did deal with Classical subjects, they were transplanted into a Christian world. His small scene of *Philemon and Baucis* . . . in the National Gallery in Washington, is bathed in a transcendent atmosphere not unlike that of a *Supper at Emmaus*.[22] His Homer, Aristotle, and Lucretia do not radiate the heroism and self-reliance, the grandeur and beauty, which the Classic concept called for and Baroque naturalism had modified but not really transformed. In Rembrandt's hands the proud figures of the ancient world became humble human beings, bearing the stamp of suffering or old age but inwardly receptive and therefore open to divine mercy.

Just as Rembrandt's contemporaries did not fully comprehend the spiritual attitude implied in his art, they also failed to see the clear interdependence between his ideas and the form he chose for expressing them. Rembrandt was by no means totally opposed to Classic art. We know from his inventory that he owned examples of ancient sculpture and that he admired the art of the great Renaissance masters. He derived motifs from Mantegna, Leonardo, Raphael, Dürer, and Lucas van Leyden. The Venetians exerted a considerable influence upon his style.[23] We have seen that for his own ends Rembrandt employed certain characteristic features of Renaissance art, such as simplicity, breadth, and solemnity, as well as its tectonic and monumental qualities. But other features fundamental to the Classic conception were unacceptable to him.

"Clarity," to the Classicist, meant a complete plastic representation of tangible objects, with no break in their contours, and set within a rationally constructed space. Rembrandt had little use for this kind of clarity, which brought the visible world under a firm control, but excluded any uncertainty and mystery—those intangible elements that were vital to his viewpoint. Rembrandt used both light and shadow in a far more subjective fashion, not primarily to define form, but for their suggestive and evocative qualities. Outlines are broken; they are only partly visible, partly obscured. Space takes on a less geometric character, with less tangible limitations, but suggesting an imperceptible transition from the finite to the infinite. Along with light and dark, color too gains a new symbolic significance, and a vibrating atmosphere pervades the whole picture, heightening the interdependence of all parts and preventing forms and surfaces from becoming isolated or over-distinct.

Rembrandt's concept of "unity" also differed from that of the Classicists. His was a more marked subordination of the individual form and figures to the comprehensive elements of space, atmosphere, and chiaroscuro, and this symbolized a religious rather than a rational attitude. It replaced the anthropocentric point of view by the concept of man's submission to the spiritual forces of the universe. Compositional "unity," as Rembrandt understood it, was therefore basically different from the concept of unity of a Poussin who demanded for each part its own separate and complete entity. It is true that in these respects (concept of clarity, concept of unity, departure from the anthropocentric viewpoint) Rembrandt

was a Baroque master,[24] but he went beyond the typical Baroque attitude in deepening the function and the significance of these features. His pupils were able to follow him only to a certain degree. Their formal powers were limited and none of them could approach him in the expression of content.

But Rembrandt was not alone in his time in adopting a spiritual attitude that harked back to fundamental Biblical concepts. Two other independents and, like Rembrandt, two of the greatest men of the century, took this course in opposition to the dominating rational and humanistic trend: Milton and Pascal. Science as an unlimited field for man's searching mind is repudiated in *Paradise Lost*, when the Archangel Raphael and Adam discuss astronomical problems. "Adam is exhorted to search rather things more worthy of knowledge," as the argument of Book VII puts it.

> Whether the Sun predominant in Heav'n
> Rise on the Earth, or Earth rise on the Sun . . .
> Solicit not thy thoughts with matters hid,
> Leave them to God alone.

In *Paradise Regained*[25] the aged and lonely Milton, with all his background of Classical studies, proceeded to characterize Classic thought and culture as the most subtle weapon of Satan, the last resort, as it were, in Satan's attempts to corrupt the purity of Christ's ideas.

And out of his profound faith Blaise Pascal, the great mathematician and thinker, who had absorbed the wisdom of Classic philosophy, reached a similar stand. In resisting the infringement of reason upon faith, Pascal put the realm of the heart into its own place at the side of the realm of the mind. "Le coeur a ses raisons que la raison ne connaît point: on le sait en mille choses." "C'est le coeur qui sent Dieu, et non la raison." These and many more passages in Pascal's *Pensées* strike a note congenial to Rembrandt, although most of official France, and certainly Pascal's compatriot Poussin, took an opposite attitude.

> S'il n'y avait point d'obscurité, l'homme ne sentirait point sa corruption; s'il n'y avait point de lumière, l'homme n'espérerait point de remède. Ainsi, il est non seulement juste, mais utile pour nous, que Dieu soit caché en partie, et découvert en partie, puisqu'il est également dangereux à l'homme de connaître Dieu sans connaître sa misère, et de connaître sa misère sans connaître Dieu.[26]

With this comparison of Rembrandt, Milton, and Pascal we have touched only briefly upon the significant position of three great minds in this controversial century. Each of these men became more or less isolated in his own country, and what they stood for was swept aside by the leading intellectual and artistic trends which lined up with the newly consolidated forces of society, church, and state. Rembrandt's art left hardly a trace in Holland for generations to follow.

In trying to define more closely this much disputed place of Rembrandt in seventeenth-century Holland, it will be of particular interest to listen first to the opinions of two distinguished Dutch scholars: Frederik Schmidt-Degener, the art historian, and Johan Huizinga, the historian of culture. In a brilliant essay on "Rembrandt and Vondel"[27] Schmidt-Degener contrasts the painter and the poet. Vondel is to him the typical representative of the Dutch Baroque which had its roots in Flanders rather than Holland and is characterized by a rhetorical and pictorial splendor. Official Holland, this author holds, always took the side of Flemish pompousness instead of recognizing the true representatives of Dutch character who were modest and reserved and tended to withdraw into themselves.[28] Schmidt-Degener's essay concludes with the statement that the mature Rembrandt not only resisted Baroque tendencies but was on the point of rescuing the great tradition of the Italian Cinquecento from the Baroque trend; that he therefore represents the last of the great Renaissance artists of universal significance, and that it was his official rejection as a monumental painter for the Town Hall of Amsterdam which robbed him of the opportunity to show himself as Raphael's true successor.[29]

Huizinga, in his penetrating study of the Dutch culture of the seventeenth century,[30] sees the best qualities of Dutch art in its unpretentious and sincere rendering of reality, but stresses its limitations both in style and form. According to him Rembrandt was a Romanticist who tried to depict an imaginary world in order to escape the narrowness of his actual surroundings. Thus the artist strove to rival the grandeur of the Baroque but was doomed to fail because of the general weakness of Dutch art on the formal side (*Schwäche des Formgefühls*). Only on a small scale, in graphic art, does he consider that Rembrandt was really successful.

It is clearly evident that these two authors contradict each

other. Where, then, lies the truth? Huizinga we believe goes too far in assuming a continuous Baroque tendency as the leading one in Rembrandt's art. We have seen that his work shows a decided change from a Baroque phase in the early part of his career to a style that was closer to classic art yet remained markedly divergent from it. While agreeing with Huizinga that Rembrandt strove to represent an imaginary world since the visual reality around him did not satisfy his creative fancy, we know that he turned from this to a deeper perception of man's inner life, in which the romantic aspect became subordinated to a spiritual tendency.

On the other hand, we feel that Schmidt-Degener, who is well aware of Rembrandt's development in all its phases and has high praise for his artistic achievement, relates the artist's mature style too closely to the Renaissance tradition. He could have reached this conclusion only by overlooking the fundamental difference which exists between Rembrandt's spiritual world and the Classic one. It was this difference, as we have tried to show, which necessitated a very different artistic form, and which conditioned the unclassical features in Rembrandt's late work. Schmidt-Degener may not have admitted this difference as a fundamental one. In fact, he interprets Rembrandt's religious art in the tradition of nineteenth-century humanitarianism,[31] and sees the artist, accordingly, as a forerunner of Jean-Jacques Rousseau and Ernest Renan. One might argue that Rembrandt's art was broad enough to allow this interpretation, and that, by his strong humanization of the Biblical world, the great Dutch master paved the way for the purely humanitarian concept of later centuries. But such an assumption draws Rembrandt too far from the center of his spiritual world and thus means a distortion of historical reality. It is true that Rembrandt was unique in his integration of the actual with the Biblical world, but with him this never deprived the Bible of its transcendental content.

We have seen that Rembrandt shared many features with his own countrymen. The Dutch painters in general showed a considerable independence of Classicism up to the beginning of the Louis XIV period. Like Rembrandt, they accepted nature, rather than academic rules, as their principal guide. Pictorial intimacy and an individual touch characterized their art as well as his. But we know that the typical Dutch painters' notion of nature was limited to the external aspect of life. We have also referred to

another limitation which set them apart from Rembrandt: the common Dutch practice of concentrating upon a single category, whether portraiture or genre, landscape, still life, or architectural scenes—not to mention even narrower subdivisions. To Rembrandt this kind of specialization was unthinkable. He brought to each category he dealt with the broader and deeper spirit which characterized his entire outlook, and which raised his art far above a national level.

*NOTES*

[1] We use the term "Baroque" here in its broadest sense, meaning the whole of seventeenth-century art, not excluding the Classicistic trends within that period. This is possible, since Baroque features are found throughout the century, though in varying degree. In other parts of the book, however, we use "Baroque" in the more specific sense, that is, Baroque as opposed to Classicism. We hope that this rather loose and flexible application of the term (somewhat common in art history) will not confuse the reader. Up to now, better words have not been found to define either the broad meaning of the term, embracing the whole century, or the more specific meaning that signifies only certain characteristic features within this period.

[2] Fromentin called Rembrandt "the least Dutch among the Dutch painters." Alois Riegl expressed the same idea somewhat differently in describing him as "the greatest Romanist among the Dutch of the seventeenth century." See Werner Weisbach, *Rembrandt* (1926), p. 595.

[3] Rembrandt's predilection for excessive Baroque ornamentation (*Ohrmuschelstil*) may also be mentioned in this connection. Carl Neumann, *Rembrandt*, II (4th ed., 1924), pp. 758 ff., devotes to this feature an interesting study.

[4] Frank J. Mather, Jr., *Western European Painting of the Renaissance* (New York, 1939), p. 475, calls Rembrandt "the first rebel genius in painting, the first painter of the modern sort."

[5] Paul Chantelou, *Journal de voyage du Cavalier Bernin en France* (Paris, 1885); Filippo Baldinucci, *Vita des Giovanni Lorenzo Bernini, mit Übersetzung und Kommentar von Alois Riegl* (Vienna, 1912).

[6] G. P. Bellori, *Vite de' pittori, scultori e architetti moderni* (Rome, 1672); André Félibien, *Entretiens sur les vies et les ouvrages des plus excellens peintres anciens et modernes* (1st ed., pt. IV, Paris, 1685); *Correspondance de Nicolas Poussin*, edited by Jouanny (Paris, 1911).

[7] *Correspondance de Rubens. (Codex Diplomaticus Rubenianus)*, edited by C. Ruelens and Max Rooses, 6 Vols. (Antwerp, 1887–1909).

[8] C. Hofstede de Groot, *Die Urkunden über Rembrandt* (1906), p. 329 [hereinafter "Urk."]; also J. von Sandrart, *Rembrandt, Selected Paintings*, ed. Borenius, p. 21.

[9] Rotterdam, 1678 (Urk., p. 337).

[10] "Dat hy niet alleen schijne de konst te beminnen, maer dat hy in der daet, in de aerdicheden der bevallijke natuur uit te beelden, verlieft is."

[11] In 1641 Philips Angel, in a speech delivered in Leyden on St. Luke's Day

(published as *Philips Angels Lof der Schilder Konst* [Leyden, 1642]), praised Rembrandt's *Marriage of Samson* because it showed intimate knowledge of the story as well as the artist's own thoughtfulness (Urk., p. 91).

[12] Urk., p. 338: "De rechte meesters brengen te weeg, dat haer geheele werk eenwezich is . . . Rembrandt heeft dit in zijn stuk op den Doele tot Amsterdam zeer wel, maer na veeler gevoelen al te veel, waergenomen."

[13] J. von Sandrart, *Rembrandt, Selected Paintings,* edited by Borenius, p. 21.

[14] See Hofstede de Groot, "Rembrandt onderwijs aan zijne leerlingen," *Bredius Feest-Bundel,* pp. 74 ff.; also G. Falck, in *Jahrbuch der preussischen Kunstsammlungen,* XLV (1924), pp. 192 ff.

[15] Arnold Houbraken, *De groote Schouburgh der nederlantsche konstschilders en schilderessen,* I (1718), p. 25.

[16] The German painter, Mathias Scheits, who had studied in Holland under Philips Wouwerman, wrote in 1679 some notes about deceased contemporary masters in his copy of van Mander's *Schilderboek.* The remark about Rembrandt contains the following passage which confirms the decline of the artist's reputation toward the end of his life: "Rembrandt . . . wass achtbaer ende groht van aensien door sein konst geworden, het welck doch in 't lest mit hem wat verminderde. . . ." (Urk., p. 348).

[17] The keen French critic, Roger de Piles, went perhaps farthest in the positive appreciation of Rembrandt's art.

[18] The term "historical" painting included Biblical subjects, and, according to the Classicists, ranked highest among the various categories of subject matter. See Félibien, *op. cit.,* and Rensselaer W. Lee, "Ut Pictura Poesis," *Art Bulletin,* XXII (1940), p. 213.

[19] Baldinucci, *op. cit.,* p. 23: "But after it had become commonly known that whoever wanted to be portrayed by him had to sit to him for some two or three months, there were few who came forward. The cause of this slowness was that, immediately after the first work had dried, he took it up again, repainting it with great and small strokes, so that at times the pigment in a given place was raised more than half the thickness of a finger. Hence it may be said of him that he always toiled without rest, painted much and completed very few pictures." Houbraken, *op. cit.,* p. 25: "But it is to be regretted that, with such a bent towards alterations or easily driven towards something else, he should have but half carried out many of his pictures, and even more of his etchings, so that only the completed ones can give us an idea of all the beauty that we would possess from his hand if he had finished everything the way he had begun it."

[20] Andries Pels, in his *Gebruik en misbruik des tooneels* (Amsterdam, 1681), devotes a long passage to Rembrandt, whom he holds up as a warning to those who tend to depart from the traditional paths of art. He ends his criticism with the following lines, lamenting the waste of Rembrandt's genius, his neglect of principles and his excessive independence:

> What a loss it was for art that such a master hand
> Did not use its native strength to better purpose.
> Who surpassed him in the matter of painting?
> But oh! the greater the talent, the more numerous the aberrations
> When it attaches itself to no principles, no rules,
> But imagines it knows everything of itself.

See Urk., p. 352. English translation, *Rembrandt, Selected Paintings*, ed. by Borenius, p. 26.

[21] Johan Huizinga, *Holländische Kultur des siebzehnten Jahrhunderts* (Jena: Diederichs, 1933), pp. 57–58.

[22] See Wolfgang Stechow's article on "The Myth of Philemon and Baucis in Art," *Journal of the Warburg Institute*, IV, 1940–2, pp. 103 ff. Emil Kieser (*op. cit.*, pp. 129 ff.), gives an account of Rembrandt's dealing with Classical motives. He also stresses the fact that Rembrandt endows his Classical subjects with a Biblical flavor.

[23] See J. L. van Rijckevorsel, *Rembrandt en de Traditie*.

[24] See Heinrich Wölfflin's *Principles of Art History* (7th ed., New York, 1932). This author uses the terms "absolute" versus "relative" clarity, and "multiplicity" versus "unity," to distinguish between the Renaissance and Baroque Styles.

[25] Book IV, particularly lines 272–365.

[26] *Oeuvres de Blaise Pascal* (Paris, 1904–14), XIII, *Pensées*, 277, 278, XIV, *Pensées*, 586. Another passage of particular interest is the following (*ibid.*, XIII, 525): "Les philosophes ne prescrivaient point des sentiments proportionnés aux deux états. Ils inspiraient des mouvements de grandeur pure, et ce n'est pas l'état de l'homme. Ils inspiraient des mouvements de bassesse pure, et ce n'est pas l'état de l'homme. Il faut des mouvements de bassesse, non de nature, mais de pénitence; non pour y demeurer, mais pour aller à la grandeur. Il faut des mouvements de grandeur, non de mérite, mais de grâce, et après avoir passé par la bassesse." See also the chapter on the Jews and the Christians beginning with the sentence, "Pour montrer que les vrais Juifs et les vrais Chrétiens n'ont qu'une même religion" (*ibid.*, XIV, 610).

[27] *De Gids*, LXXXIII (1919), pt I, p. 222. German edition: *Rembrandt und der holländische Barock* (Leipzig, 1928). See the review by Hans Jantzen in *Deutsche Literaturzeitung*, Feb. 1, 1930, pp. 226 ff.

[28] "Hollands Wessen spricht aus dem Besten, das Lukas van Leyden schuf und das hat etwas Scheues und Verschlossenes" (*Rembrandt und der holländische Barock*, p. 35).

[29] "Von Rembrandts Hand würde die Folge riesenhafter Kompositionen die Fortsetzung des siebzehnten Jahrhundrets zu Raffaels Stanzen gewesen sein. . . . Mit Rembrandt erscheint der Letzte der Renaissancisten, der Letzte der grossen universalen Meister . . . Rembrandt erweist Europa den Dienst, die Renaissance aus der Barockphase zu retten, in der sie im Begriff war zu versanden" (*ibid.*, pp. 36, 43). For a discussion of Rembrandt's relationship to Classicism see also Ludwig Münz, "Rembrandts Altersstil und die Barockklassik," *Jahrbuch der kunsthistorischen Sammlungen in Wien*, N.F., IX, 1935, pp. 183 ff.

[30] Huizinga, *op. cit.*

[31] "Niemals predigt er Religion. Seine Darstellung der heiligen Geschichten bringt einen gewissen Rationalismus" (*ibid.*, p. 45). Later, in his introduction to the catalogue of the 1935 Rembrandt exhibition (Amsterdam: Rijksmuseum, 1935), Schmidt-Degener slightly modified his point of view without any basic changes.

# *12.* BERNINI

## *Rudolf Wittkower*

INTRODUCTION

One of the outstanding features of Bernini's artistry, whether sculptural or architectural—or that synthesis of these which he mastered to an unusual degree—is its capacity to draw the viewer into physical as well as psychic relationship with its forms. His sculptures, in stressing— even demanding—selected viewing-stations, structure the experience of these works in such a way that even the intervening space is charged with significance. This space, like that in the concert hall or theater, is no mere quantitative element, but the resonant medium through which Bernini's conception is communicated. This orchestration of direct relationships involving the created forms, the beholder, and the ambience that holds them all is environmental in scope and synthetic in method. And nowhere is this better demonstrated than in Bernini's solution to the problem of the Piazza San Pietro and in his design of the Cornaro Chapel, which are the chief foci of the selection by Rudolf Wittkower chosen for this anthology.

In recent years there has been considerable interest in the creation of "environments" where sculptural clusterings and architectural space are joined to empathic images which are sometimes, with almost narcissistic irony, our own reflections. We have also seen how Op Art has absorbed the beholder into its formal configurations by the sheer aggressiveness of its visual magic. One does not easily escape the pull of the Op image except to yank one's eyes from its optical clamps and turn firmly away. It seems reasonable, therefore, to suggest that eyes and sensibilities engaged by these recent developments in art might discover in the grand disposition of space, mass, color, and light in Bernini's art certain affinities that overcome the barriers of time and alien taste.

The chief source for Bernini's life is Filippo Baldinucci's *Vita de Gian Lorenzo Bernini* (1682), now available in an English translation by Catherine Enggass, with a foreword by Robert Enggass (1966). For

Bernini's sculpture the best source in English is Rudolf Wittkower, *Gian Lorenzo Bernini*, 2nd ed. (1966). Among other studies by the same author are his "Works by Bernini at the Royal Academy," *Burlington Magazine*, XCIII (1951); "Bernini Studies—I: The Group of Neptune and Triton," *Burlington Magazine*, XCIV (1952); "Bernini Studies—II: The Bust of Mr. Baker," *ibid.*, XCV (1953), in two parts; "The Role of Classical Models in Bernini's and Poussin's Preparatory Work," *Studies in Western Art, Acts of the Twentieth International Congress of the History of Art*, III (1963). Other works are: A. Underwood, "Notes on Bernini's Towers for St. Peter's in Rome," *The Art Bulletin*, XXI (1939); Pamela Askew, "Relation of Bernini's Architecture to the Architecture of the High Renaissance and of Michelangelo," *Marsyas*, V (1947–1949); W. S. Heckscher, "Bernini's Elephant and Obelisk," *The Art Bulletin*, XXIX (1947); Timothy Kitao, "Bernini's Church Facades: Method of Design and the *Contrapposti*," *Journal of the Society of Architectural Historians*, XXIV (1965), and, by the same author, *Circle and Oval in the Square of St. Peter's: Design and Meaning in Bernini's Plan* (1973); J. S. Pierce, "Visual and Auditory Space in Baroque Rome," *Journal of Aesthetics and Art Criticism*, XVIII (1959); and Irving Lavin, *Bernini and the Crossing of St. Peter's* (1969). To this list should be added Howard Hibbard, *Bernini* (1965, 1974); George C. Bauer, ed., *Bernini in Perspective* (1976); Irving Lavin, *Bernini and the Unity of the Visual Arts*, 2 vols. (1980), and *Drawings by Gianlorenzo Bernini* (1982); and Cecil Gould, *Bernini in France: An Episode in Seventeenth-Century History* (1982).

The selection that follows is from *Art and Architecture in Italy, 1600–1750* (*The Pelican History of Art,* 2nd revised edition, 1965). Copyright © Rudolph Wittkower, 1958. Reprinted by permission of the author and the publishers, Penguin Books, Ltd.

Few data are needed to outline the life's story of the greatest genius of the Italian Baroque. Bernini was born at Naples on 7 December 1598, the son of a Neapolitan mother and a Florentine father. His father Pietro was a sculptor of more than average talent and moved with his family to Rome in about 1605. Until his death seventy-five years later Gianlorenzo left the city only once for any length of time, when he followed in 1665, at the height of his reputation, Louis XIV's call to Paris. With brief interruptions his career led from success to success, and for more than fifty years, willingly or unwillingly, Roman artists had to bow to his eminence. Only Michelangelo before him was held in similar esteem by the popes, the great, and the artists of his time. Like Michelangelo he regarded sculpture as his calling and was, at the same time, architect, painter, and poet; like Michelangelo he was a born craftsman and marble was his real element; like Michelangelo he was capable of almost superhuman concentration and single-mindedness in pursuing a given task. But unlike the terrible and lonely giant of the sixteenth century, he was a man of infinite charm, a brilliant and witty talker, fond of conviviality, aristocratic in demeanor, a good husband and father, a first-rate organizer, endowed with an unparalleled talent for creating rapidly and with ease.

His father's activity in Paul V's Chapel in S. Maria Maggiore determined the beginning of his career. It was thus that the pope's and Cardinal Scipione Borghese's attention was drawn to the young prodigy and that he, a mere lad of nineteen, entered the orbit of the most lavish patron of the period. Until 1624 he remained in the service of the cardinal, creating, with brief interruptions, the statues and groups which are still in the Villa Borghese. After Urban VIII's accession to the papal throne, his preeminent position in the artistic life of Rome was secured. Soon the most important enterprises were concentrated in his hands, and from 1624 to the end of his days he was almost exclusively engaged on religious works. In February 1629, after Maderno's death, he was appointed "Architect to St. Peter's" and, although his activity in that church began as early as 1624 with the com-

34. Bernini, Baldacchino, St.
Peter's, Rome, 1624–1633

mission of the Baldacchino (Fig. 34), the majority of his sculptural, decorative, and architectural contribution lay between 1630 and his death.

In the early 1620s he was one of the most sought-after portrait sculptors, but with the accretion of monumental tasks on an unprecedented scale, less and less time was left him for distractions of this kind. In the later 1620s and in the thirties he had to employ the help of assistants for such minor commissions, and from the last thirty-five years of his life hardly half a dozen portrait busts exist by his hand. The most extensive works—tombs, statues, chapels, churches, fountains, monuments, and the Square of St. Peter's—crowd into the three pontificates of Urban VIII, Innocent X, and Alexander VII. Although he was active to the very end, it was only during the last years that commissions thinned out. From all we can gather, this was due to the general dearth of artistic activity rather than to a decline of his creative capacity in old age. His work as a painter was mainly confined to the 1620s;

later he hardly touched a brush and preferred using professional painters to express his ideas. Most of his important architectural designs, on the other hand, belong to the later years of his life, particularly to the period of Alexander VII's reign.

## SCULPTURE WITH ONE AND MANY VIEWS

It is one of the strange and ineradicable misapprehensions, due, it seems, to Heinrich Wölfflin's magnetic influence, that Baroque sculpture presents many points of view.[1] The contrary is the case, and nobody has made this clearer than the greatest Baroque artist —Bernini himself. Many readers may, however, immediately recall the Borghese Gallery statues and groups which, standing free in the center of the rooms, invite the beholder to go round them and inspect them from every side. It is usually forgotten that their present position is of fairly recent date and that each of these works was originally placed against a wall. Right from the beginning Bernini "anchored" his statues firmly to their surroundings and with advancing years found new and characteristic devices to assure that they would be viewed from preselected points.

It is, of course, Renaissance statuary that comes to mind when we think of sculpture conceived for one main aspect. Most Renaissance figures leave not a shadow of doubt about the principal view, since by and large they are worked like reliefs with bodies and extremities extending without overlappings in an ideal forward plane. Quite different are Bernini's figures: they extend in depth and often display complex arrangements of contrasting spatial planes and movements. . . . It appears then that Bernini's statues are conceived in depth and that the sensation of their spatial organization should and will always be realized, but that they are nevertheless composed as images for a single principal viewpoint. One must even go a step further in order to get this problem into proper focus. Bernini's figures not only move freely in depth but seem to belong to the same space in which the beholder lives. Differing from Renaissance statuary, his figures need the continuum of space surrounding them and without it they would lose their *raison d'être*. Thus the *David* aims his stone at an imaginary Goliath who must be assumed to be somewhere in space near the beholder; the *Bibiana* is shown in mute communication

with God the Father, who, painted on the vault above her, spreads his arms as if to receive her into the empyrean of saints; *Longinus* looks up to the heavenly light falling in from the dome of St. Peter's; *Habakkuk* points to the imaginary laborers in the field while the angel of God is about to remove him to Daniel's den across the space in which the spectator stands. The new conceptual position may now be stated more pointedly: Bernini's statues breathe, as it were, the same air as the beholder, are so "real" that they even share the space continuum with him, and yet remain picture-like works of art in a specific and limited sense; for although they stimulate the beholder to circulate, they require the correct viewpoint not only to reveal their space-absorbing and space-penetrating qualities, but also to grasp fully the meaning of the action or theme represented. To be sure, it is Bernini's persistent rendering of a transitory moment that makes the one-view aspect unavoidable: the climax of an action can be wholly revealed from one viewpoint alone.

While Bernini accepts on a new sophisticated level the Renaissance principle of sculpture with one view, he also incorporates in his work essential features of Mannerist statuary, namely complex axial relationships, broken contours, and protruding extremities. He takes advantage, in other words, of the Mannerist freedom from the limitations imposed by the stone. Many of his figures and groups consist of more than one block, his *Longinus* for instance of no less than five. Mannerist practitioners and theorists, in the first place Benvenuto Cellini, discussed whether a piece of sculpture should have one or many views. Their verdict was a foregone conclusion. Giovanni Bologna in his *Rape of the Sabines* (1579–83) showed how to translate theory into practice and gave a group of several figures an infinite number of equally valid viewpoints. The propagation of multiple viewpoints in sculpture came in the wake of a deep spiritual change, for the socially elevated sculptor of the sixteenth century, refusing to be a mere craftsman, thought in terms of small models of wax or clay. Thus he created, unimpeded by the material restrictions of the block. The Renaissance conception of sculpture as the art of working in stone ("the art of subtracting") began to be turned into the art of working in clay and wax ("modelling," which is done by adding—for Michelangelo a painterly occupation), and this sixteenth-century revolution ultimately led to the decay of

sculpture in the nineteenth century. Although Bernini could not accept the many views of Mannerist statuary because they would interfere with his carefully planned subject–object (beholder–work) relationship and, moreover, would prevent the perception at a glance of one center of energy and one climax of action, he did not return to the Renaissance limitations dictated by the block-form, since he wanted to wed his statues to the surrounding space. By combining the single viewpoint of Renaissance statues with the freedom achieved by the Mannerists, Bernini laid the foundation for his new, Baroque, conception of sculpture.

Only on rare occasions did he conceive works for multiple viewpoints. This happened when the conditions under which his works were to be seen were beyond his control. Such is the case of the angels for the Ponte S. Angelo, which had to have a variety of viewpoints for the people crossing the bridge. These angels clearly present three equally favorable views—from the left, the right, and the center; but they do not offer coherent views either in pure profile or from the back, for these aspects are invisible to the passers-by.

During his middle period Bernini brought new and most important ideas to bear upon the problem of defined viewpoints. He placed the group of *St. Teresa and the Angel* in a deep niche under a protective architectural canopy (Fig. 35), and this makes it virtually impossible to see the work unless the beholder stands in the nave of the church exactly on the central axis of the Cornaro Chapel. Enshrined by the framing lines of the architecture, the group has an essentially pictorial character; one may liken it to a *tableau vivant*. The same is true of later designs whenever circumstances permitted. The Cathedra was conceived like an enormous colorful picture framed by the columns of the Baldacchino (Fig. 34). Similarly, the pictorial concepts of the *Constantine* and the *Blessed Lodovica Albertoni* are revealed only when they are looked at from inside the portico of St. Peter's and from the nave of S. Francesco a Ripa respectively. Indeed, the carefully contrived framing devices almost force upon the spectator the correct viewing position.

In spite of their *tableau vivant* character, all these works are still vigorously three-dimensional and vigorously "alive"; they are neither reliefs nor relegated to a limited space. They act on a stage of potentially unlimited extension. They still share, therefore, our

35. The Cornaro Chapel, Sta. Maria della Vittoria, Rome, 18th-century painting
(Staatliches Museum, Schwerin)

space continuum, but at the same time they are far removed from us: they are strange, visionary, unapproachable—like apparitions from another world.

## COLOR AND LIGHT

It is evident that Bernini's pictorial approach to sculpture cannot be dissociated from two other aspects, color and light, which require special attention.

Polychrome marble sculpture is rather exceptional in the history of European art. The link with the uncolored marbles of ancient Rome was never entirely broken, and it is characteristic that in Florence, for instance, polychromy was almost exclusively reserved for popular works made of cheap materials. But during the late sixteenth century it became fashionable in Rome and elsewhere to combine white marble heads with colored busts, in imitation of a trend in late antique sculpture. The naturalistic element implicit in such works never had any attraction for Bernini. The use of composite or polychrome materials would have interfered with his unified conception of bust or figure. In his Diary the Sieur de Chantelou informs us that Bernini regarded it as the sculptor's most difficult task to produce the impression and effect of color by means of the white marble alone. But in a different sense polychromy was extremely important to him. He needed polychrome settings and the alliance of bronze and marble figures as much for the articulation, emphasis, and differentiation of meaning as for the unrealistic pictorial impression of his large compositions. It may be argued that he followed an established vogue.[2] To a certain extent this is true. Yet in his hands polychromy became a device of subtlety hitherto unknown.

Bernini's tomb of Urban VIII certainly follows the polychrome pattern of the older counterpart, Guglielmo della Porta's tomb of Paul III. But in Bernini's work the white and dark areas are much more carefully balanced and communicate a distinct meaning. The whole central portion is of dark, partly gilded bronze: the sarcophagus, the life-like figure of Death, and the papal statue, i.e., all the parts directly concerned with the deceased. Unlike these with their magic color and light effects, the white marble allegories of Charity and Justice have manifestly a this-worldly quality. It is these figures with their human reactions and their sensual and

225

appealing surface texture that form a transition between the be-holder and the papal statue, which by virtue of its somber color alone seems far removed from our sphere of life.

More complex are the color relationships in Bernini's later work. The Cornaro Chapel is, of course, the most perfect example. In the lowest, the human zone, the beholder is faced with a color har-mony of warm and glowing tones in red, green, and yellow. St. Teresa's vision, the focal point of the whole composition, is dramatically accentuated by the contrast between the dark fram-ing columns and the highly polished whiteness of the group. Other stimuli are brought into play to emphasize the unusual character of the event which shows a seraph piercing her heart with the fiery arrow of divine love, symbol of the saint's mystical union with Christ. The vision takes place in an imaginary realm on a large cloud, magically suspended in mid-air before an iridescent alabaster background. Moreover, concealed and directed light is used in support of the dramatic climax to which the beholder be-comes a witness. The light falls through a window of yellow glass hidden behind the pediment and is materialized, as it were, in the golden rays encompassing the group.[3]

It is often observed that Bernini drew here on his experience as stage designer. Although this is probably correct, it distracts from the real problem. For this art is no less and no more "theatrical" than a Late Gothic altarpiece repeating a scene from a mystery play, frozen into permanence. Bernini's approach to the problem of light is in a clearly defined pictorial tradition of which the examples in Baroque painting are legion. The directed heavenly light, as used by Bernini, sanctifies the objects and persons struck by it and singles them out as recipients of divine Grace. The golden rays along which the light seems to travel have yet another meaning. By contrast to the calm, diffused light of the Renaissance, this directed light seems fleeting, transient, impermanent. Im-permanence is its very essence. Directed light, therefore, supports the beholder's sensation of the transience of the scene represented: we realize that the moment of divine "illumination" passes as it comes. With his directed light Bernini had found a way of bring-ing home to the faithful an intensified experience of the supra-natural.

No sculptor before Bernini had attempted to use real light in this way. Here in the ambient air of a chapel he did what painters tried to do in their pictures. If it is accepted that he translated

back into the three dimensions of real life the illusion of reality rendered by painters in two dimensions, an important insight into the specific character of his pictorial approach to sculpture has been won. His love for chromatic settings now becomes fully intelligible. A work like the Cornaro Chapel was conceived in terms of an enormous picture.

This is true of the chapel as a whole. Higher up the color scheme lightens and on the vaulting the painted sky opens. Angels have pushed aside the clouds so that the heavenly light issuing from the Holy Dove can reach the zone in which the mortals live. The figure of the seraph, brother of the angels painted in the clouds, has descended on the beams of light.

Along the side walls of the chapel, above the doors, appear the members of the Cornaro family kneeling behind prie-dieus and discussing the miracle that takes place on the altar. They live in an illusionist architecture which looks like an extension of the space in which the beholder moves.

In spite of the pictorial character of the design as a whole, Bernini differentiated here as in other cases between various degrees of reality. The members of the Cornaro family seem to be alive like ourselves. They belong to our space and our world. The supranatural event of Teresa's vision is raised to a sphere of its own, removed from that of the beholder mainly by virtue of the isolating canopy and the heavenly light.[4] Finally, much less tangible is the unfathomable infinity of the luminous empyrean. The beholder is drawn into this web of relationships and becomes a witness to the mysterious hierarchy ascending from man to saint and Godhead. . . .

With his revolutionary approach to color and light, Bernini opened a development of immeasurable consequences. It is not sufficiently realized that the pictorial concepts of the mature Bernini furnish the basis not only for many later Roman and North Italian works, but above all for the Austrian and German Baroque. Even the color and light orgies of the Asam brothers add nothing essentially new to the repertory created by Bernini.

## THE PIAZZA OF ST. PETER'S

While he was in Paris, Bernini's greatest work, the Square of St. Peter's, was still rising. But by that time all the hurdles had been

36. Aerial View, St. Peter's, Rome

taken and, moreover, Bernini had a reliable studio with a long and firmly established tradition to look after his interests. His "office" supplied, of course, no more than physical help towards the accomplishment of one of the most complex enterprises in the history of Italian architecture.[5] Bernini alone was responsible for this work which has always been universally admired, he alone had the genius and resourcefulness to find a way through a tangle of topographical and liturgical problems, and only his supreme authority in artistic matters backed by the unfailing support of Pope Alexander VII could overcome intrigues and envious opposition[6] and bring this task to a successful conclusion (Fig. 36). Among a vast number of issues to be considered, particular importance was attached to two ritual ones right from the start. At Easter and on a few other occasions the pope blesses the people of Rome from the Benediction Loggia above the central entrance to the church. It is a blessing symbolically extended to the whole

228

world: it is given *urbi et orbi*. The piazza, therefore, had not only to hold the maximum number of people, while the Loggia had to be visible to as many as possible, but the form of the square itself had to suggest the all-embracing character of the function. Another ceremony to be taken into account was the papal blessing given to pilgrims from a window of the private papal apartment situated in Domenico Fontana's palace on the north side of the piazza. Other hardly less vital considerations pertained to the papal palace. Its old entrance in the northwest corner of the piazza could not be shifted and yet it had to be integrated into the architecture of the whole.[7] The basilica itself required an approach on the grandest scale in keeping with its prominence among the churches of the Catholic world. In addition, covered passageways of some kind were needed for processions and in particular for the solemn ceremonies on the day of Corpus Domini; they were also necessary as protection against sun and rain, for pedestrians as well as for coaches.

Bernini began in the summer of 1656 with the design of a trapezoid piazza enclosed by the traditional type of palace fronts over round-headed arcades. This scheme was soon abandoned for a variety of reasons, not the least because it was of paramount importance to achieve greatest monumentality with as little height as possible. A palazzo front with arcades would have been higher than the present colonnades without attaining equal grandeur. So by March 1657 the first project was superseded by one with arcades of free-standing columns forming a large oval piazza; soon after, in the summer of the same year, Bernini replaced the arcades by colonnades of free-standing columns with a straight entablature above the columns. Only such a colonnade was devoid of any associations with palace fronts and therefore complied with the ceremonial character of the square more fully than an arcaded scheme with its reminiscences of domestic architecture. On ritualistic as well as artistic grounds the enclosure of the piazza had to be kept as low as possible. A high enclosure would have interfered with the visibility of the papal blessing given from the palace window. Moreover, a comparatively low one was also needed in order to "correct" the unsatisfactory impression made by the proportions of the façade of St. Peter's.

This requires a word of explanation. The substructures of Maderno's towers, standing without the intended superstructures, look now as if they were parts of the façade, and this accounts for

its excessive length. A number of attempts were made in the post-Maderno period to remedy this fault,[8] before Urban VIII took the fateful decision in 1636 of accepting Bernini's grand design of high towers of three tiers.[9] Of these only the southern one was built, but owing to technical difficulties and personal intrigues construction was interrupted in 1641, and finally in 1646 the tower was altogether dismantled. Since the idea of erecting towers ever again over the present substructures had to be abandoned, Bernini submitted during Innocent X's pontificate new schemes for a radical solution of the old problem.[10] By entirely separating the towers from the façade, he made them structurally safe, at the same time created a rich and varied grouping, and gave the façade itself carefully balanced proportions. His proposals would have involved considerable structural changes and had therefore little chance of success. When engaged on the designs for the piazza, Bernini was once again faced with the intractable problem of the façade. Although he also made an unsuccessful attempt at reviving Michelangelo's tetrastyle portico,[11] which would have broken up the uniform "wall" of the façade, he now had to use optical devices rather than structural changes as a means to rectify the appearance of the building. He evoked the impression of greater height in the façade by joining to it his long and relatively low corridors which continue the order and skyline of the colonnades.[12] The heavy and massive Doric columns of the colonnades and the high and by comparison slender Corinthian columns of the façade form a deliberate contrast. And Bernini chose the unorthodox combination of Doric columns with Ionic entablature[13] not only in order to unify the piazza horizontally but also to accentuate the vertical tendencies in the façade.

For topographical and other reasons Bernini was forced to design the so-called *piazza retta* in front of the church. The length and slant of the northern corridor, and implicitly the form of the *piazza retta*, were determined by the position of the old and venerable entrance to the palace. Continuing the corridor, the new ceremonial staircase, the Scala Regia, begins at the level of the portico of the church. Here the problems seemed overwhelming. For his new staircase he had to make use of the existing north wall and the old upper landing and return flight.[14] By placing a columnar order within the "tunnel" of the main flight and by ingeniously manipulating it, he counteracted the convergence of

the walls towards the upper landing and created the impression of an ample and festive staircase.

There was no alternative to the *piazza retta,* and only beyond it was it possible to widen the square. The choice of the oval for the main piazza suggested itself by a variety of considerations. Above all the majestic repose of the widely embracing arms of the colonnades were for Bernini expressive of the dignity and grandeur here required. Moreover, this form contained a specific *concetto.* Bernini himself compared the colonnades to the motherly arms of the Church "which embrace Catholics to reinforce their belief, heretics to reunite them with the Church, and agnostics to enlighten them with the true faith."

Until the beginning of 1667 Bernini intended to close the piazza at the far end opposite the basilica by a short arm continuing exactly the architecture of the long arms. This proves conclusively that for him the square was a kind of forecourt to the church, comparable to an immensely extended atrium. The "third arm" which was never built would have stressed a problem that cannot escape visitors to the piazza. From a near viewpoint the drum of Michelangelo's dome, designed for a centralized building, disappears behind Maderno's long nave and even the visibility of the dome is affected. Like Maderno before him,[15] Bernini was well aware of the fact that no remedy to this problem could possibly be found. In developing his scheme for the piazza, he therefore chose to disregard this matter altogether rather than to attempt an unsatisfactory compromise solution. Early in 1667 construction of the piazza was far enough advanced to begin the "third arm." It was then that Bernini decided to move the "third arm" from the perimeter of the oval back into the Piazza Rusticucci,[16] the square at one time existing at the west end of the Borghi (that is, the two streets leading from the Tiber towards the church). He was led to this last-minute change of plan certainly less by any consideration for the visibility of the dome than by the idea of creating a modest ante-piazza to the oval. By thus forming a kind of counterpart to the *piazza retta,* the whole design would have approached symmetry. In addition, the visitor who entered the piazza under the "third arm" would have been able to embrace the entire perimeter of the oval. It may be recalled that in centralized buildings Bernini demanded a deep entrance because experience shows—so he told the Sieur de Chantelou—that peo-

ple, on entering a room, take a few steps forward and unless he made allowance for this they would not be able to embrace the shape in its entirety. In S. Andrea al Quirinale he had given a practical exposition of this idea and he now intended to apply it once again to the design of the Piazza of St. Peter's. In both cases the beholder was to be enabled to let his glance sweep round the full oval of the enclosure, in the church to come to rest at the aedicule before the altar and in the piazza at the façade of St. Peter's. Small or large, interior or exterior, a comprehensive and unimpaired view of the whole structure belongs to Bernini's dynamic conception of architecture, which is equally far removed from the static approach of the Renaissance as from the scenic pursuits of northern Italy and the Late Baroque.

The "third arm," this important link between the two long colonnades, remained on paper forever, owing to the death of Alexander VII in 1667. The recent pulling down of the *spina* (the houses between the Borgo Nuovo and Borgo Vecchio), already contemplated by Bernini's pupil Carlo Fontana and, in his wake, by other eighteenth- and nineteenth-century architects,[17] has created a wide roadway from the river to the piazza. This has solved one problem, and only one, namely that of a full view of the drum and dome from the distance; may it be recalled that they were always visible in all their glory from the Ponte S. Angelo, in olden days the only access to the precincts of St. Peter's. To this fictitious gain has been sacrificed Bernini's idea of the enclosed piazza and, with no hope of redress, the scale between the access to the square and the square itself has been reversed. Formerly the narrow Borgo streets opened into the wide expanse of the piazza, a dramatic contrast which intensified the beholder's surprise and feeling of elation.

The most ingenious, most revolutionary, and at the same time most influential feature of Bernini's piazza is the self-contained, free-standing colonnade.[18] Arcades with orders of the type familiar from the Colosseum, used on innumerable occasions from the fifteenth century onwards, always contain a suggestion of a pierced wall and consequently of flatness. Bernini's isolated columns with straight entablature, by contrast, are immensely sculptural elements. When crossing the piazza, our ever-changing view of the columns standing four deep[19] seems to reveal a forest of individual units; and the unison of all these clearly defined statuesque shapes produces a sensation of irresistible mass and

power. One experiences almost physically that each column displaces or absorbs some of the infinitude of space, and this impression is strengthened by the glimpses of sky between the columns. No other Italian structure of the post-Renaissance period shows an equally deep affinity with Greece. It is our preconceived ideas about Bernini that dim our vision and prevent us from seeing that this Hellenic quality of the piazza could only be produced by the greatest Baroque artist, who was a sculptor at heart.

As happens with most new and vital ideas, after initial sharp attacks the colonnades became of immense consequence for the further history of architecture. Examples of their influence from Naples to Greenwich and Leningrad need not be enumerated. The aftermath can be followed up for more than two and a half centuries.

*NOTES*

[1] However, a passage in *Kunstgeschichtliche Grundbegriffe,* first published in 1918, shows that Wölfflin was very well aware that Baroque sculpture has a "picture-like" character and is therefore composed for one viewpoint.

[2] Polychrome settings became common after Sixtus V's chapel in S. Maria Maggiore.

[3] This device is fully effective only in the afternoon, when the sun is in the west.

[4] In the Teresa group, as in the allegories of the tomb of Pope Urban, marble seems to turn into flesh. But the psychological effect is different; for while here the group has its own mysterious setting, there the allegories stand before the niche, in the spectator's space.

[5] The only detailed discussion of the history of the Piazza is in H. Brauer and R. Wittkower, *Die Zeichnungen des Gianlorenzo Bernini* (Berlin, 1931), pp. 64–102. See also V. Mariani, *Significato del portico berniniano di S. Pietro* (Rome, 1935), and the recent interesting contribution by C. Thoenes, *Zeitschrift für Kunstgeschichte,* xxvi (1963), pp. 97–145. Bernini's principal assistants were his brother Luigi, Mattia de' Rossi, Lazzaro Morelli, and the young Carlo Fontana.

[6] Opposition was centered in reactionary ecclesiastical circles. They supported an elaborate counter-project of which twenty-five drawings survive which time and again are attributed to Bernini himself. For the whole problem see Wittkower in *Journal of the Warburg and Courtauld Institutes,* iii (1939–40). Also Brauer-Wittkower, pp. 96 ff.

[7] This made it necessary to pull down Ferrabosco's tower [built 1616–17].

[8] Mainly by Ferrabosco; see D. Frey, "Berninis Entwürfe für die Glockentürme von St. Peter in Rom," *Jahrbuch der kunsthistorischen Sammlungen, Wien,* xii (1938), pp. 220 f., figures 243–5.

[9] The complex history of these towers is discussed in Brauer-Wittkower, pp. 37–43; see also Frey, *op. cit.,* and Underwood in *Art Bulletin,* xxi (1939),

p. 283; H. Millon in *Art Quarterly*, xxv (1962), p. 229, summarized the whole question.

[10] Brauer-Wittkower, pp. 41 ffff., plates 156–57; D. Frey, *op. cit.*, pp. 224 f.

[11] Brauer-Wittkower, plate 164B, and Wittkower in *Bollettino d' Arte*, xxxiv (1949), pp. 129 ff.

[12] Bernini himself talked about this in Paris (Chantelou, *Journal du Voyage du Cav. Bernin en France*, ed. Lalanne [Paris, 1885], pp. 42). Similar arguments also in Bernini's report of 1659–60 (fol. 107v, see Brauer-Wittkower, p. 70).

[13] First used by Pietro da Cortona in S. Maria della Pace.

[14] Brauer-Wittkower, pp. 88 ff. Previous discussion of the Scala Regia with partly different results, Panofsky, *Jahrbuch der Preussischen Kunstsammlungen*, xL (1919) and Voss, *ibid.*, xLIII (1922).

[15] D. Frey, *op. cit.*, 217.

[16] The whole material for this question in Wittkower, *Boll. d' Arte, loc. cit.*

[17] For Carlo Fontana's projects see Coudenhove-Erthal, *op. cit.*, pp. 91 ff. and plate 39. For later and similar projects see T. A. Polazzo, *Da Castel S. Angelo alla basilica di S. Pietro* (Rome, 1948).

[18] This statement is true in spite of the fact that this type of colonnade was first devised by Pietro da Cortona.

[19] There are two passages for pedestrians and between them a wider one for coaches.

# *13.* JACQUES LOUIS DAVID

# AND ROMAN VIRTUE

## *L. D. Ettlinger*

### INTRODUCTION

The sober rhetoric of David's *Oath of the Horatii*, blending ideality and realism, didactic purpose, and antique theme in a firm, clear style, has long been considered a paradigm of Neoclassic painting. First exhibited in Rome in 1785, its reputation was instantly assured: the wave of Neoclassicism (begun earlier in the century under the stimulus of excavations at Pompeii and Herculaneum, the publications of Winckelmann and Stuart and Revett, Piranesi's views of ancient monuments, and a widespread antiquarianism) was cresting at this point. Neoclassicism had also a reformatory aspect, as a counter-style to the rococo manner identified with the milieu of the aristocratic courts. Thus, Neoclassicism, by accident of history, its didactic tone, and its adaptability to patriotic content, became the style of the French Revolution and David its chief purveyor.

The *Oath of the Horatii* is the key work in this article by Ettlinger, which examines the antique content of David's art and makes the important point that the climate in which Neoclassicism was formed was conditioned by the educational tradition of the era. This seems a fruitful area for research in determining the predilections that help shape styles.

For further reading there are three works available in paperback editions that provide an excellent picture of this era and beyond it into the height of Romanticism: Michael Levey, *Rococo to Revolution* (1966); Robert Rosenblum, *Transformations in Late Eighteenth Century Art* (1967, 1969); Walter Friedlaender, *David to Delacroix* (1952). A good general survey of Neoclassicism is Hugh Honour, *Neo-classicism*

235

(1973); David Irwin, *English Neoclassical Art: Studies in Inspiration and Taste* (1966), is an important study, considering the significance of the English contribution to the genesis of the movement; and, in this connection specifically, there is Ellis K. Waterhouse, "The British Contribution to the NeoClassical Style," *Proceedings of the British Academy*, XL (1954), 57–74. Other works of interest are James A. Leith, *The Idea of Art as Propaganda in France, 1750–1799: A Study in the History of Ideas* (1965); Harold T. Parker, *The Cult of Antiquity and the French Revolutionaries* (1965); David L. Dowd, *Pageant-Master of the Republic: Jacques-Louis David and the French Revolution* (1948, 1969); J. C. Sloane, "David, Robespierre, and 'The Death of Bara',," *Gazette des Beaux-Arts*, series 6, LXXIV (September 1969), 143–160; Robert Rosenblum, "A Source for David's 'Horatii'," *The Burlington Magazine*, CXII (May 1970), 269–273, which deals with pictorial antecedents of this painting; Hugh Honour, "Canova and David," *Apollo*, new series, 96 (October 1972), 312–317; Robert Rosenblum, "Inherited Myths, Unprecedented Realities: Painting Under Napoleon, 1800–1814," *Art in America*, LXIII (March 1975), 48–57; A. A. Kagan, "Classical Source for David's 'Oath of the Tennis Court'," *The Burlington Magazine*, CXVI (July 1974), 395–396; P. Spencer-Longhurst, "Premier Peintre de l'Empereur: The Role of Jacques-Louis David Under the Empire," *Connoisseur*, 193 (December 1976), 317–323; Robert Rosenblum, *The International Style of 1800: A Study in Linear Abstraction* (1976); Diane Kelder, *Aspects of "Official" Painting and Philosophic Art, 1789–1799* (1976); S. A. Nash, "David, Socrates, and Caravaggism: A Source for David's 'Death of Socrates'," *Gazette des Beaux-Arts*, series 6, XCI (May–June 1978), 202–206.

The selection that follows is reprinted from the *Journal of the Royal Society of Arts,* January 1967, Fred Cook Memorial Lecture, by permission of the author, L. D. Ettlinger, and the Royal Society of Arts.

When David, that icy star, rose above the horizon of art, with Guérin and Girodet . . . a great revolution took place. Without analysing here the goal which they pursued; without endorsing its legitimacy or considering whether they did not overshoot it, let us state quite simply that they had a goal, a great goal which consisted in reaction against an excess of gay and charming frivolities, and which I want neither to appraise nor to define; further, that they fixed this goal steadfastly before their eyes, and that they marched by the light of their artificial sun with a frankness, a resolution and an *esprit de corps* worthy of true party-men. . . . But these masters, who were once overpraised and to-day are over-scorned, had the great merit—if you will not concern yourself too much with their eccentric methods and systems—of bringing back the taste for heroism in the French character. That endless contemplation of Greek and Roman history could not, after all, but have a salutary, Stoic influence. But they were not always quite so Greek and Roman as they wished to appear. David, it is true, never ceased to be heroic—David the inflexible, the despotic evangelist.[1]

These words were written in 1855 by the most perceptive and knowledgeable of French critics, a poet to whom morality was a central force in all artistic creation. When Charles Baudelaire appraised the essence of David's art he had before his eyes the visible authority of paintings such as the *Oath of the Horatii,* the *Brutus,* the *Death of Socrates.* Had he wanted to prove the correctness of his interpretation, he might have quoted the master himself who, in one of his speeches before the Convention, had declared: "C'est à côté des actions mémorables que dans l'antiquité brillait le génie des arts. Ces vertus reparaissent . . ."

Our own historians and critics have taken a rather different line with David. Perhaps, having forgotten Baudelaire, they are too much fascinated by the weird spectacle of a Court painter who became a fiery revolutionary and, as a deputy, was deeply involved in the cabals of the Convention. Recently, for example, we have been told by a good authority that the *Oath of the Horatii,* first shown in the Salon of 1785, is already "fully republican." This was said in spite of the fact that the incident illustrated comes

from a period when Rome was still ruled by a king, in spite of the fact that the picture was painted years before anyone in France seriously considered the abolition of the monarchy. In any case, it is a little hard to see why Roman subjects, even when treated in David's most severe manner, should become at once revolutionary or republican. Moreover, it is hardly fair to attribute the views held by the politician of the 1790's to the painter of the 1780's. Finally—and perhaps most important of all—we oversimplify a complex sequence of events—the French Revolution—if we see them only with the wisdom of our hindsight. The Revolution was not a straight single track running from the Fall of the Bastille to the establishment of a republic. It began, if one can fix a beginning, when on 17th June 1789 the Tiers Etat met in the Jeu de Paume to adopt the designation National Assembly; the Constituent Assembly of 1791 still voted for a monarchy—albeit with restraints on the absolute power of the King—and even Robespierre wanted to retain it. In the end the monarchy was not abolished until September 1792, and Louis XVI was executed on 21st January 1793. These dates tell their own cautionary tale.

It is, of course, true that in the eighteenth century the French were deeply interested in Roman ideas and Roman history. While in England and Germany philosophy, education, literature and the arts were transformed by a new interest in Greek ideas, it was the cult of Rome which in France profoundly influenced the arts, just as it pervaded philosophy, political thinking, and in the end politics themselves. But a simple equation between a Roman attitude and a republican attitude does not meet the facts, and the foundations for the cult of Rome were laid long before the Revolution. Indeed, it can be safely claimed that the French Revolution would have looked different if its leaders in their youth under the *ancien régime* had not undergone a thorough classical education, if their minds had not been filled with Roman ideas and Roman imagery. But this education—like all true education—was concerned not with politics but with morals. Republicanism followed from these morals only after the final failure of the monarchy and its partisans.

Of the protagonists of the French Revolution many had received their education at one or other of the famous *Collèges*, where Virgil, Horace and Ovid were staple reading. Even greater attention was paid there to the ancient historians, to Sallust and Tacitus, and above all to Livy, whose first three books dealing

with the early days of Rome were the most popular. Cicero was studied a great deal, preference being given to his political orations over his letters and philosophical works. That means that he was regarded rather as a source for Roman history than as a paragon of an elegant style. This reading in ancient authors was supplemented by an intensive study of ancient history as set out by modern authorities, among whom Rollin's *Histoire ancienne* and, characteristically, Montesquieu's early essay *Considérations sur les causes de la grandeur des Romains et de leur décadence* were the most important.

Latin authors, of course, were read in the original. To them we have to add one fundamentally important Greek writer who was available in French translation: Plutarch. It is significant that both Amyot's and Dacier's French versions were printed several times during the eighteenth century. *The Parallel Lives* became recommended reading in the schools because they describe the triumph of virtue, the punishment of pride, and above all stoic self-control and an unfaltering sense of duty. Plutarch's moral outlook impressed itself on the minds of his readers more than that of any other classical author, with the possible exception of Livy.

Rousseau read Plutarch in Amyot's translation when he was only 6 years old; by the time he was 8 he knew the *Parallel Lives* by heart. Mme. Roland tells us: "I shall never forget the spring of 1763, I was nine years old at the time, when I carried Plutarch to church instead of my prayer book. It is from that moment that I date the impressions and ideas which were to make me a republican. . . . Plutarch inspired in me a real enthusiasm for the public virtues and for liberty." The same Mme. Roland wept because she had not been born a Greek or Roman. Charlotte Corday spent a day reading Plutarch before she assassinated Marat, and Louis Sébastien Mercier summed up these sentiments by remarking that after learning about the virtues of the Roman people, about the brave suicide of Cato and the murder of Caesar, he found it painful to realize that he himself was still a citizen of the France of Louis XVI. We know that David as a student was an assiduous reader of Plutarch, and I shall refer later to at least one significant example in which we can trace the influence of this author in his art.

It seems hardly surprising that the men who had undergone so thorough a classical education could hardly open their mouths in the Convention without at once uttering examples of Roman

virtue, of fortitude, of integrity and justice, of the simple life. But these virtues were never discussed in abstract terms; they were demonstrated through the memorable figures of the Roman past, through Junius Brutus, Mucius Scaevola, the three Horatii and many others.[2]

Jacques Louis David had his share of this education. He had been a pupil at the Collège des Quatre Nations, and later, as an art student, he became an *élève protégé* at the Ecole Royale where a strict classical curriculum was in force, apart from instruction in drawing and painting.

In 1747 the Comte de Caylus—antiquarian and connoisseur— had discussed the benefits young artists could derive from reading the best classical authors. A year later the Ecole Royale des Elèves Protégés was founded by Tournehem and Coypel as a school which was to give young art students a wide cultural background before they went to Rome, there to continue their studies. Lenormant de Tournehem, the Directeur-Général des Bâtiments, addressed the first group of students, saying,

> Gentlemen, your august patron the King having been informed that often enough the young students sent to Rome had gone there without a suitable education, wishes, with the help of new grants, to allow them in future to go on this journey with greater knowl- edge and ability. His Majesty has founded six scholarships for students who will be housed and fed together. They will be supervised by a governor chosen from among the professors of the Académie. The Governor will instruct them in their art, but a man of letters . . . will teach them History, Mythology, Geography and other disciplines connected with their art. He will be allo- cated as much time for History lessons as the professors teaching anatomy and perspective are given for their subjects.[3]

The chief text-book for History classes was Bossuet's *Historie Universelle*, written *ad Usum Delphini* at the end of the seven- teenth century; Rollin's *Historie Ancienne* was also used, as were the writings of Livy and Tacitus. Yet the study of history was not a purely academic matter, since the students' reading was related to their artistic training and they had to illustrate subjects dis- cussed in the History classes. Dandré Bardon, the Professor of History during David's student days, was in fact a painter turned writer and historian. His instruction followed certain ideas first voiced by two influential contemporaries of his, Caylus and La

Font de Saint-Yenne. Yet in their turn these two authors had only brought up to date traditional French theories about the moral aims of history painting. They had done so by applying rigorously the moral cult of the ancients which was the backbone of all eighteenth-century education in France. Dr. Anita Brookner rightly has drawn attention to the central rôle played by La Font de Saint-Yenne in this connection and in the rise of French neo-classical doctrine.[4] When he demanded great and noble subjects as the only proper ones for history painters he could point to classical history as a treasure house where they would be found. In fact, the subjects which he ranked highest were to be read up in the College text-books known to every student.

In 1754 La Font de Saint-Yenne published a short treatise under the title *Sentiments sur quelques Ouvrages du Salon de 1753*. If we read this short work we may well believe that we have before us a document appropriate to the spirit which we associate with the French Revolution and its art. La Font followed Rousseau in rejecting mythological subjects as absurd and immoral; instead he pleads for true history painting as "une école des moeurs." He wants to see in painting: ". . . les actions vertueuses et héroïques des grands hommes, les exemples d'humanité, de générosité, de grandeur, de courage, de mépris des dangers et même de la vie, d'un zèle passionné pour l'honneur et le salut de la patrie. . . ."[5] In drawing up a list of subjects which could illustrate these high ideals La Font refers, needless to say, to two sources, the Old Testament and ancient history, claiming significantly that Plutarch alone could supply all the painters of Europe with appropriate subjects. His examples include the virtues of Cyrus, the model of all sovereigns; the great figures of Socrates and Epaminondas; the admirable exploits of Decius; of Marcus Curtius; of Coriolanus. It should be noted that he also included among the recommended stories—some thirty-five years before the French Revolution—*Brutus Condemning his Sons to Death*, the very subject painted by David and submitted for the Salon of 1789. To the reader of classical authors the moral implications of the story must have been obvious.

Diderot expressed more forcibly and with great ability a similar philosophy—after all, he did much more than plead for the art of Greuze—when he complained in the Salon of 1761 *à propos* of Boucher that classical severity was lacking in his art.

It is clear that the demands made by French education, by La

Font, by Diderot and by many others, have little or nothing to do with politics and cannot be called, even by implication, republican. These writers were concerned with the moral content of the educational programme, applicable to everyone including artists. But young art-students—such as David—were formed by more than a classical education.

Both Anton Raphael Mengs and Gavin Hamilton are supposed to have fathered Neo-classicism, but its true begetter was Poussin. French painters of the second half of the eighteenth century and their mentors turned increasingly to his art for the finest examples of classical—more specifically Roman—severity and morality. Diderot summed up these sentiments perfectly when he exclaimed: "O le Poussin! O le Sueur! Où est le *Testament d'Eudamidas?*" He was, of course, alluding to one of Poussin's most famous paintings, hardly by chance the illustration of a truly stoic tale. It is a sign of Poussin's popularity that this picture was newly engraved in 1757 and thought worthy of a special notice in the *Mercure de France*. This is not the place to discuss the Poussin revival in detail, but I should like to mention that at the time he was compared to Corneille, and that the Roman elements in his art drew special attention. In 1782 his Apotheosis was celebrated in the Pantheon in Rome, and several fulsome eulogies were published.

The kind of classical education I sketched briefly a moment ago and an early exposure to Poussin were, in my view, the decisive experiences shaping the personality and art of Jacques Louis David, at least to the end of the 1790's. These two factors were more important than anything he learned from his master Vien, more important than his contact with that taste for Neo-classicism which swept across Europe in the wake of Winckelmann's writings and of the publications making known Pompeii, Herculaneum and other new sites. David's brand of Classicism follows from older aesthetic precepts, those truly characteristic of the eighteenth century. For the assiduous reader of Livy and Plutarch, the disciple of La Font de Saint-Yenne and Diderot held that there should be close correspondence between content and form, and that a true Roman spirit demanded also archaeological accuracy of representation. Hence Montfaucon's *l'Antiquité expliquée* became one of his most important source books.

David, born in 1748, went to Italy with a Prix de Rome in 1773. After his return he showed in the Salon of 1781 *Blind Belisarius*

*Begging* [Lille, Museum], a picture illustrating one of those senti-
mental yet stoic tales from ancient history. The former general of
the Emperor Justinian, who has fallen from grace and is reduced
to asking for alms, is recognized by one of his own soldiers. It has
been said that the story of Belisarius illustrates the vanity of all
earthly glory. That is of course true, but to anyone in the eigh-
teenth century the picture must have meant a great deal more.
While in Italy David had spent some of his time in the company
of Caylus, who never stopped urging painters to fulfil their chief
task: to transmit to posterity examples of moral heroism. David's
*Blind Belisarius* answers this demand admirably.

Diderot at once recognized the true strength of David's pic-
ture. When he saw it on exhibition he remarked in his *Salon* of
1781: "Ce jeune homme montre de la grande manière dans la
conduite de son ouvrage," and he added a significant phrase: "Il
a de l'âme . . ."[6] This is not vague praise, since the term *âme* had
a precise meaning in eighteenth-century aesthetics. It could never
have been applied to Boucher, for example, because it implied
that a heroic subject had been treated in the Grand Manner, that
expression and gestures were in accordance with the nature of
the action represented. In other words, the term covers a well-
known Aristotelian poetic concept now transferred to the theory
of history painting, and in this sense Dandré Bardon, David's
history teacher, had defined it in his *Traité de Peinture* of 1765.[7]
Diderot, in according David's picture this very quality, was
carefully weighing his praise. For him it was never enough that a
painting should treat a noble Roman subject, and it was, in fact,
one of the recurring themes of his Salon criticism that subject
matter and manner of presentation had been incompatible, be-
cause the inner meaning—the noble greatness of the stoic Romans
—had not been shown.

Let me give just one example of this. We no longer have the
canvas by which the French painter Beaufort gained admission
to the Académie in 1771, *The Oath of Brutus to Avenge the Rape
of Lucretia.** But I can use a contemporary substitute, a painting
close in manner to Beaufort's style. Fortunately Gavin Hamilton
had treated the same subject a few years earlier, while he was
still in Rome, and it is very likely that Beaufort knew Hamilton's

* See Rosenblum's article in *The Burlington Magazine,* cited in the introduc-
tion to this selection.

composition. Diderot sharply criticized Beaufort's picture, and every word he wrote can also be applied to Gavin Hamilton's version: "The painter did not succeed in showing Lucretia stabbed and becoming Roman. . . . This is not in the Roman style. It is small and mean."[8]

Unfortunately Diderot did not live to see David's *Horatii* (Fig. 37) in the Salon of 1785, the picture which takes the spirit and the style of the *Belisarius* a great deal further. But surely he would have approved of the moral subject and its noble treatment. What he, Caylus, La Font and others had preached for decades was at last brought to pass by a painter of genius.

The true significance of this painting emerges, I think, if we now consider briefly its genesis. In 1782 David saw at the Comédie Française Corneille's tragedy *Horace*, first performed more than a century earlier in 1640. It has been suggested that, deeply stirred by the play and a fine performance, David went

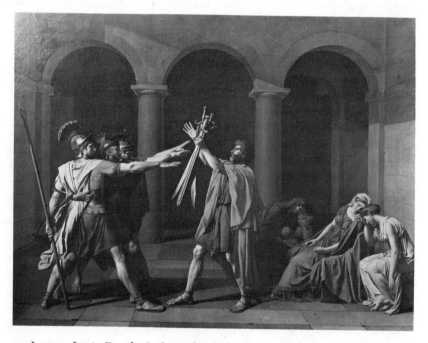

37. Jacques Louis David, *Oath of the Horatii,* 1784, Oil on canvas, 10′9⅛″ x 13′10¼″ (The Louvre; Photo LAUROS-GIRAUDON, Paris)

38. Jacques Louis David, *Old Horatius Defending His Son, c.* 1784, Drawing, Black chalk with Chinese ink wash, Approximately 8″ x 11″ (The Louvre, Paris; Archives photographics)

home and sketched his own vision of the closing scene: old Horatius's plea for his son, who has slain a sister out of patriotic fervour (Fig. 38). Professor Wind has already pointed out that David's drawing does not correspond to any scene in Corneille's drama, and he suggested Rollin's *Histoire*—the school textbook I mentioned earlier—as David's most likely source.[9]

While it is obvious that we must rule out the inspiration of Corneille, I do not believe that David turned to Rollin for his story. I am sure that his source in this particular case was none other than Livy, and I think it highly significant in our context that after seeing Corneille's *Horace* David should have re-read the story in a Roman historian. In order to prove this point I must remind you of Corneille's rendering first.

During a war between Rome and the neighbouring town of Alba it is decided that the issue is to be settled by the combat of three Roman brothers against three brothers from Alba. Horace

and his brothers will fight for Rome, Curiace and his for the other side. But it so happens that the two families are closely linked because Horace is married to Sabine, the sister of Curiace, who himself is betrothed to Camille, sister of Horace. Nevertheless Horace feels that his duty to Rome is more important than love or bonds of family. The actual combat is not shown on the stage, but reported to the old father, and we learn in this manner that Horace, both his brothers having fallen, kills in the end all three enemies. On his victorious return home he meets his sister, who curses Rome and weeps over the loss of her lover. Horace, enraged, kills her for siding with the enemy. He is led before the King for this murder, and his father pleads for him. The King pardons Horace, since the victory for Rome cancels his crime.

If David was in fact stimulated by a performance of Corneille's tragedy, such stimulation must have been negative, so to speak, for he changed Corneille's interpretation of Roman history and Roman virtue to bring them into accordance with the convictions of the eighteenth century. Corneille had paid tribute to the absolute and divine right of kings, and hence it is the King who pardons the murderer. But such an outlook, which implied that patriotism comes before morality and that rulers are above the moral laws, must have appalled anyone with David's educational background. He could not accept the Cornelian philosophy—a characteristic seventeenth-century version of Roman history—and instead he went back to an original source, the account of the incident given in Livy's first book. There he found something very different. The King, refusing to take upon himself alone responsibility for judgement and punishment, calls together an assembly of the people and appoints two officials to try the case. One of them finds Horatius guilty of murder and sends the lictor to bind his hands. When that happens the accused appeals to the assembly of the people, who after a plea by Horatius's father absolve the murderer, "more in admiration of his valour than from the justice of his cause," as Livy puts it.[10]

Obviously, all details of Livy's account can be found in David's drawing: there is the King on the tribunal, the lictors are arriving to bind Horatius, the father is imploring the assembled people. Clearly, David has made this appeal his central motive.

Originally David intended the subject depicted in this drawing for a Salon picture of 1783, but he changed his mind and in the end submitted two years later the *Serment des Horaces*. This

picture has even less connection with Corneille's tragedy than the drawing which we have just discussed. For one thing: Corneille brings only one brother—Horace—on the stage; for another he has no oath-taking scene. But in any case, we have just seen that David went back to a classical source in the first instance because he disapproved of Corneille's sentiments. Perhaps the change in plan was also prompted by a glimpse of another ancient author.

I have already hinted that from the moral point of view as widely held in the eighteenth century the story as told by Livy and illustrated by David in his first drawing can hardly have shown Roman virtue at its most exemplary. Livy himself had pointed out that Horatius was acquitted more in admiration of his valiant exploit than for the justice of his cause. In other words, while patriotic, Horatius had shown a notable lack of one of the main stoic virtues: self-control in the face of provocation. But the story of the Horatii did contain one feature which was in perfect accord with eighteenth-century morality, and moreover displayed a characteristic Roman virtue in its finest form: the selfless resolve of three youths to sacrifice their lives for the sake of their country.

In the end David decided to depict this moral act of the three young men rather than their father's morally dubious plea for Horatius. Another drawing shows a new pictorial idea and also gives a clue to the painter's source (Fig. 39). Now the father is arming his three sons and sending them to battle. This incident is not described by Livy but by a lesser known ancient historian, Dionysius of Halicarnassus, a contemporary of Augustus who wrote in Greek an early history of Rome, which survives in part. He tells us that the Horatii, when asked by the King to fight the enemy, refused to go out to battle unless their father approved of their doing so. The King therefore commanded them to seek permission, and thereupon the eldest son addressed his father, saying: " 'Father, we would rather be dead than live unworthy of you and of our ancestors'. . . . Their father, upon learning their resolve, rejoiced and lifting up his hands to heaven said he rendered thanks to the gods for having given him noble sons." Accordingly the sons go out to the battle.[11]

It is true, there is in Dionysius of Halicarnassus no mention of any oath, but in all other respects his account corresponds to this drawing and to David's painting. The old man's raised arms—his

39. Jacques Louis David, *Old Horatius Arming His Sons, c.* 1784, Drawing, pencil and pen on paper, 7¹³⁄₁₆″ x 10⁷⁄₁₆″ (Ecole Nationale Supérieure des Beaux-Arts, Paris)

looking up to heaven—must have been suggested to the artist by the classical author. Moreover, bearing in mind the moral implications of the Horatii story, David has now fixed on the climacteric moment, and he is showing us an action which can be made clear through gestures and expressions alone. We must remember that the classical theory of painting, as taught at the French Academy, recommended those representations which did not require us to imagine any speech on the part of the participants.

But why did David introduce the motive of the *oath* of the three brothers, which is not mentioned in any of the classical sources at his disposal? Various theatrical sources have again been suggested, among them a ballet which had been shown in Paris. But in that particular case the oath—other differences apart— was sworn on the field of battle.

But I do not think we need turn to so far-fetched and unlikely

a source in the case of an artist as well versed in the classics as David. The ancient authors are full of stories about oaths sworn to fight for one's country, come what may. The most celebrated example—which also inspired many painters—is, of course, the oath of Brutus and his friends over the body of the defiled Lucretia. I have already referred to Gavin Hamilton's and Beaufort's renderings of this subject dating from 1764 and 1771 respectively. In 1773 Benjamin West depicted an *Oath of the young Hannibal to punish Rome;* Lagrenée painted in 1781 an *Oath of Agamemnon.* For the Salon of 1785 Ménageot proposed once again the favourite, the *Serment de Brutus.* The significance of the solemnity of an oath-taking would not have been lost on David, for this motif gave an extra dimension to the moral content of his story. The resolve to fight was made before the gods.

The *Oath of the Horatii,* shown in Paris four years before the onset of the Revolution, is a veritable paradigm of moral history painting; it extols civic virtue in personal terms, but makes no allusion—overtly or otherwise—to any of the political issues of the day. In the Salon of 1789, however, David exhibited a picture which, superficially anyhow, seems to fit the moment particularly well, the *Brutus* [Paris, Louvre]. The first Roman Consul is awaiting the bodies of his sons, who have been executed at his order for siding with the enemy. Originally the story comes again from Livy. Brutus—another of those "steady Romans," in Dr. Johnson's inimitable phrase—has driven out the last of the kings, the tyrant Tarquinius Superbus, who fled to the Etruscans. With their help the tyrant attempted to regain his throne, and the sons of Brutus were among those who supported him. Putting his duty to Rome before parental love, the father had them punished for their treachery.[12]

There are two distinct elements in this story: the expulsion of a tyrant, and a stoic sense of duty. Which of them did David illustrate in his painting? A scholar who recently examined David's record as a revolutionary, has written:

> The Court was determined that the Salon should not become an avenue for revolutionary propaganda and therefore all paintings were carefully censored before being hung. . . . When the newspapers reported that the government had prohibited the exhibition of David's *Brutus* public opinion was outraged. In fact,

popular feeling was so aroused that the "subversive" picture had to take its appointed place at the exhibition, where it was protected by art students wearing the uniform of the newly created National Guard.[13]

Unfortunately all this is based on a misunderstanding of the facts. Before considering this picture any further I should like to set the record straight, not only because I think that truth is better than romantic fiction when writing history, but also because David's *Brutus* placed in its proper context immediately reveals something of its meaning.

It is perfectly true that this picture was not on view when the Salon opened on 25th August 1789, but the reason for this was purely technical. For reasons we do not know David had not sought the approval of the Directeur-Général des Bâtiments for the subject he wished to send in. But acceptance was required, and for the court-painters normally brought in its train an official commission. In the case of the *Brutus* the authorities therefore acted within their rights, though their action may seem mean and bureaucratic. Still, it is hardly surprising that it was impossible to treat France's most illustrious painter in this manner, and in the end the picture had to be hung. The recently formed National Guard did indeed protect the Salon—not from irate royalists— because they were the Paris security force, and the art student members had asked for the special privilege of guarding the works of their masters. Furthermore, though not commissioned, the picture celebrating the first Consul was acquired by the King, who paid 6,000 livres for it. The entry in the royal inventory is not without significance in interpreting this painting: ". . . it represents Brutus, the first Consul, returning home after condemning to death his two sons, who had conspired against Roman liberty" —"*contre la liberté romaine.*"[14] David's picture was acceptable, even to the King, because it conformed to current standards of Grand Manner history painting, representing a truly stoic theme: the conflict between the love for country and family.

When David chose *Brutus*'s rectitude as the theme of his Salon painting for 1789 he did nothing extraordinary, nothing in any way linked with current political views. He did not paint the man who drove out an oppressive ruler, but an example of stern Roman virtue. The same story had already fascinated Diderot—it is too

perfect an example of stoic morality to have been missed by him
—and just twenty years earlier he had tried to persuade Greuze
to use it for his *morceau de réception*. La Font de Saint-Yenne had
recommended it to artists, and in 1785 *Brutus faisant punir de
mort ses propres enfants* had been the subject set by the Académie
for those competing with reliefs for the Grand Prix.[15] David him-
self, in a letter addressed to his colleague Wicar, has told us
clearly what he had in mind when painting his *Brutus:* "I am
working on a picture of my own invention. Brutus as a man and
father. Having robbed himself of his sons he has returned to his
house, when they are brought back so that he may bury them.
He is seated at the feet of the statue of *Roma,* and his crying wife
and fainting daughter distract him from his sorrow. . . ."[16] The
most important words in this letter surely are: *Brutus as a man
and father.* David was giving his public not a political but a moral
rendering of a well-known Roman subject.

The death of Lucretia—painted so often since the Renais-
sance—and the oath of Brutus and his friends to be revenged on
Tarquin and his family are subjects of a different kind. The former,
though not without its stoic undertones, is rarely free from an
erotic element; the latter cannot quite shed an undisguised hint of
private retribution. The moral grandeur of Brutus could only be
illustrated through his sternness as a magistrate. It is worth
noting that Livy, when telling of the execution, had mentioned
Brutus's ill-concealed parental feelings which he could hardly
subordinate to his duty.[17] Plutarch, on the other hand, had written
that Brutus did not allow pity to smooth his stern countenance.
He went on to argue that we must not doubt the virtue of this
great man, or regard his action as brutal, since he acted in the
interests of Rome.[18] It is obvious that David, in interpreting
the character of Brutus, followed not Livy but Plutarch. He places
him symbolically at the feet of the goddess Roma—the personifi-
cation of the country—and his features do not betray any sign of
weakness. He looks stern and unmoved. This self-control is
dramatically all the more effective because David has contrasted
it with the helpless grief of the women on the right. When he
took up Plutarch's reading of the story, David may well have re-
membered something he had learnt at school. For one of Des-
moulins' teachers—David's exact contemporary and fellow
revolutionary—has recorded that Collège students were taught

251

to admire the first Brutus not because he had given political liberty
to Rome, but on account of the stoicism he had shown in sacri-
ficing his sons for the sake of the country.[19]

Still Plutarch does not help us to explain one particular feature
of David's painting: the setting of this sombre scene in the house
of Brutus. The classical authors whose accounts David could have
known—Plutarch, Livy and Dionysius of Halicarnassus—speak
of the trial and execution which took place on the Roman Forum,
as was customary. There is nowhere any reference to the sorrowful
domestic scene depicted by David. Of course, in contrasting the
calm of Brutus with the agonized weeping of the women David
employed a device well known to French painters since Poussin
had successfully used it in the *Testament d'Eudamidas,* a picture
of great importance to eighteenth-century art, as I pointed out
earlier. Moreover, his teacher Dandré Bardon had explained that
it was not enough to have in a picture groups of figures formally
contrasting with each other. He had told his students that the
contrast had to extend to expressions.[20] Yet I do not think it is
sufficient to explain David's choice of setting and groups in purely
formal—or theoretical—terms. In order to understand the staging
and truly Roman nature of David's *Brutus* we have to turn to a
very different source.

Voltaire's tragedy *Brutus* had been produced for the first time
in 1730. In compliance with the dramatic unities the scene is set
throughout in the house of Brutus, and the drama deals with yet
another conflict between love and duty, celebrating the first
Consul as a true stoic philosopher. Titus, his son, is in love with
Tullia, the daughter of Tarquin, the overthrown tyrant. He is
therefore easily persuaded to betray Rome to Porsenna, who is
besieging the town in order to restore the King to his throne.
Brutus, on learning of his son's treason, sends him to death. The
play ends with a short scene which—in a manner of speaking—
directly precedes the incident depicted by David: Brutus, alone
in his house, awaits the news that his son has been executed.

It is hardly surprising that a painter who was also a superb
stage manager should have been inspired by the tragedy of an
author with whose views he must have been in full sympathy.
With true understanding of the pictorially most effective, David
fixed on that moment which showed Brutus's virtue at its strongest.
The suggestion that he was in fact inspired to his composition by
Voltaire's tragedy is borne out by an incident in which play and

picture became one. When *Brutus* was performed again in the autumn of 1790 David's painting was staged as a *tableau vivant* right at the end, and the painter himself made the arrangements for this singular production.

David's painting, like Voltaire's tragedy, belongs to the eighteenth century and celebrates Roman virtue in a truly classical idiom. True to his convictions, David has taken care to give a Roman story a Roman look. The figure of Roma is derived from an ancient statue and the features of the first Consul are borrowed from a famous bust in the Capitoline Museum. His brooding yet dignified posture can be traced back to an engraving after the statue of a Roman philosopher—and it is again significant that David should have chosen this type—which was found in Montfaucon's *Antiquité expliquée*.

To David in 1789 Brutus had still been an embodiment of Roman Virtue. But during the French Revolution—and only during the French Revolution—Brutus did become a political symbol when Roman imagery was turned into a weapon of propaganda. The process by which this happened, however, was gradual and David himself had little or nothing to do with it.

When Voltaire wrote his *Brutus* the radical sentiments which he expressed were hardly a political programme or anti-royalist propaganda. While attacking privilege and authority he praised love of liberty and patriotism. Even as late as 1790 the play was still liked for its example of civic virtue. We know through Voltaire's friend La Harpe that before 1791 Paris audiences did not attach any political significance to the outbursts against royal power which occur repeatedly in the play. But after October 1791, when the Revolution had taken a decidedly republican turn, Voltaire's *Brutus* was also seen in a new light. Those in power made use of it when they wished to whip up republican sentiments. Special performances were given on the day after the royal family had been brought back from Varennes and again on the eve of Louis XVI's execution.[21]

The cult of Brutus grew to be the very centre of the imagery of the Revolution. But now he was shown in isolation, no longer as a virtuous hero in action. His bust was displayed on the rostrum of the Convention; Sèvres porcelain copies of it were on sale to the public. At one time it was intended to decorate the newly issued paper money—the *assignats*—with his features, but this seems never to have been done. Streets and towns were re-

named after him, and many people exchanged their Christian names for Roman ones, often favouring Brutus. Babeuf wrote: "To erase all traces of royalism . . . we have given republican names to our streets. . . . The decree by which it became permissible to declare that one no longer wanted to be called 'Roche' or 'Nicodème' but rather wanted to take as a patron and example 'Brutus' was a wise and moral one."

One final example of this political cult of Brutus which takes us back to Jacques Louis David: in 1798 he organized the triumphal procession in which the works of art looted by Napoleon in Italy were carried into Paris. The Belvedere Apollo, the Laocoön, celebrated paintings by the great masters and so forth were displayed on carriages, and the long pageant was concluded by the bust of Brutus—stolen from the Capitol in Rome.[22]

This *Festival of Arts and Sciences* was by its very nature a political event, and effective propaganda was no doubt part of its purpose. But it would be wrong to assume, I feel, that David, once he had taken an active part in the Revolution, forgot the high moral purpose of his art and became simply a time-serving political propagandist. When he arranged the various festivals and pageants of the new republic he did confine himself to narrow political ends. When he painted the martyrs of the Revolution, even at the behest of the Convention, he preserved something of the high moral aims which had directed his earlier efforts. Only instead of embodying a moral truth in the representation of a Brutus or Horatius he now likened the heroes of his day to the heroes of yore.

Lepelletier, one of the deputies, was murdered the day before the execution of Louis XVI by one of the King's former bodyguards, wishing to revenge his monarch on those who had voted his death. The Convention used the assassination for its own ends and addressed the French people in a manner which to-day cannot but ring ominously in our ears: "Citizens, it is not just one man who has been slain—it is you! It is not Michel Lepelletier who has been murdered—it is you! This blow was not dealt against the life of one deputy, but against the life of the nation, against liberty, against the sovereignty of the people."[23] But David's commemoration of the dead deputy was far from rabble-rousing. Only a drawing and engraving survive to show us what he did, but they suffice to demonstrate the great dignity—the classical poise—of his homage. David—a painter grown up in the great tradition of the eighteenth century—did not produce some

flat and realistic reportage. The dead man, nude like a classical hero, is stretched out on a bed or bier. Above him hangs a bloody sword, to which is affixed a sheet of paper inscribed with the words: "I voted the death of the tyrant." Lepelletier's pose has been likened to that of Christ in traditional representations of the Lamentation. But I do not think that this obvious comparison can tell us very much. Another derivation of the pose seems more to the point. Even now David has not forgotten the pose of the dying Eudamidas, though here he has reversed the figure. David had used the same formula when painting a dead classical hero: *Hector, lamented by Andromache*. In the last resort the supine heroic corpse can be traced back to a classical model, a *Meleager Sarcophagus*, drawn by David during his student days in Rome. The recurring formula has its deeper meaning. Hector, Eudamidas and Lepelletier are equals in their noble heroism. Ancient virtue can also be found in the fighters of the Revolution.

The same sentiments also fired David's imagination when he had to commemorate Marat, who had been murdered in 1793 by Charlotte Corday. The painter had visited the deputy shortly before his death, finding him sick but working even in his bath. The fatal interview with Charlotte Corday took place under the same circumstances. Although it was David's intention to show Marat as he had died, he did not produce a narrative painting. He shows the dead man alone as on a sepulchral monument. The body gleams before the dark ground, and there is no indication of any domestic setting. We are reminded of a sharply cut marble relief. The improvised writing-table bearing the name recalls a simple tombstone. These devices are highly original, and the conscious choice of that undramatic moment when all is already over makes the dead deputy into a timeless hero, into someone belonging to a world which is different from ours.

Nevertheless we can detect here a definite change in David's attitude to ancient virtue. In the paintings of the 1780's moral concepts had been exemplified by depicting noble Romans. Now it is made apparent that the consequences of learning about Stoicism have borne fruit, and that the moderns—in the words of Desmoulins, brought up by reading Cicero—have themselves become noble Romans. Even so, we must not mistake the homage to Lepelletier for political propaganda. The revolutionary became great only in death, and David never overused his art to extole the living leaders of the Revolution. His art was turned into

40. Jacques Louis David, *The Oath of the Army after the Distribution of the Eagles,* 1810, Oil on canvas, Approximately 20' x 30' (Versailles Museum; French Cultural Services)

propaganda only once Napoleon had replaced republican virtue by imperial pomp.

Of this I need give here only one example. In 1810 David painted the *Serment de l'armée après la distribution des aigles* (Fig. 40). The austere rite of the *Oath of the Horatii* has become a glittering fair. But the painter, still remembering his upbringing, at first suggested transforming the military and imperial ceremony into a dignified allegory. While the army is swearing loyalty a winged Victory was to appear in the sky. But Napoleon, proudly relying on the power of his own personality, rejected this symbol of divine intercession. In the final version David had to leave out the Victory.

It is idle to debate whether David betrayed his former moral ideals when he accepted Napoleon and his patronage. By the early 1800's the challenge the world offered to his artistic imagination had changed just as it had changed once before when the

Revolution put Marat into the place of Brutus or Horatius. David remained true to himself in accepting this challenge. Surely Baudelaire was right: "David, il est vrai, ne cessa jamais d'être l'héroïque, l'inflexible David, le révélateur despote."

## NOTES

1 Ch. Baudelaire, *Exposition universalle de 1855*. Here quoted from *Mirror of Art*, translated by J. Mayne, 1955, p. 200.

2 The classical bias of French eighteenth-century education is discussed by H. T. Parker, *The Cult of Antiquity and the French Revolution*, 1937. Most of our examples come from this book. See also A. Cobban, *A History of Modern France*, Vol. I, 1957, pp. 174 ff.

3 J. Locquin, *La peinture d'histoire en France de 1747 à 1785*, 1912, pp. 9 ff., 87 ff.; N. Pevsner, *Academies of Art*, 1940, pp. 82 ff.

4 'Aspects of Neo-Classicism in French Painting', *Apollo*, June 1957. See also the same author's paper 'David, the Sentimental Neo-Classicist', published in Acts of the 21st International Art Historical Congress. For a different interpretation of David's attitude, see M. Levey, 'Reason and Passion in J.-L. David', *Apollo*, Vol. LXXX, 1964, pp. 206 ff.

5 La Font de Saint-Yenne, *Sentiments sur quelques ouvrages du Salon de 1753*, 1754, pp. 51 f.; Locquin, op. cit., p. 163.

6 J. Seznec, *Essais sur Diderot et l'antiquité*, 1957, p. 101.

7 P. 33: 'L'âme d'une figure, n'est autre chose que la flexibilité de tous les membres convenables à son action.'

8 Diderot, Salon of 1771; Locquin, op. cit., pp. 142 and 250 f. On Hamilton's *Brutus* see R. Rosenblum, 'Gavin Hamilton's *Brutus* and its Aftermath', *Burlington Magazine*, Vol. CIII, 1961, pp. 8 ff.

9 E. Wind, 'The Sources of David's *Horaces*', *Journal of the Warburg and Courtauld Institutes*, Vol. IV, 1941, pp. 124 ff. For the preparatory drawings see F. H. Hazel-Hurst, 'The Artistic Evolution of David's *Oath*', *Art Bulletin*, Vol. XLII, 1960, pp. 59 ff.

10 Livy, I, 26.

11 Dionysius of Halicarnassus, *Roman Antiquities*, Vol. III, p. 17. Professor Wind already drew attention to Dionysius.

12 Livy, II, 5.

13 D. L. Dowd, *Pageant-Master of the Republic. J. L. David and the French Revolution*, 1948, p. 19. Cuvillier's letter to Vien of 10th Aug. 1789 (*Nouvelles archives de l'art français*, 3rd series, Vol. XII, 1906, pp. 263 f.), quoted by Dowd, does not speak of any official ban but voices apprehension about subjects which could be misunderstood. David's *Brutus* is not mentioned by name, but Cuvillier says that David's work is far from ready.

14 F. Engerand, *Inventaire des tableaux commandés et achetés par la direction des bâtiments du Roi*, 1900, pp. 138 f.; J. L. L. David, *Le peintre Louis David*, 1880, p. 55.

15 Montaiglon, *Procès-verbaux de l'Académie Royale de peinture et sculpture*,

Vol. IX, 1909, p. 253. About Diderot's attitude to Brutus see Seznec, op. cit., p. 99.

[16] *Gazette des Beaux-Arts,* 1875, pp. 414 ff.

[17] Livy, II, 5.

[18] Plutarch, *Publicola,* VI.

[19] H. T. Parker, op. cit., p. 32.

[20] M. F. Dandré Bardon, *Traité de peinture,* 1765, p. 109.

[21] Dowd, op. cit., pp. 34 f.; Parker, op. cit., pp. 139 ff.

[22] G. Morey, *Le livre des fêtes françaises,* 1930, pp. 320 ff.

[23] Dowd, op. cit., pp. 99 ff.

# 14. CONSTABLE

# AND WORDSWORTH

*Morse Peckham*

### INTRODUCTION

In 1800, when the English poet William Wordsworth published the
second edition of *Lyrical Ballads,* he added a preface which defended
the romantic spirit in poetry that had replaced formalism with "inci-
dents and situations from common life," colored by the poet's imagina-
tion but presented in simple language. Wordsworth favored themes
from rustic life, for there, he felt, the elementary feelings were in their
natural habitat where, "incorporated with the beautiful and permanent
forms of nature," these "essential passions of the heart" would find "a
better soil."

To read certain passages from Wordsworth's preface is like touching
veins of feeling that reach easily and naturally out to the landscapes
of John Constable, to the painter's own expressed sentiments about
nature and art, and to the Suffolk countryside so many of his works
affectionately record. Affinities between poetry and painting—from the
classic humanist *ut pictura poesis* to the symbolists and beyond—have
nourished over the centuries a rich and varied continuity in these arts;
and no relationship between the two is more evocative of shared
content and analogous means than the works of Wordsworth and
Constable. As Herbert Read put it some years ago, "both went back to
the natural fact and built up their work on an intuitive apprehension
of that fact," while representing "the spirit of the English landscape
with an unrivalled intensity."

For further reading on relationships between literature and painting,
see Rensselaer W. Lee, *Ut Pictura Poesis: The Humanistic Theory of
Painting* (1967), originally published in *The Art Bulletin,* XXII (1940);

Mario Praz, *Mnemosyne: The Parallel Between Literature and the Visual Arts* (1970); and Karl Kroeber, *Romantic Landscape Vision: Constable and Wordsworth* (1975). Of the extensive literature on Constable, the following titles represent a fair sampling: Charles Robert Leslie, *Memoirs of the Life of John Constable, R.A.* (1843), and numerous later editions of this pioneer work on the artist; R. B. Beckett, *John Constable and the Fishers. The Record of a Friendship* (1952); Michael Kitson, "John Constable, 1810–1816: A Chronological Study," *Journal of the Warburg and Courtauld Institutes*, XX (July–December 1957), 338–357; *John Constable, Correspondence and Discourses*, 8 vols., ed. by R. B. Beckett (1962–1976); Graham Reynolds, *Catalogue of the Constable Collection in the Victoria and Albert Museum* (1960); and by the same author, *Constable, the Natural Painter* (1965); Kurt Badt, *John Constable's Clouds* (1971); Lawrence Gowing, *John Constable* (1971); Basil Taylor, *Constable: Paintings, Drawings and Watercolours* (1973); Leslie Parris, Ian Fleming-Williams, and Conal Shields, *Constable: Paintings, Watercolours, and Drawings* (1976); John Walker, *John Constable* (1979); and Ronald Paulson, *Literary Landscape: Turner and Constable* (1982).

The selection that follows is reprinted by permission of the author, Morse Peckham.

Obvious resemblances between Constable and Wordsworth have been noted often enough: devotion to the natural world and to humble life, accurate observation, a vague pantheistic feeling. But recently an even more striking connection has been suggested. In 1950 Kurt Badt offered a new explanation for Constable's extraordinary oil sketches, which he began to do in 1808, by pointing to Wordsworth's theory of the creative imagination, as it appears in the Preface to the *Lyrical Ballads*, first published in 1800, and reprinted in 1802 and in 1805.[1] Badt disclaims any attempt to prove that Constable knew Wordsworth's theories,[2] but he has raised a problem which has teased me for years. Are there any reasons for thinking that Constable consciously applied Wordsworth's ideas about writing poetry to his own creative activity, painting? A positive answer would be of the greatest interest to the student of nineteenth-century culture as well as to the student of the relations between poetry and painting, not less interesting to the literary historian than to the historian of art. For more may be involved than the influences of Wordsworth on Constable. If we accept the idea, as Andrew Shirley puts it in his introduction to his edition of Leslie's *Life of Constable*,[3] that modern art goes back to Constable, through the Impressionists, the Realists, the Barbizon school, and the painters who saw the Constables at Paris in 1824 and after, does it not follow that modern art goes back to Wordsworth, providing of course that what Constable gained from Wordsworth he passed on to his French successors? In what follows, I shall suggest two answers: first, Constable was almost certainly conscious of Wordsworth's ideas; and second, the characteristics of art which he derived from Wordsworth's precepts and practice were taken up by later painters.

The crucial year in Constable's life is 1808, when he began to do the amazing oil sketches (Fig. 41) which still are fresh and modern. Only a look at his work in chronological order tells that these sketches were entirely new, a deliberate experiment, a complete break with what had gone before; new because, as Shirley puts it, of the "quality of their light or by the violence of the transi-

41. John Constable, *Barges on the Stour: Dedham Church in the Distance, c.* 1812, Oil on paper on canvas, 10¼″ x 12¼″ (The Victoria and Albert Museum, London)

tory effect presented,"[4] and that their unique character was not realized in his large "finished" paintings until the mid-1820's, if ever. That Constable was conscious of his daring and his novelty appears in a remark he made that spring to Benjamin Robert Haydon. Joseph Farington, painter, student of Richard Wilson's, diarist, friend of Constable's since 1798, records for May 19, 1808, the following: "Constable called.—Haydon asked him 'Why He was anxious abt. what he was doing in art?'—'Think, sd. He, what I am doing,' meaning how much greater the object and the effort."[5]

Certainly up to 1808 Constable's originality had shown itself only in a conscious effort to be truthful to nature. On May 29, 1802, he wrote to his old friend Thomas Dunthorne that he was determined to be a "natural painter." He felt there was "room enough," judging by the current academy. "Nature is the fountain's head, the source from whence all originality must spring."[6] There is nothing really new here. Such an idea could have come from Wordsworth, but it could have come from innumerable

sources, some of which are suggested by Leslie and his editor, Shirley. The most probable source is simply the current Natural Theology of England. Another 1802 passage is more significant. "For the last two years I have been running after pictures, and seeking the truth at second hand. I have not endeavored to represent nature with the same elevation of mind with which I set out, but have rather tried to make my performances look like the work of other men."[7] His problem was this; it is all very well to be true to nature, but to what in nature should one be true, and how? He had the consciousness of the great Romantics that his mission was to found a new mode of art, but no painter then living could have told him what to do. It was, I think, Wordsworth who pointed the way.

There is one obvious connection between Wordsworth and Constable. From East Bergholt, where Constable's family lived, it is only a short walk to Dedham, where Golding Constable owned a mill. In Dedham lived the Dowager Lady Beaumont, and at her house, sometime before 1795, Constable was introduced to her son, Sir George Beaumont, born in 1753, painter, connoisseur, collector, quasi artistic dictator of London. Beaumont had perceived Constable's talent and thus the introduction was effected. The two men were intimate, more or less, as much as two men of different ages and different levels of society could be, until Beaumont's death in 1827.[8] In Leslie's *Life* there are frequent references to visits to Beaumont, to favors conferred by Beaumont upon Constable, to Beaumont's directions to Constable to take care of his health, when, between the ages of 35 and 40, he came close to a breakdown. In 1823, when Constable visited Beaumont at Coleorton, which Beaumont, after 1809, preferred to his ancestral estates at Dunmow, in Essex, Beaumont read parts of Wordsworth's *The Excursion* to him, and Constable was most impressed. It is plain, from Farington's diary, that not long after Constable came to London more or less permanently, around 1800, he became a part of the circle of artists around Beaumont, a group which included, among others, Haydon and Wilkie.[9]

One of the most important events in Beaumont's life occurred in August, 1803. In the spring, he had met Coleridge at the poet Sotheby's, and had disliked him at once. When he went to the Lake District in August of that year, he was at first distressed that, having taken lodgings at Jackson's, in Keswick, he was a neighbor of Coleridge's, who leased Greta Hall, practically next

door. But on August 6, 1803, Coleridge wrote to Wordsworth at Grasmere that the Beaumonts, Sir George and the sensitive, sentimental, easily excited, and slightly absurd Lady Beaumont, "are half mad to see you."[10] Apparently they did not meet at that time, but within a few weeks Beaumont had bought a plot of land where Wordsworth and Coleridge could build together, though Wordsworth, knowing his S.T.C.,* never did. Well within a year William and Dorothy Wordsworth were carrying on an active correspondence with Sir George and Lady Beaumont. It is unnecessary to enter into the details of these letters, except to note that they are frequent to 1808 and sporadic thereafter.[11] Occasionally the Beaumonts summered at the Lakes, and in the winter and spring of 1806 and 1807 the entire Wordsworth family spent the winter at Coleorton, where the new house, for which Wordsworth designed a winter garden, had not yet been built. When Wordsworth was in London he often stayed at Beaumont's. In April and May, 1806, he stayed with them. In 1807, April and May, he was again in London; at this time his *Poems in Two Volumes* was published. Though he did not stay with his aristocratic friends, the three of them called on Farington.[12] In March, 1808, again in London, to take care of Coleridge, he spent part of his visit at Dunmow.

Constable first met Wordsworth in 1806. At the suggestion of his Uncle, David Pike Watts, and perhaps with the approval of Sir George, he had gone on a sketching trip to the Lake Country. Farington records: "Constable remarked upon the high opinion Wordsworth obtains of himself; . . . He also desired a Lady, Mrs. Loyd, near Windermere when Constable was present to notice the singular conformation of his Skull.—Coleridge remarked that this was the effect of intense thinking."[13] When he was in London, Constable called frequently on Farington, once or twice a month at least; and he was in London during Wordsworth's 1806 and 1807 visits, though perhaps not during the visit of March, 1808, when Beaumont was not in town. Wordsworth was again in London at Beaumont's in May, 1812, and visited London in 1815 and in 1820. This is important, for there are two bits of information from another source that indicate that at least once Constable met Wordsworth at Beaumont's house in Grosvenor Square.

* Samuel Taylor Coleridge—Ed.

## Constable and Wordsworth

In August, 1824, Henry Crabb Robinson, diarist and friend of most of the major Romantics, was at Brighton on a holiday. Part of his entry for August 26 reads as follows: "of the party Mr. Constable, a landscape painter of great merit, Masquerier says: he knew Wordsworth formerly, took an interest in his conversation, and preserved some memorials of his composition when they met at Sir George Beaumont's."[14] On the following December 13, he wrote to Dorothy Wordsworth: "At Brighton I met with a painter who had met Mr. W: at Sir Geo: Beaumonts Mr. Constable—It was some years ago. He seemed to have retained just impressions of your brothers personal distinction among the poets, tho' too passionately & exclusively attached to his own art to allow himself leisure for the study of any other."[15]

The reference to "some years ago" could refer to any of Wordsworth's visits to London. A vague phrase, it cannot be pressed too hard. On the other hand, the diary entry, written down when the meeting with Constable was still fresh in Robinson's mind, seems to indicate more than just one dinner meeting at Beaumont's; that meeting probably took place in 1812 or in 1815, since, with one exception, all of Wordsworth's poems to Beaumont were published in 1815. The important thing is that Constable, who "when young, was extremely fond of reading poetry," was impressed by Wordsworth, and took the trouble to "preserve some memorials of his composition." In his published letters he mentions only Cowper, Wordsworth, and Coleridge of contemporary poets, and of Wordsworth quotes only the "Thanksgiving Ode."[16]

It is not, fortunately, necessary to depend solely upon the meager evidence of a few meetings to get a better idea of what Constable may have picked up from Wordsworth. The poet kept Beaumont thoroughly informed about what he was doing in poetry. Especially he told him about *The Prelude*, as it was later called, the poem about the growth of his own mind. He finished it in 1805, at least the first version, though it was not published until 1850, and the fact that Beaumont knew of it in 1804 and had read it by 1808 is of the greatest importance, for in *The Prelude* are to be found the most important expositions of Wordsworth's ideas. Farington, who met Wordsworth at Beaumont's in 1806, reveals how the Beaumonts broadcast Wordsworth's fame from 1803 to 1809. On November 29, 1803, Beaumont told Farington

about the greatness of Coleridge and Wordsworth at Keswick the previous August. On March 21, 1804, he told him all over again and added information about *The Recluse,* as *The Prelude* was then known. He read "Tintern Abbey" to him, a poem which, Beaumont said, he had read a hundred times. Again at dinner at Beaumont's on November 7, 1806, Farington heard more about *The Prelude,* and in 1809 Lady Beaumont praised the great Preface to the *Lyrical Ballads.*[17] Beaumont, in these years when Constable was forming his style, knew more about Wordsworth's work than almost anyone outside of the immediate Wordsworth-Coleridge circle. Coleridge had shown him parts of *The Excursion* by May, 1804, probably when he was staying at Dunmow before going to Malta in late March, 1804. Wordsworth wrote to him about *The Prelude* in December, 1804. By May, 1805, both the Beaumonts had seen "some books" of it. In June, 1805, Wordsworth sent Beaumont the first 61 lines of Book VIII. In 1805 Dorothy expected that he would read him the whole work. Most important of all, the Beaumonts were entrusted to take care of the binding of the copy of the work destined for Coleridge, on his return from Malta, and this bound copy was received at Grasmere, along with other books and presents from the Wordsworth children, in June, 1806. It is not surprising, therefore, that Beaumont told Farington more about the poem in the following November; by that time he had read it. It was planned that he should; apparently, not wishing to make Beaumont wait for the return of the dilatory Coleridge from Malta and no doubt anxious to have a reaction from a man for whom he had great affection and respect, Wordsworth sent him the poem so that he could read it, and have the MS bound for Coleridge.[18]

From these facts it is quite permissible to conclude that Beaumont told Constable about *The Prelude,* and persuaded him to read the Preface as well as Wordsworth's poetry, of which two important volumes appeared in 1807. It will also be remembered that the Preface became available easily with the republication of *Lyrical Ballads* in 1805. When he was fifty years old, Beaumont became the patron of the two greatest creative artists in England, Wordsworth and Coleridge. If he and Lady Beaumont told an old but apparently never intimate friend like Farington about them and their writings, they undoubtedly told a great many other people, especially since they lionized Wordsworth when he came to London. Would Constable, who was in and out of their house

when they were in London for the season, whom Beaumont always regarded as a kind of pupil and protégé, who probably visited them at Dunmow and certainly in later years visited at Coleorton, whom Beaumont knew intimately and constantly advised for over thirty years—would Constable have been kept in the dark? It seems most unlikely. I think we can assume with considerable confidence that Constable knew Wordsworth's poetry, published and unpublished, his principal essay on poetry, and Coleridge's "The Rime of the Ancient Mariner," which was to be read only in the *Lyrical Ballads* until it reappeared, revised, in 1817 in *Sibylline Leaves*. And this poem, in 1824, Constable called the best modern poem. Presumably he knew others. The next step is to ascertain what Constable might have learned from Wordsworth; to this problem I now turn.

The following analysis is based upon a concept of early nineteenth-century Romanticism of which I have published elsewhere a more detailed account.[19] The fundamental assumption of Romanticism is that the cosmos, or external reality, is a living organism, and that the psycho-physical personality is also a living organism. From this idea are derived others. Change is a positive value; the artist's task is to reveal a world in which "reality" lies in the process of change, not in forms which underlie illusions of mutability. In the same way he reveals the processes of the internal world of mind and emotion, or spirit. The poet and the musician can show the process itself, but the painter must reveal the unique moment of change, both external and internal. Change depends upon imperfection, another positive Romantic value; hence lack of "finish" is desirable in a painting. Change and imperfection involve novelty; the artist can bring something new into the world, create something out of nothing. His instrument is the creative imagination, the source of which is in the unconscious mind. Both poet and artist, therefore, turn from the imitation of the real or ideal worlds in traditional genres to unique and original insights expressed in unique forms; here is the source of the all-important break with the subject. Form and matter become identified. The meaning of the work of art lies not in what is represented but in how the work is presented. As Pater put it, "It is the art of music which most completely realises this . . . perfect identification of matter and form." "In art's consummate moments the end is not distinct from the means, the form from the matter, the subject from the expression;—and to it therefore . . .

all the arts may be supposed constantly to tend and aspire." The formal qualities of a work of art, more than the subject matter or even rather than the subject matter, have an emotional effect. Contemplation of a work is in itself a form of creation. The observer's imagination creates a moment of intense perception and self-revelation from the "unfinished" materials the artist has assembled for him. To quote Pater again, "Not the fruit of experience, but experience itself, is the end." To the Romantic poet and artist, the dignity of a work of art does not depend on the subject but on the way it is used in pure creative activity. A poem—and a painting—can be made about anything.[20]

Now all of this is in Wordsworth, though sometimes confused with and overlaid by eighteenth-century thinking. And the great places to find it are "Tintern Abbey" (1798), the Preface to the *Lyrical Ballads* (1800), and *The Prelude*, finished in 1805 and known to Beaumont by June, 1806, and through Beaumont available by report to Constable. The acceptance of change is the point of *The Prelude*, which Wordsworth often referred to as the poem about the growth of a poet's mind. "Tintern Abbey" is concerned with the differences between Wordsworth's feelings at two different times in his life. *The Prelude* is built around "spots of time," moments of unique self-realization inspired by certain aspects of the visible world, specific places at specific times, under the influence of specific conditions of weather. He repeatedly emphasizes that the world itself is a living thing, and his connection with it he characterizes as standing "in Nature's presence a sensitive being, a creative soul," with a "power like one of Nature's," just as in "Tintern Abbey" he speaks "of all the mighty world of eye and ear,—both what they half create,/ And what perceive." Stylistically, the concept of imperfection appears in the alternation between the neutral style, neither prose nor poetry, and a heightened or poetic style. To Wordsworth the sources of creative activity are in the unconscious mind. Furthermore, Wordsworth threw off the tyranny of the genres when he treated pastoral subjects in an epic, or lofty and dignified, manner. Although he arrived at the idea by the way of eighteenth-century sentimental humanitarianism, the important thing about his choice of insignificant subjects, both in the human and in the natural worlds, is that style "will entirely separate the composition from the vulgarity and meanness of ordinary life"; this is a profoundly different concept of style from that of his predecessors, who searched

for a style appropriate to the subject matter. And in fact, he regarded himself not as a poet of nature, but as a poet of psychology. Hence he was interested in the growth of the mind and in the nature of creation as a process. Hence "poetry takes its origin from emotion recollected in tranquillity; the emotion is contemplated till, by a species of re-action, the tranquillity gradually disappears, and an emotion, kindred to that which was before the subject of contemplation, is gradually produced, and does itself actually exist in the mind." The initial shock of illumination sinks into the conscious and unconscious mind, becomes an organic part of the artist's psycho-physical personality, gradually rises to the surface in a "spontaneous overflow of powerful feelings," and takes poetic form. Thus, instead of being imitation, poetry is creation, the emergence of novelty in the world, the creation of something out of nothing. The excellence of the work of art does not depend upon what is represented, but upon the style, which is an expression of the organic and intellectual superiority of the poet; hence the rejection of poetic diction, which is the expression of the distinction between form and matter. Poetic diction, like the genres, was externally applied to give charm to the idea. Wordsworth, however, emphasized rhythm, to which "the Poet and Reader both willingly submit"; aesthetic creation and aesthetic contemplation are different functions of the same power, imagination, the faculty which gives the experience of unity with the outer world, the experience of simultaneously creating and perceiving.

Again and again the Preface has profoundly stimulated the minds of young poets. Imagine what even an imperfect notion of the character and possibilities of these ideas might have meant to an artist who felt himself a dedicated spirit, but who had arrived at his thirtieth year without yet knowing how to go about fulfilling his mission. Constable spent most of 1804 and 1805 in Suffolk, but in 1806 he went to the Lakes and met Wordsworth, and thereafter he was often in London, in contact with Beaumont and his circle, including Farington, and in a position to hear about Wordsworth from Beaumont and discuss him with Beaumont and his friends. In 1807 he tells Farington that he thinks that he is on the track of "something original," and in 1808, in May, shortly after the first of his wonderful oil sketches, he expresses to Haydon his agitation over what he is trying to do, his sense of what is at stake both for himself and for the future of his art.

Now it is necessary to show how many of these ideas of Wordsworth's are expressed in Constable's painting, especially in the great sketches of the years following 1808 and occasionally in his later works, and also how they are expressed in his letters and recorded remarks. First of all, consider the acceptance of change. If an artist wishes to symbolize the idea that reality lies in change, both internal and external, and if he wishes to paint landscapes, he must focus on a unique aspect of landscape, a particular spot at a particular time, and on a moment of unique response, for he must paint in terms of the most transitory qualities he observes, light and weather. To quote Shirley again, Constable meant by chiaroscuro "that the world is comprehended by the eye in terms of light and shade, that in fact one never sees line but only coloured light and dark." Hence he uses the palette knife and blots of color. Again, these sketches are "typical of the later Constable either by the quality of their light or by the violence of the transitory effect presented." "In these sketches Constable shows for the first time complete mastery of his new method for expressing light in motion." Gradually he began to get this quality in his paintings. Shirley points out that in 1811–13 his pictures began to have an air of impending change in the sky.[21]

Yet his problem was not fully solved. Badt's first point is that the landscape and sky were not yet perfectly organized into aesthetic unity. According to him, the release came with Constable's study of Luke Howard's *Climate of London,* published in London from 1818 to 1820, which included Howard's classification of clouds and their place in the levels of the atmosphere. From 1821 to 1822 Constable was absorbed in huge cloud studies, oil on paper, based on Howard's classifications. The studies enabled him to bring together the appearance of the landscape with the appearance of the sky and get the quality of unity he had so far missed. Badt feels that only after these paintings did Constable realize his ambition to catch the particular moment. And indeed, such was his ambition. "Yet, in reality, what are the most sublime productions of the pencil but selections of some of the forms of nature, and copies of a few of her evanescent effects."[22]

Now according to Wordsworth, the sensitive soul before nature also created in a state of aroused emotion. And this is also apparent in Constable's work, especially in the sketches. Shirley notes the "violence of the transitory effect presented," and Badt's second main point is that the Constable sketch bears exactly the

same relation to the final picture as Wordsworth's original emotion does to the spontaneous overflow of powerful emotions which find themselves expression in poetic language. I think Badt is quite correct, and I shall say nothing more about it, except to emphasize the creative activity of the artist.

In 1824 Constable wrote: "It is the business of a painter not to contend with nature, and put such a scene, a valley filled with imagery fifty miles long, on a canvas of a few inches; but to make something out of nothing, in attempting which, he must almost of necessity become poetical."[23] From this important passage I would first point out the phrase, "make something out of nothing." Here is the concept of radical creative activity, alike in both poetry and painting. The neoclassic idea was that the resemblance of painting and poetry lay in the subject, but Constable finds the relation in the making of something out of nothing, that is in the making, or style. "Chiaroscuro," he once said in later years, "colour, and composition, are all poetic qualities."[24] Later in 1824, the year his paintings appeared at the Salon in Paris, he wrote: "My wife is translating for me some of the French criticisms. They are very amusing and acute, but very shallow and feeble. This one—after saying 'it is but justice to admire the *truth*, the *color*, and *general vivacity* and richness.'—Yet they want the objects more formed and defined—etc., etc., and say that they are like the rich preludes in musick, and the full harmonies of the Eolian Lyre—which *mean* no thing and they call them orations, and harangues, and highflown conversations affecting a careless ease—etc., etc., etc., . . . Is not some of this *blame* the highest *praise?* What is poetry? What is Coleridge's *Ancient Mariner*—(the best Modern poem) but something like this."[25]

This leads us to subject matter. The typical eighteenth-century attitude was expressed by J. T. Smith, one of Constable's early mentors, in his introduction to a series of etchings of cottages published in 1797. "I am content," he says, "that rural and cottage-scenery shall be considered as no more than a *low-comedy* landscape."[26] Badt points out the Wordsworthian nature of Constable's devotion to humble landscape.[27] "The ordinary things," wrote Wordsworth in his Preface, "should be presented to the mind in an unusual aspect." But Badt does not realize the full significance of this in Constable's work. True enough, subjects can be found everywhere, "under every hedge," as Constable put it once, but the important thing was the break from the tyranny

of the subject. Sentimental humanitarianism could lead to humble subjects, and did, but in Constable the dignity of the painting did not lie in the subject. Two passages are important here. The first again comes from 1824, in November. "I have to combat from high quarters even from Lawrence, the plausible argument that *subject* makes the picture."[28] The second comes from a letter of March 12, 1831. "The painter [meaning himself] is totally unpopular, and ever will be on this side the grave; *the subjects nothing but the art,* and the buyers wholly ignorant of that."[29] This is to Lucas, the engraver for the book of plates from Constable's paintings, a project which brought him immense trouble and little profit.

We come finally to the concept of the positive value of imperfection, which lies at the very heart of Romanticism. Badt and others have pointed out that Constable's sketches, even more than his paintings, lack the traditional qualities of composition, yet somehow hang together. I have mentioned the importance of rhythm to Wordsworth. It seems to me that these early sketches are given their special excitement by exactly that quality. The large rough brush strokes, dashed on in heat of inspiration, or moment of imaginative shock, the patches of paint smeared on with a palette knife, directly express the psychophysical relation of the painter's organism to the work in hand. One can feel the movement of the painter's hand and arm; the swing of his body is recorded in the application of the paint; the observer reconstructs the moment of creative inspiration. Again, especially in the cloud studies, the unity, the felt organization, comes from the rhythmic repetition of elements presented spatially with just enough regularity to be noticeable. The technique of these sketches, then, necessarily leads to lack of finish, or to imperfection.

That imperfection *is* a positive value, indicating capacity for growth, symbolizing the world, inner and outer, caught in the moment of mutation, is one of the central ideas of Romanticism. Farington and others were always telling Constable that he lacked "finish," by which they meant that if you look at his paintings close up you find that they lack the representational quality. Yet Constable persisted in his ways, and his loose, roughly impressionistic technique gradually became more and more conspicuous in his Academy paintings, especially, according to Shirley, after 1829.[30] Such a technique, regularized by the French Impression-

ists, has its well-known representational advantages, but I should like to emphasize its expressive quality, that is, its symbolization of a growing inner and outer world by, according to traditional standards, its very incompleteness. But even more, it brings the observer into the aesthetic situation. From blobs and spots and loose strokes of paint assembled from his point of view by the artist, the observer creates a painting. He is not a passive observer; he half creates and half perceives. He also experiences the workings of the creative imagination, the experience of unity with the outer world. It is not surprising that Pater was able to adapt Wordsworth's ideas about nature to the world of painting.

I am convinced, then, that Constable had the opportunity through Sir George Beaumont to become acquainted with the ideas of Wordsworth, as expressed in conversation, in letters, in published prose, and in poetry, published and unpublished, and that he did actually become acquainted with them, that he was profoundly affected by them, and that the sudden redirection of his art worked out in the sketches beginning in 1808 was the result of that impact upon his mind and sensibility. If all this is true, and if Constable is one of the major sources of modern art, through the several dozen pictures and sketches in Paris beginning in 1824,[31] and through the study of Constable made by Monet and Pissarro on their visit to London, we are presented with a fascinating possibility.

For those terms in which I have described the similarities of Wordsworth and Constable can be just as successfully applied to the Impressionists. The first category, the acceptance of change, is even more strikingly worked out in the work of the Impressionists than in Constable's. Monet's famous haystacks, painted under an immense range of light and weather conditions, are perhaps the most perfect example, while the Impressionists' technique is, of course, even more "unfinished" than that of Constable. The principal difference is, of course, that the Impressionists methodized their technique by the study of color, but the impulse behind that effort is the same as Constable's, the determination to catch the changing aspect of the world.[32] Further, the ultimate success of Constable in getting unity of sky and landscape was carried further and fully consummated by the Impressionists' technique. Light, the most evanescent quality of observable nature, becomes the means of organizing the whole

painting into an aesthetic structure. Each painting catches, literally, one of Wordsworth's "moments of illumination."

This principle of seizing the moment can even be extended to their treatment of space. They paint, as it were, a spatial moment. The observer is aware that the landscape or the interior extends beyond the frame of the picture; there is no particular reason why it should stop where it does. There is something deliberately arbitrary about the selection of both the spatial and the temporal limitations of the picture. That the will, or creative power, of the painter is arbitrarily imposed upon the landscape is forced to our attention. Thus our attention is directed to the painter rather than to the objects. Consequently, he is pretty indifferent to what he paints.

Although the sociological and moral critic can find something extremely significant in the fact that the Impressionists painted "vacation scenes" or scenes, as Degas and Renoir did, of bourgeois amusement—pretty flowers, the "Townsman's landscape," boating trips, picnics, race meetings, the ballet—from the point of view of the aesthetic critic, the important thing is that the Impressionists constantly indicate their lordly indifference to the subject, their deliberate refusal to get an emotional response by choosing subjects which have a sentimental lure. The radical creativeness of the artist is the important thing. He paints a picture; he doesn't make a representation of an object. Perhaps this radical break with the subject matter is the most important thing which Constable contributed to the French tradition.

Finally, to these categories of growth, of change, of the moment of illumination, of radical creativity, may be added "imperfection." Even more than in Constable, the technique of the Impressionists forces the observer to experience the moment of internal illumination, of union of the inner and outer worlds, forces him to create the painting. So that the value of painting becomes the opportunity it offers painter and observer to experience the creative act. "Not the fruit of experience, but experience itself, is the end," said Pater in the 1860's, in the decade when the Impressionists were beginning to formulate their theory. "The moment of illumination," objective and subjective, allies Wordsworth, Constable, and the Impressionists—"the moment of illumination" with all its associated and supporting ideas of change, organicism, imperfection, growth, radical creativity.

A fascinating vista—Wordsworth to the Impressionists—but

when we think of how the work of the latter has led to the astonishing achievements of painting in this century, the possibility that Constable's accomplishments can be traced to Wordsworth's ideas and poetry becomes immensely important. To me the line from Wordsworth to the moderns through Constable and the Impressionists is irresistible. It will not be to everyone, of course, but at the very least it is a possibility that requires examination and consideration. If art historians think I have asked a serious question about the sources and continuity of the art of the past century and a half, I shall be satisfied.

*NOTES*

[1] Kurt Badt, *John Constable's Clouds* (London, 1950), Chap. IX.

[2] Badt, 81.

[3] Charles R. Leslie, *Memoirs of the Life of John Constable,* ed. Hon. Andrew Shirley (London, 1937), lvii.

[4] Leslie, lxii.

[5] Joseph Farington, *Diary,* ed. James Gleig (London, 1924), V, 65.

[6] Leslie, 20. See also Farington for Feb. 10, 1804 (III, 189).

[7] Leslie, 21.

[8] Leslie, 5–6.

[9] Farington, V. 94; Leslie, 152.

[10] Samuel Taylor Coleridge, *Unpublished Letters,* ed. E. L. Griggs (London, 1932), I, 266.

[11] See Ernest de Selincourt's edition of the Wordsworth family letters: *Early Letters of William and Dorothy Wordsworth (1787–1805)* (Oxford, 1935); *The Letters of William and Dorothy Wordsworth: The Middle Years (1806–1820)* (Oxford, 1937).

[12] Farington, April 28, 1807, IV, 129. Wordsworth called on Farington again on April 26, 1808 (Farington, III, 206). I have determined Beaumont's movements from Farington's diary, the Wordsworth letters, and the Coleridge letters, including both the Griggs edition and *Letters,* ed. E. H. Coleridge (London, 1895). I have also consulted *Memorials of Coleorton: being Letters from Coleridge, Wordsworth and his Sister, Southey, and Sir Walter Scott to Sir George and Lady Beaumont of Coleorton, Leicestershire, 1803–1834,* ed. W. Knight (Edinburgh, 1887). Leslie is also of some value for this purpose.

[13] Farington, IV, 239. "Mrs. Loyd" was presumably the wife of Charles Lloyd, friend of Wordsworth, Coleridge, Lamb, and DeQuincey. Christopher Wordsworth, William's brother, married Priscilla Lloyd, Charles's sister.

[14] *Henry Crabb Robinson on Books and their Writers,* ed. Edith J. Morley (London, 1938), I, 312. Wordsworth wrote a number of poems referring to Beaumont or dedicated to him: "Elegiac Stanzas suggested by a picture of Peele Castle in a Storm, painted by Sir George Beaumont" (wr. 1805, pub. 1807); "Inscriptions in the Grounds of Coleorton," etc. (wr. 1808, pub. 1815); "Written at the Request of . . . Beaumont . . . and in his name, for an Urn . . . in the Same Grounds" (wr. 1808, pub. 1815)—this is the monument in the painting

finished by Constable in 1836 (Leslie, 341); "Epistle to . . . Beaumont" (wr. 1811, pub. 1842); "Upon the Sight of a Beautiful Picture Painted by . . . Beaumont" (wr. 1811, pub. 1815); "In a Garden of . . . Beaumont" (wr. 1811, pub. 1815); "For a Seat in the Groves of Coleorton" (wr. 1811, pub. 1815).

[15] H. C. Robinson, *Correspondence with the Wordsworth Circle,* ed. Edith J. Morley (Oxford, 1927), I, 134.

[16] Leslie, 361, 141.

[17] Farington, II, 172, 207; IV, 42; V, 132.

[18] Wordsworth, *Early Letters,* 392, 424, 495, 517, 561; *Middle Years,* I, 36.

[19] "Toward a Theory of Romanticism."

[20] See also my essay on modern art, "The Triumph of Romanticism," *The Magazine of Art,* XLV (1952), 291–99.

[21] Leslie, lxv, 47.

[22] See Leslie, Chapter XVIII, Lecture V, June 16, 1836, next-to-last paragraph. He also said, "Painting is a science, and should be pursued as an inquiry into the laws of nature. Why, then, may not landscape painting be considered as a branch of natural philosophy, of which pictures are but the experiments." The contrast between this remark and such statements as that quoted below on the comparison of his own work to Coleridge's "Ancient Mariner" is striking. Any attempt to discuss this inconsistency would take me far beyond the limits of my subject. However, it may be said (1) that the notions which I have called "Romantic" are also to be found in nineteenth and twentieth-century science and philosophy; and (2) the attempt to justify art, especially to the Philistine, by putting it on a level with science, was common in the nineteenth century and is far too common today. Those who try to make science and art rivals do not know what either is. Constable's intellectual background of Natural Theology (see Leslie, 10) is one of the most common sources of the confusion of art and science in nineteenth-century England. It got Ruskin into even more trouble than Constable.

[23] Leslie, 173. This letter, dated Aug. 29, 1824, was written three days after he met Robinson and talked about Wordsworth.

[24] Lecture III, June 9, 1836, last paragraph. Leslie, Chap. XVIII.

[25] Leslie, 180. Note the interesting anticipation of Pater.

[26] Shirley's addition to Leslie, 7.

[27] Badt, Chapter IX.

[28] Leslie, 175.

[29] Leslie, 260. Cf. Farington's complaint to Constable that his paintings were "unfinished" (July 23, 1814, VI, 152).

[30] Leslie, lxxiii.

[31] In his edition of Leslie, Shirley included a large amount of new material about Constable's pictures in France and about his art dealers there. See especially p. 205 for the number of Constable's pictures on exhibition or in collections in and near Paris from 1824 to 1838.

[32] Another obvious relation between the two is the attempt of both Constable and the Impressionists to base their work on scientific observation. (See Note 22, above.) I do not, however, think this is particularly important. For one thing, presumably the Impressionists did not know about Constable's scientific interests, and for another, the attempt to have the arts rival the sciences by placing them on a "scientific" basis was so common in the nineteenth century, in all schools of art and criticism, that it would probably be impossible to find a source.

# 15. DELACROIX'S ART THEORY

## George P. Mras

### INTRODUCTION

Eugène Delacroix is a figure of crucial importance to the art of the nineteenth century. He is one of that century's greatest masters and represents, in a unique way, both the continuity of tradition and the innovative thrust of new directions. Baudelaire, the French poet, sensitive critic of the arts, and admirer of Delacroix, wrote in his remarks on the Paris Salon of 1846, "But take away Delacroix and the great chain of history is broken. . . ." This may be overstatement, but it dramatizes Delacroix's real links with the past—with classical antiquity, the Renaissance, and the Baroque—all of which are brought to light in his drawings and paintings and in his own words from his *Journal*, his correspondence, and his sketch for a proposed *Dictionnaire des beaux-arts*. Thoroughly involved with literary tradition, Delacroix drew themes for his art from Dante, Shakespeare, Goethe, Scott, and Byron, among others. As a central figure of the Romantic movement, as an opponent of entrenched reaction, as a colorist in theory and practice, and one who extended the passion and bravura of the painted sketch into new significance, he was one to whom later generations of artists looked back, respectfully, as to a spiritual ancestor.

He was one of those rare artists whose intellect and passion, equally intense, seem to have been finely balanced. This becomes clear when one reads the thoughts he himself set down and measures them against his painting. Then the truth of Baudelaire's assertion that Delacroix "was passionately in love with passion and coldly determined to seek the means of expressing it" comes through as a fitting epigram.

The study by George P. Mras, from which the following selection is taken, is the first to examine methodically Delacroix's theories. It conclusively reveals the kinship between the artist's ideas and past tradition and places in better perspective that stereotyped, troublesome line of confrontation so often drawn between Classicism and Romanticism. Indeed, it could be said—and not facetiously—that the full range of Delacroix's statements, visual and verbal, goes far to make the ambiguity of that line remarkably clear.

For further reading, there are: among other articles by George Heard Hamilton on this artist, "Delacroix and Lord Byron," *Gazette des Beaux-Arts*, series 6, XXIII (1943), 99–110, and "Hamlet or Childe Harold? Delacroix and Byron," *Gazette des Beaux-Arts*, series 6, XXVI (1944), 365–386; Lee Johnson's articles, "The Etruscan Sources of Delacroix's 'Death of Sardanapalus'," *Art Bulletin*, XLII (1960), 296–300, "Two Sources of Oriental Motifs Copied by Delacroix," *Gazette des Beaux-Arts*, series 6, LXV (1965), 163–168; "Towards Delacroix's Oriental Sources," *The Burlington Magazine*, CXX (March 1978), 144 ff., and (September 1978) 603; and "Delacroix, Dumas, and Hamlet," *The Burlington Magazine*, CXXIII (December 1981), 717–721; René Huyghe, "Delacroix et Baudelaire: A New Epoch in Art and Poetry," *Arts Yearbook*, II (1958), 27–46; Beaumont Newhall, "Delacroix and Photography," *Magazine of Art*, XLV (1952), 300–303; and Robert Rosenblum, " 'Demoiselles d'Avignon' Revisited," *Art News*, LXXII (April 1973) 45–48, which cites one of the sources of Picasso's famous painting as Delacroix. Two articles by Mras are incorporated in the text of *Eugène Delacroix's Theory of Art:* "Literary Sources of Delacroix's Conception of the Sketch and the Imagination," *Art Bulletin*, XLIV (1962), 103–111, and "*Ut Pictura Musica:* A Study of Delacroix's *Paragone*," *Art Bulletin*, XLV (1963), 266–271. Among the books on Delacroix, there are Raymond Escholier, *Delacroix: peintre, graveur, écrivain*, 3 vols. (1926); René Huyghe, *Delacroix* (1963); Lee Johnson, *Delacroix* (1963); and Frank Anderson Trapp, *The Attainment of Delacroix* (1971). Jack Spector, *The Murals of Eugène Delacroix at Saint-Sulpice* (1968), treats a special area of the artist's work, as does the same author's *Delacroix: The Death of Sardanapalus* (1974). Finally, there are Charles Baudelaire's fine obituary tribute to the artist, translated by J. Mayne in *The Mirror of Art* (1955), 308 ff., and the various editions of Delacroix's own writings, especially his *Journal*, translated

by Walter Pach (1937), and H. Wellington, ed., trans. by Lucy Norton (1951). A French edition of the *Journal* is *Journal d'Eugène Delacroix*, edited by André Joubin, 3 vols. (1960).

Translations of the French passages in this selection appear in the notes, beginning on page 306.

The selection that follows is from *Eugène Delacroix's Theory of Art* by George P. Mras. Copyright © 1966 by Princeton University Press. Published for the Department of Art and Archaeology, Princeton University. Selections from chapter III, pp. 72–98, reprinted by permission of Princeton University Press.

# THE CREATIVE PROCESS

Perhaps the most extraordinary aspect of Delacroix's art theory is that which treats the creative process. For, while eloquent and comprehensive discussions of the nature of painting and the role of imitation abound in the history of art theory, it remained for the Romantic period to explore more thoroughly the mysterious and subjective elements of the genesis of the work of art. In this field the extensive treatment Delacroix devotes to such crucial topics as imagination, finish, genius, rules, and boldness acquires special significance, not only as a document in the history of Romantic aesthetics but also as the product of an artist intimately involved in the drama of the creative act. Furthermore, his exquisite awareness of the complex and subtle facets of this phenomenon coupled with the unique clarity of his vision enabled him to shed valuable light on the creative origin and development of his own art. As a result, one can clearly discern that he did not theorize merely on the basis of his practice; rather, he mingled with the results of practical experience ideas enunciated by earlier art theorists. Moreover, he flatly contradicts those authorities on his art who pose a dichotomy between his rational theory and his irrational expression. As we shall discover, he valued the "Classical" and the "Romantic" aspects of artistic creation, both of which he considered necessary for the proper evolution of an effective work of art.

## IMAGINATION

Consider, to begin, that faculty with which he has been universally credited—the power of imagination. When Baudelaire wrote that for Delacroix "l'imagination était le don le plus précieux, la faculté la plus importante,"[1] he merely echoed the sentiments of the artist himself, who had once decisively stated: "*Imagination.* Elle est la première qualité de l'artiste."[2] Such wholehearted commitment to the sovereignty of this Romantic deity would seem to suggest a belief in the irrational inspiration of

281

creation. Typically, however, Delacroix's allegiance in this matter is not undivided. Although he valued highly the operation of the imagination, he never intended to abandon himself completely to its dictates without observing the compensatory restraint of rational control. Examples in the realms of both the visual arts and literature provided evidence of the dangers of the workings of the unbridled imagination. Rubens, whose works he generally admired, occasionally suffered under the domination of an imaginative faculty which engendered various faults: "Sa peinture, où l'imagination domine, est surabondante partout; ses accessoires sont trop faits; son tableau ressemble à une assemblée où tout le monde parle à la fois."[3] And he noted in the works of Edgar Allan Poe, whose morbidly imaginative effects he might have been expected to relish, an alien and reprehensible license that was in no way to be taken as a model for French artists, who by temperament and tradition were allied to a more Classical approach. . . .[4] The imagination, rather, was to be restrained from excessive flights of fancy by the power of reason, with intellect at all times exerting its tempering influence.[5]

This reassertion of the role of reason in the creative process challenged the position of purer Romantics such as Jean-Jacques Rousseau, who exalted freedom from the limited vistas of reason. . . .[6] Even more suspect to Delacroix would have been the dictum of Chateaubriand who had asserted, in *Génie du Christianisme* (1802), that "la peinture, l'architecture, la poésie et la grand éloquence ont toujours dégénéré dans les siècles philosophiques. C'est que l'esprit raisonneur, en détruisant l'imagination, sape les fondements des beaux-arts."[7] And, by his adherence to reason, Delacroix tempered the advice of Madame de Staël, otherwise his acknowledged mentor, when she was wont to describe the imagination as "la prêtresse de la nature."[8]

French art and literary criticism offered Delacroix a consistent and durable tradition for the primacy of reason as an element in the creative process. Boileau, in *L'Art poétique*, which the painter knew intimately and often quoted,[9] argues that reason nourishes rather than stifles poetry. . . .[10] Of greater interest, in the light of Delacroix's distaste for the fantastic flights of Poe's fancy, is the nature of Dubos' warning against the dangers of the enflamed imagination in poets who are "pleins de verve, mais qui n'ont jamais peint la nature, parce qu'ils l'ont coppiée d'après les vains phantômes que leur imagination brûlée en avait formés. . . ."[11] A

word of caution from Voltaire was actually copied by the artist, who derived from the *Questions sur l'Encyclopédie* a passage which declared that "la chose la plus rare est de joindre la raison avec l'enthousiasme; la raison consiste à voir toujours les choses comme elles sont. Celui qui dans l'ivresse voit les objets doubles est alors privé de la raison."[12]

Note that both Dubos and Voltaire had sounded the call to reason in order to prevent a flight from reality on the part of the unbridled imagination. How similar sounds Delacroix when in the concluding sentence of his paragraph on Poe he declares: "Il ne faut pas croire que ces auteurs-là aient plus d'imagination que ceux qui se contentent de décrire les choses comme elles sont, et il est certainement plus facile d'inventer par ce moyen des situations frappantes, que par la route battue des esprits intelligents de tous les siècles."[13]

Another writer familiar to Delacroix, Roger de Piles, while fulfilling the role of liberator of French art from the more stifling strictures of the Academy and advocating the exploitation of the imagination, carefully prescribed a just balance between it and the power of reason. He urged those students who have mastered the essentials of their art to depart from the trodden paths and to exercise their personal geniuses in the treatment of novel subject matter. . . .[14] Nevertheless, like Dubos and Voltaire, de Piles, while granting that there exist "des songes bizarres qui avec un peu de modération seroient capables de mettre beaucoup d'esprit dans la composition d'un Tableau,"[15] revealed the native French suspicion of an extravagant and irresponsible imagination. . . .[16]

In this matter, it is well to recall that de Piles was one of the first to ascribe to Rubens strong imaginative powers. In the *Dissertation sur les ouvrages des plus fameux peintres*,[17] which Delacroix knew and quoted at length,[18] he discerns that quality in the Flemish master but, at the same time attributes to him a greater degree of rational control than Delacroix had. . . .[19]

Delacroix's approval of the traditional French limitation of the imagination by reason must not blind us, however, to the importance he attached to the more Romantic faculty. For though he deplored Poe's fantasies he was not, on the other hand, so committed to the rational limits of reality as to advocate the confinement of the imaginative inspiration. Especially on those occasions when he was exposed to the new Realist aesthetic he tended to adopt the opposite point of view. In the course of one of his

lively diatribes against that movement he claimed, in a manner reminiscent of Madame de Staël, that "devant la nature elle-même, c'est notre imagination qui fait le tableau."[20] And, at another time, he did not hesitate to bring to the attention of the Realists the instructive example of great artists of the past, asserting that "il n'est pas bien difficile, en effet, de voir que les ouvrages de Raphaël, que ceux de Michel-Ange, du Corrège et de leurs plus illustres contemporains, doivent à l'imagination leur charme principal et que l'imitation du modèle y est secondaire et même tout à fait effacée."[21]

It seems clear, then, that Delacroix was seeking to achieve the right proportion of reason and imagination just as he was determined, in respect to the problems of imitation, to avoid the extremes of Courbet's Realism and Ingres' Mannerism.

The general consistency of his point of view in relation to these problems of artistic creation is apparent in his definition of the imagination. For, just as he declined to indulge in the Romantic conception of the unlimited imagination he also retained in his definition of that faculty certain traditional elements that prohibited an absolutely pure conception of the creative imagination.

Now Delacroix not only attributed to the imagination certain creative powers but also identified the source of these powers in the characteristically Romantic area of the "soul"—that favorite breeding place of Romantic content according to those German aestheticians who had influenced him through the vehicle of Madame de Staël.[22] For his description of the imaginative process reads as follows: "Imaginer une composition, c'est combiner les éléments d'objets qu'on connaît, qu'on a vus, avec d'autres qui tiennent à l'intérieur même, à l'âme de l'artiste."[23] However, while the latter part of Delacroix's statement accords nicely with Romantic theory, the former prescription—"combiner les éléments d'objets qu'on connaît, qu'on a vus"—relies upon antecedent theory. As with the appeal to reason which various authorities cited as the antidote to radical departures from nature, there appeared in the seventeenth and eighteenth centuries definitions of the imagination which described the matter of imaginative thought as derived from exterior reality.

. . . This insistence upon things seen as the raw material of imaginative content occurs again and again in eighteenth-century thought, especially in such important sources for Delacroix's theory as the works of Voltaire and Diderot.[24]

One may conclude, then, that the more conservative aspects of Delacroix's conception of the imagination—his insistence that its raw material consist of known values and his rejection of fantastic, Poe-like spectacles—probably account for the nature of the subject matter treated in his art. For it is, perhaps, surprising to discover the painter to whom Baudelaire ascribed the profoundest imaginative powers of his time utilizing subject matter that has roots in nature (portraits, landscapes, still life, Moroccan studies, etc.), in literature (from the works of Goethe, Shakespeare, Byron, Scott, Tasso, etc.), in the Old and New Testaments, and in contemporary, Renaissance, Medieval, and Ancient history. That is to say, Delacroix derived his subjects from exterior sources unlike Blake and Redon who, in many of their works, explored the more fantastic reaches of the unlimited imagination.

This preoccupation with the phenomenon of the imagination did not end with the consideration of its lore in the genesis of the work of art; he was equally concerned with the manner in which the spectator might be invited to exercise his powers of imagination—a concern which would prove to be of momentous importance for the nature of his art, especially its sketchlike quality in his mature period.

Even his early pictures appeared novel and reprehensible in technique to many of the conservative critics who opposed his technical challenge to the smooth surfaces of David and his followers. Delécluze only repeated the opinion of other hostile writers when he accused Delacroix of an alleged inability to complete his pictures. In the *Execution of Marino Faliero* of 1826 (Fig. 42) he saw nothing but "une esquisse brillante."[25] . . . Delacroix, however, persevered in his attempt to make sketchlike technique an expressive device—a visual stimulus intended to activate the spectator's imagination into creative response.

However revolutionary his exploitation of sketchlike technique may have appeared to Delécluze, Delacroix was only one of a long line of writers on art who had described its advantages. The history of the reputation of the sketch is, in fact, an especially interesting one. A brief outline of its evolution will furnish a background and a context that may serve to illuminate the particular sources—de Piles, Diderot, Reynolds, La Rochefoucauld, and Lord Byron—which inspired Delacroix's conception of the sketch.

Already in the Ancient period, Pliny the Elder reported that

42. Eugène Delacroix, *The Execution of the Doge Marino Faliero*, 1826, Oil, 57″ x 54″ (Reproduced by permission of the Trustees of the Wallace Collection, London)

Apelles of Kos felt he had surpassed Protogenes in painting since he knew "when to take his hand from a picture," an opinion shared by Pliny who considered this criticism "a memorable saying, showing that too much care may often be hurtful."[26] This

interest in the value of unfinish appears again in Italy in the Renaissance. Alberti declared that "it is best to avoid the vitiating effect of those who wish to eliminate every weakness and make everything too polished. In their hands the work becomes old and squeezed dry before it is finished."[27] In the view of the French Academy in the seventeenth century, however, such technical freedom became suspect. André Félibien criticized the sketchy and loose quality of Rubens' pictures. . . .[28] The anti-sketch position became one of the rallying points of French Classicism in other fields as well. Boileau, in *L'Art poétique*, prescribed for literature a mode of artistic creation that would culminate in a highly finished work. . . .[29]

Nevertheless, it was an author of the seventeenth century who provided Delacroix one of his sources for a pro-sketch statement. On June 29, 1857, he noted in the Journal[30] the 627th maxim of La Rochefoucauld, which states: "Il y a de belles choses qui ont plus d'éclat quand elles demeurent imparfaites, que quand elles sont trop achevées."[31] Indicative of his ability to range freely in the realm of art theory is the reminder following this quotation that this passage was intended (probably in the projected *Dictionnaire*) "pour aller avec ce que Lord Byron dit du poète Campbell qu'il finit trop ses ouvrages."[32] Delacroix had, in fact, on July 15, 1850,[33] transcribed a lengthy quotation from Captain T. Medwin's *Journal of the Conversations of Lord Byron*, which provided contemporary authority from one of his favorite poets for La Rochefoucauld's assertion that lack of finish produced greater brilliance of effect. According to Captain Medwin, Byron had asserted (in the French translation) that "les poésies de Campbell . . . sentent trop la lampe. Il n'est jamais content de ce qu'il fait. Il a gâté ses plus belles productions en voulant trop les finir. Tout le brillant du premier jet est perdu. Il en est des poèmes commes des tableaux. Ils ne doivent pas être trop finis. Le grand art est l'effet, n'importe comment on le produit."[34]

So far, however, art theorists had advocated lack of finish in order to avoid dryness, in order to achieve spontaneity or brilliance of effect. For the impact of the sketch upon the imagination we must seek elsewhere for Delacroix's sources.

Roger de Piles, in his *Conversations sur la peinture*, which appeared in the *Recueil de divers ouvrages sur la peinture et le coloris*, a work that Delacroix knew,[35] had introduced the concept of the imagination into the discussion of the sketch. One of the

two participants in the conversation, Pamphile, remarks that "les ouvrages les plus finis . . . ne sont pas toujours les plus agréables; et les tableaux artistement touchés font le même effet qu'un discours, où les choses n'étant pas expliquées avec toutes leurs circonstances, en laissent juger le lecteur, qui se fait un plaisir d'imaginer tout ce que l'auteur avoit dans l'esprit."[36] Significantly, because of Delacroix's well-known penchant for Rubensian technique, Pamphile, in this passage, had been defending Rubens against the charge that it was the Flemish painter's fiery genius which prevented him from achieving the required finish in his pictures.

The power of the sketch to stimulate the imagination of the spectator became a widespread notion and, surprisingly, appears even in the predominantly Classical theory of the Comte de Caylus, who declared in a discourse presented to the Academy in 1732: "Il me semble qu'un simple trait déterminant souvent une passion et prouvant combien l'Esprit de l'auteur ressentoit alors la force et la vérité de l'expression; l'œil curieux et l'imagination animée se plaisent et sont flattés d'achever ce qui souvent n'est qu'ébauché."[37]

It is no wonder, then, that the idea appears again in the Proto-Romantic Theory of Diderot who contributes a new element by emphasizing the liberating influence of the sketch upon the imagination. For while de Piles and the Comte de Caylus had limited the achievement of the stimulated imagination of the spectator to the original inspiration of the artist, Diderot permits the imagination to use the sketch as a springboard for original and creative thought: "L'esquisse," he claims, "ne nous attache peut-être si fort, que parce qu'étant indéterminée, elle laisse plus de liberté à notre imagination, qui y voit tout ce qu'il lui plaît."[38]

Across the Channel, Sir Joshua Reynolds, Delacroix's favorite English theorist,[39] eloquently expounded a similar conception of the relation of the sketch and the imagination. In his view, the imagination played a primary role in art for he declares, in his Fourth Discourse, of December 10, 1771, that "the great end of the art is to strike the imagination."[40] And, elsewhere, he suggested that a finished work might appear to the spectator less appealing than its sketch, which possessed special evocative powers: "It is true, sketches, or such drawings as painters usually make for their works, give this pleasure of the imagination to a high degree. From a slight undetermined drawing, where the

ideas of the composition and character are, as I may say, only just touched upon, the imagination supplies more than the painter himself, probably, could produce; and we accordingly often find that the finished work disappoints the expectation that was raised from the sketch. . . ."[41]

Therefore, Delécluze's criticism of the sketchlike quality of Delacroix's finished paintings disregards the existence of theoretical tradition, which provides ample justification for this particular technique. Of course, he was unaware that Delacroix had availed himself of the two traditional arguments for the lack of finish: high finish or polish as depriving the finished work of brilliance of effect and the power of the sketch to stimulate the imagination, especially the concept of the liberation of the spectator's imagination beyond the original conception of the artist.

Delacroix's interest in the special properties of the sketch derived, no doubt, from his dissatisfaction with the Davidian tradition that considered perfection of finish as one of the basic ingredients of the Neo-Classical style. Ingres, Delacroix's arch-foe, in this matter, had once declared that "il faut faire disparaître les traces de la facilité; ce sont les résultats et non les moyens employés qui doivent paraître. . . ."[42] No wonder Delacroix once complained that Ingres possessed "point d'imagination,"[43] for his paintings demonstrate an ever-increasing exploitation of a sketchlike technique which culminates in late works such as *Tobias and the Angel* of 1863 where linear precision and discreet brushwork, both hallmarks of Neo-Classical technique, are obliterated by the free, broad application of pigment. Precise detail and smooth surfaces disappear and, in their place, a rapid, summary, almost autonomous network of brushstrokes creates a brilliant, agitated entity which, alone, conveys an adequate expression of Delacroix's impassioned rejection of Neo-Classical vision.

The shock value of this revolution in technique for his contemporary critics may strike the sophisticated spectator of the twentieth century as difficult to grasp in view of Impressionist, Post-Impressionist, and modern indulgence in sketchlike effects. However, to a Neo-Classic critic like Delécluze, even the early *Marino Faliero* of 1826 (Fig. 42) was open to question. And, indeed, its disregard of precise rendering of minute detail, flat rendering of color areas, and rejection of linear emphasis must have appeared novel and sketchlike. Hence, his characterization of it as "une esquisse brillante."

To the modern spectator, the nature of the technique in this early work suggests that Delacroix, in the 1820's, utilized lack of detail and a broad brushstroke in order to obtain the result described by La Rochefoucauld and Byron: a heightened measure of sensuous brilliance. It is quite appropriate in this particular case since the subject matter is Venetian. Moreover, we know that he admired the brilliant color effects of Veronese and Titian.[44]

Nevertheless, in the 1820's (witness such examples as *Dante and Virgil, Massacre at Chios* and *Death of Sardanapalus*), he did not yet attempt to render in a finished work the vibrancy, spontaneity, and visual ambiguity inherent in the sketch. There is nothing visually ambiguous in the *Marino Faliero*. If each detail lacks precision of rendering, the general characteristics of each object do retain identity. In the 1830's, certain works, especially *Boissy d'Anglas at the Convention* of 1831 [Bordeaux Museum], display a loosening of technique but it was not until the 1840's that the exploitation of unfinish became a dominant characteristic of his style. Thus he anticipated in practice what was to be formulated in theory in the 1850's—the stimulation of the responsive imagination by a provocatively unfinished technique. In *St. George and the Dragon* of 1847 [Louvre, Paris] brushwork has become entirely negligent of descriptive detail; faces are summarily indicated; boundaries of individual objects and figures have been violated by active brushstrokes, so that objects tend to lose their linear identity and to become fused in the agitated surface of paint. Furthermore, ample areas of impenetrable gloom contribute to the suggestive power of this picture, which exemplifies Delacroix's belief that an unfinished quality would appeal to "l'imagination, laquelle se plaît au vague et se répand facilement, et embrasse de vastes objets sur des indications sommaires."[45]

And yet, the fact remains that his finished pictures never approached the complete freedom of visual expression evident in his sketches. Consider the painted sketch for the *Lion Hunt* of 1855 (Fig. 43). It brings to mind Delacroix's prophetic statement that painting need not always have a subject.[46] The entangled mass of men, animals, and weapons has been rendered with such broad, summary treatment that the precise nature of the action and the role of the combatants have been submerged. Swirling, vibrant strokes of the brush have taken precedence so that the main effect resembles an abstract expression of the physical and psychical action involved in this tumultuous theme. On the other hand, the

finished picture (Fig. 44; half destroyed by fire in 1870)[47] departs appreciably from the freedom of brush in the direction of a relatively literal, tight rendering of the scene. The figures and animals here receive a vibrant and pulsating treatment, to be sure. Nevertheless, the brushstrokes also describe the tone and texture of specific objects, leaving less for the imagination to supply.

The question arises: Why did Delacroix, in his finished pictures, never abandon himself to the absolute freedom of the sketch, which, with its power to stimulate the imagination, obviously presented an admirable solution to the problem of Romantic expression? The answer lies in his characteristic ability to appreciate the advantages of contrasting approaches to art. In 1853, in the very act of demonstrating the value of the sketch, he conceded that finish as opposed to sketchiness afforded the painter unique advantages. While granting "l'effet immanquable de l'ébauche comparée au tableau fini, qui est toujours un peu gâté quant à la touche," he nevertheless held in good regard the finished work "dans lequel l'harmonie et la profondeur des expressions deviennent une compensation."[48]

In this matter it is well to point out that his pictures were rarely the product of one, swift campaign before the easel under the inspiration of the moment. Rather, he adhered to the traditional, Academic method of a reasoned and measured solution of pictorial problems by means of preparatory work. The preparatory sketch for the *Lion Hunt* is but one example. After his death, the executors of his estate discovered more than six thousand drawings in various media.[49] In writing, he confirmed this practice suggesting that while "l'exécution, dans la peinture, doit toujours tenir de l'improvisation,"[50] a rational and critical development of the original engendered a higher degree of "harmonie et la profondeur des expressions." In this respect, he once again echoed Diderot, who had indicated the different factors that should control the sketch and the finished product. . . .[51]

One can discern, then, in Delacroix's conception of the sketch and the finished painting a characteristic ability to appreciate both sides of the coin. Relying upon the authority of La Rochefoucauld, Byron, Roger de Piles, Diderot, and Reynolds, he felt free to seek in his pictures a varying degree of unfinish, both for greater brilliance and for imaginative stimulation; as a result, he liberated painting from the tight, polished surfaces of the schools of David and Ingres in the interests of subjective expres-

43. Eugène Delacroix, painted sketch for the *Lion Hunt*, *c.* 1854, Oil, 31½" x 45¼" (Private collection, France; Archives photographics)

44. Eugène Delacroix, *Lion Hunt* (partially destroyed), 1855, Oil, Approximately 5' x 11' (Musée des Beaux-Arts, Bordeaux)

sion. Yet, true to the national genius, he retained traditional control in the finished product in the belief that greater harmony and profundity provided compensatory values.

The fundamental importance of the rational process in Delacroix's conception of creativity also finds expression in his definition of genius. The characteristic Romantic notion of the irrationally inspired genius had advocates in eighteenth-century England. Edward Young, in *Conjectures on Original Composition* of 1759, had defined the irrational nature of this essential endowment, which he attributed to the intervention of divine favor: "Learning we thank, genius we revere; that gives us pleasure, this gives us rapture; that informs, this inspires; and is itself inspired; for genius is from heaven; learning from man."[52] Delacroix, however, preferred to temper this conception by way of including the inhibitory ingredient of rational control. For his part, he had little patience with contemporary painters, writers, and musicians who justified extravagant licenses in art and life by a claim to original genius. . . .[53] In personal conduct, of course, Delacroix was noted for aristocratic and gentlemanly bearing and in art he demanded a similar rational restraint. So we are not surprised to discover that his definition of genius makes reason its dominant feature. "Le plus grand génie n'est qu'un être supérieurement raisonnable," he wrote in 1855;[54] and elsewhere he noted that in such favorite masters as Mozart, Molière, and Racine, reason amounted to the primary element of their genius: "Mozart, ni Molière, ni Racine ne devaient avoir de sottes préférences, ni de sottes antipathies; leur *raison,* par conséquent, était à la hauteur de leur *génie,* ou plutôt était *leur génie même.*"[55]

Numerous art theorists whose works were known to Delacroix had voiced opposition to free indulgence in the inspiration characteristic of genius. Even Longinus, who otherwise linked the attainment of the sublime with the operation of genius, declared that "genius needs the curb as often as the spur."[56] De Piles, while admitting that "le Génie est la première chose que l'on doit supposer dans un Peintre,"[57] still held that it alone was not sufficient for the production of an enduring work of art. "Il faut donc du Génie," he granted, "mais un Génie éxercé par les règles, par les réfléxions, et par l'assiduité du travail. Il faut avoir beau-

coup vû, beaucoup lû et beaucoup étudié pour diriger ce Génie, et pour le rendre capable de produire des choses dignes de la postérité."[58]

The portrayal of the unbridled imagination as a dangerous principle without some degree of rational moderation was the essential theme of Diderot's *Paradoxe sur le comédien,* which Delacroix knew.[59] Therein, Diderot maintained that both inspiration and judgment are required in the actor's art. . . . And the speaker of this argument develops his theme in terms that anticipate Delacroix's distaste for the irrational and eccentric spirits of his age. . . .[60]

It is tempting to surmise that another element of the traditional conception of genius was in part responsible for Delacroix's aversion to art schools and academies as well as his reluctance to found a school of his own. We have already noted his hostile attitude towards the Academy, which fostered, in his opinion, a tendency to stifle the student's imagination in favor of sterile copying of fashionable old masters.[61] Apart from this, however, his personal disinclination to found a school[62] must have been influenced by the venerable notion that genius simply could not be taught.

Already in the seventeenth century literary theory had endowed genius with the power to suggest mysterious and irrational qualities by means of art—qualities, furthermore, that were described as untransmittable by precept to students. . . .[63]

For Delacroix the most stimulating discussion of this problem occurred, no doubt, in the pages of the *Spectator.* In the Journal entry of October 26, 1853, he cites Addison on this topic and develops a lengthy discussion. "Le *Spectateur,*" he observes, "parle de ce qu'il appelle *génies de premier ordre,* tels que Pindare, Homère, la Bible,—confus au milieu de choses sublimes et inachevées,—Shakespeare, etc.; puis de ceux dans lesquels il voit plus d'art, tels que Virgile, Platon, etc. . . ."[64] This conception derives from the *Spectator* paper of September 3, 1711, in which Addison had stated his well-known distinction between first-class and second-class geniuses. The first category, which includes Homer, comprises those "great natural Genius's that were never disciplined and broken by Rules of Art,"[65] while the second category comprised "those that have formed themselves by Rules, and submitted the Greatness of their natural Talents to the Corrections and Restraints of Art."[66]

Especially noteworthy is Addison's desire to admonish those lesser poets of restricted imagination who would dare to emulate the privileged way of geniuses of the first class. "I cannot," he sternly remarks, "quit this Head without observing that *Pindar* was a great Genius of the first Class, who was hurried on by a Natural Fire and Impetuosity to vast Conceptions of things, and noble Sallies of Imagination. At the same time, can anything be more ridiculous than for Men of a sober and moderate Fancy to imitate this Poet's Way of Writing in those monstrous Compositions which go among us under the Name of Pindaricks?"[67] Delacroix, in his commentary on this passage, adopts the view that geniuses of the undisciplined type afford dangerous examples for study to eager admirers. . . . This passage is followed by a warning to all those who would hope to emulate such formidable masters. . . .[68]

For his own part, Delacroix, even as a youth, had felt qualified to emulate the most unequal and disheveled of painterly geniuses, namely Michelangelo and Rubens, and, no doubt, considered himself to be a genius. For although he constantly endeavored to adjust the irrational aspects of his creative gift to the restraint of reason—thereby qualifying for the title of both first-class and second-class genius according to Addisonian terminology—he regarded the nature of his own creative work to be such that it was useless to attempt to transmit it to a school of young followers.[69]

Yet another traditional aspect of genius colored his conception —the customary attribution of justifiable faults to the fiery type and a more consistent perfection to the cooler, more rational variety. He held the view that Michelangelo, Corneille, and Shakespeare were to be allowed faults and lapses in style and inspiration because of the compensating heights they attained in artistic expression. More restrained creators such as Virgil and Racine maintained, on the other hand, a steady and even flow of unblemished art. . . .[70]

The comparison of Shakespeare as the undisciplined genius and Racine as the more rational one depends on a widespread use of these two writers as exponents of the two opposed modes of creation during the eighteenth century. Voltaire, for example, in his *Questions sur l'Encyclopédie* (which Delacroix knew) referred to Shakespeare as the more natural artist in whose works "c'est la vérité, c'est la nature elle-même qui parle son propre langage sans

aucun mélange de l'art."[71] Racine, on the other hand, whom he endowed with the eighteenth-century attribute of taste, never fell into error: "Le génie conduit par le goût ne sera jamais de faute grossière, aussi *Racine* depius *Andromaque*, le *Poussin*, *Rameau* n'en ont jamais fait."[72]

It is in the context of the hostile reaction that often greeted his pictures that this preoccupation with the nature of genius takes on particular significance. In the traditional conception of justifiable lapses from correctness for the type of genius represented by Homer, Shakespeare, and Corneille, Delacroix must have found solace to ease the discouraging attacks of critics such as Guyot de Fère, who in 1835 announced: "M. Delacroix, à ce qu'il nous semble, va toujours *decrescendo*, que dire de sa pochade du *Prisonnier de Chillon* où tant d'incorrections se font sentir?"[73]

The license traditionally accorded the genius had other ramifications for Delacroix's thought. For a Romantic painter the validity of Academic rules was an especially sensitive subject. Here, too, his position is one that avoids iconoclasm and rash rejection of all restraints.

RULES

Previous art theory had condoned in the genius not only faulty expression but also a corresponding release from the customary dictates of Academic rules. Roger de Piles was one of those who described the freedom allowed in such cases. . . .[74] This liberality of viewpoint towards rules found welcome support in England where critics had never felt comfortable under the imposition of Academic precepts imported from France as exemplified in the theory of Dryden. Addison turned to an ancient author, Longinus, as an authoritative source for the antirational tendencies eighteenth-century criticism would soon take. "I must also observe with *Longinus*," he wrote, "that the Productions of a great Genius, with many Lapses and Inadvertencies, are infinitely preferable to the works of an inferior kind of Author, which are scrupulously exact and conformable to all the Rules of correct Writing."[75] Not much later, a similar tendency appeared in France. Diderot, in his *Pensées détachées*, advised the use of rules only for very ordinary individuals and deplored the debilitating effect of rules on art. . . .[76]

Romantic aesthetics, which generally sought to free the artist from restraint of any kind, inevitably adopted and intensified this opposition to creation according to prescribed formulae. Madame de Staël, for example, dismissed rules as fit only for rank beginners claiming that "ces règles ne sont que des barrières pour empêcher les enfants de tomber."[77] Delacroix, however, characteristically sought authority in Classical sources for this liberal position.

Distaste for rules is evident in the approval he accorded a statement of one of his friends, Abel-Jean-Henri Dufresne.[78] In 1824, during his youth, when dissatisfaction with Academic rule was naturally quite strong, he recorded in the Journal Dufresne's attitude. . . .[79]

The part rules played in the creative process had been one of the most controversial issues involved in the battle of the Ancients versus the Moderns that had raged in the seventeenth and eighteenth centuries.[80] It is from writers of this vintage that Delacroix culled authority for the liberal interpretation of this problem. In 1855, for example, he copied from M. Bret's *Supplément à la vie de Molière* an account of that playwright's refusal to alter a few words of *Tartuffe* for the purpose of stricter adherence to more perfect rhyme forms. . . .[81] Worth noting is the fact that this passage also cites Boileau's liberal interpretation of rules in the fourth book of *L'Art poétique*. . . .[82]

That freedom from tyranny of rules implicit even in French Classical theory was congenial to Delacroix is evident in the comment he makes on this matter: "Je suis ravi pour ma part'de cet exemple: Molière est ici évidemment plus grand artiste que Racine qui ne se montre qu'homme de métier."[83] And in the works of Montesquieu he found further justification for freedom from rule for the outstanding individual—one might correctly say the genius. "Montesquieu dit très bien," he remarked, "*qu'un homme qui écrit bien n'écrit pas comme on écrit, mais comme il écrit,* c'est-à-dire comme il pense."[84] This notion of Montesquieu which is derived from his *Pensées diverses*,[85] he underscored precisely in that part which declares the sanctity of freedom of expression dear to every Romantic artist.

So, once more the curious mixture of iconoclasm and traditionalism appears in Delacroix's thought. While exalting the principle of Romantic license in regard to the rules, he nevertheless turned to various non-Romantic sources in order to justify this course,

thus displaying the innate and consistent conservatism which always tempered his Romantic fire.

## BOLDNESS

Another aspect of the creative process which can be described as fundamentally Romantic was *hardiesse* or boldness—a quality that found an ardent advocate in Delacroix, who ascribed much of Rubens' impact to its presence in his art. . . .[86]

Traditionally, boldness had long been cited as one of the requisite attributes of genius. Sir Joshua Reynolds, for example, had, on condition that a solid foundation in knowledge of the old masters be observed, advised its cultivation, suggesting that "when an Artist is sure that he is upon firm ground, supported by the authority and practice of his predecessors of the greatest reputation, he may then assume the boldness and intrepidity of genius."[87]

Delacroix shared Reynolds' belief in the need for a solid foundation for the bold flights of genius citing experience as the indispensable basis: "L'expérience est indispensable pour apprendre tout ce qu'on peut faire avec son instrument. . . ."[88] Yet (and it is worth noting the existence of this strong element of Romantic enthusiasm in the mature artist of 1850) he emphatically endorses the bold attack on artistic problems: "Et pourtant il faut être très hardi! Sans hardiesse et une hardiesse extrême, il n'y a pas de beautés."[89]

Boldness and enthusiasm, however, were not to be maintained with the aid of artificial stimulants à la De Quincey. Nineteenth-century experiments with intoxicants and drugs in order to induce creative energy were rejected by the surprisingly proper leader of the Romantic Movement in painting. He harbored no sympathy for Byron's indulgence in gin. He records in the Journal his conversation with Jenny Le Guillou, his faithful servant and confidante, concerning Byron's advocacy of gin as an aid to the Muses. "Jenny me disait, quand je lui lisais ce passage de Lord Byron, où il vante le genièvre comme son Hippocrène, que c'était à cause de la hardiesse qu'il y puisait."[90] This reference derives from Thomas Medwin's *Journal of the Conversations of Lord Byron* wherein Medwin reports that the poet had suggested "humorously enough" the following words of advice: "Why don't you drink, Medwin? Gin-and-water is the source of all my inspiration. If you

were to drink as much as I do, you would write as good verses: depend on it, it is the true Hippocrene."[91]

The canny insight of his untutored but shrewd servant met with her master's approval. Intoxicants, he surmised, were the probable source of boldness of spirit that enabled many artists to attain otherwise inaccessible heights. "Je crois que l'observation [of Jenny] est juste, tout humiliante qu'elle est pour un grand nombre de beaux esprits, qui ont trouvé dans la bouteille cet *adjuventum* du talent qui les a fait atteindre à la crête escarpée de l'art."[92] Furthermore, a state of bold inspiration was indeed required in order to exploit fully the potentialities of the creative spirit. . . .[93] And yet, he declined approval of Romantic indulgence in artificial stimulants to artistic productivity, preferring the example of Voltaire who required no such stimulation: "Heureux, qui, comme Voltaire et autres grands hommes, peut se trouver dans cet état inspiré, en buvant de l'eau et en se tenant au régime!"[94] His own abstemious and frugal habits during the working day (frequently omitting the midday meal in order to avoid the blunting of artistic purpose)[95] demonstrate this austere principle in action. Fortunately his creative powers flowed freely without recourse to artificial stimulants. "Ma palette fraîchement arrangée et brillante du contraste des couleurs suffit pour allumer mon enthousiasme."[96] Yet, even had he been denied the gift of a naturally spontaneous fount of imagination, he would no doubt have declined the Hippocrene of gin and drugs. The overwhelming evidence of his commitment to the powers of reason explains his hostile attitude. This manner of attaining boldness would have provided only one aspect of the process of artistic creation while extinguishing the equally necessary control that only reason and judgment furnish.

In sum, Delacroix's thoughts on various aspects of the creative process reaffirm the dominant theme of his total aesthetic—the tempering of Romantic passion by the power of reason. He rejects fantastic flights of the imagination and retains a traditional definition of that faculty which favors a rational observance of reality. Although his predilection for sketchlike techniques belongs to the progressive current of Romanticism, he cites traditional sources for its ability to attain spontaneity, brilliance, and stimulation of the imagination and acknowledges the benefits of finish in the final product. His rejection of Byron's bottle of gin in favor of Voltaire's glass of water is in keeping with this moderate position.

His aim was to achieve creative ardor without abandoning the rational control that might be drowned in the artificially stimulating founts of Hippocrene.

## ASPECTS OF THE WORK OF ART

### COLOR

During the first half of the nineteenth century, artistic circles in France witnessed a revival of the controversy concerning the primacy of color or line which had flourished during the last quarter of the seventeenth century. At this time the advocates of line had exalted Poussin as their champion while the colorists rallied around the example of Rubens.[97] Repeating the situation of the earlier period, a Neo-Classical faction championed the intellectual and austere qualities of line while the more progressive group (chiefly artists of the Romantic persuasion) exploited the sensuous and emotive possibilities of color.

Delacroix's role as a propagandist for color is well known. This commitment was due, at least in part, to his aversion to the styles of David and Ingres where line dominated color. Delécluze, in his biography of David, cites with relish that master's advice to a student who had demonstrated a reprehensible taste of coloristic devices. To the unlucky novice, David exclaimed: "Tu fais passer le dessin après la couleur. Eh bien, mon cher ami, c'est mettre la charrue avant les boeufs."[98] Later, Ingres displayed a similar predilection for contour. "La couleur," he conceded, "ajoute des ornements à la peinture; mais elle n'en est que la dame d'atours, puisqu'elle ne fait que rendre plus aimables les véritables perfections de l'art."[99]

Needless to say, Delacroix, despite a generous admiration for some aspects of Ingres' art, firmly rejected his conception of color both in theory and in practice. . . . Color [in his view was] one of the chief means by which a painter endows his work with the semblance of life. . . . A close friend, Baron Rivet, reported that Delacroix, while describing the evolution of the *Death of Sardanapalus*, had specified color in painting as the equivalent of style in literature and equally subject to the control of the intellect.[100] Since we know his admiration for Diderot, it is difficult to resist the hypothesis that he had absorbed an idea that

figures in Diderot's Salon of 1761 where a similar analogy between painting and literature was sustained. . . .[101] The spontaneous reappearance of this sentiment in the course of a friendly dialogue demonstrates how deeply influential knowledge gained from reading had become in his thought.

Another conception of the function of color in which he shows links with the past appeared when, in 1852, he asserted that "la couleur donne l'apparence de la vie."[102] Throughout the history of art theory, writers rarely failed to note this advantage. Plutarch praised its enhancement of the illusion of reality, declaring that "just as in pictures, color is more stimulating than line-drawing because it is life-like, and creates an illusion."[103] The Renaissance revived this argument. Lodovico Dolce, for one, recited a list of ancient painters—Parrhasius, Apelles, and Zeuxis—who utilized color in order to heighten the sense of reality in their works. . . .[104] Roger de Piles established one more link in the chain of tradition in the *Cours de peinture par principes*, claiming that "la couleur est ce que rend les objets sensibles à la vûë. Et le Coloris est une des parties essentielles de la Peinture, par laquelle le Peintre sçait imiter les apparences des couleurs de tous les objets naturels, et distribuer aux objets artificiels la couleur qui leur est la plus avantageuse pour tromper la vûë."[105] And Diderot, in the *Essais sur le peinture*, endeavored to formulate a definitive statement on the issue of color versus line that would prescribe the fundamental function and value of each element. In this scheme, color, in the traditional manner, served to animate the inert forms fixed by line. . . .[106] How closely, not only in sentiment but in terminology, this statement anticipates Delacroix's repetition of this theme ("la couleur donne l'apparence de la vie")!

Yet another time-honored attribute of color—its unifying power —found its way into Delacroix's thought. In the course of a lengthy comparison of the art of Poussin and Lesueur, he deplored in Poussin's paintings "cette absence d'unité, de fondu, d'effet, qui se trouvent dans Lesueur et dans tous les coloristes."[107] In so doing, he echoed the idea of that earlier champion of color, Roger de Piles, who, in his *Dialogue sur le coloris*, made one of the protagonists of the piece, Pamphile, establish the unifying power of this element: ". . . ne sçavez-vous pas que vous détruisez le tout si vous en retranchez une partie, principalement quand elle est aussi essentielle à son tout, comme est celle du Coloris à l'Art de Peinture."[108]

301

Delacroix departed from the mainstream of traditional conceptions of the function of color when he specified the faculty in the spectator that was to be stimulated by means of color. He rejected disdainfully the oft-repeated idea that color should speak to the physical eye in charmingly sensuous terms. "La couleur," he declared, "n'est rien si elle n'est convenable au sujet, et si elle n'augmente pas l'effet du tableau par l'imagination. Que les Boucher et les Vanloo fassent des tons légers et charmants à l'œil, etc."[109] On this occasion, he aligned himself with the Davidian enemy camp, placing in disrepute the frivolous and sensuous courtly art of the eighteenth century in which color had played a major role.

In the seventeenth century, the French Academy had viewed color with suspicion derived from the easy appeal of color to the physical eye rather than to the intellect.[110] De Piles, foreshadowing developments in the next century, took the opposite view and seized upon this seductive power as one of the most potent weapons in the painter's technical arsenal. . . .[111] In his view, painting was no longer to direct all its resources towards an appeal to the mind; rather, it should be content to seduce the eye alone. . . .[112] Thus he prepared the way for the art of Watteau, Boucher, and Fragonard, whose fragile, delicately tinted works appealed so powerfully to the aristocratic taste of the eighteenth century.

For once, Delacroix, who usually found de Piles' ideas congenial, adopted a position closer to that of the Academy. He rejected the notion that painting possesses merely sensuous appeal. Like the Academy, he endowed it with a more profound and serious purpose. But, on the other hand, he rejected Academic subordination of color, which he considered the most persuasive factor in painting. Furthermore, this persuasive power was to be utilized to appeal to a new center of reception, the Romantic imagination, in place of the Academic intellect. In his notes for the projected *Dictionnaire*, we discover the following item: "*Couleur:* De sa supériorité ou de son exquisivité, si l'on veut, sous le rapport de l'effet sur l'imagination."[113]

By assigning to color a major role in the rendering of Romantic content he thus assumed a progressive position in relation to the schools of David and Ingres. Even so, this typically Romantic attitude was not without anticipation in the history of art theory, for as early as 1699 the theoretician, Dupuy du Grez, in his *Traité*

*sur la peinture,* had suggested that color appealed to the imagination. . . .[114]

It is abundantly clear, then, that Delacroix, rebelling against Neo-Classical emphasis on linearity, frequently resorted to past authority in order to justify a revival of color as the primary factor in painting. For the analogy between color and literary style he appears indebted, as so often before, to the example of Diderot. The writings of Dolce, de Piles, and Diderot were among the many works that included descriptions of the life-giving qualities of color. De Piles, furthermore, had already alluded to color as a unifying agent in painting. Finally, he revived the old issue of the function of color in regard to the end of painting and abandoned the Academic conception in favor of the progressive view of color as a primary means of enabling Romantic content to stir the spectator's imagination.

LINE

This firm insistence on the primacy of color over line does not mean, however, that Delacroix was unaware of the importance of line. . . . He attempted to evolve a new concept of line—a concept that might be termed painterly line.

In part, his rejection of the linearism of David and Ingres stemmed from his desire to base his art on a fundamental adherence to natural appearances. Where, he inquired, in a passage which clearly foreshadows Impressionist attitudes, does nature present the firmly contoured forms of the Neo-Classicists? "Je suis à ma fenêtre," he wrote, "et je vois le plus beau paysage: l'idée d'une ligne ne me vient pas à l'esprit. L'alouette chante, la rivière réfléchit mille diamants, le feuillage murmure: où sont les lignes qui produisent ces charmantes sensations?"[115] In practice he had achieved these charming, linearless sensations in a work of the 1840's, *Landscape at Champrosay* [Private Collection].[116] All the elements of this landscape fuse into an atmospheric whole—a fusion engineered by the exploitation of soft, broad brushstrokes that operate freely across the surface of the canvas unhindered by any restrictive contour lines. Stylistically, it shows seeds of that alleged formlessness which hostile critics would later profess to see in Impressionist landscapes. . . .

In order to reinforce his argument against the linearists, Delacroix attacked the frequently sponsored conception of line as an

essential ingredient of beauty. For those critics who maintained such a position he had nothing but scorn. . . .[117]

Among those writers who had suggested the adoption of the serpentine line was Giovanni Paolo Lomazzo, the Mannerist theorist, who in 1584 decreed that "straight lines and sharp angles should always be avoided" ("lasciandone sempre indi le linee rette, e gli angoli acuti . . .") . . . .[118] The specific connection between beauty and the serpentine line, however, was made by William Hogarth in the *Analysis of Beauty* of 1753. One is tempted to conjecture that Delacroix had in mind the words of Hogarth when referring to this concept since he was familiar, if not with his writings, at least with the nature of his art.[119] In Hogarth's scheme, the serpentine quality of an undulating, curvilinear line constituted the very essence of beauty. In a famous passage of the *Analysis of Beauty* he maintained that "the eye hath this sort of enjoyment in winding walks, and serpentine rivers, and all sorts of objects, whose forms, as we shall see hereafter, are composed principally of what, I call, the *waving* and *serpentine* lines. Intricacy in form, therefore, I shall define to be that peculiarity in the lines, which compose it, that *leads the eye a wanton kind of chace,* and from the pleasure that gives the mind, intitles it to the name of beautiful."[120]

In his refutation of Hogarth's enticing formula, Delacroix had substantial support in the writings of Diderot who, in a similarly scornful manner, denounced all sorts of curvilinear devices. . . .[121]

Further motivation for his rejection of serpentine line may be discerned in a quotation he culled from Poussin's writings. Poussin, as reported by Giovanni Pietro Bellori, had prescribed the following rule for the judicious use of line: "The design of the objects . . . should be of a similar nature as are the expressions for the concepts of these same objects. The structure or composition of the parts should not be laboriously studied, nor *recherché,* nor labored, but true to nature."[122] Delacroix paraphrased this passage in the following manner: "Il faut, dit-il [Poussin], que le dessin tourne toujours au profit de la pensée: le dessin ni la composition de toutes les parties ne doit point être recherché, ni étudié, ni trop élaboré, mais conforme en tout à la nature du sujet."[123]

Poussin's appeal for a reaction against the involved, labored, and elaborate drawing of the Mannerists elicited a sympathetic response from Delacroix, who opposed what he considered the

equally mannered styles of both the Rococo period and the school of Ingres. Hence, no doubt, the relative sobriety of many of his drawings, which often suppress a display of technical flourish for its own sake. Consider, for example, the preparatory sketch for *Jacob Wrestling with the Angel* [1854–61, Private Collection]. Here technique, while abundantly expressive, bows to the dictates of naturalness and the nature of the content. For nowhere do the heavy, blunt pencil strokes emerge as brilliant entities to be admired for their own sake; they serve instead to establish the gnarled, tortured quality of the trees which seem to respond sympathetically to the struggle of the antagonists. Or, by the modest means of simple, vertical hatchings, they render the softer bulk of the mountains in the background. And, with a notable indifference to legible detail, they outline and enliven the pulsating, intertwined forms involved in cosmic combat.

This sketch also serves to introduce another aspect of Delacroix's conception of the proper function of line. For, in addition to avoidance of overt virtuosity, it manifests a fundamentally painterly quality—the result of a lack of linear clarity that is evident especially in the foreground where an almost liquid fusion of elements evokes the technique of the brush rather than the technique of pencil.

The painterly quality achieved here in the linear realm of drawing assumes an even greater emphasis, of course, in actual paintings. . . .

In both theory and practice, then, Delacroix endeavored to avoid the hard, dry, firm contours of Neo-Classicism. For authority in this painterly problem, he turned to the writings of Sir Joshua Reynolds. In the Journal entry of January 11, 1857, under the heading *Pinceau,* we find: "Beau pinceau. Reynolds disait qu'un peintre devait dessiner avec le pinceau."[124] The source of this paraphrase of Reynolds' counsel occurs in the Second Discourse, which stated: "What, therefore, I wish to impress upon you is, that whenever an opportunity offers, you paint your studies instead of drawing them."[125]

The evolution of Delacroix's conception of line, one may conclude, was influenced by a number of authorities: Like Lodovico Dolce, he found no evidence in nature for the existence of firm, opaque contour. As part of his reaction against the "mannered" drawing of both the Rococo and Ingres, he cited the example of

Poussin, who favored a sober conformity of line to the rule of thought and of nature. Rather surprisingly, for an artist who often revived the dynamic, curvilinear patterns of the Baroque style, he rejected the primacy of serpentine line—especially as a factor in the attainment of beauty in the Hogarthian sense. Diderot, in this matter, had already furnished a precedent by referring to all such theories as absurd. Finally, as support for the type of painterly drawing he had already achieved in both sketches and paintings, he paraphrased Sir Joshua Reynolds' appeal for painted rather than drawn sketches.

## NOTES

[1] [imagination was the most precious gift, the most important faculty] Baudelaire, "L'Œuvre et la vie d'Eugène Delacroix," p. 427.

[2] [*Imagination*. It is the foremost quality of the artist.] *Journal*, III, p. 44 (January 25, 1857).

[3] [His (Rubens') painting, where imagination dominates, is superabundant throughout; his accessories are too thoroughly worked out; his picture resembles a public meeting where everyone talks at once.] *Journal*, II, p. 85 (October 12, 1853).

[4] *Journal*, II, p. 437 (April 6, 1856).

[5] *Journal*, II, pp. 86–87 (October 12, 1853). Compare William Wordsworth, in *The Prelude* (1805) where the imagination is described as "but another name for absolute power/ And clearest insight, amplitude of mind,/ And Reason in her most exalted mood." See *The Complete Poetical Works of William Wordsworth*, Boston, 1910, III, p. 314. René Huyghe, *Delacroix*, p. 239, attributes to the influence of the concept of Dandyism the balance of reason and emotion sought by Delacroix: "This equilibrium . . . is his Dandyism. . . . To attain this fullness involves the cultivation both of the imagination, which responds to what is welling up in the depths of us, and the reason, which gives it embodiment."

[6] *Œuvres complètes de J. J. Rousseau*, Paris, 1833, XVI, p. 274.

[7] [painting, architecture, poetry, and great oratory have always declined in the philosophical centuries. This is because the spirit of reason, by subverting the imagination, undermines the foundations of the fine arts.] François Auguste René Chateaubriand, "Génie du Christianisme," *Œuvres de M. le vicomte de Chateaubriand*, Paris, 1833, II, p. 295.

[8] [the priestess of nature] De Staël, *De l'Allemagne*, p. 491.

[9] See *Journal*, II, p. 358 (July 18, 1855) for a quotation from the fourth book which treats the function of rules in the creative process.

[10] *Œuvres complètes de Boileau Despréaux*, p. 242.

[11] [full of fancy, but who have never depicted nature, because they have copied from shadowy phantoms that their inflamed imaginations had given shape . . . ] Dubos, *Réflexions critiques sur la poésie et sur la peinture*, II, p. 14.

[12] [the rarest thing is to join reason with rapture; reason consists in always seeing things as they are. That which in its frenzy sees deceiving objects is then

## Delacroix's Art Theory

deprived of reason.] Voltaire, *Questions sur l'Encyclopédie*, II, Part V, p. 151. Delacroix's quotation appears in the *Supplément* of the *Journal*, III, p. 399.

13 [One must not believe that such writers (as Poe) have more imagination than those who describe things as they are, and surely it is easier to invent by means of striking situations than by the beaten path intelligent minds have followed throughout the centuries.] *Journal*, II, p. 438 (April 6, 1856).

14 De Piles, *Cours de peinture par principes*, p. 63.

15 [bizarre dreams which with a little moderation could contribute a great deal of spirit to the composition in a Picture] *Ibid.*, pp. 117–118.

16 *Ibid.*, p. 118.

17 Included in de Piles' *Recueil de divers ouvrages sur la peinture et le coloris*, pp. 236–286.

18 Delacroix, in his article on Prud'hon, had underscored those passages in which de Piles relates his efforts to overcome the prejudices of French opinion against the art of Rubens; see *Œuvres littéraires*, II, p. 153. This is one of the examples of his sympathetic response to beleaguered artists and critics of the past.

19 De Piles, *op. cit.*, p. 257.

20 [in the presence of nature herself, it is our imagination that makes the picture] *Journal*, III, p. 232 (September 1, 1859).

21 [it is not very difficult, in effect, to perceive that the works of Raphael, like those of Michelangelo, Correggio, and their most famous contemporaries, owe their principal charm to the imagination and that the imitation of the model is secondary to it and quite unobtrusive.] *Journal*, III, p. 269 (February 22, 1860).

22 See above p. 19, n. 30 [in Mras, *Eugène Delacroix's Theory of Art*, 1966].

23 [To imagine a composition is to combine the components of objects which one knows, which one has seen, with others that cling to the inner self, to the soul of the artist.] *Œuvres littéraires*, I, p. 58.

24 Quoted by Margaret Gilman, "The Poet according to Diderot," *Romantic Review*, XXXVII, p. 39. This article provides a valuable account of the history of the imagination. [And, remarks from] Diderot's Salon of 1767; *see Œuvres complètes de Diderot*, XI, p. 131.

25 [a brilliant sketch] From J. E. Delécluze's Salon of 1827, which appeared in the *Journal des débats* of December 20, 1827. Quoted by Lucie Horner, *Baudelaire: critique de Delacroix*, Geneva, 1956, p. 18.

26 K. Jex-Blake and E. Sellers, *The Elder Pliny's Chapters on the History of Art*, London, 1896, Bk. XXXV, pp. 120–121. "Et aliam gloriam usurpavit [Apelles], cum Protogenis opus immensi laboris ac curae supra modum anxiae miraretur, dixit enim omnia sibi cum illo paria esse aut illi meliora, sed uno se praestare, quod manim de tabula sciret tollere, memorabili praecepto nocere saepe nimiam diligentiam."

27 Alberti, *On Painting*, p. 97. He also cites the example of Protogenes who "did not know how to raise his hand from his panel." *Loc. cit.* For Michelangelo's conception of the role of lack of finish in art see Robert J. Clements, "Michelangelo on Effort and Rapidity in Art," *Journal of the Warburg and Courtauld Institutes*, XVII (1954), pp. 301–310.

28 Félibien, *Entretiens sur les vies et sur les ouvrages des plus excellens peintres*, II, p. 214.

29 *Œuvres complètes de Boileau-Despréaux*, p. 244.

[30] *Journal,* III, pp. 108–109 (June 29, 1857).

[31] [There are beautiful things which have more radiance when they remain unfinished, than when they are too finished.] François de la Rochefoucauld, *Œuvres complètes,* ed. L. Martin-Chauffier, Argenteuil, 1935, p. 347. Here it appears among the "maximes supprimées." According to E. B. O. Borgerhoff (*The Freedom of French Classicism,* Princeton, 1950, p. 108), maxim 627 appeared only in the edition of 1665 of La Rochefoucauld's works, after which it was deleted.

[32] [to accompany that which Lord Byron said of the poet Campbell that he finished his works too much]

[33] *Journal,* I, p. 388.

[34] [the poems of Campbell . . . smell of midnight oil. He is never content with what he does. He spoils his most beautiful works in desiring to give them a high finish. All the brilliance of the first cast is lost. It is with poems as with pictures. They should not be too highly finished. The great art is effect, it matters not how one brings it forth.] Thomas Campbell (1773–1844) [was a] Scottish poet.

Captain Medwin's English reads: "Like Gray," said he [Byron], "Campbell smells too much of the oil: he is never satisfied with what he does, his finest things have been spoiled by over-polish—the sharpness of the outline is worn off. Like paintings, poems may be too highly finished. The great art is effect, no matter how produced." Thomas Medwin, *The Journal of the Conversations of Lord Byron,* New York, 1824, pp. 73–74. According to George Heard Hamilton ("Eugène Delacroix and Lord Byron," *Gazette des Beaux-Arts,* February 1943, pp. 99–110, and *ibid.,* July–December 1944, pp. 365–386), Delacroix utilized Amadée Pichot's translation of the works of Byron, *Œuvres complètes de Lord Byron,* 4th ed., Paris, 1822–1825. This included a translation of Medwin's Journal. For French translations of Byron's works, see Edmond Estève, *Byron et le romantisme français,* Paris, 1907, pp. 526–533.

[35] See above pp. 75–76 and nn. 17, 18 [in Mras, *Eugène Delacroix's Theory of Art,* 1966].

[36] [the most finished works . . . are not always the most pleasing; and skillfully painted pictures achieve the same effect as a discourse wherein things are not explained in all their circumstances, allowing the reader to judge, which gives him the pleasure of imagining all that the author had in mind.] De Piles, *Recueil de divers ouvrages sur la peinture et le coloris,* p. 62.

[37] [It strikes me as a simple decisive touch often expressing an intense emotion and proving how the Mind of the author at the time feels the strength and truth of the expression; the inquisitive eye and the spirited imagination are delighted and flattered to put the finishing touch to what is often no more than roughly sketched.]

This discourse was delivered to the Academy June 7, 1732, by the Comte de Caylus. Entitled "Discours du Comte de Caylus sur les dessins," it was published in the *Revue universelle des arts,* IX (1859), pp. 314–323, whence I have derived the cited passage (p. 318). In 1745, a similar notion was advanced by A. J. Dezallier d'Argenville in *Abrégé de la vie des plus fameux peintres,* Paris, 1745, I, pp. xxxj–xxxij: "Les grands maîtres finissent peu leurs desseins, ils se contentent de faire des esquisses, ou griffonnemens faits de rien, qui ne plaisent pas aux demiconnoisseurs, ils veulent quelque chose de terminé qui soit agréable aux yeux: un vrai connoisseur pense autrement; il voit dans un croquis la manière de penser d'un grand maître pour caractériser chaque objet avec peu de traits; son imagina-

tion animée par le beau feu qui régne dans le dessein perce à travers ce qui manque, elle apperçoit souvent ce qui n'y est pas et ce qui y doit être."

<sup></sup> 38 [The sketch does not perhaps bind us so firmly, because being indeterminate, it allows more freedom to our imagination, which sees in it all that brings delight.] From Diderot's Salon of 1767; see *Œuvres complètes de Diderot*, XI, p. 246.

39 See the *Supplément* of the *Journal*, III, pp. 358–359, in which Delacroix liberally cites Reynolds in the preparatory notes for his article on Raphael.

40 *Sir Joshua Reynolds: Discourses on Art*, p. 59.

41 *Ibid.*, pp. 163–164. This passage is from the Eighth Discourse of December 10, 1778.

42 [he ought to make the traces of easy fluency disappear; it is the results and not the means employed which should be visible . . . ] Jean Auguste Dominique Ingres, *Écrits sur l'art*, Paris, 1947, p. 14.

43 [no imagination at all] *Journal*, II, p. 153 (March 24, 1854).

44 See pp. 57–60 of the *Journal*, III, for extensive analysis of the art of these two Venetian masters. See René Huyghe, *Delacroix*, p. 204, for the relation of this picture with the art of Bonington.

45 [the imagination, that faculty which delights in vagueness, expands freely, and embraces vast objects at the merest hint] *Journal*, II, pp. 102–103 (October 26, 1853).

46 "La peinture n'a pas toujours besoin d'un sujet." *Journal*, III, p. 24 (January 13, 1857).

47 A small replica of this picture in a private collection (illustrated in Jean Cassou, *Delacroix*, Paris, 1947, pl. 34) indicates the nature of the lost section of the completed picture. The Louvre possesses a pencil study for the left part of the picture; see the catalogue of the centenary exhibition, *Centenaire d'Eugène Delacroix: 1798–1863*, Paris, 1963, no. 467.

48 [the unfailing effect of the sketch as compared to the finished picture, which is always a trifle spoiled with respect to touch] . . . [in which harmony and depth of expression become a compensation] *Journal*, II, p. 58 (May 21, 1853).

49 According to Philippe Burty, ed., *Lettres de Eugène Delacroix*, Paris, 1878, p. x. Burty also asserts that "il voulait qu'après sa mort, ils [his drawings] vinssent, comme un argument solonnel, protester contre les reproches amers d'improvisation et de facilité dont on l'avait poursuivi, et prouver qu'une 'improvisation' aussi abondante et aussi solide que celle dont il avait fait preuve dans ses travaux décoratifs et ses tableaux, qu'une semblable facilité à exprimer le sentiment et l'idée, à adapter l'esprit du dessin et de la couleur aux convenances du sujet choisi, eussent été, sans le secours préalable de l'étude la plus persistante et la plus méthodique, des phénomènes sans exemples dans l'histoire de l'art." *Ibid.*, p. xi.

50 [execution in painting should always involve some improvisation] *Journal*, I, p. 174 (January 27, 1847).

51 [harmony and depth of expression] From Diderot's Salon of 1767; see *Œuvres complètes de Diderot*, XI, p. 332.

52 Edward Young, "Conjectures on Original Composition," *The Works of the Author of the Night-Thoughts*, London, 1773, V, pp. 102–103.

53 *Journal*, II, p. 371 (August 31, 1855).

54 [The greatest genius is simply a being of superior reason.] *Ibid.*, pp. 371–372.

55 [Neither Mozart, Molière, nor Racine would have had silly preferences or

silly antipathies; their *reason,* consequently, was on a level with their *genius,* or rather was *their genius itself.*] *Ibid.,* p. 318 (March 15, 1855). The italics are Delacroix's.

[56] Longinus, *On the Sublime,* p. 127.

[57] [Genius is the foremost thing one should take for granted in a Painter.] De Piles, *Abrégé de la vie des peintres,* p. 1.

[58] [Some Genius is surely necessary, but Genius practicing by rules, by thought, and by application to work. It is necessary to have seen very much, read very much, and studied very much in order to direct this Genius, and to render it capable of producing worthy things for posterity.] *Ibid.,* p. 14.

[59] On January 27, 1847, Delacroix, inspired by a recent discussion of Diderot's work at a social gathering, devotes a lengthy passage in the Journal to a comparison of the arts of painting and of acting. *Journal,* I, pp. 170–174.

[60] Denis Diderot, "Paradoxe sur le comédien," *Œuvres complètes de Diderot,* VIII, p. 367. In this matter it is worth noting the opinion of Immanuel Kant, who played such an important role in the formulation of Romantic aesthetics, whose ideas were popularized by Madame de Staël, and whose works were available in France in translation at an early period (see M. Vallois, *La formation de l'influence Kantienne en France,* Paris, n.d., esp. pp. 46–47). He, too, conforms to the traditional conception of the necessity of rational restraint of the dictates of genius: "Genius can only furnish rich material for products of beautiful art; its execution and its *form* require talent cultivated in the schools, in order to make such a use of the material as will stand examination by the Judgement." *Kant's Critique of Judgment,* tr. J. H. Bernard, London 1914, p. 193.

[61] This hostility is evident in the sarcastic passage entered in the Journal on November 25, 1855: "Tirer de son imagination des moyens de rendre la nature et ses effets, et les rendre suivant son tempérament propre: chimères, étude vaine que ne donnent ni le prix de Rome, ni l'Institut; copier l'exécution du Guide ou celle de Raphaël, suivant la mode." *Journal,* II, p. 414.

[62] In a letter of June 8, 1855 (Joubin's date), he declared that "les écoles, les coteries ne sont autre chose que des associations de médiocrités, pour se garantir mutuellement un semblant de renommée qui à la vérité est de courte durée mais qui fait traverser la vie agréablement." *Correspondance générale,* III, p. 265.

[63] R. Rapin, "Réflexions sur la poétique," *Œuvres,* The Hague, 1725, II, p. 130; quoted by Borgerhoff, *The Freedom of French Classicism,* pp. 181–182. [Also De Piles, *op. cit.,* p. 1.]

[64] [The *Spectator* speaks of what it calls *geniuses of the first order,* such as Pindar, Homer, and the Bible—a confusion of sublime and imperfect things—Shakespeare, etc.; then of those in whom it sees more artistry, such as Virgil, Plato, etc. . . .] *Journal,* II, p. 102.

[65] Addison and Steele, *The Spectator,* I, Vol. 2, p. 283.

[66] *Ibid.,* p. 285.

[67] *Ibid.,* p. 284.

[68] *Journal,* II, pp. 103–104 (October 26, 1853).

[69] Nevertheless, Delacroix, probably because of the aid required for the execution of the monumental works in public buildings in Paris, trained a select number of pupils and assistants, notably Pierre Andrieu, Gustave Lassalle-Bordes, and Louis de Planet. See Escholier, *Delacroix: peintre, graveur, écrivain,* III, for the role played by these and other assistants in these works.

70 *Journal*, II, p. 456 (June 10, 1856).

71 [it is truth, it is nature herself who speaks her true language without any mixture of art] Voltaire, *Questions sur l'Encyclopédie par des amateurs*, I, Part II, p. 142.

72 [Genius guided by taste would never be in clumsy error, therefore *Racine* after *Andromache, Poussin, Rameau* never made any.] *Ibid.*, II, Part VI, p. 182.

73 [M. Delacroix, it strikes us, always goes *decrescendo,* what am I to say of his rough sketch of *The Prisoner of Chillon* where so many errors make themselves felt?] Quoted by Tourneux, *Eugène Delacroix devant ses contemporains*, p. 62.

74 De Piles, *Dialogue sur le coloris*, pp. 41–42.

75 Addison and Steele, *The Spectator*, II, Vol. 4, p. 154; from paper 291 of February 2, 1712. Opposition to French criteria was voiced by Edward Filmer: "These *Corneillean* Rules are as Dissonant to the *English* Constitution of the Stage, as the *French* Slavery to our *English* liberty." Edward Filmer, *Defense of Dramatic Poetry* (1698), II, p. 28; quoted by Walter Jackson Bate, *From Classic to Romantic*, New York, 1961, p. 46.

76 Diderot, *Essais sur la peinture*, p. 121.

77 [those rules are nothing but railings to prevent children from falling] De Staël, *De l'Allemagne*, p. 482.

78 Abel-Jean-Henri Dufresne (1788–1862) was a versatile personality active as magistrate, writer, and painter. A student of Watelet, he first exhibited in the Salon of 1817.

79 *Journal*, I, p. 87 (March 27, 1824). Both Lucien Rudrauf, *Delacroix et le problème du romantisme artistique*, p. 285, and Hubert Gillot, *E. Delacroix: l'homme, ses idées, son œuvre*, p. 270, misrepresent the last sentence of this passage as Delacroix's own assertion. Actually it is a part of his paraphrase of Dufresne's argument—which, to be sure, he approves.

80 See Mras, *Eugène Delacroix's Theory of Art*, Princeton (1966), p. 17, n. 21, for bibliography on this subject.

81 *Journal*, II, p. 358 (July 17, 1855). Delacroix included in this entry a number of quotations derived from M. Bret, "Supplément à la vie de Molière," *Œuvres de Molière*, ed. M. Bret, I, Paris, 1804. The cited quotation is from p. 55.

82 Bret, *op. cit.*, p. 56.

83 [For my part I am charmed by this example: Molière is here clearly a greater artist than Racine who only shows himself to be a mechanic.] *Journal*, II, p. 359.

84 [Montesquieu puts it very well: *that a man who writes well does not write as one writes, but as he writes,* that is to say as he thinks.] *Ibid.*

85 Charles Louis de Secondat Montesquieu, "Pensées diverses," *Œuvres complètes de Montesquieu*, Paris, 1823, v, p. 236. The complete passage reads: "Un homme qui écrit bien n'écrit pas comme on écrit, mais comme il écrit; et c'est souvent en parlant mal qu'il parle bien."

86 *Journal*, III, pp. 307–308 (October 21, 1860).

87 *Sir Joshua Reynolds: Discourses on Art*, p. 90; from the Fifth Discourse of December 10, 1772.

88 [Experience is indispensable in order to learn all that can be done with one's own instrument. . . .] *Journal*, I, p. 393 (July 21, 1850).

89 [And yet one must be very bold! Without boldness and an extreme boldness, there are no beauties.] *Ibid.*, p. 394.

90 [Jenny told me, when I was reading to her a passage from Lord Byron,

where he praises gin as his Hippocrene, that this was because of the boldness he gained from it.] *Ibid.* See Huyghe, *Delacroix,* p. 518 (n. 17) for a discussion of the relationship between Delacroix and Jenny.

[91] Medwin, *The Journal of the Conversations of Lord Byron,* pp. 195–196.

[92] [I believe that the observation of Jenny is true, as humiliating as it is for the great number of fine minds who have found in the bottle that *adjuventum* of talent which has helped them to reach the rocky heights of art.] *Journal,* I, p. 394 (July 21, 1850).

[93] *Ibid.*

[94] [Happy is the one who, like Voltaire and other great men, can attain that inspired state while drinking water and keeping to a plain diet.] *Ibid.*

[95] According to his friend, Léon Riesener, "son art a été le but de sa vie. Il lui a tout sacrifié et même en dernier lieu sa vie elle-même. Pour avoir la tête plus lucide, pour être plus propre au travail, il avait fini par supprimer le déjeuner et ne mangeait qu'une fois par jour." Information given to Philippe Burty by Riesener; see Philippe Burty, *Lettres de Eugène Delacroix,* p. xix. Already in 1668 Du Fresnoy had struck a similar puritanical note, claiming that "la peinture ne se plaît pas trop dans le vin ni dans la bonne chère . . ." Du Fresnoy, *L'Art de peinture,* p. 76.

[96] [My palette freshly set and brilliant with the contrast of colors suffices to fire my enthusiasm.] *Journal,* I, p. 392 (July 21, 1850).

[97] For discussions of this controversy, see especially A. Fontaine, *Les doctrines d'art en France,* and F. P. Chambers, *The History of Taste,* New York, 1932.

[98] [You pass on to the drawing after the color. Well, my dear friend, that is putting the plow before the oxen (or, the cart before the horse).] Delécluze, *Louis David: son école et son temps,* p. 60.

[99] [Color adds ornaments to painting; but it is only a handmaiden to it, since it does no more than render more pleasing the true perfections of art.] Jean Auguste Dominique Ingres, *Écrits sur l'art,* p. 8.

[100] From an unpublished article by Baron Rivet destined for the *Revue des Deux-Mondes;* quoted by Piron, *Eugène Delacroix: sa vie et ses œuvres,* Paris, 1865, p. 70.

[101] *Œuvres complètes de Diderot,* x, p. 127.

[102] [color gives the semblance of life] *Journal,* I, p. 459 (February 23, 1852).

[103] Plutarch, "How the Young Man Should Study Poetry," *Moralia,* tr. F. C. Babbitt, London, 1927, I, p. 83.

[104] Dolce, *Dialogue sur la peinture, intitulé l'Aretin,* p. 217.

[105] [color is that which renders objects palpable to the eyes. And Coloring is one of the essential parts of Painting, by which the Painter knows how to imitate the appearance of the color of all natural objects, and to give to artificial objects the color which is the most favorable to them in order to beguile the eyes.] De Piles, *Cours de peinture par principes,* p. 303.

[106] Diderot, *Essais sur la peinture,* p. 43.

[107] [that absence of unity, of blending, of effect, qualities which are found in Lesueur and in all the colorists] *Journal,* I, p. 439 (June 6, 1851).

[108] [. . . do you not know that you destroy the whole if you cut off a part of it, especially when it is also as essential to the whole as Coloring is to the Art of Painting.] De Piles, *Dialogue sur le coloris,* pp. 9–10.

[109] [Color is nothing if it is not appropriate to the subject, and if it does not

enhance the effect of the picture through the imagination. Let men like Boucher and Vanloo make tones light and charming to the eye, etc.] *Journal,* II, p. 1 (January 2, 1853).

110 See Fontaine, *Les doctrines d'art en France,* p. 67.

111 De Piles, *Cours de peinture par principes,* p. 9.

112 *Ibid.,* p. 3.

113 [*Color:* of its superiority or of its refinement, however one wishes it, in respect to the effect on the imagination.] *Journal,* III, p. 56 (January 25, 1857). For the possible influence of scientific theories of color on Delacroix's thought, see Johnson, *Delacroix,* pp. 64–72.

114 Bernard Dupuy du Grez, *Traité sur la peinture pour en apprendre la téorie et se perfectionner dans la pratique,* Toulouse, 1699, p. 208.

115 [I am at my window and I look out on the most beautiful landscape: the idea of a line does not enter my mind. The lark sings, the river reflects a thousand diamonds, the foliage stirs; where are the lines which produce these charming sensations?] *Journal,* I, p. 299 (July 15, 1849).

116 [Fig. 36 in Mras, *op. cit.*] Champrosay was the village near Fontainebleau where Delacroix maintained a retreat and the place where he recorded his characterization of lines in nature. See Huyghe, *Delacroix,* pls. 24–25, for photographs of Delacroix's house there.

117 *Journal,* I, p. 299 (July 15, 1849).

118 From Giovanni Paolo Lomazzo's *Treatise on the Art of Painting,* tr. R. Haydock, Oxford, 1598, in Elizabeth Holt, *A Documentary History of Art,* Princeton, 1947, p. 263. The Italian is from Gio. Paolo Lomazzo, *Trattato dell'arte della pittura, scultura, ed architettura,* Rome, 1844, II, p. 97. Leonardo, too, had been aware of the serpentine quality of line: "The contours of any object should be considered with the most careful attention, observing how they twist like a serpent. These serpentine curves are to be studied to see whether they turn as parts of a round curvature or are of an angular concavity." Leonardo da Vinci, *Treatise on Painting,* I, p. 64.

119 For references to Hogarth's achievement in art, see the *Journal,* II, pp. 339 and 341 (June 17, 1855).

120 William Hogarth, *The Analysis of Beauty,* ed. Joseph Burke, Oxford, 1955, p. 42. (1st ed., 1753).

121 Diderot, "Pensées détachées," *Essais sur la peinture,* p. 196.

122 Poussin, "Observations on Painting," p. 368. Anthony Blunt has suggested that most of the matter contained in the section entitled "Di alcune forme della maniera magnifica," of which the quoted passage is a part, constitutes a reading note by Poussin from Agostino Mascardi's *Dell'arte historica,* Rome, 1636. See Blunt, "Poussin's Notes on Painting," p. 346.

123 [(Poussin) says that drawing must turn always in favor of the thought: neither drawing, nor the composition of all the parts should be mannered, or studied, or too labored, but conform entirely to the nature of the subject.] From the article on Poussin: see *Œuvres littéraires,* II, p. 93.

124 [Good brushwork. Reynolds used to say that a painter should draw with the brush.] *Journal,* III, p. 10.

125 *Sir Joshua Reynolds: Discourses on Art,* p. 34.

# 16. RODIN

*Albert Elsen*

## INTRODUCTION

Rodin is a difficult figure to assess. He has been viewed by some as a rebel, by others as a romantic conservative; and while it is likely that these categories, taken singly, will prove quite unreliable, it is equally likely that each label designates a measure of the truth about Rodin. These two selections from Albert Elsen's writings on the great French sculptor emphasize this problem by affirming both the important position he occupies historically, and at the same time the stubborn dichotomy of this historical position. Rodin emerges as a Janus-image who —by his literary tendencies, his passion for the great traditions of the Gothic and the Renaissance, and by his commitment to external anatomy—faces the past, but who also looks to the future by stressing a reverence for the integrity of the subjective self.

His bronzes are generally expressive of the restless psychological life of man and this energy is communicated through their mass, surface, and total gesture. When one considers the bronzes—the aggressive thrust of the Balzac monument, the ruggedness of the *Burghers of Calais,* and the awkward stretch of *St. John the Baptist Preaching*—it is apparent that they are conceived according to a different principle from that governing those works designed for finishing in marble. The latter are soft, sensuous, the antithesis of the bronzes. This cannot be explained merely by the differences in media; the basic principle is different.

Like Michelangelo's slaves, or his *St. Matthew* in the Academy at Florence, Rodin's marbles oppose the smoothly finished surfaces of the flesh to the roughly-chiselled matrix of the stone. But unlike the sculptures of the Florentine, Rodin's figures do not struggle to free themselves from their marble prison. Instead they seem to be melting back into the shelter of the stone.

In addition to the two works from which these selections were taken,

315

*Rodin* (1963) and *Rodin's Gates of Hell* (1960), Albert Elsen has published such articles as "The Genesis of Rodin's Gates of Hell," *Magazine of Art*, XLV (1952), which initiated his dominant role in the field of Rodin studies, and "The Humanism of Rodin and Lipchitz," *College Art Journal*, XLVII (1958). He has also edited an important anthology, *Auguste Rodin: Readings on His Life and Work* (1965) which reprints the essays by T. H. Bartlett originally published in 1889, the essay by Henri Dujardin-Beaumetz originally published in 1913, and the well-known essay by Rilke. For Rodin's own views, there is his *Art*, translated by Romilly Fedden (1912) and reprinted under the title *On Art and Artists* (1957). Other selected readings are Judith Cladel, *Rodin, The Man and His Art, With Leaves from His Notebook*, translated by S. K. Star (1917) from the original in French of 1908; the Phaidon editions, Sommerville Story, *Rodin* (1939, 1961); Rainer Maria Rilke, *Auguste Rodin*, originally published in 1903, trans. by J. Lemont and H. Trausil (1946), and more recently by G. Craig Houston in Rilke's *Selected Works, I, Prose* (1960). Among articles on Rodin, there are Parker Tyler, "Rodin and Freud: Masters of Ambivalence," *Art News*, LIV (1955) and Albert Alhadeff, "Rodin: A Self-Portrait in the *Gates of Hell*," *The Art Bulletin*, XLIX (1967) and "Michelangelo and the Early Rodin," *ibid.*, XLV (1963). Also of interest is the review of Elsen's *Rodin* by Ruth Mirolli, *The Art Bulletin*, XLVI (1964) and the review of Elsen's anthology by John Schnorrenberg, *ibid.*, XLVIII (1966). Robert Descharnes and J.-F. Chabrun, *Auguste Rodin* (1967), is a beautifully illustrated volume.

In addition, there are Albert Elsen, J. Kirk Varnedoe, et al., *The Drawings of Rodin* (1972); J. L. Tancock, *The Sculpture of Auguste Rodin: The Collection of the Rodin Museum, Philadelphia* (1976); Jacques de Caso and Patricia B. Sanders, *Rodin's Sculpture: A Critical Study of the Spreckels Collection, California Palace of the Legion of Honor* (1977); *The Rodin Museum of Paris* (1977), a picture book; Albert Elsen, *In Rodin's Studio: A Photographic Record of Sculpture in the Making* (1980), illustrated with a fascinating series of old photographs; and Albert Elsen, et al., *Rodin Rediscovered*, Exhibition Catalogue, National Gallery of Art, Washington, D.C. (1981).

## RODIN'S CONSERVATISM

The image of Rodin generally presented nowadays is that of the rebel. In their zeal to legitimize him as the ancestor of modern sculpture, his admirers single out certain aspects of his art for praise while conveniently overlooking others. Thus they give credence to the notion that throughout his life Rodin rebelled against the pontiffs of academic art, most of whom have since been consigned to oblivion. (Who remembers the names of Guillaume, Schoenewerk, Dalou, J.-P. Laurens and Chapuis?) This concept of Rodin as a revolutionary far in advance of his time gains acceptance by default. Today it is difficult to find even photographs to conjure up the look of the nineteenth-century Salons in which Rodin exhibited throughout his career.[1]

But if his disagreement with "the School," as he referred to the Ecole des Beaux-Arts, bears restating, so also do those large areas of agreement. Like Delacroix and Manet before him, Rodin was willing to accept official recognition and honors when they came. He was even elected to the French Academy, although ironically the official vote was cast a few days after his death. Rodin's sculpture, like the painting of Manet and the Impressionists, would have been unthinkable without academic art as a point of departure. Visualizing his sculpture in its original context, it becomes clear that in many ways his modernity is grounded in the conservatism of his time; it cannot be said to have sprung full-blown from an imagination oblivious to the style and subject matter approved by the Ecole des Beaux-Arts. Unlike Cézanne, whose art developed totally independent of official recognition, Rodin produced some of his greatest works thanks to state and municipal commissions.

His theories that art should ennoble, instruct and edify the general public, expressed in innumerable statements after 1900, allied him with his most reactionary colleagues. In his conversations on art published in 1911,[2] Rodin championed sculptors and painters who by embodying in their work the great French national virtues—heroism, wit, courage, self-denial, and respect

for lofty sentiment—made the beholder feel that he himself was capable of noble deeds. "Without doubt, very fine works of art are appreciated only by a limited number; and even in galleries and public squares they are looked at only by a few. But, nevertheless, the thoughts they embody end by filtering through to the crowd."[3] Much of Rodin's own artistic education came from visiting galleries and museums and studying public monuments. His most vivid exposure to the myths of antiquity came not from books, but from works of art in the Louvre and the Salons. Looking upon the artist as a synthesizer and popularizer of culture, Rodin proclaimed that his profession should "bring within the reach of the multitude the truths discovered by the powerful intellects of the day."[4]

By the time he published these statements, Rodin himself had become the supreme pontiff of the art world. Proudly he traced the lineage of his art and dogma back not only to the Renaissance and the Gothic, but beyond these periods to ancient Greece and Rome. If this "grandfather" of modern sculpture could witness the work of his descendants and measure their ideas against his own, he would probably reconsider his belief that his mission was to provide a firm guide for the future by linking his time with the past. There is, in fact, no evidence that Rodin was ever aware of, or in sympathy with, the revolution in sculpture undertaken early in this century by Picasso, Matisse, Brancusi, Boccioni, Duchamp-Villon, Archipenko and others. The artists he admired and praised were his own satellites—Bourdelle, Despiau, Claudel and the Schnegg brothers. What he approved in the early talent of Brancusi, Maillol and Lipchitz was the evidence of their affinity with his own art or ideas concerning the imitation of nature.

A comparison of Rodin's staggering production with that of his contemporaries in the late nineteenth- and early twentieth-century Salons makes it difficult to consider him a precursor of modern art in respect to his subject matter. As was common practice at the time, a considerable portion of his *œuvre* consisted of portraits. A cursory inventory of the themes, titles and characters of his other figures reveals the extent to which his ideas and choice of subjects were common to those of other artists of the time. Characteristic themes were sin, melancholy, sorrow and despair; all stages of love, from desire and the embrace to abduction and rape; sleep, fatigue, awakening; revery, thought, and meditation. Perennial subjects were the inspiration of the artist or writer by his muse;

maternity, and exchanges of affection between brothers and sisters; play and peril; self-sacrifice, death for country or for a noble cause; primeval man awakening to nature or to his own soul. Like other artists of his time, Rodin followed the old tradition of personification and used the human figure to embody time, the seasons, the elements and various flora. (In his writings and conversations, he frequently compared natural phenomena, trees, water and clouds with the human body.) His work abounded in angels, spirits and genii, nymphs, satyrs, bacchantes, sirens, centaurs, and endless bevies of dancers and bathers. Biblical figures included Satan, Adam and Eve (both before and after the Fall), Christ, St. John the Baptist and Mary Magdalen. They were rivaled by the pagan legions of Pan, Bacchus, Psyche, Orpheus, Ariadne, and Danaïd, Perseus and the Medusa, Aphrodite, Apollo and Mercury. Some of the most popular heroes and heroines derived from literature were Pygmalion and Galatea, Ugolino, Paolo and Francesca, and Romeo and Juliet. The titles in Rodin's work that refer to Classical antiquity do not decrease after 1900. Rodin's titles brought him notoriety—partly because they offended public notions of how they should be portrayed in art, and partly because he could derive them from a corps of famous literary friends. His frequent practice of giving several titles to the same sculpture, or the same title to different works, makes identification difficult in many cases. Perhaps it was against such labels that the insurgent younger generation of the early twentieth century rebelled, believing that sculpture must be freed from literary influence and from its long subservience to illustration and mute theater.

For Rodin, to give a pair of nude figures a title from Ovid was a natural result of his education. From the time of his apprenticeship, which lasted until he was almost forty, all his decorative work in furniture, jewelry, ceramics, mantlepiece or table ornament, and architectural sculpture was identifiable with antique or Renaissance motives. On the beds, he carved appropriately tender amors: his vases were braced by bacchic idyls; balconies were supported by caryatids; fountains were flanked by huge masks of sea gods; pediments were crowned with allegorical figures representing Fame or the continents. These were the subjects that the public expected in decoration.

Rodin had a startling facility for adapting his mode to his subject, scale and medium. The gigantic and brilliant masks intended

for the Trocadéro would stand out as fine Mannerist sculpture and hold their own in the Bomarzo Gardens. His caryatids would seem at home if placed next to those Puget carved for the Toulon Town Hall, while his busts of garlanded adolescents belong in Rococo boudoirs. He was trained both to think and work "in the manner of"—*what* or *whom* depended upon the whim of the client. In the oldest and fullest sense, Rodin trained himself long and well as a professional sculptor. Throughout his life, his talents were available for varied projects in many modes, to those who could pay for them.

Unlike today, in Rodin's youth it was unquestioned that the young artist should work from the human figure. Unless he specialized like Barye in animal sculpture, or in floral decoration, the artist had no alternative. The study of anatomy, and drawing and modeling from the studio model, were a matter of course as part of his training. No French sculptor contested the academic dicta that the human form was the noblest means by which to express the human spirit and great ideas, and that ancient Greece and Rome provided paradigms for the figure's proportion, symmetry and movement. Rodin's chief dissent from the Academy lay in its failure to acknowledge or recognize the beauty of Gothic art, which he considered equaled that of antiquity. Modern appreciation of the Gothic owes a great deal to Rodin—not for his archeological information but for his meaningful reading of its form, and his ability to see it as a view of life expressed in beautiful art that rivals the best of any period.

The nineteenth-century editions of Charles Blanc's *Grammar of the Arts of Drawing, Architecture, Sculpture, Painting* and the reviews of the Salons in the *Gazette des Beaux-Arts* enable us to reconstitute the official views of what sculpture should look like and the services it should perform. To manifest "universal life" in the grand figure style that alone could produce strong personalities represented the triumph of civilization over barbarism, for what the French thought of as their "race." These heroes were expected to show pride, majesty and grace by bodies constructed according to prescribed systems of measurement. A repertory of gestures and facial expressions existed with which to convey exalted thoughts and noble feelings. Rhetorical gestures had to seem natural in accordance with standards derived from Greek and Roman prototypes. In the characterization, eloquence and firm articulation were necessary to bring the message most directly to

the beholder. Sculptors were enjoined to choose simple, uncomplicated and stable postures, leaving movement to be extended or amplified by the viewer's trained imagination. Deformity or exaggerated, strenuous movement ranked as heresy. Ugliness was not permissible in sculpture, since it would usurp that immortality of which only true beauty was worthy and would have a negative moral influence upon the susceptible. Though more widely interpreted in practice, beauty was narrowly defined by the School as selective: it was not imitative of a single model but was of a generic type, brooking no idiosyncrasies or flaws in proportion or movement. Given this fixed ideal, the sculptor's task was to find the right model. The sculptor, like his subjects, was expected to "cover his inner fire" and seem always master of himself. Correct work in marble allowed no improvisation, for this grave, formal medium was deemed the least suitable to express transient or vigorous movement. Only in sketches might the sculptor's passion be revealed, and the rough or unfinished be tolerated.

Rodin was in some respects an academician *manqué*. It was not his fault but rather his fortune that he failed three times to gain admission to the Ecole des Beaux-Arts where, in spite of his recognized technical precocity, his youthful eighteenth-century style ill suited the taste of his classically oriented examiners. Rodin admired and emulated much that the School stood for—its discipline, its master-pupil relationships, its study of the past and its provision of public monuments. Throughout his life he sought not to overthrow the School, but rather to reform and liberalize it.

His dissents from its principles and practice were nevertheless critical. One of his many statements summarizing his position on the subject was made in 1899:

> The actual fault of the School is to fear everything outside of five or six agreed-upon formulas. It has made the public likewise timid and fearful of change. Nature offers thousands and still thousands of ideas and movements, all equally beautiful. But a small number of axioms which in truth are deformities have been imposed upon us. When we see an individual or group of human beings wed to the attitudes of such academic work, we understand immediately that we are confronted with something false.[5]

Rodin would have established nature as the stern master and measure of art, with students dedicating their lives to its thoughtful

45. Rodin, *The Age of Bronze,* 1876, Bronze, 68½" high (Musée Rodin; © by s.p.a.d.e.m., Paris, 1976 )

imitation. On one occasion, he commented that the School was so committed to convention that it could never look truth in the face. He believed that it was not theories and plaster casts but the experiences of the senses coordinated with the mind which brought the sculptor into contact with life, and thus with truth.

The case for Rodin's importance as an artist who rose above his own conservatism and that of his day must rest on his recognition that official art suffered from too great an aesthetic and emotional distance from life, and that its content was also remote from, and irrelevant to, the deepest human needs of the time. His efforts to close these gaps gave his sculpture its distinction and produced its disquieting impact when it was first exhibited. Rodin attempted to remedy the ills of conservative sculpture and reform public art but contributed to their demise by attracting to his ideas the best youthful talent and by opening the way to more viable alternatives than he himself could ever have foreseen.

By 1876, the date of his first major signed work, *The Age of Bronze* (Fig. 45), Rodin was fully aware of sculpture's dilemma. He recognized that it had degenerated into a demonstration of studio rules, whose mastery produced only formal clichés and empty rhetoric. Having arrogated to itself from ancient art certain norms (often misinterpreted), the School in the name of preserving the eternal verities had shut off all possibilities for growth and flexibility. Rodin saw no opportunity under this closed system

for revelation or work inspired by fresh discoveries made either from nature or from great art of the past. Temperamentally unable, in making a major, personal work, to maintain the dispassionate controlled attitude expected of the artist, he reacted against what he termed "polish versus thought" and the frigid rationalization that was supposed to dominate aesthetic decisions. The most enduring of Rodin's precepts was that the artist be tenaciously truthful in translating what he *felt*. An important aspect of his modernity was that he assigned primacy to feeling as the source of art. Just as he cherished unfettered individual intuition rather than blind acceptance of rules, so he rejected the corseting of studio models in arbitrary proportions and predetermined stances that divested them of their human attributes.

Rodin's attitude toward the body was humane. None of his contemporaries had such compassionate understanding, acuity of observation, or sensitive rendering of the nude. He could find humanity in a hand or a foot. As Lipchitz has mentioned, it was the skin rather than the word that for Rodin bore the precious trace of what it meant to live at any time. His desire to make the public and artists seriously aware of sculpture, and of the possibilities for new and meaningful emotional encounters with it, was closely related to his conviction of the need for a sincere awareness of the human body itself. In the body, Rodin saw both man's fatality and his own destiny.

Much of Rodin's modernity rest upon his belief that the artist must devote his life to empirical discovery for and of himself. His empiricism, which denied the possibility of conforming to impersonal norms, was the single trait that above all others prevented Rodin from being an academician and a consistent conservative. The modern ethic that the artist should work from personal experience in ways that he has individually acquired is strongly rooted in Rodin's life and art. This partially explains the natural and violent reactions against him at the turn of the century on the part of younger avant-garde artists, who consciously or not were following his ethic to its logical conclusions.

Rodin himself felt, however, that his empiricism linked him with the great artists of the past, rather than with those of the future. One of his many secretaries has nicely put the sculptor's estimate of his position: "He never claimed that he had introduced anything fresh, but that he had rediscovered what had been long lost by the academicians. The Greeks had possessed it, and so also

had the Gothics. But in the official art of the day it was entirely lacking. His contribution . . . was therefore an act of restoration."[6] And to quote Rodin's own words: "It is not thinking with the primitive ingenuity of childhood that is most difficult, but to think with tradition, with its acquired force and with all the accumulated wealth of its thought."[7]

## CONCLUSIONS

(FROM *Rodin's Gates of Hell*)

In 1880 Auguste Rodin was commissioned by the French government to create a decorative portal (Fig. 46) based upon *The Divine Comedy*. His preliminary figure drawings, influenced by Dante's poem, suggest that he was preoccupied exclusively with "The Inferno," and especially with themes of passion, violence, and despair. He did not undertake a literal, sequential illustration of "The Inferno," but interpreted the poem's qualities of movement, conflict, and melancholy introspection.

During the formative years for the portal—the late 1870's and early 1880's—the influence of Baudelaire mingled with that of Dante. The fact that Rodin shared Baudelaire's interest in sin, in the vain but inevitable pursuit of carnal pleasure, and in the apparently uncaused moods of depression that make the body a prison of passion, comes to light in his drawing for the *Fleurs du Mal*. Although there is no documentary proof, Rodin's interest in man's perversity and rebelliousness—the consequence of man's indifference to religion and moral values—may have been his reaction to the complex and tense religious atmosphere of the time that saw the undermining of the Roman Catholic Church's authority.

The style and much of the spirit of the Gates come from the major and militant sculptures of the late 1870's—"The Age of Bronze," "John the Baptist," and "Adam." The sculptor's personal and artistic maturity appears in the themes of suffering and striving. But by contrast, he was inexperienced in designing architectural elements, such as a large portal. His admiration for the Renaissance explains the early sketches for the doorway, which are derived from the eastern door of Ghiberti's baptistery. When he began to work in clay and plaster, his thinking became more

46. Rodin, *The Gates of Hell*, 1880–1917, 18′ high (Musée Rodin; © by S.P.A. D.E.M., Paris, 1976)

sculptural and susceptible to Gothic and Baroque influences. The last model done before the full-scale erection of the Gates was shaped by a personal vision of Hell and the recognition of the timelessness and universality of his theme. He rejected almost all literal references to Dante and Baudelaire, and relied upon movement, light and shadow, and the expressiveness of his anonymous figures to carry his ideas.

From the standpoint of utility, the doors are deficient, although

with a few minor changes it would be possible for them to open and close. After 1885, the Gates were no longer intended as an entrance to a building and practical requirements were eliminated. Rodin then indulged his fantasy and the doors assumed a poetic character. The architecture is certainly eclectic, but in good taste and thoughtfully designed as a foil for the agitated sculpture.

Rodin's way of working upon his project included drawing upon older art and literature, upon his own sculpture, and upon observation from life. He became engrossed in the creation of an autonomous sphere of life with its unique space and scale relationships that, in Baroque fashion, narrow the gap between the world of the viewer and the world of art.

The ever-increasing scope of his ideas for the portal, physical fatigue, a more optimistic view of life that emerged during the 1890's, and perhaps a desire for atonement—all these made a definitive realization impossible. Yet though their present state is reconstructed and incomplete, the Gates give a moving presence to Rodin's ideas about society. The subject of the door is the loneliness that results from the absence of spiritual values. Life is an Icarian flight from reality toward the unattainable that ends only in disillusion and destruction. Society provides no checks to restrain nor goals to satisfy the individual. Modern man's problem is the eternal internal hell created by his insatiable passions. And the torment of life continues after death in the form of restless and purposeless movement.

Rodin was one of many modern artists who found in the life of the artist an ideal existence. He insisted upon the artist's freedom of experience; his life and art were based upon empirically derived values that were often at variance with those of his society. In romantic fashion, there is a close connection between Rodin's personal life and the evolution of his art. By 1880, when he began work on the Gates, he could no longer celebrate the rational theories of the Academy or the theology of the Church. "The Gates of Hell" show his desire to interpret the world in terms of his own interior reactions. The core of his most successful art was formed of themes about which he felt most strongly: death, the emotions, the ugly, and the beautiful. The romantic cult of energy had no more distinguished an exponent than Rodin. Through tremendous effort he created a poetical equivalent of the society

he lived in. Rather than allowing him to escape from life, his art led him to explore its problems and truths, and ultimately provided an otherwise unattainable form of understanding of himself and his environment.

From an aesthetic standpoint, the Gates are weak in design. They lack a powerful and cohesive facture, perhaps the result both of Rodin's limitations as a composer and of the nature of the problem he had set for himself. The work is richest in its humanitarian sentiments and sculptural details. In the small groups and individual figures can be seen the wellsprings of his art and in some respects his legacy to sculpture.

In many works Rodin raised aesthetic value above ethical or intellectual content. He had explored the expressive properties of structure, volume, light, and rhythm. Recognizing this, Lipchitz speaks of Rodin as "the great composer of light."[8] Though it is possible that some of Degas' daring undated sculptures may have preceded Rodin's work of the late seventies and eighties, it was Rodin's imaginative modeling that reestablished sculpture as exaggeration rather than description or literal imitation.[9] It was the extent and the manner of Rodin's departure from the actual model that strongly influenced Lehmbruck, Matisse, Picasso, Brancusi, and Epstein at the beginning of this century. His use of portions of the body, a technique that served to reduce the literary demands with which sculpture had been burdened, increased his influence on later sculptors. His making the body a study of processes and mobility captured the imagination of Boccioni. Outside of his contemporary followers, Rodin's thoughtful explorations of gesture and his instinct for the significant posture did not manifest an important influence until the work of Lipchitz in the 1930's.[10] The nineteenth-century academic taste for a finished surface and its compartmentalized attitude toward the beautiful and the ugly was ignored by Rodin; his ideas and work helped to expand the aesthetic of modern sculpture. The violence and strenuousness with which artists such as Maillol and Brancusi reacted against Rodin must be counted as an important, though negative, influence. The shadow cast by Rodin, from which so many gifted young sculptors sought to escape, was a partial incentive to the fresh thinking and the daring that led to the revolution in sculpture before the First World War.[11]

To many present-day critics and artists, Rodin's work seems

dated. This is owing partly to Rodin's literary affinities, his sentimentality, his Baroque schemes, and his imaging of man exclusively in terms of the external anatomy. Rodin is the culmination of a tradition beginning with the late Middle Ages and reaching down into the nineteenth century in which the artist relies upon the outward appearance of the body to interpret the inner life. Like that of Renaissance and Baroque sculptors before him, Rodin's artistic world was man-centered, and all that was noble or pathetic in human history could be personified in it. During an age of great technical advancement, Rodin's sensibility was unswervingly directed to the private emotional and psychological life. He was convinced that the flesh could mirror the stirrings of the soul. In this century, as a result of Cubism and fantasist art of the twenties and thirties, there has been a widening and enriching of the images of the body, as seen in new and imaginative physiologies, so that advanced sculptors of today such as Lipton, Roszak, and Smith can feel that they have passed the point of no return to realistic external human anatomy. The tragic moral and spiritual problems with which Rodin was concerned in his art have since his time been largely ignored or replaced by the themes of man submitting to a nameless catastrophe, no longer in conflict with his God, but in tension with life itself or confronted by nothingness. Many sculptors recognize, however, that Rodin helped to retrieve sculpture from an intellectual and aesthetic limbo by his rediscovery and energetic demonstration of the power and seriousness of which sculpture is capable. In Simmel's words, "Rodin did not give a new content to the plastic arts, but he gave them for the first time a style by which they express the attitude of the modern soul before life."[12] Man lives by manifestations, and though Rodin may not today supply us with a complete alter image or fulfillment of our needs, he has made an important addition to the richness and variety of modern art that is essential to a speculum of humanity. "The Gates of Hell," like Baudelaire's poetry, expresses ideas and feelings that have meaning at more than one moment in history.

Rodin's Gates are historically valuable as an expression of the *Weltangst* of the late nineteenth century that is also found in the art of Munch, Ensor, and Van Gogh, and that led to the art of the German Expressionists. Meyer Schapiro puts this relationship into focus: "The theme of humanity as a whole is impressive, like the

manner of treatment. It points to the twentieth century and particularly to German Expressionism where the image of man is a generalized picture of impulse and suffering. It is also ahistorical, for it represents neither the Last Judgment nor particular events in time; it is a panorama of the soul and the body in abstraction from the culture-forming historical human being who creates the community, art, technology and science."[13]

Rodin's Gates are one of the last works of modern art that attempt to deal with the whole community. They also look forward to the advanced art of this century with its concern for the self rather than the group and with the anonymous hero or victim. Even in bringing together the community he showed simultaneously the traces of its atomization, so keenly felt by artists who have followed. Like the German Expressionists, Rodin presents us with the nonsocial human in his private existence rather than with the social being. The individual has been thrown back upon himself and unremittingly desires fulfillment outside himself. Life is a succession of obstacles that induce both inertia and action. The Expressionists' feelings about man's hopelessness, estrangement, and sense of loss in the vast universe are already present in the Gates.

With his consciousness of man's diversity and unity, his aspirations and dignity tempered by finite capacities, Rodin transforms weakness into spirituality. The range of his art from animality to spirituality is also present in Munch, Van Gogh, Heckel, Nolde, and Lehmbruck. This transformation and this range are symptomatic of the shift in modern times from a religious spiritual art in which the feelings of reverence, faith, and hope formerly addressed to Christ and the saints are transferred to man. The holiness of the living is seen in their suffering, rather than in the passion of the martyrs of the Church.

Like Heckel, Nolde, and Munch, Rodin did not hesitate to draw upon literature—Dante and Baudelaire instead of Dostoievsky—to express his sentiments.[14] For all these artists, literature, art, and life were one. For them, furthermore, art was not creating for pleasure, but the difficult communication of difficult times.

Rodin's lifelong concern was the imaginative rendering of the moral problems of his society.[15] His insights in the Gates preceded by several years the writings of Emile Durkheim. What Durkheim says about societies afflicted by *anomie*, or the absence of moral

codes, in his *Suicide,* published in 1897, reads in part like an analysis of "The Gates of Hell."

Irrespective of any regulatory force our capacity for feeling is in itself an insatiable and bottomless abyss. But if nothing external can restrain this capacity, it can only be a source of torment to itself. Unlimited desires are insatiable by definition and insatiability is rightly considered a sign of morbidity. Being unlimited, they constantly and infinitely surpass the means at their command; they cannot be quenched. Inextinguishable thirst is constantly renewed torture. It has been claimed indeed, that human activity naturally aspires to go beyond assignable limits and sets itself unattainable goals. . . . To pursue a goal which by definition is unattainable is to condemn oneself to a perpetual state of unhappiness.[16]

Rodin is the Janus-headed figure of modern sculpture. In one sense his art is addressed to the past and its heritage. He did not consider himself a revolutionary, but often spoke of himself as a worker, insisting that he had not invented anything new, but was simply rediscovering the great tradition of older art. "The Gates of Hell" were for Rodin the descendants of the cathedral portals, Ghiberti's great door, Michelangelo's frescoes—monuments by which the artists had intervened in public life. "The Gates of Hell" also look forward to modern art, for they mark the beginning in sculpture of attitudes toward man that were articulated by the philosopher William Barrett in 1958:[17]

> The modern artist sees man not as the rational animal, in the sense handed down to the West by the Greeks, but as something else. . . . Our time, said Max Scheler, is the first in which man has become thoroughly and completely problematic to himself. Hence the themes that obsess both modern art and existential philosophy are the alienation and strangeness of man in his world; the contradictoriness, feebleness, and contingency of human existence; the central and overwhelming reality of time for man who has lost his anchorage in the eternal. . . . There is a painful irony in the new image of man that is emerging, however fragmentarily, from the art of our time. . . . The disparity between the enormous power which our age has concentrated in its external life, and the inner poverty which our art seeks to expose to view.

The story of its formation and the meaning of the sculpture join "The Gates of Hell" to the great tradition of art which has been

involved in the everlasting struggle of mankind for its own mastery.

*N O T E S*

¹ The best sources of such photographs are the albums devoted to French sculptors in the library of the Musée des Arts Décoratifs, and the Archives Photographiques of the Caisse Nationale des Monuments Historiques in the Palais Royal, Paris. Contemporary issues of the *Gazette des Beaux-Arts* contain abundant illustrations of Salon sculpture.

² *L'Art: Entretiens réunis par Paul Gsell* (Paris: Grasset, 1911).

³ *On Art and Artists*, New York, Philosophical Library, 1957, p. 244. This is a translation, with introduction by Alfred Werner, of *L'Art*.

⁴ *Loc. cit.*

⁵ A. Alexandre, "Croquis d'après Rodin," *Figaro* (Paris), July 21, 1899.

⁶ A. Ludovici, *Personal Reminiscences of Auguste Rodin* (Philadelphia: Lippincott, 1926), p. 190.

⁷ *Les Cathédrales de France* (Paris: Colin, 1946), p. 180.

⁸ *The Heritage of Auguste Rodin*, catalogue of a Bucholz Gallery exhibition, December, 1950.

⁹ In his *Pittura, Scultura D'Avanguardia, 1890–1950*, Raffaele Carrieri tries to show that Rodin was indebted to Medardo Rosso for this mode of his style. He says that Rosso was the first to combine in sculpture movement, atmosphere, and instantaneous effect, and to join form to light and the body to air. He also says that Rosso's visit to Paris and an exchange of sculptures with Rodin influenced Rodin's statue of Balzac. Carrieri overlooks the entire development of the Gates many years before, Rodin's earlier discoveries of the use of light in such works as "John the Baptist," as well as the influence of Donatello and the history of older sculpture in the formation of his style.

¹⁰ This comparison is developed by my article, "The Humanism of Rodin and Lipchitz," *College Art Journal*, Spring, 1958.

¹¹ The best assessment of Rodin's place in modern sculpture that I have encountered has been made by Leo Steinberg in a brilliant review of Andrew Ritchie's *Sculpture of the Twentieth Century*. In stating the grounds upon which Rodin may be claimed for our own century, Steinberg writes, "Rodin does belong to us; not by virtue of his light-trapping modeling, but because in him, for the first time, we see firm flesh resolve itself into a symbol of perpetual flux. Rodin's anatomy is not the fixed law of each human body but the fugitive configuration of a movement. Form is a viscous flow that melts and reconstitutes itself before our eyes. In the 'Défense,' the human form just shaped hangs on the brink of dissolution. The male torso seethes like a blistering sheet of lava. It has none of the resilience of solid forms. A prying finger, one feels, would push through the mass instead of rebounding, as it would from a Greek surface. And the strength of the Rodinesque forms does not lie in the suggestion of bone, muscle and sinew. It resides in the more irresistible energy of liquefaction, in the hot, molten pour of matter as every shape relinquishes its antique claim to permanence. Rodin's form thus becomes symbolic of an energy more intensely material, more destructible and more universal than muscle power. It is here,

I believe, that Rodin links up with contemporary vision. The sculptor studying not states of being, but forms of transition—this is the common factor that unites Rodin's 'Défense,' Picasso's Cubist head, Gabo's spiral theme and Roszak's Spectre of Kitty Hawk." ( *Art Digest,* August, 1953. )

[12] Simmel, *op. cit.,* p. 128.

[13] Letter from Meyer Schapiro, January 24, 1954.

[14] While Rodin's use of literary themes was criticized at the beginning of this century by young avant-garde sculptors, today, as seen in the art of Lipchitz and Roszak and many others, there is a willingness to turn again to this source for subject matter and inspiration.

[15] There are some who contend that art should not show human weakness but present man with positive ideals after which his life should be patterned. Simmel has written the most impressive alternative to this view. "If one feels that the end of art is to deliver us from the troubles and disturbances of life, to furnish peace outside of the movements and contradictions of life, one must not forget that the artistic liberation from the anxiety or insufferable character of life can be obtained, not only by taking refuge in that which is the contrary to this agitation, but also, and above all, by the most perfect stylization and the most intense purity of the contents of this reality. [Art such as Rodin's] makes us relive our life in the most profound way, in the sphere of art, and it delivers us precisely from that which we are living in the sphere of reality." ( *Op. cit.,* p. 138. )

[16] Emile Durkheim, *Suicide, A Study in Sociology,* pp. 246 ff. This work was called to my attention by Professor Arthur Danto.

[17] *Irrational Man, A Study in Existential Philosophy,* pp. 56–57.

While I am sympathetic with much of Hilton Kramer's characterization of Rodin's art, his assignment of Rodin's views about life entirely to a "proto-Renaissance" conception is obviously at variance with mine. Concerning Rodin, Kramer wrote in his column, "Month in Review," *Arts,* September 1957: "By comparison [with Degas] Rodin looks like the last master of the Renaissance. His vision still adheres to a heroism which often embarrasses the modern eye and makes it ironic. Rodin was still able to draw his themes from the heroic mythologies and draw them straight without mockery or parody or the sense of loss which characterizes so many modern confrontations of heroic myth. He was what everyone said he was—a kind of prophet, prodigious in vision, energy and achievement, and thus even his modern subjects are endowed with a grandeur which, without falsity, has its roots nonetheless in a proto-Renaissance conception of life. His portrait heads tell us what modern life would be like if viewed under the aspect of Classical heroism. Rodin thus stands as the 'father of modern sculpture' in a Freudian as well as in a historical sense. He is both the end and a beginning."

In his *The Nude,* Kenneth Clark has written, "In spite of the vitality with which he maintained this tradition, we feel that with Rodin an epoch and an episode have come to an end. The idea of pathos expressed through the body has reached its final stage and is in decay" (p. 271). In some respects this is true, but Clark might have commented on the art of Lehmbruck, certain phases of Lipchitz, and Marini.

# *17.* CLAUDE MONET:

## SEASONS AND MOMENTS

### *William C. Seitz*

INTRODUCTION

It was a long career, which began in the 1850s with the caricatures he produced as a youth in Le Havre before Boudin led him into painting, and ended in the 1920s with the large panoramic canvases of the lily pond at Giverny. Over this stretch of time Monet had made a major contribution to painting, and not merely through prolific creativity of a high order. By virtue of a remarkably dedicated exploration of both his subject and his means, Monet was to be a central figure of a revolution in European painting that would begin by directly and spontaneously recording nature's ephemeral effects of atmosphere and light, only to evolve into a shift of emphasis that would have profound implications for future art. This came about gradually as some painters—chief among them Monet—edging into lyrical chromatic enhancements of a world transformed by light, began to veer from a more or less exclusive concentration on the problems of direct transcription of visual sensation to the attractions of their technical means—the microstructure of broken color—and, so, to the very process of painting itself. The possibilities of a "pure" painting, freed of ascertainable reference to the material world and to the normal visual experience of things in it, now drew closer to realization. Monet and his fellow "impressionists" never stepped across this border, but Monet came up to the very edge of it in his series of haystacks and in his façades of the cathedral at Rouen, finally summing up the experience of that borderland in the great waterscapes of his last years.

333

The selection that follows is taken from one of the most sensitive essays ever written on Monet's painting and traces the artist's development throughout his career. From the extensive literature on French Impressionism, the following titles are suggested for further reading: John Rewald, *History of Impressionism*, rev. ed. (1961); Jean Leymarie, *Impressionism*, 2 vols. (1966); Lionello Venturi, "The Aesthetic Idea of Impressionism," *Journal of Aesthetics and Art Criticism*, I (1941), 34–45; J. C. Webster, "The Technique of Impressionism: A Reappraisal," *College Art Journal*, IV (1944), 3–22; Richard F. Brown, "Impressionist Technique: Pissarro's Optical Mixture," *Magazine of Art*, XLIII (1950), 12–15; William C. Seitz, *Monet* (1960); W. I. Homer, *Seurat and the Science of Painting* (1964); Phoebe Pool, *Impressionism* (1967), a handy survey; Mark Roskill, *Van Gogh, Gauguin, and the Impressionist Circle* (1970); Albert Boime, *The Academy and French Painting in the 19th Century* (1970); Jean Sutter, ed., *The Neo-Impressionists* (1970); Joel Isaacson, *Monet: Le Déjeuner sur l'Herbe* (1972); *Camille Pissarro: Letters to His Son Lucien*, ed. by John Rewald (1972); Kermit Champa, *Studies in Early Impressionism* (1973); *Impressionism: A Centenary Exhibition*, Metropolitan Museum of Art, New York (1974), an excellent, well-illustrated catalogue; Steven Z. Levine, *Monet and His Critics* (1976); Grace Seiberling, *Monet's Series* (1976); Joel Isaacson, *Observation and Reflection: Claude Monet* (1978); *Monet's Years at Giverny: Beyond Impressionism*, Metropolitan Museum of Art, New York (1978), an important exhibition catalogue; Barbara Ehrlich White, ed., *Impressionism in Perspective*, a convenient source book with an introductory essay by the editor; R. Herbert, "Method and Meaning in Monet," *Art in America*, LXVII (September 1979), 90–108; Robert Gordon and Charles F. Stuckey, "Blossoms and Blunders: Monet and the State," *Art in America*, LXVII (January–February 1979), 102–117 (a second part of the preceding article, by Charles F. Stuckey, appears in the September 1979 issue of *Art in America*, 109–125); Joel Isaacson, *The Crisis of Impressionism 1878–1882*, University of Michigan Museum of Art (1980), a fine exhibition catalogue touching on dissension within the impressionist circle and including several lesser-known artists; and Paul Hayes Tucker, *Monet at Argenteuil* (1982). Two works were of special significance to the Impressionists themselves: Michel-Eugène Chevreul, *The Principles of Harmony and Contrast of Colours*, trans. by Charles Martel (1872),

334

and Ogden N. Rood, *Modern Chromatics* (1879), also under the title *Students' Text-Book of Color* (1881).

Over a period of almost seventy years—from the fifties, the decade marked by Courbet's realism, to those of cubism, abstract art, and surrealism—Claude Monet produced a virtually unbroken succession of paintings. Including those destroyed or lost, the total could exceed three thousand. Of this number the vast majority are landscapes, seascapes, or riverscapes. . . . [and] the diversity of his landscape paintings derives directly from that of nature, to which, without need for metaphysical justification, he was entirely devoted.

. . . [But] even the most cursory survey—from the great *Seine at Bougival,* let us say, to the engulfing jungle of the last versions of the Japanese Footbridge series painted just before his cataract operation in 1923—reveals a diversity arising from the artist's psyche as well as from nature and vision. Neither his choices of subject nor his modes of seeing, composing, and executing were accidental, nor were they dictated by a systematic theory. Monet's changes were the result of interrelated factors, and consideration of them suggests a fascinating and complicated investigation that would chart their month-by-month permutations. Yet, beneath the eddies in the flow of his art always lay an unswerving determination to paint truthfully the world in which he lived.

For the historical role of pushing naturalism to its bursting point Monet's background, physique, and personality (at least as it developed through feats of inner adjustment) were ideally fitted. He loved solitude and disliked city life. "I assure you that I don't envy your being in Paris," he wrote to the painter Bazille from Fécamp in 1868. "Frankly, I believe that one can't do anything in such surroundings. Don't you think that directly in nature and alone one does better?"[1] Physically, he was vigorous enough to withstand the rigors of a life that bore as much resemblance to that of a hunter or fisherman as it did to that of a studio painter. He could appear before his motif at dawn and paint all day in the hot sun, in wind or snow, or even in the rain. At the age of fifty-five he worked outdoors in a Norse winter, and also on the frozen Seine near Giverny, warming his hands on a hot water bottle when they became too stiff to hold the brush. Like his

337

friends Zola and Clemenceau he was skeptical, distrustful of intellectual or religious dogma, but had tremendous respect for sense data as the basis for truth. Toward the authority of the Renaissance tradition—quite differently from Manet, Degas, or even Courbet—he showed a radical disrespect that kept academic solutions and clichés from inhibiting his sensibility. . . .

Essential to Monet's impressionism, also, was his ability to preserve appearances from adulteration by the conceptualized visualization of practical life. It is in this context that we must understand his stated desire to see the world through the eyes of a man born blind who had suddenly gained his sight: as a pattern of nameless color patches.[2] . . .

Monet's immersion in perceptual reality unified the dualism typical of so many classical, romantic, and expressionistic landscape painters. However a new kind of anguish, like that of Boudin [his first teacher], resulted from the very totality of his involvement—from his drive to capture the full range of natural effects, however impalpable or transitory. . . . The passage of time became a maddening challenge; inclement weather, if it prevented outdoor work, led to deep discouragement.

Thus Monet's emotional life did become enmeshed with his subjects, but in an empathetic rather than a projective way. . . .

It is as if, within Monet's psyche, there were a scale analogous to that of the weather, grading from chromatic luminosity, vibrant with light and joy, through an infinite range of tinted and toned grays implying as many median emotional nuances, and finally down to blackness; nullity; immobility; non-being. . . .

To eyes accustomed to the mahogany browns of the Barbizon school landscapes, or even the silvery tones of Corot, the brighter colors and accentuated brushstroke of Monet's pictures of the 1870s were brutally harsh, and they seemed utterly false to appearances. To modern taste, however, which discerns a reference to nature even in the most abstract painting, certain works of Monet seem to narrow, and sometimes almost to close, the gap between nature and art. Almost never are the objects he represents shifted, as in most post-impressionist landscapes, from the relative positions which they would have occupied on a photographer's ground glass. And despite all adjustments of rhythm, color, and contour, the impact of an original impression is always retained. Avoiding dry, detailed empiricism by strong brushwork, Monet came closer to perceptual reality than has anyone else.

Still and motion photography in color have shown us, however, that the world has a million modes of appearance, not one; and that a neutral stone façade can appear mauve, green, blue, or indeed any other color tone, depending on the light and atmosphere. Monet despised the unrelieved local colors, enameled surfaces, static bulks, and hard edges of academic painting. Reacting against them, and naturally drawn toward the world's shifting panorama, he beheld an animated and multi-hued curtain of interacting color patches, opaque or transparent, dull or brilliant, textured or smooth, sharply edged or merging. As his early landscapes show, he was a consummate master, like Corot, of closely related color tones; and though his modes of visualization and representation were to change many times, it is the perception of the world as color and pattern that underlies them.

## THE SERIES

The "series" method of representing nature originated in an attention to more and more specific phenomena of weather, and is inseparable from Monet's choice of subjects, visualization, and style. Boudin had already discovered that "everything that is painted directly and on the spot always has a force, a power, a vivacity of touch that cannot be recreated in the studio,"[3] and had also recognized that the suffusion of a single quality of light over a scene results in a new kind of compositional unity. In 1864 and 1865 Johan Jongkind, master of both Monet and Boudin, painted several views of Notre Dame Cathedral and the Seine from the same position but under different lighting conditions, though according to his practice only preparatory sketches in watercolor were painted on the spot. A year or two later Monet finished—in all probability outdoors—two studies of an identical view of the road from the now-famous Ferme Saint-Siméon to Honfleur, one with the trees in full leafage and the other with the countryside completely covered with snow.[4] Here arc the starting points of a development that combined a constantly narrowing temporal focus, an increasing probity (and consciousness) of vision, an attendant increase of psychosomatic tension, and a continuous improvisation of new formal equivalents for visual phenomena.

During these years Monet was also making other discoveries.

In *The Terrace at the Seaside, Sainte-Adresse,* which shows his father gazing seaward, flower beds are interpreted as a rhythmic staccato of warm and cool spots; at Honfleur, in the winter, he observed the wide chromatic range, from warm lights to bright cerulean shadows, of snow subjects; on the Seine, along with the quick movements of vacationers and the parade of small boats, he explored the water surface as well. "When landscape is mirrored in water," wrote D. S. MacColl (a now all-but-forgotten commentator on impressionism) in 1902, "the forms of trees, buildings, and other objects are not only simplified and broadened, but inverted and distorted, for in any troubling of the surface by ripple or wave the water is broken up into a series of mirrors tilted at different angles and with various degrees of convexity and concavity. Into the shivering fragments of these, elongated, shortened, and twisted images of objects on the bank are worked kaleidoscopically bits of sky and cloud, and this undulating hash of half-coherent forms which we can gaze at almost as abstract colour and tone gives the nearest [approach] to the dream of an art that should be a play of colour only. Something of this state of mind Monet applied to his seeing of unreflected objects, treating trees, for example, by loose groups [of] touches that indicate roughly the place of reflected and transmitted lights and shadows. . . ."[5] It is impossible to overestimate the importance of water, in its fusion with reflection, light, and movement, for Monet's art. Through its mediating image the material world is both abstracted and animated. Within a realistic framework brush and pigment are freed to seek their own path toward an independent beauty, and the painter is given an object lesson in the transformation of nature into art.

But before 1870, and even in the bold beach studies at Trouville, Monet's work does not reveal the concern for the palpability of atmosphere that gains such importance after 1886. He must have been familiar with the fogs that so often blanket coastal Normandy, but until his wartime visit to England the air that fills his picture-space is usually crystal clear. In London he and Pissarro saw the Thames River with its luminescent fogs, and at the museums the sunsets, moonlights, storms, and dissolutions of Turner. "At one time I admired Turner greatly," Monet said in 1918; "today I like him much less. . . ."[6] There is reason to believe, also, that he may have seen one or two of the misty and

patternized Nocturnes of Whistler. But whatever the reasons or influences, it can be said that his London studies show a new interest in atmosphere.

Monet was of course not the first French artist to represent fleeting effects: a critic of the Salon of 1859 accused the painter Ziem of imitating "the bad period of the Englishman Turner";[7] Daubigny showed a *Sunset* and a *Moonrise;*[8] the Salon of 1864 included a work of Chintreuil entitled *Sun Dispelling Mist;*[9] that of 1865, his *Evening Vapors,* and Jongkind's *Moonlight Effect.*[10] Such subjects, it is apparent, were common long before Monet attempted them, and go back to Claude Lorrain and even earlier masters; but the very belatedness of Monet's interest in them indicates its authenticity. It was not imaginative, hypothetical, or drawn from tradition, but the result of direct perception. Except for the isolated studies of Leicester Square (1899–1904), night scenes, a stock-in-trade of Jongkind, Cazin, and others, are not found in Monet's art, for, by necessity, his day began with sunrise and ended by dark. . . .

The landscapes Monet painted at Argenteuil between 1872 and 1877 are his best-known, most popular works, and it was during these years that impressionism most closely approached a group style. Here, often working beside Renoir, Sisley, Caillebotte, or Manet, he painted the sparkling impressions of French river life that so delight us today. Following the example of Daubigny, he outfitted a *bateau atelier,* in which he was portrayed by Manet while painting.

Whether in scenes of the smiling Seine, fields of wildflowers, or village streets piled high with snow, the Argenteuil landscapes are human in scale and reference. Where a passage of grass, foliage, or water demands it, the color is vibratory and broken; but almost as often it is applied in virtually flat areas. And the brush and color treatments . . . adapt themselves to the surfaces, movements, and effects of the river, town, and countryside with an entirely relaxed mastery. Natural textures are interpreted by calligraphic analogy. Only a few river views, painted in 1875 or later, anticipate the oscillating technique that (as in the later series works) seems to raise the pigment touches from the objects they depict and circulate them freely in the air.

During 1876, 1877, and 1878 Monet's life was upset by the hostile reception then accorded all impressionist painting, dire

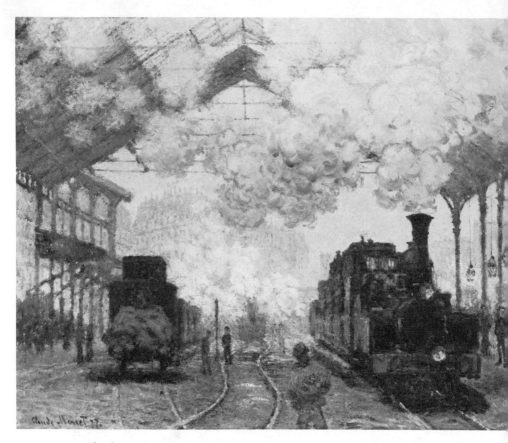

47. Claude Monet, *Gare Saint-Lazare, Paris*, 1877, Oil on canvas, 32¼″ x 39¾″ (Courtesy of the Fogg Art Museum, Harvard University, Maurice Wertheim Collection)

financial distress, the birth of his son Michel, several domestic relocations, and [his first wife] Camille's increasing illness. These were nevertheless years richly productive of both figure and landscape painting—at Argenteuil and Montgeron . . . and, for the last time, in Paris. These cityscapes are as important in Monet's stylistic growth as they are beautiful. The third impressionist exhibition, of 1877, included at least seven revolutionary studies of the yards and skylighted train shed of the Saint-Lazare Station (Fig. 47) seen against an iridescent backdrop of sky, buildings, and the elevated thoroughfare, the Pont de l'Europe. Scrutinizing this totally urban and mechanical motif, with its drama of arrivals and departures taking place amid a spectacle of sun, smoke, and steam, Monet may well have been

seized, as Georges Rivière was at the time, by "the same emotion as before nature."[11] In the puffing, blowing, merging, and dissipating vapors that intercepted and suspended light and shadow Monet found a new subject and treatment of space. Physical objects have lost bulk through flat pattern, color, and summary handling while air has become visible and almost sculptural. . . .

. . . It was [between 1878 and 1881], in all probability, that he began to utilize a slotted box containing several canvases of a given size from which, on returning to his motif from day to day, he could choose the one that best conformed to the light of the moment, continue working until the light changed (seldom more than a half hour), and replace it with another. In conversations during the nineties Monet explained the reasons for this method. He believed that the first look at the motif was likely to be the truest and most unprejudiced one, and that as much of the canvas as possible should be covered at the first session, no matter how roughly, "so as to determine at the outset the tonality of the whole."[12] He often began with wide, separated strokes . . . afterward filling the spaces between them with others as the subject began to emerge more clearly. He felt that it was essential to cease work the instant an effect changed in order "to get a true impression of a certain aspect of nature and not a composite picture."[13] . . .

1880, the year in which Monet announced his independence of the impressionist group, marks an important change in his style and choice of subjects. During the next, intensely busy decade he worked at Poissy, at Etretat and many other locations along the Norman coast, on the Italian and French Rivieras, in Holland, at Belle-Ile, in the rugged valley of the Creuse river, and of course along the Seine and at Giverny, his home after 1883. It is a spectacularly varied sequence of new sites and brilliant formal innovations; a geographical and stylistic quest that led him to seek more and more dramatic and often brightly colored subjects.

Certain common procedures and solutions underlie the works of this period, though they inhere as much in the motif as in its interpretation. As before, compositions are "discovered" by blocking off a portion of a scene without rearranging its elements, but now it is done with much less regard for the Western landscape tradition. The radical cropping calls to mind Japanese prints, of which Monet became an avid collector. . . . A broad vocabulary

of coloristic calligraphy simultaneously translates into pigment both the vibration of light and the rhythms and textures of grasses, earth, clouds, foliage, rock surfaces, and waves. . . .

If a sufficient number of works from the eighties could be brought together, the degree to which the series method is potential in them would be evident. One could assemble sequences of high and low tide; fair and stormy weather; morning, noon, and sunset; . . . calm and rough sea. . . .

To see such paintings together would also reveal Monet's increasing tendency to ignore local, theoretically invariable color tones in favor of the induced coloration of the total environment. As a corollary the individual brushstrokes become smaller by 1888, emphasizing optical mixture more than calligraphic naturalism. At Bordighera and Menton in 1884, though the brushing and brilliant hues predict the manner of van Gogh and the fauves, Monet already saw the need for "a palette of diamonds and precious stones";[14] four years later at Antibes, in one of the first systematically cyclical portrayals of light, his almost pointillist touches have just this effect, and the enduring tones of leaves, branches, and earth are wholly supplanted by the scintillating permeation of a Mediterranean morning, noon, and afternoon. With this group the series method is fully postulated. . . .

## THE HAYSTACKS

The majority of Monet's output during the nineties falls into sequential groups, each representing one subject in many versions, as a cycle of light, weather, and sometimes of season. . . . Of these the first was the group of haystacks that stood on the slope above Monet's farmhouse in the fall and winter. Although the earliest versions are dated 1884, the year after his arrival at Giverny, . . . they already evince the exclusiveness of intent typical of those exhibited in 1891. The bucolic theme, moreover, is divested of every shred of the sentiment traditionally associated with it. This anti-picturesque blandness was a necessary prerequisite to Monet's new aims, for brilliant local color and topographical appeal would have deflected or overpowered them. Inert and porous, set in the midst of neutral or snow-covered surroundings, the masses of piled hay are vitalized, and become one with their

344

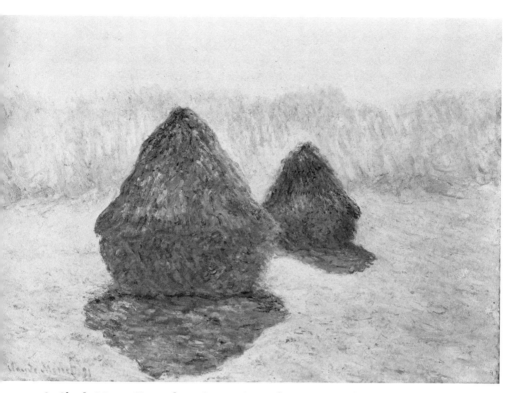

48. Claude Monet, *Haystacks in Snow,* 1891, Oil on canvas, 25¾" x 36¼" (The Metropolitan Museum of Art, Bequest of Mrs. H. O. Havemeyer, 1929, The H. O. Havemeyer Collection)

background, through the momentary permeation of a unifying light. . . .

Monet has described the goal of the Haystacks (Fig. 48) as "instantaneity." A totally realistic principle, it was at the same time an implicitly abstract mode of pictorial unification. With the physical bulk of objects absorbed by the luminous medium encircling them, the colored particles—at once dancing points of light and touches of pigment—seem to adhere, like ice on a window pane, to the actual canvas surface. They gather in a translucent but tactile crust with a beauty independent of subject matter.

On a path parallel to that which connects Cézanne with cubism, but distinct from it, the Haystack series stands at a crucial point: it marks an outpost of realism, specific in both time and place, and simultaneously foreshadows the autonomy of pure painting. . . .

345

## POPLARS ON THE EPTE

. . . Monet was stimulated to paint the series Poplars along the Epte by the stately procession of their tall trunks. . . . As in the later art-nouveau landscapes of Gustav Klimt, however, the verticals waver between the swaying lines of growth and geometry, as if Monet sensed a fusion of the two poles in nature.

Considered as a cycle of light, this series exhibits more clearly than ever Monet's substitution of atmospheric color for the material pigmentation of objects. Certain of the effects he sought lasted, it is reported, only seven minutes, or "until the sunlight left a certain leaf." Painted (according to a neighbor of Monet) "from a broad-bottomed boat filled up with grooves to hold a number of canvases,"[15] the Poplars unfold a fragile poetry of summer in France through unnameable gradations, modulations, and juxtapositions composed of such hues and tints as cobalt, robin's-egg, jonquil, gold, chartreuse, and lilac. As unseizable by the mind as they are penetrating to the senses, their optical mixture cannot be stilled into static color tone. The partial fusion dances with the energy of both atmosphere and subjective visual sensation. To critics who discussed the exhibition in 1892 this series, like the Haystacks and the Cathedrals, expressed a cosmic pantheism. Monet's power was seen to lie in his ability to make a "purely transient phenomenon" represent "the sensation of duration, and even of eternity."[16] He gave little support to these extravagant interpretations and insisted, up to the year of his death, that his only aim was to paint "directly from nature, striving to render my impressions in the face of the most fugitive effects."[17] Yet behind Monet's brusque statements, and implicit in his obsession with more and more evanescent effects and activities of nature, one can discern a ruthlessly devaluated transcendentalism.

## ROUEN CATHEDRAL

During the late winter months of 1892 and 1893, and on return visits in 1894, Monet set up his easel in the window of a shop, Au Caprice, on the second floor at 81 rue du Grand Pont, facing the square opposite Rouen Cathedral. A few canvases represent other

views, but most of the more than thirty studies of the façade
were begun—if not in every case finished—from this location.
Though he was not religious, Monet's choice of a motif should
not be surprising. His brother lived in Rouen, less than forty miles
from Giverny. Pissarro had painted there, and Monet had visited
him. The Cathedral was the most famous building in upper
Normandy, and Monet had painted it from the river as early as
1872.

The great façade, its rich but neutrally toned expanse of
sculpture and tracery ordered by an architectural skeleton, . . . is
a giant textured screen upon and before which an infinite range
of light and atmosphere can play. Changing canvases with the
hours, Monet followed the light from early morning until
sunset. . . .

Concerning the fidelity of Monet's interpretations it should be
said that his vision was anything but naive by the nineties, and
that a process of analytical separation, in which certain dense
shadows and stains on the masonry were discarded, surely pre-
ceded the final optimal synthesis. By adding white to his pig-
ments (thus raising the color key), and by scumbles and dry
glazes, Monet was able to disentangle the transparent film of
light from the surface beneath it. . . .

A peak in Monet's materialization of the ephemeral is arrived
at in the Cathedrals. Even in his early canvases he painted the
visual curtain rather than conceptual bulk. Later on impressions
were interpreted, controlled, and intensified. But gradually, as
his eyes probed more deeply, as he analyzed more carefully both
what he saw and his responses to it, he painted *sensations* as well
as appearances. Finally, in these works, subject, sensation, and
pictorial object have all but become identical. . . .

It has often been argued that the famous series of the nineties
were overly theoretical, and that they therefore constitute a
decline in Monet's power. In the case of a lesser artist indeed,
such could have been the result. But the hypertension of the
Rouen ordeal was broken even before the exhibition in 1895 by
the trip to Norway. The scenes of fjords, of the village of
Sandviken, and the series of Mount Kolsaas are a total change.
Grayed in tone, and painted in a vigorous, relaxed brush which
recalls that of the seventies, they have the immediacy of sketches.
For Monet, each return to nature was an antidote for mannerism.

Until recently it was often forgotten that Monet was an artist

347

of the twentieth as well as the nineteenth century. As we look back at his later work today, however, it appears anything but anachronistic. Sixty years old in 1900, his energy and inventiveness showed absolutely no signs of slackening. He had just embarked on two immense projects: a series representing the Thames River that by 1904 comprised more than one hundred canvases, and another of his water garden at Giverny that he continued to enlarge almost until his death in 1926. The next year a cycle of huge murals was installed in two oval salons, each over seventy feet long, in the Orangerie of the Tuileries. These two series—or rather, groups of series—share a new, almost romantic aura of mystery and indefiniteness, though in most other ways they are opposed. The "water landscapes" climax the expanding, curvilinear trend of Monet's development whereas the London riverscapes continue the geometric trend begun on the Thames in 1871.

## LONDON

Monet made a painting trip to London each winter between 1899 and 1901. . . . He has eloquently explained the attraction that London held for him. Before anything else he was hypnotized by the *brume* and the *brouillard*—the enveloping mantle of mist and fog within which architectural masses became weightless phantoms in the refracted sulphur, blue, or reddish light from the muffled sun. In the manifestations of the Thames Monet discovered qualities—mystery, extreme simplification, protean variability, amplitude—that he loved and sought out, but would never invent. Here he found reality with the enigmatic beauty and melancholy of the dream. More than any other group of works, these exotic riverscapes disclose the romanticism that lay within his personality: it is evident in the Gothicizing attenuation of the Parliament towers. Not each motif, but each *apparition* has its peculiar color and key, stroke type, and tempo. . . . Touched with gleams of light, water merges with air in a single medium—volume without mass.

Fascinating oddities from one of the London trips—and it should be mentioned that such "sports" can be discovered throughout Monet's career—are the two virtually abstract views of Leicester Square by night. If proof is needed that the "look" of the 1950s can be approached from either side of the line separat-

ing realism from abstraction, here it is. . . . If impressionism is conceived as the representation of one in a sequence of natural aspects as it appears momentarily, Monet was more of an impressionist in 1900 on the Thames than he was in Argenteuil. As his feverish scramble for the appropriate canvas proves, he was not representing a process of change, but painting *against* time with the goal of eternalizing the instant. . . .

## THE WATER GARDEN

No other landscape motif (except, perhaps, Cézanne's Mont Sainte-Victoire) has been subject to so close a scrutiny, has been the setting for such a range of subjective experience, or has been the source of so rich a harvest of art works as Monet's water garden. In 1890, after the purchase of the farmhouse in which he lived at Giverny, he acquired a tract of flood land that lay across the road and the one-track railroad from his front gateway. On it grew some poplars, and a tiny branch of the Epte River provided a natural boundary. Excavation was immediately begun to result, after several enlargements of the plan, in a 100 by 300 foot pond through which the flow of water from the river was controlled by a sluice at either end. Curvilinear and organic in shape, it narrowed at the western end to pass beneath a Japanese footbridge. Willows, bamboo, lilies, iris, rose arbors, benches, and on one shore curving steps leading to the water were added, providing a luxuriant setting for the spectacle of cloud reflections and water lilies floating on the pond's surface. Except for a single gate, the water garden was fenced with wire upon which rambling roses were entwined; sealed off from the outside world it formed an encircling whole; a work of art with nature as its medium, conceived not as a painting subject, but as a retreat for delectation and meditation.

The earliest study of the water garden is dated 1892, but it was not until six or seven years later that it became Monet's major subject. . . .

The twenty-seven-year period of water landscapes begins with the series of the Japanese footbridge exhibited in 1900. . . . The first impact of these works is of an almost tropical profusion of trees, shrubs, festoons of weeping willow, and iris beds; its exotic abundance, dramatized by florid accents, is akin to the extrava-

gant literary descriptions of Monet's friend Octave Mirbeau or the atonal music of Debussy and Stravinsky. Upon the saturated greens, blues, siennas, and ochres of the pool and its wavering reflections, the lily pads and blossoms, viewed in recession, lie like a rich but tattered carpet worked with threads of pink and white.

. . . By 1903 a new relationship of space and flatness had evolved. Its patterns are open, curvilinear, and expanding, and of a random naturalness; yet the clusters are nevertheless held in mutual attraction by a geometry as nebulous as that of the clouds whose reflections passed over the pond's surface. . . . In their isolation from other things, and because of the mood they elicit, they seem, like pure thought or meditation, abstract.

. . . In August 1908 . . . he wrote to Geffroy that "these landscapes of water and reflections have become an obsession. They are beyond the powers of an old man, and I nevertheless want to succeed in rendering what I perceive. I destroy them . . . I recommence them . . . and I hope that from so many efforts, something will come out."[18] Discouraged, troubled with weakening eyesight, attacks of vertigo, and fatigue, in September Monet accepted an invitation to visit Venice, where he had never been.

## VENICE

Judged by the aesthetic of "instantaneity" the Venetian pictures, like many of the late works painted within the water garden, are not a true series. Monet was delighted with Venice, and regretted not having visited it earlier; but even though he extended his stay until December and returned again the following fall, most of the pictures were completed at Giverny. . . . Except for a romantic view of San Giorgio Maggiore at twilight they share a common, generalized interpretation of the rose, blue, and violet tremolo of Venetian light. Because they were finished from memory, Monet felt that nature had "had its revenge," and he was deeply dissatisfied.[19] . . .

Of this buoyantly beautiful group of paintings, the close-up views of palaces are especially interesting. Ignoring romantic clichés, and advancing from the precedent of his Poplars and the Rouen Cathedrals, Monet affixed the truncated façades of the Mula, Contarini, and Dario Palaces to the tops of his compositions, square with the frame and exactly parallel to the canvas surface.

The rhythmic horizontal and vertical architectural divisions re-inforce the sparkle of light and shadow on the lapping water. . . . These are the last of Monet's architectural works and the purest examples of the levitational predisposition that ties his art to that of the twentieth century. "It seems that the rose and blue façades float on the water," wrote a young French writer, Henri Genet, when the pictures were exhibited.[20]

## THE WATER LANDSCAPES

After he returned from his first Venice trip in 1908, Monet saw his canvases of the water garden with a "better eye," and began choosing from them for an exhibition to be called *Les Nymphéas: série de paysages d'eau*.[21] Forty-eight, dated between 1903 and 1908, were shown in May 1909 at the Durand-Ruel Gallery.

The conception of an ovoid salon decorated with water land-scapes probably entered Monet's mind (if he had not thought of it earlier) at this time. During the eighties he had experimented with enlarging landscapes to mural size, and combining small panels in a decorative scheme; but the enlargements lost their impressionist immediacy and the combinations lacked unity. In the water garden, however, he had already created a motif for which such a room would be the ideal equivalent. It was apparent, moreover, that the individual canvases of water lilies, though carefully composed and therefore satisfying in themselves, were also fragments that begged to be brought together in an en-compassing whole. . . .

Such a project was without precedent, an ambitious one even for a young man, and by 1912 when the Venetian series was finished Monet was over seventy, with a film already forming over one eye, and despondent over the death of his second wife.

In 1914 came the war and the death of his son Jean. Still in mourning, Monet was visited by his most intimate friend, Clemenceau, to whom he spoke nostalgically of the decoration he would have undertaken had he been younger. "It is superb, your project! You can still do it," was Clemenceau's reply.[22] Monet's resolve was also strengthened when a lady admirer wrote suggesting "a room almost round that you would decorate and that would be encircled by a beautiful horizon of water."[23] Plans were immediately begun for a huge studio that was finished, in spite of war shortages of material and labor, by 1916. Meanwhile

Monet had already begun working around the lily pool on large canvases that were placed on a specially constructed easel by one of the gardeners and replaced when the light changed. By 1917 the plan, in its first phase, was well under way, and at Giverny in November (it is said on November 18th, the day allied troops entered Strasbourg) the "Tiger of France," Clemenceau, accepted Monet's offer of a commemorative gift to the state of a group of water landscapes.[24]

The next year, when Monet was visited by the art dealers Georges Bernheim and René Gimpel (who had heard gossip about an "immense and mysterious decoration on which the artist worked") they saw assembled in the new studio "a strange artistic spectacle: a dozen canvases placed in a circle on the floor, one beside the other, all about two meters [78¾"] wide and one meter twenty [47¼"] high; a panorama made up of water and lilies, of light and sky. In that infinitude, water and sky have neither beginning nor end. We seem to be present at one of the first hours in the birth of the world. It is mysterious, poetic, delightfully unreal; the sensation is strange; it is a discomfort and a pleasure to see oneself surrounded by water on all sides."[25] There were about thirty of these panels in all.

In 1919, with neither the final form nor the location of the proposed decoration determined, Monet began to work on larger panels, within the studio. . . . It was in 1920 . . . that Monet spoke of his intention to donate to the Hôtel Biron (The Rodin Museum) "twelve of my latest decorative canvases of which each measures four meters twenty [just under fourteen feet]."[26] It is mainly canvases of this size that make up the murals in the Orangerie of the Tuileries.[27]

Since 1917, however, the cataracts on Monet's eyes had become constantly worse, and he was obliged to wear heavy glasses. He worked in a broader style, with long, flexible brushes. "I am passionately fond of this work on large canvases," he explained; "last year I tried to paint on small canvases, and not very small: impossible; I cannot do it any more because today I am used to painting broadly and with large brushes."[28] His color vision was also affected, but it would be as false to undervalue the late outdoor studies for their altered visualization as it would be to dismiss Beethoven's last quartets because of his deafness. . . .

. . . Virtual blindness stopped his work early in the fall of 1922. The decision to place the large decoration in the Orangerie had

been approved the previous year, and Monet had brought the individual panels close to completion. Somehow, when working on the decorations in the studio, Monet was able to maintain his color scheme by familiarity with a controlled range already established, but outdoors he was forced to rely on vision he knew to be distorted. "How do you see that?" he would ask at the table, fiercely indicating his dinner plate; "I see it yellow."[29] During the tragic summer of 1922, fearful of ruining the water landscapes if he continued to work on them, he went into the garden seized, as Louis Gillet has recalled, by a demon of work, and returned to the footbridge motif that had first attracted him in 1892. "He painted . . . wild landscapes of a more and more feverish aspect; hallucinated, in impossible color schemes, all red or all blue, but of a magnificent aspect. The claw of the lion could always be felt."[30] Thus the long sequence of Japanese Footbridge canvases comprises a new kind of series, tracing moments of physiological and emotional, as well as natural, metamorphosis; from impressionism to an art in which nature was re-formed according to distorted vision and inner anguish to produce Monet's only truly expressionistic works.

An operation on one eye was performed successfully in February 1923. When the bandages were removed Monet's first sensation was of a permeating blueness, and on returning home he was amazed by the odd coloration of his most recent painting. By November he was once again at work. Even at night in his dreams he concentrated on the decorations and, always dissatisfied, continued perfecting them as long as he was able: "I shall work on them until my death," he had predicted in 1920, "that will help me in passing my life."[31]

Monet was a severe critic of his own work. Knowing that everything he had touched would be preserved if he did not destroy it himself, he burned discarded canvases. At his death, nevertheless, the studios at Giverny contained a treasure of large paintings, most of them unsigned and undated, and many of them unfinished. . . . Most of the works of Monet's great final period lay all but forgotten for more than twenty years, and some were damaged by shells from tanks and artillery during the Nazi retreat from France. It was not until after 1950 that they were once more deemed worthy of their creator, and understood as masterpieces with a meaning for our time as well as his.

The universe that Monet discovered in the suspended quiet of

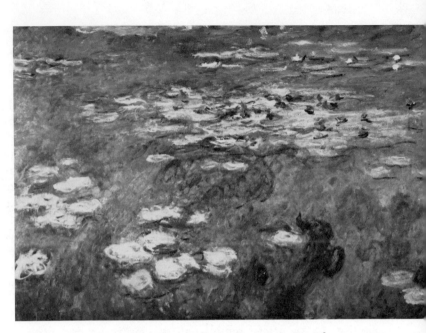

49. Claude Monet, *Nymphéas* (*Water Lilies*), c. 1920–1921, Oil on canvas, 6′8½″ x 19′9¼″ (Museum of Art, Carnegie Institute, Pittsburgh; acquired through the generosity of Mrs. Alan M. Scaife, 1962)

his water garden, and recreated in his last canvases, reawakens dulled sensibilities by cutting perception loose from habitual clues to position, depth, and extent (Fig. 49). It is a world new to art, ultimately spherical in its allusions, within which the opposites of above and below, close and distant, transparent and opaque, occupied and empty are conflated. Nevertheless—notably in the Museum of Modern Art's breath-taking triptych [see note 27]—equilibrium is maintained by an indeterminate horizontal; a shadowy equator before which the surrounding globe of the sky, seen in the iridescent clouds that curve downward in an inverted image, becomes one with the water to form a common atmosphere. The pond's surface is only barely adumbrated by the unfinished constellations of lily pads that, like flights of birds, punctuate the expanding space.

In the darkness below, the life-rhythm that Monet worshipped is all but stilled. It is the tangibility of the work of art that keeps it alive—the saturated, shuttling color tones, the scraped and scumbled flatness of the canvas surface, the nervous tangles that

354

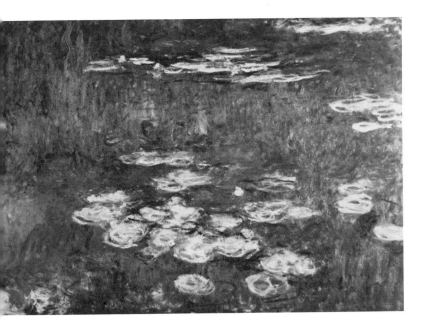

will not retreat into illusion, and the few furtive stabs of white, yellow, pink, or lilac that we recognize as blossoms.

To Monet these final landscapes of water, like those of the Norman beaches, the Seine, or the open sea, were records of perceived reality, neither abstract nor symbolistic; but to him, from the beginning, nature had always appeared mysterious, infinite, and unpredictable as well as visible and lawful. He was concerned with "unknown" as well as apparent realities. "Your error," he once said to Clemenceau, "is to wish to reduce the world to your measure, whereas, by enlarging your knowledge of things, you will find your knowledge of self enlarged."[32]

*NOTES*

[1] John Rewald, *The History of Impressionism*, 2nd ed., New York, The Museum of Modern Art, 1946, p. 164.

[2] Lilla Cabot Perry, "Reminiscences of Claude Monet from 1889 to 1909," *The American Magazine of Art*, Vol. 18, No. 3, March 1927, p. 120.

[3] Gustave Cahen, *Eugène Boudin, sa vie et son oeuvre,* Paris, Floury, 1900, p. 181.

[4] Rewald, *op. cit.,* reproduces two of the Jongkinds, pp. 100–101, and the two Monets, p. 103.

[5] D. S. MacColl, *Nineteenth Century Art,* Glasgow, Maclehose, 1902, p. 163.

[6] Quoted by René Gimpel [Unpublished journal], Paris.

[7] Zacharie Astruc, *Les quatorze stations du Salon,* Paris, 1859, p. 249.

[8] *Ibid.,* p. 303; and M. Aubert, *Souvenirs du Salon de 1859,* Paris, 1859.

[9] [Salon catalogue], Paris, 1864.

[10] [Salon catalogue], Paris, 1865.

[11] In *l'Impressionniste,* Paris, April 6–28, 1877. See Venturi, *Les archives de l'Impressionnisme,* 2 vols., Paris, Durand-Ruel, 1939, Vol. 2, p. 312.

[12] Perry, *op. cit.,* p. 120.

[13] *Ibid.,* p. 121.

[14] From a letter to Théodore Duret. See Charles Léger, *Claude Monet,* Paris, Crès, 1930, p. 10.

[15] Perry, *op. cit.,* p. 121.

[16] C. Janin, *l'Estafette,* Paris, March 10, 1892.

[17] Evan Charteris, *John Sargent,* New York, Scribners, 1927, p. 131.

[18] Gustave Geffroy, *Claude Monet, sa vie, son temps, son oeuvre,* 1st ed., Paris, Crès, 1922, p. 238.

[19] Marthe de Fels, *La vie de Claude Monet,* Paris, Gallimard, 1929, pp. 190–191.

[20] In *l'Opinion,* June 1, 1912. See Geffroy, *op. cit.,* p. 247.

[21] Venturi, *op. cit.,* p. 419.

[22] Duc de Trévise, "Le pélerinage de Giverny," *Revue de l'art ancien et moderne* [special edition], 1927, pp. 24–25.

[23] *Ibid.,* p. 26.

[24] Louis Gillet, *Trois variations sur Claude Monet,* Paris, Plon, 1927, pp. 77–78.

[25] Gimpel, *op. cit.*

[26] Gimpel, *op. cit.*

[27] The 42-foot composition acquired by The Museum of Modern Art in 1959 is plainly a variant of that opposite the entrance door in the first of the two oval rooms in the Orangerie, and it is also made up of three panels approximately 14 feet in width.

[28] Gimpel, *op. cit.*

[29] Gillet, *op. cit.,* p. 104.

[30] *Ibid.,* p. 96. The strange coloration of Monet's Japanese Footbridge canvases painted between 1919 and 1922 can, it would appear, be explained thus: The earlier golden yellow versions show the change in his vision. Later, realizing that his eyes exaggerated yellow, he used less of it, but overcompensated. Green or warm-toned subjects therefore became, respectively, bluish or reddish.

[31] Gimpel, *op. cit.,* p. 96.

[32] Georges Clemenceau, *Claude Monet: The Water Lilies,* trans. George Boaz, Garden City, Doubleday, 1930, pp. 154–155.

# 18. GAUGUIN

## AND PRIMITIVISM

*Robert Goldwater*

### INTRODUCTION

During the latter half of the nineteenth century and the early years
of the twentieth, an awakening to the riches of non-Western art turned
many European artists toward these sources of inspiration in ways that
differed appreciably from the exoticisms of the romantic era. If some
residue of the old romantic mystery of alien cultures remained, what
seemed now to matter more were the stylistic features of the arts of
distant places and the ways in which these features could be adapted
to the Western artist's means. The consequences were mutations, of
various kinds and degrees, in the styles of Western art. One manifesta-
tion of a new kind of exoticism developed after the end of Japanese
isolationism in the 1850s. The discovery and increasing popularity of
Japanese prints fostered by the mid-1860s a wave of *japonisme* that
would sweep through European painting and design in the latter part
of the century. In the early twentieth century, as artists became at-
tracted to the sculptural arts of black Africa, the island cultures of the
Pacific, and the pre-Columbian New World, sculptors like Brancusi,
Lipchitz, and Henry Moore, and painters like Picasso—to cite only a
few of the more obvious cases—assimilated various aspects of these
"primitive" or exotic arts. The early twentieth-century expressionist
movements—*Les Fauves* in France and *Die Brücke* and *Der Blaue
Reiter* in Germany—were also aware of African and Oceanic art and
some added children's art to their repertoire of primitivisms.

In the preface to the revised edition (1967) of *Primitivism in Modern
Art*, from which this selection is taken, Goldwater points out that his
purpose is to show why and under what conditions the modern artist
turned to primitive art for inspiration. At the same time he advances

357

a cautionary note by asserting that primitive art and modern art really have little in common, despite the formal linkages forged by modern artists, since the aesthetic forms and social functions of primitive art are quite different from those of art produced in the modern Western world.

In the case of Paul Gauguin the primitive and exotic elements were not only varied as to source but intricately layered in his art. His response to the Japanese print mingled with his assimilations of Southeast Asian, Persian, ancient Greek, and Egyptian sources in a personal and hybrid form of exoticism that subsumed as well a primitivism which was, roughly speaking, a composite of his yearning for a simple, elemental life and the quest for it in "primitive" locales: the peasant ambience of Brittany and the fancied Edenic paradise of the South Seas. Robert Goldwater's essay deals with the anatomy of Gauguin's primitivism, probing both its substance and its form and weighing the degree to which the artist was influenced by Oceanic art.

There are two works of exceptional importance to the study of the impact of the primitive world upon the literary and visual arts of the West: H. N. Fairchild, *The Noble Savage: A Study in Romantic Naturalism* (1928) and Bernard Smith, *European Vision and the South Pacific, 1768–1850: A Study in the History of Art and Ideas* (1960). Of the extensive literature on Paul Gauguin, the following titles represent some of the most useful sources for further information on the subject of this selection: Paul Gauguin, *Noa Noa* (1919 and later editions); Paul Gauguin, *Intimate Journals*, trans. by Van Wyck Brooks (1936 and later editions); S. Løvgren, *The Genesis of Modernism: Seurat, Gauguin, Van Gogh, and French Symbolism in the 1880s* (1959); Christopher Gray, *Sculpture and Ceramics of Paul Gauguin* (1963); Bengt Danielsson, *Gauguin in the South Seas*, trans. by Reginald Spink (1966); Mark Roskill, *Van Gogh, Gauguin, and the Impressionist Circle* (1970); Wayne Andersen, *Gauguin's Paradise Lost* (1971); W. Jaworska, *Gauguin and the Pont-Aven School*, trans. by Patrick Evans (1972); Richard S. Field, *Paul Gauguin: The Paintings of the First Voyage to Tahiti* (1977); and *The Writings of a Savage: Paul Gauguin*, edited by Daniel Guérin, with an introduction by Wayne Andersen (1978). There are also a number of articles the reader may wish to consult, among which are Bernard Dorival, "Sources of the Art of Gauguin From Java, Egypt, and Ancient Greece," *The Burlington Magazine*, XCIII (April–July 1951), 118–123, 237; Henri Dorra, "Ia Orana Maria,"

*Metropolitan Museum Bulletin*, new series, X (May 1952), 254–260; Henri Dorra, "The First Eves in Gauguin's Eden," *Gazette des Beaux-Arts*, series 6, XLI (March 1953), 189–202, 225–227; Merete Bodelesen, "Gauguin and the Marquesan God," *Gazette des Beaux-Arts*, series 6, LVII (March 1961), 167–180; B. Danielsson, "Exotic Sources of Gauguin's Art," *Expedition*, XI, 4 (Summer 1969), 16–26, and in the same issue, Richard S. Field, "Gauguin's Woodcuts," 27–29; Wayne Andersen, "Gauguin's Motifs from Le Pouldu," *The Burlington Magazine*, CXII (September 1970), 614–620; Ziva Amishai-Maisels, "Gauguin's Early Tahitian Idols," *The Art Bulletin*, LX, 2 (June 1978), 331–341; M. L. Zink, "Gauguin's Poèmes Barbares and the Tahitian Chant of Creation," *Art Journal*, XXXVIII, 1 (Fall 1978), 18–21; and J. H. Teilhet, "Te Tamari No Atua: An Interpretation of Paul Gauguin's Tahitian Symbolism," *Arts Magazine*, LIII (January 1979), 110–111. In addition, *The Burlington Magazine*, CIX (April 1967), contains several contributions to Gauguin studies, and a brief account of the appearance of the primitive world in Western art can be found in Harold Spencer, *The Image Maker* (1975), 467–504.

In any study of the influences of the primitive in modern paint-
ing, Paul Gauguin obviously occupies an important place.
His name, which has become synonymous with a geographical
romanticism that has not yet lost its flavor, has been made a sym-
bol for the throwing off of the stifling superfluities of the hothouse
culture of Europe in favor of return to that more natural way of
life of which Rousseau is the generally accepted advocate. In the
first years of the twentieth century Gauguin was considered the
typical bohemian-artist rejecter of bourgeois living and morality,
with its stupid, encumbering artificialities; the typical simplifying
artist, cutting both his life and his art to the bone in order that he
might find and express reality. Not only did he become the symbol
and the type but, by a shift familiar in the history of art, he came
to be considered the originator of the movement he summarized:
He became the "discoverer" of a primitivism which was simply
the crutch of an ailing art; he was said to have begun a trend that
achieved its final culmination in the "Negro review"; he was the
"calm madman" embodying sanity.[1] We have seen that such
praise or such reproach cannot be laid at Gauguin's door. He was
not the first to feel the attraction of the provinces, either at home
or overseas, and except for definite imitators, artists' voyages after
his time lessened rather than increased in extent. And the simplifi-
cations practiced by the artistic movement that succeeded him,
whether the *fauves* in France or the expressionists in Germany,
though they received an impetus from his life and from his paint-
ing, were hardly due to his influence alone. There is, however, no
doubt that this influence was great, and for this reason, as well as
for his later position as a symbol, it is important to determine the
exact nature of Gauguin's primitivism, and to analyze his art so
that we may fix his position in the history of primitivist evolution.

Because of the identification of Gauguin's life and his art, it is
not merely permissible, but compulsory, to try to discover from his
own writings his attitude toward the primitive. That Gauguin felt
it was necessary to write about himself, to express himself through
"private journals" written with an eye to the public as well as
through his painting, indicates in itself that his relation to the

primitive world in which he had chosen to live was not simple and direct. The whole tone of *Noa Noa* and *Avant et Après* is one of self-conscious revolt against a watching world.[2] It is not simply that the comparisons between the barbarian life of his choice and civilization are always in favor of the former, nor that his complaints are those of the misunderstood artist. It would not be natural that he should write otherwise; Tahiti, in spite of all its difficulties, gave him a better reception than Paris. But each incident that he relates, whether it is about the South Seas or not, each point that he makes, is a kind of parable that contains in itself and explains all the wrongs of the insincere and complicated society that he had left, contrasting them with the simplicity and naturalness of the people of the South Seas. Thus his hatred of the church and its hypocrisies is concentrated in the story of the bishop and Thérèse, and his dislike of the provincial government with which he had such difficulty in the account of the administrator Ed. Petit.[3] Each such story that he tells, whether it be of his exhibition in Copenhagen, closed on the morning of the first day, or of the Cabanels in the museum at Montpellier, is proof of his own rightness and the infamy of an overcomplicated culture.[4] It is nevertheless this civilization which sets his standard of judgment and to which all other modes of existence must be referred, so that it is impossible for him to describe his own life in Tahiti or that of the natives in the Marquesas without thinking of their tremendous distance from the European life that he has left. Such continual comparison means that Gauguin was dependent upon Paris for more than simply his livelihood, and that try as he might to assimilate himself to the native way of life, the center of his attention was still the artistic world of Paris. Yet Gauguin did not leave Paris merely to find a cheaper mode of living (although this was an important consideration), or he would not have gone to Tahiti after having been to Martinique, nor have gone back to Tahiti in 1895, leaving it in 1901 to spend the two last years of his life in the Marquesas.[5] His was an exoticism which thought that happiness was elsewhere but which at the same time—and this is what is characteristic of his part in a new tendency—sought not the luxurious and the intricately exotic of the earlier nineteenth century, but the native and the simple.[6]

Because it judges on the basis of contrast rather than directly, such an attitude identifies as primitive any things sufficiently far removed from the kind or the style of object which it seeks to

avoid, even though they may differ greatly among themselves. This opposition point of view makes it possible, and in a sense even reasonable, for Gauguin to say,

> Have before you always the Persians, the Cambodians, and a little of the Egyptian. The great error is the Greek, however beautiful it may be,

since these arts, however they may differ, all express themselves, as he says (using the vocabulary of the symbolist poets and critics), "parabolically" and "mysteriously," deforming nature in order to achieve a symbolic, and consequently a meaningful, beauty.[7] It did not clash with these opinions that he should counsel his daughter:

> You will always find nourishing milk in the primitive arts, but I doubt if you will find it in the arts of ripe civilizations,[8]

because for him the Persians and the Egyptians, not being in the classic tradition which had degenerated into a naturalistic art, were "primitive." Nor was Gauguin's occasional use of antique motifs (drawn from the extensive stock of photographs to which he so often referred) more than a superficial contradiction. He saw in the Parthenon frieze and the reliefs of the column of Trajan, from which he borrowed figure poses, a flat and stylized art opposed to the three-dimensional and naturalistic. He therefore could consider it "primitive" and symbolic, just as the critic Albert Aurier, in finding parallels to Gauguin's work, could put Egyptian, Greek, and primitive art together on the grounds that they were all equally "decorative." Similarly Gauguin acquired a piece of Javanese carving and photographs of Cambodian sculpture, copied Aztec sculpture at the Exposition of 1889, praised the absence of values and perspective in Japanese art because this eliminates the possibility of taking refuge in the "illegibility" of "effects," and wrote what are probably the first lines in appreciation of Marquesan art, describing the "unparalleled sense of decoration" and the "very advanced decorative art" of the people he was pleased to call "Maori."[9] It is characteristic of Gauguin that his consideration of the excellence of this art should immediately lead him to a violent denunciation of the petty officials who could not appreciate it, and that his thought should

then lead back, by way of the impudence of the officials' judgment in view of their dowdiness, to the "real elegance" of the Maori race, and particularly of Maori women.[10]

Gauguin's identification of the barbarian in art and the barbarian in living is important for our understanding of the development of primitivism, since in its subsequent evolution these two factors are separated.[11] Their union in Gauguin's mind and the symbolic value of the former for the latter, may be inferred from Gauguin's reply to Strindberg's letter declining to write a preface for the exhibition of February, 1895.[12] In his refusal, which he said was forced upon him because he did not understand Gauguin's art, Strindberg characterizes Gauguin as "the savage, who hates a whimpering civilization, a sort of Titan, who, jealous of the Creator, in his leisure hours makes his own little creation, the child who takes his toys to pieces so as to make others from them. . . ."[13] Gauguin answers that what he had wished to realize was a revolt,

> a shock between your civilization and my barbarianism. Civilization from which you suffer, barbarianism which has been a rejuvenation for me. Before the Eve of my choice whom I have painted in the forms and the harmonies of another world, your memories have evoked a painful past. The Eve of your civilized conception nearly always makes you, and makes us, misogynist; the ancient Eve, who frightens you in my studio, might some day smile at you less bitterly. This world, which could perhaps not rediscover a Cuvier, nor a botanist, would be a Paradise that I would have merely sketched. And from the sketch to the completion of the dream it is far. What matter! Is not a glimpse of happiness a foretaste of nirvana.[14]

It is true that Gauguin is talking here in a metaphor, but it accurately describes his attitude toward the "barbarian" (a word which he preferred to "primitive," perhaps because it renders more precisely his active opposition to the "civilized"), and suggests the atmosphere which pervades his pictures, because in them he uses the same metaphor recurrently.[15] Gauguin approved Achille Delaroche's description of him as a painter of primitive natures, one who "loves them and possesses their simplicity, their suggestions of the hieratic, their somewhat awkward and angular naïveté."[16] Nevertheless his primitives still have something of *luxe barbare* about them, a heritage of the

entire exoticism of the nineteenth century, not quite so easily or wholeheartedly forgotten or suppressed.[17] He said of himself that he had two natures, the Indian and the sensitive; and he whistled to keep up his courage: "The sensitive has disappeared, which allows the Indian to proceed straight and firmly."[18] With these considerations in mind we may finally turn to the sentence which is often taken to sum up Gauguin's whole aesthetic:

> I have gone far back, farther back than the horses of the Parthenon
> . . . as far back as the Dada of my babyhood, the good rocking-
> horse.[19]

A whole aesthetic may indeed be there, but it is not the aesthetic of Gauguin.

The most direct and obvious influence of primitive art upon the work of Gauguin is to be found in a certain number of his sculptures and woodcuts, in which he makes use of decorative motifs common in the wood and bone carving of the Marquesas. Marquesan decoration is found chiefly on ornamental club heads and stilt foot rests and, on a smaller scale, on fan handles, ear plugs and diadems. It is almost wholly made up of the squat, semi-seated figure (the ancestral "tiki" which may be sacred or secular), and of stylizations of the face or separate features of the face—derived originally from "tiki" representations—the pattern most often used being the outline of the two eyes, with the lines of the nose and prominent nostrils between. Such motifs are to be found in ten of the sculptures published by Gray and half a dozen of the woodcuts catalogued by Guérin.[20] In Number 28, *Nave Nave Fenua*, for example, the band which borders the picture at the left consists of such Marquesan stylizations of the face, and these are used again in Number 44, identified as the figure of a Tahitian idol. In Number 50, a lithograph of the painting *Manao Tupapu*, Gauguin uses the Marquesan form of nostrils and mouth below his initials in the upper left corner.

The restricted number of these direct copyings from the art of the South Seas almost certainly cannot be explained by the fact that Gauguin did not go to the Marquesas until 1901, only two years before his death.[21] It is true that Tahiti, the island of his earlier residence, is comparatively poor in indigenous art and produces almost no wood or stone sculpture and little decorative carving. The influence from this source was obviously negligible,

and *Avant et Après,* which we have quoted above in praise of the Marquesan sense of decoration, was written after 1901. But, as Gray remarks, Marquesan objects were as accessible in Tahiti as in the Marquesas themselves, and Gauguin showed that he was familiar with Easter Island script as early as 1893. Therefore it is not surprising that the work that employs the most extensive repertory of Polynesian motifs was probably done about 1895 (Fig. 50). It is a carved cylinder showing a Crucifixion: a Christ of Marquesan features, with bodily proportions and rendering derived from Easter Island statuettes and set against Easter Island ideograms. Above the figure of Christ are designs adapted from one form of Marquesan war-club decoration, but with one of the tiny heads set into the tiki eyes turned in profile.[22]

It is characteristic that Gauguin was sympathetic to the surface, or at most the relief aspects of Marquesan art. He must have encountered its massive stone sculpture but it apparently held little attraction for him.[23] Thus it was only the flat and decorative aspects of the "primitive" (whether Mediterranean, Asian, or Oceanic) that were accessible to Gauguin and whose individual motifs he assimilated. We shall see from an analysis of his paintings that this restriction to the decorative is not accidental, and we can conclude that even had he had a greater opportunity to study the art of Polynesia, the grace and pre-Raphaelite simplicity which were an integral part of Gauguin's conception of the primitive would not have permitted the assimilation of any of its intense and angular forms.

It is also typical of Gauguin that having traveled half across the world he should still have been more generally influenced, though in a less precise and accurate way, by an art that was even then removed from him and that had nothing to do with the simple life he had sought out. The Indonesian deities sitting crossed-legged on their stelae (which he must have seen in Paris museums, and which he had known since at least 1889 in photographs of Borobudur which he took with him to Tahiti) seem to have made a real impression on him. The sitting posture of the Indonesian deities is of course also that of Polynesians and thus it correctly appears in Gauguin's paintings in which natives are portrayed. That memories of Indian figures were also still at work in Gauguin's mind is seen most clearly in several of the sculptured pieces, where motifs of definite Indian iconography are repeated. The figure in *Idole à la Perle,* for example, touches her right hand

366

50. A. (*Left*) Paul Gauguin, *Christ on the Cross*, c. 1896, Woodcut (The Metropolitan Museum of Art, Harris Brisbane Dick Fund, 1929)
B. (*Above*) Polynesia, Marquesas Islands, late 19th-century chief's staff, Carved hardwood, 55″ long x 6½″ wide (The Brooklyn Museum, Gift of Appleton Sturgis)
C. (*Below*) Marquesas warrior's headband (University Museum, University of Pennsylvania)

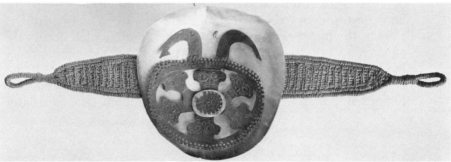

to the ground and lays the other palm up in her lap, in typical Buddhist gestures. The votary figure on the two cylinders of *Hina* comes from the Borobudur photographs and sways in Eastern fashion, while the Tahitian goddess herself—one of Gauguin's favorites—also derives from Indonesian art, modified by a certain stiffness, rather than from the hard angular bodies of Polynesian sculpture.[24]

Though our chief concern is with his painting, we have purposely approached Gauguin's art through his wood blocks and his wood sculpture. The use of these media is in itself significant, permitting as they do the production of direct and immediate effects by simple means. The woodcut particularly—working through extreme contrasts of large areas of light and dark, and necessarily doing away with any delicacy of line or refinement of modeling—is especially suited to the simplifying artist (or more exactly, one kind of simplifying artist), and we shall find it coming into prominence again among the German expressionists, who had much in common with Gauguin in their attitude toward the primitive. In the woodcuts, those characteristics that appear in Gauguin's painting in diluted form and mixed with the other ingredients of a more complicated method, are present in an obvious concentration.

In the paintings, his major form of this expression, his attitude toward the primitive is basically no different, although the elements derived from South Sea art count less and there is almost no direct transcription of Polynesian motifs. The various figures which are meant to portray Polynesian gods represent not only the gods themselves, but Gauguin's idea of the manner in which the natives wished to render them. The deity in *The Day of the God* (1894), for example, has that mixture of Polynesian and Indian traits which we have already noted in the cylinder with Hina, and which Gauguin will use once again in the background figure of *Whence Do We Come* . . . (1897–98). The posture and headdress of the god are anything but native. The goddess Hina appears again in the background of *The Parrots* (1902), with the same gestures, and a similar figure appears in the self-portrait of 1898 in the upper right corner.[25] But the figure which occurs the most frequently, and which was apparently of most importance to Gauguin, is one seated in profile on a low stool, with its hands in its lap. The features of the face, with its flat nose and continuous line of forehead, nose, and lips, square chin and large

long ear, are Gauguin's way of typifying and generalizing the Polynesian facial characteristics, and he often gives them a more naturalistic rendering, as in the attendant figure in *The Nativity* (1896). While the result bears some relation to the Marquesan stylization, it is apparent that Gauguin evolved the type himself. In Marquesan sculpture the generalization is achieved through geometrizing and angularizing the original contours so that the form is never that of an individual, much less a copy of a living person.[26] With Gauguin, however, while there has been a smoothing and reduction of the contours in order to bring them within the oval of the head, an intensity of individual character remains, borne out by the curved forms of the rest of the body. He has nevertheless given his idols a symbolic distance and thus produced the brooding, terrifying quality by which he meant to convey the atmosphere of primitive religion. Good examples of this magical figure are to be found in *Sacred Mountain* (1892), *Arearea* (1892) and *Hina Maruru* (1893), where the mystery is emphasized by the profile position of the figure staring into space. It reappears in the ancestral presence in the *Spirit of the Dead Watching* (1892)—however calculated or (as Gauguin would have us believe) spontaneous its introduction was. The same effect of hovering, unplaceable, awful spirits, which was one element in Gauguin's notion of the primitive, is also present in *The Moon and the Earth* (1893), in the much more tangibly rendered, enormous, dark half-figure rising from nowhere in the background; and in the *Poèmes Barbares* (1896), where it is conveyed by the little crouching figure with bright staring eyes seated on a table in the left foreground.[27] To be sure, this conception of primitive religion has little to do with the rather cheerful mythology of the Society Islands, but this only emphasizes the eclectic nature of Gauguin's ideas and the degree to which he came to Oceania with established preconceptions of the primitive.[28]

There is another side to Gauguin's rendering of the primitive, perhaps as far removed from the truth as his "barbaric" interpretation, yet directly opposed to it. On the one hand he wished to bring out the exotic and the mysterious, and so expatiated upon the personal freedom that was possible among the children of nature in contrast to the "civilized" restrictions of society, the family, and the church, institutionalized and hypocritical. This is one of the constant themes of his writings. On the other hand he interprets many Polynesian scenes in Christian terms, transform-

ing the natives into historic figures of the church. The best-known example of this tendency is the *Ia Orana Maria* (see cover illustration) painted at the beginning of Gauguin's first stay at Tahiti (1891), a picture which is a transplantation of the Adoration to the South Seas, now done with native scenery and native actors. As with so many of his pictures, his sources are composite, and only very partially based on direct observation. The poses of the two adoring figures come from his photographs of the Borobudur reliefs—and it is unlikely he never saw a Tahitian infant carried on its mother's shoulder—while the haloes and the angel are clear references to the supernatural. Yet by making it a scene from primitive life, the poses apparently unstudied and the composition unsymmetrical, he has sought to take the hierarchical quality from it and thus to show again its original "simple" human meaning. Nevertheless he is thinking in Christian terms, even if in idyllic, Virgilian, Early Christian terms, and imposing a European tradition and European morality, which he himself had professedly gone so far to avoid, upon a people whose unspoiled naturalness he claimed to enjoy and to have come to seek. The same almost missionary spirit is shown again in the drawing called *Adam and Eve*, in which Adam has become a Polynesian fisherman, dressed in a loincloth and with his rod over his shoulder, while Eve wears a shift of European manufacture, and the two are accompanied by the scrawny South Sea mongrel that Gauguin depicts so often. In *The Idol* (1897), he has combined the barbaric and the Christian, placing behind the dark stone figure which overshadows the native group in the foreground in a typically mysterious way (the base contains barely distinguishable Marquesan motifs) the scene of the Last Supper, with the tiny lighted form of Christ coming directly behind the native idol. In this manner Gauguin portrayed the unity of Christian and Polynesian beliefs; the latter might be mysterious, but behind them lay the same truth. It is obvious that the feeling for the necessity of this demonstration was at variance with a simple acceptance of native life and customs.

The pictures which lack this specifically religious content—such as *Nave Nave Mahana* (1896), the two versions of *Maternity* (1896 and 1899), *Woman and Children* (1901), and finally the allegory of life, *D'où venons-nous? Que sommes-nous? Où allons-nous?* (1897–98), and what is perhaps its pendant, the quiet, friezelike *Faa Iheihe* (1898)—while they show the "state of nature," the desire for which we ordinarily connect with primi-

tivism, nevertheless conceive this state of nature as having all those moral elements that Gauguin claimed to despise: work, family life, and calm human contacts. His search for the primitive and his belief in its powers of creative renewal, and his pridefully recurring description of himself as a "savage," must be interpreted in the light of the quiet, almost contemplative ideal projected in his paintings—whatever the sources of their formal or symbolic detail may be. Of course this idyllic conception of the primitive fits in with the general European tradition of the original golden day, and particularly with that of Rousseau, whose "state of nature" refers not to a primeval condition, but to one in which a definite cultural level had been reached; yet it was against this tradition, and especially against the sense of "duty" of this tradition, that Gauguin was rebelling.[29]

The infusion of religious motifs in Gauguin's work, and their interpretation in simple terms, leads naturally to a consideration of the painting of Gauguin's stay in Brittany. These pictures, painted in the years 1889 and 1890, already demonstrate many of the attitudes toward the primitive which we have discussed. They were influenced, as Maurice Denis mentioned and as is clear from the pictures themselves, by the local religious art, by Japanese prints, and by the *images d'Epinal*.[30] The last two influences show themselves in the bright colors applied in broad flat areas with clearly marked lines of separation; the first, in the actual themes of the pictures. As Charles Chassé discovered, the *Calvary* (1889) is directly inspired by the stone Calvary of Brasparts, and the figure on the cross of *The Yellow Christ* (1889) derives from the Crucifixion sculpture of the Trémalo Chapel. Again we see contact with a variety of arts related merely by comparison with the art Gauguin was trying to avoid, and though they have in common a simplification of technique and an intensity of subject matter, their spirit is very different. And further it is obvious that Gauguin was attracted by the "simplicity" of the Breton peasants, and by their "simple"—that is, their wholehearted—faith. He renders them not as individuals who happen to be peasants, but as examples of the typical peasant. Their expressions, as in the group around the Christ, are without variation, and their gestures, as in *Jacob Wrestling with the Angel* (1888) or *Breton Girl in Prayer* (1894), remain, in the symmetry and angularity of their motions, symbols rather than portrayals of religious reverence. In the same way the popular

religious monuments are rendered in even further reduction and simplification than the originals, so that they become symbols of religious symbols, and lose the expressive quality of the popular originals. Yet if these pictures are closer to the spirit of the scenes they portray (and by this we do not mean closer to the exact rendering of a particular scene) than are the similar subjects of Tahiti, it is because Gauguin was approaching the latter through these Brittany pictures, and because the French provincial scenes themselves were closer to that idea of the primitive Gauguin had in his mind.

We have thus far not treated the purely formal elements of Gauguin's art directly, because the influence—even if not the assimilation—of the primitive and his attitude toward it are more obvious in the subject matter of his pictures. Nor need we discuss here the thorny question of the creation of the synthetist style in the years 1888–89. Gauguin's method of painting was more primitivizing than primitive, both in the form that he attempted to achieve and in the interpretation of this form. In his use of broad areas of color applied flatly and in strong contrast with one another, he was influenced, as we have mentioned, by Japanese prints and by the *images d'Epinal;* they lead in the direction of simplification and a return to the fundamental elements of painting.[31] These influences are of course more evident during the Brittany period, when synthetist methods of flat planes and strong contours are boldly employed, and light tones predominate, than in the later work, where there is less obvious stylization. Even here, however, Gauguin did not really assimilate the "primitive" factors, but substituted a smooth line and rhythmic undulating composition for the angularities and jagged sequences of these arts and close color harmonies for their strong contrasts. Already in this early work, where he was not really dealing with the primitive at all, he insisted, as Maurice Denis said, "on putting grace into everything."[32] The same may be said of the lack of perspective and the reduction of the picture to a single plane, of which theoreticians have made so much; Gauguin achieves rather a succession of planes set up parallel to the picture surface and with spaces in between, much as a stage set might be arranged and without the construction of any real spatial volume.[33] There is a more generally significant connection with the work of Puvis de Chavannes than the occasional borrowing of single figures.[34] The similarities, both of pictorial arrangement and iconographical

ideals, with a painter whose most obvious quality is an idyllic sweetness are important to note, similarities which become strikingly apparent in the romantic transformation of Gauguin's effort at pictorial simplification by the members of the "School" of Pont-Aven, particularly in the art of Maurice Denis and Emile Bernard.

It cannot be our purpose here to discuss how far Gauguin approved the theoretical doctrines of the symbolist school, or to what extent he was their originator. They found their justification in his painting if not in his words. The theories themselves, as developed by Aurier, Sérusier, and Maurice Denis, differ among themselves, those of Aurier and Sérusier tending toward the metaphysical and mystical, while those of Denis are more purely formal in character.[35] They have in common, however, that they seek to return to the essential elements of art, to rid art of its anecdotal, documentary character and to make it a reflection of the important truths of the universe. Even Gauguin, though he is said not to have liked the theorizing tendencies of his disciples, wished to cease working through the eye, and instead to "seek at the mysterious center of the universe."[36] Aurier, in more high-flown language, desired to "reclaim the right to dream, the right to the pasturages of the sky, the right to take flight toward the denied stars of absolute truth."[37] The "subjective deformation" of which Denis speaks, is an attempt to rid art of the personal character of "nature seen through a temperament," by means of "the theory of equivalence of the symbol" thus making a picture the plastic reproduction of the emotion caused by a particular scene in nature, so that by the common symbol the same emotion might be produced in the spectator.[38] Such ideas, they held, only seemed new because art had been lead astray by an unimaginative naturalism; in fact they "are at the bottom of the doctrines of art of all ages, and there is no true art which is not symbolist." For this reason "the innovators of 1890 wished to ignore all the learned epochs, and to prefer the naïve truths of the savage to the 'acquired ones' of the civilized."[39]

Maurice Denis has pointed out that synthetism, which only became symbolism in contact with poetry, was not at first a mystic movement although it implied a correspondence "between exterior forms and subjective states."[40] If however, to synthetize meant "to simplify in the sense of rendering intelligible," it is strange that the painters should have had any contact at all with poets who

were following the opposite course. Neither the ideal of Verlaine *"pas la couleur, rien que la nuance,"* nor Mallarmé's preference for white and his wish finally to get rid of limiting words entirely had anything formally in common with the broad, flat, undifferentiated colors separated by a sharp dividing line and the bright hues that were the goal of the painters. The two groups were, nevertheless, allied in this: both attempted to enter directly into the essence of things and to express them with as little intervening formal material as possible. Charles Chassé has indicated the emphasis of painters and poets on intuition, and has shown the parallel of Gauguin's eulogy of the savage and Veilé-Griffin's exaltation of the intuitive responses of illiterate conscripts.[41] Mallarmé went even further than Gauguin, since, not content with interpretation through a symbol, he wished to do away with this also, leaving nothing but the white page, evocative of all because it contained nothing. If artists formally so far apart could recognize this affinity to the point of friendship and discussion, we are not mistaken in recognizing in the desire to return to the ultimate bases of experience one of the main elements of the art of the "School of Pont-Aven." We have already discussed the largely romantic form—a romanticism partly historic and partly geographic—that the expression of this desire takes in the painting of Gauguin. There is no need to consider in detail the work of the other members of the group, except to point out that aspects of Gauguin's art become clearer in their work. Thus Sérusier continued the "early Christian" elements of Gauguin, adding, however, a romantic medievalism of the kind that used early French spelling; and Bernard carried on the master's provincialism in subject matter and the colors of the Brittany period.

*NOTES*

[1] *Cf.* Max Deri, *Die neue Malerei: sechs Vortraege* (Leipzig: Seemann, 1921), pp. 138–139. "So entdeckte er die 'Exotik.' Und in der Gefolge zog nun alles herauf, was Gegenpart gegen das differenzierte Erleben des fin de siècle bieten konnte."

[2] Paul Gauguin, *Avant et Après* (Paris: Crès, 1923); and *Noa Noa* (Paris: Crès, 1929).

[3] Paul Gauguin, *The Intimate Journals of Paul Gauguin.* Translated by Van Wyck Brooks (London: Heinemann, 1931), pp. 11, 63.

[4] *Ibid.,* pp. 180, 191.

[5] *Cf.* a letter to Willemsen: "Je vais aller dans quelque temps à Tahiti, une petite île de l'Océanie où la vie matérielle peut se passer d'argent." Quoted in Charles Chassé, *Gauguin et le groupe de Pont-Aven* (Paris: Floury, 1921), p. 11. Also the letter to his wife of February, 1891: "Puisse venir le jour (et peut-être bientôt) où j'irai m'en-fuir dans les bois sur une île de l'Océanie, vivre là d'extase, de calme et de l'art. Entouré d'une nouvelle famille, loin de cette lutte européenne après l'argent." M. Malingue, ed., *Lettres de Gauguin à sa femme et à ses amis* (Paris: Grasset, 1946), No. 100.

[6] *Cf.* Gaspard Tschann, "Paul Gauguin et l'Exotisme," *L'Amour* de l'art, IX (1928), pp. 460–464. Tschann places Gauguin in the direct line coming from the eighteenth century. Contrast the *splendeur orientale* of Baudelaire's *L'Invitation au Voyage* with the simplicity of Gauguin's ideal.

[7] *Lettres de Paul Gauguin à Georges-Daniel de Monfried* (Paris: Crès, 1920), p. 187. (Letter of October, 1897.)

[8] From the manuscript of Gauguin's *Notes éparses* in the *Bibliothèque d'Art et d'Archéologie,* quoted in M. Guérin, *L'Oeuvre gravé de Gauguin* (Paris: H. Floury, 1927), p. xx; and from his letter of 1889 to Emile Bernard. *Cf. Lettres de Gauguin à sa femme . . . ,* LXXXI, p. 157. Also Bernard Dorival, "The Sources of the Art of Gauguin from Java, Egypt and Ancient Greece," *The Burlington Magazine,* XCIII, No. 577 (April, 1951), pp. 118–122.

[9] Gauguin, *Intimate Journals,* p. 75. "And I shall maintain that for me the Maoris are not Malaysians, Papuans, or Negroes." Gauguin's contention that the Marquesans and the Maoris are of the same race has been supported by recent ethnology. See Ralph Linton, *Ethnology of Polynesia and Micronesia* (Chicago: Field Museum, 1926), pp. 12, 16.

[10] Gauguin, *ibid.,* p. 69.

[11] See below, Chaps. V and VI.

[12] The letter and reply were, together, used as a preface to the exhibition, held at the Hotel Drouot, February 18, 1895. They are quoted by Jean de Rotonchamp, *Paul Gauguin* (Paris: Druet, 1906), pp. 131–134.

[13] Gauguin, *Intimate Journals,* p. 29.

[14] Rotonchamp, *loc. cit.*

[15] See also Gauguin's dedication of the *Intimate Journals.* "Moved by an unconscious sentiment born of solitude and savagery—idle tales of a naughty child . . ." The union of savagery and childhood is characteristic.

[16] *Ibid.,* p. 31.

[17] Tschann, *op. cit., passim.*

[18] From a letter of February, 1888, to his wife. *Cf. Lettres de Gauguin . . . ,* LXI, p. 126.

[19] Gauguin, *Intimate Journals,* p. 22. We must here emphasize the distinction, which we will attempt to make throughout, between the artist's expressed attitude to the primitive and that actually to be found in his painting.

[20] Christopher Gray, *Sculpture and Ceramics of Paul Gauguin* (Baltimore: The Johns Hopkins Press, 1963), Catalogue Nos. 96, 99, 102, 104, 105, 117, 122, 125, 140, 145. Guérin, *op. cit.* In addition to those mentioned in the text, there are the following: No. 18, showing a Marquesan stylized face on a log (?) in the upper left corner; No. 30, showing, to the right, a figure like that in the Alden Brooks collection, and, to the left, seated figures like those on the cylinder in the Monfried

collection; No. 84, with three heads showing Marquesan influence but less stylized than these. No. 63 shows a Buddha with one hand in the gesture of meditation, the other that of calling the earth to witness.

[21] April, 1901. He went to the island of Dominique. The change was occasioned by an influenza epidemic, and by the fact that life was said to be much cheaper in the Marquesas than it had become in Tahiti. Charles Kunstler, *Gauguin* (Paris: H. Floury, 1934), p. 126.

[22] In the collection of Daniel de Monfried. The reverse also contains a copy of an Easter Island statuette. This combination fits in with the interpretation we have given of the paintings. Robert Rey, "Les Bois Sculptés de Paul Gauguin," *Art et Décoration*, LIII (1928), pp. 57–64. Gray, *op. cit.*, p. 69, Catalogue No. 125. The print made from the Crucifixion is not published by Guérin. The distinction between sculpture made as such, and that done as a block from which to print is not always clear.

[23] *Cf.* Merete Bodelsen, "Gauguin and the Marquesan God," *Gazette des Beaux-Arts*, 6th per. Vol. LVII (1961), pp. 167–181. The drawing of the large stone god, Takaii, of Hiva Oa was taken from a photograph rather than *in situ*.

[24] Gray, *op. cit.*, Catalogue Nos. 94, 95, 96; and Dorival, *op. cit.*, fig. 20.

[25] Apparently Gauguin used the figure he had made as a model, rather than inserting it from memory.

[26] That this stylization is not due to any lack of ability to create naturalistically may be seen from the statue in red tuff now in the Trocadéro Museum.

[27] Figures such as these occur nowhere in Polynesian art. Gauguin's explanation of the *Spirit of the Dead Watching* (in his *Notes éparses*), was probably suggested by Poe's analysis of *The Raven*.

[28] Gauguin apparently became interested in Maori mythology early in 1892. *Cf.* letter to Sérusier of March, 1892 in Paul Sérusier, *ABC de la Peinture* (Paris: Floury, 1950), p. 60. Gauguin's debt for his ideas to Moerenhout's *Voyages aux îles du Grand Océan* (Paris: Bertrand, 1837), has been fully explored by René Huyghe in his introduction to the facsimile edition of *Ancien Culte Mahorie* (Paris: Beres), 1951.

[29] For an analysis of Rousseau's conception of the "state of nature" see A.O. Lovejoy, "The Supposed Primitivism of Rousseau's Discourse on Inequality," *Modern Philology*, XXI (1923), pp. 165–186. Lovejoy shows that Rousseau advocated what was to him a third, rather than a primeval stage of development.

[30] Maurice Denis, "De Gauguin et de Van Gogh au classicisme," *Théories: 1890–1910* (Paris: Rouart & Watelin, 1930), p. 263. Yvonne Thirion, "L'Influence de l'estampe japonaise dans l'oeuvre de Gauguin," in *Gauguin, sa vie, son oeuvre* (Paris: Gazette des Beaux-Arts, 1958), pp. 95–114. Charles Chassé, *Gauguin et son temps* (Paris: La Bibliothèque des Arts, 1955). *Images d'Epinal* are popular illustrations printed in Epinal, France since the sixteenth century.

[31] Gauguin, *Intimate Journals*, p. 162:

> When I am in doubt about my spelling my handwriting becomes illegible. How many people use this stratagem in painting—when the drawing and color embarrass them. In Japanese art there are no values. Well, all the better!

[32] Denis, *op. cit.*, p. 270. "Malgré sa volonté de faire *rustique* en Bretagne et *sauvage* à Tahiti, il met de la grâce en tout." However, it is not "in spite of," as

we have seen; grace is an integral part of Gauguin's conception of the primitive. Chassé, *op. cit.*, p. 88.

[33] See for example *The Day of the God*, where there are three such planes; and *Breton Girl* and *Breton Children* where there is a lack of middle ground such as is found in *quattrocento* portraits.

[34] *Cf. The Sunflowers*, in which there is a copy of Puvis' *Hope*. The sideways sitting posture, with, however, the full width of the shoulders shown, that Puvis uses in his *Normandy* (1893) and his *Magdelene* (1897) is used by Gauguin in *The Queen of the Aréois* and *Te Matete*; the latter has an Egyptian origin. *Cf.* Dorival, *op. cit.*

[35] Denis, *op. cit., passim.* Paul Sérusier, *ABC de la peinture* (Paris: Floury, 1950), Albert Aurier, "Les Peintres symbolistes," *Revue Encyclopédique* (1892). Denis' painting, however, is as mystical-medieval as that of Sérusier; *cf.* his *Annunciation* in the Luxembourg. On the origins of synthetism and symbolism, *cf.* H.R. Rookmaaker, *Synthetist Art Theories* (Amsterdam: Swets and Zeitlinger, 1959); and Sven Løvgren, *The Genesis of Modernism* (Stockholm: Almquist and Wiksell, 1959).

[36] Quoted in Denis, *op. cit.*, p. 268.

[37] Aurier, *loc. cit.*

[38] Denis, *op. cit.*, p. 267. The phrase to which Denis objects was first used by Zola in an article on Courbet and Proudhon: "Une oeuvre d'art est un coin de la création vu à travers un tempérament." Emile Zola, *Mes Haines* (Paris: Charpentier, 1913), p. 24.

[39] Denis, *op. cit.*, p. 271. *Cf.* Matisse's desire to do away with the "acquired means."

[40] Maurice Denis, "L'Influence de Paul Gauguin," *Théories: 1890–1910* (Paris: Rouart & Watelin, 1930), p. 168.

[41] Charles Chassé, "Gauguin et Mallarmé," *L'Amour de l'art*, III (1922), pp. 246–256.

# 19. CÉZANNE

## Clement Greenberg

INTRODUCTION

When Clement Greenberg says in this selection that Cézanne's art "endures in its newness" he identifies the essential quality of all great art: its capacity to remain relevant after it has passed into history. The special relevance of Cézanne's work is not to be measured solely in terms of its historical impact, or even by its aesthetic significance, but must also comprehend the patient dedication of the artist to the frustrating labor of realizing his artistic mission. He worked deliberately, focused with exceptional intensity on the subject before him—in what the poet Rilke called the "incorruptible" objectivity of his vision. Plane by plane in modulated units he laid down his strokes of color, structuring his painting in a tightly interwoven patchwork of which each unit seems to signal the complete identification of the color strokes with the "little sensations" he perceived in the actual subject before him. So firm is the bond in his late paintings between clear, reductive structure and the planar components of his brushwork that it is understandable why he was linked to Cubism by the Cubists themselves, why Gleizes and Metzinger, in *Du Cubisme* (1912), remarked that whoever understood Cézanne was close to Cubism. And so it was for many as Cézanne, considered purely in a formalist light, became a frame of reference and a source for abstract painting.

More recent scholarship and criticism have also extracted from the character of the artist's formal means—such as his color, line, and method of composing his pictures—the perceptual process involved in the act of painting. Recent critics have begun to consider, as well, the context of Cézanne's art through documents relating to his life and work, and to apply psychoanalytic theory to explorations of content. This extended range is appropriate to the study of such a complex artist as Cézanne.

Still a basic work for Cézanne studies is Lionello Venturi, *Cézanne,*

*son art—son oeuvre*, 2 vols. (1936), a thoroughly illustrated catalogue of his work, to which one should add Adrien Chappuis, *The Drawings of Paul Cézanne: A Catalogue Raisonné*, 2 vols. (1973). The first work in English devoted to the art of Paul Cézanne was Roger Fry's brief monograph, *Cézanne: A Study of His Development*, published in London in 1927 and reprinted several times since. Of the extensive literature on this artist, the following titles represent a selected sampling: Gerstle Mack, *Paul Cézanne* (1935); Paul Cézanne, *Letters*, 5th rev. ed., ed. by John Rewald (1981); Meyer Schapiro, *Paul Cézanne* (1952); Erle Loran, *Cézanne's Composition*, 3rd ed. (1963), an analysis by a painter who first photographed Cézanne's *motifs* in Provence; John Rewald, *Paul Cézanne*, trans. by M. H. Liebman (1950), and later reprints; Kurt Badt, *The Art of Cézanne*, trans. by S. A. Ogilvie (1965), and its review by Alfred Neumeyer in *The Art Bulletin*, XLIX (1967); Judith Wechsler, ed., *Cézanne in Perspective* (1975), a handy source book with an introductory essay by the editor; William Rubin, ed., *Cézanne: The Late Years* (1977), published in conjunction with an important exhibition of Cézanne's work from the last decade of his life; Judith Wechsler, *The Interpretation of Cézanne* (1981). For Cézanne's relationship to the art of the past and analyses of his imagery there are a series of articles by Theodore Reff: "Cézanne and Poussin," *Journal of the Warburg and Courtauld Institutes*, XXIII (1960), 150–174; "Cézanne's Bather with Outstretched Arms," *Gazette des Beaux-Arts*, series 6, LIX (1962), 173–190; "Cézanne, Flaubert, St. Anthony, and the Queen of Sheba," *The Art Bulletin*, XLIV (1962), 113–125; "Cézanne's Dream of Hannibal," *ibid.*, XLV (1963), 148–152; "Cézanne and Hercules," *ibid.*, XLVIII (1966), 35–44; and "Cézanne's Card-players and Their Sources," *Arts Magazine*, LV (November 1980), 104–117. In addition there are Meyer Schapiro, "The Apples of Cézanne: An Essay on the Meaning of Still-life," *Art News Annual*, XXXIV (1968), 33–53, and also in Schapiro's *Modern Art: 19th and 20th Centuries* (1978), an anthology; Sara Lichtenstein, "Cézanne and Delacroix," *The Art Bulletin*, XLVI (1964), 55–67; Theodore Reff, "Cézanne on Solids and Spaces," *Artforum*, XVI (October 1977), 34–37; M. L. Krumrine, "Cézanne's Bathers: Form and Content," *Arts Magazine*, LIV (May 1980), 115–123; C. Donnell-Kotrozo, "Cézanne and the Continuing Cubist Controversy," *Art International*, XXIV (January–February 1981), 61–68; and N. Turner, "Subjective Curvature in Late Cézanne," *The Art Bulletin*, LXIII (1981), 665–669. A series of

related articles on Cézanne are M. Bate, "Phenomenologist as Art Critic: Merleau-Ponty and Cézanne," *British Journal of Aesthetics,* XIV, 4 (Autumn 1974), 344–350; Joyce Brodsky, "Cézanne and the Image of Confrontation," *Gazette des Beaux-Arts,* series 6, LXXXIV (September 1978), 84–86; M. Fera, "Cézanne and Merleau-Ponty: Perception, Language, Being," *The Structurist* (1979–1980), 19–20, 70–75; and Joyce Brodsky, "A Paradigm Case for Merleau-Ponty: The Ambiguity of Perception and the Paintings of Paul Cézanne," *Artibus et Historiae,* II, 4 (1981), 125–134; and in conjunction with this series, Maurice Merleau-Ponty, "Cezanne's Doubt," in *Sense and Non-Sense* (1961).

Cézanne's art may no longer be the overflowing source of modernity it was thirty years back,* but it endures in its newness and in what can even be called its stylishness. There remains something indescribably racy and sudden for all its familiarity by now, in the way his crisp blue line can separate the contour of an object from its mass. Yet how distrustful Cézanne himself was of bravura, speed—all the apparent concomitants of stylishness. And how unsure at bottom of where he was going.

He was on the verge of middle age when he had the crucial revelation of his artist's mission. Yet what he *thought* was revealed was largely inconsistent with the means he had already developed to meet and fulfill his revelation, and the problematic quality of his art—the source perhaps of its unfading modernity—came from the ultimate necessity of revising his intentions under the pressure of a method that evolved as if in opposition to them. He was making the first pondered and conscious attempt to save the key principle of Western painting—its concern for an ample and literal rendition of stereometric space—from the effects of Impressionist color. He had noted the Impressionists' inadvertent silting up of pictorial depth; and it was because he tried so hard to reexcavate that space without abandoning Impressionist color, and because this effort, while vain, was so profoundly conceived, that his art became the discovery and turning point it did. Like Manet, and with almost as little real appetite for the role of a revolutionary, he changed the direction of painting in the very effort to return it by new paths to its old ways.

Cézanne accepted his notion of pictorial unity, of the realized, final effect of a picture, from the Old Masters. When he said that he wanted to redo Poussin after nature and "make Impressionism something solid and durable like the Old Masters," he meant apparently that he wanted to impose a composition and design like that of the High Renaissance on the "raw" chromatic material provided by the Impressionist registration of visual experience. The parts, the atomic units, were still to be supplied by the Im-

* [Written in 1951.]

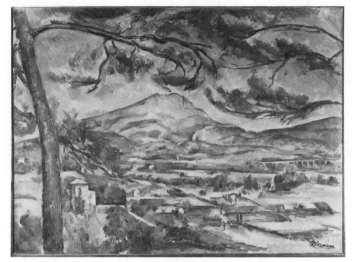

51. Paul Cézanne, *Mont Sainte-Victoire*, 1885–1887, Oil on canvas, 26⅜" x 36¼" (Home House Society Trustees, Courtauld Institute Galleries, London; Courtauld Collection)

pressionist method, which was held to be truer to nature; but these were to be organized into a whole on more traditional principles (Fig. 51).

The Impressionists, as consistent in their naturalism as they knew how to be, had let nature dictate the over-all design and unity of the picture along with its component parts, refusing in theory to interfere consciously with their optical impressions. For all that, their pictures did not lack structure; insofar as any single Impressionist picture was successful, it achieved an appropriate and satisfying unity, as must any successful work of art. (The overestimation by Roger Fry and others of Cézanne's success in doing exactly what he said he wanted to do is responsible for the cant about the Impressionist lack of structure. What is missed is geometrical, diagrammatic and sculptural structure; in its stead, the Impressionists achieved structure by the accentuation and modulation of points and areas of color and value, a kind of "composition" which is not inherently inferior to or less "structural" than the other kind.) Committed though he was to the motif in nature in all its givenness, Cézanne still felt that it could not of its own accord provide a sufficient basis for pictorial unity; what he wanted had to be more emphatic, more tangible in its articulation and therefore, supposedly, more "permanent." And it had to be *read* into nature.

# Cézanne

The Old Masters had assumed that the members and joints of pictorial design should be as clear as those of architecture. The eye was to be led through a rhythmically organized system of convexities and concavities in which manifold gradations of dark and light, indicating recession and salience, were marshaled around points of interest. To accommodate the weightless, flattened shapes produced by the flat touches of Impressionist color to such a system was obviously impossible. Seurat demonstrated this in his *Sunday Afternoon on Grand Jatte Island,* as well as in most of his other completed group compositions, where the stepped-back planes upon which he set his figures serve—as Sir Kenneth Clark has noted—to give them the quality of cardboard silhouettes. Seurat's Pointillist, hyper-Impressionist method of filling color in could manage a plausible illusion of deep space, but not of mass or volume within it. Cézanne reversed the terms of this problem and sought—more like the Florentines than like the Venetians he cherished—to achieve mass and volume first, and deep space as their by-product, which he thought he could do by converting the Impressionist method of registering variations of light into a way of indicating the variations in planar direction of solid surfaces. For traditional modeling in dark and light, he substituted modeling with the supposedly more natural —and Impressionist—differences of warm and cool.

Recording with a separate pat of paint each larger shift of direction by which the surface of an object defined the shape of the volume it enclosed, he began in his late thirties to cover his canvases with a mosaic of brushstrokes that called just as much attention to the physical picture plane as the rougher dabs or "commas" of Monet, Pissarro and Sisley did. The flatness of that plane was only further emphasized by the distortions of Cézanne's drawing, which started out by being temperamental (Cézanne was never able to master a sculptural *line*) but turned into a method, new in extent rather than in kind, of anchoring fictive volumes and spaces to the surface pattern. The result was a kind of pictorial tension the like of which had not been seen in the West since Late Roman mosaic art. The overlapping little rectangles of pigment, laid on with no attempt to fuse their edges, brought depicted form toward the surface; at the same time, the modeling and shaping performed by these same rectangles drew it back into illusionist depth. A vibration, infinite in its terms,

was set up between the literal paint surface of the picture and the "content" established behind it, a vibration in which lay the essence of the Cézannian "revolution."

The Old Masters always took into account the tension between surface and illusion, between the physical facts of the medium and its figurative content—but in their need to conceal art with art, the last thing they had wanted was to make an explicit point of this tension. Cézanne, in spite of himself, had been forced to make the tension explicit in his desire to rescue tradition from— and at the same time with—Impressionist means. Impressionist color, no matter how handled, gave the picture surface its due as a physical entity to a much greater extent than had traditional practice.

Cézanne was one of the most intelligent painters about painting whose observations have been recorded. (That he could be rather intelligent about many other things has been obscured by his eccentricity and the profound and self-protective irony with which he tried, in the latter part of his life, to seem the conformist in matters apart from art.) But intelligence does not guarantee the artist a precise awareness of what he is doing or really wants to do. Cézanne overestimated the degree to which a conception could precipitate itself in, and control, works of art. Consciously, he was after the most exact communication of his optical sensations of nature, but these were to be ordered according to certain precepts for the sake of art as an end in itself—an end to which naturalistic truth was but a means.

To communicate his optical sensations exactly meant transcribing, however he could, the distance from his eye of every part of the motif, down to the smallest facet-plane into which he could analyze it. It also meant suppressing the texture, the smoothness or roughness, the hardness or softness, the tactile associations of surfaces; it meant seeing prismatic color as the exclusive determinant of spatial position—and of spatial position above and beyond local color or transient effects of light. The end in view was a *sculptural* Impressionism.

Cézanne's habits of seeing—his way, for instance, of telescoping middleground and foreground, and of tilting forward everything in the subject that lay above eye level—were as inappropriate to the cavernous architectural schemes of the Old Masters as were Monet's habits of seeing. The Old Masters elided and glided as they traveled through space, which they

treated as the loosely articulated continuum that common sense finds it to be. Their aim in the end was to create space as a theater; Cézanne's was to give space itself a theater.

His focus was more intense and at the same time more uniform than the Old Masters'. Once "human interest" had been excluded, every visual sensation produced by the subject became equally important. Both the picture as picture, and space as space, became tighter and tauter—distended, in a manner of speaking. One effect of this distention was to push the weight of the entire picture forward, squeezing its convexities and concavities together and threatening to fuse the heterogeneous content of the surface into a single image or form whose shape coincided with that of the canvas itself. Thus Cézanne's effort to turn Impressionism toward the sculptural was shifted, in its fulfillment, from the structure of the pictorial illusion to the configuration of the picture itself as an object, as a flat surface. Cézanne got "solidity," all right; but it is as much a two-dimensional, literal solidity as a representational one.

The real problem would seem to have been, not how to do Poussin over according to nature, but how to relate—more carefully and explicitly than Poussin had—every part of the illusion in depth to a surface pattern endowed with even superior pictorial rights. The firmer binding of the three-dimensional illusion to a decorative surface effect, the integration of plasticity and decoration—this was Cézanne's true object, whether he said so or not. And here critics like Roger Fry read him correctly. But here, too, his expressed theory contradicted his practice most. As far as I know, not once in his recorded remarks does Cézanne show any concern with the decorative factor except—and the words are the more revelatory because they seem offhand—to refer to two of his favorite Old Masters, Rubens and Veronese, as "the decorative masters."

No wonder he complained till his last day of his inability to "realize." The effect toward which his means urged was not the one he had conceived in his desire for the organized maximum of an illusion of solidity and depth. Every brushstroke that followed a fictive plane into fictive depth harked back—by reason of its abiding, unequivocal character as a mark made by a brush—to the physical fact of the medium; and the shape and placing of that mark recalled the shape and position of the flat rectangle which was being covered with pigment that came from tubes. ( Cézanne

wanted an "elevated" art, if anyone ever did, but he made no bones about the tangibility of the medium. "One has to be a painter through the very qualities of painting," he said. "One has to use coarse materials.")

For a long while he overpacked his canvases as he groped along, afraid to betray his sensations by omission, afraid to be inexact because incomplete. Many of his reputed masterpieces of the later 1870's and the 1880's (I leave to one side the proto-Expressionist feats of his youth, some of which are both magnificent and prophetic) are redundant, too cramped, lacking in unity because lacking in modulation. The parts are felt, the execution is often exact, but often there is too little of the kind of feeling that precipitates itself in an instantaneous whole. (No wonder so many of his unfinished paintings are among his best.) Only in the last ten or fifteen years of Cézanne's life do pictures whose power is complete as well as striking and original come from his easel with real frequency. Then the means at last fulfills itself. The illusion of depth is constructed with the surface plane more vividly, more obsessively in mind; the facet-planes may jump back and forth between the surface and the images they create, yet they are one with both surface and image (Figs. 52, 53). Distinct yet summarily applied, the square pats of paint vibrate and dilate in a rhythm that embraces the illusion as well as the flat pattern. The artist seems to relax his demand for exactness of hue in passing from contour to background, and neither his brushstrokes nor his facet-planes remain as closely bunched as before. More air and light circulate through the imagined space. Monumentality is no longer secured at the price of a dry airlessness. As Cézanne digs deeper behind his broken contours with ultramarine, the whole picture seems to unsheathe and then re-envelop itself. Repeating its rectangular enclosing shape in every part of itself, it seems also to strain to burst the dimensions of that shape.

Had Cézanne died in 1890, he would still be enormous, but more so in innovation than in realization. The full, triumphant unity that crowns the painter's vision, the unity offered like a single sound made by many voices and instruments—a single sound of instantaneous yet infinite variety—this kind of unity comes for Cézanne far more often in the last years of his life. Then, certainly, his art does something quite different from what he said he wanted it to do. Though he may think as much as before about its problems, he thinks much less into its execution.

Having attracted young admirers, he expands a little, has his re-
marks taken down and writes letters about his "method." But if
he did not then confuse Emile Bernard, Joachim Gasquet and
others among his listeners, he confuses us today, who can only
read what he had to say. I prefer, however, to think with Erle
Loran (to whose *Cézanne's Composition* I am indebted for more
than a few insights into the essential importance of Cézanne's
drawing) that the master himself was more than a little confused
in his theorizing about his art. But did he not complain that
Bernard, with his appetite for theories, forced him to theorize
unduly? (Bernard, in his turn, criticized Cézanne for painting
*too much* by theory.)

To the end, he continued to harp on the necessity of modeling,
and of completeness and exactness in reporting one's "sensations."

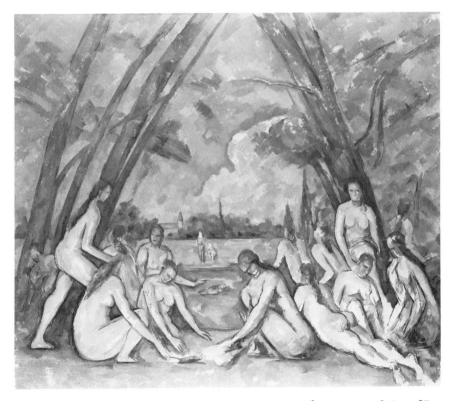

52. Paul Cézanne, *The Large Bathers*, c. 1898–1905, Oil on canvas, 83″ x 98″
(Philadelphia Museum of Art: Purchased: W. P. Wilstach Collection)

53. Paul Cézanne, *Pines and Rocks (Fontainebleau?)*, 1898–1899, Oil on canvas, 32″ x 25¾″ (Collection, The Museum of Modern Art, New York, Lillie P. Bliss Collection)

He stated his ideal, with more than ordinary self-awareness, as a marriage between *trompe-l'oeil* and the laws of the medium, and lamented his failure to achieve it. In the same month in which he died, he still complained of his inability to "realize." Actually, one is more surprised, in view of the gathering abstractness of his last great paintings, to hear Cézanne say that he had made a "little progress." He condemned Gauguin and Van Gogh for painting "flat" pictures: "I have never wanted and will never accept the lack of modeling or gradation: it's an absurdity. Gauguin was not a painter; he only made Chinese pictures." Bernard reports him as indifferent to the art of the primitives of the Renaissance; they, too, apparently, were too flat. Yet the path of which Cézanne said he was the primitive, and by following which he hoped to rescue Western tradition's pledge to the three-dimensional from both Impressionist haze and Gauguinesque decoration, led straight, within five or six years after his death, to a kind of painting as flat as any the West had seen since the Middle Ages.

The Cubism of Picasso, Braque and Léger completed what Cézanne had begun. Its success divested his means of whatever might have remained problematical about them. Because he had exhausted so few of his insights, Cézanne could offer the Cubists all the resources of a new discovery; they needed to expend little effort of their own in either discovery or rediscovery. This was the Cubists' luck, which helps explain why Picasso, Léger and Braque, between 1909 and 1914, were able to turn out a well-nigh uninterrupted succession of "realizations," Classical in the sufficiency of their strength, in the adjustment of their means to their ends.

Cézanne's honesty and steadfastness are exemplary. Great painting, he says in effect, ought to be produced the way it was by Rubens, Velasquez, Veronese and Delacroix; but my own sensations and capacities don't correspond to theirs, and I can feel and paint only the way I must. And so he went at it for forty years, day in and out, with his clean, careful *métier*, dipping his brush in turpentine between strokes to wash it, and then depositing each little load of paint in its determined place. It was a more heroic artist's life than Gauguin's or Van Gogh's, for all its material ease. Think of the effort of abstraction and of eyesight necessary to analyze every part of every motif into its smallest negotiable plane.

Then there were the crises of confidence that overtook Cézanne

almost every other day (he was also a forerunner in his paranoia). Yet he did not go altogether crazy: he stuck it out at his own sedentary pace, and his absorption in work rewarded him for premature old age, diabetes, obscurity and the crabbed emptiness of his life away from art. He considered himself a weakling, a "bohemian," frightened by the routine difficulties of life. But he had a temperament, and he sought out the most redoubtable challenges the art of painting could offer him in his time.

# 20. CUBISM

## Robert Rosenblum

### INTRODUCTION

Robert Rosenblum's *Cubism and Twentieth-Century Art* is an important contribution to the study of the movement itself but ranges beyond this to deal with the impact of Cubism on the Futurists, the German Expressionists, abstract and fantastic art, as well as twentieth-century sculpture and artists in England and America. It is, therefore, to some degree, a survey of major currents in twentieth-century art. Particularly commendable is the way in which Rosenblum approaches the development of Cubism through a careful analysis of individual works of art, which will be apparent in the following selection from his book.

The most important single document of this movement is the collaborative effort of the Cubist artists and theorists, Albert Gleizes and Jean Metzinger: *Du Cubisme*, published in 1912 and translated into English in 1913. It is available, with some revisions in the 1913 translation, in *Modern Artists on Art*, edited by Robert L. Herbert (1964). Of nearly equal importance is the more familiar work by Guillaume Apollinaire, *Les Peintres Cubistes* (1913), available in English as *The Cubist Painters* (1949). See also Herschel B. Chipp, *Theories of Modern Art: A Source Book by Artists and Critics* (1969). Among other works are the following selected titles: A. J. Eddy, *Cubists and Post-Impressionism*, a pioneer work first published in Chicago in 1914, followed by a London edition in 1915; D. H. Kahnweiler, *The Rise of Cubism* (1949), a translation of his 1920 publication *Der Weg zum Kubismus*; Alfred Barr, *Cubism and Abstract Art* (1936); Picasso, *Fifty Years of His Art* (1946); Christopher Gray, *Cubist Aesthetic Theories* (1953); John Golding, *Cubism: A History and an Analysis, 1907–1914* (1959); and Edward Fry, *Cubism* (1966). A good account of Cubism can be found in Werner Haftmann, *Painting in the Twentieth Century*, 2 vols. (1965). Among numerous articles are Winthrop Judkins,

"Toward a Reinterpretation of Cubism," *Art Bulletin*, XXX (1948), 270–278; Edward F. Fry, "Cubism 1907–1908: An Early Eyewitness Account," *Art Bulletin*, XLVIII (1966), 70–73; Clement Greenberg, "The Role of Nature in Modern Painting," *Partisan Review*, XVI (January 1949), 78–81; Christopher Gray, "Cubist Conception of Reality," *College Art Journal*, XIII, 1 (1953), 19–23; D. H. Kahnweiler, "Cubism: The Creative Years," *Art News Annual*, XXIV (1955), 107–116; Clement Greenberg, "Pasted-Paper Revolution," *Art News*, LVII (September 1958), 46–49; and Linda Henderson, "A New Facet of Cubism: 'The Fourth Dimension' and 'Non-Euclidean Geometry' Reinterpreted," *Art Quarterly*, XXXIV, 4 (1971), 410–433.

In addition there are S. Marcus, "Typographic Element in Cubism, 1911–1915: Its Formal and Semantic Implications," *Art International*, XVII (May 1973), 24–27; Lynn Gamwell, *Cubist Criticism* (1980); W. Bohn, "In Pursuit of the Fourth Dimension: Guillaume Apollinaire and Max Weber," *Arts Magazine*, LIV (June 1980), 166–169; Harry E. Buckley, *Guillaume Apollinaire as an Art Critic* (1981); D. J. Robbins, "Sources of Cubism and Futurism," *Art Journal*, XLI, 4 (Winter 1981), 324–327; and A. H. Murray, "Henri Le Fauconnier's 'Das Kunstwerk': An Early Statement of Cubist Aesthetic Theory and Its Understanding in Germany," *Arts Magazine*, LVI (December 1981), 125–133.

The selection that follows is from *Cubism and Twentieth-Century Art* by Robert Rosenblum, published in 1961 by Harry N. Abrams, Inc., New York. Reprinted by permission of the publishers.

There are moments in the history of art when the genesis of a new and major style becomes so important that it appears temporarily to dictate the careers of the most individual artists. So it was around 1510, when the diverse geniuses of Michelangelo, Raphael, and Bramante rapidly coalesced to create the monumental style of the High Renaissance; and around 1870, when painters as unlike as Monet, Renoir, and Pissarro approached a common goal in their evolution toward Impressionism. And so it was again around 1910, when two artists of dissimilar backgrounds and personalities, Picasso and Braque, invented the new viewpoint that has come to be known as *Cubism*.

From our position in the second half of the twentieth century, Cubism emerges clearly as one of the major transformations in Western art. As revolutionary as the discoveries of Einstein or Freud, the discoveries of Cubism controverted principles that had prevailed for centuries. For the traditional distinction between solid form and the space around it, Cubism substituted a radically new fusion of mass and void. In place of earlier perspective systems that determined the precise location of discrete objects in illusory depth, Cubism offered an unstable structure of dismembered planes in indeterminate spatial positions. Instead of assuming that the work of art was an illusion of a reality that lay beyond it, Cubism proposed that the work of art was itself a reality that represented the very process by which nature is transformed into art.

In the new world of Cubism, no fact of vision remained absolute. A dense, opaque shape could suddenly become a weightless transparency; a sharp, firm outline could abruptly dissolve into a vibrant texture; a plane that defined the remoteness of the background could be perceived simultaneously in the immediate foreground. Even the identity of objects was not exempt from these visual contradictions. In a Cubist work, a book could be metamorphosed into a table, a hand into a musical instrument. For a century that questioned the very concept of absolute truth or value, Cubism created an artistic language of intentional ambiguity. In front of a Cubist work of art, the spectator was to realize

54. Pablo Picasso, *Les Demoiselles d'Avignon*, 1907, Oil on canvas, 8′ x 7′8″ (Collection, The Museum of Modern Art, New York, Acquired through the Lillie P. Bliss Bequest)

that no single interpretation of the fluctuating shapes, textures, spaces, and objects could be complete in itself. And, in expressing this awareness of the paradoxical nature of reality and the need for describing it in multiple and even contradictory ways, Cubism offered a visual equivalent of a fundamental aspect of twentieth-century experience.

The genesis of this new style, which was to alter the entire course of Western painting, sculpture, and even architecture, produced one of the most exhilarating moments in the history of art. . . .

This new world began with an explosion, for [Picasso's] *Les Demoiselles D'Avignon* (Fig. 54), projected in 1906 but worked

on mostly in the spring of 1907, appears to be the thunderous outburst that released the latent forces of the preceding year. . . . Like most major pictorial revolutions, *Les Demoiselles d'Avignon* (whose title, a reference to a Barcelona red-light district, was given it later) mirrors the past and proclaims the future, for it both resumes an earlier tradition and begins a new one. Yet no masterpiece of Western painting has reverberated so far back into time as Picasso's five heroic nudes, who carry us across centuries and millenniums. To begin, we sense the immediate heritage of Cézanne's studies of bathers, and, through them, the whole Renaissance tradition of the monumental nude, whether the noble structural order of Poussin and Raphael or—in the extraordinary anatomical compression of the two central figures—the anguish of Michelangelo's slaves. But *Les Demoiselles* can take us even further back in time, and in civilization, to ancient, pre-Christian worlds. The three nudes at the left, who twist so vigorously from their draperies, evoke first the Venuses and Victories of the Hellenistic world, and then, cruder and more distant, the squat, sharp-planed figures of the pagan art of Iberia. And in the two figures at the right, this atavism reaches a fearsome remoteness in something still more primitive—the ritual masks of African Negro art.

The most immediate quality of *Les Demoiselles* is a barbaric, dissonant power whose excitement and savagery were paralleled not only by such eruptions of vital energy as Matisse's art of 1905–1910, but by music of the following decade—witness the titles alone of such works as Bartók's *Allegro barbaro* (1910), Stravinsky's *Le Sacre du printemps* (1912–1913), and Prokofiev's *Scythian Suite* (1914–1916). *Les Demoiselles* marks, as well, a shrill climax to the nineteenth century's growing veneration of the primitive—whether Ingres' enthusiasm for the linear stylizations of Greek vase painters and Italian primitives or Gauguin's rejection of Western society in favor of the simple truths of art and life in the South Seas. In *Les Demoiselles*, this fascination with the primitive is revealed not only in explicit references to Iberian sculpture in the three nudes at the left and to African Negro sculpture in the two figures at the right but in the savagery that dominates the painting. The anatomies themselves are defined by jagged planes that lacerate torsos and limbs in violent, unpredictable patterns. So contagious, in fact, are the furious

energies of these collisive, cutting angles that even the still life in the foreground is charged with the same electric vitality that animates the figures. The scimitarlike wedge of melon, contrasted with the tumbling grapes and pears, seems to generate the ascending spirals of pink flesh; and, similarly, other inanimate forms, such as the curtain at the left, seem to echo the harsh junctures of the human anatomies.

This primitive power of form is fully complemented by the magnetic expression of the heads. Here, one senses above all the hypnotic presence of staring eyes that have a ritualistic fixity amid all this splintering animation. One moves from the single eye of the figure at the extreme left, placed frontally on a profile head as in Egyptian painting, to the more demonic pair of eyes, in different shades of blue and on different levels, that invests the squatting figure in the right foreground with magical force. Viewed as prophecy, this emphasis on the mysterious psychological intensity of a staring eye was to be a constant element in Picasso's later work, even in some of his most cerebral Cubist paintings.

*Les Demoiselles d'Avignon* has often been criticized for its stylistic incoherence, especially apparent in the shift from the Iberian stylizations of the three women at the left to the more sinister and grotesque style of the heads of the two women at the right, presumably repainted under the influence of African Negro sculpture. Yet this very inconsistency is an integral part of *Les Demoiselles*. The irrepressible energy behind its creation demanded a vocabulary of change and impulse rather than of measured statement in a style already articulated. The breathless tempo of this pregnant historical moment virtually obligated its first masterpiece to carry within itself the very process of artistic evolution. In fact, the velocity of stylistic change from left to right in this single painting foreshadows, in contracted form, the comparably swift creation of a more disciplined Cubist vocabulary in the years that follow.

What are the pictorial problems that *Les Demoiselles d'Avignon*, with its still molten vocabulary, had posed but not yet solved? The radical quality of *Les Demoiselles* lies, above all, in its threat to the integrity of mass as distinct from space. In the three nudes at the left, the arcs and planes that dissect the anatomies begin to shatter the traditional sense of bulk; and in the later figures at the right, this fragmentation of mass is even

more explicit. The nudes' contours now merge ambiguously with the icy-blue planes beside them, and the concavities of the noses tend to disrupt the sense of a continuous solid. The square plane that describes the breast of the figure at the left still adheres to her torso, whereas the square plane that describes the breast of the figure at the upper right suddenly becomes detached from the body to assert its independent existence. Just as the impulse to explore the autonomous life of linear and planar rhythms seems almost to dominate Picasso's contact with perceived reality, the colors, too, have become more abstract. The blues and pinks used earlier in the Blue and Rose periods to convey moods of depression and frailty are now almost independent from expressive or representational ends. Most remarkably, the brilliant and varied pinks of the nudes exist first as autonomous means of fracturing these bodies into their agitated planar components and only second as means of representing flesh. And it is exactly this new freedom in the exploration of mass and void, line and plane, color and value—independent from representational ends—that makes *Les Demoiselles* so crucial for the still more radical liberties of the mature years of Cubism. . . .

In *Les Demoiselles*, the influence of African Negro art is evident. . . . Primitive sculpture apparently exemplified, for Picasso, the freedom to distort anatomy for the sake of creating a rhythmic structure that can merge solids and voids and invent new shapes. For another, its terrifying power and suggestion of a supernatural presence seem to have been equally stimulating. . . .

The violence of 1907 can be felt in the still lifes of that year. The emotional neutrality that we might expect in a still life is upset, for example, in the *Still Life with Skull* [1907, The Hermitage Museum, Leningrad], not only by the way in which Picasso has adapted the jagged, twisting rhythms of *Les Demoiselles* but by his use of a riotous, almost Expressionist palette, whose searing reds, blues, and lavenders add to the dissonance. The very choice of still-life objects contributes to the surprising drama of a table top, for, amid the sensuous and intellectual pleasures of artist's palette, pipe, and books, Picasso has introduced the traditional still-life theme of vanity and human transcience by including a mirror and a skull. In so doing, he recalls the original allegorical intention of *Les Demoiselles*—in which a figure carrying a skull was to enter the hedonistic environment of five nudes, a sailor, and an arrangement of flowers and fruit—and foreshadows,

as well, the impassioned expressive qualities with which he will so often invest his later still lifes, even without the help of such traditional symbolism. . . .

In the following year, Picasso temporarily purged himself of these barbaric impulses in order to concentrate on the more measured and systematic study of the formal problems created so violently in *Les Demoiselles d'Avignon.* The less impassioned, more resolute qualities of the works of 1908 may be explained, in part, by the almost inevitable calm and control that might be expected to follow the cathartic vehemence of 1907. It may also be explained by the disciplining influence of the French tradition, which confronted Picasso in historical retrospect at the famous Cézanne memorial exhibition held at the Salon d'Automne in 1907 and in living actuality in the person of Georges Braque, whom he met at about the same time through the poet Guillaume Apollinaire and the dealer—and, later, historian of Cubism—Daniel Henry Kahnweiler. In his work of 1908, Picasso seems more and more to suppress the pathos and fury of his earlier art, substituting the rigorous control of eye and intellect recurrent in the French pictorial tradition. . . .

Conspicuous in Picasso's *oeuvre* of 1908 were still lifes and landscapes. Though he had painted these subjects before, and often with vigor and drama, their new predominance in his work of 1908 indicates a turning from his earlier preoccupation with the human figure as a vehicle of feeling. Just as Cézanne in the 1870's, under the impact of Impressionism, was to reject or, rather, to harness the human passions that animated his early work, so, too, did Picasso abandon subjects that evoked human compassion in order to focus on the emotionally more neutral themes that are provided by still life and landscape. . . .

From 1907 on, Picasso's development cannot be understood without also considering the evolution of the Frenchman Georges Braque. From the time of their first meeting in 1907 until about 1914, the art of the two men followed a closely interrelated course that for several years attained a disciplined vocabulary that subordinated individual eccentricities to a comparatively objective standard. As a Frenchman who had come to Paris from Le Havre in 1900, Braque could hardly have been less like Picasso in background. While Picasso was painting scenes of allegory and human despair, Braque worked within the confines of the Impressionist viewpoint, painting candidly observed landscapes and still lifes.

By 1906, he had given his temporary allegiance to the coloristic exuberance of the Fauves, producing such works as the landscape at L'Estaque. Yet here, in historical retrospect, we can already perceive a certain insistence on the analysis of solids that distinguishes Braque from his fellow Fauves and allies him more closely to the structural bent of Cézanne, who had earlier scrutinized this very Provençal landscape in terms of its volumetric fundamentals. And in the following year, 1907, Braque painted another of Cézanne's sites, the *Viaduct at L'Estaque*, in which the angular definition of planes in the central vista of earth, bridge, and houses grows even more emphatic, especially by contrast with the looser definition of the trees that frame the view. . . .

. . . In 1908, he continued to explore landscape and still life as a means to pictorial rather than emotive ends. The *Houses at L'Estaque* of that year is perhaps even more advanced than any of Picasso's contemporary work. Again, a comparison with Cézanne is inevitable and demonstrates once more that Braque, like Picasso in 1908, had resolved the precarious tension of Cézanne's dual homage to optically perceived nature and intellectually conceived art in favor of art. Next to a Cézanne landscape like the *Turning Road at Montgeroult* of 1899, Braque's canvas consciously disregards the data of vision. His Provençal houses, boldly defined by the most rudimentary planes, have so thoroughly lost contact with the realities of surface texture or even fenestration that at places—as in the background and the lower right foreground—they are subtly confounded with the green areas of vegetation. And, just as the description of surfaces becomes remote from reality, so, too, do the colors take leave of perceived nature and tend toward an ever more severe monochrome that permits the study of a new spatial structure without the interference of a complex chromatic organization.

In the same way, the light follows the dictates of pictorial rather than natural laws. Although multiple sources of light are often implied in Cézanne's work, his painting never violates so completely the physical laws of nature. In Braque's painting, however, the houses are illuminated from contrary sources—from above, from the front, from both sides—in order to define most distinctly the planar constituents of architecture and landscape. And spatially, too, no painting of Cézanne's is so congestedly two-dimensional; for Braque's houses, despite their ostensible bulk

and suggestions of perspective diminution, are so tightly compressed in a shallow space that they appear to ascend the picture plane, rather than to recede into depth.

Yet, within this apparently rudimentary vocabulary there are the most sophisticated and disconcerting complexities. It may be noticed, for example, that whereas the planar simplifications suggest the most primary of solid geometries, the contrary light sources that strongly shadow and illumine these planes permit, at the same time, unexpected variations in the spatial organization. Suddenly a convex passage becomes concave, or the sharply defined terminal plane of a house slides into an adjacent plane to produce a denial of illusionistic depth more explicit than Cézanne's.

Both Matisse and Louis Vauxcelles, the critic who had unwittingly given the Fauves their name, referred to Braque's work of the time and to this painting in particular as being composed of cubes—remarks that were destined to name the Cubist movement for history. Yet their observation was only partially right. For all the seeming solidity of this new world of building blocks, there is something strangely unstable and shifting in its appearance. The ostensible cubes of *Houses at L'Estaque* were to evolve into a pictorial language that rapidly discarded this preliminary reference to solid geometry and turned rather to a further exploration of an ever more ambiguous and fluctuating world. . . .

By the beginning of 1910, impelled to an ever greater fragmentation of mass and to a more consistently regularized vocabulary of arcs and angles, Picasso treated even the human figure with a stylistic coherence that finally confounded the organic and the inorganic. The *Girl with Mandolin* (Fig. 55), a Corot-like studio portrait of a girl named Fanny Tellier, takes us far beyond the 1909 figure paintings. . . . With its paradoxes of plane, light, and texture, the *Girl with Mandolin* introduces the strangely elusive and fluctuating world of the mature years of Cubism, a world in which the fixed and the absolute are replaced by the indeterminate and the relative.

As in the aesthetic and structural innovations of contemporary architecture, in which transparent glass planes and free-standing walls both define a volume and belie that definition by implying a fusion with the space around it, the precise boundaries of the contours that describe the model and her mandolin cannot be located with visual certainty. In this unstable world of bodiless

55. Pablo Picasso, *Girl with Mandolin* (Fanny Tellier), 1910, Oil, 39½″ x 29″ (Collection, The Museum of Modern Art, New York, Nelson A. Rockefeller Bequest)

yet palpable shapes, the integrity of matter undergoes an assault comparable to that made on the once indivisible atom. The contours of the hair, for example, destroy the solidity of the head by merging with the planes that describe the adjacent space, just as the bent elbows seem to dematerialize in their transparent ambiance.

Similarly, spatial positions must now be defined relatively rather than absolutely. Unlike the fixed positions determined by Renaissance perspective systems, planes here are in a state of constant flux, shifting their relative locations according to a changing context. Is the cylinder of the upper arm behind or before the incomplete cubes at the left? Are these same cubes concave or convex? Do they move toward us or away from us? Even the texture of the painting shares such ambiguity. The shaded planes evoke the illusion, on the one hand, of modeled, opaque solids, and on the other, of a curiously translucent substance whose complex structural order is as visually puzzling as the spatial relations in a house of mirrors.

If fixed spatial relations are rejected by the continual shifting and rearrangement of planes, so, too, are fixed temporal relations. In observing how the profile of the head is repeated or how the upper arm shifts to a plane different from the plane of the shoulder, the spectator is obliged to assume that the figure is pieced together of fragments taken from multiple and discontinuous viewpoints. The ambiguous quality of time in a Cubist painting derives from this very phenomenon, for one senses neither duration nor instantaneity, but rather a composite time of fragmentary moments without permanence or sequential continuity.

In so creating a many-leveled world of dismemberment and discontinuity, Picasso and Braque are paralleled in the other arts. For example, their almost exact contemporary, Igor Stravinsky, demonstrates a new approach to musical structure that might well be called "Cubist." Often his melodic line—especially in *Le Sacre du printemps* (1912–1913)—is splintered into fragmentary motifs by rhythmic patterns as jagged and shifting as the angular planes of Cubist painting and equally destructive of a traditional sense of fluid sequence. Similarly, Stravinsky's experiments in polytonality, as in *Petrouchka* (1911), where two different tonalities (C and F♯ major in the most often cited example) are sounded simultaneously, provide close analogies to the multiple images of

Cubism, which destroy the possibility of an absolute reading of the work of art. In literature as well, James Joyce and Virginia Woolf (both born within a year of Picasso and Braque) were to introduce "Cubist" techniques in novels like *Ulysses* (composed between 1914 and 1921) and *Mrs. Dalloway* (1925). In both these works the narrative sequence is limited in time to the events of one day; and, as in a Cubist painting, these events are recomposed in a complexity of multiple experiences and interpretations that evoke the simultaneous and contradictory fabric of reality itself.

Despite the fact that the more consistent vocabulary and radical disintegrations of *Girl with Mandolin* introduce a more advanced and abstruse stage of Cubism, Picasso somehow preserves much of the physical and emotional integrity of his model. Her feminine form, with its rounded patterns of breasts and coiffure echoing the arc of the mandolin, is by no means obscured totally in the Cubist network of planes; and there even emerges something of a quiet introspective melancholy (not unlike that of the Circus period) from a style that has so often been narrow-mindedly interpreted as coldly antagonistic to so-called "humanistic" values. . . .

Braque's exploration of the ever more complex language of Cubism closely paralleled Picasso's, although portraiture, which attracted Picasso throughout his career, was foreign to Braque, who generally preferred landscapes, still lifes, and anonymous figures. In one of the epoch-making canvases of Cubism, the *Still Life with Violin and Pitcher* of 1909–1910 (Fig. 56), Braque's decomposition of solids into air-borne, twinkling facets is as fully advanced as in any of Picasso's work of the time and creates perhaps even richer visual and intellectual paradoxes. Transparent and opaque forms are confounded wittily: the pitcher, which might well be made of glass, appears more opaque than the violin, whose fragile transparencies belie its wooden substance. Space, too, is fascinatingly ambiguous: the illusion of depth inferred from the sharp cut of the wall and triple molding at the right is contradicted by the continuous oscillation of planes that seem to cling to the picture surface as if magnetized. But most brilliant is the *trompe-l'oeil* nail that projects obliquely from the very top center of the canvas, a device that Braque uses in a comparable work of this time, the *Violin and Palette*, in which the nail projects through the artist's palette. Here we have an essential key to the

56. Georges Braque, *Still Life with Violin and Pitcher*, 1909–1910, Oil, 46½″ x 28¾″ (Kunstmuseum, Basel)

complex interchanges of art and reality that were later to be explored in collage, for the illusionistic nail helps to establish one of the basic meanings of Cubism—that a work of art depends upon both the external reality of nature and the internal reality of art.

This proposition may seem a truism in the sense that almost all art of the past reveals this dual responsibility toward nature and toward its own language, but it was Braque and Picasso who first made this quality explicit in demonstrating, as it were, the very process by which nature becomes art. In these terms, the nail shatters the deception that Renaissance perspective would sustain in its attempt to transform the surface of the picture into a transparent window through which we see an illusion of reality. By appearing to cast a shadow upon the flat surface of the canvas, the *trompe-l'oeil* nail also casts doubts upon the illusions around it. If the painter's medium is now so irrevocably proved to be two-dimensional, then the dog-eared corner and the oblique thrust of wall and molding in the upper right of the *Still Life with Violin and Pitcher* are patently deceptions, as are the tilted, overlapping sheets of music below the nail in the *Violin and Palette*. But the implications go still further. The *trompe-l'oeil* nail is, after all, no more and no less real than the ostensibly unreal Cubist still life below, just as the almost palpable scroll of the violin in both pictures is actually no more and no less real than the body of the violin, which slips out of its material skin like a specter. The inevitable conclusion is that a work of art presents a complex interchange between artifice and reality. A picture depends upon external reality, but the Cubist means of recording this reality—unlike the means devised by the Renaissance—are not absolute but relative. One pictorial language is no more "real" than another, for the nail, conceived as external reality, is just as false as any of the less illusionistic passages in the canvas—or conversely, conceived as art, is just as true. . . .

It is therefore essential to realize that, no matter how remote from literal appearances Cubist art may at times become, it always has an ultimate reference to external reality, without which it could not express the fundamental tension between the demands of nature and the demands of art. Even the color, texture, and light of Braque's *Still Life with Violin and Pitcher* testify to this dual responsibility. Although it has often been pointed out that the ascetic ochers, silvers, and grays of 1910 and 1911 move

far from the variegated colors of reality into a more abstract realm, the artificial colors of this painting are nevertheless partially relevant to the world of appearances. The browns of the violin and the table top at its right are directly appropriate to the colors of wood, just as the milky white planes of the tablecloth and the pitcher can allude, not implausibly, to the folds of a fabric and to the crystalline facets of what is perhaps a transparent pitcher. In the same way, the light in this painting, for all the arbitrariness of the contradictory patterns of highlight and shadow, conveys a luminosity that refers to the laws of physics and visual perception as well as to the laws of art. . . .

Generally, however, the works of 1910–11 grow progressively more distant from a legible transcription of visual reality and increasingly difficult to decipher in their extraordinary degree of transformation from nature to art. A Picasso drawing of 1910, a study of a nude (Fig. 57), can indicate perhaps even more clearly than the paintings of the time the extreme purity that the Cubist vocabulary had attained by 1910. The impulse toward fragmentation of surfaces into component planes is now so strong that the very core of matter seems finally to be disclosed as a delicately open structure of interlocking arcs and angles. Yet paradoxically, if this form appears to dissolve outward into the openness of the surrounding void, it also appears to coalesce inward into a strangely crystalline substance.

Ironically, this advanced moment of Cubism is at once simpler and more complex than the earlier phases. On the one hand, the vocabulary, in its almost complete restriction to flattened arcs and straight lines and its abstention from irrelevant literal detail, has reached a pristine simplicity. On the other hand, the syntax has achieved an infinite sophistication revealed, for example, in the endlessly intricate shifting of planes within a hairbreadth, or in the equally rich variations of light and dark that make this gossamer scaffolding quiver in unpredictable ways upon the white surface of the paper. To accuse such a drawing of being a dry exercise in geometry is to ignore, for one thing, the extraordinarily subtle deviations from an absolute geometric purity in both the irregularities of touch and the irregularities of shape of these slightly imperfect curves and straight lines. In addition, it is to overlook the intellectual exhilaration with which the human form has been translated magically into a spider web of mysterious spatial relations. Not since the century of Donatello, Uccello, and

408

57. Pablo Picasso, *Nude,* 1910, Charcoal drawing, 19 1/16″ x 12 5/16″ (The Metropolitan Museum of Art, The Alfred Stieglitz Collection, 1949)

Piero della Francesca has there been so exalted a union of art, nature, and geometry....

... [By the summer of 1911] it is astonishing to see how closely Braque's art and Picasso's have converged in the pursuit of this new pictorial world. Once more, there are reminders of paintings by Monet, Renoir, and Pissarro in the 1870's that, at times, are almost indistinguishable from one another. But, for all the ostensible anonymity of the Cubist style of 1911, differences between the two masters are still discernible. Typically, the rhythms of the Picasso are sharper and more strident . . . ; and the alternations of light and dark are comparably more sudden and nervous. Braque, by contrast, retains a greater suppleness in his transitions and a more obvious equilibrium of structure....

In two masterpieces of this climactic year of Cubism—Braque's *Portuguese* (Fig. 58), painted in the spring of 1911, and Picasso's *Ma Jolie*, painted in the winter of 1911–1912—we are again confronted with a figure playing a stringed instrument. Although the attraction of Picasso and Braque to this subject and to musical instruments in general has often been interpreted in rather speculative terms (such as the analogies between the abstract nature of Cubism and that of music), the frequency of violins, guitars, and mandolins may be explained better, perhaps, by the fact that these instruments provided a convenient and easily manipulated example in reality of the purified pictorial forms of early Cubism. Indeed, a stringed instrument, with its clear oppositions of curved and rectilinear shape, solid and void, line and plane, is almost a dictionary of the Cubist language of 1910–1912. Moreover, the specific juxtaposition of human figure and stringed instrument presented an opportunity to confound the anatomy of man and guitar in the kind of punning between the animate and the inanimate which was seen in earlier Cubist works and which now becomes more explicit. Again, both these canvases, for all the remoteness from the everyday world implied by their fantastic geometries, depend upon what is essentially a commonplace situation. Braque's point of departure is a Portuguese musician in a Marseilles bar; Picasso's is a woman—not improbably his new love, Eva (Marcelle Humbert)—who plays a stringed instrument (perhaps a guitar). But, within these almost trivial scenes, there appear strangely disconcerting elements—letters, numbers, and symbols. In the Braque, the D BAL, D CO, &, and 10,40 can be explained in literal terms as fragments from posters that one

58. Georges Braque, *The Portuguese*, Spring 1911, Oil, 45⅞" x 32⅛" (Kunst-museum, Basel)

would expect to find on the wall of a bar (the D BAL, for example, is undoubtedly the latter half of GRAND BAL); and in the Picasso, the MA JOLIE, the $\flat$, and the four-lined music staff are explicit descriptions of the music being played and sung, a piece whose apparent title, "Ma Jolie," refers, with Cubist *double-entendre*, both to the refrain of a popular tune of the time ("O Manon, ma jolie, mon coeur te dit bonjour") and to Picasso's affectionate name for Eva. Yet, in the context of the unliteral vocabulary of Cubism, these letters, numbers, and symbols offer another major innovation in the history of Western painting.

Confronted with these various alphabetical, numerical, and musical symbols, one realizes that the arcs and planes that surround them are also to be read as symbols, and that they are no more to be considered the visual counterpart of reality than a word is to be considered identical with the thing to which it refers. The parallelism of these traditional symbols and Braque's and Picasso's newly invented geometric symbols is insisted upon through the way in which both are subjected to the same fragmentation. In a world of shifting and partial appearances, these old-fashioned signs, too, are first dismembered and then reintegrated with the dense visual and intellectual fabric of the painting. Thus, the title "Ma Jolie" slips into two different levels and the D BAL hovers in space and fades at the edges. Or, similarly, in the Picasso the four-lined music staff becomes an analogue of the four fingerlike parallels (perhaps the fluting of a glass) in the lower right and the strings of the musical instrument (slightly below center). By this fusion of the traditional symbols for words, numbers, and music with the newly created geometric symbols of Cubism, Braque and Picasso offer a decisive rejection of one of the fundamentals of Western painting since the Renaissance, namely, that a picture presents an illusion of perceived reality. In its place, we have almost a reversion to a medieval viewpoint in which a pictorial image is a symbol and its relation to reality is conceptual. It is tempting to say that the medieval manuscript page suggests the closest parallel to the Cubist mixture of conventional symbols and extremely stylized images of reality. Nevertheless, it would be a gross simplification to consider Cubism a simple reassertion of the symbolic viewpoint that had prevailed in the art of the Middle Ages or of early periods of antiquity. Cubism obviously expresses a much more complex and ambiguous relation to reality than does any art of the past.

Though we may stress the symbolic nature of the Cubist vocabulary, it is also true that, by contrast with the abstract quality of letters and numbers, Braque's and Picasso's geometric description of perceived reality still has the immediacy of pictorial illusion, containing, as it does, fragments of light and texture, of strings, clothing, wood. Once more, then, as with the *trompe-l'oeil* nail, the implication is that a painting is neither a replica nor a symbol of reality, but that it has a life of its own in a precarious, fluctuating balance between the two extremes of illusion and symbol. In a sense, what Picasso and Braque discovered was the independent reality of the pictorial means by which nature is transformed into art upon the flat surface of a canvas.

With this growing awareness of a painting as a physical fact in itself, it was inevitable that Cubism would evolve an increasingly acute consciousness of the two-dimensional reality of the picture surface that Renaissance perspective had succeeded in disguising. In the *Portuguese* and *Ma Jolie*, space has been so contracted that a new kind of pictorial syntax is created. The overlapping planes and their complicated light and shadow imply relationships in an illusory depth, yet each plane is committed to a contact with the picture surface. The printed symbols appear to shift and fade in space, yet, at the same time, they rest as flatly upon the opaque plane of the canvas as printed letters on a page. Once again, the constant rearrangement and shuffling of spatial layers in these pictures call explicit attention to the paradoxical process of picture making. The traditional illusionistic devices of textural variation and chiaroscuro are simultaneously contracted by the subordination of each pictorial element to the sovereignty of the flat picture surface.

It is precisely such willfully ambiguous descriptions of phenomena that make the *Portuguese* and *Ma Jolie* the masterpieces that they are. Their language, like the language of modern poetry, is multi-leveled, and conforms to the twentieth century's refusal to accept a single, absolute interpretation of reality. The contradictions in these works are endless. A prosaic subject is transformed into a fantastic structure of the highest conceptual complexity; a taut, architectonic design dissolves into the shimmering vibrations of delicately stippled textures and flickering light; a rigorously restricted and impersonal vocabulary of simple geometric shapes is executed with a keen sense of the artist's individual and irregular

brushwork; a monkishly somber palette of ochers, grays, and browns is treated with a sumptuous subtlety that rivals the dark chromatic modulations of the late Titian or Rembrandt; a fabric of bewildering translucence and density asserts the opacity of the canvas underneath; an unfamiliar world of hieroglyphs is punctuated by vivid fragments of reality. Yet, if these paintings illumine those complex paradoxes that pertain so specifically to our century's destruction of absolutes, it should not be forgotten that they also stand securely in the great tradition of Western painting that stems from the Renaissance. Like the masterpieces of the past—whether by Masaccio, Rubens, or Cézanne—these canvases present a tense and vital equilibrium between the reality of nature and the reality of art.

If Cubism wished to make explicit the means by which nature becomes art, then the growing complication of Cubist syntax in 1911 must have threatened the balance between dependence upon nature and autonomy of art. For example, in Braque's circular *Soda* of 1911 the teeming fragments of still-life objects (which appear to include a wineglass, a pipe, a sheet of music, and the label SODA) have become so intricate that not only the composition itself but its references to the external world are dangerously obscured. Although Picasso never reached so complex a degree of analysis as this, both he and Braque apparently began to feel a strong urge toward clarifying their ever more diffuse and labyrinthine pictorial structure and their increasingly illegible constructs of reality. With the same intellectual exhilaration that characterized the successive revolutions of 1907–1911, first Picasso and then Braque resolved the crisis of 1911 by revitalizing their contact with the external world in a way that was as unexpected as it was disarmingly logical.

This revolution in picture making was inaugurated by Picasso's *Still Life with Chair Caning* (Fig. 59), which has traditionally been dated winter 1911–1912, but is now dated, according to a recent conversation between Douglas Cooper and Picasso, May 1912. Here, within this small and unpretentious assemblage of the letters JOU (from *Le Journal*), a pipe, glass, knife, lemon, and scallop shell, another fundamental tradition of Western painting has been destroyed. Instead of using paint alone to achieve the appearance of reality, Picasso has pasted a strip of oilcloth on the canvas. This pasting or, to use the now familiar French term, *collage*, is perhaps even more probing in its commentary

414

59. Pablo Picasso, *Still Life with Chair Caning*, 1912, Oil, pasted oilcloth simulating chair caning on canvas, 10⅝" x 13¾" (oval) (Picasso Collection © by S.P.A.D.E.M., Paris, 1976)

on the relation between art and reality than any of such earlier Cubist devices as *trompe-l'oeil* or printed symbols, since the result now involves an even more complex paradox between "true" and "false." The oilcloth is demonstrably more "real" than the illusory Cubist still-life objects, for it is not a fiction created by the artist but an actual machine-made fragment from the external world. Yet, in its own terms, it is as false as the painted objects around it, for it purports to be chair caning but is only oilcloth. To enrich this irony, the most unreal Cubist objects seem to have a quality of true depth, especially the *trompe-l'oeil* pipe stem, which is rendered even more vivid by juxtaposition with the flatness of the *trompe-l'oeil* chair caning below. And, as a final assault on our suddenly outmoded conceptions about fact

and illusion in art and reality, Picasso has added a rope to the oval periphery of the canvas, a feature that first functions as a conventional frame to enclose a pictorial illusion and then contradicts this function by creating the illusion of decorative woodcarving on the edge of a flat surface from which these still-life objects project.

Perhaps the greatest heresy introduced in this collage concerns Western painting's convention that the artist achieve his illusion of reality with paint or pencil alone. Now Picasso extends his creative domain to materials that had previously been excluded from the world of canvas or paper and obliges these real fragments from a nonartistic world to play surprisingly unreal roles in a new artistic world. Moreover, this destruction of the traditional mimetic relationship between art and reality becomes even more emphatic by the very choice of a material that in itself offers a deception. For here Picasso mocks the illusions painstakingly created by the artist's hand by rivaling them with the perhaps more skillful illusions impersonally stamped out by a machine. If the reality of art is a relative matter, so, too, is the reality of this seemingly real chair caning, which is actually oilcloth.

The close interchange of ideas between Picasso and Braque and the still very disreputable dates traditionally assigned to many works of this period make it difficult to establish any secure chronological priority in the various innovations of collage. Generally, however, it is claimed that in his drawn and pasted *Fruit Dish* of September 1912, Braque was the first to initiate *papier collé* (pasted paper), a term that refers specifically to the use of paper fragments as opposed to the more inclusive term *collage*. In any case, Braque's *Fruit Dish* continues that complex juggling of fact and illusion which makes Picasso's earlier *Still Life with Chair Caning* so compelling to the eye and the intellect. Again, as in Picasso's collage, the true elements pasted into the picture are even falser than the drawn fiction of the Cubist still life, for they are strips of wallpaper simulating the grain of oak. Once more, these fragments of reality are made to perform roles even more unreal than those implied by their simple function as decorative facsimiles of wood. . . .

If collage, with its material references to nonartistic realities, acted as an antidote to the growing illegibility of so many Cubist works of 1911, it nevertheless enriched considerably the paradoxes involved in the Cubist dialectic between art and reality. It

effected, moreover, a profound reorganization of the very structure of Cubist painting. In the first place, the size of these clippings is now larger than those increasingly small and diffuse pictorial units of 1911, and therefore begins to establish a simpler and more readily grasped pattern of fewer and bolder shapes. Thus, in opposition to the painted works preceding them, these early collages are compositionally lucid and extremely restricted in the number of their pictorial elements. But, more important still, the technique of pasting so strongly emphasizes the two-dimensional reality of the picture surface that even the few vestiges of traditional illusionism clinging to earlier Cubist painting—the vibrant modeling in light and dark, the fragmentary diagonals that create a deceptive space—could not survive for long. Rapidly, the luminous shimmer and the oblique disposition of planes in earlier Cubism were to be replaced by a new syntax in which largely unshaded planes were to be placed parallel to the picture surface. In the case of actual collage, the placement was quite literally on top of the opaque picture surface, thereby controverting another fundamental principle of Western painting since the *quattrocento,* if not earlier—namely, that the picture plane was an imaginary transparency through which an illusion was seen. . . .

Besides contributing such stylistic clarifications, collage stimulated an even greater consciousness of the independent reality of pictorial means than had been achieved in earlier Cubism. In these drawn and pasted pictures there is a new and radical dissociation of the outlines defining an object and the textured or colored area (represented by the pasted papers) traditionally filling these shapes. Now, the contours of objects seem to function in counterpoint, as it were, to their textured or colored substance, so that the previously inseparable elements of line, texture, and color suddenly have independent existences. This phenomenon, although adumbrated in paintings of 1910–1911, had never reached the autonomy of separate pictorial means so explicitly defined in collage. . . .

The crucial transformations of Cubist style that occurred in 1912 make it necessary to draw a distinction between works that precede and works that follow this year. The most familiar terms for the earlier and the later phases—*Analytic Cubism* and *Synthetic Cubism*—are so commonly accepted today that, even if one were to cavil at their precision, they are no more likely to

be abandoned or replaced than the far more imprecise name of Cubism itself.

The term *Analytic Cubism* is perhaps the more accurately descriptive of the two. It refers explicitly to the quality of analysis that dominates the searching dissections of light, line, and plane in the works of 1909–1912 (Figs. 55, 58). Indeed, no matter how remote from appearances these works may become, they nevertheless depend quite clearly on a scrutiny of the external world that, at times, is almost as intense as that of the Impressionists. By contrast, the works that follow have a considerably less objective character, and suggest far more arbitrary and imaginative symbols of the external world. In this they parallel the change from the Impressionists' fidelity to objective visual fact in the 1870's to the Post-Impressionists' more subjective and symbolic constructs of reality in the late 1880's. Ostensibly, Synthetic Cubism is no longer so concerned with exploring the anatomy of nature, but turns rather to the creation of a new anatomy that is far less dependent upon the data of perception. Instead of reducing real objects to their abstract components, the works following 1912 appear to invent objects from such very real components as pasted paper, flat patches of color, and clearly outlined planar fragments. The process now seems to be one of construction rather than analysis; hence the term *synthetic*.

Although this convenient classification of the creative processes before and after 1912 may be applicable to many works, it can also be somewhat misleading in its implication that after 1912 there is an about-face in the Cubists' relation to nature. It is certainly true that many Synthetic Cubist drawings and paintings after 1912 offer a capricious rearrangement of reality that would be impossible in the Analytic phase. However, it must be stressed that this presumed independence of nature is more often of degree than of kind. . . . The post-1912 works of Picasso, Braque, and other Cubists often depend on as close a scrutiny of the data of perception as did the pre-1912 works, however different the results may seem. Without this contact with the external world, Cubism's fundamental assertion that a work of art is related to but different from nature could not be made; for there would be no means of measuring the distance traversed between the stimulus in reality and its pictorial re-creation.

It is probably more meaningful, then, to think of Synthetic Cubism, not primarily in terms of a dubious reversal of the

Cubists' relation to nature, but, rather, in terms of a demonstrable reorganization of Cubist pictorial structure. Now illusionistic depth is obliterated by placing the newly enlarged and clarified pictorial elements—line, plane, color, texture—parallel to and, by implication, imposed upon the two-dimensional truth of the canvas or paper. Beginning in 1912, the work of Picasso and Braque—and ultimately, most major painting of our century— is based on the radically new principle that the pictorial illusion takes place upon the physical reality of an opaque surface rather than behind the illusion of a transparent plane. . . .

# *21.* THE AESTHETIC THEORIES OF KANDINSKY AND THEIR RELATIONSHIP TO THE ORIGIN OF NON-OBJECTIVE PAINTING

*Peter Selz*

INTRODUCTION

The first decade of the twentieth century saw European art moving along a number of fronts in the general direction of an art without representational imagery—toward an art purely of colors, lines, and shapes that bore no direct relationship to the appearance of the outside world. If convenience impels us to fix on these years for the genesis of the non-objective art that finally emerged between 1910 and 1914, historical sense urges us to recognize that the process had been gathering force in art and thought for many decades and that the representational habit, with the authority of centuries of tradition behind it, was not easily sloughed. From the superior comfort of our retrospective vision we have probably determined most of the elements that went into this process. We recognize the contributions of the Jugendstil aesthetics of the 1890s, the impact of the Symbolists and Post-Impressionists, of Les Fauves, and Orphism. The "chemistry" of the process may still be imperfectly understood, but it is reasonably certain that Wassily Kandinsky was its final catalyst.

To cite but one symptom of the conditions within which the process was maturing, it is rewarding to read in conjunction with Kandinsky's *Concerning the Spiritual in Art*, that remarkable little book, George Santayana's *The Sense of Beauty* (1896), and particularly Santayana's remarks on the sensuous level of perception. He saw pure sensations of color as being antecedent to the constructive effects of form, and these sensations of color at a fundamental level as having affinities with the qualities of other sensations, especially sound. A general development of the capacity to grasp the connections and to sense these qualities— "sensibility" was Santayana's word for this capacity—"would make possible a new abstract art, an art that should deal with colors as music does with sound." By the end of the century a spokesman for the Jugendstil would speak of "the music of color" and Kandinsky himself, in his *Concerning the Spiritual in Art*, wrote of color as the keyboard on which the artist plays "to cause vibrations of the soul."

For bibliographical details of Kandinsky's *Concerning the Spiritual in Art*, see note 5 in this selection by Peter Selz. Kandinsky's short autobiography, *Rückblicke*, can be found in English translation by Hilla Rebay; also "Retrospects" in *Kandinsky*, ed. by Hilla Rebay (1945), and trans. by Mrs. R. L. Herbert, as "Reminiscences" in *Modern Artists on Art*, ed. by Robert L. Herbert (1964). Kandinsky's treatise of 1926, *Punkt und Linie zur Fläche*, was translated as *Point and Line to Plane* by H. Dearstyne and Hilla Rebay (1947). Other selected works of relevance are: James Johnson Sweeney, *Plastic Redirections in 20th Century Painting* (1934); Piet Mondrian, *Plastic Art and Pure Plastic Art, 1937, and Other Essays, 1941–1943* (1945); L. Moholy-Nagy, *The New Vision*, 4th rev. ed. (1949); Georges Duthuit, *The Fauvist Painters* (1950); Peter Selz, *German Expressionist Painting* (1957); and Werner Haftmann, *Painting in the Twentieth Century*, 2 vols., rev. ed. (1965). Additional works are Will Grohmann, *Wassily Kandinsky: Life and Work* (1958); S. Ringbom, *The Sounding Cosmos. A Study in the Spiritualism of Kandinsky and the Genesis of Abstract Painting* (1970); Peg Weiss, *Kandinsky in Munich: The Formative Jugendstil Years* (1979); and Beeke Tower, *Klee and Kandinsky in Munich and at the Bauhaus* (1981).

The selection that follows is from "The Aesthetic Theories of Wassily Kandinsky and Their Relationship to the Origin of Non-Objective Painting," by Peter Selz, *The Art Bulletin*, XXXIX (1957). Reprinted by permission of the publisher and the author.

At a time when so much painting is in the non-objective vein, it seems relevant to investigate the aesthetic theories of the artist who was the first champion of non-objective art, or "concrete art,"[1] as he preferred to call it.

It is possible that non-objective paintings may have been painted prior to Kandinsky's first non-objective watercolor of 1910* and his more ambitious *Impressions, Improvisations* (Fig. 60), and *Compositions* of 1911. There are abstractions by Arthur Dove, for example, which are dated 1910. Picabia and Kupka began working in a non-objective idiom not much later,[2] and Delaunay painted his non-objective *Color Disks* in 1912.[3] In Germany Adolf Hoelzel ventured into non-objective paintings as early as 1910, but whereas for Hoelzel it was merely experiment in additional possibilities, Kandinsky made non-objectivity the very foundation of his pictorial imagery.[4]

Kandinsky formulated his ideas of non-objective painting over an extended period of time. Notes for his essay, *Concerning the Spriutal in Art*,[5] date back to 1901 while the book was completed in 1910. His thoughts were continued in his essay "Über die Formfrage" for the famous almanac *Der blaue Reiter*.[6] Both essays were first published in 1912.[7] These essays are to a considerable extent based on previous aesthetic theory and were very much in keeping with the avant-garde thinking of the prewar years. They also constitute almost a programmatic manifesto for the expressionist generation.[8]

Kandinsky's particular didactic style makes his writings difficult to read and analyze. Kenneth Lindsay in his study of Kandinsky's theories described Kandinsky's peculiar literary style as follows: "Characteristic of Kandinsky's writing is the technique of breaking up the given topic into opposites or alternatives. These opposites or alternatives usually follow directly after the posing of the problem and are numbered. Often they suggest further sets of opposites and alternatives. The sequence of thought is

* [Later research has indicated that this work must be dated later than 1910, probably 1912 or 1913. Letter from Peter Selz to editor, November 14, 1967.]

60. Vasily Kandinsky, *Improvisation 28*, 1912, Oil on canvas, 44″ x 63¾″ (The Solomon R. Guggenheim Museum, New York; Photo: Robert E. Mates)

flexible, sometimes abrupt and cross-tracking, and frequently associative. The dominating relativity of the thought process contrasts strongly with the conclusions, which are often positively stated."[9]

## THE REJECTION OF MATERIAL REALITY

Kandinsky was always strongly predisposed toward sense impressions. In his autobiography he indicates that he experienced objects, events, even music primarily in terms of color, and he did not conceive of color in its physical and material aspects but rather in its emotional effect. During his scientific studies he lost faith in the rational scientific method and felt that reality could be fully comprehended only by means of creative intuition.

Kandinsky was not alone in his rejection of positivism and pragmatism at the turn of the century. Generally it might be said that "the twentieth century has in its first third taken up a position of reaction against classic rationalism and intellectualism."[10]

Even in the pure sciences the value of the intuitive as against the purely experimental was stressed during the early part of the twentieth century, so that by 1925 Werner Heisenberg was able to formulate the "Principle of Uncertainty," stating that there is a limit to the precision with which we can observe nature scientifically. This did not mean a return to metaphysics, but it indicated the inherent limitations of quantitative observation.

Kandinsky's doubt of the ultimate possibilities of quantitative analysis was shared by many philosophers also. His philosophy finds perhaps its closest parallel in the thinking of Henri Bergson, who taught that true reality can be grasped only through artistic intuition, which he contrasted to intellectual conception. The intellect, according to Bergson, is man's tool for rational action, but "art, whether it be painting or sculpture, poetry or music, has no other object than to brush aside the utilitarian symbols, the conventional and socially accepted generalities, in short, everything that veils reality from us, in order to bring us face to face with reality itself."[11]

Similarly Kandinsky turns away from the representation of visible objects in his attempt to penetrate beneath the epidermis of appearances to the ultimate or "inner" reality.[12] As early as his first encounter in Moscow with the paintings by Monet, Kandinsky felt that the material object was not a necessary element in his painting: "I had the impression that here painting itself comes into the foreground; I wondered if it would not be possible to go further in this direction. From then on I looked at the art of icons with different eyes; it meant that I had 'got eyes' for the abstract in art."[13] Later he wrote: "The impossibility and, in art, the purposelessness of copying an object, the desire to make the object express itself, are the beginnings of leading the artist away from 'literary' color to artistic, i.e., pictorial aims."[14]

Agreeing with earlier writers such as the symbolists, Van de Velde, and Endell, Kandinsky felt that art must express the spirit but that in order to accomplish this task it must be dematerialized. Of necessity, this meant creating a new art form.

It was not only for philosophic reasons that Kandinsky wished to forsake objective reality. Psychological reasons, it seems, also played their part. Speaking about his period of study at the Munich Art Academy, he wrote: "The naked body, its lines and movement, sometimes interested me, but often merely repelled

me. Some poses in particular were repugnant to me, and I had to force myself to copy them. I could breathe freely only when I was out of the studio door and in the street once again."[15]

It is significant that the human body, which is found as an almost universal motif in the art forms of most cultures, is here eschewed as subject matter.[16] It is true that the art of the west emphasized the nonhuman aspects during the nineteenth century, when painters turned their attention to still life and landscape. The conscious rejection of the human form, however, is certainly psychologically significant. Indeed a psychological interpretation of the reasons for this response might give us a more profound understanding of the non-objective artist and his work.

From the point of view of the history of aesthetics it is also interesting that Kandinsky's rejection of the forms of nature occurred at approximately the same time as Worringer's publication, *Abstraction and Empathy*. Here Worringer submits the theory that the cause for abstraction is man's wish to withdraw from the world or his antagonism toward it. The lifeless form of a pyramid or the suppression of space in Byzantine mosaics clearly shows that what motivated the creation of these works of art was a need for refuge from the vast confusion of the object world—the desire for "a resting-place in the flight of phenomena."[17] Worringer's thesis of abstraction as one of the bases of artistic creation preceded Kandinsky's first non-objective painting by about two years, and it is important to keep in mind that the two men knew each other in Munich during this critical period.

Kandinsky himself maintained that the immediate cause of his first essay at non-objective painting was the shock of suddenly entering his studio to see one of his paintings lying on its side on the easel and being struck with its unusual beauty. This incident, he believed, made it clear to him that the representation of nature was superfluous in his art.[18] The emphasis on the element of distance in the aesthetic experience found a parallel in the theories of the contemporary English psychologist, Edward Bullough: "The sudden view of things from their reverse, usually unnoticed, side, comes upon us as a revelation, and such revelations are precisely those of art."[19]

Kandinsky felt, however, that he could not immediately turn to "absolute painting." In a letter to Hilla Rebay,[20] he pointed out that at that time he was still alone in the realization that painting ultimately must discard the object. A long struggle for increasing

426

abstraction from nature was still necessary. In 1910 he was still writing: "Purely abstract forms are in the reach of few artists at present; they are too indefinite for the artist. It seems to him that to limit himself to the indefinite would be to lose possibilities, to exclude the human and therefore to weaken expression."[21]

But he was already pointing out at that time that the abstract idea was constantly gaining ground, that the choice of subjects must originate from the inner necessity of the artist; material, or objective, form may be more or less superfluous. He insists that the artist must be given complete freedom to express himself in any way that is necessary according to the "principle of inner necessity." He looked hopefully to the future where the eventual predominance of the abstract would be inevitable in the "epoch of great spirituality."[22]

In 1910 Kandinsky painted his first abstract painting, a watercolor. [See editor's note at beginning of article.] The first large non-objective oil dates from 1911, and throughout 1912 he did both "objective" and "concrete" paintings. After 1912 there were very few "objective" works. His art had become completely free from nature and like music its meaning was now meant to be inherent in the work itself and independent of external objects.

Kandinsky distinguished what he called "objective" art from "concrete" art by distinguishing between the means chosen by the artists. In "objective" art both artistic and natural elements are used, resulting in "mixed art," while in "concrete" art exclusively artistic means are used, resulting in "pure art."[23] In a short article, published in 1935, he gave a lucid example of this distinction: "There is an essential difference between a line and a fish. And that is that the fish can swim, can eat and be eaten. It has the capacities of which the line is deprived. These capacities of the fish are necessary extras for the fish itself and for the kitchen, but not for the painting. And so, not being necessary they are superfluous. That is why I like the line better than the fish—at least in my painting."[24]

The element of representation is thus rejected by Kandinsky for his art. He insists that a picture's quality lies in what is usually called form: its lines, shapes, colors, planes, etc., without reference to anything outside of the canvas. But here occurs an apparent contradiction in Kandinsky's theory, because he—like expressionists in general—did not believe that a picture must be evaluated from its formal aspects. Kandinsky and the expression-

ists did not agree with "formalists" like Roger Fry, who believe that the aesthetic emotion is essentially an emotion about form. Seeing Kandinsky's first abstractions, Fry concerned himself only with their form: ". . . one finds that . . . the improvisations become more definite, more logical and more closely knit in structure, more surprisingly beautiful in their color oppositions, more exact in their equilibrium."[25]

Kandinsky himself takes strong issue with this theory. In his aesthetics the formal aspect of a work of art is as unimportant as its representational quality.

## THE INSIGNIFICANCE OF FORM

Form, to Kandinsky, is nothing but the outward expression of the artist's inner needs. Form is matter, and the artist is involved in a constant struggle against materialism. Kandinsky's words are reminiscent of medieval thought when he says: "It is the spirit that rules over matter, and not the other way around."[26]

The artist should not seek salvation in form, Kandinsky warns in his essay, "Über die Formfrage," because form is only an expression of content and is entirely dependent on the innermost spirit. It is this spirit which chooses form from the storehouse of matter, and it always chooses the form most expressive of itself. Content always creates its own appropriate form. And form may be chosen from anywhere between the two extreme poles: the great abstraction and the great realism. Kandinsky then proceeds to prove that these opposites, the abstract and the realistic, are actually identical, and that form is therefore an insignificant concern to the artist. This he does as follows:

In the "great realism" (as exemplified in the art of Henri Rousseau) the external-artificial element of painting is discarded, and the content, the inner feeling of the object, is brought forth primitively and "purely" through the representation of the simple, rough object. Artistic purpose is expressed directly since the painting is not burdened with formal problems. The content is now strongest because it is divested of external and academic concepts of beauty. Kandinsky preferred this "great realism," also found in children's drawings, to the use of distortion, which he felt always aroused literary associations.

Since the "great abstraction" excludes "real" objects, the con-

tent is embodied in non-objective form. Thus the "inner sound" of the picture is most clearly manifest. The scaffolding of the object has been removed, as in realism the scaffolding of beauty has been discarded. In both cases we arrive at the spiritual content itself. "The greatest external differentiation becomes the greatest internal identity:

$$\text{Realism} = \text{Abstraction}$$
$$\text{Abstraction} = \text{Realism"}[27]$$

The hypothesis that the minimum of abstraction can have the most abstract effect, and vice versa, is based by Kandinsky on the postulation that a quantitative decrease can be equal to a qualitative increase: 2 plus 1 can be less than 2 minus 1 in aesthetics. A dot of color, for example, may lose in its *effect* of intensity if its *actual* intensity is increased.[28] The pragmatic function of a form and its sentient meaning are dissimilar, yet abstraction and realism are identical.

Kandinsky cites several examples to prove this thesis. A hyphen, for instance, is of practical value and significance in its context. If this hyphen is taken out of its practical-purposeful context and put on canvas, and if it is not used there to fulfill any practical purpose at all—such as the delineation of an object—it then becomes nothing but a line; it is completely liberated from signification and abstracted from all its meaning as a syntactical sign; it is the abstract line itself. At the same time, however, it has also become most real, because now it is no longer a sign but the real line, the object itself.

It may be argued that Kandinsky uses a very narrow definition of both the abstract and the realistic, and that the line may be a great deal more realistic and more meaningful as a sign, such as a hyphen, in its context, than it is as a line only. It is a valid objection to say that this identity of the abstract and the real holds true only in this verbal analogy, and that Kandinsky has not presented logical proof. Kandinsky, however, was not concerned with the correctness of intellectual thought, or with the proof of his spiritual values. He admits: "I have always turned to reason and intellect least of all."[29]

He concludes his analysis of form by saying: "In principle there is no problem of form."[30] The artist who expresses his "soul vibrations" can use any form he wants. Formal rules in aesthetics are

not only impossible but a great stumbling block to the free expression of spiritual value. It is the duty of the artist to fight against them to clear the way for free expression. Often in the history of art, artists were bogged down by matter and could not see beyond the formal. The nineteenth century was such a period, in which men failed to see the spirit in art as they failed to see it in religion. But to seek art and yet be satisfied with form is equivalent to the contentment with the idol in the quest for God. Form is dead unless it is expressive of content. There cannot be a symbol without expressive value.

In his introduction to the second edition of *Der blaue Reiter* Kandinsky states the aim of the book as "to show by means of examples, practical arrangement and theoretical proof, that the problem of form is secondary in art, that art is above all a matter of content."[31]

Kandinsky understood his own time as being the beginning of a new spiritual age when the abstract spirit was taking possession of the human spirit.[32] Now artists would increasingly recognize the insignificance of form per se, and realize its relativity, its true meaning as nothing but "the outward expression of inner meaning."

## ART THE AFFIRMATION OF THE SPIRIT

We have seen that in Kandinsky's aesthetics form as well as object, the formal and representational aspects of art, have no importance by themselves and are meaningful only insofar as they express the artist's innermost feelings. Only through the expression of the artist's inner emotion can he transmit understanding of true spiritual reality itself. The only "infallible guide" which can carry the artist to "great heights" is the *principle of internal necessity* (italics his).[33] This concept of internal necessity is the core and the basis of Kandinsky's aesthetic theory and becomes a highly significant element in expressionist criticism in general.

The period of spiritual revolution which Kandinsky believed to be approaching, he called the "spiritual turning point." He perceived indications of this period of transition in many cultural manifestations. In the field of religion, for instance, Theosophy was attempting to counteract the materialist evil. In the Theosophical Society, "one of the most important spiritual move-

ments,"[34] man seeks to approach the problem of the spirit by the way of inner enlightenment. In the realm of literature he cites Maeterlinck as, ". . . perhaps one of the first prophets, one of the first reporters and clairvoyants of the *decadence*. . . . Maeterlinck creates his atmosphere principally by artistic means. His material machinery . . . really plays a symbolic role and helps to give the inner note. . . . The apt use of a word (in its poetical sense), its repetition, twice, three times, or even more frequently, according to the need of the poem, will not only tend to intensify the internal structure but also bring out unsuspected spiritual properties in the word itself."[35]

By using pure sound for the most immediate effect upon the reader or listener, the writer depends on prelanguage signs, i.e., sounds which—like music—do not depend on language for their meaning. This level of signification is also the basis of Kandinsky's non-objective painting. In music Kandinsky points to Schönberg's panchromatic scheme, which advocates the full renunciation of functional harmonious progression and traditional form and accepts only those means which lead the composer to the most uncompromising self-expression: "His music leads us to where musical experience is a matter not of the ear, but of the soul—and from this point begins the music of the future."[36] Kandinsky conceived of music as an emancipated art, which furthermore had the quality of time-extension and was most effective in inspiring spiritual emotion in the listener. Painting, while still largely dependent on natural form was showing similar signs of emancipation. Picasso's breakdown of volumes and Matisse's free use of color for its own sake were manifestations of the turning point toward a spiritual art.[37]

How would the artist achieve full spiritual harmony in his composition? Kandinsky pointed out that the painter had two basic means at his disposal—form and color—and that there was always an unavoidable mutual relationship between them.

In his prewar writings he still did not come forth with a thorough analysis of forms as he did later with his systematic *Point and Line to Plane*, yet he was already stating: "Form alone, even though abstract and geometrical, has its internal resonance, a spiritual entity whose properties are identical with the form. A triangle . . . is such an entity, with its particular spiritual perfume."[38]

But color is the most powerful medium in the hand of the

painter. It has a psychic as well as a physical effect upon the observer. It can influence his tactile, olfactory, and especially aural senses, as well as his visual sense, and in chromotherapy it has been shown that "red light stimulates and excites the heart, while blue light can cause temporary paralysis."[39] Color is the artist's means by which he can influence the human soul. Its meaning is expressed metaphorically by Kandinsky: "Color is the keyboard, the eyes are the hammers, the soul is the piano with many strings. The artist is the hand that plays, touching one key or another purposively, to cause vibrations of the soul."[40]

Kandinsky then proceeds to develop an elaborate explanation of the psychic effect of color. This contrasts to the more scientific color theories of Helmholtz, Rood, Chevreul and Signac and closely approaches the psychological color theory of Goethe and metaphysics of color of Philipp Otto Runge. Like his romanticist predecessor, Kandinsky believed that color could directly influence the human soul.[41]

Blue in Kandinsky's system is the heavenly color; it retreats from the spectator, moving toward its own center. It beckons to the infinite, arousing a longing for purity and the supersensuous. Light blue is like the sound of the flute, while dark blue has the sound of the cello.

Yellow is the color of the earth. It has no profound meaning; it seems to spread out from its own center and advance to the spectator from the canvas. It has the shrill sound of a canary or of a brass horn, and is often associated with the sour taste of lemon.

Green is the mixture of blue and yellow. There the concentricity of blue nullifies the eccentricity of yellow. It is passive and static, and can be compared to the so-called "bourgeoisie," self-satisfied, fat and healthy. In music it is best represented by the placid, long-drawn middle tones of the violin.

White, which was not considered a color by the Impressionists, has the spiritual meaning of a color. It is the symbol of a world void of all material quality and substance. It is the color of beginning. It is the "sound" of the earth during the white period of the Ice Age.

Black is like eternal silence. It is without hope. It signifies termination and is therefore the color of mourning.

By the symbolic use of colors combined "according to their spiritual significance," the artist can finally achieve a great composition: "Color itself offers contrapuntal possibilities and, when

combined with design, may lead to the great pictorial counter-
point, where also painting achieves composition, and where pure
art is in the service of the divine."[42]

Kandinsky's color symbolism is in no way based upon physical
laws of color or the psychology of color vision. He himself pointed
out when writing about color that "all these statements are the
results of empirical feeling, and are not based on exact science."[43]
This may even explain his own inconsistencies such as his state-
ment in *Concerning the Spiritual in Art* that "red light stimulates
and excites the heart"[44] contradicted by his assertion that "red . . .
has brought about a state of partial paralysis."[45]

It is also true that specific colors call forth different associations
in people as well as cultures. Specific reactions to specific colors
have never been proved experimentally. Max Raphael in his book,
*Von Monet bis Picasso,* points out that colors have had altogether
different meanings for those individuals most occupied with them.
Yellow, for example, signified the earth for Leonardo, had gay,
happy characteristics for Goethe, meant friendliness to Kant and
heavenly splendor to Van Gogh, suggested the night to Gauguin
and aggressiveness to Kandinsky.[46] We might add that it symbol-
izes jealousy in German usage, an emotion which is associated
with green in English idiom.

Such examples could be increased *ad infinitum* and it is very
doubtful that Kandinsky attempted to set down scientific rules for
color associations. He was articulating his own personal associa-
tions; he stated: "It is clear that all I have said of these simple
colors is very provisional and general, and so are the feelings
(joy, grief, etc.) which have been quoted as parallels to the colors.
For these feelings are only material expressions of the soul. Shades
of color, like those of sound, are of a much finer texture and
awaken in the soul emotions too fine to be expressed in prose."[47]

In his second significant book, *Point and Line to Plane*, sub-
titled "A Contribution to the Analysis of the Pictorial Elements,"
Kandinsky presented his grammar of line, forms, and space in a
manner similar to his color theory in *Concerning the Spiritual in
Art.*

It is the task of the painter, according to Kandinsky, to achieve
the maximum effect by bringing his media, color and form, into
orderly and expressive composition. Each art has its own lan-
guage, and each artist, be he painter, sculptor, architect, writer
or composer, must work in his specific medium and bring it to the

expression of greatest inner significance. But once painting, for example, is divested of the scaffolding of natural form and becomes completely abstract, the pure law of pictorial construction can be discovered. And then it will be found that pure painting is *internally* closely related to pure music or pure poetry.

## SYNTHESIS OF THE ARTS

Kandinsky points out that human beings, because of individual differences, differ in the type of art expression to which they are most receptive. For some it is musical form, for others painting or literature, which causes the greatest aesthetic enjoyment. He also realized that the artist could achieve aesthetic effects in sensory fields not limited to his own medium. He was much interested, for instance, in Scriabin's experiments with sound-color combinations. The re-enforcement of one art form with another by means of synaesthesia will greatly increase the final aesthetic effect upon the receptor. The greatest effect can be obtained by the synthesis of all the arts in one "monumental art," which is the ultimate end of Kandinsky's aesthetics.

Kandinsky here continues the nineteenth century tradition—from Herder to Wagner—with its desire for a union of all arts. Kandinsky believes that a synthesis of the arts is possible because in the final analysis all artistic means are identical in their inner meaning: ultimately the external differences will become insignificant and the internal identity of all artistic expression will be disclosed. Each art form causes a certain "complex of soul vibrations." The aim of the synthesis of art forms is the refinement of the soul through the sum-total of these complexes.

In his essay "Über Bühnenkomposition"[48] and in his "Schematic Plan of Studies and Work of the Institute of Art Culture,"[49] Kandinsky outlines the possible steps to be taken for the achievement of "monumental art." Present-day drama, opera, ballet are criticized as much as the plastic arts. By discarding external factors in "stage composition,"[50] particularly the factors of plot, external relationship, and external unity, a greater internal unity can be achieved. Kandinsky then experiments with such a composition, "Der gelbe Klang."[51] There he attempts to combine music, the movement of dancers and of objects, the sound of the human

voice (without being tied down to word or language meanings), and the effect of colortone, as experimented with by Scriabin.

Kandinsky admits that his "stage composition" is weak but believes the principle to be valid. It is necessary to remember, he maintains, that we are still at the very beginning of the great abstract period in art. Materialism still has its grasp on modern activity and is not as yet completely vanquished. But the new, "the spiritual in art," already manifests itself in most fields of creativity.

Kandinsky made his first attempt at the realization of a synthesis of the arts when he proposed and founded the Institute of Art Culture in Moscow in 1920, a comprehensive institute for the study and development of the arts and sciences. Kandinsky was active in this organization as vice-president for about a year; then political pressure forced his resignation and he found a similar field of activity in the Bauhaus in Weimar, which he joined in 1922.

CONCLUSION

Expressionism, which began by shifting emphasis from the object to be painted to the artist's own subjective interpretation—reached in Kandinsky the total negation of the object. In this respect he was of great inspiration to succeeding artists. The final phase of Expressionism also became the beginning of an altogether new artistic concept, non-objective painting, and Kandinsky was heralded as its innovator by the following generation, even by painters such as Diego Rivera working in an altogether different style: "I know of nothing more real than the painting of Kandinsky—nor anything more true and nothing more beautiful. A painting by Kandinsky gives no image of earthly life—it is life itself. If one painter deserves the name 'creator,' it is he. He organizes matter as matter was organized, otherwise the Universe would not exist. He opened a window to look inside the All. Someday Kandinsky will be the best known and best loved by men."[52]

In his rejection of the representational aspect of art, Kandinsky cleared the way for new values in art. By experimenting with the possibility of an expressive—rather than a formalistic—art in the

non-objective idiom, he threw out a challenge which performed a most valuable function in the history of modern art. Through his activity as an aesthetician as well as a painter he was able to write a series of books which fully articulate his ideas and have become as influential in the history of modern painting as his paintings themselves.

Kandinsky's aesthetic theory continues, among other things, the precept that the elements of painting—lines and colors and their combinations—evoke emotional associations in the observer. This precept is basic to Expressionism, although not original with the Expressionist movement. Much of it is implied in romanticist aesthetics and clearly stated in the theory of empathy. It is set forth differently in Paul Signac's theory of Neo-Impressionism and occurs again in Bergson's *Essai sur les données immédiates de la conscience*.[53] It is significant for an understanding of symbolism and its corollary *Jugendstil*, and was reiterated by such men as Gauguin, Denis, Sérusier, Walter Crane, and August Endell.

Kandinsky's essays, however, are exceedingly important because they were written by the man who himself was the innovator of non-objective painting. Now in the total absence of representational objects the plastic elements were to become sole carriers of the artist's message. This probably is why he felt called upon to express verbally what he had done in his painting through the intuition of "inner necessity."

In the analysis of his color theory it was pointed out that no direct parallels can be established between the artist's statement and the observer's response. Both projections rest on highly personal and subjective factors. This, however, does not greatly differ from music. It has, for example, been shown that the major and minor modes are by no means endowed with characteristics which would call forth identical reactions in different listeners.[54] A great deal depends on previous experience and training.

As Kandinsky himself has indicated, prose cannot express the shades of emotion awakened by sound and color. Each person may verbalize differently about the experience of a work of art and his verbalization may be at great variance with that of the artist. Yet direct communication can take place on a primary visual (preverbal) level, before either spectator or artist articulates. It is toward this level of communication that the art of Kandinsky and other Expressionists was directed.

436

# The Aesthetic Theories of Kandinsky

NOTES

This article is based on a chapter of the author's book, *German Expressionist Painting*, University of California Press. It was originally a part of a doctoral dissertation, "German Expressionist Painting from Its Inception to the First World War," University of Chicago, 1954. The author wishes to acknowledge his debt particularly to Drs. Ulrich Middeldorf and Joshua Taylor, under whose supervision this dissertation was prepared. The translations are by the author unless otherwise indicated in the footnotes.

[1] Wassily Kandinsky, "Abstrakt oder Konkret," *Tentoonstelling abstrakte Kunst* (Amsterdam: Stedelijk Museum, 1938).

[2] Kupka's *Red and Blue Disks* in the Museum of Modern Art, New York, is dated 1911–1912, but it is just possible that this date was added later.

[3] Germain Bazin in his biographical notes to René Huyge's *Les Contemporains* (Paris: Editions Pierre Tisné, 1949), cites 1914 as the year in which Delaunay did the first non-objective painting in France. This author is able to predate this by two years, since he has seen Delaunay's *Color Disks* (Delaunay Studio, Paris), a completely non-objective painting, dated 1912. It remains possible, however, that Picabia did non-objective paintings in Paris before then. Recently it has been maintained that the self-taught Lithuanian artist, M. K. Čiurlionis, painted non-objective pictures between 1905 and 1910 (Aleksis Rannit, "M. K. Čiurlionis," *Das Kunstwerk*, i, 1946–47, pp. 46–48, and *idem*, "Un pittore astratto prima di Kandinsky," *La Biennale*, viii, 1952, no. 8). Čiurlionis' work is now in the Čiurlionis Gallery in Kaunas. The reproductions included in Mr. Rannit's articles on Čiurlionis, however, are highly symbolic abstractions, verging on the fantastic art of Kubin, Redon, or some Surrealists.

[4] Hans Hildebrandt, *Adolph Hoelzel* (Stuttgart: W. Kohlhammer, 1952), p. 14.

[5] Kandinsky, *Concerning the Spiritual in Art* (New York, Wittenborn, Schultz, 1947). This book was first published by Piper in Munich as *Über das Geistige in der Kunst* in 1912. The first English translation was undertaken by Michael Sadleir under the title *The Art of Spiritual Harmony* (London, 1914). The first American edition, called *On the Spiritual in Art*, appeared in 1946 (New York, Solomon R. Guggenheim Foundation). The 1947 edition, authorized by Mme. Kandinsky and translated by Francis Golffing, Michael Harrison and Ferdinand Ostertag, will be used here because it is much closer to the original text.

[6] Kandinsky and Franz Marc (eds.), *Der blaue Reiter* (Munich: R. Piper and Co., 1912).

[7] In 1926 Kandinsky published his most systematic treatise, *Punkt und Linie zur Fläche* (Bauhaus Book, ix, Munich, Albert Langen Verlag, 1926). This book, translated as *Point and Line to Plane* by Howard Dearstyne and Hilla Rebay (New York, Solomon R. Guggenheim Foundation, 1947), was written at the Bauhaus and elucidates most clearly Kandinsky's thinking during this later period. It falls, however, beyond the realm of discussion in this study.

[8] "If *Der blaue Reiter*, published by R. Piper, is taken together with Kandinsky's *Das Geistige in der Kunst*, as a unity, then this double volume is just as much *the* book of the prewar years as Hildebrandt's *Problem der Form* was *the* book of the turn of the century. The separation of the two generations is already

made clear in the title, which emphasizes form in the one and spirit in the other." Hans Hildebrandt, *Die Kunst des 19. und 20. Jahrhunderts* (Handbuch der Kunstwissenschaft) (Potsdam-Wildpark, 1924), p. 382.

[9] Kenneth Lindsay, "An Examination of the Fundamental Theories of Wassily Kandinsky," unpublished doctoral dissertation, University of Wisconsin, 1951. Dr. Lindsay establishes incisive relationships between Kandinsky's theories and his paintings. While doing research in Kandinsky's studio in Neuilly-sur-Seine during the spring of 1950, I had adequate opportunity to compare my interpretations with those of Lindsay, which has led to a fruitful exchange of ideas. In a good many instances our interpretations differ, especially as to the placing of emphasis.

I am also indebted to Dr. Klaus Brisch for many provocative ideas on Kandinsky. I unfortunately have not been able to see Brisch's doctoral dissertation, "Wassily Kandinsky: Untersuchung zur Entstehung der gegenstandslosen Malerei," University of Bonn, 1955.

[10] Thomas Mann, *The Living Thoughts of Schopenhauer* (New York: Longmans Green and Co., 1929), p. 29.

[11] Henri Bergson, *Laughter* (New York: Macmillan, 1911), p. 157.

[12] Very much the same idea is expressed by Franz Marc: "I am beginning more and more to see behind or, to put it better, through things, to see behind them something which they conceal, for the most part cunningly, with their outward appearance by hoodwinking man with a façade which is quite different from what it actually covers. Of course, from the point of view of physics this is an old story. . . . The scientific interpretation has powerfully transformed the human mind; it has caused the greatest type-change we have so far lived to see. Art is indisputably pursuing the same course, in its own way, certainly; and the problem, our problem, is to discover the way." (Franz Marc, diary entry, Christmas 1914, in Peter Thoene [pseud.], *Modern German Art*, Harmondsworth, Pelican Books, 1938.)

[13] Kandinsky, "Notebooks," quoted in Nina Kandinsky, "Some Notes on the Development of Kandinsky's Painting," in Kandinsky, *Concerning the Spiritual in Art*, p. 10.

[14] Kandinsky, *Concerning the Spiritual in Art*, p. 48.

[15] Kandinsky, "Text Artista," *Wassily Kandinsky Memorial* (New York: Solomon R. Guggenheim Foundation, 1945), p. 65 (hereafter cited as "Text Artista"). This is Kandinsky's autobiography, written in 1913 and first published under the title *Rückblicke* by Der Sturm in Berlin in the same year.

[16] Franz Marc, turning toward non-objective painting shortly before his death, gave a very similar reason: "Very early in life I found man ugly; the animal seemed to me more beautiful and cleaner, but even in it I discovered so much that was repelling and ugly that my art instinctively and by inner force became more schematic and abstract." (Marc, letter, April 12, 1915, in *Briefe, Aufzeichnungen und Aphorismen*, Berlin, 1920, II, p. 50.)

In this respect Kandinsky and Marc differed decidedly from their associate in the Blaue Reiter, Paul Klee, who was always concerned with creating symbols to interpret man and the forces of nature: "The naked body is an altogether suitable object. In art classes I have gradually learned something of it from every angle. But now I will no longer project some plan of it, but will proceed so that all its essentials, even those hidden by optical perspective, will appear upon

438

the paper. And thus a little uncontested personal property has already been discovered, a style has been created." (Paul Klee, June, 1902, "Extracts from the Journal of the Artist," in Margaret Miller [ed.], *Paul Klee* [New York: Museum of Modern Art, 1945], pp. 8–9.)

[17] Wilhelm Worringer, *Abstraktion und Einfühlung* (Munich: R. Piper and Co., 1948), p. 29. First published Munich, 1908. English edition: *Abstraction and Empathy* (London: Routledge and Kegan Paul, 1953).

[18] Kandinsky, "Text Artista," p. 61.

[19] Edward Bullough, "Psychical Distance as a Factor in Art and an Aesthetic Principle," *British Journal of Psychology*, v, 1912, pp. 87–118.

[20] Kandinsky, letter to Hilla Rebay, January 1937, *Wassily Kandinsky Memorial*, p. 98.

[21] Kandinsky, *Concerning the Spiritual in Art*, p. 48.

[22] *Ibid.*, p. 77.

[23] Kandinsky, "Abstrakte Kunst," *Cicerone*, xvii, 1925, pp. 639–647.

[24] Kandinsky, "Line and Fish," *Axis*, ii, 1935, p. 6.

[25] Roger Fry in *The Nation*, August 2, 1913, quoted in Arthur J. Eddy, *Cubists and Post-Impressionism* (Chicago: A. C. McClurg and Co., 1914), p. 117.

[26] Kandinsky, "Text Artista," p. 64.

[27] Kandinsky, "Über die Formfrage," *Der blaue Reiter*, p. 85.

[28] *Ibid.*, p. 84.

[29] Kandinsky, "Text Artista," p. 71.

[30] Kandinsky, "Über die Formfrage," in Kandinsky and Marc, *op. cit.*, p. 88.

[31] *Der blaue Reiter* (2d ed.) (Munich, 1914). p. v.

[32] This idea is very similar to Herder's theory of Inspiration: J. G. Herder, *Ideen zur Philosophie der Geschichte der Menschheit* (Leipzig, 1821).

[33] Kandinsky, *Concerning the Spiritual in Art*, pp. 51–52.

[34] *Ibid.*, p. 32. Kandinsky himself—as Lindsay has pointed out ("An Examination of the Fundamental Theories of Wassily Kandinsky," pp. 208–213)—was not a member of the Theosophical Society. He admired, however, the cosmology of Mme. Blavatzky which attempted to create a significant synthesis of Indian wisdom and Western civilization. The antimaterialistic concepts of the Theosophical movement attracted a good many artists and writers yearning for a new religious spirit during the early part of the century. Besides Kandinsky: Piet Mondrian, Hans Arp, Hugo Ball, William Butler Yeats.

[35] Kandinsky, *Concerning the Spiritual in Art*, pp. 33–34.

[36] *Ibid.*, p. 36.

[37] *Ibid.*, p. 39.

[38] *Ibid.*, p. 47.

[39] *Ibid.*, p. 45.

[40] *Ibid.*

[41] The following remarks about color are taken from "The Language of Form and Color," *Concerning the Spiritual in Art*, Chap. vi, pp. 45–67.

[42] *Ibid.*, pp. 51–52.

[43] *Ibid.*, p. 57n.

[44] *Ibid.*, p. 45.

[45] Kandinsky, "Text Artista," p. 75.

[46] Max Raphael, *Von Monet bis Picasso* (Munich, 1919), p. 102.

[47] Kandinsky, *Concerning the Spiritual in Art*, p. 63.

[48] In Kandinsky and Marc, *Der blaue Reiter,* pp. 103–113.

[49] Kandinsky, "Text Artista," pp. 75–87.

[50] By "stage composition"—*Bühnenkomposition*—Kandinsky is referring to the totality of movement on the stage.

[51] Kandinsky, "Der gelbe Klang," in Kandinsky and Marc, *Der blaue Reiter,* pp. 119–131. The possibilities of such a synthesis in the film were not yet explored in 1912.

[52] Diego Rivera, quoted in "Notes on the Life, Development and Last Years of Kandinsky," in *Wassily Kandinsky Memorial,* p. 100.

[53] Bergson, *Essai sur les données immédiates de la conscience* (Paris, 1904).

[54] Christian P. Heinlein, "The Affective Characteristics of the Major and Minor Modes in Music," dissertation, Johns Hopkins University, Baltimore, 1928; quoted in Lindsay, "An Examination of the Fundamental Theories of Wassily Kandinsky," p. 104.

# 22. FRANK LLOYD WRIGHT AND TWENTIETH-CENTURY STYLE

*Vincent Scully, Jr.*

### INTRODUCTION

This selection is the keynote paper in a series of five on the subject of Frank Lloyd Wright and his contemporaries delivered at the Twentieth International Congress of the History of Art in 1961. In this paper Professor Scully plots Wright's work in the context of international developments in architecture during the first half of the twentieth century and in relation to a likely thrust of fresh architecture in the second half. Of particular interest are the remarks concerning Wright's relationship to past traditions; the full reciprocal circle of Wright's early impact on European architecture through De Stijl channels to the International Style, and from the latter back to Wright in the form of a "regenerating influence"; and the comparisons between Wright's architecture from 1902 to 1906 and that of Louis I. Kahn from the mid-1950s to the early 1960s.

Apart from Wright's own publications, much of the basic literature is cited in Professor Scully's bibliographical note at the end of this selection. Additions to this should include Norris K. Smith, *Frank Lloyd Wright: A Study in Architectural Content* (1966); H. A. Brooks, "Frank Lloyd Wright and the Wasmuth Drawings," *The Art Bulletin*, XLVIII (1966); Mark L. Peisch, *The Chicago School of Architecture: Early Followers of Sullivan and Wright* (1965); James Birrell, *Walter Burley Griffin* (1964); and the series of papers mentioned above, pub-

lished in *Studies in Western Art, Acts of the Twentieth International Congress of the History of Art*, IV (1963).

Other works are N. K. Smith, *Frank Lloyd Wright: A Study in Architectural Content* (1966); Dimitri Tselos, "Frank Lloyd Wright and World Architecture," *Journal of the Society of Architectural Historians*, XXVIII (March 1969), 58–72; H. Allen Brooks, *The Prairie School; Frank Lloyd Wright and His Midwest Contemporaries* (1972); and William A. Storrer, *The Architecture of Frank Lloyd Wright: A Complete Catalog* (1974), an important publication of visual and factual data, providing a fresh overview of Wright's work.

Of the architect's own writings mention should be made of *An Autobiography* (1932); *The Future of Architecture* (1953); *Frank Lloyd Wright on Architecture*, ed. by Frederick Gutheim, 2nd ed. (1960); *Frank Lloyd Wright: Writings and Buildings*, ed. by E. Kaufmann and Ben Raeburn (1960). In a special category is the important publication edited by Arthur Drexler, *The Drawings of Frank Lloyd Wright* (1962); and for contextual material there are Henry-Russell Hitchcock, *Architecture: Nineteenth and Twentieth Centuries* (1963) and Henry-Russell Hitchcock and Philip Johnson, *The International Style: Architecture Since 1922* (1932).

Additional works are Frank Lloyd Wright, *In the Cause of Architecture*, ed. by Frederick Gutheim (1975), which includes a symposium of eight articles by Wright's associates; John Sergeant, *Frank Lloyd Wright's Usonian Houses: The Case for Organic Architecture* (1976); Robert L. Sweeney, *Frank Lloyd Wright: An Annotated Bibliography* (1978); and the series of ten volumes of photographic studies of Wright's architecture by Yukio Futagawa, published in Tokyo (1967–1976).

The selection that follows is from *Studies in Western Art, Vol. 4: Problems of the 19th and 20th Centuries*, edited by Millard Meiss. Copyright © 1963 by Princeton University Press. This article, by Vincent Scully, Jr., pp. 7–21, is reprinted by permission of Princeton University Press.

Some years ago a student asked Frank Lloyd Wright how he could make his own work wholly original. Wright replied, in effect, "You can't. I invented a new architecture . . . about 1900, and all you can do is learn its principles and work with them." At the time, this answer seemed to me to be one of unparalleled, if delightful, arrogance. Now I am not so sure that it was far from being the simple truth. And the period of Wright's work upon which the scholar must concentrate, in order to seek out the truth, is the period cited by Wright himself, that which spanned the two centuries and came to a close at about the fateful date of 1914.

In this distinguished company I make no pretence of being prepared to produce fresh data about Wright. Nor can all the many qualities of his work be discussed or illustrated here. Instead, despite the risk of repeating what I, or others, have written elsewhere, I should like to present a thesis for argument, developed as follows: first, that Wright not only created a style of architecture but also, through his long life span, carried that style through all its possible phases; second, that Wright's early work, of the period noted above, was more solely his own than the work of the later periods normally was, and more fully embodied a balance between his two major principles of design than the later work usually did; third, that out of one of those principles the International Style of the following decades took form, and out of another the new architecture of the second half of the century—the architecture which may succeed that of Wright—would now seem to be making its beginning.

This thesis as a whole implies that Wright's work indeed had two major separable aspects and sought two distinct objectives which he himself was able to merge only when at his most complete. Both these objectives were built into Wright's life by the circumstances of his birth. One was the creation of building form through a totally integrated structural system; the other was the creation of spaces which were, in his own term, "continuous." The first objective derived from the Gothic Revival theory of the middle of the nineteenth century, and into the Gothic Revival

Wright was, literally, born. As we all know, his mother determined before his birth in 1869 that he should be an architect and, to that end, hung nineteenth-century engravings of English cathedrals in the room she had prepared for him. Her impulse may be taken to have been picturesque, transcendental, possibly partly Ruskinian in tone. Some of these attitudes were to cling to Wright all his life, and he read Ruskin later. But, as he himself tells us, the book that most affected him and which, in his own words, "was the only really sensible book on architecture in the world," was Viollet-le-Duc's *Dictionnaire raisonné*. Here the attitude was a tough and mechanistic one, expressive of nineteenth-century positivism and scientism and insisting that the forms of Gothic architecture derived purely from the logical demands of its skeletal structural system. In this way the later nineteenth century was able to see Gothic architecture according to its own pragmatic and materialistic image of reality and to embody such, as Banham has otherwise shown, in its own architectural theory.[1]

But Wright was also born into another engrossing nineteenth-century attitude, one which achieved its greatest symbolic force in America. This was the sense of continuous expansion, of the endless opening up of the environment. The print of 1868 by Palmer and Ives, comprehensively entitled *Across the Continent: Westward the Course of Empire Makes Its Way,"* makes this point. All was to flow on endlessly, boundlessly, in the unity that comes with flow. Physical space, biological evolution, and the democratic future were alike regarded in terms of such unified progress forward.

Here, then, were two concepts, structural and spatial, and both directly expressive of the major goals and symbols of their time. Wright was to set himself the task of integrating the two through the chemistry of his art, and of weaving them into single organisms at once unified and serene. Before his birth and in his childhood the way was already being prepared for him. During the mid-century the American Stick Style, carried by the Pattern Books which began with those of Andrew Jackson Downing, had attempted to apply Gothic Revival principles of structural expression to American domestic programs and wood frame techniques. And Wright tells us that when, as a beginning architect, he first settled in Oak Park in 1887, it was not the new houses but Mr. Austin's "old barn vertically boarded and battened," that he loved. But by this time, when he himself was about to build, the

other image, that of spatial continuity, had become dominant in American work. It had begun in England during the sixties, with Richard Norman Shaw's tile-hung "old English" houses planned around living halls, and later in the United States to be associated with American colonial work and called Queen Anne. This mode was introduced into America by Henry Hobson Richardson in his shingled Watts Sherman House of 1874, where the horizontal continuity of the surface, expressive of the new continuities of interior space, was made even more decisive. By the mid-eighties such spatial continuity reached a point in America never approached by the English houses. Wilson Eyre's Ashurst House of 1885, with its horizontally extended and open interior, its projecting porches, and its bands of windows, is an excellent example. By 1886, another architect of this Shingle Style, Bruce Price, had organized the new open interior space into that cross-axial type which had been popular in North America since Jefferson's time; and Wright's own house in Oak Park, of 1889, was closely derived from the houses of Price, although the cross-axial plan was not yet employed in it. Around 1900, however, when Wright came into his first maturity, as in the Ward Willitts House, he used Price's cross axis to create a set of horizontal continuities which recall those of Eyre but are infinitely more decisive and are extended with low ceilinged compulsiveness. Indeed, the house as a whole seems to have passed beyond the underlying picturesque eclecticism of the Shingle Style into a new style that is entirely its own. It is true, as many critics have pointed out, that other sources of inspiration can be seen here, such as the Japanese Ho-O-Den at the World's Fair of 1893. The stripping, the cross-axis, and the projecting roofs are common to both, but Wright has so woven together the structural and cladding elements, reminiscent of those of the Stick Style, that the building fabric as a whole is now completely in accord with the continuously expanding spaces it defines.

With these wooden houses of the beginning of the century, therefore, Wright's integration of continuous space with frame structure was already complete. Instantly, in 1902, he turned to the same problem in masonry, where his image of continuity could be given permanent, monumental form. Here I must apologize for recalling a sequence of development that is familiar to us all, but the need to do so will, I hope, be apparent at the end of this talk. In the Heurtley House the direct influence of Richard-

son's eminently permanent masonry can be felt, as from the Glessner House in Chicago, which Wright knew at first hand, or from the Quincy Library, which was well published. But Wright divides Richardson's engrossing shell, with its volumetric gable roof, into separate planes, across which the wooden spanning elements stretch with the running continuity of bridges. Spatial movement and sculptural mass were in this sense combined. Immediately, having developed his masonry as plane, Wright turned to masonry as pier. Perceiving the vertical demands of such, he also sensed the volumetric bay which the pier somehow wants to bound. So, in the Hillside Home School, also of 1902, the four piers support a symmetrically placed hip roof, defining a volume of space which is fundamentally static but which is brought into the cross-axes of spatial expansion through projected window bays and cantilevered ceiling planes.

In 1904 a further step was taken in the Martin House, where the piers were exploited to the full as space definers, marching outward in companies to form the major spaces and, where the axes cross, grouping in fours to create smaller service spaces for heating and lighting equipment. Thus the unification of spatial desires with structural and mechanical demands is so complete that the house approaches the integration of a working machine. The only exception to this is the widely overhanging roof, where the desire for horizontal spatial extension causes steel beams to be concealed in the wooden structure and so introduces an element lacking the inner structural rationale of the other forms. But in the Larkin Building—also of 1904 and now tragically demolished—the spatial continuity was contained by the building fabric, and the integration of space with structure was complete. Concrete beams supported brick parapets, threaded horizontally through the vertically continuous piers, and capped them above. The whole was a tensile unity in which major and minor volumes were structurally formed through the bay system into an industrial cathedral that should have delighted Viollet-le-Duc. The mechanics never faltered. The thickness of the piers received the filing cabinets; vertical circulation was clearly separated into corner towers, and all these major, minor, and service spaces worked together to create the building's exterior form. The only captious elements, the globes and putti, seem related to European development of the period, as perhaps to Olbrich's Sezession

446

Building, in Vienna, of 1898–99, whose romantic-classic, geometric severity Wright's building also shared.

Yet it is clear that this industrial form could not have been built as it was without the example of Louis Sullivan, and its vertical piers and interwoven horizontal spandrels recall those of Sullivan's first great skyscraper, the Wainwright Building of 1890–91. Wright has recorded his emotion when Sullivan laid the first sketches for the Wainwright Building on his drawing board. But Wright himself was attempting something fundamentally different from the master's work. Sullivan's building was integrated façade design, at most a schematic description of the character of the spaces it contained, but Wright's was an integral embodiment of those spaces. Sullivan's building was conceived as a standing body, with a base, a middle, and an end, and can therefore be described, as Sullivan described it, in terms of the classic column. But Wright's solids, though supremely strong, expressed the volume of space they defined. Thus the exterior of his building was that of a container of spaces and is to be read not as a column but as a galleried cavern.

This difference, which I have discussed elsewhere, is important because of the fundamental polarity in attitude it reveals. When Sullivan looked at Richardson's work, as for example at the Marshall Field Warehouse, of 1885, he saw it not in terms of spatial definition, but in anthropomorphic and humanistic terms with which Wright had nothing to do. So, in his *Kindergarten Chats*, Sullivan wrote of this building, "Here is a man for you to look at. A man that walks on two legs instead of four, has active muscles . . . lives and breathes . . . in a world of barren pettiness, a male."[2] Therefore, in his own Guaranty Building of 1895, designed after Wright had left the office, Sullivan developed Richardson's forms further in terms of skeletal skyscraper construction and caused the building truly to stand upon its legs, stretch, and stir. In these ways it became primarily the expression of a physical presence rather than of spatial environment. Indeed, the Guaranty Building, with its doubled piers and its calculated drama of compression and tension, purposely overrode its description of its space and structure in favor of the sculptural unity of its body. Such intentions have ultimately Hellenic rather than medieval backgrounds; they seem related to the Greek rather than the medieval revival of the early nineteenth century and, in

447

part, to the general Classicizing reaction of its close. They have become central to some mid-twentieth century architecture other than Wright's. So the late skyscrapers of Mies van der Rohe stand upon exposed columns and multiply their vertical mullions in order to achieve bodily unity in terms which, though now rather frozen, are still Sullivan's figural rather than spatial ones. More forcefully, the late buildings of Le Corbusier culminate this modern expression of the human presence and its act. They stand as muscular forces, and mask, where necessary, both their interior spaces and their actual structure in order to appear to be the sculptural embodiments of powers with which men can identify their own.

But Wright's way was the opposite. Perhaps no less sculptural, it yet sought a sculpture that was constructivist and environmental, rather than figurally active, in effect. Unity Temple, of 1906, culminated its integration. Here, as Wright most lucidly describes in his *Autobiography,* square hollow piers, flat planes, crossed beams and projecting slabs in poured concrete all worked together to create the kinds of space desired, and the building's plastic solids wholly revealed both the shapes of those spaces and the structural process whereby they were formed (Fig. 61).

If Unity Temple may be regarded as a culmination of Wright's integration, the Robie House (Fig. 62) documents his movement beyond it toward a more arbitrary state. Now the desire for continuous space most movingly dominates the fabric. The heavy masses of brick are lifted by that compulsion, and the steel-concealing, low-hipped roofs take wing. In that sense the solids burst apart, like—as so many critics have pointed out—those of contemporary Cubist painting. At the same time, the Robie House, designed as if in exaltation, sums up several hundred years of American imagery. The containing, protective box of Colonial architecture, which had exerted considerable influence upon the architects of the Shingle Style and thus upon Wright himself, now splits around the central fireplace mass and embodies to the full the nineteenth-century feeling for spatial expansion and flight.

With this house Wright summed up his earlier intentions and burst their boundaries. Its completion in 1909 coincided with a decisive break in his own personal life. Thereafter he had no fixed place in the American nineteenth-century suburban culture—and especially middle western suburban culture—that had nourished him. Indeed that culture itself, as a creative milieu, began to break

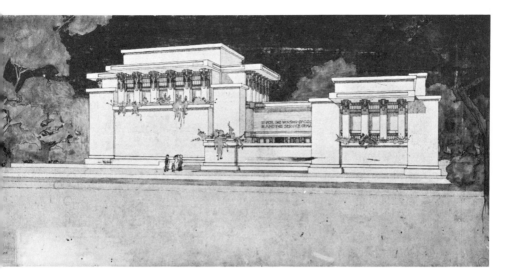

61. Frank Lloyd Wright, Unity Church, Oak Park, Illinois, 1906, Perspective, Brown ink and watercolor wash on tracing paper mounted to board, 12″ x 25⅛″ (Collection, The Frank Lloyd Wright Foundation; Photograph courtesy of The Museum of Modern Art, New York)

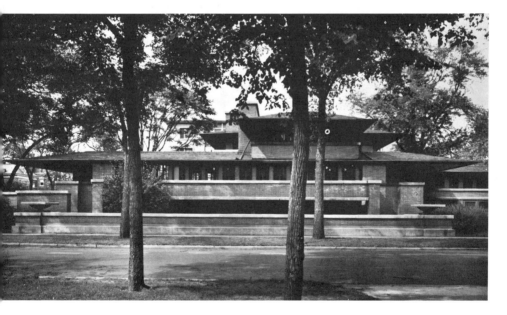

62. Frank Lloyd Wright, Robie House, Chicago, Illinois, 1908–1909. (Historic American Buildings Survey, Washington, D.C.; Cervin Robinson)

449

up by the time of World War I. The reasons for this are still in dispute and cannot be developed here, but the fact remains that the middle western suburb had been prepared to support the idealistic radicalism of its architects: it then became, and has generally remained, carefully conservative. It is as if Wright, having lost his functional place—and never again to have around him so mature and productive a group of followers, associates, and sympathetic but free and equal critics as the other architects of the Prairie School had been—was now forced to seek out only the most grandly personal and mythic of objectives. So, at the Midway Gardens of 1914 he forced his earlier forms into vast spatial continuities, like those of some nineteenth-century American landscapes, where the solid shapes, however symmetrically framed, are eaten through by space and slide forward and out continuously under the empty sky.

After 1914, now personally involved in the tragic flux of American culture and totally uprooted from his past, Wright seems to have felt a need to begin again upon cultural foundations more wholly permanent. His overt dependence upon precedent, here upon Mayan forms, became much more marked than it had been in any of the work done between 1900 and 1914. A wish for overwhelmingly stable mass dominates, spatially appropriate perhaps in the A. D. German Warehouse of 1915, less so in the Barnsdall House of 1920. There, too, the desire for structural integrity was entirely given up in order to achieve the Mayan mansarded roof profile in lath and plaster. And even when, in his splendid block houses of the twenties and his inspired 1929 project for St. Mark's Tower, Wright achieved once again a complete integration of structure and space, and Mayoid inspiration was still seen as much to the fore.

Yet through these decades so difficult for him, the influence of Wright's work had acted more strongly than any other single force to give form to the new architecture of modern Europe, and the special way it had acted is of critical importance. Wright's work had become generally known through the great Wasmuth publications in 1910 and 1911. From such publications Berlage, whose Amsterdam Bourse of 1903 had also been a brick structure with an enclosed court, saw the Larkin Building as an eminently machine architecture, as Banham has shown. We may assume that Berlage understood, in other words, its complete integration of function and structure. The formal influence of Wright upon other

Dutch architects and upon Gropius in the teens need not be discussed here. But the Dutch De Stijl group of the late teens and early twenties, whose members also admired Wright, must be considered. This group appears to have seen Wright's work not in terms of integration but through its own predilections for line and plane, Classicizing severity, and the abstract manipulation of space. This is important because it was clearly through De Stijl that the International Style of the twenties found its characteristic shapes. The process, whatever it also owed to both Cubism and Futurism, can be traced almost step by step from the illustrations in Wasmuth. If we take a photograph of the side of the Ward Willitts House from the 1911 volume and concentrate upon the running, asymmetrical pattern of dark stripping, we can derive from it a painting by Van Doesburg of 1918. Ignoring the lines and focusing upon the advanced and recessed masses, we arrive at a construction, a constructivist sculpture, by Van Tongerloo, of 1919. Hollowing out the masses and seeing the surfaces as thin, sharp-edged planes defining volumes of space, we approach a house project by Van Doesburg, of 1922. Finally, stretching the whole out once more into an asymmetrical organization of interlocked, thin-surfaced boxes, we come to Gropius' Bauhaus of 1925–26, and to the full International Style. The bounding solids are now merely planes which exist to define volumes. There is no structural mass and no question of structural and spatial integration; in fact the space definers and the supporting members are normally kept separate, one from the other. The relation to the machine, which was of persistent importance in European theory, and of which Banham has brilliantly made so much, is now not, as in the Larkin Building, primarily in how the building functions as a working machine, but how, industrially glazed and brightly stuccoed, it looks.

The fullest understanding of Wright's continuity of space was shown during the twenties by Mies van der Rohe, as a comparison between a plan of 1906 by Wright and one of 1923 by Mies clearly shows. And Mies' Barcelona Pavilion of 1929, itself a piece of constructivist sculpture, is a synthesis between Wright's fluid, American planning, as reinterpreted by De Stijl, and the Classicizing containment that was also desired by European sensibility. At the same time the planes are everywhere detached from the structural columns and therefore act purely as arbitrary space definers. Such separation is to be contrasted with the integration

451

of space and structure in a somewhat similar project by Wright, the Yahara Boat Club, of 1902, published by Wasmuth in 1910. If, however, we step forward instead of back in Wright's work, we find that the influence of Mies and, very secondarily, of other European architects of the International Style, has, by the thirties, come to exert a direct and indeed regenerating influence upon Wright's own design. The "parti" of the entrance side of the Goetsch-Winkler House of 1939, for example, shows the relationship very clearly. Wright's earlier influence upon Europe now bore fruit for him, but, as indicated, a certain metamorphosis had taken place in the process. Now, for example, Wright creates his space almost entirely by flat planes rather than by an interwoven skeletal fabric. In wood in the Usonian Houses (though steel flitches were often inserted between their joists) and in reinforced concrete in such a great masterpiece as the Kaufmann House, Wright found various ways to make those planes structural, but the dominance of International Style intentions seems clear. So the Kaufmann House, though creating a splendidly complex and serene spatial ambient, and being itself a structure of much daring, is also a kind of mature constructivist sculpture, recalling types developed by the Europeans out of Wright's earlier work.

Finally, when he attempted to escape from the International Style through the continuously curvilinear form of his last decades —which themselves (like those of the Johnson Wax Building) reveal other immediate sources of inspiration that need not concern us here—Wright often manipulated the solids, whether as walls or columns, so that all structural demands and expressions were, visually, denied by them and it was truly, in his own words, "space, not matter," that became the reality. Similarly, it is clear, as the researches of Folds have shown, that Wright was never entirely sure how the continuous spiral of the Guggenheim Museum was to be constructed, so that, in the final version, the vertical piers, which do much of the actual work, are in conflict with the helical conception of the space, and injure it. All this sharply contrasts with the balance between solid and void in the similarly top-lighted and galleried Larkin Building, where the members, fully creating the space and expressive of it, were structurally convincing as well.

Wright may therefore be said to have pushed his style to its ultimate, space-dominant, solid-denying phase—to what may perhaps be referred to as its Late Baroque phase. That is to say, if

Brunelleschi stated a clear principle of the relation of solid to void, and of structure to space, and Alberti and others developed the system into a balance between mass and space, in which solid and void were sculpturally interdependent, so the Late Baroque may be said to have dissolved the solids in favor of the space, bending them entirely to the service of the total environment they created. If a similar course can be traced in Wright, it can also be perceived in the International Style as a whole. Because that style had begun, by Wright's last years, to exhibit characteristics that were almost Rococo. The lacy fragmentation of mass in Yamasaki's recent work is one example among many, while Stone's fluttery elegance in his project for a National Cultural Center is even more striking. Many recent Russian works, most of them apparently inspired by Stone, show the same characteristics. So Stone's project of 1961 closely resembles one of the schemes submitted in the new competition for a Palace of the Soviets, of 1959, which in turn seems to have taken as its point of departure Stone's American Pavilion at Brussels, of the year before. The new Rococo is thus strikingly international.

If, therefore, the International Style saw Wright purely in terms of defined space, and if it and he seem to have reached concluding phases together, we are compelled to ask how the fresh architecture of the second half of the century is to take shape. Where is it to begin? That question is significant for this paper because the answer would appear to be that the new architecture is now beginning not where Wright ended but where Wright began, and, as indicated earlier, is apparently developing according to one of his principles, the structural one. Several names might be associated with this movement, but the one which most architects would, I think, now advance as essential is that of Louis I. Kahn, and it is Kahn whose influence upon architectural students, at least in the United States, is presently greater than that of any other architect. This is not the place to describe Kahn's unusual career or to analyze his theory and design in detail. I should only like to point out that, from about 1955 to the present, his development has paralleled that of Wright between 1902 and 1906 in almost every significant detail. I do not say that this relation to Wright was necessarily conscious on Kahn's part; indeed, the fact that it was probably unconscious makes it doubly significant. Clearly enough it has followed a course laid down in Kahn's own theory, which is itself ultimately based upon Viollet-

le-Duc and Choisy: functional ("What," as Kahn puts it, "does the building want to be?"); integrational, as he insists, like Wright, the architecture is the "making of spaces" and that those spaces should be defined by structure. At the same time, considerable influence from some of Le Corbusier's later buildings in brick and concrete, such as the Maisons Jaoul, has obviously played an important part.

Yet the parallel with Wright seems central, since Kahn's fully mature projects can be said to have begun with his archaic Trenton Bath House of 1955. Here hollow piers support hipped roofs to create structurally conceived bays of space which closely recall Wright's Hillside Home School, of 1902. To go further, the plan of the Bath House is cross-axial, defined by the piers. In this it of course strikingly recalls Wright's work, like the plan of the Gale House of 1902. But here a difference is apparent. Wright's squares interlock, and the axes penetrate each other, creating the kind of continuously fluid space that was so expansively extended in the Ward Willitts plan. Kahn's spaces are not continuous, but separate. The squares do not interlock; each volume has its own roof cap with oculus, and in the central unroofed square the opposite geometric shape, a circle, is inscribed. The Kahn plan is thus intended to be static and fixed; Vitruvian and Renaissance conceptions, and indeed the cubes and spheres of Brunelleschi, are recalled. Where, however, Brunelleschi could define his spatial areas with slender, solid columns, Kahn's piers are hollow, containing those services which are essential to most modern buildings and which, therefore, Kahn now integrates into the structural and spatial concept as a whole. We have, of course, seen this before and in exactly this sequence. Wright's Martin plan, of 1904, with its grouped columns containing heating and lighting elements, comes to mind, as do the hollow piers of Unity Temple. So, too, in sequence, comes Kahn's project for the Trenton Community Center as a whole, now recalling the columnar groupings of the Martin House and making both major and service spaces with them. But again Kahn caps each bay with its own precast, hipped roof, even where the demands of the spaces below require that the column system be interrupted. In this way Kahn again rejects the nineteenth-century image of expansive continuity in favor of the separateness of parts, but, as with Wright, it is the structure that makes the space and the two together which produce a convincingly fresh and powerful form.

454

The same holds true in Kahn's Medical Research Laboratories for the University of Pennsylvania, completed in 1960, when the next step in the sequence, that to the Larkin Building, is taken. Again, vertical service towers, clad in brick, house stairways and, here, ventilating ducts, while the floor levels are defined by horizontal spandrels plaited, as by Wright, through vertical piers. At the same time, Kahn's cantilevering of the floor levels off exposed columns recalls the system used in the Philadelphia Savings Fund Society Building of 1930–32, designed by George Howe, later one of Kahn's closest associates and mentors, and William Lescaze, while the stepped diminution of the cantilevered precast trusses was prefigured in the similar beam treatment of one of the buildings in Richard Neutra's Rush City Reformed Project of the twenties. Now, however, Kahn makes the space through an interweaving of the toughly scaled armature of the reinforced concrete skeleton, as Wright had done, but the space itself differs once more. The functions are surely less integrated with the structure —here in Kahn a cross-axial structure—than Wright's admittedly simpler program permitted, but there is a difference of intention as well. Wright's spaces pull the observer in, enclose, release, soothe him, drawing all finally together into an expansive harmony; but Kahn's spaces are exposed, pushed out by the structural members, not sequential but fundamentally separate, while the scheme of the complex as a whole avoids Wright's embracing envelope to insist upon the separateness of each structurally conceived, eight-columned tower.

The larger differences between Wright and Kahn can now be determined. Wright develops fluid spatial sequences, Kahn units of space. Wright will, if choice be necessary, override the structure in favor of the space; Kahn, if necessary, the space in favor of the structure. Wright emphasizes the continuous plastic unity of parts, Kahn their jointed separateness. Wright insists upon the expansiveness and serenity of the environment, Kahn upon its pressures, difficulties, and demands. Both earnestly attempt to balance human desires against the intrinsic physical requirements of the thing made. Wright will normally, and with lyric fervor, opt for the former; Kahn, with a kind of tragic intensity, for the latter. The first set of attitudes adds up to a late nineteenth-century view of human possibility, the second to a mid-twentieth-century perception of human fate. So each of these buildings belongs to the best thought of its own generation, but that they

455

also belong to the same family is clear. And it seems most important for the future of American architecture that the relationship should be a familial one, because Kahn, for the first time among those Americans whose work has consistently recalled Wright's, seems not a follower, but a descendant.

Their mutual sequence is by no means concluded. Kahn's project of 1960–61 for the First Unitarian Church in Rochester recalls Wright's Unity Temple of 1906. Their exteriors are strongly fortified masses, lighted primarily from above and expressive of the deeply enclosed volumes they contain. Kahn, however, avoids Wright's projected roof slabs, expressive of spatial interlocking and horizontal continuities. So, too, a plan for church and school resembling Wright's was considered but rejected by Kahn on spatial and functional grounds. And again, though in the final plan the units are brought into a closer grouping by Kahn, they still retain their spatial, structural, and formal separateness and discontinuity, and are not woven into interlocking echoes of each other as Wright, with his concern for rhythmic unity, has them. At the same time, a system of precast bent slabs, supported on crossed beams, forms Kahn's top-lighted roof, and recalls in this way Wright's system in the Temple.

The church at Rochester is now under construction, and many other projects by Kahn are developing the creative sequence further. Some, like that for the Salk Center in California, seem to show evidence of influences from sources that were also important to Wright in his later years. What this may foretell cannot be determined at present. (It is discussed in detail in my recent book on Kahn.)

It is now apparent, however, that a family of principle, of complicated ancestry but brought to form by Wright, produced, comparatively late in his own life, a new champion, who may, perhaps most significantly, be creating another indigenously American school. The forms of that family rise across the general picturesque eclecticism of much of the century and indeed across the International Style of the intervening years. The two generations differ in the fundamental spatial symbol to which each adheres, but they are alike in the governing desire for spatial and structural integration that binds them. Each, though considerably more concerned with the mechanics of function than the International Style usually was, still belongs to the tenacious Western tradition of solid, monumental building in common materials, as

456

the International Style had not always seemed to do. Their specific ancestry lies in that large segment of Western experience which has been primarily concerned with the construction of interior spaces. Their opposite, equally important today, is eventually Hellenic in ancestry, and seeks, with subjective idealism, to embody the human act in architectural form. They, however, seek to image not the human body but the objectively realistic force of the settings constructed for it.

There is clearly room and need for both symbols in the modern world, and indeed both have been sought by it in one way or another since its beginnings. Wright's and Kahn's principle, whatever its backgrounds, has been especially sympathetic to Americans, since, under the prod of anarchic change, it passionately insists upon the need to produce a permanent environment that shall be abstractly moral, insofar as it embodies fixed principle and law. Ironically enough, the fluid instability of modern times destroyed Wright's building. But it now comes to life once more through the revival of an intention that was most succinctly stated by its builder many years ago, when he wrote, "Above all, integrity."[3]

*NOTES*

[1] Reyner Banham, *Theory and Design in the First Machine Age* (New York, 1960).

[2] Louis Henry Sullivan, *Kindergarten Chats* (Lawrence, Kansas, 1934).

[3] Since this talk was intended to reappraise and realign material already well known, it is presented here as given, without footnotes. For the same reason its numerous illustrations have all been omitted since most of them can be easily found elsewhere, as in my books: *The Shingle Style* (New Haven, 1955); *Frank Lloyd Wright* (New York, 1960); *Modern Architecture* (New York, 1961); and *Louis I. Kahn* (New York, 1962). For further photographs of Wright's work the reader is referred to Henry-Russell Hitchcock, *In the Nature of Materials; 1887–1941; The Buildings of Frank Lloyd Wright* (New York, 1942), and for the early period to Grant C. Manson, *Frank Lloyd Wright to 1910: The First Golden Age* (New York, 1958).

# 23. THE NEW YORK SCHOOL:

## ARTISTS, CRITICS,

## AND DEALERS

*Dore Ashton*

### INTRODUCTION

Like the selection by Michael Baxandall on Italian Renaissance artists and their partons, this excerpt from Dore Ashton's study of the New York School is about context rather than the work of art itself. As the writer points out in her Author's Note to that volume, knowing about an artist's ambience does not "explain" an artist's work, any more than the fertilizer explains the flower; but "a close scrutiny of the components of fertilizer . . . , undeniably, has *something* to do with the flower." So, she has "written a book that is not about art, nor about artists individually, but about artists in American society"—and therefore about some of the forces that worked to shape that vital period in American art during the Second World War and in the years that followed when painters like Pollock, Rothko, Gorky, de Kooning, Motherwell, and Kline brought a new wave of art into the foreground of America's—and the world's—art-consciousness.

The literature on this subject is extensive. What follows is a stringently pared list of titles the reader will find useful: Julien Levy, *Surrealism* (1936), a book of some importance to the group; J. J. Sweeney, *Jackson Pollock* (1943), an early study of the artist; Robert Motherwell and Ad Reinhardt, eds., *Modern Artists in America* (1951); John I. H. Baur, *Revolution and Tradition in Modern American Art* (1951); Thomas B. Hess, *Abstract Painting: Background and American Phase* (1951); H. H. Arnason, *American Abstract Expressionists and*

*Imagists* (1961); Peter Selz, *Mark Rothko* (1961); Clement Greenberg, *Art and Culture* (1961); Dore Ashton, *The Unknown Shore: A View of Contemporary Art* (1962); Harold Rosenberg, *The Anxious Object: Art Today and Its Audience* (1964); Maurice Tuchman, ed., *The New York School, The First Generation: Paintings of the 1940s and 1950s* (1965); Julien Levy, *Arshile Gorky* (1966); Francis V. O'Connor, *Jackson Pollock* (1967); John Gordon, *Franz Kline: 1910–1962* (1968); Herschel B. Chipp, ed., *Theories of Modern Art* (1968); Henry Geldzahler, ed., *New York Painting and Sculpture, 1940–1970* (1969); Thomas B. Hess, *Willem de Kooning* (1969); Irving Sandler, *The Triumph of American Painting: A History of Abstract Expressionism* (1970); Leo Steinberg, *Other Criteria: Confrontations with Twentieth-Century Art* (1972); Hilton Kramer, *The Age of the Avant-Garde* (1973); Irving Sandler, *The New York School: The Painters and Sculptors of the Fifties* (1978); Francis V. O'Connor and Eugene V. Thaw, eds., *Jackson Pollock: A Catalogue Raisonné of Paintings, Drawings, and Other Works*, 4 vols. (1978); Ellen H. Johnson, ed., *American Artists on Art From 1940–1980* (1982); and Dore Ashton, *American Art Since 1945* (1982).

The selection that follows is from *The New York School: A Cultural Reckoning*, by Dore Ashton. Originally published in England by Adams & Dart Publishers under the title *The Life and Times of the New York School, American Painting in the Twentieth Century*. Copyright 1972 by Dore Ashton. Reprinted by permission of Viking Penguin, Inc.

How Jackson Pollock (Fig. 63) broke the ice—quite aside from his genuine esthetic contribution, which was quickly recognized by the *cognoscenti*—is neatly summarized by Peggy Guggenheim, his first commercial agent. Writing about his first one-man show at Art of this Century, held in November 1943, she cites all the significant factors in his success:

> The introduction to the catalogue was written by James Johnson Sweeney, who helped a lot to further Pollock's career. In fact, I always referred to Pollock as our spiritual offspring. Clement Greenberg, the critic, also came to the fore and championed Pollock as the greatest painter of our time. Alfred Barr bought the *She Wolf*, one of the best paintings in the show, for the Museum of Modern Art. Dr Morley asked for the show in her San Francisco Museum, and bought the *Guardians of the Secret*.[1]

Unquestionably, the intervention of all these powerful figures— Sweeney, well-connected with the international art world, Barr, the key arbiter of the enlightened middle echelons of culture, Greenberg, the first polemical art critic with literary standing, and Dr. Morley, the most successful museum director on the West Coast interested in the avant-garde—headed Pollock toward the kind of success that he was to find so hard to bear. The support of these well-placed cultural pundits, with the inevitable dependence of the artist on their initiatives, was at once a blow to the pride of the bohemian artist and a source of both secret joy and secret despair. The stories of Pollock's violent behavior and his ability to be highly uncivil to the very people who most "helped" him to success can certainly be interpreted partly by his extreme discomfort at having been the first avant-garde artist to "break the ice." With Pollock in hand, the forces interested in sponsoring an American painting culture capable of breaking the hegemony of Europe had a powerful weapon. Only think how an artist would feel knowing that someone—even someone as charmingly naïve as Peggy Guggenheim—could speak of him as "our spiritual offspring."

461

63. Jackson Pollock, *Autumn Rhythm,* 1950, Oil and enamel on canvas, 105" x 207" (The Metropolitan Museum of Art, George A. Hearn Fund, 1957)

As Elaine de Kooning later said, Pollock was "the first American artist to be devoured as a package by critics and collectors (whom he cowed)."[2] By 1949 *Life* magazine was beginning to see the popular news value of artistic wildlife. A famous article in the issue of August 8, 1949, was given the title "Is Jackson Pollock the Greatest Living Painter in the United States?" by which the editors virtually invited the readers to respond indignantly in the negative. The article presented Pollock as a kind of mad genius, whose techniques and manners are incomprehensible:

> Even so, Pollock, at the age of 37, has burst forth as the shining new phenomenon of American art. . . . Pollock was virtually unknown in 1944. Now his paintings hang in five United States museums and forty private collections. . . . Last winter he sold twelve out of eighteen pictures.

This little success story, with its proper American emphasis on how many pictures had been sold, and its patent disrespect for the artist as such, typified the new processing the media gave the avant-garde and caused many a New York painter to grind his teeth in chagrin.

Making the first perceptive comment on Pollock's temperament, James Johnson Sweeney had written in the catalogue to the exhibition in 1943 that Pollock's talent was volcanic, lavish, explosive, and untidy. He praised Pollock's freedom to throw himself into the sea and, significantly, bolstered his independence, making it seem an avant-garde virtue. "But young painters, particularly Americans, tend to be too careful of opinion. Too often the dish is allowed to chill in the serving. What we need is more young men who paint from inner impulsion without an ear to what the critic or spectator may feel—painters who risk spoiling a canvas to say something in their own way." In this sentiment, Sweeney was to be followed by all those who willed a New York School.

Greenberg in a review in *The Nation* of November 27 also praised Pollock's audacity, energy, and force; while Pollock's young colleague, Robert Motherwell, writing in *Partisan Review* in the winter of 1944, called him "one of the younger generation's chances." The ranks were forming and a constellation of people was consciously embarking on a public adventure. For some time, all this energy was centered on Peggy Guggenheim's gallery, which lost no time in presenting the work of young artists who painted from the inner impulsion that Sweeney had demanded. In fact, several of the artists were presented by Sweeney himself. One-man shows of Baziotes, Motherwell, Rothko, and Still followed in the next couple of years. Sweeney wrote the catalogue introduction for Motherwell's exhibition, again stressing the importance of process: "With him a picture grows, not in the head but on the easel." The Museum of Modern Art duly acquired its first Motherwell, and the San Francisco Museum, under Dr. Morley's adventurous leadership, then held a one-man show. So it went. Now, a milieu rapidly became enlarged to include not only artists with a sense of growing importance, but also patrons, critics, museum officials, and an increasing circle of *aficionados*.

Not all the artists experienced such effective dispatch in the propagation of their work. The senior member of the avant-garde —at least in terms of exhibiting—was Arshile Gorky, and his experience was one of constant anxiety in relation to the success he felt he merited. Although the Museum of Modern Art had acquired one of his paintings as early as 1941, largely because his close friends decided to contribute it (as they contributed paintings to the San Francisco Museum), Ethel Schwabacher has pointed out that in the seven remaining years until his death, no

more paintings by Gorky were bought by museums or presented to them, nor did he receive any grants or prizes.[3] And when he had his first important one-man show at Julien Levy's gallery in March 1945, for which Breton wrote a celebrated foreword, it found a cold reception. Clement Greenberg went so far as to say that "Gorky has at last taken the easy way out,"[4] a comment that was perhaps doubly cruel because of Breton's sponsorship. Jeanne Reynal, Gorky's close friend who was then in San Francisco, wrote angrily to Gorky about the review and urged him to try to get to France where his work would be appreciated. There was more than a little asperity in the New York milieu toward the artist who had most obviously thrown in his lot with those visible reminders of the once-powerful European leading strings.

All the same, increasing press coverage, however hostile, and more and more serious reviews in the specialized journals, forced the artists—who had once lamented their isolation—to recognize their new, and not always welcome, relationship with society. The acceptance of abstract art as the appropriate avant-garde mode was accomplished before the war was over. By 1946 the hostile critic Milton Brown could write in the April issue of the *Magazine of Art* of the "vogue" for abstraction and remark testily that "the experience of the war and world crisis have not shaken the artist out of his esthetic shell." Brown specifically lamented the success of Avery, Graves, and Tobey, the last of whom had had a one-man show at the Willard Gallery in 1944 in New York—the first since 1917.

The number of seriously engaged critics grew rapidly during the war years. From the surrealist camp came Parker Tyler, with his sophisticated reviews of both films and painting, and Nicolas Calas, a young Greek poet and critic whose volatile temperament was first revealed in the pages of *View*. From the ranks of the old left-wing literati came both Clement Greenberg and Harold Rosenberg, whose voices continue to dominate American art criticism today, although both have changed considerably in tone. These and a few others managed to keep a steady stream of intelligent discourse and commentary alive in the pages of both political and literary reviews. Barr, Sweeney, James Thrall Soby, and others identified with institutions also contributed to the growing literature on contemporary American art. For the first time, the visual arts began to assume for editors the importance they had always given to music, literature, and even the dance.

## The New York School: Artists, Critics, and Dealers

*The Nation,* which as late as 1940 was resolutely silent on painting and sculpture (in its 75th Anniversary issue in February 1940 there were commentaries on music, records, books, theater, and film, but no art), engaged Clement Greenberg, who began regular reviewing of art shows early in 1941. (Before that time Greenberg, like most other intellectuals, had been largely interested in a socialist analysis of the arts—an attitude he later relinquished almost entirely, leaving the field to Rosenberg.) *The New Republic,* which had featured sociological film criticism by Manny Farber, which had covered poetry and literature exceptionally well and was even advanced enough to have a regular column on science and technology during the war years, was finally persuaded about 1945 to recognize painting and sculpture. Manny Farber then switched to art criticism, bringing insight and verve to his reviews, especially of the works exhibited at Art of This Century.

The art magazines were on the whole unaware of the new situation. Between 1941 and 1945, the *Magazine of Art* did not mention a single abstract expressionist; but when Robert Goldwater was appointed editor in 1948 he promptly ran features on de Kooning, Motherwell, and Still. *Art Digest* was consistently unfavorable; and even *Art News,* which was shortly to become, in the hands of Thomas B. Hess, the leading advocate of abstract expressionist painting, was singularly unimpressed by it during the war years.

It was largely in *Partisan Review,* where George L. K. Morris, Motherwell, Sweeney, and finally Greenberg wrote, and in *The Nation,* where Greenberg passionately promoted the new reputations, that the critical writing became significant. The most consistent writer was Greenberg who, after 1939, abandoned Marxist analysis in favor of descriptive writing about specific artists and works of art. He assumed the role of leading art critic during the war years, forsaking the mantle of the man of letters. He showed himself to be a good pupil of Hofmann, and in one of his first *Nation* pieces analyzed the characteristic bias of the American mind as its positivism, its reluctance to speculate, its eagerness for quick results, and its optimism. All the same, his own bias soon appeared when he launched attacks on what he called "neo-romanticism." His bêtes noires were the surrealists, whom he accused of reversing the anti-pictorial trend of cubist and abstract art (on November 14, 1942). The "laws" of which Hofmann had

always spoken were very attractive to Greenberg, who adapted the rhetoric of Hofmann's studio in his early criticism, always referring to cubist space and to the crimes of those who poked holes in the canvas, those whose work was anecdotal, and those who abandoned the tenets of modernism as passed down from Cézanne to the cubists. In 1943 he attacked Mondrian's *Broadway Boogie-Woogie* as wavering and awkward (and in the next issue had to apologize for having reported that there was orange, purple, and impure color in the painting). He also criticized Matta for making "the comic strips of abstract art," and he complained of the Museum of Modern Art's taste for the School of Paris. For the next year or so, Greenberg continued to harry the museum for its support of the romantic revival, which he considered retrograde. In January 1944 he remarked that American art, like American literature, seemed to be in retreat and lamented that everyone couldn't see that the only possibility of originality was in abstract art. There is clear evidence of Hofmann's teachings in all his criticism written between 1943 and 1944. His insistence that a painting must not be a window in a wall, and that two-dimensionality and the picture plane must be respected, comes through again and again. Greenberg's tendency toward obiter dicta appears early and nearly always sounds prescriptive. His antipathy for the surrealists was unbounded, and he would point out their deficiencies whenever he could. In view of his devotion to Pollock, from whom he undoubtedly learned a great deal, it is strange that he never modified his views about the surrealists. But this was not in his temperament, as subsequent years would prove. Rather, he had a stern exclusive preoccupation, which made him inaccessible to anything that appeared to depart from the central abstract tradition: "The extreme eclecticism now prevailing in art is unhealthy and it should be counteracted, even at the risk of dogmatism and intolerance" (June 10, 1944).

The growing interest in Kandinsky around 1945 incensed Greenberg, who again employs Eighth-Street studio rhetoric to denounce Kandinsky's paintings—in which the picture planes are "pocked with holes" and the "negative space" is not properly accounted for. Perhaps Pollock's obvious regard for Kandinsky and Gorky's outright homage galled Greenberg. In his review of Gorky's show in 1945 he didn't mention Kandinsky, but instead reproached Gorky for replacing Miró and Picasso with "that

prince of the comic strippers, Matta," and for the easy "bio-morphism" to which it led; and on April 7, 1945, in reviewing Pollock's second one-man show, he complained that Pollock sometimes left "gaping holes" in his canvas. (Given Greenberg's distaste for the free expressionist works of Kandinsky and Gorky, his devotion to Pollock might almost seem an aberration; perhaps it was the personal contact with Pollock which made Greenberg, for a time, his most eloquent advocate.)

Greenberg's resistance to the increasingly lyrical tendency in the abstract painters can be felt in his review of an exhibition at Howard Putzel's new gallery. In the issue of June 9, 1945, he commented on the "New Metamorphism," seeing in the tendency toward poetry and imagination a rebellion against cubism which he found regrettable. What he called the "return of elements of representation, smudged contour lines and the third dimension" are, in his opinion, regressive. He objected because "instead of exploring the means of his art in order to produce his subject matter, he will hunt about for new 'ideas' under which to cover up the failure to develop his means."

Pollock was obviously exploring *his* means in 1945, but he probably had more in common with his poetic confrères than Greenberg wished to concede. In fact, he had to insist that Pollock's "habits of discipline" and "unity" stemmed from his obeisance to the fundamentals of cubism. A certain scholastic insistence on category underlines all Greenberg's early criticism. By repeating the magic word cubism (either as what artists must respect as fundamental to the modern tradition, or as what they must go beyond, as exemplars of the modern tradition) Greenberg keeps his footing in the world of form. Everything that seemed to deviate from this position (and it is astonishing that in his eyes Pollock did not) came in for criticism. For instance, when Gottlieb, Rothko, Still, and Newman first appeared on the horizon, Greenberg was distinctly hostile. Of Gottlieb's exhibition he wrote in the issue of December 6, 1947:

> I myself would question the importance this school attributes to the symbological or metaphysical content of its art; there is some-thing half-baked and revivalist in a familiar American way about it. But as long as this symbolism serves to stimulate ambitious and serious painting, differences of "ideology" may be left aside.

467

What made the first phase of Greenberg's criticism important in the genesis of the new American painting was his willingness to speak firmly, and often with keen passion, of the issues that pre-occupied the artists who interested him. His ear for studio talk—always important to a good art critic—was alert, and his ambition for his chosen artists was tremendous. This ambition made it possible for him to claim, unabashedly, superior status for Pollock and later for one or two others. It enabled him to declare that Pollock was "great" (a statement that would have made another art critic blush), and that there was something brewing in America that was superior to developments elsewhere. His role as *agent provocateur* in relation to the general public was indispensable. When Greenberg said "great," the press replied "heaven forbid"; but Greenberg's consistency and his confidence could not be ignored.

Another extremely important function he performed, along with the few other things writing in the intellectual weeklies and monthlies, was to bring painting and sculpture into focus as a significant sector in the arts. By their writing in *The Nation* or *Partisan Review* or *The New Republic,* these few critics reached what Maritain called the enlightened public, the same public that Alfred Barr had been patiently besieging for two decades. When the man of letters, the poetry lover, or the college-educated professional opened the pages of these publications, he was reminded again and again not only that America had painters and sculptors, but also that they were exceptional. In this way the growing sense of importance felt by the artists and critics themselves was communicated to a widening public. And since so intelligent and perceptive a man as Greenberg was willing to see greatness in this new phase of American culture, it was not difficult for others to accept the possibility that it was true. Even if the seemingly wild and anarchic creations of Pollock were not understood, the knowledge that he and a few others—the mad geniuses of America—existed was very appealing to the perpetually hungry cultural enthusiasts.

The artists themselves, unaccustomed to so much serious approval, began to feel they really had something going that required close examination. Conversations in the Waldorf Cafeteria took on new color, and issues were discussed in new terms. Gradually reference to European precedents was sublimated. By the end of the war, the New York artists and their friends on the

West Coast were fairly certain that their special situation was new and the idea that there was indeed a modern *American* painting grew in their consciousness, no matter how obliquely. This liberated many spirits from old conflicts, enabling them to address themselves to the broader issues. One of the artists most given to discourse, Robert Motherwell, tried to summarize these issues in a talk given at Mount Holyoke College in 1944 and published by his friend Paalen in *Dyn*. Given Motherwell's position within the new situation—his intimacy with Baziotes, Pollock, and for a time Rothko and Matta, and his exhibiting at Art of This Century—it is safe to assume that the questions he discussed were commonly regarded by the New York painters as pressing and worth discussion.

Calling his essay "The Modern Painter's World," Motherwell, only a few years removed from his studies with Meyer Schapiro, undertook an analysis of the relation of the painter to the middle-class world. Schapiro's views are reflected when Motherwell says that modern artists have always met with hostility from the middle class:

> In the face of this hostility, there have been three possible attitudes of which the artist was not always conscious; to ignore the middle class and seek the eternal, like Delacroix, Seurat, Cézanne, the cubists and their heirs; to support the middle class by restricting oneself to the decorative like Ingres, Corot, the impressionists in general, and the fauves; or to oppose the middle class like Courbet, Daumier, Pissarro, Van Gogh and the dadaists. . . .

This discussion in terms of a class society, of historical values, of the roles of Marxism and Freudianism, reflects Motherwell's inheritance from the thirties. But the optimistic and often naïve assumptions made by the Marxist critics during that period are avoided in Motherwell's propositions. He isolates one central problem for the young artists who had emerged from the experience of war and genocide: "The artist's problem is *with what to identify himself.* The middle class is decaying, and as a conscious entity the working class does not exist. Hence the tendency of modern painters to paint for each other." Motherwell sees little hope of mending the breach between the modern artist and his predominantly middle-class society, and he sees the real crisis in "the modern artist's rejection, almost in toto, of the values of the

bourgeois world." He acknowledges that the surrealists have attacked those values too but rejects their abjuration of the mind (or formal values) which, as he says, can be actualized in the act of painting (here, he speaks in concert with Paalen, who had already announced his departure from surrealist convictions): "Painting is therefore the mind realizing itself in color and space. The greatest adventures, especially in the brutal and *policed* period, take place in the mind."

Throughout the essay there is a rueful, pessimistic undertone, a consciousness of the degradation of war-prone bourgeois society and, necessarily, the artists within it. Motherwell examines the possible ways of expressing the epoch and concludes that the eternal esthetic values—those that derive purely from form—provide the only means for the modern artist who stands in opposition to society; that basically he has little choice but to strengthen and deepen his abstraction. This, clearly, is a regretful conclusion on Motherwell's part. His earlier thoughts on Marxism, and his initial excitement about surrealism, have had to give way. On this point particularly there must have been widespread agreement among the artists of the New York School. As they gained confidence, so they found the courage to throw out even their most cherished assumptions. The drift toward metaphysics and toward pure estheticism were both to be means of escape from the confusion of the nineteen-thirties. Motherwell's regret that the American artist could not paint a *Guernica,* that he could no longer hope to find the symbols that would relate him to his fellows, was, as he later demonstrated in his own series of symbolic paintings on the Spanish Civil War, permanent. The conflicts were never to be resolved, but as the artist moved into the second half of the forties, the issue of his relationship to society was more or less forgotten.

Most artists seemed inclined to accept Motherwell's first proposition to ignore the middle class to seek the eternal; a few, however, set themselves up as "personalities" in aggressive opposition. Only three years later, when Motherwell and Harold Rosenberg founded what was to be a single-issue magazine, *Possibilities,* the tone had become even more pessimistic. This was all the more significant in view of Rosenberg's immediate past. He had seen the keenest moments of accomplishment during the W.P.A. period, and must certainly have shared the soaring hopes of his generation just before World War II. After his brief stint as

editor of *Art Front*, Rosenberg went to Washington on the writers' project, where he was national art editor of the American Guide Series. This remarkable group of books, produced by many distinguished writers, set out the history and cultural history of various American regions and remains a model for such undertakings. As editor from 1938–42, Rosenberg would have seen a vast amount of previously neglected cultural material. With this broad synoptic view, he laid the foundation for his penetrating cultural criticism in years to come. While the American Guides were being produced, everyone involved saw broad cultural opportunities but, writing in the journal *Possibilities* only a few years later, Motherwell felt they had become depressingly circumscribed.

Rosenberg and Motherwell declared that "through a conversion of energy something valid may come out, whatever situation one is forced to begin with . . . if one is to continue to paint or to write as the political trap seems to close upon him he must perhaps have the extremest faith in sheer possibility. . . ."[5] This pessimistic statement that something *might* come out of what realistically appeared a hopeless situation undoubtedly reflected one aspect of the abstract expressionists' ambivalence. As a statement of their last remaining value—that of their individuality somehow mirrored forth in their work—it represents both their despair and their wild hope. It definitely indicates that their earlier faith in the value of political action, symbolic social-content painting, group activity and programatic movements had been eroded. All that remained was what Rosenberg later called their "action" on the canvas, and the "extremist faith in sheer possibility."

Looking back in 1955, Greenberg found that 1947 and 1948 constituted a turning point. He wrote that in 1947 there had been a great stride forward in general quality, and that in 1948 "painters like Philip Guston and Bradley Walker Tomlin 'joined up' to be followed two years later by Franz Kline. Rothko abandoned his 'surrealist' manner; de Kooning had his first show; and Gorky died." His slighting reference to those who "joined up" indicates that the long-hoped-for constellation that could be called a New York school was becoming visible, and also viable. There was unquestionably a surge of enthusiasm among painters all over the country as they began to hear of a real movement, and they

were drawn eastward. People down at the Waldorf Cafeteria were talking away, their ranks swelling daily. Uptown there were new galleries opening; museums were beginning to take notice. The myths that had supported the vanguard few were slowly being controverted, although the decisive moment didn't arrive until several years later.

Greenberg took note of those myths in an article in *Horizon* in October 1947, writing that

> The morale of that section of New York's Bohemia which is inhabited by striving young artists has declined in the last 20 years, but the level of its intelligence has risen, and it is still downtown, below 34th Street, that the fate of American art is being decided— by young people, few of them over forty, who live in cold-water flats and exist from hand to mouth. Now they all paint in the abstract vein, show rarely on 57th Street, and have no reputations that extend beyond a small circle of fanatics, art-fixated misfits who are isolated in the United States as if they were living in Paleolithic Europe.

And three months later in *Partisan Review* he again referred to fifth-floor cold-water studios, poverty and the "neurosis of alienation." He maintained that the myth of bohemia in nineteenth-century Paris was only an anticipation; it was in New York that it had become completely fulfilled, and it was clear that he believed in the myth as a constructive force. Having already reached an art-for-art's-sake position by 1945, Greenberg found it congenial, while lamenting the "alienation"—a term that appeared not only in his own column in *Partisan Review* but also in the writing of almost everyone else's work published there in 1948— to take solace in the fierce individualism such alienation engendered. He was attracted, as intellectuals often are, to the Promethean violence of conviction many of the downtown artists displayed when times were hard. From this band who had touched spiritual bottom he expected to force a movement, even though he pretended to see their plight as injurious, and asked plaintively in 1947, "what can fifty do against a hundred and forty million?"

Greenberg's discernment showed when he grasped that the real fruits of the spiritual malaise of his *peintres maudits* were those large and daring paintings that led him to speak of "The Crisis of the Easel Picture."[6] It is quite possible that he got this idea from Pollock, who early in 1947 wrote in his application for a Guggen-

heim grant that he intended to paint "large, movable pictures that will function between the easel and mural," and added: "I believe easel painting to be a dying form, and the tendency of modern feeling is toward the wall picture or mural." Thereafter, Greenberg raised the issue again and again, always suggesting that the easel painting would be replaced by the new "polyphonic" modes suggested in Pollock's paintings. Curiously, his article in *Partisan Review* included a number of reproductions of the work of de Kooning, whose first exhibition had been a signal event that year, and who stubbornly persisted in easel painting.

De Kooning's myth was well established. He had been considered, as Hess understood, a "painters' painter" since the thirties. He was, as Denby has said many times, absolutely incorruptible, a man who lived a life of total honesty, and who chose the uncomfortable rather than conform to anyone else's idea of what a painter's life should be. He had always lived as a "loft rat" and at the same time had always been a cosmopolitan. His cosmopolitanism was exemplified in his association with so rarely sensitive an intellectual as Denby; with Graham, Gorky, and Bruckhardt; with Cage; and with a great many poets, writers, and connoisseurs who were not intimately connected with his downtown routines. It was apparent in his tremendously knowledgeable conversation about painting and in his deep interest in the history of art and culture. He loved the complexity of the cosmopolis, and he found in its physical appearance an excitement and beauty that he consciously tried to reflect in his paintings.

Throughout the forties, those who gravitated to New York, or who painted by day and talked with each other by night, heard stories of de Kooning's courageous resistance to blandishments both from dealers and from occasional patrons. It was well known that he and Gorky chose poverty rather than to compromise in their work. De Kooning's reputation for working slowly, scraping out, starting all over again, and never really finishing a painting, was legendary already in 1943, when Denby recalls how conscientiously de Kooning sought to avoid the gratuitously beautiful, and how, despite the chance to exhibit in a good uptown gallery if he could only produce finished pictures, de Kooning waited and worked. It was Charles Egan who at last managed to get together de Kooning's first one-man show. Egan, who is fondly remembered to this day by many of the artists he once exhibited, had long been acquainted with downtown bohemia. He was in-

telligent, genuinely interested in painting, and had enough humor to be acceptable to the inner circle at the Waldorf, as well as in individual studios. His own idiosyncracies and his bohemian temperament endeared him to many painters who, even when exasperated with his dilatory appearances at the gallery, never despised him as they did so many dealers who sprang up in the late forties and early fifties.

Egan had had a good background. He had begun as a young salesman in 1935 in Wanamakers' art gallery. There he immediately began introducing contemporary artists, among them John Sloan and Stuart Davis. Later he worked at the Ferrargil Galleries which also dealt in contemporary American art, and still later, he worked with the veteran J. B. Neumann. When he opened his own gallery in 1945, he began with older American painters (Stella and Walkowitz) but paid close attention to what was happening among the younger vanguard painters. His independence of spirit, always marked and sometimes detrimental to the marketing aspects of his business, must have impressed de Kooning. With his first exhibition, both he and Egan had their long labors crowned with surprising success. All those who had ever heard of the de Kooning legend flocked to the modest gallery, often to find the doors locked, since Egan always kept irregular hours and loathed the businessman's code. All the same, the press turned out in full force, the museums sent representatives, and the event was a spectacular success in the art world.

There were a few other dealers whom the artists respected, and whose energies were devoted to the realization of an important school of modern American painting. Sam Kootz, a tall, genial southerner who had already indicated his interest when he published *New Frontiers in American Painting* in 1943, and who had been responsible for the huge exhibition at Macy's, took over Baziotes and Motherwell from Peggy Guggenheim and, when he opened his gallery in 1945, represented also Byron Browne, Carl Holty, and Adolph Gottlieb. Wisely, he persuaded literary men to provide catalog introductions, so that the artists' work was often presented with well-written critical essays. He was also shrewd enough to stock his back room with Picassos to keep the gallery going until the market for his young rebels would materialize. In his memoir in the *Archives of American Art*[7] he recalls that Alfred Barr liked Motherwell, Gottlieb, and Baziotes—a fact that would be very significant to any dealer at that time trying to get started

with an American stock. He also mentions how few the sales were during the period, and how low the prices; for example, one picture by de Kooning from the "Black and White Show" in 1949 (the only one he sold) went for $700.

Another influential dealer whom the artists liked was Betty Parsons. She had the advantage of having come from the upper classes, of being familiar with their mores and their peculiar areas of snobbery, and of knowing many of the patrons of the Museum of Modern Art through her family connections. Her other advantage was that she had rebelled at an early age and had gone to Paris to study art. She began exhibiting in New York in the mid-thirties. Her acquaintance with such influential figures as Frank Crowninshield of *Vanity Fair* (a close friend of most of the Museum of Modern Art's original trustees) undoubtedly made her entrée in the field of art-dealing easier. Her first notable gestures were when she was a partner at the Wakefield Bookstore, where she was a cordial and sympathetic viewer of almost any art brought to her attention. When Mortimer Brandt took over the shop, he made Betty Parsons director of the contemporary section, and it was there she presented Theodore Stamos, Adolph Gottlieb (with a catalogue introduction by Barnett Newman), and works by Rothko, Hedda Sterne, and Ad Reinhardt. In September 1946 she opened the Betty Parsons Gallery.

Peggy Guggenheim relates that when she closed up shop she tried to find a dealer willing to take on Jackson Pollock. The only one courageous enough was Betty Parsons, who also fell heir to Rothko and Still. Her first show was arranged by Barnett Newman, whose judgment and humor Betty Parsons keenly appreciated. Thereafter, Newman was a considerable force in the decisions of the gallery and, for a time, Newman, Rothko, and Still formed a distinct trio in the gallery, with Pollock somewhat apart. Because of her intelligence and her outstanding sense of justice, Betty Parsons was able to cope with the considerable temperamental tension these men generated. Both Still and Rothko had already begun to shield themselves from the encroachment of an affluent society by provocative gestures of refusal and statements of their incorruptibility. For a dealer trying to build a market, such behavior could be very trying, but Betty Parsons, herself an artist, was not only patient, but also supportive. In their efforts to control the "life" of their paintings, Still, Rothko, and Newman seemed to have consulted with each other. Still, in his letters to

Betty Parsons, was constantly arguing against group exhibitions and art appreciation in general, and he and Rothko refused to show at the Whitney Museum, proffering arguments that were phrased practically identically. This early quarrel with the establishment grew more acute as the fame of these artists grew, and their dealers' problems increased accordingly.

All the same, the new dealers were working effectively with the museums and the small sympathetic press, and mutual interest served to create an ever-widening interest. For instance, when *Life Magazine*, with rather pompous pride, presented its first Round Table on Modern Art[8] ("in which fifteen distinguished critics and connoisseurs undertake to clarify the strange art of today") the paintings of "young American extremists" reproduced and discussed by the experts included de Kooning's 1948 *Painting*, which had just been acquired from Egan by the Museum of Modern Art; Baziotes' *The Dwarf*, warmly defended by the Museum's own James Thrall Soby (against Greenberg's assertion that it was bad art); Gottlieb's *Vigil*, shown by Kootz the year before; Stamos' *Sounds in the Rock*; and Pollock's *Cathedral*, which had just been shown that season at Betty Parsons to the predictable praise of Greenberg and Sweeney. Both the selection of paintings and the choice of experts indicate that the newly established galleries for American vanguard art were making headway in broadcasting the importance of their venture. That so many distinguished experts—among them Meyer Schapiro, Aldous Huxley, and Georges Duthuit—could be gathered together by *Life* to consider an absurdly posed question on modern art, was in itself a measure of the need postwar America was feeling for the modern art experience. The question posed for these experts was: "Is modern art, considered as a whole, a good or bad development? That is to say, is it something that responsible people can support, or may they neglect it as a minor and impermanent phase of culture?" Their willingness to deal with such a loaded question is some indication of their missionary intentions.

The enthusiasm of the experts predictably met with increasingly agitated hostility from most of the popular papers, and in May 1949, Holger Cahill expressed in the *Magazine of Art* his anxiety concerning the growing attacks on "unintelligibility," particularly on artists who came out of the thirties. He named Rothko, Pollock, Motherwell, Baziotes, Cavallon, Still, Gottlieb,

## The New York School: Artists, Critics, and Dealers

Hare, Smith, Gorky, de Kooning, and Tomlin as significant artists who were not appreciated, and he lamented the impoverished state of art criticism. This list of names betrays Cahill's own evolution from the thirties, when he was still hoping that American art would relate to the people. Clearly, no one in his position could any longer entertain such hopes. The breach was widening rather than narrowing.

*NOTES*

[1] Peggy Guggenheim, *Confessions of an Art Addict* (New York: Macmillan, 1960).

[2] Elaine de Kooning, *Art News* (New York), April 1967.

[3] Ethel K. Schwabacher, *Arshile Gorky* (New York: Macmillan, 1957).

[4] Clement Greenberg, in *The Nation* (New York), March 24, 1945.

[5] Harold Rosenberg and Robert Motherwell, *Possibilities* (New York), Fall 1947.

[6] Clement Greenberg, *Partisan Review* (New York), April 1948.

[7] Sam Kootz, in an interview with Dorothy Seckler, April 13, 1964.

[8] *Life*, October 11, 1968.

# *24.* SYSTEMIC PAINTING

## *Lawrence Alloway*

### INTRODUCTION

This selection—by an art critic, not an art historian—like any criticism of its contemporary art scene, stands in a special relationship to the art it deals with. As Alloway points out in the Introduction to his *Topics in American Art Since 1945*, an anthology of his criticism, "the closeness in time of the critical text and the making of the work of art gives art criticism its special flavor." It is essentially "the record of spontaneous response and fast judgment to the presence of new work." Art criticism of contemporary work therefore accepts the risks of the moment along with the artists themselves. In the flux of the moment there is little of the security to be found in the relatively stable medium of history that encompasses the older arts in the museums and art history texts. History has a slow, settling process of evaluation, the accretion of countless opinions and dialogues, that functions quietly and inexorably as both preserver and destroyer. For the critic of the contemporary scene this process has barely begun.

Although Alloway feels that there is a risk of art history "abridging the freedom of the critic" when a deterministic view of historical process is imposed on the recent and current scene, there are many other—even, perhaps, inescapable—factors that shape a critic's point of view, for the critic is no more than the rest of us a *tabula rasa*, entirely free of preconceptions and partialities, the cultural hand dealt out by the years of our lives. As the reader will discover, Alloway touches on the significance of the critic's point of view when he discusses the criticism of Clement Greenberg.

For further reading on the art of the recent past, see Clement Greenberg, "Modernist Painting," *Arts Yearbook*, IV (1961), 101–108; William C. Seitz, *The Art of Assemblage* (1961); Clement Greenberg, "After Abstract Expressionism," *Art International*, VI, 8 (1962), 24–32; Michael Fried, "Modernist Painting and Formal Criticism," *The Ameri-*

can Scholar (Autumn 1964), 642–648; William C. Seitz, *The Responsive Eye* (1965); Michael Fried, *Three American Painters: Kenneth Noland, Jules Olitski, Frank Stella* (1965); Allan Kaprow, *Assemblage, Environments, and Happenings* (1966); Peter Selz and George Rickey, *Directions in Kinetic Sculpture* (1966); Kynaston McShine, *Primary Structures* (1966); Lucy R. Lippard, *Pop Art* (1966); Barbara Rose and Irving Sandler, eds., "Sensibility of the Sixties," *Art in America*, LV (1967), which consists of statements by contemporary artists; Gregory Battcock, ed., *Minimal Art: A Critical Anthology* (1968); Harold Rosenberg, *Artworks and Packages* (1969); John Coplans, *Andy Warhol* (1970); Clement Greenberg, "Avant-Garde Attitudes: New Art in the Sixties," *Studio International*, CLXXIX (April 1970), 142–145; Michael Fried, *Morris Louis* (1970); William S. Rubin, *Frank Stella* (1970); Ellen Johnson, *Claes Oldenburg* (1971); Ursula Meyer, *Conceptual Art* (1972); John Coplans, *Ellsworth Kelly* (1972); Robert Pincus-Witten, *Postminimalism: American Art of the Decade* (1978); and Edward Lucie-Smith, *Super Realism* (1979).

The selection that follows is abridged from *Systemic Painting* by Lawrence Alloway. Copyright 1966 by The Solomon R. Guggenheim Museum. Reprinted by permission of the author and The Solomon R. Guggenheim Museum.

The painting that made American art famous, done mostly in New York between 1947 and 1954, first appeared as a drama of creativity. The improvisatory capacity of the artist was enlarged and the materiality of media stressed. The process-record of the creative act dominated all other possibilities of art and was boosted by Harold Rosenberg's term Action Painting. This phrase, though written with de Kooning (Fig. 64) in mind, was not announced as such, and it got stretched to cover new American abstract art in general. The other popular term, Abstract Expressionism, shares with "action" a similar over-emphasis on work-procedures, defining the work of art as a seismic record of the artist's anxiety. However, within this period, there were painters who never fitted the lore of violence that surrounded American art. The work of Clyfford Still, Barnett Newman, and Mark Rothko was clearly not offering revelatory brushwork with autobiographical implications. Not only that, but an artist like Pollock, who in his own time seemed all audacious gesture, appears very differently now. His large drip paintings of 1950 have been, as it were, de-gesturized by a few years passing: what once looked like impulsive directional tracks have condensed into unitary fields of color. This all-over distribution of emphasis and the consequent pulverizing of hierarchic form relates Pollock to Still, Newman, and Rothko.

. . . Dissatisfaction with the expressionist bulk of New York painting was expressed by the number of young painters who turned away from gestural art or never entered it. Jasper Johns' targets from 1955, Noland's circles from late 1958, and Stella's symmetrical black paintings of 1958–59 are, it can now be seen, significant shifts from the directional brushwork and projected anxiety of the Expressionists. Rauschenberg's twin paintings, *Factum I* and *Factum II*, 1957, along with duplicated photographs, included almost identical paint splashes and trickles, an ironic and loaded image. A gestural mark was turned into a repeatable object. The changing situation can be well indicated by the opinions of William Rubin [in 1960]: he not only deplored

64. Willem de Kooning, *Woman and Bicycle*, 1952-1953, Oil on canvas, 76½" x 49" (Collection of the Whitney Museum of American Art)

"the poor quality of 'de Kooning style painting'," he also assumed the failure of de Kooning himself and praised Clement Greenberg's "prophetic insight" in foreseeing the expressionist cul-de-sac.[1] It is symptomatic that three years later Ben Heller stated, "the widespread interest in de Kooning's ideas has been more of a hindrance than a help to the younger artists."[2] In fact, it was now possible for Heller to refer to "the *post*-de Kooning world" (my italics). In the late 50's de Kooning's example was oppressively accepted and alternatives to it were only fragmentarily visible. There was (1) the work of the older Field painters, (2) the development of stained as opposed to brushed techniques (Pollock 1951, Frankenthaler 1952, Louis 1954), and (3) the mounting interest in symmetrical as opposed to amorphous

formats, clear color as opposed to dirty, hard edges as opposed to dragged ones.

Barnett Newman's paintings have had two different audiences: first the compact group of admirers of his exhibitions in New York in 1950 and 1951. Second, the larger audience of the late 50's, with the shift of sensibility away from gestural art. As with any artist who is called "ahead of his time" he has a complex relation with subsequent history. On the one hand he has created his own audience and influenced younger artists; on the other hand, his art was waited for. There was talk and speculation about Newman even among artists who had not seen his work. Newman asserted the wholistic character of painting with a rigour previously unknown; his paintings could not be seen or analyzed in terms of small parts. There are no subdivisions or placement problems; the total field is the unit of meaning. The expressionist element in Still . . . and the seductive air of Rothko, despite their sense of space as field, meant less to a new generation of artists than Newman's even but not polished, brushed but not ostentatious, paint surface. In addition, the narrow canvases he painted in 1951, a few inches wide and closely related in height to a man's size, prefigure the development of the shaped canvas ten years later. Greenberg, considering the structural principles of Newman's painting in the absence of internal divisions and the interplay of contrasted forms, suggested that his vertical bands are a "parody" of the frame. "Newman's picture becomes all frame in itself," because "the picture edge is repeated inside, and *makes* the picture instead of merely being *echoed*."[3] This idea was later blown up by Michael Fried into deductive structure[4] and applied to Frank Stella's paintings in which the stretcher, as a whole, not just the sides, sets the limits for the development of the surface.[5] Although this idea is not central to the paintings of Newman, it is indicative of his continuous presence on the scene in the 60's that a proposed esthetic should rest, at least partially, on his work.

Alternatives to Abstract Expressionism were not easily come by in the 50's and had to be formulated experimentally by artists on their own. Leon Smith, who had already suppressed modelling and textural variation in his painting, studied in 1954, the stitching patterns on drawings of tennis balls, footballs, and basketballs. These images laid the foundations of his continuous, flowing space, both in tondos, close to the original balls, and transferred to rectangular canvases. In France, Ellsworth Kelly made a series

65. Frank Stella, *Tuftonboro, IV,* 1966, Fluorescent alkyd and epoxy paint on canvas, 8'4⅛" x 9'¾" (Collection, The Museum of Modern Art, New York, Gift of David Whitney)

of panel paintings, in which each panel carried a single solid color. There is an echo of Neo-plastic pinks and blues in his palette, but his rejection of visual variation or contrast was drastically fresh, at the time, 1952–53. Ad Reinhardt, after 1952, painted all red and all blue pictures on a strictly symmetrical lay-out, combining elements from early 20th-century geometric art and mid-century Field painting (saturated or close-valued color). These . . . artists demonstrate an unexpected reconciliation of geometric art, as structural precision, and recent American painting, as colorist intensity. . . . It is to this phase of non-expressionistic New York painting that the term Hard Edge applies (Fig. 65). "The phrase 'hard-edge' is an invention of the California critic, Jules Langsner, who suggested it at a gathering in Claremont in 1959 as a title for an exhibition of four non-figurative California painters,"[6] records George Rickey. In fact, Langsner originally intended the term to refer to geometric ab-stract art in general, because of the ambiguity of the term "geo-metric," as he told me in conversation in 1958. Incidentally, the

exhibition Rickey refers to was called eventually *Four Abstract Classicists*. The purpose of the term, as I used it 1959–60, was to refer to the new development which combined economy of form and neatness of surface with fullness of color, without continually raising memories of earlier geometric art. . . .

. . . "Forms are few in hard-edge and the surface immaculate. . . . The whole picture becomes the unit; forms extend the length of the painting or are restricted to two or three tones. The result of this sparseness is that the spatial effect of figures on a field is avoided."[7] This wholistic organization is the difference that Field Painting had made to the formal resources of geometric art.[8] . . .

It is not necessary to believe in the historical succession of styles, one irrevocably displacing its predecessor, to see that a shift of sensibility had occurred. In the most extreme view, this shift destroyed gestural paintings; in a less radical view, it at least expanded artists' possible choices in mid-century New York, restoring multiplicity. Newman's celebrated exhibition at Bennington College in 1958 was repeated in New York the following year, and the echoes of his work were immense. In 1960 Noland's circles which had been somewhat gestural in handling, became more tight and, as a result, the dyed color became disembodied, without hints of modeling or textural variation. Stella's series of copper paintings in 1961 were far more elaborately shaped than the notched paintings of the preceding year; now the stretchers were like huge initial letters. In 1962 Poons painted his first paintings in which fields of color were inflected by small discs of color; Noland painted his first chevrons, in which the edges of the canvas, as well as the center, which had been stressed in the circles, became structurally important; and Downing, influenced he has said by Noland, painted his grids of two-color dots. In 1963 Stella produced his series of elaborately cut-out purple paintings and Neil Williams made his series of sawtooth-edged shaped canvases. Other examples could be cited, but enough is recorded to show the momentum and diversity of the new sensibility.

A series of museum exhibitions reveals an increasing self-awareness among the artists which made possible group appearances and public recognition of the changed sensibility. The first of these exhibitions was *Toward a New Abstraction* (The Jewish Museum, Summer 1963) in which Ben Heller proposed, as a cen-

tral characteristic of the artists, "a conceptual approach to paint-ing."[9] In the following year there was *Post Painterly Abstraction* (The Los Angeles County Museum of Art, Spring) in which Clement Greenberg proposed that the artists included in the show revealed a "move towards a physical openness of design, or towards linear clarity, or towards both."[10] Heller and Greenberg, the former no doubt affected by Greenberg's earlier writing, were anti-expressionists. . . . Noland occupied half the U.S. Pavillion at the Venice Biennale in 1964 and had a near retrospective at The Jewish Museum in the following year. In the summer of 1965 the Washington Gallery of Modern Art presented *The Washington Color Painters*, which included Noland, Downing, and Mehring. Finally, in the spring [of] 1966 The Jewish Museum put on a sculpture exhibition, *Primary Structures*. . . . Critical and public interest in the early 60's had left Abstract Expressionism, and the main area of abstract art on which it now concentrated can be identified with Clement Greenberg's esthetics.

Greenberg's *Post Painterly Abstraction* was notable as a con-solidation of the null-expressionist tendencies so open in this critic's later work. He sought an historical logic for "clarity and openness" in painting by taking the cyclic theory of Wölfflin, according to which painterly and linear styles alternate in cycles. Translated into present requirements, Abstract Expressionism figures as painterly, now degenerated into mannerism, and more recent developments are equated with the linear. These criteria are so permissive as to absorb Frankenthaler's and Olitski's free-form improvisation and atmospheric color, on the one hand, and Feeley's and Stella's uninflected systemic painting as well. It is all Post Painterly Abstraction, a term certainly adapted from Roger Fry's Post-Impressionism, which similarly lumped together painters as antithetical as Van Gogh, Gauguin, Seurat, and Cézanne. The core of Post Painterly Abstraction is a technical procedure, the staining of canvas to obtain color uninterrupted by pressures of the hand or the operational limits of brush work. Poured paint exists purely as color, "freed" of drawing and modelling; hence the term Color Painting for stain painting.[11] It is characteristic of criticism preoccupied with formal matters that it should give a movement a name derived from a technical con-stituent. The question arises: are other, less narrow, descriptions of post-expressionist art possible than that proposed by Green-

berg? It is important to go into this because his influence is extensive, unlike that of Harold Rosenberg (associated with Action Painting), but there is a ceiling to Greenberg's esthetic which must be faced.

The basic text in Greenberg-influenced criticism is an article, written after the publication of *Art and Culture,* but on which the essays in his book rest, called "Modernist Painting."[12] Here he argues for self-criticism within each art, "through the procedures themselves of that which is being criticized." Thus "flatness, two-dimensionality, was the only condition shared with no other art, and so modernist painting oriented itself to flatness." This idea has been elaborated by Michael Fried as a concentration on "problems intrinsic to painting itself."[13] This idea of art's autonomy descends from 19th-century estheticism. "As the laws of their Art were revealed to them (artists), they saw, *in the development of their work,* that real beauty which, to them, was as much a matter of certainty and triumph as is to the astronomer the verification of the result, foreseen with the light given to him alone."[14] Here Whistler states clearly the idea of medium purity as operational self-criticism, on which American formalist art criticism still rests. Whistler typifies the first of three phases of art-for-art's sake theory: first, the precious and, at the time, highly original estheticism of Walter Pater, Whistler, and Wilde; second, a classicizing of this view in the early 20th century, especially by Roger Fry, stressing form and plasticity with a new sobriety; and, third, Greenberg's zeal for flatness and color, with a corresponding neglect of non-physiognomic elements in art.

What is missing from the formalist approach to painting is a serious desire to study meanings beyond the purely visual configuration. Consider the following opinions, all of them formalist-based, which acknowledge or suppose the existence of meanings/ feelings. Ben Heller writes that Noland "has created not only an optical but an expressive art"[15] and Michael Fried calls Noland's paintings "powerful emotional statements."[16] However, neither writer indicated what was expressed nor what emotions might be stated. Alan Soloman has written of Noland's circles, which earlier he had called "targets":[17] "some are buoyant and cheerful . . . others are sombre, brooding, tense, introspective,"[18] but this "sometimes I'm happy, sometimes I'm blue" interpretation is less than one hopes for. It amounts to a reading of color and con-

centric density as symbols of emotional states, which takes us back to the early 20th-century belief in emotional transmission by color-coding.

According to Greenberg the Hard Edge artists in his *Post Painterly* exhibition "are included because they have won their 'hardness' from the softness of Painterly Abstraction."[19] It is certainly true that "a good part of the reaction against Abstract Expressionism is . . . a continuation of it," but to say of the artists, "they have not inherited it (the hard edge) from Mondrian, the Bauhaus, Suprematism, or anything that came before," is exaggerating. Since Greenberg believes in evolutionary ideas, and his proposal that Hard Edge artists come out of gestural ones shows that he does, it is unreasonable to sever the later artists from the renewed contact with geometric abstract art which clearly exists. If we omit Greenberg's improvisatory painters, such as Francis, Frankenthaler, Louis, and Olitski, and attend to the more systemic artists, there are definite connections to earlier geometric art. Kelly, Smith, and Poons had roots in earlier geometric art, for example, and it is hard to isolate modular painting in New York from international abstract art. What seems relevant now is to define systems in art, free of classicism, which is to say free of the absolutes which were previously associated with ideas of order. Thus, the status of order as human proposals rather than as the echo of fundamental principles, is part of the legacy of the 1903–13 generation. Their emphasis on the artist as a human being at work, however much it led, in one direction, to autobiographical gestures, lessened the prestige of art as a mirror of the absolute. Malevich, Kandinsky, and Mondrian, in different ways, universalized their art by theory, but in New York there is little reliance on Platonic or Pythagorean mysteries. A system is as human as a splash of paint, more so when the splash gets routinized.

Definitions of art as an object, in relation to geometric art, have too often consolidated it within the web of formal relations. The internal structure, purified of all reference, became the essence of art. . . .

The essentializing moves made by Newman to reduce the formal complexity of the elements in painting to large areas of a single color, have an extraordinary importance. The paintings are a saddle-point between art predicated on expression and art as an object. Newman's . . . *Stations of the Cross* represent both

levels: the theme is the Passion of Christ, but each Station is apparently non-iconographical, a strict minimal statement. Levels of reference and display, present in all art, are presented not in easy partnership but almost antagonistically. When we view art as an object we view it in opposition to the process of signification. Meaning follows from the presence of the work of art, not from its capacity to signify absent events or values (a landscape, the Passion, or whatever). This does not mean we are faced with an art of nothingness or boredom as has been said with boring frequency. On the contrary, it suggests that the experience of meaning has to be sought in other ways.

First is the fact that paintings . . . are not . . . impersonal. The personal is not expunged by using a neat technique; anonymity is not a consequence of highly finishing a painting. The artist's conceptual order is just as personal as autographic tracks. Marcel Duchamp reduced the creative act to choice and we may consider this its irreducible personal requirement. Choice sets the limits of the system, regardless of how much or how little manual evidence is carried by the painting. Second is the fact that formal complexity is not an index of richness of content. . . .

A possible term for the repeated use of a configuration is One Image art (noting that legible repetition requires a fairly simple form). Examples are Noland's chevrons, Downing's grids, Feeley's quatrefoils, and Reinhardt's crosses. The artist who uses a given form begins each painting further along, deeper into the process, than an expressionist, who is, in theory at least, lost in each beginning; all the One Image artist has to have done is to have painted his earlier work. One Image art abolishes the lingering notion of History Painting that invention is the test of the artist. Here form becomes meaningful, not because of ingenuity or surprise, but because of repetition and extension. The recurrent image is subject to continuous transformation, destruction and reconstruction; it requires to be read in time as well as in space. In style analysis we look for unity within variety; in One Image art we look for variety within conspicuous unity. The run of the image constitutes a system, with limits set up by the artist himself, which we learn empirically by seeing enough of the work. Thus the system is the means by which we approach the work of art. . . .

The application of the term "systemic" to One Image painting is obvious, but, in fact, it is applied more widely here. It refers to

paintings which consist of a single field of color, or to groups of such paintings. Paintings based on modules are included, with the grid either contained in a rectangle or expanding to take in parts of the surrounding space (Gourfain and Insley respectively). It refers to painters who work in a much freer manner, but who end up with either a wholistic area or a reduced number of colors (Held and Youngerman respectively). The field and the module (with its serial potential as an extendable grid) have in common a level of organization that precludes breaking the system. This organization does not function as the invisible servicing of the work of art, but is the visible skin. It is not, that is to say, an underlying composition, but a factual display. In all these works, the end-state of the painting is known prior to completion (unlike the theory of Abstract Expressionism). This does not exclude empirical modifications of a work in progress, but it does focus them within a system. A system is an organized whole, the parts of which demonstrate some regularities. A system is not antithetical to the values suggested by such art world word-clusters as humanist, organic, and process. On the contrary, while the artist is engaged with it, a system is a process; trial and error, instead of being incorporated into the painting, occur off the canvas. The predictive power of the artist, minimized by the prestige of gestural painting, is strongly operative, from ideas and early sketches, to the ordering of exactly scaled and shaped stretchers and help by assistants.

The spread of Pop Art in the 60's coincides with the development of systemic abstract painting and there are parallels. Frank Stella's paintings, with their bilateral symmetry, have as much in common with Johns' targets as with Reinhardt and, if this is so, his early work can be compared to Yves Klein's monochromes, which were intentionally problematic. The question "what is art?" is raised more than the question, "is this a good example of art?" This skeptical undercurrent of Stella's art, in which logic and doubt cohabit, is analogous to those aspects of Pop Art which are concerned with problems of signification. Lichtenstein's pointillism and Warhol's repetitive imagery are more like systemic art in their lack of formal diversity than they are like other styles of 20th-century art. A lack of interest in gestural handling marks both this area of Pop Art and systemic abstract art. In addition, there are artists who have made a move to introduce pop refer-

ences into the bare halls of abstract-art theory. One way to do this is by using color in such a way that it retains a residue of environmental echoes; commercial and industrial paint and finishes can be used in this way. . . .

Irving Sandler's term for systemic painting, both abstract and pop, is "Cool-Art,"[20] as characterized by calculation, impersonality, and boredom. "An art as negative as Stella's cannot but convey utter futility and boredom"; he considers conceptual art as merely "mechanistic." What Sandler has done is to take the Abstract Classicist label and then attack it like a Romantic, or at least a supporter of Abstract Expressionist art, should. He is against "one-shot art" because of his requirement of good artists: "they have to grope." This quotation is from a catalogue of *Concrete Expressionism,* his term for a group of painters including Al Held. He argues that theirs is struggle painting, like expressionism, but that their forms are "disassociated," his term for nonrelational. Thus Sandler locates an energy and power in their work said to be missing from hollow and easy "Cool-Art." The difference between so-called Concrete Expressionist and Abstract Expressionist paintings, however, is significant; they are flatter and smoother. Al Held's pictures are thick and encrusted with reworkings, but he ends up with a relatively clear and hard surface. The shift of sensibility, which this exhibition records, is evident in his work. Held may regard his paintings as big forms, but when the background is only a notch at the picture's margin, he is virtually dealing with fields.

The pressing problem of art criticism now is to re-establish abstract art's connections with other experience without, of course, abandoning the now general sense of art's autonomy. One way is by the repetition of images, which without preassigned meanings become the record and monument of the artist. Another way is by the retention of known iconography, in however abbreviated or elliptical form. . . . Circles have an iconography; images become motives with histories. The presence of covert or spontaneous iconographic images is basic to abstract art, rather than the purity and pictorial autonomy so often ascribed to it. The approach of formalist critics splits the work of art into separate elements, isolating the syntax from all its echoes and consequences. The exercise of formal analysis, at the expense of other properties of art, might be called formalistic positivism.[21] Formal

analysis needs the iconographical and experiential aspects, too, which can no longer be dismissed as "literary" except on the basis of an archaic estheticism.

*NOTES*

[1] William Rubin. "Younger American Painters," *Art International,* Zurich, 4, 1, January 1960, pp. 24–31.

[2] The Jewish Museum, New York, 1963, *Toward a New Abstraction.* Introduction by Ben Heller.

[3] Clement Greenberg. "American-Type Painting," *Art and Culture,* Boston, 1961, pp. 208–229.

[4] Fogg Art Museum, Harvard University, Cambridge, Mass., 1965, *Three American Painters: Kenneth Noland, Jules Olitski, Frank Stella.* Text by Michael Fried.

[5] Deductive structure is the verbal echo and opposite of what William Rubin called " 'inductive' or indirect painting" but the phrase, which meant painting without a brush, never caught on.

[6] George Rickey. "The New Tendency (Nouvelle Tendence Recherche Continuelle)", *Art Journal,* New York, 13, 4, Summer 1964, p. 272.

[7] See the author's "On The Edge," *Architectural Design,* London, 30, 4, April 1960, pp. 164–165.

[8] The formal difference between wholistic and hierarchic form is often described as "relational" and "nonrelational." Relational refers to painting like that of the earlier geometric artists, which are subdivided and balanced with a hierarchy of forms, large-medium-small. Nonrelational, on the contrary, refers to unmodulated monochromes, completely symmetrical layouts, or unaccented grids. In fact, of course, relationships (the mode in which one thing stands to another or two or more things to one another) persist, even when the relations are those of continuity and repetition rather than of contrast and interplay. (For more information on Hard Edge see John Coplans: "John McLaughlin, Hard Edge, and American Painting" *Artforum,* San Francisco, 2, 7, January 1964, pp. 28–31.)

[9] The Jewish Museum, *op. cit.*

[10] The Los Angeles County Museum of Art, Los Angeles, 1964, *Post Painterly Abstraction.* Text by Clement Greenberg.

[11] *Optical* has, at present, two meanings in art criticism. In Greenberg's esthetics color is optical if it creates a purely visual and nontactile space. It is one of the properties of "Color Painting," the term Greenberg applied to Louis and Noland in 1960 (which has been widely used, including adaptations of it such as William Seitz's "Color Image"). It is curious, since color is mandatory for all painting, that one way of using it should be canonized. The other meaning of *optical,* and its best-known usage, is as the optical in Op Art, meaning art that shifts during the spectator's act of perception.

[12] Clement Greenberg. "Modernist Painting," *Arts Yearbook,* 4, New York, 1961, pp. 101–108.

[13] Fogg Art Museum, *op. cit.*

[14] James A. McNeill Whistler. *Ten O'Clock,* Portland, Maine, Thomas Bird Mosher, 1925.

[15] The Jewish Museum, *op. cit.*

[16] Fogg Art Museum, *op. cit.*

[17] The Jewish Museum, *op. cit.*

[18] *XXXII International Biennial Exhibition of Art,* United States Pavilion, Venice, 1964, pp. 275–276. Text by Alan R. Solomon.

[19] The Los Angeles County Museum of Art, *op. cit.*

[20] Loeb Student Center, New York University, New York, 1965, *Concrete Expressionism.* Text by Irving Sandler.

[21] Adapted from Leo Spitzer's "imagistic positivism," by which he deplored literary critics' overemphasis on imagery at the expense of a poem as a whole.

# 25. WHAT'S NEW FOR ART?

## John Russell

### INTRODUCTION

As we enter the last two decades of the twentieth century, we can look back over the years and trace with some assurance the effects of the dramatic innovations artists introduced during the first two decades of the century. There has been time for that. It is quite another matter to look around from this point in the century and sort out the truly significant from the rest, much less to prophesy about the nature of art in the years that lie ahead. We could test our position, after a fashion, by asking whether, in the early 1880s, one would have been likely to have predicted with creditable accuracy the development of Cubism and De Stijl. If hindsight now can find clues, it is doubtful that foresight then could have provided the proper combination of data for the leap into respectable clairvoyance. There are those who have for some time prophesized the end of art in any traditional sense of it—at least the end of painting and sculpture in anything like their accustomed forms. But the sense of history is a preserving force firmly adhered to human consciousness, and traditions are stubborn. Even so, as the past affirms, the long, long continuity of art has been accompanied by ever innovative mutations of its forms. It seems reasonable to assume that the process goes on.

This anthology closes with a selection by an art critic that surveys the recent art scene, reflects on the conditions which pertain, and ends on a note of cautious optimism. For further reading see Robert Smithson, "A Sedimentation of the Mind: Earth Projects," *Artforum*, VII, 3 (September 1968); Sidney Tillim, "Earthworks and the New Picturesque," *Artforum*, VII, 4 (December 1968); Jack Burnham, *Beyond*

*Modern Sculpture* (1968); Christo, *Wrapped Coast, One Million Sq. Ft.* (1969), a photographic documentation; Diane Waldman, *Carl Andre* (1970); Kynaston McShine, ed., *Information* (1970); Edward F. Fry, ed., *On the Future of Art* (1970); Rudolf Arnheim, *Entropy and Art* (1971); Maurice Tuchman, *Art and Technology* (1971); Douglas Davis, *Art and the Future* (1973); Harold Rosenberg, *The De-Definition of Art* (1973), and *Art on the Edge* (1975); John Russell, *The Meanings of Modern Art*, 12 vols. (1974–1975)—small, well-illustrated volumes published by The Museum of Modern Art, New York, and a revised edition in one volume (1981); Edward Lucie-Smith, *Art Now* (1977); Barbara London, "Independent Video: The First Fifteen Years," *Artforum*, XIX, 1 (September 1980), tracing the development of video art in the United States and, in the same issue, Barbara London and Lorraine Zippay, "A Chronology of Video Activity in the United States: 1965–1980"; and "Words and Wordworks," *Art Journal*, XLII, 2 (Summer 1982).

Throughout the 1950s and '60s . . . the future of art was very much a live issue. Painting might be referred to as "bow and arrow art" by those who thought of the future of art in terms of a typewritten message, a ditch in the desert, a suitcase filled with rotting cheese, or free access to an electronic toyshop; but the thralldom of color, in particular, was as strong as ever. There was color as extension, in the stripe paintings of Kenneth Noland; color liberated from drawing, as in the tinted vapors that were as if breathed onto the canvas by Jules Olitski; and color as conspiracy, in paintings by Ad Reinhardt in which time was recruited as an ally and only a long, slow look would reveal the true nature of the picture. . . .

The priority of painting was . . . much in dispute throughout the 1960s. There were many reasons for this. There was the argument that it was in sculpture that truly revolutionary work was being done. There was the argument that a new world needed not "a new art" but new kinds of art. There was the argument that the fixed and finite physical nature of painting was bound to rule it out as the locus of some of the deepest of human concerns at a time when human expectations and motivations were in a state of radical change. There was the argument that both painting and painters were being exploited by economic forces of a detestable sort. There was the argument, finally, that the self-exploratory activities of painting were entering their terminal phase. Ad Reinhardt, for one, believed that he was painting the last pictures which would ever need to be painted. Frank Stella in the late 1970s renewed the potential of painting by annexing for it the energies inherent in the third dimension. What resulted was a form of painted sculpture which in its impact on the viewer was both galvanic and unsettling.

There was something in each and all of these arguments. Painters are people, before and after they are painters. They are as dismayed as the rest of us by what is being done to other people, and to the world, in our name. Painting is an edgy, lonely, uncertain business, and it is very disagreeable to feel that the end product of it is being used to make big money fast for a

497

pack of speculators. It is legitimate in times of crisis for a painter
to crave something more direct in the way of communication with
other people. In bad times the to-and-fro of human contact is
more than ever essential to us, and if that to-and-fro can have
something of the urgencies of art, so much the better. Traditional
art has a traditional audience, and that audience still excludes a
large part of the human race. We should not ignore one of the
central facts of our time: that new populations and new publics
are coming of age all over the world. Such people have the same
rights, in matters of art, as the handful of poets, connoisseurs and
fellow artists who alone appreciated the best new art before
1914. So it is natural to speculate as to whether the future of
art may not lie in the new forms of communication in which our
age has specialized. As recently as 1945 we were still deeply con-
servative in such matters. The formulas of the art world had set
fast, like pack ice, and showed no sign of melting. The rituals of
the opera house and the symphony orchestra had not changed
for more than half a century. Going to the theater meant sitting in
an auditorium in attitudes unchanged since the time of Sophocles
and gazing across the footlights at a play that lasted exactly two
and a half hours. A book bound in paper had something wrong
with it. A phonograph record was both heavy and fragile and
stopped after four minutes. Films were something you saw in a
movie house; and movie houses, like the Moscow subway, were
vast, ornate, and designed to blind the customer to the drabness
of life outside.

All these things were accepted as immutable. Yet it took a bare
25 years for us to adapt to improvised theater, aleatory music,
free-form architecture, magnetic tapes that run for three hours or
more, and dance dramas that owed nothing to the formalized
miming of *Swan Lake*. In all these and many other domains we
saw what Mondrian had meant when he said almost 50 years
earlier that "we are at the end of everything *old.*" Sitting through
the 25-minute monologue which constitutes Samuel Beckett's play
*Not I*, listening to Karlheinz Stockhausen's electronic *Hymnen,*
watching Merce Cunningham and his dance company give a
completely new idea of the ways in which life can be spelled out
on the stage, we might find it really rather odd that much of
painting and sculpture should still be stuck with the materials of
Rembrandt and Rodin. Perhaps it is hardly less odd that so many
of us should still think of painting and sculpture as separate enti-

498

ties, defined once and forever, when we acknowledge that the future of music may depend on new sources of sound and the future of the theater on modes of expression that owe nothing to theater as it was understood by the public of Alfred Lunt and Lynn Fontanne.

What we have witnessed, in this context, is the normalization of the avant-garde on the one hand and the abhorrence of existing conventions on the other. There is nothing new about new sources of sound: the symphony of factory chimneys as it was performed in Russia not long after the Revolution is evidence enough of that. There is nothing new about the boredom which many people feel when faced with the stereotyped subscription concert, the ritual "gallery opening" with its herd of free-loading nonentities, or the evening at the theater which costs a fortune and offers very lean pickings in terms of pleasure or enlightenment. Nor is there anything new about the freedom to restructure the arts, or to borrow freely and at will from one discipline in the service of another. To hear Kurt Schwitters recite his wordless poem was one of the great oratorical experiences of the 1920s and '30s. Poetry has arrogated to itself a total liberty on the page ever since Mallarmé published "Un Coup de Dés" in 1897. The Douanier Rousseau fancied himself as a playwright, and so did Picasso. Kandinsky wrote a drama to be performed by music, light and moving stage parts alone. But all these activities were incidental to a strenuous creativity in other domains; and they were done in a world which had not yet learned to exploit art for immediate advantage.

That is where the difference lies. There is something radically wrong with a world in which the effective life of most new books is between two and three weeks and in which works of art which are part of our universal inheritance can be hidden in vaults until the bankers' consortium which owns them can make a sufficient return on its investment. Things of this kind create a climate in which it is inordinately and unnecessarily difficult to produce good new work. They are the enemies of art; and in the 1960s artists began to fight back in the only way that was available to them— by making art that in one way or another was immune to the system.

The new art in question was of many kinds. Much of it was, and is, no good at all. How could it be otherwise? Art cannot function without an agreed social context. There must be some kind of

contract, formulated or not, between the artist and the public which he wishes to reach. Contrary to popular belief, no art of consequence was ever produced in isolation. But there are times when both art and its audience are refugees from an environmental madness: this was the case with Dada in its Swiss and German phases, and it was the case with many manifestations of the new in the 1960s. When Claes Oldenburg set up his "Store" at 107 East Second Street, New York City, in the winter of 1961–62 and sold his simulated ray guns, wedding bouquets, wristwatches, pieces of pie, gym shoes, jelly doughnuts, airmail envelopes and inscribed birthday cakes, as a standard store would sell the real thing, he got under the guard of the system. Art was flourishing, but in what looked to be a nonart situation. . . . But, as with Dubuffet, high art ended by getting its way; and those tiny and resolutely demotic pieces by Claes Oldenburg have an imaginative vitality which is very rare in mainstream sculpture of their period.

Initially in 1964 the *Giant Toothpaste Tube* came across as an act of defiance. What could such an object have to do with high art? But in time the almost empty tube of toothpaste took shape in our minds as a traditional reclining figure. And if the detached top of the tube still contradicted this—well, there remained the parallel of the Crusaders' tombs of the 14th century in Europe, where the dead warrior was sometimes portrayed with his helmet at his side. Besides, Oldenburg knew that changes of scale always bring with them changes of implication. The humble clothespin when magnified and cast in bronze and steel assumes an imperious hominoid look, as if it were halfway through changing into the image of a born leader of men, with his two feet set firmly apart, his left hand tucked into his belt and his big ears cocked to catch the latest news. The toothpaste piece and the clothespin piece are ten years apart, but the aesthetic behind them is the same.

That we have to give the name of "sculpture" to the *Giant Toothpaste Tube* is in itself instructive, by the way. If we consider that the same word is applied to a Calder mobile, a fluorescent light piece by Dan Flavin, a totem in stainless steel by David Smith and a length of felt hung from a nail by Robert Morris, it will be clear that the word "sculpture" now has wider connotations than the word "painting." The emancipation of

sculpture is one of the discreeter romances in the cultural life of our century. . . .

By 1970 a vast machinery of promotion and speculation had fastened onto the making of art. . . . How this came about is a complex question. In part it was an authentic and justified tribute to the new role of art in the imaginative life of the United States. People acknowledged that something extraordinary had happened in art. They might not like it, any more than they liked the music of Elliott Carter or the prose of Gertrude Stein, but they knew that these things resounded to the credit of the United States. To wish to get a piece of the action is intrinsic to human nature. It is fundamental to the seduction of art that we hope to become what we look at; and if we can look at it every day in our own house the process may perhaps be accelerated. That was the most reputable of the motives which led people to pay high prices for modern art.

Other factors should be spelled out. New money breeds new collectors, and new collectors do not always have the patience, the knowledge and the discrimination which are basic to the enjoyment of Old Master painting. Much of the best modern art calls for these attributes, but in the art of the 1960s there was much that was altogether readier of access. Ambiguity and complexity played no part in it. There was no question of lingering before it as we linger before Giorgione or Vermeer. Frank Stella was categorical about that in 1964: "One could stand in front of any Abstract Expressionist work for a long time, and walk back and forth, and inspect the depths of the pigment and the inflection and all the painterly brushwork for hours. But I wouldn't ask anyone to do that in front of my paintings. To go further, I would like to prohibit them from doing that in front of my paintings. That's why I make the paintings the way they are." About much of the art of the 1960s there was a bluntness and a blankness which in time gave it the status of an ostentatious form of traveler's check.

Something in this bluntness and blankness came from a revulsion against the art of the 1940s and early '50s. Among the ideas most in disfavor were that of the heroic but foredoomed failure, the approximation that could never become complete, and the acting out, either on the canvas or in three dimensions, of any kind of private drama. There was believed to be something almost

501

obscene about personalized brushstrokes, about sculpture that
bore the mark of the shaping hand and about the traditional Euro-
pean idea of the balanced composition. ("With so-called advanced
painting you should drop composition," said Stella.) Much of
this was a natural reaction against the extreme subjectivity and
the secular mysticism of much that had been made famous since
1950. But it was exploited by a public that did not want to look
hard for more than a few moments and by promoters who pre-
ferred work that avoided the classic stance—the "now and never
again," the "here and nowhere else"—of European art. From this
emerged the impersonal series-painting of the 1960s, and the
graphics industry which was often no more than an expensive
form of souvenir hunting, and the multiples which cashed in on
the prestige of art but ran none of art's risks. The remarkable
thing was not that this situation should have come about, but
rather that good work was done from time to time in spite of it.

And good work was done, right through the 1960s and the
1970s. The wish to make a monumental statement did not die out,
either. Whether in the Ocean Park series of Richard Diebenkorn,
or in the three-dimensional autobiography of Joseph Beuys, or in
the enormous paintings in which Jennifer Bartlett took image
after image to the very point of disintegration, only to bring them
safely back again, there were statements of a grand, searching,
unsubdued sweep that spoke up for mankind as clearly as they
spoke up for art. There were also compound statements, in which
art raided archaeology, raided natural history, raided cartography,
raided the skies and raided the sea-bed. Someone who did all this
and much else besides, in painting and sculpture alike, was Nancy
Graves. In her *Trace* an informed viewer will find the new open-
ness of form that we expect from sculpture since David Smith and
Anthony Caro. He will find an incorporeal lightness and radiance
of color to which neither Smith nor Caro aspired. And he will
also find a marriage, well and truly consummated, between art
and natural history.

So there were people who stayed with gallery art, museum art,
continuity art. But art did go underground, all the same. It had
gone underground before, when nobody wanted it: when the
audience for the best art numbered six or seven people and the
artist—Picasso, at his very best, and Matisse, at his very best—
did not even think of putting it on show. Now it went under-

ground for the opposite reason: because everybody wanted it. As insistently as before 1914, the times called for an alternative art. It took many forms; but what these forms had in common was that they questioned the nature of art—and, more especially, of art that was susceptible to instant marketing. Art was to go about its own concerns, in private, and if necessary take forms that denied what was fundamental to marketed art: the possibility of possession.

No one can buy a work of art that consists in the temporary and all but invisible readjustment of the city that we live in. If a work of art exists in idea form only, the idea in time will belong to everyone, and the typewritten statement that can be bought and sold is no more than an outdated token. The alternative art of the late 1960s and early '70s took forms that were ephemeral, impalpable, sometimes purely notional. Sometimes it depended on the participation of the viewer: and although this in itself was not new—every work of art has always been completed by the person who looks at it—there was often a willed ephemerality about the new art which had not been met with before.

The instruments of art had never before been so varied. At one extreme there was brought into play every newest refinement of technology: the video-tape, the hologram that hung in the air, the android or humanized robot that clanked and stumbled along the streets of New York, the computer-generated environment, the labyrinth of light and sound that is activated by the public that penetrates it, the crystals in a glass sphere that turn from solid to gas in response to atmospheric conditions. At the other extreme, there were artists who made art with pebbles picked from the foreshore and a worn-down piece of chalk, or with a folded sheet of carbon paper and a few lines ruled in pencil. There were people who went further still and said, with Joseph Kosuth, "I want to remove the experience from the work of art." ("Actual works of art," he also said, "are little more than historical curiosities.") On this last reading, art as it had existed previously was a tautology: an acting-out, in other words, of something that existed already, in definition form, and did not need to be made visible.

These were heady matters, as tempting to the near-genius as to the charlatan, and as accessible to the near-saint as to the ravening opportunist. Among the technophiles there were some who simply ran wild, like small boys let loose in a candystore. Among

the pseudo-philosophers there were some who could not tell "its" from "it's," let alone master Plato or Kant. Sometimes the wish that art once again become private was simply overridden by society. Claes Oldenburg once described how this came about; and his remarks ring true in other and later contexts. "I really don't think you can win. . . . The bourgeois scheme is that they wish to be disturbed from time to time, they like that, but then they envelop you and that little bit is over, and they are ready for the next. . . ." Sometimes, also, elements from marketed art, and from the market situation, made their way in, unbidden. The promotion of personality is as repulsive in this context as the promotion of art. The aesthetics of undifferentiated experience had been put forward to great effect by John Cage, in many of his later compositions, and by Andy Warhol (above all, in his films). It was dismal when the same point of view motivated people who had neither talent nor spontaneous impulse. Where Dada had evolved in an economy of imminent starvation, the art of the early 1970s evolved in an economy dominated by technical super-abundance; and something of the billion-dollar silliness of that economy rubbed off on the art.

It was not a healthy situation. On the one hand were artists who financially, and in terms of glamour, had replaced the movie stars of the 1930s as objects of popular attention. On the other were artists who went from town to town like wandering friars. Lodged and fed by small groups of sympathizers, they made and unmade their art wherever there was an audience, no matter how small. Both were in what is called "art"; yet on the one side a major work cost over a hundred thousand dollars, while on the other there might well be nothing to sell. Each group was pressured, however strangely, by the existence of the other. The established artist was rare in the early 1970s who did not feel that in some way he was the last of his line; many bought time, and bought silence, by stratagems of their own devising.

Absence was one of these stratagems. James Joyce's famous formula for survival ("Silence, exile, cunning") was taken up in one form or another in the 1960s and '70s by artists who wished to carve out their own space in the world. One of these was R. B. Kitaj, an American painter long resident in London who works with the recent past of Europe in much the same way as the Old Masters worked with the mythology of Greece and Rome. A voracious and adventurous reader, he constructs from his reading

a vision of our times which he then sets down on canvas, mixing old-style "good drawing" with pictorial devices of altogether more recent date. *The Autumn of Central Paris* has for its main subject a Parisian café of the kind that Pierre Bonnard painted many times over. At that café is seated among others the German-born critic and essayist Walter Benjamin, who killed himself when the German army entered Paris in 1940. The nonchalance of the party at the table is well offset by the man with the pick, who is taking apart not only the sidewalks on which they are sitting but the society which Benjamin had evoked with such eloquence in his unfinished study of Paris.

Paris after World War II did not do as much, directly, for the American expatriate artist as it had done before and after World War I. But it did do something indirectly, most notably in the case of Ellsworth Kelly. Kelly lived in Paris from 1948 to 1954, at a crucial period in his life, and for this and other reasons his work has a particularly rich, complex and liberal derivation. There is a grand assurance about his use of color which has not quite been equaled by any other American painter. The shapes in his paintings could not be more abstract, but they are never either arbitrary or doctrinaire. A Kelly which many people supposed from its title to be an evocation of the Brooklyn Bridge was in point of fact derived from a drawing of a sneaker. His many triangular paintings originated from the look of a scarf which he happened to see on the nape of the neck of a young girl in Central Park. The rectangle and the ovoid form in *Red Blue Green* are further examples of Kelly's working method, in that they derived initially from (i) the shape of the window in his studio, (ii) the way in which that shape was distorted when it reappeared as a reflection on the other side of the street. These accidental, "given" motifs were refined and rethought until they were in perfect equilibrium, with the red shape and the blue shape ideally coordinated with the green one.

Sometimes in the period we are discussing an artist could "keep his distance" simply by staying home. This was the stratagem of Joseph Cornell, who occupied himself in his tiny house in Flushing, New York, with a form of poetic object—the collaged box—which served him for a lifetime. Himself an all-time champion stay-at-home, he nourished his imagination with notional journeys —in time, in space, and in matters of the heart. In time, he preferred the Romantic period in Europe. In space, he preferred the

run-down European hotels in which his favorite 19th-century French poets eked out much of their lives. In matters of the heart his imaginary entanglements were with the great ballerinas—Cerrito, Taglioni, Grisi and Fanny Elssler—of the 1840s. He was also fascinated by archaic modes of transport. A long-extinct hotel in Belgium, a four-horse coach to a famous battlefield, a bird and a bell—these and other things add up to an image as magical as anything of its kind since Miró's *Object* of 1936.

Works such as those by Kitaj, Kelly and Cornell that I have just discussed have nothing in common except that all of them were studio products. One man in one room made them. But the studio product was not the whole of art in the 1960s and '70s, and indeed to many people it seemed to be an activity too much tied to an earlier era. Why should not the whole world be our raw material, the overarching sky our studio ceiling, and the puissance of our technology our paints and brushes and hammer and chisel?

Robert Smithson was one of the great proponents of this point of view. He was a mixture of poet, filmmaker, landscape gardener, draftsman, geologist and philosopher. He liked to work on a vast scale and in landscapes for which Nature appeared to have no further use. Both in the *Spiral Jetty* (Fig. 66) and in the *Amarillo Ramp* his working methods paralleled the use of pouring and dripping in Abstract Expressionism. But where the Action Painters had poured and dripped on a finite canvas, Smithson claimed for himself prerogatives hardly less absolute than those of Jehovah in the Old Testament. He remade the world in an image of his own devising. But he did not forget that all such images have their echoes in the past. The spiral in the *Jetty* is a form that had dominated the imagination of artists and architects from Borromini in the 17th century to Tatlin in the 20th. Smithson also knew that the sun has been figured as a spiral nebula of smaller suns beyond number. And as the critic Joseph Masheck has pointed out, Smithson was aware of "the Jungian concept of the *circumambulatio*—a compulsive spiraling-in to one's undiscovered self." What we see in these gigantic works is not a privileged playground, but an attempt to come to terms with American landscape on a scale of which Walt Whitman would have approved.

A paradoxical situation then arose, by which major adventures in art were subject to a form of almost clandestine emigration. The best sculptures of Anthony Caro were shipped out of London, for instance, to American private collections; two German col-

66. Robert Smithson, *Spiral Jetty*, 1970, Black rock, salt crystals, earth, and red water (algae), Coil 1500' long, approximately 15' wide (Great Salt Lake, Utah, Estate of Robert Smithson and John Weber Gallery; Photo: Gianfranco Gorgoni)

lectors made away with as much of the best American art as they could get their hands on; it was in Holland that Robert Morris and other American artists were encouraged to carry out environmental works for which no bidders were found in the United States. In this way there was reestablished on a worldwide scale something comparable to the pacific International which had existed in Europe before 1914. The energies inherent in the best modern art were in demand everywhere: in Japan, in Australia, in Israel, and not least in France, where most resolute efforts were made to recapture the ancient prestige of Paris as the city most receptive to the new.

All this gave a look of health and vigor to a situation which in point of fact was short of both these qualities. In America museums were built at enormous expense, only for the trustees to find that they could barely afford to keep them open, let alone find good things to put in them. To many younger artists the museum system as a whole seemed grossly paternalistic. Museums mirrored, in their view, a power structure and a chain of command which had proved so disastrous in other departments of

life that it could not go unchallenged in art. They also stood for a star system in which people who themselves were in no way creative were paid to set one artist above another. Yet such was the elasticity of the museum system, and such the self-preservative instinct of society, that even those artists who had taken what amounted to a vow of apostolic poverty were likely to find in time that the museums were ready to take them on their own terms. No form of art was so resolutely antispectacular that some ambitious curator would not put it on view. The fear of being left out is as contagious in art as it is in every other area of life; Wilfred Trotter's *Instincts of the Herd in Peace and War* (1923) has yet to go out of date.

From this there results a profound uneasiness: and, with that, a tendency to reverse roles in ways that would have been unthinkable 50 years ago. Collectors once held on to their collections; today they are tempted to trade them in as they trade in their automobiles. Museum directors once planned for eternity when they made a new acquisition; today nothing in their world is stable—least of all their own tenure of office. Artists once kept the past continually in mind, haunting it as Cézanne haunted the Louvre; today they may think, with the sculptor Donald Judd, that "if the earlier work is first-rate it is complete," and that that very completeness makes it no longer relevant. At the age of 40 Mark Rothko, Barnett Newman, David Smith and Willem de Kooning had still a protective obscurity in which to work; an artist of that age today may well seem to his juniors to be far gone in fogeydom—and the uncomplaining instrument, what is more, of a corrupt and loathsome system.

If we are to feel our way as to what will rank as art in the last decade of our century we have to bear in mind two fundamental aspects of the general situation. One is a degree of technological omnipotence which in the nature of things will grow ever greater. It is within our power to control and shape the environment in ways never before precedented, and perhaps to guarantee for our physical selves a longevity which formerly belonged to fable alone. Art would not be art if it did not negotiate with these new possibilities.

Art would also not be art if it did not sometimes take the simplest of everyday materials and give them an unprecedented eloquence. Over a period of around ten years, for instance, Robert Morris worked on the potentialities of felt as a sculptural medium.

Felt in his hands could be made to stand up like steel or aluminum. It could roll on the ground like a gundog exhausted from the chase. It could fulfill any number of rhetorical purposes. It could also cross-refer to current developments elsewhere in art. . . .

The other factor which we should watch for is something humbler and more conventionally human. It is what is called in German *Torschlusspanik:* the terror of the closing door. The end of art, as art has hitherto been conceived, is more than "the end of an era." It is the end of a god: the death of something which brought reassurance, and brought consolation, and brought an unshakable equanimity. It is very disagreeable, as I said at the outset of this survey, to think that art will one day come to an end. And it is particularly disagreeable when the art of the recent past has been of very high quality.

It is for this reason that the status of art has been claimed for activities which in themselves might seem to be no more than novelty hunting of a particularly fatuous kind. It is for this same reason, and to relieve the strain upon those rare individuals who still produce finite works of art at the highest level, that such efforts have been made to bring the notion of art into a public (if not actually into an anonymous) domain. If everything is art, and if the life of everyday can be monitored in terms of art, then we shall no longer have to apply to individual exertions the dreaded words "not good enough." We should aim, therefore, to arouse in every human being the kind of superior awareness which is in itself a form of creativity. If this were to become universal—so the argument runs—the gap between art and life would be closed once and for all.

That everyone should be an artist is, on one level, the noblest of dreams: the enfranchisement of one man in a million would give way to the enfranchisement of everyone, without exception. On a less conscious level it stands, however, for something quite different: the wish to spread among all mankind, and therefore to spread very thin, the responsibility for what is considered in the Bible, and in mythology, as a blasphemous act. It is not for mankind—so the primeval belief ran—to rival the gods. When Marsyas with his reed pipes challenged Apollo to a trial of skill, Apollo had him flayed alive. When Orpheus made music so beautiful that it overthrew the existing order of things, the gods saw to it that he lost his beloved Eurydice and was torn apart

by Maenads. When the Hebrews got above themselves and tried to build a tower that would reach to Heaven, Jehovah put an end to it by destroying the unity of language that alone made possible the control of the vast and heterogeneous work force.

Somber warnings, these. Yet in bad times we need to believe that the problems before mankind are not insoluble. We know that the breakdown of art, like the breakdown of literacy, may portend a more general breakdown, and one that is irreversible. If it is forbidden to rival the gods, it is also despicable not to attempt it. That particular rivalry, with all that it involves in the way of risk and terror and possible retribution, may well be the supreme human act: the one that best justifies our existence and may prevent it from coming to an end.

This is not a belief that we need to abandon. Rarely in human history can a decade have begun less well than the 1980s. On every hand, and in every country in the world, the present is matter for misgiving and the future a matter for dread. It is natural that at such a time people should think of art as a thing of the past. But what is natural is not always laudable, and it is a pointless diminution of our status on earth to assume that "art as we knew it" can no longer be counted upon. "Art as *who* knew it?" is the answer to that. Now more than ever we need to remember that art is the constructive act, and that the artist is the person who puts the world together after everyone else has let it go to pieces.

For what is the alternative? The silence of the German poet Friedrich Hölderlin. The silence of the French poet Arthur Rimbaud. The silence in old age of the American poet Ezra Pound. The silence of Moses, in Arnold Schoenberg's unfinished opera, when he realizes that people were turning away from the truths for which he, Moses, could not find the right words. We may never know why Hölderlin went mad, why Rimbaud left Europe to eke out a living in Africa or why Pound abjured the gift of tongues that he had used so unwisely. But we know that one of the last poets in classical Latin literature was right when he said that civilization lives by speech and dies by silence. For "speech," in our present context, we should substitute the image in all its forms, finite or variable.

It is difficult to think of today's world in terms other than those of crisis and emergency. What is at stake is the survival of the earth as a place fit to live on, and of the human race as some-

thing that will bear scrutiny. It was not in conditions such as these that the masters of early modern art grew to manhood; and a certain sympathetic indulgence should, I think, be accorded to those who aspire to be their successors. "What can we know for certain?" is a question which has haunted modern art ever since it was first posed by Cézanne. If it has lately been answered primarily in terms of art's own nature—if art, in other words, has aspired primarily to define itself—the lessons in self-knowledge which we can draw from it is nonetheless valid for being metaphorical. Art has provided us with models of our environment ever since cave paintings conjured up the bulls and the bisons that shook the earth as they passed overhead. It is still fulfilling this same function, whether in the panoramic and posthumous masterpiece of Marcel Duchamp which is now in the Philadelphia Museum, or in such more restricted studies as the miniature forest, to be viewed from what felt like a refrigerated trench, which Robert Morris contributed to an exhibition at The Museum of Modern Art in New York. Art is there to make sense of the world, and it should surprise nobody if over the last 50 years this has become progressively more difficult. In 1930, when Max Ernst made his *Voice of the Holy Father*, many of the secrets of our century were still intact. To open the book of the future was a perilous act: one to be watched, as it is watched in that little picture, with every symptom of dismay. But art could do it, and art until now has dared to do it.

It is possible, too, to be unduly discouraged. The French poet Paul Valéry was very bright indeed as a young man at the turn of this century, and he mixed with people in Paris whose business it was to know what was going on. But, like other very bright people who have been close to the work of their immediate seniors, he took a gloomy view of what was to come. To feel that nothing can be the same again is the most natural of human instincts, and Valéry may well have drawn only assent when he wrote to a friend in 1908 and said, "Will anything great ever again come out of Europe?" I shall have failed in my purpose if I have not convinced the reader that this question called for a full-throated "Yes!" The best art of our century may well remind us of what was written not long ago by the British scientist and Nobel prizewinner P. B. Medawar: "To deride the hope of progress is the ultimate fatuity, the last word in poverty of spirit and meanness of mind."

For no one can foresee in what forms of art the next generation will see itself fulfilled and justified. The poet William Carlos Williams spoke ideally well of the effect of great painting when he said that "It is ourselves we seek to see on the canvas, as no one ever saw us, before we lost our courage and our love." This sense of ourselves redeemed and made whole is the greatest gift which one human being can make to another. Art has always been there to give us that sense of ourselves, and never more so than since the springs of feeling were made over to us, unmuddied, by the Impressionists. Over and over again it has reminded us that all art consoles, and that great art consoles absolutely. What form art will take in the future no one can say; but no sane society will wish to be without it.

# Index

Page numbers of illustrations appear in boldface.